BARRON'S

AP®
Art History

WITH 5 PRACTICE TESTS

FIFTH EDITION

John B. Nici, M.A.

Adjunct Lecturer in Art History (retired)
Queens College
Flushing, New York

Teacher, Advanced Placement Art History (retired)
Lawrence High School
Cedarhurst, New York

for Judy

About the Author

John B. Nici has a master's degree in art history and is retired from teaching at both Lawrence High School in Cedarhurst, New York and at Queens College in Flushing, New York. In 2004 he was the recipient of Queens College's President's Award for Excellence in Teaching by Adjunct Faculty. He has published extensively on art history pedagogy and has presented and published scholarly papers on topics that include Byzantine art, Piero della Francesca, and Delacroix. He is the author of *Famous Works of Art—and How They Got That Way*.

Published by Kaplan, Inc.,
d/b/a Barron's Educational Series
750 Third Avenue
New York, NY 10017
www.barronseduc.com

ISBN: 978-1-5062-6050-1

10 9 8 7 6 5 4 3 2 1

Contents

Content Area: Early Europe and Colonial Americas

Content Areas: Early Europe and Colonial Americas
 West and Central Asia

Content Area: Early Europe and Colonial Americas

Content Areas: Early Europe and Colonial Americas
 Later Europe and Americas

Content Area: Later Europe and Americas

As you review the content in this book and work toward earning that **5** on your AP Art History Exam, here are five things that you **MUST** know above everything else:

Barron's **Essential** **5**

1 **Learn to fully identify each object completely.** Multiple-choice questions may ask you to know all the details about a work (for example: name of artist, if known; name of work; date; period or culture; medium and/or materials; location of architecture).

Examples:
· Funeral banner of Lady Dai (Xin Zhui), 180 B.C.E., painted silk; Chinese: Han Dynasty
· Ogata Korin, *White and Red Plum Blossoms*, 1710–1716, ink, watercolor, and gold leaf on paper; Japanese
· Templo Mayor (Main Temple), 1375–1520, stone, Tenochtitlán, Mexico City, Mexico; Mexica (Aztec)

2 **Study works of art in context.** It is important to know the names of the artists and the titles of the works, but it is *required* to know how these were meant to be seen and understood. You must know a given work's context to understand how the work can be interpreted.

3 **Study in-depth works that are important because of their location.** Many of the works that are now required have significant locations, and it is wise to study how their location influences their design. This is often asked.

Examples:
· Lanzón Stone
· Smithson, *Spiral Jetty*
· Dome of the Rock

4 **Learn vocabulary!** Most of the multiple-choice questions require you to know the basic terms art historians use to discuss great works of art. This is particularly important when discussing ancient and medieval art. Study the vocabulary sections at the end of each chapter. The most common vocabulary terms include **but are not limited to**:
· Painting techniques (including pottery)
· Parts of architectural monuments (like ancient temples and medieval churches)
· Types of printmaking (etching, woodcut, engraving, etc.)
· Methods of sculpture (lost wax process, repoussé, etc.)

5 **Select works that have cross-cultural connections.** On the newly redesigned exam, many questions focus on the interconnections between cultures.

Examples:
· Works from New Spain that show indigenous American and Spanish influence
· European works that show a Japanese influence
· Islamic works that show an influence from Chinese sources

Acknowledgments

For this fifth edition, I would like to thank all those students who generously contributed their essays for use in this book. They are from St. Andrew's Episcopal School in Austin, Texas. They are: Paige Anderson, Anna Booth, Olivia Bowness, Hannah Bray, Allie Calcote, Hector Cantu, Clarisse Chiang, Ellie Claman, Leah Claman, Sienna Del Conte, Virginia Harrell, Lily Hersch, Haley Justiz, Nathan Lietzke, Elizabeth Long, Owen McWilliams, Georgia Northway, Grace Northway, Ava Nykaza, and Christian Zhao. Special thanks to my friend and colleague Marsha Russell for facilitating the St. Andrew's essays.

PART ONE
Getting to Know the AP Exam in Art History

Introduction

HOW TO USE THIS BOOK

Students who come to Advanced Placement Art History, unlike students who take almost any other AP exam, often approach the material afresh at the beginning of the school year, with no prior study and no prior understanding of the subject. This is an extraordinary opportunity for the teacher as well as the student to confront a new subject with no preestablished prejudices. However, because the student has little background and must learn everything from scratch, the course can seem unusually daunting. All those works of art! All those images! All those unfamiliar names! All those vocabulary words! Civilizations rise and fall in only a week's time in an art history classroom. There is definitely a need for this Barron's book.

Ideally, this book serves as a refresher to complement a complete art history course. It does not function to replace any of the excellent survey texts available on the subject, nor does it pretend to duplicate any of the materials available through the College Board. However, it is a good way to easily organize study patterns for students who must deal with hundreds of images and must learn to discuss them in an intelligent way. This book can also double as a ready reference for teachers, students, and devotees of the subject as an educational resource.

Unlike textbooks in math, science, or social studies, art history books do not have review questions at the end of each chapter, and do not summarize what the student has learned. To meet this need, the teacher may wish to use the practice exams as a warm-up to the actual test. The more familiar students are with the actual exam, the more likely they are to score well on it.

A Note to the Student

You should be aware that this book is not a magic bullet to solve a year's worth of lethargy. Optimally it should be used as a complement to the course, but it will also serve well as a systematic study program to prepare you for the exam. By March you should be reviewing the earliest material, slowly going over one art period after another. It is worthwhile going over every image in the book, whether or not it is familiar to you. The more breadth of experience you have, and the greater your understanding of the subject, the more likely you will be able to handle any question that comes your way.

THE ADVANCED PLACEMENT EXAMINATION IN THE HISTORY OF ART: AN OVERVIEW

The Advanced Placement Examination in Art History is a 3-hour test composed of an hour of multiple-choice, followed by a short break, and then 2 hours of free-response. The format is as follows:

SECTION I: MULTIPLE-CHOICE QUESTIONS. 1 hour.

This section features 80 multiple-choice questions. Some of the questions have images accompanying them, some do not. All of the images on the exam will be in color. You may move freely throughout this section. It is wise to answer those questions that you do know immediately and go back to ponder those that might cause a problem.

There is no penalty for guessing! Every answer should be filled in. Nothing should be left blank. If you are told by the proctor that you only have a few minutes left, bubble in all the remaining answers.

This is extremely important because the multiple-choice questions account for 50 percent of the grade!

SECTION II: FREE-RESPONSE SECTION. 2 hours.

This section is composed of six free-response questions, most associated with illustrations. There are two 30-minute essays and four shorter essays that are timed at 15 minutes apiece.

The two 30-minute essays usually allow students to choose from a wide array of options spanning much of the course. More rarely, they address one or two periods. You are free to move among the essays; they are not individually timed. You can answer them in any order, but make sure you answer all of them. Even if you draw a complete blank, do the best you can to respond.

HOW THE TEST IS SCORED

A complicated series of calculations converts the combined raw score of the multiple-choice questions and the free-response essays into a grade of 1–5. A general rule of thumb is that three-quarters of correct responses will earn the candidate a top score of a 5. Two-thirds is a 4, and a little over half is a 3. These are guidelines, of course, but useful benchmarks nonetheless.

The five-point scoring system is standard among all AP exams:

> 5. Extremely well qualified. Almost all colleges and universities accept this score. Suggested college grade equivalent: A
> 4. Well qualified. Accepted by most colleges and universities. Suggested college grade equivalent: A-, B+, B
> 3. Qualified. Accepted by many colleges and universities. Suggested college grade equivalent: B-, C+, C
> 2. Possibly qualified. Accepted by few colleges and universities.
> 1. No recommendation. Not accepted anywhere.

There is no score of 0, although, believe it or not, there are students who submit completely blank exams.

As with every Advanced Placement exam, a predetermined percentage of students earn a final score of a 1, 2, 3, 4, or 5. Care is taken to adjust scores according to the difficulty of the exam. Sometimes an examination that seems fair going into the process turns out to be difficult when students actually take it. Adjustments are made in the final scoring to balance a test that is unintentionally too easy or too difficult.

In May 2019, 24,476 students took the Advanced Placement Examination in Art History. Although that may sound like a huge number, it pales in comparison to most exams; Advanced Placement U.S. History gathered 501,530 students. However, art history, unlike most exams, has six written responses, all of which have to be individually read and scored over the course of one week of intensive grading.

A team of dedicated professionals (college professors, high school teachers, and assessment experts) form a leadership team that sets the standards for the exam before marking. Art historians from all over the United States, indeed from some parts of the world, then gather in Salt Lake City in June to mark the free-response sections of the test. A hundred or so teachers use the standards set by the leadership team as guidelines for scoring. All readers are supervised and even self-check their own work. Even supervisors are monitored. Readers are encouraged to consult one another if a question comes up about an essay. Everything is done to ensure equality of grading across the spectrum. All of this checking and rechecking has made art history one of the most reliable Advanced Placement exams for consistency of scoring.

To the greatest extent possible, every paper is given just consideration. You should know that everything you write is taken very seriously and is considered fairly.

EXAM NOMENCLATURE

The efforts to find precise and inoffensive terms to describe commonly held ideas have been a labor at the College Board. Instead of B.C. and A.D., which have been used as standard abbreviations in the Western world, a substitution of B.C.E. and C.E. ("before the Common Era" and "Common Era") has been introduced. While this removes the potentially biased word "Christian," it creates the paradox of using a Christian numbering system without recognizing it.

Also, several terms such as "non-Western," "pre-Columbian," and "primitive," once standard in discussing art history, have been replaced by terms that are less exact, such as "art beyond the European tradition," the "art of the Americas," and "Oceanic art"—terms that are occasionally problematic.

You should also note that there are several ways of spelling names and objects that come from non-Roman scripts. In cases such as Mohammed/Muhammad, there is little to fear. But Dong QiChang is Tung Chi'Chang, depending on the method of translation used by a textbook. Every effort has been made to use the standard appearing across the spectrum of textbooks likely to be used in this class.

DATES

How accurate do you have to be about dates on the exam? Here are some rules about dates:

- If the object is very ancient, you have a 1,000-year window. For example, on the 2018 exam, those students who used the Palette of Narmer had a wide latitude given to them for the date. The instructions for the readers of the exam were "Date: c. 3000–2920 B.C.E. Also acceptable: third millennium OR a date within 1,000 years of the original."

- For objects that are ancient but dating is more secure, you have a 100-year window. For example, also on the 2018 exam, those students who used the *Alexander Mosaic* had a spread of 100 years. "Date: c. 100 B.C.E. Also acceptable: first century B.C.E. OR a date within 100 years of the original."

- For objects from the late Middle Ages to the twentieth century, when we have more of an understanding of when things were made, you are given a narrower window. On the 2018 exam, readers were told to give a 50-year spread for the *Röttgen Pietà*: "1300–1325 C.E. Also acceptable: early 1300s; middle 1300s; early/mid-fourteenth century; mid-fourteenth century; Gothic; late medieval Europe; OR a date within 50 years of the original (fourteenth century is NOT acceptable)."

- For the twentieth and twenty-first centuries, you have only a 10-year window. For Yinka Shonibare's *The Swing*, on the 2018 exam, the following was acceptable: "Date: 2001 C.E. Also acceptable: first decade of the twenty-first century OR a date within 10 years of the original (twenty-first century is NOT acceptable)."

Here are other examples from released exams:

100 years

- Great Stupa at Sanchi. Date: c. 300 B.C.E.–100 C.E. Also acceptable: a date within 100 years of the original.
- Todai-ji. Nara, Japan. Date: 743 C.E.; rebuilt twelfth century; and c. 1700 C.E. Also acceptable: a date within 100 years of the original creation (743 C.E.) or twelfth-century restoration; OR within 50 years of the 1700 restoration.
- Borobudur Temple. Date: c. 750–842 C.E. Also acceptable: 700s; 800s; eighth century; ninth century; OR a date within 100 years of the original creation.

50 years

- The Annunciation Triptych (Merode Altarpiece). Date: 1427–1432 C.E. Also acceptable: early 1400s; early/mid-fifteenth century; first half of the fifteenth century; Northern Renaissance; Early Netherlandish; OR a date within 50 years of the original (fifteenth century is NOT acceptable).
- *The Virgin of Guadalupe*. Date: c. 1698 C.E. Also acceptable: late 1600s; early 1700s; late seventeenth century; early eighteenth century; OR a date within 50 years of the original (seventeenth or eighteenth century is NOT acceptable).
- *Madonna and Child with Two Angels*. Date: 1465 C.E. Also acceptable: mid-/late 1400s; mid-/late fifteenth century; second half of the fifteenth century; Italian Renaissance; OR a date within 50 years of the original (fifteenth century is NOT acceptable).

10 years

- *Pisupo Lua Afe (Corned Beef 2000)*. Date: 1994 C.E. Also acceptable: 1990s; last decade of the twentieth century; OR a date within 10 years of the original (twentieth century is NOT acceptable).
- *Trade (Gifts for Trading Land with White People)*. Date: 1992 C.E. Also acceptable: 1990s; last decade of the twentieth century; OR a date within 10 years of the original (twentieth century is NOT acceptable).

WHAT'S NEW ABOUT THE REDESIGNED AP EXAM?

A great deal is new about the revised Advanced Placement Art History curriculum. The emphasis is still on addressing major works of art, but which works of art and how they will be addressed has changed. Here are the key differences:

1. Your teacher must teach all the works on the AP image list. Nominally there are **250** such works, but actually there are more like **400** because many of the monuments contain multiple views or ancillary material. Almost all of these works are pictured in this book.

2. Your teacher can teach additional works as well. These will not be tested in the multiple-choice section, but you can use them to answer any essay that says it welcomes choices outside the list. You can choose your own works as well and use them on the test where appropriate.

3. The new curriculum says that every work must be **completely identified**. In the past it had become acceptable to state the name and the artist of a work in order for it to be a complete identification. Now a complete identification is **very** complete. It includes:

 a. Title
 b. Artist, if known
 c. Date
 d. Medium and/or Materials
 e. Culture of Origin or Art Historical Period
 f. Location of architectural monuments

4. If you choose to use a work outside the official list, **you must be able to identify it as completely as any work on the list**.

5. Traditional discussions in art history are still in place. You still need to be able to intelligently describe what an object looks like (a formal analysis) and trace the history of artistic movements. A new emphasis, however, is placed on **why** and **how** the artistic movements change from one time and place to another.

6. **Function and context** are now stressed. Each work was created for a purpose, has a message, and was placed someplace significant. You should be able to intelligently discuss the circumstances around its creation, presentation, and reception.

7. Students will have to consider **the role of the audience** of a work of art. How can a work be interpreted one way by one group (i.e., a given culture, gender, or age) and differently by another group? How can context lead to a different interpretation?

8. Students are expected to have a firmer understanding of the various processes used to create works of art and of how these processes have an impact on what we see.

9. Students are expected to know the **history of each object**. You should be able to answer questions like:

 a. What has happened to this object after it was created?
 b. Does it still have the same significance it had when it was created? Why or why not?
 c. How has it been altered since its creation?
 d. Why or how do artistic traditions change and how is that seen in individual works?

10. There have always been attribution questions in the Advanced Placement Examination in Art History. That will not change. The attribution will shift to concentrating more on movements and periods than on individual artists. Students must be able to compare an unknown work to a work they know using stylistic analysis and contextual clues.

11. Most important: you must be able to **compare works from various cultures and time periods**. The comparisons could be of two landscapes, two still lifes, or two portraits. They could also be two works of very different functions, different contexts, and different intentions. A good exercise is to try to make the comparisons yourself to see how the works complement or challenge each other.

12. **Your writing counts.** What you say is as important as how you say it. There is no escaping this truth: in almost every test, a good writer outperforms a poor writer even when they both know the same amount of material.

ANSWERING THE MULTIPLE-CHOICE QUESTIONS

The Advanced Placement Examination in Art History requires the student to correctly answer as many of the 80 multiple-choices as possible. Each question has four possible responses, and you are asked to find the BEST answer. Often a case can be made for a second choice, but it does not fit as well as the first.

You should always do the following when approaching an AP multiple-choice question:

- Read each question twice.
- Remember that guessing is now permissible on all AP exams. Therefore, there should be no blanks on your paper!

Types of Multiple-Choice Questions

Typically, multiple-choice questions ask for the following information	Study recommendations
Name of artist	Absolutely essential
Name of work	Absolutely essential
Period or movement of a work	Absolutely essential
Medium and/or Materials of the work	Absolutely essential
Date of the work	Essential; however, don't overreact and spend all your time memorizing dates at the expense of other things.
Location	Absolutely essential only for architecture; for paintings and sculpture, it is not necessary to know the names of museums they are currently in.
Identification of key figures in the work	Absolutely essential
Art history vocabulary, and how these terms can be seen in an individual work	Absolutely essential

Typically, multiple-choice questions ask for the following information	Study recommendations
Influences on the artist	Important, and often asked.
How the work fits in/does not fit in with its times	Increasingly stressed. Works that have a political or cultural message are more apt to be used for questions like this.
Original setting of the work	Sometimes asked, especially if the setting is important to the interpretation of the work.
Patron	Asked if the patron had a great influence on the outcome of the work.
Symbolism/Subject matter	Sometimes asked, but increasingly this has fallen from favor. Symbols are mutable and subject to interpretation.
Key formal characteristics	A mainstay of traditional art history books.

As you can see, there is much to know about each object, and each object raises individual concerns expressed independently from this chart.

Examples of Multiple-Choice Questions

Changing interpretations of works of art:

1. Jan van Eyck's *Arnolfini Portrait* has been the subject of many interpretations, including

 (A) that it is a memorial to parents who are now deceased
 (B) that it represents a joyful couple celebrating childbirth
 (C) that Arnolfini is conferring legal and business privileges on his wife during an absence
 (D) that Arnolfini is pledging support in a legal proceeding about to take place

Answer: (C)

Decision about how works of art will be designed:

2. Louis Sullivan's decision to use steel coated in ceramic was a result of

 (A) his experience working on the Eiffel Tower
 (B) his understanding of why buildings were damaged by the Chicago Fire
 (C) new technologies available at the beginning of the nineteenth century
 (D) the introduction of cantilevers into early modern architecture

Answer: (B)

Cross-cultural comparisons:

3. When originally designed, the Palace of Versailles and the Ryoan-ji had this in common:

 (A) the extensive use of stone and brick
 (B) their use as hunting lodges
 (C) the symbolism of a royal residence
 (D) water as a design element

Answer: (D)

Location and meaning:

4. The location of the Vietnam Veterans Memorial is important because

 (A) it is built on the foundation of a previous monument
 (B) the artist needed an intimate space to make the message seem personal to the viewer
 (C) the monument aligns with the sun and has a cosmic interpretation
 (D) it lies between other monuments and can be interpreted in a larger context

Answer: (D)

Cross-cultural impact on a work of art:

5. Gottfried Lindauer's portrait of Tamati Waka Nene shows the impact of European art on an image of a Maori chieftain in that

 (A) it is done in watercolor, a technique that comes from Europe
 (B) the chief is wearing modern dress and is seen as if he were a European ruler
 (C) the artist has used atmospheric perspective, a technique unknown in the Pacific at the time
 (D) he is depicted wearing a beard, symbolizing wisdom

Answer: (C)

The function of an object:

6. This object has the function of being

 (A) a crown placed over the head of a king
 (B) an object to be circumambulated as part of a ritual
 (C) a symbol of the soul of a nation
 (D) a sacred vessel used in a Buddhist service

Answer: (C)

The influence of a single work on later works:

7. Monuments such as the Hagia Sophia directly influenced the construction of buildings such as

 (A) Mosque of Selim II
 (B) Great Stupa
 (C) the Kaaba
 (D) Chartres Cathedral

Answer: (A)

Materials:

8. The materials used to create the Hawaiian 'ahu 'ula were meant to signify

 (A) the fleeting nature of life
 (B) the rich abundance of tropical vegetation
 (C) the sea, a main source of living things in the Pacific
 (D) protection for the wearer from harm

Answer: (D)

9. The painting shown can be attributed to Pontormo because of

(A) its use of balance and symmetry
(B) a lack of perspective
(C) the crowded and complex composition
(D) the fact that it is an engraving

Answer: (C)

Influence:

10. Mary Cassatt drew inspiration from

(A) African masks
(B) Chinese scroll paintings
(C) Aztec sculptures
(D) Japanese prints

Answer: (D)

ANSWERING THE FREE-RESPONSE QUESTIONS

All of the essays are tied to eight **art historical thinking skills** that the College Board would like every successful student to master. These skills are the following:

1. **Visual Analysis** (Question 3): Students are expected to be conversant in the basic terms of visual analysis and to show how artistic decisions by an artist shape what we see.
2. **Contextual Analysis** (Question 4): Students are expected to understand the circumstances behind which a work of art is created, including things like function, setting, and patronage.
3. **Comparisons of Works of Art** (Question 1): Students are expected to examine similarities and differences between two works of art.
4. **Artistic Traditions** (Question 6): Students are to explain how a given work of art is typical of an artistic tradition, and also expands upon that tradition.
5. **Visual Analysis of Unknown Works** (Question 3): Taking all that is learned, students should be able to apply methods of analysis to a work they have never seen before.
6. **Attribution of Unknown Works** (Question 5): Students need to be able to attribute a work of art to a period, artist, or style by relating it to a work from the image set. They should be able to justify their attribution.
7. **Art Historical Interpretations** (Question 2): Students should be able to describe relevant interpretations of a work of art, many of which change over time.
8. **Argumentation** (Question 2): This is the most demanding aspect of the exam. It starts with the student forming a cogent thesis statement, and it is followed by examples that prove the statement to be true. It implies that the student understands the subtleties of the question and can frame the response as an argument that proves a point.

There are two types of essays on the Advanced Placement Art History examination: the four short essays of 15 minutes each and the two longer, more comprehensive essays that take 35 minutes for the first essay, and 25 minutes for the second. Each essay has a different function. Short essays concentrate on an individual concept in art history, asking specific questions about a given work. The longer essays generally have comparisons and expect a more cogent response. Question 1 involves two works of art, and Question 2 is a response to a single work of art. Question 1 will have an image. Question 2 does not have any images, and it requires you to remember the details of a given work.

Question 1: This is the longest essay, placed first on the exam so that the student is more likely to give a substantial response without test burnout. The student has 35 minutes to write a response. This essay is worth eight points.

Although 35 minutes are allotted for this response, this is only a suggestion and not enforced. You are free to move from this essay to the next and devote as much time as you like within the overall time frame.

This is the comparison essay. You will be given a work of art from the required image list and asked to compare it with another work of a similar theme—a work of your choice. For example, you could be asked to compare two images that depict religious figures, rulers, still lives, portraits, etc. The list of possibilities is nearly endless. There will always be a short list of suggested works of art that would be suited to the question. *It is wise to choose one of these choices* because you are assured that they fit the question. However, this is not required.

Keep in mind that when readers are scoring the responses, they have a guide next to them that accesses what the correct responses should be for the suggested works.

For any work, regardless of whether or not you selected it from the list, you *must* supply two identifiers. If you are unsure if your identifiers are correct, supply as many as you can. Readers only score correct responses. For example, if the work in question is *Hunters in the Snow,* you can write Pieter Bruegel the Elder (or simply Bruegel), 1565, oil on wood. That's three identifiers. But if you said tempera instead of oil or 1765 instead of 1565, it would be scored as correct as long as the other two identifiers are right. You can also simplify your responses. Artist's first names are unnecessary, and spelling is not an issue—so long as the reader knows what you mean. The dates can be approximate.

For this question, and really for any question, you must have the capability of describing the visual elements of a work of art. It is handy to know words like contrapposto, chiaroscuro, symmetrical, atmospheric perspective—in other words, the tools of the artist. To that end, *vocabulary is extremely important.*

In a comparison question, naturally you must be able to tell how the works of art are the same and yet different, not in just their visual characteristics, but in how these characteristics convey meaning. For example, *Theodora Panel* and *Kneeling statue of Hatshepsut* show female rulers in a similar light, but yet the materials used, the places in which they are placed, and the poses they are in give us a completely different impression of these women. This is the kind of comparison that is needed in a solid essay.

If you would like to practice this type of question, there are examples at the end of the following chapters: "Africa," "Gothic," "Late Gothic," "New Spain," "Pacific," and "Romanticism."

Question 2: This is a new essay. This long essay is given 25 minutes for a response. This essay is worth six points.

This is a visual and a contextual essay that relies on a student's ability to gather information relevant to a work of art and use it to defend a thesis statement.

This question has to be handled with care. Often students will be asked to select a work of art from a relevant time period—any attempt to use a different time period will nullify the essay. For example, the question might ask students to choose something from the contemporary world or East Asia. Once again, you are wise to select a work of art from the suggested list. In this way, you don't have to worry about whether or not your choice is appropriate. Once again, you must provide two identifiers to earn the first point.

Your response has to be directed to the prompt, which is usually an art historical consideration. For example, how do artists use color to evoke meaning? You are asked to provide a thesis statement which can be defended by your example—this also earns a point. You must then proceed to support your claim by using *at least two* examples of visual and/or contextual evidence. If you have more examples, certainly use them. Remember that the readers only score what is correct. If you write four examples and only two are correct, you still earn the full two points allotted. Keep in mind that your examples must always refer back to the thesis statement. To earn full credit for the question, you must supply a complete, nuanced reading of the work of art as it pertains to this question. This means that your essay must be of some length so that you can adequately discuss the ideas you present. Be sure to point to exact passages in a work of art where your examples can be found. In other words, don't just say that a color represents a certain emotion, point out where it is used in your work and explain the exact emotion the color depicts, and then point out how it contributes to the meaning of the work as a whole.

One of the new art historical thinking skills being tested on this exam, and in particular in this question, is **argumentation**. To earn the argumentation point, it is necessary to have a solid thesis statement supported by evidence that shows that the student can analyze, think clearly, and make insightful connections.

If you would like to practice this type of question, there are examples at the end of the following chapters: "China," "Contemporary," "Early Italian Renaissance," and "Islamic."

Question 3: Visual Analysis: This is a short, 15-minute question that is worth five points.

This question tests your ability to visually analyze a work of art based on all the principles of art history you have learned about this year. It may involve a work on the image set (as in Leonardo da Vinci's *Last Supper* on the 2019 exam) or an image that looks similar to something in the image set. The visual analysis is primarily formal, though it can also be iconographic. Students may be asked to connect, as in this case, the visual analysis to the large historical context of the Renaissance.

There are no identifications in this essay. To earn points, you are expected to analyze the visual elements in a work of art. You are not supposed to list them! You are supposed to apply the tools you have learned this year to the given work presented to you. You are also expected to go deeper, by explaining why the artist chose these techniques and applied them to a given work. To earn a final point, you are expected to see these techniques as part of a tradition that may have been adapted by that artist.

For example, Diego Rivera uses the time-honored technique of fresco painting, which has been around since ancient times. However, he uses it in a different way, creating huge murals in public spaces. A good essay will discuss fresco as a technique and then show how Rivera adapted it for his own purposes in a work like *Alameda Park*.

Remember: even if a question does not ask you about a work of art in the required curriculum, that does not mean you cannot reference it to make a point!

If you would like to practice this type of question, there are examples at the end of the following chapters: "Ancient Near East," "Early- and Mid-Twentieth Century," "High Renaissance," and "India."

Question 4: Contextual Analysis: This is a short, 15-minute question that is worth five points.

This essay question tests the student's ability to put a work of art in the context of the times it was created. It will be based on a work of art in the required content, and the work will be illustrated for your reference. For example, the 2019 exam asked students to connect the David Vases to the large context of the Silk Road.

Keep in mind that sometimes contextual and visual elements are intertwined when discussing a work of art, and this means it would be completely appropriate to bring up visual issues when discussing context. Context is an umbrella term that includes all of the following: patronage, function, style, materials, techniques, and location. It also includes a discussion of how a work of art was received when it was originally brought before the public, and what its subsequent reception has been. (We can assume that the current reception is good, otherwise the College Board would not be asking you to know this work.)

If you would like to practice this type of question, there are examples at the end of the following chapters: "Americas," "Byzantine," "Early Medieval," "Greek," "Late Antique," "Prehistoric," and "Romanesque."

Question 5: Attribution: This is a short, 15-minute question that is worth five points.

This question is based on a work of art that you have not studied as part of the required course content. However, it assumes that you are familiar enough with the style of a work of an artist or a movement that you can place it in its proper context.

An image is provided. You are asked to attribute the work a specific culture or artist. Your attribution is key, because it will throw off your whole essay if you indicate the wrong artist. You need to then justify your attribution by mentioning *at least two* examples of visual or contextual evidence relating the work to a work in the image set. For example, if the unknown work is by Maya Lin, it would be wise to show why it looks like Lin's work, when comparing it to the Vietnam Veterans Memorial. Definitely reference a work in the image set! Feel free to compare the similarities between, in this case, the Vietnam Veterans Memorial, and, for example, the Civil Rights Memorial in Montgomery, Alabama. Once again, if the question asks for at least two examples, feel free to supply as many as you can. This will make for a more substantial and solid response.

If you would like to practice this type of question, there are examples at the end of the following chapters: "Japan," "Late-Nineteenth Century," "Northern Renaissance," and "Rococo/Neoclassicism."

Question 6: Continuity and Change: This is a short, 15-minute question that is worth five points.

This question asks the student to see a work of art as part of a continuum. For example, a work could be a link in a long tradition of self-portraits, or woodcuts, or museum design. An image will be provided and generally completely identified.

A solid response will show how a work fits in within a given tradition. Once again, you should provide *at least two* reasons why, and more would be welcome. The question might also challenge you to describe how the work is innovative within that tradition, or reflects a more individualized approach to a given tradition.

If you would like to practice this type of question, there are examples at the end of the following chapters: "Baroque," "Egyptian," "Etruscan," and "Roman."

GENERAL RULES ABOUT ESSAYS

1. Never use value judgments or matters of taste or opinion in an essay. For example, never say that a work of art is "better" than another, or that the artist used perspective "better" or color "better." Instead, express differences in terms of values that few can object to, such as: "Painting A has more vivid colors than painting B, as can be seen in the figure on the left"; "sculpture A is more classically composed than sculpture B, as can be seen in the contrapposto in the figure on the left"; "building A is located in a city square, whereas building B was built in a rural area."

2. Never use the word "perfect" or say that a work of art is, for example, "the perfect expression of Christian belief."

3. Never use "able" or "unable," as in "The artist was unable to capture the feelings of sorrow in..." Also don't use "attempt," as in "The artist attempts to show foreshortening." What precisely does this mean?

4. Never express a preference. Don't tell the reader that you like one work more than another. It is irrelevant to the exam.

5. Be careful of the word "unique"—it means one of a kind. It does not mean special. If a work of art is unique, it means that there is no other work like it. Use it sparingly. Avoid redundant expressions like "very unique."

6. Avoid complimenting the artist on the work he or she has done. Do not say that "Michelangelo did a good job of showing perspective..."

7. People in works of art are "figures," not "characters." Characters are parts in plays.

8. Avoid phrases like "piece of art." Use "work of art" or "work."

9. It is correct form to underline the titles of works of art, with the exception of the names of buildings. In this book, italics have been substituted for underlining.

10. Always identify a work of art clearly, not generically. For example, don't identify by simply using the word "icon." There are so many! Say, instead, "the icon of the Virgin and Child between Saints Theodore and George." Similarly, don't use words such as "cathedral" or "pyramid" as a method of identification. Use instead "Chartres Cathedral" or "the Pyramids of Giza, Egypt."

11. Do not list your response. Do not use bullet points. Write complete sentences. Make sure that you write in full paragraphs.

ATTRIBUTION PRACTICE

Below are 25 works of art that are randomly arranged. Fill in the grids below being sure to list the characteristics of the work that recall works in the official image set.

 The answer key at the end will reference the works of art in this book that are related to these works.

1.	Period: Characteristics of this period as seen in this work: 1. 2. 3.
2.	Period: Characteristics of this period as seen in this work: 1. 2. 3.
3.	Artist: Period: Characteristics of this artist as seen in this work: 1. 2. 3.

4.		Period:
		Characteristics of this period as seen in this work:
		1.
		2.
		3.
5.		Period:
		Characteristics of this period as seen in this work:
		1.
		2.
		3.
6.		Period:
		Characteristics of this period as seen in this work:
		1.
		2.
		3.
7.		Period:
		Characteristics of this period as seen in this work:
		1.
		2.
		3.

8.	Period: Characteristics of this period as seen in this work: 1. 2. 3.
9.	Artist: Period: Characteristics of this artist as seen in this work: 1. 2. 3.
10.	Period: Characteristics of this period as seen in this work: 1. 2. 3.

11.	Artist: Period: Characteristics of this artist as seen in this work: 1. 2. 3.
12.	Period: Characteristics of this period as seen in this work: 1. 2. 3.
13.	Period: Characteristics of this period as seen in this work: 1. 2. 3.

14.		Architect: Period: Characteristics of this architect as seen in this work: 1. 2. 3.
15.		Period: Characteristics of this period as seen in this work: 1. 2. 3.
16.		Artist: Period: Characteristics of this artist as seen in this work: 1. 2. 3.

17. 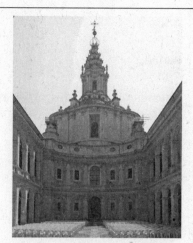	Architect: Period: Characteristics of this architect as seen in this work: 1. 2. 3.
18. 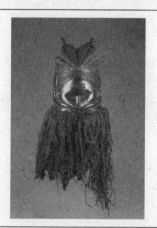	Period: Characteristics of this period as seen in this work: 1. 2. 3.
19. 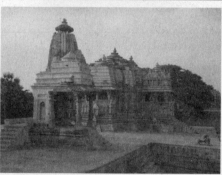	Period: Characteristics of this period as seen in this work: 1. 2. 3.

20.	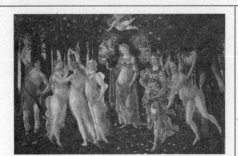	Artist: Period: Characteristics of this artist as seen in this work: 1. 2. 3.
21.		Artist: Period: Characteristics of this artist as seen in this work: 1. 2. 3.
22.		Artist: Period: Characteristics of this artist as seen in this work: 1. 2. 3.

23.		Artist: Period: Characteristics of this artist as seen in this work: 1. 2. 3.
24.		Period: Characteristics of this period as seen in this work: 1. 2. 3.
25.		Artist: Period: Characteristics of this artist as seen in this work: 1. 2. 3.

Answer Key

1. **Figure 2.2 (page 113)**
2. **Figures 4.19a, 4.19b (page 156)**
3. **Figure 17.10 (page 336)**
4. **Figure 6.14 (page 183)**
5. **Figure 12.8 (page 263)**
6. **Figure 24.5 (page 455)**
7. **Figure 9.7a (page 219)**
8. **Figure 27.6 (page 507)**
9. **Figure 17.8 (page 334)**
10. **Figure 9.5 (page 218)**
11. **Figure 25.5 (page 473)**
12. **Figure 4.3 (page 145)**
13. **Figure 26.1d (page 481)**
14. **Figure 19.5a (page 359)**
15. **Figure 11.4a (page 248)**
16. **Figure 21.3 (page 387)**
17. **Figure 17.2a (page 328)**
18. **Figure 27.9a (page 509)**
19. **Figure 23.7a (page 439)**
20. **Figure 15.4 (page 302)**
21. **Figure 28.7 (page 525)**
22. **Figure 22.4 (page 406)**
23. **Figure 17.4a (page 331)**
24. **Figure 5.4 (page 166)**
25. **Figure 27.14 (page 512)**

CONTINUITY AND CHANGE PRACTICE

1. Explain how *The Virgin of Guadalupe* represents both a continuity and a change within the traditions of European art.

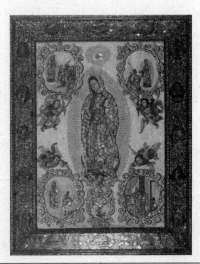

Continuity	Change
1.	1.
2.	2.
3.	3.

2. Explain how these Greek sculptures represent both a continuity and a change within the traditions of ancient art.

Titles of Works:

_____ _____

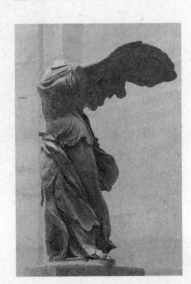

Continuity	Change
1.	1.
2.	2.
3.	3.

3. Explain how these paintings represent both a continuity and a change within the
 traditions of modern art.

Titles of Works:

_____ _____

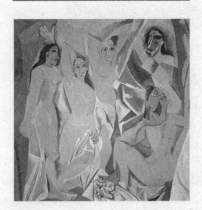

Continuity	Change
1.	1.
2.	2.
3.	3.

4. Explain how this building represents both a continuity and a change within the traditions of domestic architecture.

Title of Work: _____

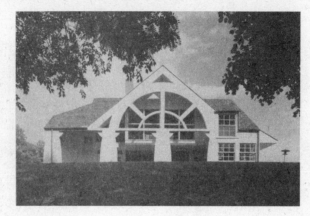

Continuity	Change
1.	1.
2.	2.
3.	3.

5. Explain how the sculpture of Buddha on the right represents both a continuity and a change within the Buddhist tradition, as represented on the left.

Titles of Works:

_____ _____

 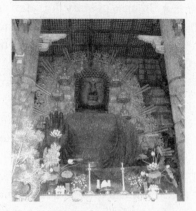

Continuity	Change
1.	1.
2.	2.
3.	3.

Answers Explained

1. **Continuity:**
 - Images of Mary are a constant in Catholic art, particularly art from colonial Latin America.
 - Images of Mary are often surrounded by depictions of episodes from her life.
 - Images of Mary are often painted in shimmering tones with rich colors.
 - Images of Mary are often framed in elaborate casings.

 Change:
 - This work illustrates a particular moment in the divine appearance of Mary to Juan Diego.
 - Brocade on Virgin's robes are made of enconchados.
 - Enconchado paintings often include ornate frames inspired on Japanese Nanban lacquer work.
 - In Guadalupe images, Mary always stands on a crescent moon surrounded by sunrays with clouds behind her.
 - An eagle perched on a cactus at the bottom center is a symbol of Mexico today.

2. **Title:** *Doryphoros* by Polykleitos and *Winged Victory of Samothrace*
 Continuity:
 - Large heroic figures.
 - Sculpted in marble.
 - Contrapposto stance.
 - Carved in the round.
 - Freestanding.

 Change:
 - The *Doryphoros* is classical: has idealized proportions; avoids eye contact; has a far-away look on the face; is heroically carved.
 - The *Winged Victory* is Hellenistic: has dramatic action; is in a swirling, complex composition; shows the effect of wind and rain on the garments; displays virtuoso carving.

3. **Title:** *Les Demoiselles d'Avignon* by Pablo Picasso and *The Portuguese* by Georges Braque
 Continuity:
 - Modern art continues to experiment with forms of abstract, based on the works of Cézanne, a generation before.
 - Cubism seeks to break down a figure from its realistic shape into a series of interlocking planes.
 - The Picasso work shows the influence of Iberian sculpture and African masks.

 Change:
 - The Braque work incorporates text into the composition.
 - The Braque painting increases the abstraction to the point in which the subject matter is suggested by the title and a few recognizable shapes.
 - The color palette is reduced and contributes to the refining of forms.

4. **Title:** House in New Castle County, Delaware by Robert Venturi, John Rauch, and Denise Scott Brown.

 Continuity:

- It is a domestic building designed for three people.
- It is designed with the interests of the patrons in mind. For the wife, a musician, a music room was created with two pianos, an organ, and a harpsichord. For the husband, a bird-watcher, large windows were installed facing the woods.
- Large, clean modern spaces offer an open spacious interior.

 Change:

- The façade contains an arch inside a pediment form.
- A squat bulging Doric colonnade is asymmetrically placed.
- The columns are actually flat rather than traditionally round forms.
- The drainpipe at left bisects the outermost column.
- The flattened forms on the interior arches echo the exterior flat columns.
- The interior forms reflect a craftsman's hand in curved, cutting elements.

5. **Title:** Jowo Rinpoche enshrined in the Jokhang Temple and Todai-ji, Great Buddha

 Continuity:

- General characteristics of a Buddha are maintained, including: large figure made of precious metals; seated; surrounded by other Buddhist figures.
- Offerings are placed before the Buddha.
- Candles are lit before the Buddha.
- The statue is often dressed.

 Change:

- It is the largest metal statue of Buddha in the world.
- It is a monumental feat of casting.
- Buddha takes on a more forbidding appearance; more of a hieratic image.
- Emperor Shomu embraced Buddhism and erected sculpture as a way of stabilizing the Japanese population during a time of economic crisis.

CONCORDANCE OF THE AP CURRICULUM FRAMEWORK AND BARRON'S AP ART HISTORY

This Barron's book is organized according to the cultural groupings that have been traditionally used in art history, and thus conforms to the approach used in most classrooms and to the structure used in most college-level survey texts. It is hoped that the student can use this book as a supplement to classroom instruction as the year progresses. However, the College Board has reorganized much of the material in a chronological format so that the dates often cross cultural boundaries. This table is meant to coordinate the College Board image set numbers and identifications with the placement in this book.

AP Image Number	Work of Art	Figure Number	Page
CONTENT AREA 1: GLOBAL PREHISTORY			
1	Apollo 11 stones. Namibia. c. 25,500–25,300 B.C.E. Charcoal on stone.	1.7	100
2	Great Hall of the Bulls. Lascaux, France. Paleolithic Europe. 15,000–13,000 B.C.E. Rock painting.	1.8	101
3	Camelid sacrum in the shape of a canine. Tequixquiac, central Mexico. 14,000–7000 B.C.E. Bone.	1.1	96
4	Running horned woman. Tassili n'Ajjer, Algeria. 6000–4000 B.C.E. Pigment on rock.	1.9	102
5	Beaker with ibex motifs. Susa, Iran. 4200–3500 B.C.E. Painted terra cotta.	1.10	102
6	Anthropomorphic stele. Arabian Peninsula. 4th millennium B.C.E. Sandstone.	1.2	97
7	Jade *cong*. Liangzhu, China. 3300–2200 B.C.E. Carved jade.	1.3	97
8	Stonehenge. Wiltshire, UK. Neolithic Europe. c. 2500–1600 B.C.E. Sandstone.	1.12	103
9	The Ambum Stone. Ambum Valley, Enga Province, Papua New Guinea. c. 1500 B.C.E. Graywacke.	1.4	98
10	Tlatilco female figurine. Central Mexico, site of Tlatilco. 1200–900 B.C.E. Ceramic.	1.5	99
11	Terra cotta fragment. Lapita. Solomon Islands, Reef Islands. 1000 B.C.E. Terra cotta (incised).	1.6	99
CONTENT AREA 2: ANCIENT MEDITERRANEAN			
12	White Temple and its ziggurat. Uruk (modern Warka, Iraq). Sumerian. c. 3500–3000 B.C.E. Mud brick.	2.1	111
13	Palette of King Narmer. Predynastic Egypt. c. 3000–2920 B.C.E. Graywacke.	3.4	127
14	Statues of votive figures, from the Square Temple at Eshnunna (modern Tell Asmar, Iraq). Sumerian. c. 2700 B.C.E. Gypsum inlaid with shell and black limestone.	2.2	113
15	Seated scribe. Saqqara, Egypt. Old Kingdom, 4th Dynasty. c. 2620–2500 B.C.E. Painted limestone.	3.5	128
16	Standard of Ur from the Royal Tombs at Ur (modern Tell el-Muqayyar, Iraq). Sumerian. c. 2600–2400 B.C.E. Wood inlaid with shell, lapis lazuli, and red limestone.	2.3	113

AP Image Number	Work of Art	Figure Number	Page
17	Great Pyramids (Menkaura, Khafre, Khufu) and Great Sphinx. Giza, Egypt. Old Kingdom, 4th Dynasty. c. 2550–2490 B.C.E. Cut limestone.	3.6	129
18	King Menkaura and queen. Old Kingdom, 4th Dynasty. c. 2490–2472 B.C.E. Graywacke.	3.7	130
19	The Code of Hammurabi. Babylon (modern Iran). Susian. c. 1792–1750 B.C.E. Basalt.	2.4	114
20	Temple of Amun-Re and Hypostyle Hall. Karnak, near Luxor, Egypt. New Kingdom, 18th and 19th Dynasties. Temple: c. 1550 B.C.E.; hall: c. 1250 B.C.E. Cut sandstone and mud brick.	3.8	131
21	Mortuary temple of Hatshepsut. Near Luxor, Egypt. New Kingdom, 18th Dynasty. c. 1473–1458 B.C.E. Sandstone, partially carved into a rock cliff, and red granite.	3.9	132, 133
22	Akhenaton, Nefertiti, and three daughters. New Kingdom (Amarna), 18th Dynasty. c. 1353–1335 B.C.E. Limestone.	3.10	133
23	Tutankhamun's tomb, innermost coffin. New Kingdom, 18th Dynasty. c. 1323 B.C.E. Gold with inlay of enamel and semiprecious stones.	3.11	134
24	Last judgment of Hunefer, from his tomb (page from the *Book of the Dead*). New Kingdom, 19th Dynasty. c. 1275 B.C.E. Painted papyrus scroll.	3.12	135
25	Lamassu from the citadel of Sargon II, Dur Sharrukin (modern Khorsabad, Iraq). Neo-Assyrian. c. 720–705 B.C.E. Alabaster.	2.5	115
26	Athenian agora. Archaic through Hellenistic Greek. 600 B.C.E.–150 C.E. Plan.	4.15	152
27	Anavysos Kouros. Archaic Greek. c. 530 B.C.E. Marble with remnants of paint.	4.1	143
28	Peplos Kore from the Acropolis. Archaic Greek. c. 530 B.C.E. Marble, painted details.	4.2	144
29	*Sarcophagus of the Spouses*. Etruscan. c. 520 B.C.E. Terra cotta.	5.4	166
30	Audience Hall (*apadana*) of Darius and Xerxes. Persepolis, Iran. Persian. c. 520–465 B.C.E. Limestone.	2.6	116
31	Temple of Minerva (Veii, near Rome, Italy) and sculpture of Apollo. Master sculptor Vulca. c. 510–500 B.C.E. Original temple of wood, mud brick, or tufa (volcanic rock); terra cotta sculpture.	5.1, 5.5	165, 167
32	Tomb of the Triclinium. Tarquinia, Italy. Etruscan. c. 480–470 B.C.E. Tufa and fresco.	5.3	166
33	Niobides Krater. Anonymous vase painter of Classical Greece known as the Niobid Painter. c. 460–450 B.C.E. Clay, red-figure technique (white highlights).	4.19	156
34	*Doryphoros* (*Spear Bearer*). Polykleitos. Original 450–440 B.C.E. Roman copy (marble) of Greek original (bronze).	4.3	145
35	Acropolis. Athens, Greece. Iktinos and Kallikrates. c. 447–410 B.C.E. Marble.	4.4, 4.5, 4.6, 4.16, 4.17	146, 147, 153, 154

AP Image Number	Work of Art	Figure Number	Page
36	Grave stele of Hegeso. Attributed to Kallimachos. c. 410 B.C.E. Marble and paint.	4.7	147
37	*Winged Victory of Samothrace*. Hellenistic Greek. c. 190 B.C.E. Marble.	4.8	148
38	Great Altar of Zeus and Athena at Pergamon. Asia Minor (present-day Turkey). Hellenistic Greek. c. 175 B.C.E. Marble (architecture and sculpture).	4.9, 4.18	149, 154, 155
39	House of the Vettii. Pompeii, Italy. Imperial Roman. c. 2nd century B.C.E.; rebuilt c. 62–79 C.E. Cut stone and fresco.	6.7, 6.13	176, 177, 182
40	*Alexander Mosaic* from the House of Faun, Pompeii. Republican Roman. c. 100 B.C.E. Mosaic.	4.20	157
41	Seated boxer. Hellenistic Greek. c. 100 B.C.E. Bronze.	4.10	150
42	Head of a Roman patrician. Republican Roman. c. 75–50 B.C.E. Marble.	6.14	183
43	Augustus of Prima Porta. Imperial Roman. Early 1st century C.E. Marble.	6.15	184
44	Colosseum (Flavian Amphitheater). Rome, Italy. Imperial Roman. 70–80 C.E. Stone and concrete.	6.8	178
45	Forum of Trajan. Rome, Italy. Apollodorus of Damascus. Forum and markets: 106–112 C.E.; column completed 113 C.E. Brick and concrete (architecture); marble (column).	6.10, 6.16	179, 180, 185
46	Pantheon. Imperial Roman. 118–125 C.E. Concrete with stone facing.	6.11	180, 181
47	Ludovisi Battle Sarcophagus. Late Imperial Roman. c. 250 C.E. Marble.	6.17	185
CONTENT AREA 3: EARLY EUROPE AND COLONIAL AMERICAS			
48	Catacomb of Priscilla. Rome, Italy. Late Antique Europe. c. 200–400 C.E. Excavated tufa and fresco.	7.1	194
49	Santa Sabina. Rome, Italy. Late Antique Europe. c. 422–432 C.E. Brick and stone; wooden roof.	7.3	196
50	Rebecca and Eliezer at the Well and Jacob Wrestling the Angel, from the *Vienna Genesis*. Early Byzantine Europe. Early 6th century C.E. Illuminated manuscript (tempera, gold, and silver on purple vellum).	8.7	208, 209
51	San Vitale. Ravenna, Italy. Early Byzantine Europe. c. 526–547 C.E. Brick, marble, and stone veneer; mosaic.	8.4, 8.5, 8.6	205, 207, 208
52	Hagia Sophia. Constantinople (Istanbul). Anthemius of Tralles and Isidorus of Miletus. 532–537 C.E. Brick and ceramic elements with stone and mosaic veneer.	8.3	204
53	Merovingian looped fibulae. Early medieval Europe. Mid-6th century C.E. Silver gilt worked in filigree, with inlays of garnets and other stones.	10.1	237
54	Virgin (Theotokos) and Child between Saints Theodore and George. Early Byzantine Europe. 6th or early 7th century C.E. Encaustic on wood.	8.8	209

AP Image Number	Work of Art	Figure Number	Page
55	*Lindisfarne Gospels*: Saint Matthew, cross-carpet page; Saint Luke portrait page; Saint Luke incipit page. Early medieval (Hiberno-Saxon) Europe. c. 700 C.E. Illuminated manuscript (ink, pigments, and gold on vellum).	10.2	238, 239
56	Great Mosque. Córdoba, Spain. Umayyad. c. 785–786 C.E. Stone masonry.	9.14	225, 226
57	Pyxis of al-Mughira. Umayyad. c. 968 C.E. Ivory.	9.4	217
58	Church of Sainte-Foy. Conques, France. Romanesque Europe. Church: c. 1050–1130 C.E.; Reliquary of Saint Foy: 9th century C.E., with later additions. Stone (architecture); stone and paint (tympanum); gold, silver, gemstones, and enamel over wood (reliquary).	11.4, 11.6	248, 249, 250
59	*Bayeux Tapestry*. Romanesque Europe (English or Norman). c. 1066–1080 C.E. Embroidery on linen.	11.7	251
60	Chartres Cathedral. Chartres, France. Gothic Europe. Original construction c. 1145–1155 C.E.; reconstructed c. 1194–1220 C.E. Limestone, stained glass.	12.4, 12.6, 12.8	260, 262, 263
61	Dedication Page with Blanche of Castile and King Louis IX of France, Scenes from the Apocalypse from *Bibles moralisées*. Gothic Europe. c. 1225–1245 C.E. Illuminated manuscript (ink, tempera, and gold leaf on vellum).	12.9	264
62	*Röttgen Pietà*. Late medieval Europe. c. 1300–1325 C.E. Painted wood.	12.7	263
63	Arena (Scrovegni) Chapel, including *Lamentation*. Padua, Italy. Unknown architect; Giotto di Bondone (artist). Chapel: c. 1303 C.E.; Fresco: c. 1305. Brick (architecture) and fresco.	13.1	275, 276
64	Golden Haggadah (The Plagues of Egypt, Scenes of Liberation, and Preparation for Passover). Late medieval Spain. c. 1320 C.E. Illuminated manuscript (pigments and gold leaf on vellum).	12.10	265, 266
65	Alhambra. Granada, Spain. Nasrid Dynasty. 1354–1391 C.E. Whitewashed adobe stucco, wood, tile, paint, and gilding.	9.15	227, 228
66	Annunciation Triptych (Merode Altarpiece). Workshop of Robert Campin. 1427–1432 C.E. Oil on wood.	14.1	286
67	Pazzi Chapel. Basilica di Santa Croce. Florence, Italy. Filippo Brunelleschi (architect). c. 1429–1461 C.E. Masonry.	15.1	299
68	*Arnolfini Portrait*. Jan van Eyck. c. 1434 C.E. Oil on wood.	14.2	287
69	*David*. Donatello. c. 1440–1460 C.E. Bronze.	15.5	302
70	Palazzo Rucellai. Florence, Italy. Leon Battista Alberti (architect). c. 1450 C.E. Stone, masonry.	15.2	300
71	*Madonna and Child with Two Angels*. Fra Filippo Lippi. c. 1465 C.E. Tempera on wood.	15.3	301
72	*Birth of Venus*. Sandro Botticelli. c. 1484–1486 C.E. Tempera on canvas.	15.4	302
73	*The Last Supper*. Leonardo da Vinci. c. 1494–1498 C.E. Oil and tempera.	16.1	312
74	*Adam and Eve*. Albrecht Dürer. 1504 C.E. Engraving.	14.3	288

AP Image Number	Work of Art	Figure Number	Page
75	Sistine Chapel ceiling and altar wall frescoes. Vatican City, Italy. Michelangelo. Ceiling frescoes: c. 1508–1512 C.E.; altar frescoes: c. 1536–1541 C.E. Fresco.	16.2	313, 314
76	*School of Athens.* Raphael. 1509–1511 C.E. Fresco.	16.3	315
77	Isenheim altarpiece. Matthias Grünewald. c. 1512–1516 C.E. Oil on wood.	14.4	289
78	*Entombment of Christ.* Jacopo da Pontormo. 1525–1528 C.E. Oil on wood.	16.5	317
79	*Allegory of Law and Grace.* Lucas Cranach the Elder. c. 1530 C.E. Woodcut and letterpress.	14.5	290
80	*Venus of Urbino.* Titian. c. 1538 C.E. Oil on canvas.	16.4	316
81	Frontispiece of the Codex Mendoza. Viceroyalty of New Spain. c. 1541–1542 C.E. Ink and color on paper.	18.1	343
82	Il Gesù, including *Triumph of the Name of Jesus* ceiling fresco. Rome, Italy. Giacomo da Vignola, plan (architect); Giacomo della Porta, façade (architect); Giovanni Battista Gaulli, ceiling fresco (artist). Church: 16th century C.E.; façade: 1568–1584 C.E.; fresco and stucco figures: 1676–1679 C.E. Brick, marble, fresco, and stucco.	16.6, 17.6	318, 332
83	*Hunters in the Snow.* Pieter Bruegel the Elder. 1565 C.E. Oil on wood.	14.6	291
84	Mosque of Selim II. Edirne, Turkey. Sinan (architect). 1568–1575 C.E. Brick and stone.	9.16	228
85	*Calling of Saint Matthew.* Caravaggio. c. 1597–1601 C.E. Oil on canvas.	17.5	332
86	*Henri IV Receives the Portrait of Marie de' Medici*, from the Marie de' Medici Cycle. Peter Paul Rubens. 1621–1625 C.E. Oil on canvas.	17.8	334
87	*Self-Portrait with Saskia.* Rembrandt van Rijn. 1636 C.E. Etching.	17.9	335
88	San Carlo alle Quattro Fontane. Rome, Italy. Francesco Borromini (architect). 1638–1646 C.E. Stone and stucco.	17.2	328
89	*Ecstasy of Saint Teresa.* Cornaro Chapel, Church of Santa Maria della Vittoria. Rome, Italy. Gian Lorenzo Bernini. c. 1647–1652 C.E. Marble (sculpture); stucco and gilt bronze (chapel).	17.1, 17.4	327, 331
90	*Angel with Arquebus, Asiel Timor Dei.* Master of Calamarca (La Paz School). c. 17th century C.E. Oil on canvas.	18.2	344
91	*Las Meninas.* Diego Velázquez. c. 1656 C.E. Oil on canvas.	17.7	333
92	*Woman Holding a Balance.* Johannes Vermeer. c. 1664 C.E. Oil on canvas.	17.10	336
93	The Palace at Versailles. Versailles, France. Louis Le Vau and Jules Hardouin-Mansart (architects). Begun 1669 C.E. Masonry, stone, wood, iron, and gold leaf (architecture); marble and bronze (sculpture); gardens.	17.3	329
94	Screen with the Siege of Belgrade and hunting scene. Circle of the González family. c. 1697–1701 C.E. Tempera and resin on wood, shell inlay.	18.3	344

AP Image Number	Work of Art	Figure Number	Page
95	*The Virgin of Guadalupe* (*Virgen de Guadalupe*). Miguel González. c. 1698 c.e. Based on original Virgin of Guadalupe. Basilica of Guadalupe, Mexico City. 16th century c.e. Oil on canvas on wood, inlaid with mother-of-pearl.	18.4	345
96	*Fruit and Insects.* Rachel Ruysch. 1711 c.e. Oil on wood.	17.11	337
97	*Spaniard and Indian Produce a Mestizo.* Attributed to Juan Rodríguez Juárez. c. 1715 c.e. Oil on canvas.	18.5	346
98	*The Tête à Tête,* from *Marriage à la Mode.* William Hogarth. c. 1743 c.e. Oil on canvas.	19.3	357
CONTENT AREA 4: LATER EUROPE AND AMERICAS			
99	Portrait of Sor Juana Inés de la Cruz. Miguel Cabrera. c. 1750 c.e. Oil on canvas.	18.6	347
100	*A Philosopher Giving a Lecture on the Orrery.* Joseph Wright of Derby. c. 1763 –1765 c.e. Oil on canvas.	19.4	358
101	*The Swing.* Jean-Honoré Fragonard. 1767 c.e. Oil on canvas.	19.1	356
102	Monticello. Virginia, U.S. Thomas Jefferson (architect). 1768–1809 c.e. Brick, glass, stone, and wood.	19.5	359
103	*The Oath of the Horatii.* Jacques-Louis David. 1784 c.e. Oil on canvas.	19.6	360
104	*George Washington.* Jean-Antoine Houdon. 1788–1792 c.e. Marble.	19.7	361
105	*Self-Portrait.* Elisabeth Louise Vigée Le Brun. 1790 c.e. Oil on canvas.	19.2	357
106	*And There's Nothing to Be Done* (*Y no hai remedio*), from *The Disasters of War* (*Les Desastres de la Guerra*), plate 15. Francisco de Goya. 1810–1823 c.e. (published 1863). Etching, drypoint, burin, and burnishing.	20.2	371
107	*La Grande Odalisque.* Jean-Auguste-Dominique Ingres. 1814 c.e. Oil on canvas.	20.3	372
108	*Liberty Leading the People.* Eugène Delacroix. 1830 c.e. Oil on canvas.	20.4	372
109	*The Oxbow* (*The View from Mount Holyoke, Northampton, Massachusetts, after a Thunderstorm*). Thomas Cole. 1836 c.e. Oil on canvas.	20.6	374
110	*Still Life in Studio.* Louis-Jacques-Mande Daguerre. 1837 c.e. Daguerreotype.	20.8	375
111	*Slave Ship* (*Slavers Throwing Overboard the Dead and Dying, Typhoon Coming On*). Joseph Mallord William Turner. 1840 c.e. Oil on canvas.	20.5	373
112	Palace of Westminster (Houses of Parliament). London, England. Charles Barry and Augustus W. N. Pugin (architects). 1840–1870 c.e. Limestone masonry and glass.	12.5, 20.1	261, 369, 370
113	*The Stone Breakers.* Gustave Courbet. 1849 c.e. (destroyed in 1945). Oil on canvas.	21.1	385
114	*Nadar Raising Photography to the Height of Art.* Honoré Daumier. 1862 c.e. Lithograph.	21.2	386
115	*Olympia.* Édouard Manet. 1863 c.e. Oil on canvas.	21.3	387

AP Image Number	Work of Art	Figure Number	Page
116	*The Saint-Lazare Station.* Claude Monet. 1877 c.e. Oil on canvas.	21.6	389
117	*The Horse in Motion.* Eadweard Muybridge. 1878 c.e. Albumen print.	21.5	388
118	*The Valley of Mexico from the Hillside of Santa Isabel (El Valle de México desde el Cerro de Santa Isabel).* Jose María Velasco. 1882 c.e. Oil on canvas.	21.4	387
119	*The Burghers of Calais.* Auguste Rodin. 1884–1895 c.e. Bronze.	21.15	396
120	*Starry Night.* Vincent van Gogh. 1889 c.e. Oil on canvas.	21.8	390
121	*The Coiffure.* Mary Cassatt. 1890–1891 c.e. Drypoint and aquatint.	21.7	390
122	*The Scream.* Edvard Munch. 1893 c.e. Tempera and pastels on cardboard.	21.11	393
123	*Where Do We Come From? What Are We? Where Are We Going?* Paul Gauguin. 1897–1898 c.e. Oil on canvas.	21.9	391
124	Carson, Pirie, Scott and Company Building. Chicago, Illinois, U.S. Louis Sullivan (architect). 1899–1903 c.e. Iron, steel, glass, and terra cotta.	21.14	395
125	*Mont Sainte-Victoire.* Paul Cézanne. 1902–1904 c.e. Oil on canvas.	21.10	392
126	*Les Demoiselles d'Avignon.* Pablo Picasso. 1907 c.e. Oil on canvas.	22.5	407
127	*The Steerage.* Alfred Stieglitz. 1907 c.e. Photogravure.	22.8	409
128	*The Kiss.* Gustav Klimt. 1907–1908 c.e. Oil and gold leaf on canvas.	21.12	394
129	*The Kiss.* Constantin Brancusi. 1907–1908 c.e. Stone.	22.7	408
130	*The Portuguese.* Georges Braque. 1911 c.e. Oil on canvas.	22.6	408
131	*Goldfish.* Henri Matisse. 1912 c.e. Oil on canvas.	22.1	404
132	*Improvisation 28* (second version). Vassily Kandinsky. 1912 c.e. Oil on canvas.	22.2	405
133	*Self-Portrait as a Soldier.* Ernst Ludwig Kirchner. 1915 c.e. Oil on canvas.	22.3	405
134	*Memorial Sheet for Karl Liebknecht.* Käthe Kollwitz. 1919–1920 c.e. Woodcut.	22.4	406
135	Villa Savoye. Poissy-sur-Seine, France. Le Corbusier (architect). 1929 c.e. Steel and reinforced concrete.	22.17	416
136	*Composition with Red, Blue and Yellow.* Piet Mondrian. 1930 c.e. Oil on canvas.	22.14	413
137	Illustration from *The Results of the First Five-Year Plan.* Varvara Stepanova. 1932 c.e. Photomontage.	22.13	413
138	*Object (Le Déjeuner en fourrure).* Meret Oppenheim. 1936 c.e. Fur-covered cup, saucer, and spoon.	22.10	411
139	Fallingwater. Pennsylvania, U.S. Frank Lloyd Wright (architect). 1936–1939 c.e. Reinforced concrete, sandstone, steel, and glass.	22.16	414, 415
140	*The Two Fridas.* Frida Kahlo. 1939 c.e. Oil on canvas.	22.11	411
141	*The Migration of the Negro, Panel no. 49.* Jacob Lawrence. 1940–1941 c.e. Casein tempera on hardboard.	22.19	417

AP Image Number	Work of Art	Figure Number	Page
142	*The Jungle*. Wifredo Lam. 1943 c.e. Gouache on paper mounted on canvas.	22.12	412
143	*Dream of a Sunday Afternoon in the Alameda Park*. Diego Rivera. 1947–1948 c.e. Fresco.	22.20	418
144	*Fountain* (second version). Marcel Duchamp. 1950 c.e. (original 1917). Readymade glazed sanitary china with black paint.	22.9	410
145	*Woman, I*. Willem de Kooning. 1950–1952 c.e. Oil on canvas.	22.21	419
146	Seagram Building. New York City, U.S. Ludwig Mies van der Rohe and Philip Johnson (architects). 1954–1958 c.e. Steel frame with glass curtain wall and bronze.	22.18	416
147	*Marilyn Diptych*. Andy Warhol. 1962 c.e. Oil, acrylic, and silkscreen enamel on canvas.	22.23	421
148	*Narcissus Garden*. Yayoi Kusama. Original installation and performance 1966 c.e. Mirror balls.	22.25	422, 423
149	*The Bay*. Helen Frankenthaler. 1963 c.e. Acrylic on canvas.	22.22	420
150	*Lipstick* (*Ascending*) *on Caterpillar Tracks*. Claes Oldenburg. 1969–1974 c.e. Cor-Ten steel, steel, aluminum, and cast resin; painted with polyurethane enamel.	22.24	421
151	*Spiral Jetty*. Great Salt Lake, Utah, U.S. Robert Smithson. 1970 c.e. Earthwork: mud, precipitated salt crystals, rocks, and water coil.	22.26	423
152	House in New Castle County. Delaware, U.S. Robert Venturi, John Rauch, and Denise Scott Brown (architects). 1978–1983 c.e. Wood frame and stucco.	22.27	424
CONTENT AREA 5: INDIGENOUS AMERICAS			
153	Chavín de Huántar. Northern highlands, Peru. Chavín. 900–200 b.c.e. Stone (architectural complex); granite (Lanzón and sculpture); hammered gold alloy (jewelry).	26.1	480, 481
154	Mesa Verde cliff dwellings. Montezuma County, Colorado. Ancestral Puebloan (Anasazi). 450–1300 c.e. Sandstone.	26.3	484
155	Yaxchilán. Chiapas, Mexico. Maya. 725 c.e. Limestone (architectural complex).	26.2	482, 483
156	Great Serpent Mound. Adams County, southern Ohio. Mississippian (Eastern Woodlands). c. 1070 c.e. Earthwork/effigy mound.	26.4	484
157	Templo Mayor (Main Temple). Tenochtitlán (modern Mexico City, Mexico). Mexica (Aztec). 1375–1520 c.e. Stone (temple); volcanic stone (Coyolxauhqui Stone); jadeite (Olmec-style mask); basalt (Calendar Stone).	26.5	485, 486
158	Ruler's feather headdress (probably of Motecuhzoma II). Mexica (Aztec). 1428–1520 c.e. Feathers (quetzal and cotinga) and gold.	26.6	487
159	City of Cusco, including Qorikancha (Inka main temple), Santo Domingo (Spanish colonial convent), and Walls at Saqsa Waman (Sacsayhuaman). Central highlands, Peru. Inka. c. 1440 c.e.; convent added 1550–1650 c.e. Andesite.	26.8	488, 489

AP Image Number	Work of Art	Figure Number	Page
160	Maize cobs. Inka. c. 1440–1533 C.E. Sheet metal/repoussé, metal alloys.	26.7	488
161	City of Machu Picchu. Central highlands, Peru. Inka. c. 1450–1540 C.E. Granite (architectural complex).	26.9	489, 490
162	All-T'oqapu tunic. Inka. 1450–1540 C.E. Camelid fiber and cotton.	26.10	490
163	Bandolier bag. Lenape (Delaware tribe, Eastern Woodlands). c. 1850 C.E. Beadwork on leather.	26.11	491
164	Transformation mask. Kwakwaka'wakw, Northwest Coast of Canada. Late 19th century C.E. Wood, paint, and string.	26.12	492
165	Painted elk hide. Attributed to Cotsiogo (Cadzi Cody), Eastern Shoshone, Wind River Reservation, Wyoming. c. 1890–1900 C.E. Painted elk hide.	26.13	492
166	Black-on-black ceramic vessel. Maria Martínez and Julian Martínez, Tewa, Puebloan, San Ildefonso Pueblo, New Mexico. c. mid-20th century C.E. Blackware ceramic.	26.14	493
CONTENT AREA 6: AFRICA			
167	Conical tower and circular wall of Great Zimbabwe. Southeastern Zimbabwe. Shona peoples. c. 1000–1400 C.E. Coursed granite blocks.	27.1	502
168	Great Mosque of Djenné. Mali. Founded c. 1200 C.E.; rebuilt 1906–1907. Adobe.	27.2	503
169	Wall plaque, from Oba's palace. Edo peoples, Benin (Nigeria). 16th century C.E. Cast brass.	27.3	504
170	Golden Stool (*Sika dwa kofi*). Ashanti peoples (south central Ghana). c. 1700 C.E. Gold over wood and cast-gold attachments.	27.4	505
171	*Ndop* (portrait figure) of King Mishe miShyaang maMbul. Kuba peoples (Democratic Republic of the Congo). c. 1760–1780 C.E. Wood.	27.5	506
172	Power figure (*Nkisi n'kondi*). Kongo peoples (Democratic Republic of the Congo). c. late 19th century C.E. Wood and metal.	27.6	507
173	Female (*Pwo*) mask. Chokwe peoples (Democratic Republic of the Congo). Late 19th to early 20th century C.E. Wood, fiber, pigment, and metal.	27.8	508
174	Portrait mask (*Mblo*). Baule peoples (Côte d'Ivoire). Early 20th century C.E. Wood and pigment.	27.7	507
175	*Bundu* mask. Sande society, Mende peoples (West African forests of Sierra Leone and Liberia). 19th to 20th century C.E. Wood, cloth, and fiber.	27.9	509
176	*Ikenga* (shrine figure). Igbo peoples (Nigeria). c. 19th to 20th century C.E. Wood.	27.10	510
177	*Lukasa* (memory board). Mbudye Society, Luba peoples (Democratic Republic of the Congo). c. 19th to 20th century C.E. Wood, beads, and metal.	27.11	510

AP Image Number	Work of Art	Figure Number	Page
178	Aka elephant mask. Bamileke (Cameroon, western grassfields region). c. 19th to 20th century c.e. Wood, woven raffia, cloth, and beads.	27.12	511
179	Reliquary figure (*byeri*). Fang peoples (southern Cameroon). c. 19th to 20th century c.e. Wood.	27.13	512
180	Veranda post of enthroned king and senior wife (Opo Ogoga). Olowe of Ise (Yoruba peoples). c. 1910–1914 c.e. Wood and pigment.	27.14	512
CONTENT AREA 7: WEST AND CENTRAL ASIA			
181	Petra, Jordan: Treasury and Great Temple. Nabataean Ptolemaic and Roman. c. 400 b.c.e.–100 c.e. Cut rock.	6.9	178, 179
182	Buddha. Bamiyan, Afghanistan. Gandharan. c. 400–800 c.e. (destroyed in 2001). Cut rock with plaster and polychrome paint.	23.2	433, 434
183	The Kaaba. Mecca, Saudi Arabia. Islamic. Pre-Islamic monument; rededicated by Muhammad in 631–632 c.e.; multiple renovations. Granite masonry, covered with silk curtain and calligraphy in gold and silver-wrapped thread.	9.11	223
184	Jowo Rinpoche, enshrined in the Jokhang Temple. Lhasa, Tibet. Yarlung Dynasty. Believed to have been brought to Tibet in 641 c.e. Gilt metals with semiprecious stones, pearls, and paint; various offerings.	23.3	434
185	Dome of the Rock. Jerusalem. Islamic, Umayyad. 691–692 c.e., with multiple renovations. Stone masonry and wooden roof decorated with glazed ceramic tile, mosaics, and gilt aluminum and bronze dome.	9.12	223, 224
186	Great Mosque (Masjid-e Jameh). Isfahan, Iran. Islamic, Persian: Seljuk, Il-Khanid, Timurid, and Safavid Dynasties. c. 700 c.e.; additions and restorations in the 14th, 18th, and 20th centuries c.e. Stone, brick, wood, plaster, and glazed ceramic tile.	9.13	224, 225
187	Folio from a Qur'an. Arab, North Africa, or Near East. Abbasid. c. 8th to 9th century c.e. Ink, color, and gold on parchment.	9.5	218
188	Basin (*Baptistère de Saint Louis*). Muhammad ibn al-Zain. c. 1320–1340 c.e. Brass inlaid with gold and silver.	9.6	218
189	*Bahram Gur Fights the Karg*, folio from the Great Il-Khanid *Shahnama*. Islamic; Persian, Il'Khanid. c. 1330–1340 c.e. Ink and opaque watercolor, gold, and silver on paper.	9.8	221
190	*The Court of Gayumars*, folio from Shah Tahmasp's *Shahnama*. Sultan Muhammad. c. 1522–1525 c.e. Ink, opaque watercolor, and gold on paper.	9.9	221
191	The Ardabil Carpet. Maqsud of Kashan. 1539–1540 c.e. Silk and wool.	9.7	219
CONTENT AREA 8: SOUTH, EAST, AND SOUTHEAST ASIA			
192	Great Stupa at Sanchi. Madhya Pradesh, India. Buddhist; Maurya, late Sunga Dynasty. c. 300 b.c.e.–100 c.e. Stone masonry, sandstone on dome.	23.4	435, 436
193	Terra cotta warriors from mausoleum of the first Qin emperor of China. Qin Dynasty. c. 221–209 b.c.e. Painted terra cotta.	24.8	457

AP Image Number	Work of Art	Figure Number	Page
194	Funeral banner of Lady Dai (Xin Zhui). Han Dynasty, China. c. 180 B.C.E. Painted silk.	24.4	454
195	Longmen Caves. Luoyang, China. Tang Dynasty. 493–1127 C.E. Limestone.	24.9	458
196	Gold and jade crown. Three Kingdoms period, Silla Kingdom, Korea. 5th to 6th century C.E. Metalwork.	24.10	458
197	Todai-ji. Nara, Japan. Various artists, including sculptors Unkei and Keikei, as well as the Kei School. 743 C.E.; rebuilt c. 1700. Bronze and wood (sculpture); wood with ceramic-tile roofing (architecture).	25.1	468, 469
198	Borobudur Temple. Central Java, Indonesia. Sailendra Dynasty. c. 750–842 C.E. Volcanic stone masonry.	23.5	436, 437
199	Angkor, the temple of Angkor Wat, and the city of Angkor Thom, Cambodia. Hindu, Angkor Dynasty. c. 800–1400 C.E. Stone masonry, sandstone.	23.8	440, 441
200	Lakshmana Temple. Khajuraho, India. Hindu, Chandella Dynasty. c. 930–950 C.E. Sandstone.	23.7	439, 440
201	*Travelers among Mountains and Streams*. Fan Kuan. c. 1000 C.E. Ink and colors on silk.	24.5	455
202	Shiva as Lord of Dance (Nataraja). Hindu; India (Tamil Nadu), Chola Dynasty. c. 11th century C.E. Cast bronze.	23.6	438
203	*Night Attack on the Sanjô Palace*. Kamakura period, Japan. c. 1250–1300 C.E. Handscroll (ink and color on paper).	25.3	471
204	The David Vases. Yuan Dynasty, China. 1351 C.E. White porcelain with cobalt-blue underglaze.	24.11	459
205	Portrait of Sin Sukju (1417–1475). Imperial Bureau of Painting. c. 15th century C.E. Hanging scroll (ink and color on silk).	24.6	455
206	Forbidden City. Beijing, China. Ming Dynasty. 15th century C.E. and later. Stone masonry, marble, brick, wood, and ceramic tile.	24.2	452, 453
207	Ryoan-ji. Kyoto, Japan. Muromachi period, Japan. c. 1480 C.E.; current design most likely dates to the 18th century. Rock garden.	25.2	469, 470
208	*Jahangir Preferring a Sufi Shaikh to Kings*. Bichitr. c. 1620 C.E. Watercolor, gold, and ink on paper.	23.9	442
209	Taj Mahal. Agra, Uttar Pradesh, India. Masons, marble workers, mosaicists, and decorators working under the supervision of Ustad Ahmad Lahori, architect of the emperor. 1632–1653 C.E. Stone masonry and marble with inlay of precious and semiprecious stones; gardens.	9.17	229
210	*White and Red Plum Blossoms*. Ogata Korin. c. 1710–1716 C.E. Ink, watercolor, and gold leaf on paper.	25.4	472
211	*Under the Wave off Kanagawa (Kanagawa oki nami ura)*, also known as the Great Wave, from the series Thirty-six Views of Mount Fuji. Katsushika Hokusai. 1830–1833 C.E. Polychrome wood-block print; ink and color on paper.	25.5	473
212	*Chairman Mao en Route to Anyuan*. Artist unknown; based on an oil painting by Liu Chunhua. c. 1969 C.E. Color lithograph.	24.7	456

AP Image Number	Work of Art	Figure Number	Page
	CONTENT AREA 9: THE PACIFIC		
213	Nan Madol. Pohnpei, Micronesia. Saudeleur Dynasty. c. 700–1600 C.E. Basalt boulders and prismatic columns.	28.1	521
214	Moai on platform (*ahu*). Rapa Nui (Easter Island). c. 1100–1600 C.E. Volcanic tuff figures on basalt base.	28.11	528
215	'Ahu 'ula (feather cape). Hawaiian. Late 18th century C.E. Feathers and fiber.	28.4	523
216	Staff god. Rarotonga, Cook Islands, central Polynesia. Late 18th to early 19th century C.E. Wood, tapa, fiber, and feathers.	28.5	523
217	Female deity. Nukuoro, Micronesia. c. 18th to 19th century C.E. Wood.	28.2	522
218	Buk (mask). Torres Strait. Mid- to late-19th century C.E. Turtle shell, wood, fiber, feathers, and shell.	28.9	526
219	Hiapo (tapa). Niue. c. 1850–1900 C.E. Tapa or bark cloth, freehand painting.	28.6	524
220	*Tamati Waka Nene.* Gottfried Lindauer. 1890 C.E. Oil on canvas.	28.7	525
221	Navigation chart. Marshall Islands, Micronesia. 19th to early 20th century C.E. Wood and fiber.	28.3	522
222	Malagan display and mask. New Ireland Province, Papua New Guinea. c. 20th century C.E. Wood, pigment, fiber, and shell.	28.8	526
223	Presentation of Fijian mats and tapa cloths to Queen Elizabeth II. Fiji, Polynesia. 1953 C.E. Multimedia performance (costume; cosmetics, including scent; chant; movement; and *pandanus* fiber/hibiscus fiber mats), photographic documentation.	28.10	527
	CONTENT AREA 10: GLOBAL CONTEMPORARY		
224	*The Gates.* New York City, U.S. Christo and Jeanne-Claude. 1979–2005 C.E. Mixed-media installation.	29.3	539
225	Vietnam Veterans Memorial. Washington, D.C., U.S. Maya Lin. 1982 C.E. Granite.	29.4	540
226	*Horn Players.* Jean-Michel Basquiat. 1983 C.E. Acrylic and oil paintstick on three canvas panels.	29.5	541
227	*Summer Trees.* Song Su-nam. 1983 C.E. Ink on paper.	29.6	541
228	*Androgyne III.* Magdalena Abakanowicz. 1985 C.E. Burlap, resin, wood, nails, string.	29.7	542
229	*A Book from the Sky.* Xu Bing. 1987–1991 C.E. Mixed-media installation.	29.8	542
230	*Pink Panther.* Jeff Koons. 1988 C.E. Glazed porcelain.	29.9	543
231	*Untitled #228*, from the History Portraits series. Cindy Sherman. 1990 C.E. Photograph.	29.10	543
232	*Dancing at the Louvre*, from the series The French Collection, Part I; #1. Faith Ringgold. 1991 C.E. Acrylic on canvas, tie-dyed, pieced fabric border.	29.11	544
233	*Trade (Gifts for Trading Land with White People).* Jaune Quick-to-See Smith. 1992 C.E. Oil and mixed media on canvas.	29.12	545
234	*Earth's Creation.* Emily Kame Kngwarreye. 1994 C.E. Synthetic polymer paint on canvas.	29.13	546

AP Image Number	Work of Art	Figure Number	Page
235	*Rebellious Silence*, from the Women of Allah series. Shirin Neshat (artist); photo by Cynthia Preston. 1994 C.E. Ink on photograph.	29.14	546
236	*En la Barberia no se Llora (No Crying Allowed in the Barbershop)*. Pepon Osorio. 1994 C.E. Mixed-media installation.	29.15	547
237	*Pisupo Lua Afe (Corned Beef 2000)*. Michel Tuffery. 1994 C.E. Mixed media.	29.16	548
238	*Electronic Superhighway*. Nam June Paik. 1995 C.E. Mixed-media installation (49-channel closed-circuit video installation, neon, steel, and electronic components).	29.17	548
239	*The Crossing*. Bill Viola. 1996 C.E. Video/sound installation.	29.18	549
240	Guggenheim Museum Bilbao. Spain. Frank Gehry (architect). 1997 C.E. Titanium, glass, and limestone.	29.1	537
241	*Pure Land*. Mariko Mori. 1998 C.E. Color photograph on glass.	29.19	550
242	*Lying with the Wolf*. Kiki Smith. 2001 C.E. Ink and pencil on paper.	29.20	551
243	*Darkytown Rebellion*. Kara Walker. 2001 C.E. Cut paper and projection on wall.	29.21	551
244	*The Swing (after Fragonard)*. Yinka Shonibare. 2001 C.E. Mixed-media installation.	29.22	552
245	*Old Man's Cloth*. El Anatsui. 2003 C.E. Aluminum and copper wire.	29.23	552
246	*Stadia II*. Julie Mehretu. 2004 C.E. Ink and acrylic on canvas.	29.24	553
247	*Preying Mantra*. Wangechi Mutu. 2006 C.E. Mixed media on Mylar.	29.25	554
248	*Shibboleth*. Doris Salcedo. 2007–2008 C.E. Installation.	29.26	554
249	MAXXI National Museum of XXI Century Arts. Rome, Italy. Zaha Hadid (architect). 2009 C.E. Glass, steel, and cement.	29.2	538
250	*Kui Hua Zi (Sunflower Seeds)*. Ai Weiwei. 2010–2011 C.E. Sculpted and painted porcelain.	29.27	555

PART TWO
Diagnostic Test

ANSWER SHEET
Diagnostic Test

Section I

1. Ⓐ Ⓑ Ⓒ Ⓓ
2. Ⓐ Ⓑ Ⓒ Ⓓ
3. Ⓐ Ⓑ Ⓒ Ⓓ
4. Ⓐ Ⓑ Ⓒ Ⓓ
5. Ⓐ Ⓑ Ⓒ Ⓓ
6. Ⓐ Ⓑ Ⓒ Ⓓ
7. Ⓐ Ⓑ Ⓒ Ⓓ
8. Ⓐ Ⓑ Ⓒ Ⓓ
9. Ⓐ Ⓑ Ⓒ Ⓓ
10. Ⓐ Ⓑ Ⓒ Ⓓ
11. Ⓐ Ⓑ Ⓒ Ⓓ
12. Ⓐ Ⓑ Ⓒ Ⓓ
13. Ⓐ Ⓑ Ⓒ Ⓓ
14. Ⓐ Ⓑ Ⓒ Ⓓ
15. Ⓐ Ⓑ Ⓒ Ⓓ
16. Ⓐ Ⓑ Ⓒ Ⓓ
17. Ⓐ Ⓑ Ⓒ Ⓓ
18. Ⓐ Ⓑ Ⓒ Ⓓ
19. Ⓐ Ⓑ Ⓒ Ⓓ
20. Ⓐ Ⓑ Ⓒ Ⓓ

21. Ⓐ Ⓑ Ⓒ Ⓓ
22. Ⓐ Ⓑ Ⓒ Ⓓ
23. Ⓐ Ⓑ Ⓒ Ⓓ
24. Ⓐ Ⓑ Ⓒ Ⓓ
25. Ⓐ Ⓑ Ⓒ Ⓓ
26. Ⓐ Ⓑ Ⓒ Ⓓ
27. Ⓐ Ⓑ Ⓒ Ⓓ
28. Ⓐ Ⓑ Ⓒ Ⓓ
29. Ⓐ Ⓑ Ⓒ Ⓓ
30. Ⓐ Ⓑ Ⓒ Ⓓ
31. Ⓐ Ⓑ Ⓒ Ⓓ
32. Ⓐ Ⓑ Ⓒ Ⓓ
33. Ⓐ Ⓑ Ⓒ Ⓓ
34. Ⓐ Ⓑ Ⓒ Ⓓ
35. Ⓐ Ⓑ Ⓒ Ⓓ
36. Ⓐ Ⓑ Ⓒ Ⓓ
37. Ⓐ Ⓑ Ⓒ Ⓓ
38. Ⓐ Ⓑ Ⓒ Ⓓ
39. Ⓐ Ⓑ Ⓒ Ⓓ
40. Ⓐ Ⓑ Ⓒ Ⓓ

41. Ⓐ Ⓑ Ⓒ Ⓓ
42. Ⓐ Ⓑ Ⓒ Ⓓ
43. Ⓐ Ⓑ Ⓒ Ⓓ
44. Ⓐ Ⓑ Ⓒ Ⓓ
45. Ⓐ Ⓑ Ⓒ Ⓓ
46. Ⓐ Ⓑ Ⓒ Ⓓ
47. Ⓐ Ⓑ Ⓒ Ⓓ
48. Ⓐ Ⓑ Ⓒ Ⓓ
49. Ⓐ Ⓑ Ⓒ Ⓓ
50. Ⓐ Ⓑ Ⓒ Ⓓ
51. Ⓐ Ⓑ Ⓒ Ⓓ
52. Ⓐ Ⓑ Ⓒ Ⓓ
53. Ⓐ Ⓑ Ⓒ Ⓓ
54. Ⓐ Ⓑ Ⓒ Ⓓ
55. Ⓐ Ⓑ Ⓒ Ⓓ
56. Ⓐ Ⓑ Ⓒ Ⓓ
57. Ⓐ Ⓑ Ⓒ Ⓓ
58. Ⓐ Ⓑ Ⓒ Ⓓ
59. Ⓐ Ⓑ Ⓒ Ⓓ
60. Ⓐ Ⓑ Ⓒ Ⓓ

61. Ⓐ Ⓑ Ⓒ Ⓓ
62. Ⓐ Ⓑ Ⓒ Ⓓ
63. Ⓐ Ⓑ Ⓒ Ⓓ
64. Ⓐ Ⓑ Ⓒ Ⓓ
65. Ⓐ Ⓑ Ⓒ Ⓓ
66. Ⓐ Ⓑ Ⓒ Ⓓ
67. Ⓐ Ⓑ Ⓒ Ⓓ
68. Ⓐ Ⓑ Ⓒ Ⓓ
69. Ⓐ Ⓑ Ⓒ Ⓓ
70. Ⓐ Ⓑ Ⓒ Ⓓ
71. Ⓐ Ⓑ Ⓒ Ⓓ
72. Ⓐ Ⓑ Ⓒ Ⓓ
73. Ⓐ Ⓑ Ⓒ Ⓓ
74. Ⓐ Ⓑ Ⓒ Ⓓ
75. Ⓐ Ⓑ Ⓒ Ⓓ
76. Ⓐ Ⓑ Ⓒ Ⓓ
77. Ⓐ Ⓑ Ⓒ Ⓓ
78. Ⓐ Ⓑ Ⓒ Ⓓ
79. Ⓐ Ⓑ Ⓒ Ⓓ
80. Ⓐ Ⓑ Ⓒ Ⓓ

Diagnostic Test

SECTION I

TIME: 60 MINUTES
80 MULTIPLE-CHOICE QUESTIONS

> **DIRECTIONS:** Answer the multiple-choice questions below. Some are based on images. In this book the illustrations are at the top of each set of questions. Select the multiple-choice response that best completes each statement or question, and indicate the correct response on the space provided on your answer sheet. You will have 60 minutes to answer the multiple-choice questions.

Questions 1–4 are based on Figure 1.

Figure 1

1. Works like Magdalene Abakanowicz's *Androgyne III* symbolize the

 (A) emptiness of modern life
 (B) return to the classical figure
 (C) advance of modern technology and its effect on the human condition
 (D) effects of pollution and global warming

2. The artist uses burlap as a material in part because it

 (A) is transparent and encourages us to see through the figures
 (B) is costly and represents elite power
 (C) imitates the appearance of human skin
 (D) is durable and needs no further care

3. The work is placed in the center of the room so that

 (A) other figures can be placed around it and interact with it
 (B) a contrast between solids and voids can be appreciated
 (C) people can be encouraged to touch the work and experience it first hand
 (D) it will block people from passing through the room and force them to consider it

4. This abstracted human form with contrasting solids and voids is compositionally similar to

 (A) Augustus of Prima Porta
 (B) *Ikenga* (shrine figure)
 (C) Nio guardian figure
 (D) Portrait of Sin Sukju

5. The choice of marble for the sculpture of George Washington by Jean-Antoine Houdon

 (A) indicates the discovery of a cheap source of marble in Vermont
 (B) symbolizes George Washington's home in Mount Vernon, Virginia
 (C) makes a parallel connection between Washington and great classical figures, who were also sculpted in marble
 (D) makes the comparison of George Washington to marble sculptures of great rulers and pharaohs of ancient Egypt

Questions 6–9 are based on Figures 2 and 3.

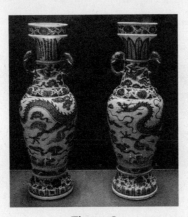

Figure 2

Figure 3

6. The objects on the left, called the David Vases, were made for

 (A) export to Europe because Asian art was greatly prized
 (B) Sir Percival David, a collector of Chinese ceramics
 (C) practical use in a Chinese home
 (D) an altar in a Chinese Daoist temple

7. Sources for the designs of works on the left are most likely from

 (A) Chinese bronzes
 (B) Japanese wood-block prints
 (C) Indian Buddhist sculpture
 (D) contact with Europeans

8. The work on the right represents a

 (A) revival of interest in pottery making in a culture that had seen a decline in that art
 (B) change to a more practical type of pottery rather than just aesthetically pleasing work
 (C) change from a tourist driven pottery market to a practical use market
 (D) move to reestablish pottery in European markets after a serious decline in quality

9. The work on the right can be compared with the works on the left in that both

 (A) are done by unidentified artists
 (B) use a combination of polished and matte surfaces
 (C) are dominated by zigzag and geometric motifs
 (D) were used in rituals

10. The Mexican flag today has an eagle perched on a cactus that rests on a rock. This symbol of Mexico can be found on which of the following works?

 (A) Screen with the Siege of Belgrade and hunting scene
 (B) Miguel González, *Virgin of Guadalupe*
 (C) Miguel Cabrera, Sor Juana Inés de la Cruz
 (D) lintel 25, structure 23, from Yaxchilán

11. The hypostyle halls common in Egyptian architecture—for example, the Temple of Amun-Re—can be said to have inspired later buildings, such as

 (A) the Altar of Zeus and Athena, Pergamon
 (B) the Mosque at Córdoba, Spain
 (C) the Pazzi Chapel by Brunelleschi
 (D) the Market of Trajan

12. Monticello reflects Thomas Jefferson's wish to reference the

 (A) spirituality of the Middle Ages in a modern context
 (B) history of ancient Greece in a modern context
 (C) ideals of the Roman Republic in a new country
 (D) latest building techniques in France and England in the New World

13. Compared with the Florentine Renaissance, the Venetian Renaissance painted religious or historical works

 (A) with a more human, worldly, and earthly quality

 (B) as a grand heroic series of accomplishments

 (C) with more geometric and mathematical precision

 (D) as if taking place in their original settings with authentic archeological costumes and architectural structures

14. Unlike most Baroque architects, Francesco Borromini

 (A) preferred to work in shades of white rather than in many colors

 (B) built palaces and avoided working for the Catholic Church

 (C) used landscaping to enhance the view of his buildings

 (D) used glass as a reflective element in his designs

Questions 15–18 are based on Figures 4 and 5.

Figure 4

Figure 5

15. Both of these works incorporate narrative, but the narrative is different in that

 (A) one tells the stories of the gods and their punishment of humans, and the other tells of the gods and how they help humans achieve enlightenment

 (B) one is in hieroglyphics and the other is in Arabic

 (C) one is read from right to left and the other from left to right

 (D) one has an uncertain ending and the other has a predetermined ending

16. The work on the top was meant to explain

 (A) vengeance upon a sinful man

 (B) an innocent person's journey to salvation and enlightenment

 (C) coming of age in a tumultuous era

 (D) the weighing of souls in the afterlife

17. The work on the bottom illustrates

 (A) an historical episode seen from the victor's point-of-view
 (B) a mythical event that sheds light on contemporary society
 (C) an allegory of war and violence
 (D) a personal challenge in the face of overwhelming odds

18. The work on the bottom was meant to be

 (A) on permanent display in a palace
 (B) put away and taken out occasionally to be viewed by interested parties
 (C) housed in a religious shrine as a moral lesson
 (D) periodically studied and examined in a library

19. Mende masks were the only African masks worn by women. They were worn during ceremonies that

 (A) prominently featured male participants
 (B) honored female ancestors
 (C) prepared girls for adulthood
 (D) commemorated African queens

20. Shiva as Lord of Dance shows the god as a divine judge devastating the world. The same sentiments are expressed in which of the following works?

 (A) Salcedo, *Shibboleth*
 (B) Last Judgment, Sainte-Foy, Conques
 (C) Giotto, *Lamentation*
 (D) Churning of the Ocean of Milk

Questions 21–24 are based on Figures 6 and 7.

Figure 6

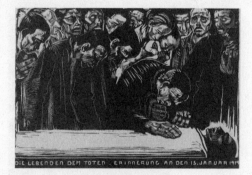

Figure 7

21. The print on the left was conceived as

 (A) an illustration of the effects of the Thirty Years' War
 (B) an indictment of Catholicism and a promotion of Protestantism
 (C) propaganda against the Counter-Reformation agents in Europe
 (D) an affirmation of the Old Testament over the New Testament

22. These works are prints which

 (A) were attached to early forms of newspapers and used as illustrations
 (B) were used as ways to educate children in schools
 (C) were deemed a higher art form than more traditional paintings
 (D) could make multiple original copies and be distributed more widely

23. These prints were done in a format called a woodcut, which has a style that can be characterized as

 (A) achieving precise details
 (B) using sfumato to shade figures
 (C) using stiff and angular figures
 (D) using the pointillist techniques

24. The work on the right was done in the memory of

 (A) a king of France who fell in love with an Italian princess and tragically died
 (B) a Catholic martyr who was misunderstood by native people and was killed
 (C) the artist's brother who died tragically in war
 (D) a slain member of the Communist party who led a revolt in Germany

25. Many works of art throughout history are made of spolia, reused architectural and sculptural elements. Which one of the following buildings is composed partly of spolia?

 (A) Santa Sabina
 (B) The Parthenon
 (C) The White Temple and its ziggurat
 (D) Il Gesù

Questions 26–29 are based on Figures 8 and 9.

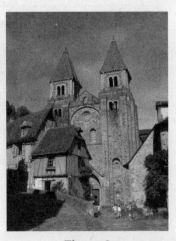

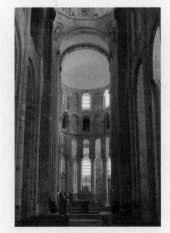

Figure 8 Figure 9

26. This church was built along pilgrimage roads headed to

(A) Jerusalem
(B) Rome
(C) Canterbury
(D) Santiago de Compostela

27. In order accommodate the number of pilgrims, the church has been designed with

(A) a large pair of bell towers
(B) sculpture on the façade
(C) an ambulatory around the altar
(D) an extensive crypt

28. As a pilgrimage center, it performs essentially the same role as

(A) the Palace of Versailles
(B) Forbidden City
(C) Great Stupa at Sanchi
(D) Basilica of Ulpia

29. As a pilgrimage center, this building houses reliquaries. A reliquary can be defined as

(A) an object that holds sacred objects
(B) a place where people were baptized into the Christian faith
(C) a series of carvings that tell the story of Jesus's life
(D) a woven product that is designed on a loom

30. Vigée Le Brun's *Self-Portrait* pays tribute to her favorite patron, Marie Antoinette, by

(A) including symbols of Marie Antoinette's reign
(B) having the artist dressed as the queen
(C) having the queen look at Vigée Le Brun with admiration
(D) including a lengthy quotation from the queen

31. The conical tower at Great Zimbabwe is modeled on

(A) a lookout tower, which made enemies more visible
(B) a minaret, which calls people to prayer
(C) a bell tower, which was used to signal royal events
(D) a grain silo, which indicated that control over food symbolized wealth and power

32. Which one of the following works is an example of a caricature?

(A) Daumier, *Nadar Raising Photography to the Height of Art*
(B) Portrait of Sin Sukju
(C) Mutu, *Preying Mantra*
(D) Smith, *Lying with the Wolf*

33. Which of the following works has experienced a form of iconoclasm?

 (A) Bamiyan Buddhas
 (B) Merovingian looped fibulae
 (C) *Lukasa* (memory board)
 (D) Velázquez, *Las Meninas*

34. Which of the following contains an imperial portrait?

 (A) White Temple and its ziggurat
 (B) Taj Mahal
 (C) San Vitale
 (D) Machu Picchu

35. The bas-reliefs on the walls of the Palace at Persepolis depict

 (A) Trajan's conquering of the Dacians
 (B) the battle between the gods and the giants
 (C) Darius's imperial guard, called the Immortals
 (D) a listing of laws outlining a civil code

Questions 36–38 refer to Figure 10.

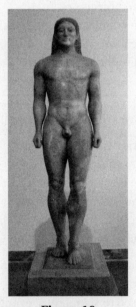

Figure 10

36. This statue is similar to other Greek kouroi in that it is inspired by

 (A) Ancient Near Eastern figures
 (B) Egyptian sculptures
 (C) Roman emperors
 (D) Polykleitos's theories

37. This sculpture was different from female sculptures of the same date in that it

 (A) was unpainted
 (B) is disproportionate to the human body
 (C) is nude
 (D) is young

38. The sculpture probably

 (A) saluted a fallen emperor or king
 (B) saluted a heroic figure from a battle
 (C) was placed in a tomb so that the spirit of the deceased could visit the earth
 (D) was designed as a symbol of a Greek city-state

 ───────────────────────

39. Although it is a Jewish manuscript, the Golden Haggadah shows cross-cultural influence in

 (A) the use of gold leaf taken from Byzantine mosaics
 (B) its illustration of stories from Christian texts
 (C) the stylistic similarities to French Gothic manuscripts
 (D) the use of Islamic kufic script

Questions 40 and 41 refer to Figures 11 and 12.

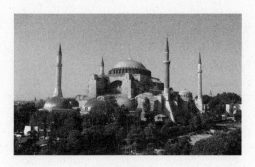

Figure 11

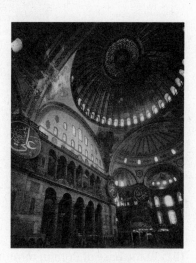

Figure 12

40. Who was the patron of this building?

 (A) Constantine the Great
 (B) Justinian
 (C) Augustus of Prima Porta
 (D) Suleyman the Magnificent

41. A key architectural feature first developed in this building is the

 (A) muqarnas
 (B) nave
 (C) narthex
 (D) pendentive

Question 42 refers to Figure 13.

Figure 13

42. This work can be attributed to which of the following artists?

 (A) Jacques-Louis David
 (B) Eugène Delacroix
 (C) Jean-Honoré Fragonard
 (D) Vincent van Gogh

43. Colophons are often seen

 (A) on Japanese screens
 (B) at the base of Roman monuments
 (C) on Renaissance frescoes
 (D) on Chinese scrolls

44. The Golden Stool is held to be a sacred item in part because it is

 (A) used as part of the throne for the kings of Ghana
 (B) the symbol of the Ashanti nation
 (C) used in all coming-of-age ceremonies
 (D) decorated with royal symbols

45. The design of the navigation charts of the Marshall Islands is difficult to interpret because the charts

 (A) are written in Polynesian script
 (B) are done in abstract designs
 (C) are understood only by the person who created them
 (D) are easily broken and have come down to us in fragmentary condition

46. Julie Mehretu's works have an animation and a sweeping vibrant pulse similar to the works of

 (A) Andy Warhol
 (B) Constantin Brancusi
 (C) Vassily Kandinsky
 (D) Meret Oppenheim

Question 47 refers to Figure 14.

Figure 14

47. This work can be attributed to which of the following art historical periods?

 (A) Amarna
 (B) Babylonian
 (C) Etruscan
 (D) Egyptian Old Kingdom

48. We know that the *Basin* by Muhammad ibn al-Zain must have been a special work for the artist because

 (A) it ended up in the possession of the King of France
 (B) he signed the work six times
 (C) he decorated it with hunting scenes
 (D) it is made of pewter

49. The International Style of mid-twentieth-century architecture stressed

(A) streamlined spaces and spare decoration
(B) a revival of hand-crafted and manually worked details
(C) a new look at traditional ornamentation, casting it in a modern way
(D) cantilever construction techniques

50. Which one of the following artists expressed his ideas about art in influential essays?

(A) Ernst Kirchner
(B) Paul Cézanne
(C) Vassily Kandinsky
(D) Georges Braque

Question 51 refers to Figure 15.

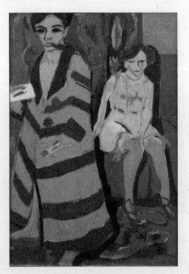

Figure 15

51. The artist of this self-portrait thought of his art as

(A) an artistic as well as a political statement
(B) an extension of the Impressionist style
(C) a bridge between traditional art forms and modern modes of expression
(D) an effort to harmonize European art techniques with African influences

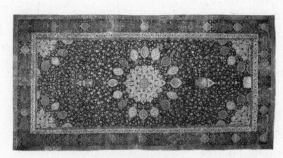

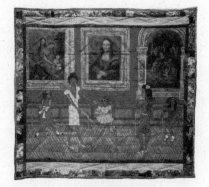

Figure 16 **Figure 17**

52. The work on the left was used for prayer for which faith?

 (A) Buddhism

 (B) Hinduism

 (C) Judaism

 (D) Islam

53. The work on the right is woven because it is

 (A) the traditional artistic occupation of women

 (B) meant to be beautiful but also have a function

 (C) a commentary on the contemporary neglect of woven works of art

 (D) meant to be worn

54. The artist in the work on the right appropriates images from the works of

 (A) Michelangelo

 (B) Gustave Courbet

 (C) Leonardo da Vinci

 (D) Rembrandt

55. The general Muslim and Jewish ban on religious images influenced the destruction of images in which period?

 (A) Byzantine

 (B) Romanesque

 (C) Gothic

 (D) Late Antique

56. Northern Renaissance altarpieces are different from Italian ones in that the Northern ones

 (A) have predellas

 (B) are cupboards with wings that close

 (C) have fanciful frames

 (D) are located in a church

57. The discovery of the caves at Lascaux solidified the opinion that

(A) the Trojan epics were retellings of actual events
(B) Pompeii was buried by volcanic ash
(C) Stonehenge was a unique ancient monument
(D) prehistoric cave paintings are genuine and not the work of modern forgers

58. The lost wax process, sometimes called *cire perdue*, is a method of sculpture seen in which of the following works?

(A) Greek marble sculpture
(B) Islamic ivories
(C) Northwest Coast Indian transformation masks
(D) Benin brasses and bronzes

59. Worshippers at the Kaaba, who are making the hajj,

(A) sacrifice animals to show that they give their most valued possessions to God
(B) bring offerings and gifts to the deity whose statue is contained within
(C) visit relics located in chapels around the east end of the shrine
(D) circumambulate the shrine seven times

Questions 60–62 refer to Figure 18.

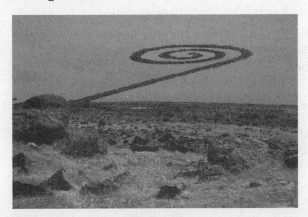

Figure 18

60. This work is *in situ* meaning it

(A) is made of man-made products
(B) can be seen with the use of a special device
(C) changes color depending on the time of day
(D) is in its original location

61. This work has been particularly designed

(A) to be far from civilization
(B) to align with the movements of the sun and the moon
(C) so that boats can dock alongside it
(D) to be viewed both by day and night

62. This work draws inspiration from works like

 (A) the Great Stupa at Sanchi
 (B) the Serpent Mound in Ohio
 (C) Machu Picchu in Peru
 (D) the ruins of the city of Pompeii

63. Daumier's *Nadar Raising Photography to the Height of Art* indicates a tone of

 (A) admiration because Daumier felt that photography could achieve a kind of greatness formerly known only to painting
 (B) condemnation in that the artist feels that a photograph is a mechanical device and not worthy of being classified as an art form
 (C) gentle mockery because Nadar is made to look foolish and funny in his situation
 (D) indifference because Daumier felt that photography was not an art form

64. The Harlem Renaissance refers to a period that

 (A) rejected any art as inspiration that was political in nature
 (B) aggressively rejected modernism
 (C) promoted African-American aesthetics in all the arts
 (D) encouraged African-Americans to conform to white standards of art production

65. Feathers were often used in Mesoamerican royal regalia because

 (A) exotic birds were plentiful and easy to catch
 (B) the feathers symbolized birds and hence freedom; kings felt they symbolically flew over other people
 (C) feathers made both lightweight and durable garments
 (D) the rareness of certain kinds of feathers indicated the wealth of the kings

66. Etchings are different from engraving in that etchings

 (A) require a metal plate as a ground
 (B) use a tool to cut into a surface
 (C) must be realized by passing paper over the impression
 (D) must be immersed in acid to achieve an image

67. Leonardo da Vinci's *Last Supper* is in a ruined condition today because

 (A) Leonardo experimented with different types of paint
 (B) the patrons were angry at the outcome and had the work mutilated
 (C) tastes change, and the work was going to be replaced because it looked out of fashion
 (D) the Nazis tried to remove it in World War II and damaged it

Figure 19

68. Contextually, the figures on the Great Portals of Chartres

 (A) physically and morally support the church behind them
 (B) act as an interpreter for those who are not Christian
 (C) are in the spot where royalty must pray
 (D) are symbols of the revival of the Catholic faith during the Counter-Reformation

69. This kind of grouping of sculpture and architecture can be found also at

 (A) the Taj Mahal
 (B) Dome of the Rock
 (C) Hagia Sophia
 (D) Lakshmana Temple

Question 70 refers to Figure 20.

Figure 20

70. The visual evidence in this work indicates that it is

 (A) a dedication page for a moralized Bible
 (B) an icon for religious worship
 (C) a cross-carpet page in a manuscript
 (D) the opening Gospel page in a manuscript

71. Quoins are architectural features used primarily

 (A) around a pediment
 (B) in Asian building traditions
 (C) on the edges of buildings
 (D) along stringcourses and cornices

72. Etruscan architecture is largely known to us today through the

 (A) writings of Vitruvius
 (B) excavations at Pompeii
 (C) books of Palladio
 (D) descriptions made by Greek historians

73. Baroque ceiling paintings, like those by Giovanni Battista Gaulli,

 (A) compartmentalize the ceiling into equal units
 (B) include general scenes in the main vault to symbolize everyday life
 (C) focus the attention of the viewer down the aisle to the altar
 (D) symbolically open up the ceiling as if looking into the sky

74. Graywacke was favored by ancient Egyptian sculptors because

 (A) the color symbolized royalty
 (B) its rarity symbolized royal wealth and trade
 (C) its denseness made it suitable for architectural elements
 (D) its hardness symbolized eternity

75. The exterior and interior decoration of the Houses of Parliament, or Palace of Westminster, shows a cultural identification with

 (A) Romanesque architecture, with its spaces designed to accommodate relics
 (B) Renaissance design principles as articulated in Italy
 (C) developments in cast-iron architecture, as a modern way to construct large-scale buildings
 (D) the symbolism of Perpendicular Gothic and its history as an English architectural style

76. A manuscript that is a moralized Bible is one in which

 (A) only excerpts from the Bible that end with morals are represented
 (B) the Old Testament stories are juxtaposed to New Testament stories
 (C) the Bible has added pages with modern commentaries
 (D) the Bible is thoroughly footnoted and researched

77. Jan Vermeer's paintings suggest that he had knowledge of

 (A) lithography
 (B) the daguerreotype
 (C) the camera obscura
 (D) the orrery

78. The material used to make bandolier bags relies on

(A) trade with European settlers
(B) manufactured goods available during the Industrial Revolution
(C) the reuse of older material in a new context
(D) the recycling of older bags for more modern use

79. In Claude Monet's *Saint-Lazare Station,* the artist represented the

(A) effect of light and air on a given subject
(B) breakdown of reality into its composite forms
(C) rearranging of reality into different geometric shapes
(D) sharp contrast of light and dark areas

Question 80 refers to Figure 21.

Figure 21

80. This painting can be attributed to Jan van Eyck because of the

(A) broad open brushwork
(B) meticulous detail
(C) symmetrical composition
(D) use of contrapposto

SECTION II

TIME: TWO HOURS
6 QUESTIONS

> **DIRECTIONS:** You have two hours to answer the six questions in this section.
> Questions 1 and 2 are long essay questions, and you are advised to spend one hour on both.
> Questions 3 through 6 are short essay questions, and you are advised to spend 15 minutes on each.
> During the actual exam, the proctor will announce when each question's time limit has been reached, but you may proceed freely from one question to another.
> Some of the questions refer to images; some do not.
> Read the questions carefully. You can receive full credit only by directly answering all aspects of the question.

Question 1: 35 minutes suggested time

Books have been created not only to preserve the written word but also to illustrate important concepts that the words represent. Often books have become highly decorated works of art in their own right, as much treasured for their illustrations as for their words.

This book shows a section from the Last judgment of Hunefer from the *Book of the Dead*, c. 1275 B.C.E., painted papyrus scroll.

Select and identify another work of art that is a selection from a book. You may select a work from the list or any other relevant work.

For both the Last judgment of Hunefer and your selected work, describe the scene in the work.

Analyze how the illustrations add meaning to the written content of *each* work.

Using *at least one* example of visual evidence, explain how *each* book is an important illustration of the culture that produced it.

Explain *at least one* difference in how these books function.

You may either select a work from the list below or select one of your own choosing. You are not limited to the works in the official image set.

The Court of Gayumars, folio from Shah Tahmasp's *Shahnama*
Frontispiece of the Codex Mendoza
Golden Haggadah (The Plagues of Egypt, Scenes of Liberation, and Preparation for Passover)

In Northern Renaissance art, artists often used symbolism to create meaning in a work of art.

Select and completely identify a work of art from the list below, or any other relevant work from the Northern Renaissance.

Explain how the artist used symbolism to create meaning in the work you have selected.

In your answer, make sure to:

- Accurately identify the work you have chosen with *at least two* identifiers beyond those given.
- Respond to the question with an art historically defensible thesis statement.
- Support your claim with *at least two* examples of visual and/or contextual evidence.
- Explain how the evidence that you have supplied supports your thesis.
- Use your evidence to corroborate or modify your thesis.

Arnolfini Portrait
Annunciation Triptych (Merode Altarpiece)
Allegory of Law and Grace

Question 3: 15 minutes suggested time

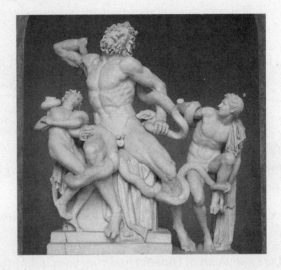

This work is Laocoön and his sons from the early first century C.E. by three artists from the Rhodes School.

Describe *at least two* visual characteristics of the work.

Using specific visual evidence, explain *at least two* techniques that the artists used to create a sense of drama in this work.

Explain how this work is part of the Hellenistic tradition of sculpture.

Question 4: 15 minutes suggested time

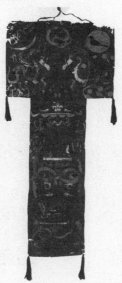

This work is the Funeral banner of Lady Dai (Xin Zhui), 180 B.C.E., painted silk.

Where was this work found?

Using specific visual evidence, discuss how the original context influenced the choice of materials *and* imagery.

Using *at least two* examples of contextual evidence, discuss how this work represents aspects of Chinese philosophy.

Question 5: 15 minutes suggested time

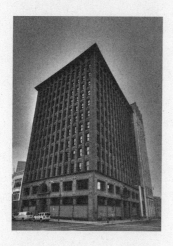

Attribute this building to the architect who designed it.

Discuss *at least two* specific details that justify your attribution by comparing this work to another work by the same architect in the required course content.

Discuss *at least two* developments in the history of architecture that this architect used in the design of this building. Use both the photograph *and* the plan in your discussion.

On the left is a *ndop*, a portrait figure of King Mishe miShyaang maMbul. On the right is a contextual image of Kuba Nyim (ruler) Kot a Mbweeky III in state dress with royal drum in Mushenge, Congo. The sculpture and the photograph represent a continuing tradition of the Kuba people which extends to today.

Explain the purpose of *ndop* figures.

Discuss *at least two* specific visual elements in this work that illustrate its purpose.

Explain *at least two* reasons how these elements continue to represent the Kuba king today, as seen in the contextual photograph.

ANSWER KEY
Diagnostic Test

Section I

1. **A**	21. **B**	41. **D**	61. **A**
2. **C**	22. **D**	42. **C**	62. **B**
3. **B**	23. **C**	43. **D**	63. **C**
4. **B**	24. **D**	44. **B**	64. **C**
5. **C**	25. **A**	45. **C**	65. **D**
6. **D**	26. **D**	46. **C**	66. **D**
7. **A**	27. **C**	47. **A**	67. **A**
8. **A**	28. **C**	48. **B**	68. **A**
9. **D**	29. **A**	49. **A**	69. **D**
10. **B**	30. **C**	50. **C**	70. **D**
11. **B**	31. **D**	51. **C**	71. **C**
12. **C**	32. **A**	52. **D**	72. **A**
13. **A**	33. **A**	53. **A**	73. **D**
14. **A**	34. **C**	54. **C**	74. **D**
15. **C**	35. **C**	55. **A**	75. **D**
16. **D**	36. **B**	56. **B**	76. **B**
17. **A**	37. **C**	57. **D**	77. **C**
18. **B**	38. **B**	58. **D**	78. **A**
19. **C**	39. **C**	59. **D**	79. **A**
20. **B**	40. **B**	60. **D**	80. **B**

ANSWERS EXPLAINED

Section I

1. **(A)** Abakanowicz's hollow sculptures symbolize, among other things, the emptiness of modern life, and the shallowness of people.

2. **(C)** The artist has said on occasion that the use of burlap has the texture of human skin and therefore symbolizes it.

3. **(B)** When placed in the center of the room, the emptiness of the insides of the sculpture become apparent. Many of this artist's works are placed in open spaces or in the center of rooms so they can be appreciated from all sides.

4. **(B)** The *Ikenga* (shrine figure) is an abstracted human form. The other three are very or fairly realistic in comparison.

5. **(C)** Marble has traditionally been used to "set in stone" the reputations of great figures in ancient history. The use of marble in this sculpture equates Washington with hallowed men from the classical past.

6. **(D)** The David Vases were originally meant to be placed on the altar of a Chinese Daoist temple.

7. **(A)** The artists were inspired by the decorations on Chinese bronzes.

8. **(A)** American Indian pottery had begun to decline when Europeans, with mass-produced pots, began to arrive. Martinez revived pottery making as an art form.

9. **(D)** The David Vases on the left have no known artist, but the work on the right was done by Maria and Julian Martínez. There are no matte surfaces on the David Vases, nor are they dominated by geometric or zigzag motifs. Only the David Vases were meant to be used in rituals. The Martinez pot was made for the tourist trade. On the other hand, they both have abstracted forms derived from nature.

10. **(B)** Although all of these works are Mexican in origin, only the painting *Virgin of Guadalupe* has an image, on the bottom center, of the eagle perched on a cactus—a symbol of Mexico itself.

11. **(B)** The hypostyle hall, with its numerous columns forming a dense interior, can be paralleled only with the Mosque at Córdoba, which has a forest of columns. The interior of the Altar of Zeus and Athena has not survived, and the last two choices have open and airy interiors.

12. **(C)** The ideals of the Roman Republic, with an early version of a democratic system of government, were seen as models for the American republic. For example, both the Romans and the Americans had a senate. Jefferson's building combines an ancient Greek portico with a Roman dome, as does the Pantheon in Rome.

13. **(A)** The Venetian Renaissance took religious and historical themes and made them more human, personal, and earthly than their Florentine counterparts.

14. **(A)** Francesco Borromini built a number of innovative and highly original churches in downtown areas of Rome. Hence, it was not possible to have extensive landscaping around his buildings. He preferred working in shades of white so that the dominant features of his building designs could stand out and not be camouflaged by brilliant colors. There is no evidence he used glass any more extensively than in windows.

15. **(C)** Egyptian writing is read left to right; Japanese writing is traditionally read right to left.

16. **(D)** The work on the left depicts the weighing of the soul of Hunefer.

17. **(A)** The work on the right is a depiction of an historical episode from Japanese history, specifically, a civil war culminating in the burning and looting of the Sanjô Palace.

18. **(B)** The work on the bottom, as is true with almost all Japanese scrolls, was never meant to be on permanent display. It was meant to be taken out, appreciated, and then stored away in scroll cabinets.

19. **(C)** Mende masks were worn by the Sande society of women, who prepared girls for adulthood and their subsequent roles in society through a ceremony in which the masks, along with appropriate costumes, were worn during a private ceremony without males.

20. **(B)** In the Last Judgment, Jesus comes at the end of the world to dictate who will go to heaven and who will go to hell. The human population on the planet will come to an end. The other choices do not reference global destruction.

21. **(B)** The Cranach print on the left is meant to promote Protestantism at the expense of Catholicism during the early stages of the Reformation.

22. **(D)** One of the many features of prints is that multiple original images can be mass produced and marketed.

23. **(C)** Angular and stiff figures are often rendered in woodcuts.

24. **(D)** The Kollwitz work on the right depicts the mourning over a deceased member of the Communist party.

25. **(A)** Santa Sabina has columns that were taken from the ruined Temple of Juno in Rome, the temple that occupied this site before Santa Sabina was built. The other choices were buildings made without reused elements.

26. **(D)** The Church of Sainte-Foy was built along a pilgrimage road to Santiago de Compostela in northwestern Spain.

27. **(C)** The huge number of pilgrims were accommodated by using an ambulatory around the apse. This architectural structure moved people from chapel to chapel without interfering with the main services held in the altar area.

28. **(C)** The Great Stupa at Sanchi was another point of pilgrimage.

29. **(A)** A reliquary is an object that houses sacred objects within it. Often the shape of the reliquary reflects the shape of the object it contains.

30. **(C)** Vigée Le Brun is at work at an easel in which the image of Marie Antoinette can be seen looking at her with admiration. She kept the queen's memory alive well after her beheading during the French Revolution.

31. **(D)** The rulers at Great Zimbabwe kept food in large grain silos to be distributed in times of need. This solidified their position as powerful providers in times of want.

32. **(A)** Daumier's exaggeration of Nadar's efforts to photograph Paris from a hot-air balloon qualifies as caricature. None of the other images seek to humorize the subject.

33. **(A)** Iconoclasm is the destruction of images. The Bamiyan Buddhas were blown up in 2001 by the Taliban in Afghanistan as an act of iconoclasm.

34. **(C)** The imperial portraits of Justinian and Theodora are housed in the church of San Vitale in Ravenna.

35. **(C)** The bas-reliefs on the walls of the Palace of Persepolis depict the imperial guard of the Persian king, Darius. Their numbers always held at 10,000, and were thus called the Immortals.

36. **(B)** The stiffness of kouros figures is similar to the erect stance of Egyptian sculptures.

37. **(C)** Both male and female Greek Archaic sculptures are painted, young, and had large human heads, but only the males are nude.

38. **(B)** The sculpture probably represents a heroic male warrior.

39. **(C)** Stylistically, a French Gothic manuscript such as Blanche of Castile and Louis IX shows a great affinity for compartmentalizing narratives into squares as well as for showing elegant, richly decorated figures and scenes, much as the Golden Haggadah does.

40. **(B)** The patron of the Hagia Sophia was Emperor Justinian.

41. **(D)** This building offered the first use of a pendentive, a triangular structure that transitions the space between the round dome and a square base.

42. **(C)** This work is by Fragonard. The similarities to *The Swing* are striking, including the use of atmospheric perspective, the soft pastel colors, and the fête galante theme.

43. **(D)** Colophons are commentaries written at the end of Chinese scrolls. They can also be publication data and commentary that appear on manuscripts from around the world.

44. **(B)** The Golden Stool is the symbol of the Ashanti nation. It cannot touch the ground; therefore it is not used as part of a throne. It is not decorated with royal symbols but does have bells attached to warn people if it is being touched. It is not used in coming-of-age ceremonies; in fact, it is rarely exhibited at all, and its whereabouts is generally unknown.

45. **(C)** The navigation charts of the Marshall Islands are intensely personal objects whose interpretation is known only to their creator. For others, the exact meaning of the diagonal lines is not easily understood, although generally it is believed they represent ocean and wind currents.

46. **(C)** Vassily Kandinsky was noted for his sweeping gestural work that initiated the world of modern abstract art.

47. **(A)** This work is from the Amarna period of Egyptian art. Indicators for this include the soft, supple shapes given to the human form, the slack jaws, the thin arms, epicene bodies, and low-hanging bellies.

48. **(B)** The artist signed his name six times on this bowl, indicating a certain degree of pride in his work.

49. **(A)** Architects of this period, Le Corbusier among others, favored streamlined, even, and sleek spaces that avoided decoration and ornamentation.

50. **(C)** Vassily Kandinsky wrote extensively on art theory. His writings were extremely influential on the history of modern art.

51. **(C)** Kirchner was a member of an art movement called The Bridge, so-called because the movement saw itself as a bridge between traditional and modern painting.

52. **(D)** The work on the left is used in Islamic prayer rituals.

53. **(A)** Weaving traditionally has been thought of as a female art form.

54. **(C)** The works in the background are three paintings by the Renaissance artist, Leonardo da Vinci. These paintings are on display in the Louvre museum.

55. **(A)** The active Muslim and Jewish ban on images influenced the Byzantine ban on Christian images in the ninth and tenth centuries.

56. **(B)** Northern Renaissance altarpieces, like the Isenheim altarpiece, are cupboards that open and close.

57. **(D)** The prehistoric cave paintings were thought by some to be forgeries until the caves of Lascaux were discovered.

58. **(D)** The lost wax process is a way of creating bronze or brass sculptures.

59. **(D)** Islam does not have statues of holy figures, nor does this shrine have an east end to house relics. There are no animal sacrifices. Muslims worship at the Kaaba by circumambulating the shrine seven times as an act of devotion.

60. **(D)** *In situ* is a Latin expression that means "in its original place."

61. **(A)** This work is located in a remote section of the Utah desert on the Great Salt Lake.

62. **(B)** *Spiral Jetty* resembles the curvilinear forms found at Great Serpent Mound in Ohio.

63. **(C)** Daumier was generally not happy about the invention of the photograph and tried to minimize its artistic impact by gently poking fun at Nadar and his photographic achievements.

64. **(C)** The Harlem Renaissance was a rich period that celebrated African-American culture in all artistic avenues.

65. **(D)** The rareness of certain birds with their colorful plumage meant that many birds had to be captured, plucked, and traded to create the garments. These garments, expensive and time consuming to make, thus carried great esteem.

66. **(D)** Etchings are dipped in acid after being covered in a wax ground. The acid eats into the surface and produces grooves filled with ink so that images can be reproduced on paper.

67. **(A)** Leonardo da Vinci was an endless experimenter, particularly in the types of paints he used. He combined watercolor, oil, and tempera paint in the creation of the *Last Supper*.

68. **(A)** The Great Portal figures symbolically hold up and support the church and its teachings.

69. **(D)** Like the Great Portals, the Lakshmana Temple has sculpture carved on its façade.

70. **(D)** This illustration comes from the medieval manuscript called *The Book of Kells*. Like the *Book of Lindisfarne*, this book has author portraits, cross pages, and decorative opening pages called incipit pages. This page does not have a dedication page with figures acting as a patron for the book, as in the dedication page with Blanche of Castile and Louis IX. Nor does it function as an iconic image as done in Byzantine art. Cross-carpet pages are dominated by large crosses that are filled in with elaborate interlacing patterns. This page has both text and image, with the opening words being emphasized. This signals the opening of a gospel book.

71. **(C)** Quoins are architectural features that are prominently placed on the edges of buildings to emphasize their perimeter.

72. **(A)** Most architecture from the Etruscan period does not survive. We know about it through the writings of the Roman author, Vitruvius.

73. **(D)** The ceilings by many Baroque masters open up the barrel vault of the church to a huge display of an infinite sky with figures, seen from below, hovering above the viewer's eyes.

74. **(D)** Graywacke is an unusually hard stone, meant to last forever and maintain the spirit of an Egyptian's ka indefinitely.

75. **(D)** Westminster Hall, adjacent to the Houses of Parliament, survived an early-nineteenth-century fire and formed the source of inspiration for the new building. Westminster Hall is a surviving example of Perpendicular Gothic, a native English architectural style.

76. **(B)** A moralized Bible compares the Old and New Testament stories, by placing them side by side.

77. **(C)** Scholars have demonstrated that Vermeer's paintings were influenced by the use of the camera obscura.

78. **(A)** The beads used in bandolier bags were obtained by trading with the Europeans.

79. **(A)** Impressionist paintings, particularly those by Claude Monet, are especially concerned with the atmospheric effects of light and air on objects.

80. **(B)** The meticulous use of detail is a hallmark of the style of Jan van Eyck. None of the other characteristics apply to him.

Section II

MODEL RESPONSE FOR QUESTION 1

Throughout history, written works have often been accompanied by illustration to add meaning and further explain the text. This is evident in the <u>Last judgment of Hunefer</u>, from his tomb, which is a page from the <u>Book of the Dead</u>. This papyrus scroll is from the ancient Egyptian New Kingdom. It clearly utilizes text hand in hand with illustration to gets its full meaning across; it is the final judgment of the scribe, Hunefer, before he can go to heaven.

Similar to pyramid and coffin texts, this scroll text was a set of instructions that Hunefer would need in the afterlife. The writing would help lead Hunefer through his judgment so that his soul could finally be weighed and he could go to heaven. The writing also includes prayers. These prayers were to aid the dead in getting through their final judgment. Lastly, the writing allows us to identify who Hunefer is in the first place. We can follow the story of the ancient scribe using the text; however, the illustration helps us to visualize it.

The illustration helps to further explain what the text is saying. It fully shows the trip that Hunefer took to be judged. The illustration also helps to clarify what Hunefer may have somewhat looked like, as well as how important Hunefer was. He is dressed in a white robe, white being a pure color associated with high status in art. In one scene on the top left, Hunefer is kneeling in front of many figures. He is pleading with them and telling them that he is in fact a good person, worthy of heaven. On the bottom far left, the man in the white robe, the god, Anubis, leads Hunefer. Hunefer's heart is being weighted against a feather to find the purity of soul. Thoth stands on the other side of the scale, recording what is going on to see if Hunefer has truly lived an ethical life. In one final scene on the right, Hunefer is introduced to one of the supreme gods, Osiris, by Osiris's son, Horus, with the falcon head. Osiris sits in front of a lotus, a flower that represents eternal life.

Another important book is the <u>Frontispiece of the Codex Mendoza</u>, c. 1542, done on pigment on paper. Although named after the viceroy of New Spain, the work actually shows scenes of the founding of Tenochtitlan in Mexico City.

The work uses two different kinds of writing: Spanish, to explain the story to a European audience, and Aztec pictograms that illustrate the story in a native language.

The purpose of the book is to show life in New Spain to an audience that would probably never go there. To that end, Aztecs carry out events in daily life, as

well as military conquests, both legible in their language and in the European tongue. Skulls, for example, represent sacrificial victims offered up in Aztec ceremonies. They are also words that symbolize this sacrifice. Therefore in the case of the Codex Mendoza, the words and pictures are actually one.

So powerful has this imagery become, that the current Mexican flag has some of the symbols seen on this frontispiece: an eagle, a cactus, and a rock.

Criteria	Student Response	Point Value	Points Earned
Task: Select and identify another work of art that is a selection from a book.			
The response must have two valid identifications other than the title already given.	"Another important book is the *Frontispiece of the Codex Mendoza*, c. 1542, done on pigment on paper."	1	1
Task: For both the Last judgment of Hunefer and your selected work, describe the scene in the work.			
The essay must describe the action taking place in the book.	"The illustration helps to further explain what the text is saying. It fully shows the trip that Hunefer took to be judged...etc." "The work actually shows scenes of the founding of Tenochtitlán in Mexico City."	2	1; the Hunefer example is complete; the Codex Mendoza example states the scene, but does not *describe* it.
Task: Analyze how the illustrations add meaning to the written content of *each* work.			
A strong connection has to be made between the written text and the illustrations in the book.	"The writing would help lead Hunefer through his judgment so that his soul could finally be weighed and he could go to heaven. The writing also includes prayers...etc." "The work uses two different kinds of writing: Spanish to explain the story to a European audience, and Aztec pictograms that illustrate the story in a native language... "	2	2
Task: Using *at least one* example of visual evidence, explain how *each* book is an important illustration of the culture that produced it.			
The essay must analyze how visual elements form a connection with the culture.		1	0; although there are many examples of visual evidence pointed out in the essay, it does not address how they reflect the culture that produced it.

Criteria	Student Response	Point Value	Points Earned
Task: Explain *at least one* difference in how these books function.			
The function of each book must be explained.	"This scroll text was a set of instructions that Hunefer would need in the afterlife." "The purpose of the book is to show life in New Spain to an audience that would probably never go there."	2	2
		Total Points Possible: 8	This essay earned: 6

MODEL RESPONSE FOR QUESTION 2

The Arnolfini Portrait by Jan van Eyck is an oil on wood painting created in the fifteenth century, more specifically done in the 1430s C.E.

A common distinguishing feature of artists in the Northern Renaissance is the presence of symbolism to create meaning in a work of art. For artists such as Jan van Eyck, this symbolism comes from "disguised symbols" or objects that appear as though they are everyday items, but hold a symbolic meaning that was quite recognizable at the time it was created.

For this piece in particular, there are many pieces of visual and contextual evidence that support the claim of symbolism being typical in the Northern Renaissance. In the foreground of the scene, a small dog stands between the couple, and while it appears as though the dog has no relevance in regards to the subject matter of the painting, the small creature holds an abundance of meaning. Not only does that particular breed of dog represent a load of wealth during the Northern Renaissance, a theme represented by many objects in this piece such as fabrics and furnishings, but it also represents marital fidelity.

While the actual action in the scene is not known entirely, one main theory is that the couple in the frame are in the middle of a betrothal ceremony, which aligns with symbol of faithfulness embodied by the dog. Another one of these disguised symbols is the lack of shoes worn by the man. This alone represents the idea of the "holy ground" and in combination of symbols such as the convex mirror and the burning candle in the background all demonstrate the omniscience and omnipresence of God. These religious symbols being disguised in works of art through everyday objects that hold meaning is common in the Northern Renaissance. The Arnolfini Portrait is just one example of the use of these disguised symbols to convey messages received by those present at the time of completion of the piece.

—Hannah B.

Criteria	Student Response	Point Value	Points Earned
Task: Select and completely identify a work of art from the list below, or any other relevant work from the Northern Renaissance.			
Two identifiers are needed in addition to the name supplied above. Hannah B. gives the artist, date, and medium.	"The *Arnolfini Portrait* by Jan van Eyck is an oil on wood painting created in the fifteenth century, more specifically done in the 1430s C.E."	1	1
Task: Respond to the question with an art historically defensible thesis statement.			
It is important when answering this question to clearly state the purpose of the essay, as reflected in the prompt.	"For artists such as Jan van Eyck, this symbolism comes from 'disguised symbols' or objects that appear as though they are everyday items, but hold a symbolic meaning that was quite recognizable at the time it was created."	1	1
Task: Support your claim with *at least two* examples of visual and/or contextual evidence.			
A connection must be firmly made between the thesis statement and examples of where this can be seen in the work. The *Arnolfini Portrait* has many symbols. Hannah gives several examples.	"Not only does that particular breed of dog represent a load of wealth..., but it also represents marital fidelity." "Another one of these disguised symbols is the lack of shoes worn by the man. This alone represents the idea of the 'holy ground'..."	2	2
Task: Explain how the evidence that you have supplied supports your thesis.			
This point is earned when the student analyzes the work of art. This essay introduces a second thesis rather than elaborating on the first.	"While the actual action in the scene is not known entirely, one main theory is that the couple in the frame are in the middle of a betrothal ceremony, which aligns with symbol of faithfulness embodied by the dog."	1	0
Task: Use your evidence to corroborate or modify your thesis.			
The student must show an understanding of the complexity of the issues involved to earn this point. This is not in evidence here.		1	0
		Total points possible: 6	This essay earned: 4

Remarks: The chosen object is a solid example of Northern Renaissance symbolism, and the list of symbols in this work could be long. This essay starts with some wise choices, but does not address the complexity of the issue.

MODEL RESPONSE FOR QUESTION 3

The sculpture is made out of marble. There are three figures in agony and it looks like they are being constricted by a snake. They are nude and idealized and are showing a lot of emotion. They are attached to a piece of stone at the bottom, and they have some cloth being draped from them.

One technique that the artists used to create a sense of drama in this work is the crisscrossing diagonals that run all throughout the sculpture. The diagonal lines make the figures in this work look like they are moving. Another technique the artists used is the comparison between light and dark. The comparison adds perspective and depth and makes it also feel more dramatic. The figure in the middle looks like he is jumping out at the viewer because he is the lightest. The facial expressions and the movements also make it appear more dramatic. It is obvious that they are in pain by not only their face but their bodies. They are twisting all over in agony.

This work is part of the Hellenistic tradition for multiple different reasons. First of all, it is showing intense violence and overwhelming, raw emotion. The figures are very expressive and it is showing a dramatic theatricality. This was a big change from the earlier Greek Classical period which demonstrated a calmness and rationality. It is a snapshot of a scene, which is obvious by the twisting and straining bodies, the crisscrossing diagonals, and the vigorous movement. Lastly, it is showing a strong contrast of light and dark.

—Ellie C.

Criteria	Student Response	Point Value	Points Earned
Task: Describe *at least two* visual characteristics of the work.			
There are many visual characteristics of this work; nudity and idealization are two of them, as Ellie suggests. Remember that while the prompt asks for at least two, you can supply as many valid responses as you like. Also remember that the prompt asks the student to describe, not just list.	"They are nude and idealized and are showing a lot of emotion."	2	1
Task: Using specific visual evidence, explain *at least two* techniques that the artists used to create a sense of drama in this work.			
Ellie points out the diagonal lines that create a sense of movement in the work. The observation about light and dark in a sculpture is less valid. Perhaps it would be better expressed as negative space.	"One technique that the artists used to create a sense of drama in this work is the crisscrossing diagonals that run all throughout the sculpture. The diagonal lines make the figures in this work look like they are moving. Another technique the artists used is the comparison between light and dark."	2	1
Task: Explain how this work is part of the Hellenistic tradition of sculpture.			
This prompt requires the student to know what the chief characteristics of the Hellenistic period are, and how they can be seen in this work.	"First of all, it is showing intense violence and overwhelming, raw emotion. The figures are very expressive and it is showing a dramatic theatricality."	1	1
		Total points possible: 5	This essay earned: 3

Remarks: This response shows how the student has carefully analyzed a new image by using techniques learned in class. Prompts that use expressions like "describe" or "explain" require a fuller development.

The <u>Funeral banner of Lady Dai</u> was found in China laid on top of her innermost of four coffins.

An example of visual evidence that shows influence on materials is the use of silk. During the Han Dynasty, only wealthy people could afford silk garments. By using silk, Lady Dai was showing her wealth and power.

An example of visual evidence that shows influence on imagery is the artist's use of symbols. For example, of the use of bi: symbol of heaven. This shape is seen twice on the banner: on the bottom where it is created by the intertwining of fish, and in the middle where the dragons intertwine. The bi shape has also been found with the jade congs in early Chinese graves. The symbol has continuously been connected with funerary art.

One example of contextual evidence that represents aspects of Chinese philosophy is the use of the banner. The banner was used to attract the spirit of Lady Dai to her tomb where she could begin her journey in the afterlife.

Another example of contextual evidence representing aspects of Chinese philosophy is where the banner was placed. The <u>Funeral banner of Lady Dai</u> was encompassed by three other coffins that were filled with offerings she would use in the afterlife. Confucianism is represented by Lady Dai's relatives showing her respect with offerings and rituals. This is seen in the lower middle part of the banner where Lady Dai's funeral is being held. Her body is on a platform with a table full of vessels holding food and wine offered by her family.

—Ava N.

Criteria	Student Response	Point Value	Points Earned
Task: Where was this work found?			
The name of the tomb is unnecessary, but it is important to show that this was a funerary object that was placed in the tomb sanctuary.	"The Funeral banner of Lady Dai was found in China laid on top of her innermost of four coffins."	1	1
Task: Using specific visual evidence, discuss how the original context influenced the choice of materials *and* imagery.			
The student needs to respond to how the context of being a funerary object is reflected in the choice of materials used in the banner and the imagery depicted on it.	"By using silk, Lady Dai was showing her wealth and power." "For example, of the use of bi: symbol of heaven. This shape is seen twice on the banner: on the bottom where it is created by the intertwining of fish, and in the middle where the dragons intertwine."	2	2
Task: Using *at least two* examples of contextual evidence, discuss how this work represents aspects of Chinese philosophy.			
A connection must be firmly made between this work and Chinese philosophy, particularly concerning the afterlife. This response targets imagery on the funerary banner with Confucianism. It could also respond to the yin and yang images depicted on the banner, and their meaning within the context of Chinese philosophy.	"Confucianism is represented by Lady Dai's relatives showing her respect with offerings and rituals. This is seen in the lower middle part of the banner where Lady Dai's funeral is being held. Her body is on a platform with a table full of vessels holding food and wine offered by her family."	2	1
		Total points possible: 5	**This essay earned: 4**
Remarks: This response proves to the reader that the student has carefully studied the image and is aware of the contextual issues behind the object's placement and imagery.			

MODEL RESPONSE FOR QUESTION 5

This building can be attributed to Louis Sullivan.

One specific detail that justifies my attribution is the inclusion of strips of vertical windows covering each side of this building and Sullivan's Carson, Pirie, Scott and Company Building.

Another detail that justifies my attribution is the break from traditional architecture evident in the design of this building and the Carson, Pirie, Scott building. Sullivan's motto became "Form Follows Function," asserting that the building's architecture should reflect its function or purpose. In addition, Sullivan utilizes terra cotta cladding in between the long strips of window to further emphasize the building's function by revealing its structural system.

In his buildings, Sullivan uses steel girder framing which is best known in the development of architectural history for enabling buildings to have large, glass windows. As visible in the image of the plan, the steel framing allows for large windows to pour light and ventilation into the building, a concern of modern architects.

Sullivan also uses an elevator in his building. This is what allowed architects to create higher buildings that more efficiently fulfilled the needs of citizens.

—Allie C.

Criteria	Student Response	Point Value	Points Earned
Task: Attribute this building to the architect who designed it.			
Louis Sullivan is the correct response, although just Sullivan would be accepted as well.	"This building can be attributed to Louis Sullivan."	1	1
Task: Discuss *at least two* specific details that justify your attribution by comparing this work to another work by the same architect in the required course content.			
The work in the required course content is the Carson, Pirie, Scott, which Allie correctly identifies. The prompt asks the student to justify the attribution with details that both buildings have in common. Allie responds with three reasons, although only two are required. This is a good strategy, because it convinces the reader that the student has a solid grasp of the content.	"One specific detail that justifies my attribution is the inclusion of strips of vertical windows covering each side of this building and Sullivan's Carson, Pirie, Scott and Company Building." "In addition, Sullivan utilizes terra cotta cladding in between the long strips of window to further emphasize the building's function by revealing its structural system."	2	2
Task: Discuss *at least two* developments in the history of architecture that this architect used in the design of this building. Use both the photograph *and* the plan in your discussion.			
Since the prompt requires the student to respond to the plan as well the photo, it is wise to signal to the reader that you have used both, in case there is any ambiguity. Here, Allie clearly states, "As visible in the image of the plan…"	"In his buildings, Sullivan uses steel girder framing which is best known in the development of architectural history for enabling buildings to have large, glass windows. As visible in the image of the plan, the steel framing allows for large windows to pour light and ventilation into the building, a concern of modern architects. Sullivan also uses an elevator in his building. This is what allowed architects to create higher buildings that more efficiently fulfilled the needs of citizens."	2	2
		Total points possible: 5	**This essay earned: 5**
Remarks: Students generally perform very poorly on architecture questions on the AP Art History exam. You would do well to follow a model like this in which the student addresses each section of the prompt one at a time. Make sure to point out the references both to the photograph and the plan.			

MODEL RESPONSE FOR QUESTION 6

This Ndop on the left is one of numerous other commemorative portraits portraying a Kuba ruler's idealized spirit that celebrates the success and achievements contributed by each respective African ruler's reign. Since these wooden figures were commissioned posthumously, they replaced deceased Kings and acted as containers for their spirit. The Kuba people believed in the secular value of material possessions and the Ndop reflects this through the usage of royal regalia.

The King is shown sitting cross-legged on a base instead of directly on the surface, suggesting his high status. His facial expression appears disinterested, reflecting a detachment from worldly affairs. The peace knife in his left hand has its handle turned outward, symbolizing the peace that Kuba enjoyed under his authority.

The amount of accessories the artist included in this statue, such as the headdress or necklace, serves to communicate the economic prosperity of the rule and affluence of the King. His stiff posture evokes an aura of dignity to the audience.

The photo of Kuba King Nyim in regal dress on the right was taken during a royal event. Just as the Ndop figure, the King in the picture stands on a platform as opposed to directly on the ground with his subjects. As seen in the photograph, this ruler also wears an excessive amount of royal regalia. This method of conveying wealth, status, and power through costume and dress is a continuation within African art. Lastly, the amount of effort put into this event reveals the lasting tradition of honoring the Kuba Kings with grand festivity and many celebratory objects.

Criteria	Student Response	Point Value	Points Earned
Task: Explain the purpose of *Ndop* figures.			
The essay must express an awareness of the purpose of a *ndop* figure.	"Since these wooden figures were commissioned posthumously, they replaced deceased kings and acted as containers for their spirit."	1	1
Task: Discuss *at least two* specific visual elements in this work that illustrate its purpose.			
The essay needs to fully articulate *at least two* elements in the work that help express its purpose.	"The king is shown sitting cross-legged on a base instead of directly on the surface, suggesting his high status. His facial expression appears disinterested, reflecting a detachment from worldly affairs. The peace knife in his left hand has its handle turned outward, symbolizing the peace that Kuba enjoyed under his authority."	2	2
Task: Explain *at least two* reasons how these elements continue to represent the Kuba king today, as seen in the contextual photograph.			
The essay must meaningfully connect the contextual photograph with the *ndop* figure.	"Just as the *ndop* figure, the king in the picture stands on a platform as opposed to directly on the ground with his subjects. As seen in the photograph, this ruler also wears an excessive amount of royal regalia. This method of conveying wealth, status, and power through costume and dress is a continuation within African art."	2	2
		Total points possible: 5	**This essay earned: 5**
Remarks: This essay firmly makes the connection between the work of art and the contextual photograph. Students should make sure to definitely point out exactly where the answers lie in each image.			

EVALUATION OF DIAGNOSTIC TEST

NOTE: Because the AP Art History exam has been redesigned, there is no way of knowing exactly how the raw scores on the exams will translate into a 1, 2, 3, 4, or 5. The formula provided below is based on past commonly accepted standards for grading the AP Art History exam. Additionally, the score range corresponding to each grade varies from exam to exam, and thus the ranges provided below are approximate.

Section I: Multiple-Choice (50% of grade)

Your diagnostic test score can now be computed. The multiple-choice section of the actual test is scored by computer, but it uses the same method you will use to compute your score manually. Each correct answer earns one point. Each incorrect answer has no value, and cannot earn or lose points. Omitted questions or questions that the computer cannot read because of smudges or double entries are not scored at all. Go over your answers and mark the ones correct with a "C" and the ones incorrect with an "X."

Enter the total number of correct answers: _____

Conversion of Raw Score to Scaled Score

Your raw score is computed from a total of 80 questions. In order to coordinate the raw score of the multiple-choice section with the free-response section, the multiple-choice section is multiplied by a factor of 1.25. For example, if the raw score is 65, the weighted score is 81.25. Enter your weighted score in the box on the right.

> **Enter your weighted multiple-choice score:**
>
> _____

Section II: Essay (50% of grade)

When grading your essay section, be careful to follow the rubric so that you accurately assess your achievement. The highest point total for this section is 34.

Essay 1: (Total score: 8 points) _____

Essay 2: (Total score: 6 points) _____

Essay 3: (Total score: 5 points) _____

Essay 4: (Total score: 5 points) _____

Essay 5: (Total score: 5 points) _____

Essay 6: (Total score: 5 points) _____

Total Raw Score on Essay Section: _____

In order to weight this section appropriately, the raw score is multiplied by 2.942, so that the highest weighted score is 100.

> **Enter your weighted essay score:**
>
> _____

Final Scoring

Add your weighted scores. A perfect score is 200. Although the weighting changes from year to year, a general rule of thumb is that 75% correct is a 5, 66% is a 4, and 55% is a 3. Use the following table as an estimate of your achievement.

5	150–200 points
4	132–149 points
3	110–131 points
2	75–109 points
1	0–74 points

Enter your total weighted score:

Enter your AP score:

EXAMPLE

Section I: Multiple-Choice:

Number correct: ____60____ (out of 80)

Number correct × 1.25: ____75____ (out of 100)

Section II: Scores on the six essays could be:

Essay 1:	4
Essay 2:	5
Essay 3:	4
Essay 4:	3
Essay 5:	4
Essay 6:	2
Total:	$22 \times 2.942 = 64.7$

Section I score: 75
Section II score: 64.7

Total score: 139.7
This test would likely score a 4.

PART THREE
Content Review

Prehistoric Art

TIME PERIOD

Paleolithic Art 30,000–8000 B.C.E. in the Near East; later in the rest of the world

Neolithic Art 8000–3000 B.C.E. in the Near East; later in the rest of the world

ENDURING UNDERSTANDING: The culture, beliefs, and physical settings of a region play an important role in the creation, subject matter, and siting of works of art.

Learning Objective: Discuss how the culture, beliefs, or physical setting can influence the making of a work of art. (For example: Stonehenge)

Essential Knowledge:

- Prehistoric art existed before writing.
- Prehistoric art has been affected by climate change.
- Prehistoric art can be seen in practical and ritual objects.
- Prehistoric art shows an awareness of everything from cosmic phenomena (astronomy and solstices) to the commonplace (materials such as clay and stone).

ENDURING UNDERSTANDING: Art making is influenced by locally available materials and processes.

Learning Objective: Discuss how material, processes, and techniques influence the making of a work of art. (For example: Jade *cong*)

Essential Knowledge:

- The oldest objects are African or Asian.
- The first art forms appear as rock paintings, geometric patterns, human and animal motifs, and architectural monuments.
- Ceramics are first produced in Asia.
- The people of the Pacific are migrants from Asia, who bring ceramic-making techniques with them.
- European cave paintings and megalithic monuments indicate a strong tradition of rituals.
- Early American objects use natural materials, like bone or clay, to create ritual objects.
- Similarities with Asian shamanic religious practices can be found in ritual ancient American objects.

ENDURING UNDERSTANDING: Art history is best understood through an evolving tradition of theories and interpretations.

Learning Objective: Discuss how works of art have had an evolving interpretation based on visual analysis and interdisciplinary evidence. (For example: Running horned woman)

Essential Knowledge:

- Scientific dating of objects has shed light on the use of prehistoric objects.
- Archaeology increases our understanding of prehistoric art.
- Basic art historical methods can be used to understand prehistoric art, but our knowledge increases with findings made in other fields.

PREHISTORIC BACKGROUND

Although prehistoric people did not read and write, it is a mistake to think of them as primitive, ignorant, or even nontechnological. Some of their accomplishments, like Stonehenge, continue to amaze us forty centuries later.

Archaeologists divide the prehistoric era into periods, of which the two most relevant to the study of art history are Paleolithic (the Old Stone Age) and Neolithic (the New Stone Age). These categories roughly correspond to methods of gathering food: In the Paleolithic period people were hunter-gatherers; those in the Neolithic period cultivated the earth and raised livestock. Neolithic people lived in organized settlements, divided labor into occupations, and constructed the first homes.

People created before they had the ability to write, cipher math, raise crops, domesticate animals, invent the wheel, or use metal. They painted before they had anything that could be called clothes or lived in anything that resembled a house. The need to create is among the strongest of human impulses.

Unfortunately, it is not known why these early people painted or sculpted. Since no written records survive, all attempts to explain prehistoric motivations are founded on speculation. From the first, however, art seems to have a function. These works do not merely decorate or amuse, they are designed with a purpose in mind.

Prehistoric Sculpture

Most prehistoric sculpture is portable; indeed, some are very small. Images of humans, particularly female, have enlarged sexual organs and diminutive feet and arms. Carvings on cave walls make use of the natural modulations in the wall surface to enhance the image. More rarely, sculptures are built from clay and lean upon slanted surfaces. Some sculptures are made from found objects such as bones, some from natural material such as sandstone, and some carved with other stones. Early forms of human-made materials, such as ceramics, are also common.

Figure 1.1: Camelid sacrum in the shape of a canine, from Tequixquiac, central Mexico, c. 14,000–7000 B.C.E., bone, National Museum of Anthropology, Mexico City, Mexico

Camelid sacrum in the shape of a canine, from Tequixquiac, central Mexico, 14,000–7000 B.C.E., bone, National Museum of Anthropology, Mexico City, Mexico (Figure 1.1)

Materials
- Bone sculpture from a camel-like animal.
- The bone has been worked to create the image of a dog or wolf.

Content

- Carved to represent a mammal's skull.
- One natural form used to take the shape of another.
- The sacrum is the triangular bone at the base of a spine.

Context

- Mesoamerican idea that a sacrum is a "second skull."
- The sacrum bone symbolizes the soul in some cultures, and for that reason it may have been chosen for this work.

History

- Found in 1870 in the Valley of Mexico.

Content Area Global Prehistory, Image 3

Web Source *http://research.famsi.org/aztlan/uploads/papers/stross-sacrum.pdf*

- **Cross-Cultural Comparisons for Essay Question 1: The Depiction of Animals**
 - Tuffery, *Pisupo Lua Afe (Corned Beef 2000)* (Figure 29.16)
 - Muybridge, *The Horse in Motion* (Figure 21.5)
 - Cotsiogo (also known as Cadzi Cody), Hide Painting of a Sun Dance (Figure 26.13)

Anthropomorphic stele, Arabian Peninsula, 4th millennium B.C.E., sandstone, National Museum, Riyadh, Saudi Arabia (Figure 1.2)

Form and Content

- Anthropomorphic: resembling human form but not in itself human.
- Belted robe from which hangs a double-bladed knife or sword.
- Double cords stretch diagonally across body with an awl unifying them.

Function

- Religious or burial purpose, perhaps as a grave marker.

Context

- One of the earliest known works of art from Arabia.
- Found in an area that had extensive ancient trade routes.

Figure 1.2: Anthropomorphic stele, Arabian Peninsula, 4th millennium B.C.E., sandstone, National Museum, Riyadh, Saudi Arabia

Content Area Global Prehistory, Image 6

Web Source *https://www.nytimes.com/2010/07/24/arts/24iht-melik24.html?_r=0*

- **Cross-Cultural Comparisons for Essay Question 1: Anthropomorphic Images**
 - Mutu, *Preying Mantra* (Figure 29.25)
 - Female deity from Nukuoro (Figure 28.2)
 - Braque, *The Portuguese* (Figure 22.6)

Jade *cong* from Liangzhu, China, c. 3300–2200 B.C.E., carved jade, Shanghai Museum, Shanghai, China (Figure 1.3)

Form

- Circular hole placed within a square.
- Abstract designs; the main decoration is a face pattern, perhaps of spirits or deities.
- Some have a haunting mask design in each of the four corners—with a bar-shaped mouth, raised oval eyes, sunken round pupils, and two bands that might indicate a headdress—resembles the motif seen on Liangzhu jewelry.

Figure 1.3: Jade *cong* from Liangzhu, China, c. 3300–2200 B.C.E., carved jade, Shanghai Museum, Shanghai, China

Materials and Techniques
- Jade is a very hard stone, sometimes carved using drills or saws.
- The designs on *congs* may have been produced by rubbing sand.
- The jades may have been heated to soften the stone, or ritually burned as part of the burial process.

Context
- Jades appear in burials of people of high rank.
- Jades are placed in burials around bodies; some are broken, and some show signs of intentional burning.
- Jade religious objects are of various sizes and found in tombs, interred with the dead in elaborate rituals.
- The Chinese linked jade with the virtues of durability, subtlety, and beauty.
- Many of the earliest and most carefully finished examples (the result of months of laborious shaping by hand) are comparatively compact.
- Made in the Neolithic era in China.

Theory
- Later works have these characteristics: rectilinear quality symbolizes the earth; central circular hole represents the sky. It is not known if these characteristics apply to these earlier works as well.

Content Area Global Prehistory, Image 7

Web Source *http://www.alaintruong.com/archives/2018/05/31/36449097.html*

- **Cross-Cultural Comparisons for Essay Question 1: Geometric Designs**
 - Mondrian, *Composition with Red, Blue and Yellow* (Figure 22.14)
 - Relief Sculpture from Chavín de Huántar (Figure 26.1c)
 - Martínez, Black-on-black ceramic vessel (Figure 26.14)

The Ambum Stone from Ambum Valley, Enga Province, Papua New Guinea, c. 1500 B.C.E., graywacke, National Gallery of Australia, Canberra (Figure 1.4)

Form
- Composite human/animal figure; perhaps an anteater head and a human body.
- Ridge line runs from nostrils, over the head, between the eyes, and between the shoulders.

Theories
- Masked human.
- Anteater embryo in a fetal position; anteaters thought of as significant because of their fat deposits.
- May have been a pestle or related to tool making.
- Perhaps had a ritual purpose; considered sacred; maybe a fertility symbol.
- Maybe an embodiment of a spirit from the past, an ancestral spirit, or the Rainbow Serpent.

History
- Stone Age work; artists used stone to carve stone.
- Found in the Ambum Valley in Papua New Guinea.
- When it was "found," it was being used as a ritual object by the Enga people.
- Sold to the Australian National Gallery.
- Damaged in 2000 when it was on loan in France; it was dropped and smashed into three pieces and many shards; it has since been restored.

Figure 1.4: The Ambum Stone from Ambum Valley, Enga Province, Papua New Guinea, c. 1500 B.C.E., graywacke, National Gallery of Australia—Canberra

- **Cross-Cultural Comparisons for Essay Question 1: Animal Forms**
 - Detail from the Lakshmana Temple (Figure 23.7c)
 - Tuffery, *Pisupo Lua Afe (Corned Beef 2000)* (Figure 29.16)
 - Buk (mask) (Figure 28.9)

Tlatilco female figurine, Central Mexico, site of Tlatilco, c. 1200–900 B.C.E., ceramic, Princeton University Art Museum, Princeton, New Jersey (Figure 1.5)

Figure 1.5: Tlatilco female figurine, Central Mexico, site of Tlatilco, c. 1200–900 B.C.E., ceramic, Princeton University Art Museum, Princeton, New Jersey

Form

- Flipper-like arms, huge thighs, pronounced hips, narrow waists.
- Unclothed except for jewelry; arms extending from body.
- Diminished role of hands and feet.
- Female figures show elaborate details of hairstyles, clothing, and body ornaments.

Technique

- Made by hand; artists did not use molds.

Function

- May have had a shamanistic function.

Context and Interpretation

- Some show deformities, including a female figure with two noses, two mouths, and three eyes, perhaps signifying a cluster of conjoined or Siamese twins and/or stillborn children.
- Bifacial images and congenital defects may express duality.
- Found in graves, and may have had a funerary context.

Tradition

- Tlatilco, Mexico, an area noted for pottery.

- **Cross-Cultural Comparisons for Essay Question 1: Human Figure**
 - Veranda post (Figure 27.14)
 - Power figure (Figure 27.6)
 - Reliquary of Sainte-Foy (Figure 11.6c)

Terra cotta fragment, Lapita, Reef Islands, Solomon Islands, 1000 B.C.E., incised terra cotta, University of Auckland, New Zealand (Figure 1.6)

Figure 1.6: Terra cotta fragment, Reef Islands, Solomon Islands, 1000 B.C.E., incised terra cotta, University of Auckland, New Zealand (Photo: plaster copy in the Metropolitan Museum of Art, New York)

Form

- Pacific art is characterized by the use of curved stamped patterns: dots, circles, hatching; may have been inspired by patterns on tattoos.
- One of the oldest human faces in Oceanic art.

Materials

- Lapita culture of the Solomon Islands is known for pottery.
- Outlined forms: they used a comb-like tool to stamp designs onto the clay, known as dentate stamping.

Technique
- Did not use potter's wheel.
- After pot was incised, a white coral lime was often applied to the surface to make the patterns more pronounced.

Tradition
- Continuous tradition: some designs found on the pottery are used in modern Polynesian tattoos and tapas.

Content Area Global Prehistory, Image 11

Web Source for Lapita Pottery *http://www.metmuseum.org/toah/hd/lapi/hd_lapi.htm*

- **Cross-Cultural Comparisons for Essay Question 1: Motifs in Pacific Art**
 - Hiapo (Figure 28.6)
 - Malagan mask (Figure 28.8)
 - Lindauer, *Tamati Waka Nene* (Figure 28.7)

Prehistoric Painting

Most prehistoric paintings that survive exist in caves, sometimes deeply recessed from their openings. Images of animals dominate with black outlines emphasizing their contours. Paintings appear to be placed about the cave surface with no relationship to one another. Indeed, cave paintings may have been executed over the centuries by various groups who wanted to establish a presence in a given location.

Although animals are realistically represented with a palpable three-dimensionality, humans are depicted as stick figures with little anatomical detail.

Handprints abound in cave paintings, most of them as negative prints, meaning that a hand was placed on the wall and paint blown or splattered over it, leaving a silhouette. Since most people are right-handed, the handprints are generally of left hands, the right being used to apply the paint. Handprints occasionally show missing joints or fingers, perhaps indicating that prehistoric people practiced voluntary mutilation. However, the thumb, the most essential finger, is never harmed.

Figure 1.7: Apollo 11 stones, c. 25,500–25,300 B.C.E., charcoal on stone, State Museum of Namibia, Windhoek, Namibia

Apollo 11 stones, c. 25,500–25,300 B.C.E., charcoal on stone, State Museum of Namibia, Windhoek, Namibia (Figure 1.7)

Form
- Animal seen in profile, typical of prehistoric painting.
- Perhaps a composite animal rather than a particular specimen.

Materials
- Done with charcoal.

Context
- Some of the world's oldest works of art, found in Wonderwerk Cave in Namibia.
- Several stone fragments found.
- Originally brought to the site from elsewhere.
- Cave is the site of 100,000 years of human activity.

History
- Named after the Apollo 11 moon landing in 1969, the year the cave was discovered.

Content Area Global Prehistory, Image 1

Web Source *http://metmuseum.org/toah/hd/apol/hd_apol.htm*

■ **Cross-Cultural Comparisons for Essay Question 1: Figures in Profile**
- Grave stele of Hegeso (Figure 4.7)
- Tomb of the Triclinium (Figure 5.3)
- Akhenaton, Nefertiti, and three daughters (Figure 3.10)

Great Hall of the Bulls, Paleolithic Europe, 15,000–13,000 B.C.E., rock painting, Lascaux, France (Figure 1.8)

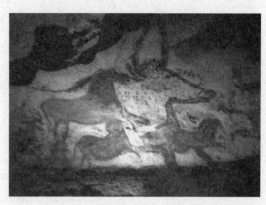

Figure 1.8: Great Hall of the Bulls, Paleolithic Europe, 15,000–13,000 B.C.E., rock painting, Lascaux, France

Content
■ 650 paintings: most common animals are cows, bulls, horses, and deer.

Form
■ Bodies seen in profile; frontal or diagonal view of horns, eyes, and hooves; some animals appear pregnant.
■ Twisted perspective: many horns appear more frontal than the bodies.
■ Many overlapping figures.

Materials
■ Natural products were used to make paint: charcoal, iron ore, plants.
■ Walls were scraped to an even surface; paint colors were bound with animal fat; lamps lighted the interior of the caves.
■ No brushes have been found.
 - May have used mats of moss or hair as brushes.
 - Color could have been blown onto the surface by mouth or through a tube, like a hollow bone.

Context
■ Animals placed deep inside cave—some hundreds of feet from the entrance.
■ Evidence still visible of scaffolding erected to get to higher areas of the caves.
■ Negative handprints: are they signatures?
■ Caves were not dwellings, as prehistoric people led migratory lives following herds of animals; some evidence exists that people did seek shelter at the mouths of caves.

Theories
■ A traditional view is that they were painted to ensure a successful hunt.
■ Ancestral animal worship.
■ Represents narrative elements in stories or legends.
■ Shamanism: a religion based on the idea that the forces of nature can be contacted by intermediaries, called shamans, who go into a trancelike state to reach another state of consciousness.

History
■ Discovered in 1940; opened to the public after World War II.
■ Closed to the public in 1963 because of damage from human contact.
■ Replica of the caves opened adjacent to the original.

Content Area Global Prehistory, Image 2

Web Source http://www.lascaux.culture.fr/?lng=en#/en/00.xml

■ **Cross-Cultural Comparisons for Essay Question 1: Mural Paintings**
- Tomb of the Triclinium (Figure 5.3)
- Leonardo da Vinci, *Last Supper* (Figure 16.1)
- Walker, *Darkytown Rebellion* (Figure 29.21)

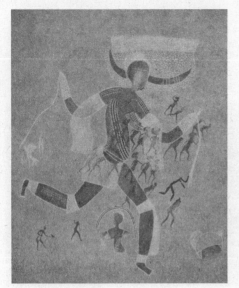

Figure 1.9: Running horned woman, 6000–4000 B.C.E., pigment on rock, Tassili n'Ajjer, Algeria

Running horned woman, 6000–4000 B.C.E., pigment on rock, Tassili n'Ajjer, Algeria (Figure 1.9)

Form
- Composite view of the body.
- Many drawings exist—some are naturalistic, some are abstract, some have Negroid features, and some have Caucasian features.
- The female horned figure suggests attendance at a ritual ceremony.

Content
- Depicts livestock (cows, sheep, etc.); wildlife (giraffes, lions, etc.); humans (hunting, harvesting, etc.).
- Dots may reflect body paint applied for ritual or scarification; white patterns in symmetrical lines may reflect raffia garments.

Context
- More than 15,000 drawings and engravings were found at this site.
- At one time the area was grasslands; climate changes have turned it into a desert.
- The entire site was probably painted by many different groups over large expanses of time.

Content Area Global Prehistory, Image 4

Web Source http://whc.unesco.org/en/list/179

- **Cross-Cultural Comparisons for Essay Question 1: Masks and Headdresses**
 - Aka elephant mask (Figure 27.12)
 - *Ikenga* (shrine figure) (Figure 27.10)
 - Malagan mask (Figure 28.8)

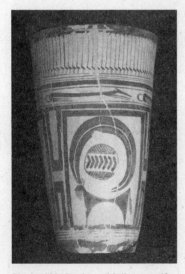

Figure 1.10: Beaker with ibex motifs, Susa, Iran, 4200–3500 B.C.E., painted terra cotta, Louvre, Paris

Beaker with ibex motifs, Susa, Iran, 4200–3500 B.C.E., painted terra cotta, Louvre, Paris (Figure 1.10)

Form and Content
- Frieze of stylized aquatic birds on top, suggesting a flock of birds wading in a Mesopotamian river valley.
- Below are stylized running dogs with long narrow bodies, perhaps hunting dogs.
- The main scene shows an ibex with oversized abstract and stylized horns.

Materials and Techniques
- Probably made on a potter's wheel, a technological advance; some suggest instead that it was handmade.
- Thin pottery walls.

Context and Interpretation
- In the middle of the horns is a clan symbol of family ownership; perhaps the image identifies the deceased as belonging to a particular group or family.
- Found near a burial site, but not with human remains.
- Found with hundreds of baskets, bowls, and metallic items.
- Made in Susa, in southwestern Iran.

Content Area Global Prehistory, Image 5

Web Source http://www.louvre.fr/en/oeuvre-notices/bushel-ibex-motifs

Prehistoric Architecture

Prehistoric people were known to build shelters out of large animal bones heaped in the shape of a semicircular hut. However, the most famous structures were not for habitation but almost certainly for worship. Sometimes **menhirs**, or large individual stones, were erected singularly or in long rows stretching into the distance. Menhirs cut into rectangular shapes and used in the construction of a prehistoric complex are called **megaliths**. A circle of megaliths, usually with lintels placed on top, is called a **henge**. These were no small accomplishments, since these Neolithic structures may have been built to align with the important dates in the calendar. Prehistoric people built structures in which two uprights were used to support a horizontal beam, thereby establishing **post-and-lintel** (Figure 1.11) architecture, the most fundamental type of architecture in history.

Figure 1.11: Post-and-lintel construction

Stonehenge, c. 2500–1600 B.C.E., sandstone, Neolithic Europe, Wiltshire, United Kingdom (Figures 1.12a and 1.12b)

Technique
- Post-and-lintel building; lintels grooved in place by the mortise and tenon system of construction.
- Large megaliths in the center are over 20 feet tall and form a horseshoe surrounding a central flat stone.
- A ring of megaliths, originally all united by lintels, surrounds a central horseshoe.
- Hundreds of smaller stones of unknown purpose were placed around the monument.
- Builders did not have the wheel or pulleys. Stones may have been rolled on logs or on a sleigh greased with animal fat to get them to the site.

Context
- Some stones weigh more than 50 tons; the size of each stone reflects the intended permanence of the structure.
- Some stones were imported from over 150 miles away, an indication that the stones must have had a special or sacred significance.

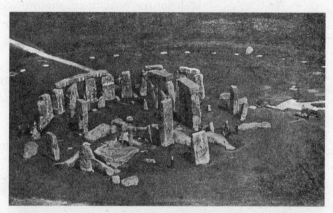
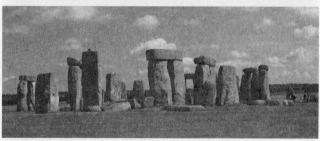

Figures 1.12a and 1.12b: Stonehenge, c. 2500–1600 B.C.E., sandstone, Neolithic Europe, Wiltshire, United Kingdom

History
- Perhaps took 1,000 years to build; gradually redeveloped by succeeding generations.
- Probably built in three phases:
 – First Phase: circular ditch 36 feet deep and 360 feet in diameter containing 56 pits called Aubrey Holes, named after John Aubrey who found them in the eighteenth century. Today the holes are filled with chalk.

– Second Phase: wooden structure, perhaps roofed. The Aubrey Holes may have been used as cremation burials at this time. Adult males were buried at these sites, generally men who did not show a lifetime of hard labor, signifying it was a site for a select group of people.

– Third Phase: stone construction.

Tradition

■ May have been inspired by previously erected wood circles; the British Isles are rich in forested areas.

■ Stone circles are a common sight, even today, in Great Britain, indicating great popularity in the Neolithic world.

Theories

■ Generally thought to be oriented toward sunrise at the summer solstice (the longest day of the year) and sunset at the winter solstice; may also predict eclipses, acting as a kind of observatory.

■ A new theory posits that Stonehenge was the center of ceremonies concerning death and burial; elite males were buried here.

■ An alternate theory suggests it was a site used for healing the sick.

Content Area Global Prehistory, Image 8

Web Source *http://www.english-heritage.org.uk/visit/places/stonehenge/*

■ **Cross-Cultural Comparisons for Essay Question 1: Ritual Centers**

– Chavín de Huántar (Figures 26.1a, 26.1b)

– Pantheon (Figures 6.11a, 6.11b)

– Great Mosque of Djenné (Figure 27.2)

VOCABULARY

Anthropomorphic: having characteristics of the human form, although the form itself is not human (Figure 1.2)

Archaeology: the scientific study of ancient people and cultures principally revealed through excavation

Cong: a tubular object with a circular hole cut into a square-like cross section (Figure 1.3)

Henge: a Neolithic monument, characterized by a circular ground plan. Used for rituals and marking astronomical events (Figure 1.12b)

Lintel: a horizontal beam over an opening (Figure 1.12)

Megalith: a stone of great size used in the construction of a prehistoric structure

Menhir: a large uncut stone erected as a monument in the prehistoric era; a standing stone

Mortise and tenon: a groove cut into stone or wood, called a mortise, that is shaped to receive a tenon, or projection, of the same dimensions

Post-and-lintel: a method of construction in which two posts support a horizontal beam, called a lintel (Figure 1.11)

Shamanism: a religion in which good and evil are brought about by spirits which can be influenced by shamans, who have access to these spirits

Stele (plural: **stelae**): an upright stone slab used to mark a grave or a site (Figure 1.2)

Stylized: a schematic, nonrealistic manner of representing the visible world and its contents, abstracted from the way that they appear in nature (Figure 1.2)

SUMMARY

Prehistoric works of art have the power to amaze and intrigue viewers in the modern world, even though so little is known about their original intention, creation, or meaning. The creative impulse exists with the earliest of human endeavors, as is evidenced by the cave paintings from Lascaux and sculptures such as the anthropomorphic stele. The first type of construction, the post-and-lintel method, was developed during the Neolithic period to build monumental structures like Stonehenge.

PRACTICE EXERCISES

Multiple-Choice

1. A number of theories have been proposed about the purpose of the Lascaux Cave paintings. Among the likely theories is

 (A) prehistoric kings believed they absorbed the power of the animals
 (B) the drawings reflected primitive masks used for ritual purposes
 (C) shamans perhaps entered into a trancelike state before the paintings
 (D) they illustrate the first occurrence of ritual tattooing

2. The unusual anatomical shapes of the Tlatilco female figures probably indicate

 (A) a cluster of unusual congenital abnormalities
 (B) the influence of similar works produced in Southeast Asia
 (C) a reliance on artistic traditions going back to cave paintings
 (D) their placement in ritual centers that emphasized the triumph of death over the mundane world of the living

3. Prehistoric images of people wearing masks, such as the "running horned woman," indicate an ancient interest in

 (A) coronation of royalty and a sophisticated power structure
 (B) a formal hierarchy of religious leaders, including women
 (C) ceremonial centers and designated performers
 (D) ritual presentations in which the participants paint their bodies and dance

4. The "beaker with ibex motifs" was found at a site in the city of Susa, indicating that it was used

 (A) as part of a burial tradition
 (B) in business transactions
 (C) in a domestic setting
 (D) for governmental correspondence

5. Many works of prehistoric art had a funerary purpose as can be seen in

 (A) the running horned woman who is escaping an enemy
 (B) the Ambum Stone, which represents a sacred animal in a deathlike pose
 (C) the camelid sacrum, which is carved from a dead animal
 (D) the jade *cong*, which is found in a burial site

Short Essay

Since the global prehistoric unit is such a small proportion of the testing material, the College Board has indicated that it is not likely that a short essay question will appear on this subject. However, an essay question is presented here so that students can practice a contextual analysis essay.

Practice Question 4: Contextual Analysis
Suggested Time: 15 minutes

This jade *cong* was made in Neolithic China. It has a function that can be surmised from the site it is associated with.

Where were jade *congs* found?

What symbolic associations did jade have to the Chinese?

What can be understood about jade *congs* given the context of their find spots?

Describe the images done in relief on the *cong, and* interpret their contextual meanings.

ANSWERS EXPLAINED

Multiple-Choice

1. **(C)** Shamans may have been involved in trancelike experiences before the paintings. Since there is only one human on the walls, a stick figure at that, there is no evidence of tattooing. No aristocracy is known in the prehistoric world in England and France. Prehistoric masks from this time do not survive.

2. **(A)** According to modern theories, the unusual anatomical shapes may have been a reflection of a fascination with several congenital abnormalities centered in the Tlatilco in Mexico. There is no cave painting tradition in this area, nor are there influences from other parts of the world. Their original placement is unknown.

3. **(D)** Rituals were important aspects of prehistoric culture; hence, they are depicted fairly regularly in the prehistoric art that survives in Africa.

4. **(A)** The beaker was found at a burial site and was used for mortuary purposes, although no trace of human remains was found inside.

5. **(D)** The Chinese jade *cong* was found in a burial site. There is no indication that any of the other works were used for funerary purposes.

Short Essay Rubric

Task	Point Value	Key Points in a Good Response
Where were jade *congs* found?	1	Answers could include: ■ Jades appear in burials of people of high rank. ■ Jade religious objects found in tombs; interred with the dead in elaborate rituals.
What symbolic associations did jade have to the Chinese?	1	Answers could include: ■ Jade was treasured by the Chinese for its durability and its color. ■ Jade buried along with the dead indicates a special reverence for the dead. ■ Chinese linked jade with virtues: durability, subtlety, beauty. ■ Jade must have possessed a special spiritual quality since it was found in so many burials.
What can be understood about jade *congs* given the context of their find spots?	1	Answers could include: ■ Placed in burials around bodies; some are broken, and some show signs of intentional burning. ■ Jade *congs* have a spiritual significance.
Describe the images done in relief on the *cong*...	1	Answers could include: ■ Abstract designs; main decoration is a face pattern, perhaps of spirits or deities. ■ Four corners of the *cong* usually carry masklike images with pronounced eyes and a fanged mouth. ■ Some have a haunting mask design in each of the four corners—with a bar-shaped mouth, raised oval eyes, sunken round pupils, and two bands that might indicate a headdress—which resembles the motif seen on Liangzhu jewelry.
...*and* interpret their contextual meanings.	1	Answers could include: ■ Designs represent human, animal, or spiritual faces in a stylized manner.

Ancient Near Eastern Art

2

TIME PERIOD: 3500 B.C.E.–641 C.E.

Sumerian Art	c. 3500–2340 B.C.E.	Iraq
Babylonian Art	1792–1750 B.C.E.	Iraq
Assyrian Art	883–612 B.C.E.	Iraq
Persian Art	c. 559–331 B.C.E.	Iran

ENDURING UNDERSTANDING: The culture, beliefs, and physical settings of a region play an important role in the creation, subject matter, and siting of works of art.

Learning Objective: Discuss how the culture, beliefs, or physical setting can influence the making of a work of art. (For example: Statues of votive figures from Tell Asmar)

Essential Knowledge:

- Ancient Near Eastern art takes place mostly in the city-states of Mesopotamia.
- Religion plays a dominant role in the art of the Ancient Near East.

ENDURING UNDERSTANDING: Art making is influenced by available materials and processes.

Learning Objective: Discuss how material, processes, and techniques influence the making of a work of art. (For example: White Temple on its ziggurat)

Essential Knowledge:

- Figures are constructed within stylistic conventions of the time, including hierarchy of scale, registers, and stylized human forms.

ENDURING UNDERSTANDING: Cultural interaction through war, trade, and travel can influence art and art making.

Learning Objective: Discuss how works of art are influenced by cultural interaction. (For example: Persepolis)

Essential Knowledge:

- There are many similarities among artistic styles in the Ancient Near East, which indicates a vibrant exchange of ideas.
- Ancient Near Eastern artistic conventions influenced later periods in art history.

ENDURING UNDERSTANDING: Art and art making can be influenced by a variety of concerns including audience, function, and patron.

Learning Objective: Discuss how art can be influenced by audience, function, and/or patron. (For example: Code of Hammurabi)

Essential Knowledge:

- Ancient Near Eastern art concentrates on royal figures and gods.
- Ancient Near Eastern architecture is characterized by ziggurats and palaces that express the power of the gods and rulers.

ENDURING UNDERSTANDING: Art history is best understood through an evolving tradition of theories and interpretations.

Learning Objective: Discuss how works of art have had an evolving interpretation based on visual analysis and interdisciplinary evidence. (For example: Standard of Ur)

Essential Knowledge:

- The study of art history is shaped by changing analyses based on scholarship, theories, context, and written record.

HISTORICAL BACKGROUND

The Ancient Near East is where almost everything began first: writing, cities, organized religion, organized government, laws, agriculture, bronze casting, even the wheel. It is hard to think of any other civilization that gave the world as much as the ancient Mesopotamians.

Large populations emerged in the fertile river valleys that lie between the Tigris and Euphrates Rivers. City centers boomed as urbanization began to take hold. Each group of people vied to control the central valleys, taking turns occupying the land and eventually relinquishing it to others. This layering of civilizations has made for a rich archaeological repository of successive cultures whose entire history has yet to be uncovered.

Patronage and Artistic Life

Kings sensed from the beginning that artists could help glorify their careers. Artists could aggrandize images, bring the gods to life, and sculpt narrative tales that would outlast a king's lifetime. They could also write in cuneiform and imprint royal names on everything from cylinder seals to grand relief sculptures. This was the start of one of the most symbiotic relationships in art history between patron and artist.

ANCIENT NEAR EASTERN ART

One of the most fundamental differences between the prehistoric world and the civilizations of the Ancient Near East is the latter's need to urbanize; buildings were constructed to live, govern, and worship in. However, in the Near East, stone was at a premium and wood was scarce but earth was in abundant supply. The first great buildings of the ancient world, **ziggurats**, were made of baked mud, and they were tall, solid structures that dominated the flat landscape. Although mud needed care to protect it from erosion, it was a cheap material that could be resupplied easily.

Human beings did not play a central role in prehistoric art. Lascaux has precisely one male figure but more than six hundred cave paintings of animals. A few human figures like

the anthromorphic stele populated a sculptural world full of animals and spirals. However, in the Near East artists were more likely to depict clothed humans with anatomical precision. Near Eastern figures are actively engaged in doing something: hunting, praying, performing a ritual.

One of the characteristics of civilizations that settle down rather than nomadically wander is the size of the sculpture they produce. Nomadic people cannot carry large objects on their migrations, but cities retain monumental objects as a sign of their permanence. Near Eastern sculptures could be very large—the **lamassus**, man-headed winged bulls, at Persepolis are gigantic. The interiors of palaces were filled with large-scale relief sculptures gently carved into stone surfaces.

The invention of writing enabled people to permanently record business transactions in a wedge-shaped script called **cuneiform**. Laws were written down, taxes were accounted for and collected, and the first written epic, *Gilgamesh*, was copied onto a series of tablets. Stories needed to be illustrated, making narrative painting a necessity. Walls of ancient palaces not only had sculptures of rulers and gods but also had narratives of their exploits.

Near Eastern art begins a popular ancient tradition of representing animals with human characteristics and emotions; some Sumerian animals have human heads. The personification of animals was continued by the Egyptians (the Sphinx) and the Greeks (the Minotaur), sometimes producing fantastical creations. There was also a trend to combine animal parts, as in the **Lamassu** (c. 700 B.C.E.) (Figure 2.5), with the human head at the top of a hoofed winged animal.

SUMERIAN ART

Sumerian art, as contrasted with prehistoric art, has realistic-looking figures acting out identifiable narratives. Figures are cut from stone, with **negative space** hollowed out under their arms and between their legs. Eyes are always wide open; men are bare-chested and wear a kilt. Women have their left shoulder covered; their right is exposed. Nudity is a sign of debasement; only slaves and prisoners are nude. Sculptures were placed on stands to hold them upright. There was a free intermixing of animal and human forms, so it is common to see human heads on animal bodies, and vice versa. Humans are virtually emotionless.

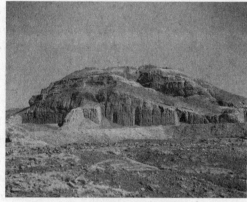

Important figures are the largest and most centrally placed in a given composition. Such an arrangement is called **hierarchy of scale** and can be seen in the **Standard of Ur** (c. 2600 B.C.E.) (Figures 2.3a, 2.3b), in which the king is the tallest figure, located in the middle of the top register.

In the Sumerian world the gods symbolized powers that were manifest in nature. The local god was an advocate for a given city in the assembly of gods. Thus, it was incumbent upon the city to preserve the god and his representative, the king, as well as possible. The temple, therefore, became the center point of both civic and religious pride.

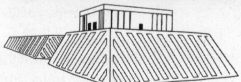

Figures 2.1a and 2.1b: White Temple and its ziggurat with reconstruction, c. 3500–3000 B.C.E., mud brick, Uruk (modern Warka), Iraq

White Temple and its ziggurat, c. 3500–3000 B.C.E., mud brick, Uruk (modern Warka), Iraq (Figures 2.1a and 2.b)

Form

- Buttresses spaced across the surface to create a contrasting light-and-shadow pattern.
- The ziggurat tapers downward so that rainwater washes off.
- Entire form resembles a mountain, creating a contrast between the vast flat terrain and the man-made mountain.
- *Bent-axis plan:* ascending the stairs requires angular changes of direction to reach the temple (compare Mortuary temple of Hatshepsut, Figure 3.9a)

Function

- On top of the ziggurat is a terrace for outdoor rituals and a temple for indoor rituals.
- The temple on the top was small, set back, and removed from the populace; access reserved for royalty and clergy; only the base of the temple remains.
- The temple interior contained a cella and smaller rooms meant for the deities to assemble before a select group of priests.

Materials

- Mud-brick building built on a colossal scale and covered with glazed tiles or cones.
- Whitewash used to disguise the mud appearance; hence the modern name of White Temple.

Context

- Large settlement at Uruk of 40,000, based on agriculture and specialized labor.
- Uruk may be the first true city in history; the first with monumental architecture.
- Ziggurat sited within the city.
- Deity was Anu, the god of the sky, the most important Sumerian deity.
- Gods descend from the heavens to a high place on Earth; hence the Sumerians built ziggurats as high places.
- Four corners oriented to the compass; cosmic orientation.

Content Area Ancient Mediterranean, Image 12

Web Source *https://www.learner.org/series/art-through-time-a-global-view/the-urban-experience/ruins-of-the-white-temple-and-ziggurat/*

- **Cross-Cultural Comparisons for Essay Question 1: Religious Centers on Man-Made or Natural Hilltops**
 - Yaxchilán Structure 40 (Figure 26.2a)
 - Templo Mayor, Tenochtitlán (Figure 26.5a)
 - Acropolis (Figure 4.16a)

Statues of votive figures, from the Square Temple at Eshnunna (modern Tell Asmar, Iraq), c. 2700 B.C.E., gypsum inlaid with shell and black limestone, Iraq Museum, Baghdad, and the University of Chicago, Chicago, Illinois (Figure 2.2)

Form

- Figures are of different heights, denoting hierarchy of scale.
- Hands are folded in a gesture of prayer.
- Huge eyes in awe, spellbound, perhaps staring at the deity.
- Men: bare chested; wearing belt and skirt; beard flows in ripple pattern.
- Women: dress draped over one shoulder.
- Arms and feet cut away.
- Pinkie in a spiral; chin a wedge shape; ear a double volute.

Function

- Some have inscriptions on back: "It offers prayers." Other inscriptions tell the names of the donors or gods.
- Figures represent mortals; placed in a temple to pray before a sculpture of a god.

Context

- Gods and humans physically present in their statues.
- None have been found in situ, but buried in groups under the temple floor.

Content Area Ancient Mediterranean, Image 14

Web Source *http://www.metmuseum.org/TOAH/hd/edys/hd_edys.htm*

- **Cross-Cultural Comparisons for Essay Question 1: Shrine Figures**
 - Female deity from Nukuoro (Figure 28.2)
 - Veranda post (Figure 27.14)
 - *Ikenga* (shrine figure) (Figure 27.10)

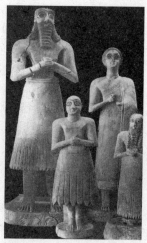

Figure 2.2: Statues of votive figures, from the Square Temple at Eshnunna (modern Tell Asmar, Iraq), c. 2700 B.C.E., gypsum inlaid with shell and black limestone, Iraq Museum, Baghdad and the University of Chicago, Chicago, Illinois

Standard of Ur from the Royal Tombs at Ur (modern Tell el-Muqayyar, Iraq), c. 2600–2400 B.C.E., wood inlaid with shell, lapis lazuli, and red limestone, British Museum, London (Figures 2.3a and 2.3b)

Form

- Figures have broad frontal shoulders; bodies in profile; twisted perspective.
- Emphasis on eyes, eyebrows, ears.
- Organized in registers; figures stand on ground lines.
- Reads from bottom to top.

Content

- Two sides: war side and peace side; may have been two halves of a narrative; early example of a historical narrative.
- *War side*: Sumerian king, half a head taller than the others, has descended from his chariot to inspect captives brought before him, some of whom are debased by their nakedness; in lowest register, chariots advance over the dead.
- *Peace side*: food brought in a procession to the banquet; musician plays a lyre; ruler is the largest figure—he wears a kilt made of tufts of wool; may have been a victory celebration after a battle.

Context

- Found in tomb at the royal cemetery at Ur in modern Iraq.
- Reflects extensive trading network: lapis lazuli from Afghanistan, shells from the Persian Gulf, and red limestone from India.

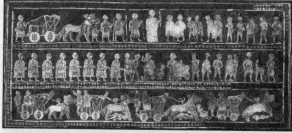
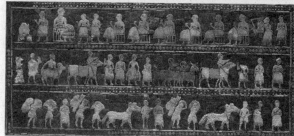

Figures 2.3a and 2.3b: War (top) and Peace (bottom) from the Standard of Ur from the Royal Tombs at Ur (modern Tell el-Muqayyar, Iraq), c. 2600–2400 B.C.E., wood inlaid with shell, lapis lazuli, and red limestone, British Museum, London

Theories

- Perhaps used as part of soundbox for a musical instrument; modern name of "standard" comes from the theory that it was once placed on a pole and carried in a procession (few now accept this).
- The two scenes may illustrate the dual nature of an ideal Sumerian ruler: the victorious general and the father of his people, who promotes general welfare.

Content Area Ancient Mediterranean, Image 16

Web Source *https://research.britishmuseum.org/research/collection_online/collection_object_details.aspx?objectId=368264&partId=1*

- **Cross-Cultural Comparisons for Essay Question 1: Narrative in Art**
 - *Bayeux Tapestry* (Figures 11.7a, 11.7b)
 - Column of Trajan (Figure 6.16)
 - *Night Attack on the Sanjô Palace* (Figures 25.3a, 25.3b)

BABYLONIAN ART

Because of the survival of the famous **Code of Hammurabi** (c. 1792–1750 B.C.E.) (Figure 2.4), Babylon comes down to us as a seemingly well-ordered state with a set of strict laws handed down from the god Shamash himself. Nothing was spared in the decoration of the capital, Babylon, covered with its legendary hanging gardens and walls of glazed tile.

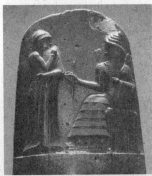

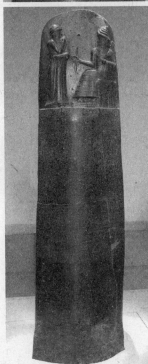

Figures 2.4a and 2.4b: Code of Hammurabi, Babylon (modern Iran), Susian, c. 1792–1750 B.C.E., basalt, Louvre, Paris

Code of Hammurabi, Babylon (modern Iran), Susian, c. 1792–1750 B.C.E., basalt, Louvre, Paris (Figures 2.4a and 2.4b)

Form
- A stele meant to be placed in an important location.

Function
- Below the main scene contains one of the earliest law codes ever written; symbolically shows a ruler's need to establish civic harmony in a civilized world.
- 300 law entries placed below the images, symbolically showing the god Shamash handing the laws to Hammurabi.

Content
- Sun god, Shamash (patron of justice), enthroned on a ziggurat, hands Hammurabi a rope, a ring, and a rod of kingship.
- Shamash is in a frontal view and a profile at the same time; headdress is in profile; rays (wings?) appear from behind his shoulders.
- Shamash's beard is fuller than Hammurabi's, illustrating Shamash's greater wisdom.
- Shamash, judge of the sky and the earth, with a tiara of four rows of horns, presents signs of royal power, the scepter and the ring, to Hammurabi.
- They stare at one another directly even though their shoulders are frontal; composite views.
- Hammurabi depicted with a speaking/greeting gesture.

Context
- Written in cuneiform.
- Text in Akkadian language, read right to left and top to bottom in 51 columns.
- Law articles are written in a formula: "If a person has done this, then that will happen to him."

History
- Hammurabi (1792–1750 B.C.E.) united Mesopotamia in his lifetime.
- Took Babylon from a small power to a dominant kingdom; after his death the empire dwindled.

Content Area Ancient Mediterranean, Image 19

Web Source *http://musee.louvre.fr/oal/code/indexEN.html*

- **Cross-Cultural Comparisons for Essay Question 1: Humans and the Divine**
 - Jayavarman VII as Buddha (Figure 23.8d)
 - Bichitr, *Jahangir Preferring a Sufi Shaikh to Kings* (Figure 23.9)
 - Bernini, *Ecstasy of Saint Teresa* (Figures 17.4a, 17.4b)

ASSYRIAN ART

Assyrian artists praised the greatness of their king, his ability to kill his enemies, his valor at hunting, and his masculinity. Figures are stoic, even while hunting lions or defeating an enemy. Animals, however, possess considerable emotion. Lions are in anguish and cry out for help. This domination over a mighty wild beast expressed the authority of the king over his people and the powerful forces of nature.

Cuneiform appears everywhere in Assyrian art; it is common to see words written across a scene, even over the bodies of figures. Shallow **relief sculpture** is an Assyrian specialty, although the lamassus are virtually three-dimensional as they project noticeably from the walls they are attached to.

Lamassu, from the citadel of Sargon II, Dur Sharrukin (modern Khorsabad, Iraq), c. 720–705 B.C.E., alabaster, Louvre, Paris (Figure 2.5)

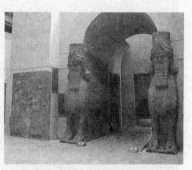

Figure 2.5: Lamassu, from the citadel of Sargon II, Dur Sharrukin (modern Khorsabad, Iraq), c. 720–705 B.C.E., alabaster, Louvre, Paris

Form
- Human-headed animal guardian figures: face of a person, ears and body of a bull.
- Winged.
- Appears to have five legs: when seen from the front, it seems to be standing at attention; when seen from the side, the animal seems to be walking.
- Faces exude calm, serenity, and harmony.

Materials
- Carved from a single piece of stone.
- Meant to hold up the walls and arch of a gate.
- Stone is rare in Mesopotamian art and contrasts greatly with the mud-brick construction of the palace.

Function
- Meant to ward off enemies both visible and invisible.
- Inscriptions in cuneiform at the bottom portion of the lamassu declare the power of the king and curse his enemies.

Context
- Sargon II founded a capital at Khorsabad; the city was surrounded by a wall with seven gates.
- The protective spirits (guardians) were placed at either side of each gate.

Content Area Ancient Mediterranean, Image 25

Web Source *http://www.louvre.fr/en/oeuvre-notices/winged-human-headed-bull*

- **Cross-Cultural Comparisons for Essay Question 1: Hybrid Figures**
 - Sphinx (Figure 3.6a)
 - Buk (mask) (Figure 28.9)
 - Mutu, *Preying Mantra* (Figure 29.25)

PERSIAN ART

Persia was the largest empire the world had seen up to this time. As the first great empire in history, it needed an appropriate capital as a grand stage to impress people at home and dignitaries from abroad. The Persians erected monumental architecture, huge audience halls, and massive subsidiary buildings for grand ceremonies that glorified their country and their rulers (Figures 2.6a and 2.6b). Persian architecture is characterized by columns topped by two bull-shaped **capitals** holding up a wooden roof.

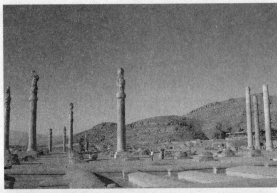

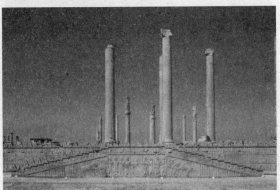

Figures 2.6a and 2.6b: above: Audience Hall (*apadana*) of Darius and Xerxes; below: apadana stairway, c. 520–465 B.C.E., limestone, Persepolis, Iran

Audience Hall (*apadana*) of Darius and Xerxes, c. 520–465 B.C.E., limestone, Persepolis, Iran (Figures 2.6a and 2.6b)

Form
- Built on artificial terraces, as is most Mesopotamian architecture.
- Columns have a bell-shaped base that is an inverted lotus blossom; the capitals are bulls or lions.
- Everything seems to have been built to dwarf the viewer.

Function
- Built not so much as a complex of palaces, but rather as a seat for spectacular receptions and festivals.
- One enters the complex through gigantic gates depicting lamassu figures. Above the gates is an inscription, the Gates of All Nations, which proudly announces this complex as the seat of a great empire.
- Audience hall (apadana) had 36 columns covered by a wooden roof; held thousands of people; was used for the king's receptions; had stairways adorned with reliefs of the New Year's festival and a procession of representatives of 23 subject nations.
- Hypostyle hall, derived from Egypt, is an indication of one of the many cultures that inspired the complex.

Materials
- Mud brick with stone facing; stone symbolizing durability and strength.

Context and Interpretation
- Relief sculptures depict delegations from all parts of the empire bringing gifts to be stored in the local treasury; Darius selected this central location in Persia to ensure protection of the treasury.
- Carved onto the stairs are the immortals, the king's guard, who were so called because they always numbered 10,000; originally painted and adorned with metal accessories; some covered in gold leaf.
- Stairs have a central relief of the king enthroned with attendants, the crown prince behind him, and dignitaries bowing before him.
- Orderly and harmonious world symbolized by static processions.

History
- Built by Darius I and Xerxes I; destroyed by Alexander the Great, perhaps as an act of revenge for the destruction of the Acropolis in Athens (Figure 4.16a).
- Many cultural influences (Greeks, Egyptians, Babylonians) contributed to the building of the site, as a sign of Persian cosmopolitan imperial culture.

Content Area Ancient Mediterranean, Image 30

Web Source http://whc.unesco.org/en/list/114/

■ **Cross-Cultural Comparisons for Essay Question 1: Ceremonial Spaces**
 – Forum of Trajan (Figure 6.10a)
 – Forbidden City (Figure 24.2a)
 – Great Zimbabwe (Figures 27.1a, 27.1b)

VOCABULARY

Apadana: an audience hall in a Persian palace (Figure 2.6a)

Apotropaic: having the power to ward off evil or bad luck

Bent-axis: an architectural plan in which an approach to a building requires an angular change of direction, as opposed to a direct and straight entry (Figure 2.1)

Capital: the top element of a column

Cella: the main room of a temple where the god is housed

Cuneiform: a system of writing in which the strokes are formed in a wedge or arrowhead shape

Façade: the front of a building. Sometimes, more poetically, a speaker can refer to a "side façade" or a "rear façade"

Ground line: a baseline upon which figures stand (Figures 2.3a, 2.3b)

Ground plan: the map of a floor of a building

Hierarchy of scale: a system of representation that expresses a person's importance by the size of his or her representation in a work of art (Figure 2.2)

Lamassu: a colossal winged human-headed bull in Assyrian art (Figure 2.5)

Lapis lazuli: a deep-blue stone prized for its color

Negative space: empty space around an object or a person, such as the cut-out areas between a figure's legs or arms of a sculpture

Register: a horizontal band, often on top of another, that tells a narrative story (Figures 2.3a, 2.3b)

Relief sculpture: sculpture that projects from a flat background. A very shallow relief sculpture is called a **bas-relief** (pronounced: bah-relief) (Figures 2.4a, 2.4b)

Stele (plural: **stelae**): a stone slab used to mark a grave or a site (Figures 2.4a, 2.4b)

Votive: offered in fulfillment of a vow or a pledge (Figure 2.2)

Ziggurat: a pyramid-like building made of several stories that indent as the building gets taller; thus, ziggurats have terraces at each level (Figure 2.1)

SUMMARY

The Ancient Near East saw the birth of world civilizations, symbolized by the first works of art that were used in the service of religion and the state. Rulers were quick to see that their image could be permanently emblazoned on stelae that celebrated their achievements for posterity to admire. The invention of writing created a systematic historical and artistic record of human achievement.

Common characteristics of Ancient Near Eastern art include the union of human and animal elements in a single figure, the use of hierarchy of scale, and the deification of rulers.

Because the Mesopotamian river valleys were poor in stone, most buildings in this region were made of mud brick and were either painted or faced with tile or stone. Entranceways to cities and palaces were important; fantastic animals acted as guardian figures to protect the occupants and ward off the evil intentions of outsiders.

Multiple-Choice

1. The Standard of Ur, an ancient Sumerian work, shows that at an early date there was extensive trading between peoples as illustrated by the use of

 (A) lapis lazuli from Afghanistan
 (B) bronze from India
 (C) papyrus from Egypt
 (D) marble from Greece

Questions 2–4 refer to the images below.

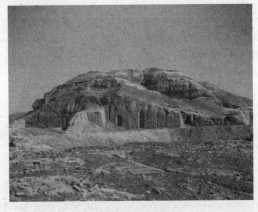

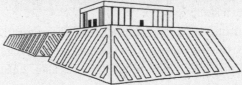

2. The White Temple is constructed on a large platform base that raises it above the ground and gives the structure considerable height. This technique was highly influential for hundreds of years and can be seen in

 (A) the Great Stupa from Sanchi, India
 (B) the Great Pyramids of Giza, Egypt
 (C) the Palace of Darius, at Persepolis, Iran
 (D) Stonehenge in Wiltshire, United Kingdom

3. The White Temple and its ziggurat symbolize

 (A) that the gods required their buildings to be of mud brick to represent the impermanence of life
 (B) the belief that a bent-axis plan limits the number of worshippers on the site
 (C) that the gods live in relative seclusion at the top of a ziggurat, approachable by a select few
 (D) the power of the Persian state to build a massive temple

4. The White Temple and its ziggurat has the following design element:

 (A) It has tapered sides for the purpose of washing off rainwater.
 (B) It was guarded by composite sculptures called lamassus.
 (C) It has a columned hall, called an *apadana,* used for ceremonies.
 (D) It has a small interior chamber that held the tomb of the king.

5. The laws expressed on the Code of Hammurabi can be summarized as

 (A) forgiveness is the highest form of justice
 (B) the only way to deter crime is to use the death penalty
 (C) justice depends on your ability to pay
 (D) the punishment reflects the crime

Short Essay

Practice Question 3: Visual Analysis
Suggested Time: 15 minutes

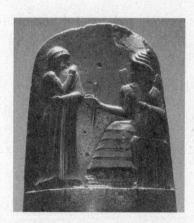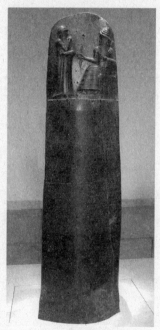

This is the Code of Hammurabi from c. 1792–1750 B.C.E.

Describe the subject matter of the Code of Hammurabi.

Describe *at least two* visual characteristics of the Code of Hammurabi.

Using specific contextual evidence, explain how the Code of Hammurabi was intended to function.

Using specific visual evidence, explain how the subject matter or visual characteristics of the Code of Hammurabi reinforce its function.

ANSWERS EXPLAINED

Multiple-Choice

1. **(A)** The work has no marble, papyrus, or bronze in it. Lapis lazuli, a rich blue stone, was imported from Afghanistan.

2. **(C)** The Palace of Darius is also raised on a high platform to give it a more formidable presence.

3. **(C)** Ziggurat temples were accessible to only a few important figures in Sumerian society. The ziggurat is not built of impermanent materials because it represents the passing of life; it was built of mud brick because that was the only building material available to the Sumerians. A bent-axis plan does not limit the number of participants; it was used for ceremonial purposes.

4. **(A)** There is no indication that there were any burials associated with the White Temple or its ziggurat; nor did it have guardian figures or columned halls. The sides were pitched so that rainwater would not collect on the mud brick and erode the structure.

5. **(D)** The laws on the Hammurabi code can be summarized as the severity of the punishment reflects the magnitude of the crime. What you have done will be done unto you.

Short Essay Rubric

Task	Point Value	Key Points in a Good Response
Describe the subject matter of the Code of Hammurabi.	1	Answers could include: ■ Below the main scene contains one of the earliest law codes ever written; symbolically shows a ruler's need to establish civic harmony in a civilized world. ■ 300 law entries placed below the grouping, symbolically given from the god Shamash to Hammurabi.
Describe *at least two* visual characteristics of the Code of Hammurabi.	1 point each	Answers could include: ■ Sun god, Shamash, enthroned on a ziggurat, hands Hammurabi a rope, a ring, and a rod of kingship. ■ Shamash is in frontal view and profile at the same time; headdress is in profile; rays (wings?) from behind his shoulder. ■ They stare at one another directly even though their shoulders are frontal; composite views. ■ Hammurabi depicted with a speaking/greeting gesture.
Using specific contextual evidence, explain how the Code of Hammurabi was intended to function.	1	Answers could include: ■ A stele meant to be placed in an important location. ■ The stele spells out the laws of the land in a clear and orderly fashion. ■ The stele represents the power of the king to organize human behavior. ■ The stele represents Shamash's will as expressed through Hammurabi.
Using specific visual evidence, explain how the subject matter or visual characteristics of the Code of Hammurabi reinforce its function.	1	Answers could include: ■ Shamash's beard is fuller than Hammurabi's, illustrating Shamash's greater wisdom. ■ Shamash, judge of the sky and the earth, with a tiara of four rows of horns, presents signs of royal power, the scepter and the ring, to Hammurabi. ■ By placing the god and the king in the same space, it indicates a direct relationship between the two, and reinforces the legitimacy of the laws inscribed in the code.

Egyptian Art

TIME PERIOD: 3000–30 B.C.E.

The most relevant artistic periods in Egyptian art are the following:

Old Kingdom	2575–2134 B.C.E.
New Kingdom	1550–1070 B.C.E.

ENDURING UNDERSTANDING: The culture, beliefs, and physical settings of a region play an important role in the creation, subject matter, and siting of works of art.

Learning Objective: Discuss how the culture, beliefs, or physical setting can influence the making of a work of art. (For example: the Innermost coffin of King Tutankhamun)

Essential Knowledge:

- Egyptian art expresses the ideas of permanence, rebirth, and eternity.
- Egyptian figure styles follow a formula that expresses differences in status.

ENDURING UNDERSTANDING: Art making is influenced by available materials and processes.

Learning Objective: Discuss how material, processes, and techniques influence the making of a work of art. (For example: Temple of Amun-Re)

Essential Knowledge:

- Egyptians developed the use of the clerestory to provide light into darkened interiors.
- The god-king is expressed in monumental stone structures that Egypt has become famous for.

ENDURING UNDERSTANDING: Cultural interaction through war, trade, and travel can influence art and art making.

Learning Objective: Discuss how works of art are influenced by cultural interaction. (For example: Great Pyramids of Giza)

Essential Knowledge:

- There are many similarities among artistic styles in Egypt, which indicates a vibrant exchange of ideas.

ENDURING UNDERSTANDING: Art and art making can be influenced by a variety of concerns including audience, function, and patron.

Learning Objective: Discuss how art can be influenced by audience, function, and/or patron. (For example: Last judgment of Hunefer)

Essential Knowledge:

■ Egyptian art is sometimes centered on elaborate funerary practices and the numerous artifacts associated with them.

ENDURING UNDERSTANDING: Art history is best understood through an evolving tradition of theories and interpretations.

Learning Objective: Discuss how works of art have had an evolving interpretation based on visual analysis and interdisciplinary evidence. (For example: Palette of King Narmer)

Essential Knowledge:

■ The study of art history is shaped by changing analyses based on scholarship, theories, context, and written records.

HISTORICAL BACKGROUND

Egypt gives the appearance of being a monolithic civilization whose history stretches steadily into the past with little change or fluctuation. However, Egyptian history is a constant ebb and flow of dynastic fortunes, at times at the height of its powers, other times invaded by jealous neighbors or wracked by internal feuds.

Historical Egypt begins with the unification of the country under King Narmer in predynastic times, an event or a series of events celebrated on the **Narmer Palette** (3000–2920 B.C.E.) (Figure 3.4). The subsequent early dynasties, known as the Old Kingdom, featured massively built monuments to the dead, called **pyramids**, which are emblematic of Egypt today.

After a period of anarchy, Mentihotep II unified Egypt for a second time in a period called the Middle Kingdom. Pyramid building was abandoned in favor of smaller and less expensive rock-cut tombs.

More anarchy followed the breakdown of the Middle Kingdom. Invaders from Asia swept through, bringing technological advances along with their domination. Soon enough, Egyptians righted their political ship, removed the foreigners, and embarked upon the New Kingdom, a period of unparalleled splendor.

One New Kingdom pharaoh, Akhenaton, markedly altered Egyptian society by abandoning the worship of the many gods and substituting one god, Aton, with himself portrayed as his representative on Earth. Aton was different from prior Egyptian gods because he was represented as a sun disk emanating rays, instead of gods that were human and/or animal symbols. This new religion ushered in a dramatic change in artistic style called the **Amarna period**. Although Akhenaton's religious innovations did not survive him, the artistic changes he promoted were long lasting.

After the demise of the New Kingdom, Egypt felt prey to the ambitions of Persia, Assyria, and Greece, ultimately undoing itself at the hands of Rome in 30 B.C.E.

Modern Egyptology began with the 1799 discovery of the Rosetta Stone, from which hieroglyphics could, for the first time, be translated into modern languages. Egyptian paintings and sculpture, often laden with text, could now be read and understood.

The feverish scramble to uncover Egyptian artifacts culminated in 1922 with the discovery of King Tutankhamun's tomb by Howard Carter. This is one of the most spectacular archaeological finds in history because it is the only royal Egyptian tomb that has come down to us undisturbed.

Patronage and Artistic Life

Egyptian architecture was designed and executed by highly skilled craftsmen and artisans, not by slaves, as tradition often alleges. The process of mummification, which became a national industry, was handled by embalming experts who were paid handsomely for their exacting and laborious work.

Most artists like Imhotep, history's first recorded artist, should more properly be called artistic overseers, who supervised all work under their direction. They were likely ordained high priests of Ptah, the god who created the world in Egyptian mythology.

As the royal builder for King Djoser, Imhotep erected the first and largest pyramid ever built, the Stepped Pyramid. Indeed, Imhotep's reputation as a master builder so fascinated later Egyptians that he was deified and worshipped as the god of wisdom, astronomy, architecture, and medicine. Few other Egyptian artists' names come down to us.

EGYPTIAN ARCHITECTURE

The iconic image of Egyptian art is the **pyramid**, sitting as it does adrift in the sands of the Sahara. Pyramids were never built alone but as part of great complexes, called **necropolises**, dedicated to the worship of the spirits of the dead and the preservation of an individual's **ka**, or soul.

At first, Egyptians buried their dead in more unassuming places called **mastabas** (Figure 3.1). A mastaba is a simple tomb that has four sloping sides and an entrance for mourners to bring offerings to the deceased. The body was buried beneath the mastaba in an inaccessible area that only the spirit could enter.

Later rulers with grander ambitions began to build larger monuments, heaping the mastaba form one atop the other in smaller dimensions until a pyramid was achieved. The first such example of this is the Stepped Pyramid of King Djoser. Imhotep's complex included temples with **engaged columns** (Figure 3.2).

After several experiments with the pyramid form, the archetypal pyramids such as the ones at Giza (Figure 3.6) evolved with sleek prismatic surfaces. Interiors included false doors so that the ka could come and go when summoned by the faithful.

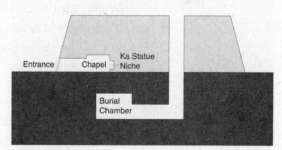

Figure 3.1: Sectional diagram of a mastaba

An Egyptian specialty is carving from living rock. Huge monuments such as the **Great Sphinx** (c. 2500 B.C.E.) (Figure 3.6a) were hewn from a single great rock; tombs like those at Beni Hasan were carved into hillsides, hollowing out chambers filled with **reserve columns**.

In the New Kingdom, temples continued to be built into the sides of rock formations, as at **Hatshepsut's Mortuary Temple** (1473–1458 B.C.E.) (Figure 3.9a). However, this period also produced freestanding monuments as at **Luxor** (Figure 3.8a), which had massive **pylons** on the outside protecting the sanctuary. Behind the pylons lay a central courtyard that greeted the worshipper. The god was housed in a sacred area just beyond, which was surrounded by a forest of columns, called a **hypostyle** hall. Some of the columns were higher than others, allowing limited light and air to enter the complex. This upper area is called a **clerestory**. In a sanctuary submerged in the half-light of the closely placed columns, the god was sheltered

Figure 3.2: Engaged columns

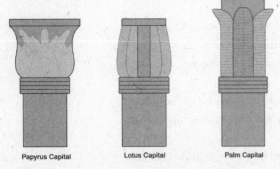

Papyrus Capital Lotus Capital Palm Capital

Figure 3.3: Papyrus, lotus, and palm capitals

so completely that only the high priest or the pharaoh could enter.

Egyptian pyramids are known for their sleek solid surfaces and their monumental scale. They are made from stone blocks and built without mortar. Once the dead were interred, no one was permitted entry into these sealed structures. The sides of the pyramids are oriented to the four cardinal points of the compass. The benben (coming from a root meaning to "swell up") was a pyramid-like stone at Heliopolis, Egypt, which formed the prototype for the capstone of the pyramids and/or the pyramids themselves. Pyramid Texts, the oldest religious texts in existence, confirm that the pharaoh's body could be reenergized after death and ascend to the heavens using ramps, stairs, or ladders. He could even become airborne.

The pyramids do not exist in isolation, but are part of a vast temple complex that was strictly organized. The complexes are on the west side of the Nile, so that the pharaoh was interred in the direction of the setting sun. The temples are on the east side of the pyramids, facing the rising sun. Like the pyramids, most Egyptian temples have an astronomical orientation.

Columns used in New Kingdom temples were based on plant shapes: the lotus, the palm, and the papyrus. These column types reflected early construction methods done at a time when Egyptian buildings were supported by perishable materials (Figure 3.3).

EGYPTIAN PAINTING AND SCULPTURE

The monumentality of stone sculpture, unseen in ancient Sumeria, is new to art history. Even Egyptian **sarcophagi** were hewn from enormous stones and placed in tombs to protect the dead from vandals.

Hieroglyphics describe the deceased and his or her accomplishments in great detail, without which the dead would have incomplete afterlives. Writing appears both on relief sculpture and on sculpture in the round, as well as on a paper surface called **papyrus**. Hieroglyphics help modern Egyptologists rediscover some of the original intentions of works of art.

Egyptians believed superhuman forces were constantly at work and needed continuous worship. Egyptian funerary art was dedicated to the premise that things that were buried were to last forever and that this life must continue uninterrupted into the next world. To that end, artists affirmed this belief by representing the human figure as completely as possible.

The Egyptian canon of proportions allows for little individuality. Shoulders are seen frontally, while the rest of the body, except the eye, is turned in profile. Often, heads face one direction while the legs face another. Men are taller than women and are painted a ruddy brown or red. Women are shorter—children shorter still—and are painted with a yellowish tinge. Shading is rare.

The ideal is to represent successful men and women acting in a calm, rational manner. Episodes of violence and disorder are limited only to scenes of slaughtering animals for sacrifices or overthrowing the forces of evil; otherwise, Egyptian art is a picture of contentment and stability.

Figures rest on a **ground line** often at the front of the picture plane. When figures are placed on a line above in a **register**, they are thought to be receding into the distance.

Because Egyptians believed in a canon of proportions, artists placed a grid over the areas to be painted and outlined the figures accordingly. Unfinished figures rendered the subject's existence incomplete in the afterlife. Even animals had to be drawn as completely as possible.

In the **Amarna period** there is a general relaxation of canon rules. Figures are depicted as softer, with slack jaws and protruding stomachs over low-lying belts. Arms become thinner and limbs more flexible, as in the sculpture of **Akhenaton, Nefertiti, and three daughters** (Figure 3.10) in the fourteenth century B.C.E.

Egyptian sculpture ranges in size from the most intimate pieces of jewelry to some of the largest stone sculptures ever created. Huge portraits of the pharaohs are meant to impress and overwhelm; individualization and sophistication are sacrificed for monumentality and grandeur. The stone of choice is limestone from Memphis. Other stones, like gypsum and sandstone, are also used, but hard stones like granite are avoided when possible because of the difficulty in carving with soft metal tools. Wooden sculpture is painted unless made of exceptionally fine material. Metal sculptures of copper and iron also exist.

Large-scale sculptures are rarely entirely cut free of the rock they were carved from. For example, **Menkaura and queen** (c. 2490–2472 B.C.E.) (Figure 3.7) has the legs attached to the front of the throne, making the figures seem more permanent and solid. Colossal sculptures, like the **Great Sphinx**, are carved on the site, or **in situ**, from the local available rock.

Relief sculptures follow the same figural formula as paintings. When relief sculptures are carved for outdoor display, they are often cut into the rock so that shadows showed up more dramatically, and the figures thereby become more visible. When carved indoors, reliefs are raised from the surface for visibility in a dark interior.

Palette of King Narmer, predynastic Egypt, 3000–2920 B.C.E., graywacke, Egyptian Museum, Cairo (Figures 3.4a and 3.4b)

Form

- Hierarchy of scale.
- Figures stand on a ground line.
- Narrative.
- Schematic lines delineate Narmer's muscle structure: forearm veins and thigh muscles are represented by straight lines, the kneecaps by half circles.
- Composite view of the human body: mostly seen in profile, but chest, eye, and ear are frontal.
- Hieroglyphics explain and add to the meaning, and they identify Narmer in the cartouche.

Function

- Palette used to prepare eye makeup for the blinding sun, although this palette was probably commemorative.
- Palettes carved on two sides were for ceremonial purposes.

Content

- Relief sculpture depicting King Narmer uniting Upper and Lower Egypt.
- Depicted four times at the top register is Hathor, a god as a cow with a woman's face, or Bat, a sky

Figures 3.4a and 3.4b: Palette of King Narmer, predynastic Egypt, 3000–2920 B.C.E., graywacke, Egyptian Museum, Cairo

goddess who has the power to see the past and the future, or a bull which symbolizes the power and strength of the king.

- On the front:
 - Narmer, who is the largest figure, wears the cobra crown of Lower Egypt and is reviewing the beheaded bodies of the enemy; the bodies are seen from above, the heads carefully placed between their legs.
 - Narmer is preceded by four standard bearers and a priest; his foot washer or sandal bearer follows.
 - In the center, mythical animals with elongated necks are harnessed, possibly symbolizing unification; at the bottom is a bull knocking down a city fortress—Narmer knocking over his enemies.
- On the back:
 - The falcon is Horus, god of Egypt, who triumphs over Narmer's foes; Horus holds a rope around a man's head and a papyrus plant, symbols of Lower Egypt.
 - Narmer has a symbol of strength, the bull's tail, at his waist; wears a bowling-pin-shaped crown as king of united Egypt, beating down an enemy. (This refers to a smiting pose seen in Egyptian predynastic works.)
 - A servant behind Narmer holds his sandals as he stands barefoot on the sacred ground as a divine king.
 - Defeated Egyptians lie beneath his feet.

Theories

- Represents the unification of Upper and Lower Egypt under one ruler.
- Unification is expressed as a concept or goal to be achieved.
- May represent a balance of order and chaos.
- May reference the journey of the sun god.

Content Area Ancient Mediterranean, Image 13

Web Source https://www.ancient.eu/Narmer_Palette/

- **Cross-Cultural Comparisons for Essay Question 1: Interpreting Symbols**
 - Delacroix, *Liberty Leading the People* (Figure 20.4)
 - Cotsiogo, Hide Painting of a Sun Dance (Figure 26.13)
 - Frontispiece of the Codex Mendoza (Figure 18.1)

Seated scribe, Saqqara, Egypt, c. 2620–2500 B.C.E., Old Kingdom, 4th Dynasty, painted limestone, Louvre, Paris (Figure 3.5)

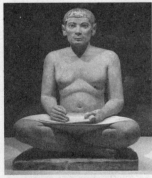

Figure 3.5: Seated scribe, Saqqara, Egypt, c. 2620–2500 B.C.E., Old Kingdom, 4th Dynasty, painted limestone, Louvre, Paris

Form

- Not a pharaoh: sagging chest and realistic body rather than the idealistic features reserved for a pharaoh; the scribe contrasts with the ideally portrayed pharaoh.
- Figure has high cheekbones, hollow cheeks, and a distinctive jaw line.
- Meant to be seen from the front.
- Color still remains on the sculpture.

Function

- Created for a tomb at Saqqara as a provision for the ka.

Content

- Amazingly lifelike but not a portrait—rather, it's a conventional image of a scribe.
- Inlaid crystal eyes.
- Holds papyrus in his lap; his writing instrument (now gone) was in his hand ready to write.

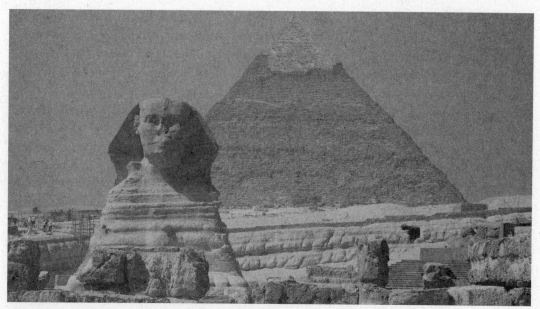

Figure 3.6a: Great Pyramids (Menkaura, Khafre, and Khufu) and the Great Sphinx, c. 2550–2490 B.C.E., Old Kingdom, 4th Dynasty, cut limestone, Giza, Egypt

Context

- Attentive expression; thin angular face; in readiness for the words the pharaoh might dictate.
- Seated on the ground to indicate his comparative low station.

Content Area Ancient Mediterranean, Image 15

Web Source *http://musee.louvre.fr/oal/scribe/indexEN.html*

- **Cross-Cultural Comparisons for Essay Question 1: Human Figure**
 - Shiva as Nataraja (Figure 23.6)
 - Great Buddha from Todai-ji (Figure 25.1b)
 - Abakanowicz, *Androgyne III* (Figure 29.7)

Great Pyramids (Menkaura, Khafre, and Khufu), c. 2550–2490 B.C.E., Old Kingdom, 4th Dynasty, cut limestone, Giza, Egypt (Figures 3.6a and 3.6b)

Form

- Each pyramid is a huge pile of limestone with a minimal interior that housed the deceased pharaoh.
- Each pyramid had an enjoining mortuary temple used for worship.

Function

- Giant monuments to dead pharaohs: Menkaura, Khufu, and Khafre.
- Preservation of the body and tomb contents for eternity.
- Some scholars also suggest that the complex served as the king's palace in the afterlife.

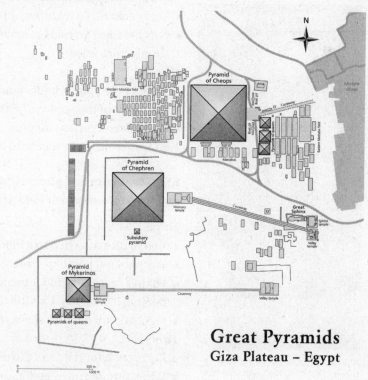

Great Pyramids
Giza Plateau – Egypt

Figure 3.6b: Plan of the pyramid field

Context

- Each pyramid has a funerary complex adjacent connected by a formal pathway used for carrying the dead pharaoh's body to the pyramid to be interred.
- Shape may have been influenced by a sacred stone relic called a benben, which is shaped like a sacred stone found at Heliopolis. Heliopolis was the center of the sun god cult.
- Each side of the pyramid is oriented toward a point on the compass, a fact pointing to an association with the stars and the sun.
- Giza temples face east, the rising sun, and have been associated with the god Re.

Content Area Ancient Mediterranean, Image 17

Web Source *http://whc.unesco.org/en/list/86*

- **Cross-Cultural Comparisons for Essay Question 1: Commemoration of Ruler and Country**
 - Taj Mahal (Figures 9.17a, 9.17b)
 - Houdon, *George Washington* (Figure 19.7)
 - Terra cotta warriors (Figures 24.8a, 24.8b)

Great Sphinx, c. 2500 B.C.E., limestone, Giza, Egypt (Figure 3.6a)

Form

- Carved in situ from a huge rock; colossal scale.
- Body of a lion, head of a pharaoh and/or god.
- Originally brightly painted to stand out in the desert behind the figure, which once rose near ramps rising from the Nile.

Function

- The Sphinx seems to be protecting the pyramids behind it, although this theory has been debated.

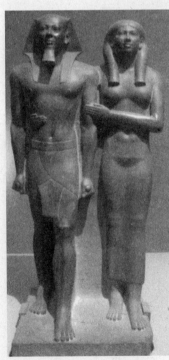

Context and Interpretation

- Very generalized features, although some say it may be a portrait of Khafre.
- Cats are royal animals in ancient Egypt, probably because they saved the grain supply from mice.

History

- Head of the Sphinx badly mauled in the Middle Ages.
- Fragment of the Sphinx's beard is in the British Museum.

Content Area Ancient Mediterranean, Image 17

Web Source *https://www.britishmuseum.org/collection/object/Y_EA58*

King Menkaura and queen, Old Kingdom, 4th Dynasty, 2490–2472 B.C.E., graywacke, Museum of Fine Arts, Boston (Figure 3.7)

Form

- Two figures attached to a block of stone; arms and legs not cut free.
- Traces of red paint exist on Menkaura's face and black paint on the queen's wig.
- Figures seem to stride forward, but simultaneously are anchored to the stone behind; it is unusual for the female figure to be striding with the male.
- Figures stare out into space (the afterlife?).

Function

- Receptacle for the ka of the pharaoh and his queen.
- Wife's simple and affectionate gesture, and/or presenting him to the gods.

Figure 3.7: King Menkaura and queen, Old Kingdom, 4th Dynasty, 2490–2472 B.C.E., graywacke, Museum of Fine Arts, Boston

Materials

- Extremely hard stone used; symbolizes the permanence of the pharaoh's presence and his strength on earth.

Context

- Menkaura's powerful physique and stride symbolize his kingship, as does his garb: nemes on the head, an artificial beard, and a kilt with a tab.
- Original location was the temple of Menkaura's pyramid complex at Giza.
- Society's view of women is expressed in the ankle-length tightly draped gown covering the queen's body; men and women of the same height indicated equality.
- Society's view of the king is expressed in his broad shoulders, muscular arms and legs, and firm stomach.

Theory

- Because of the prominence of the female figure, it has been suggested that she is not his wife but his mother, or the goddess Hathor—although the figure has no divine attributes.

Content Area Ancient Mediterranean, Image 18

Web Source *www.mfa.org/collections/object/king-menkaura-mycerinus-and-queen-230*

- **Cross-Cultural Comparisons for Essay Question 1: Royalty**
 - Lindauer, *Tamati Waka Nene* (Figure 28.7)
 - Wall plaque from Oba's palace (Figure 27.3)
 - Augustus of Prima Porta (Figure 6.15)

Figure 3.8a: Temple of Amun-Re and Hypostyle Hall, Temple: 1550 B.C.E., Hall: 1250 B.C.E., New Kingdom, 18th and 19th Dynasties, cut sandstone and mud brick, Karnak, near Luxor, Egypt

Temple of Amun-Re and Hypostyle Hall, Temple: 1550 B.C.E., Hall: 1250 B.C.E., New Kingdom, 18th and 19th Dynasties, cut sandstone and mud brick, Karnak, near Luxor, Egypt (Figures 3.8a, 3.8b, and 3.8c)

Form

- Axial plan.
- Pylon temple.
- Hypostyle halls.
- Massive lintels link the columns together.
- Huge columns, tightly packed together, admit little light into the sanctuary.
- Tallest columns have papyrus capitals; a clerestory allows some light and air into the darkest parts of the temple.
- Columns elaborately painted.
- Columns carved in sunken relief.
- Bottom of columns have bud capitals.
- Massive walls enclose complex.
- Enter complex through massive sloped pylon gateway into a peristyle courtyard, then through a hypostyle hall, and then into the sanctuary, where few were allowed.

Function

- Egyptian temple for the worship of Amun-Re.
- God housed in the darkest and most secret part of the complex, only accessed by priests and pharaohs.

Figure 3.8b: Hypostyle Hall, 1250 B.C.E., New Kingdom, 18th and 19th Dynasties, cut sandstone and mud brick, Karnak, near Luxor, Egypt

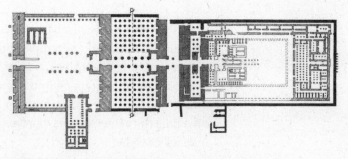

Figure 3.8c: Plan of Temple of Amun-Re and Hypostyle Hall, Temple: 1550 B.C.E., Hall: 1250 B.C.E., New Kingdom, 18th and 19th Dynasties, cut sandstone and mud brick, Karnak, near Luxor, Egypt

Context

- Adjacent is an artificial sacred lake—a symbol of the sacred waters of the world that existed before time.
- Located on the east side of the Nile, linked by a road with the Karnak temple for the Opet festival.
- The complex was built near this lake over time; symbolically, it arose from the waters the way civilization did.
- Theory that the temple represents the beginnings of the world:
 - Pylons are the horizon.
 - Floor rises to the sanctuary of the god.
 - Temple roof is the sky.
 - Columns represent plants of the Nile: lotus, papyrus, palm, etc.

History

- Built by succeeding generations of pharaohs over a great expanse of time.

Content Area Ancient Mediterranean, Image 20

Web Source http://whc.unesco.org/en/list/87

- **Cross-Cultural Comparisons for Essay Question 1: Houses of Worship**
 - Lakshmana Temple (Figures 23.7a, 23.7b, 23.7c, 23.7d)
 - Santa Sabina (Figures 7.3a, 7.3b, 7.3c)
 - Great Mosque, Isfahan (Figures 9.13a, 9.13b, 9.13c)

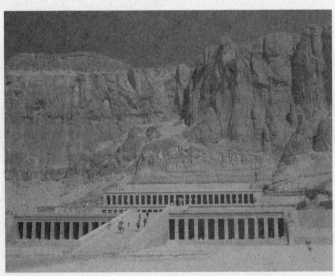

Figure 3.9a: Mortuary temple of Hatshepsut, c. 1473–1458 B.C.E., New Kingdom, 18th Dynasty, sandstone partly carved into a rock cliff, near Luxor, Egypt

Mortuary temple of Hatshepsut, c. 1473–1458 B.C.E., New Kingdom, 18th Dynasty, sandstone partly carved into a rock cliff, near Luxor, Egypt (Figure 3.9a)

Form

- Three colonnaded terraces and two ramps.
- Visually coordinated with the natural setting; long horizontals and verticals of the terraces and colonnades repeat the patterns of the cliffs behind; patterns of dark and light in the colonnade are reflected in the cliffs.
- Terraces were originally planted as gardens with exotic trees.

Function

- Hatshepsut declared that she built the temple as "a garden for my father, Amun" (Hatshepsut claimed to have been of divine birth, sired by the god Amun).

- Was used only for special religious events; lacks subsidiary buildings for storing offerings, the accommodation of priests, temple administration, workshops, and other function-structures.
- For reasons of cultic purity, the royal burial could not be in the temple. The royal tomb was located in the mountain behind the temple and reached by way of the Valley of the Kings.

Context

- First time the achievements of a woman are celebrated in art history; Hatshepsut's body is interred elsewhere.
- Temple aligned with the winter solstice, when light enters the farthest section of the interior.
- Located on the west side of the Nile across from Thebes.
- Perhaps designed by Senenmut, a high-ranking official in Hatshepsut's court.

Content Area Ancient Mediterranean, Image 21

Web Source *https://oi.uchicago.edu/sites/oi.uchicago.edu/files/uploads/shared/docs/saoc69.pdf*

- ■ **Cross-Cultural Comparisons for Essay Question 1: Architecture and Setting**
 - – Acropolis, Athens (Figure 4.16a)
 - – Wright, Fallingwater (Figure 22.16)
 - – Nan Madol (Figures. 28.1a, 28.1b)

Kneeling statue of Hatshepsut, 1473–1458 B.C.E., red granite, Metropolitan Museum of Art, New York (Figure 3.9b)

Form

- ■ Male pharaonic attributes: nemes or headcloth, false beard, kilt.
- ■ Wears the white crown of Upper Egypt.
- ■ Queen is depicted in male costume of a pharaoh, yet slender proportions and slight breasts indicate femininity.

Function

- ■ Statue of the god brought before sculpture in a procession.
- ■ Processions up the mortuary temple passed in front of this statue of Hatshepsut.
- ■ One of 200 statues placed around the complex.

Context

- ■ One of 10 statues of Hatshepsut with offering jars, part of a ritual in honor of the sun god; pharaoh would kneel only before a god.
- ■ Inscription on base says she is offering plants to Amun, the sun god.

Content Area Ancient Mediterranean, Image 21

Web Source *https://www.metmuseum.org/art/collection/search/544449*

- ■ **Cross-Cultural Comparisons for Essay Question 1: Guardian Figures**
 - – Nio guardian figure (Figures 25.1c, 25.1d)
 - – Staff god (Figures 28.5a, 28.5b)
 - – Lamassu (Figure 2.5)

Figure 3.9b: Kneeling statue of Hatshepsut, 1473–1458 B.C.E., red granite, Metropolitan Museum of Art, New York

Akhenaton, Nefertiti, and three daughters, New Kingdom (Amarna), 18th Dynasty, 1353–1335 B.C.E., limestone, Egyptian Museum, Berlin (Figure 3.10)

Content

- ■ Akhenaton holds his eldest daughter (left), ready to be kissed.
- ■ Nefertiti holds her daughter (right) with another daughter on her shoulder.
- ■ Intimate family relationships are extremely rare in Egyptian art.

Form

- ■ State religion shift indicated by an evolving style in Egyptian art:
 - – Smoother, curved surfaces.
 - – Low-hanging bellies.
 - – Slack jaws.
 - – Thin arms.
 - – Epicene bodies.
 - – Heavy-lidded eyes.

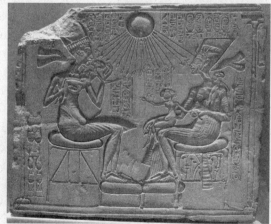

Figure 3.10: Akhenaton, Nefertiti, and three daughters, New Kingdom (Amarna), 18th Dynasty, 1353–1335 B.C.E., limestone, Egyptian Museum, Berlin

- At the end of the sun's rays, ankhs (an ankh is the Egyptian symbol of life) point to the king and queen.

Function

- The domestic environment was new in Egyptian art; the panel is for an altar in a home.

Technique

- Sunken relief, which is less likely to be damaged than raised relief.
- Sunken relief creates deeper shadows and can be appreciated in the sunlight.

Context

- Akhenaton abandoned Thebes and created a new capital, originally named Akhenaton and later changed to Amarna; the style of art from this period is called the Amarna Style.
- The state religion was changed by Akhenaton to the worship of Aton, symbolized by the sun-disk with a cobra; he changed his name from Amenhotep IV to Akhenaton to reflect his devotion to the one god Aton; this is an early example of monotheism.
- Akhenaton and Nefertiti are having a private relationship with their new god, Aton.
- After Akhenaton's reign, the Amarna style was slowly replaced by more traditional Egyptian representations.

Content Area Ancient Mediterranean, Image 22

Web Source http://egyptian-museum-berlin.com/c52.php#n_hausaltar_01.jpg

- **Cross-Cultural Comparisons for Essay Question 1: Genre Scenes**
 - Vermeer, *Woman Holding a Balance* (Figure 17.10)
 - Courbet, *Stone Breakers* (Figure 21.1)
 - Grave stele of Hegeso (Figure 4.7)

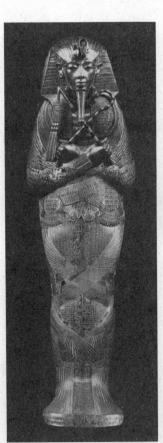

Figure 3.11: Innermost coffin of King Tutankhamun's tomb, New Kingdom, 18th Dynasty, c. 1323 B.C.E., gold with inlay of enamel and semiprecious stones, Egyptian Museum, Cairo

Innermost coffin of King Tutankhamun's tomb, New Kingdom, 18th Dynasty, c. 1323 B.C.E., gold with inlay of enamel and semiprecious stones, Egyptian Museum, Cairo (Figure 3.11)

Form

- Gold coffin (6 feet, 7 inches long) containing the body of the pharaoh.
- Smooth, idealized features on the mask of the boy king.
- Holds a crook and a flail, symbols of Osiris.

Function

- Mummified body of King Tutankhamun was buried with 143 objects, on his head, neck, abdomen, and limbs; a gold mask was placed over his head.

Context

- When Akhenaton died, two pharaohs ruled briefly, and then his son Tutankhamun reigned for ten years, from age 9 to 19.
- Tutankhamun's father and mother were brother and sister; his wife was his half-sister; perhaps he was physically handicapped because of genetic inbreeding.

History

- Famous tomb discovered by Howard Carter in 1922.

Content Area Ancient Mediterranean, Image 23

Web Source http://metmuseum.org/toah/hd/tuta/hd_tuta.htm

- **Cross-Cultural Comparisons for Essay Question 1: Commemoration**
 - *Sarcophagus of the Spouses* (Figure 5.4)
 - Moai (Figure 28.11)
 - *Ndop* (Figure 27.5a)

Last judgment of Hunefer, from his tomb (Page from the *Book of the Dead*), New Kingdom, 19th Dynasty, c. 1275 B.C.E., painted papyrus scroll, British Museum, London (Figure 3.12)

Form

■ Narrative on a uniform register (read right to left).

Function

■ Illustration from the *Book of the Dead*, an Egyptian book of spells and charms that acted as a guide for the deceased to make his or her way to eternal life.

Content

■ Top register: Hunefer in white at left before a row of judges.

■ Main register: the jackal-headed god of embalming, Anubis, leads the deceased into a hall, where his soul is weighed against a feather. If his sins weigh more than a feather, he will be condemned.

■ The hippopotamus/lion figure, Ammit, between the scales, will eat the heart of an evil soul.

■ The god Thoth, who has the head of a bird, is the stenographer writing down these events in the hieroglyphics that he invented.

■ Osiris, god of the underworld, enthroned on the right, will subject the deceased to a day of judgment.

Context

■ Hunefer was a scribe who had priestly functions.

Content Area Ancient Mediterranean, Image 24

Web Source https://www.bbc.com/news/av/entertainment-arts-11669904/a-rare-view-of-egyptian-book-of-the-dead

■ **Cross-Cultural Comparisons for Essay Question 1: Scrolls**
 – *Night Attack on the Sanjô Palace* (Figures 25.3a, 25.3b)
 – *Bayeux Tapestry* (Figures 11.7a, 11.7b)
 – Bing, *A Book from the Sky* (Figures 29.8a, 29.8b)

Figure 3.12: Last judgment of Hunefer, from his tomb (Page from the *Book of the Dead*), New Kingdom, 19th Dynasty, c. 1275 B.C.E., painted papyrus scroll, British Museum, London

VOCABULARY

Amarna style: art created during the reign of Akhenaton, which features a more relaxed figure style than in Old and Middle Kingdom art (Figure 3.10)

Ankh: an Egyptian symbol of life

Axial plan: a building with an elongated ground plan (Figure 3.8c)

Clerestory: a roof that rises above lower roofs and thus has window space beneath

Engaged column: a column that is not freestanding but attached to a wall (Figure 3.2)

Ground line: a baseline upon which figures stand (Figure 3.4a)

Hierarchy of scale: a system of representation that expresses a person's importance by the size of his or her representation in a work of art (Figure 3.4a)

Hieroglyphics: Egyptian writing using symbols or pictures as characters (Figure 3.12)

Hypostyle: a hall that has a roof supported by a dense thicket of columns (Figure 3.8b)

In situ: a Latin expression that means that something is in its original location

Ka: the soul, or spiritual essence, of a human being that either ascends to heaven or can live in an Egyptian statue of itself

Mastaba: Arabic for "bench," a low, flat-roofed Egyptian tomb with sides sloping down to the ground (Figure 3.1)

Necropolis: literally, a "city of the dead," a large burial area (Figure 3.6b)

Papyrus: a tall aquatic plant whose fiber is used as a writing surface in ancient Egypt (Figure 3.12)

Peristyle: a colonnade surrounding a building or enclosing a courtyard (Figure 3.8a)

Pharaoh: a king of ancient Egypt (Figure 3.11)

Pylon: a monumental gateway to an Egyptian temple marked by two flat, sloping walls between which is a smaller entrance (Figure 3.8a)

Register: a horizontal band, often on top of another, that tells a narrative story (Figure 3.4)

Relief sculpture: sculpture which projects from a flat background. A very shallow relief sculpture is called a **bas-relief** (pronounced: bah-relief) (Figure 3.4) *Contrast:* Sunken relief

Reserve column: a column that is cut away from rock but has no support function

Sarcophagus (plural, **sarcophagi**)**:** a stone coffin

Stylized: A schematic, nonrealistic manner of representing the visible world and its contents, abstracted from the way that they appear in nature

Sunken relief: a carving in which the outlines of figures are deeply carved into a surface so that the figures seem to project forward (Figure 3.10)

SUMMARY

Egyptian civilization covers a huge expanse of time that is marked by the building of monumental funerary monuments and expansive temple complexes. The earliest remains of Egyptian civilization show an interest in elaborate funerary practices, which resulted in the building of the great stone pyramids.

Egyptian figural style remained constant throughout much of its history, with its emphasis on broad frontal shoulders and profiled heads, torso, and legs. In the Old Kingdom the figures appear static and imperturbable. In the Amarna period the figures lose their motionless stances and have body types that are softer and increasingly androgynous.

The contents of the tomb of the short-lived King Tutankhamun give the modern world a glimpse into the spectacular richness of Egyptian tombs. One wonders how much more lavish the tomb of Ramses II must have been.

Multiple-Choice

1. The purpose of the seated scribe sculpture is to

 (A) illustrate the large retinue the pharaoh had
 (B) show how the pharaoh was literate and intelligent
 (C) indicate how the pharaoh used scribes to write down his deeds
 (D) attend to the pharaoh's needs in the afterlife

Question 2 refers to the following image.

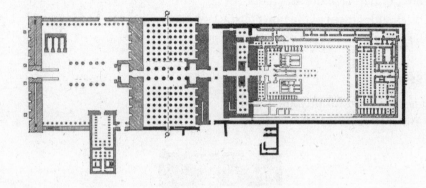

2. The ground plan of this building indicates that

 (A) vast spaces are vaulted for large interiors
 (B) there are four entrances, one for each cardinal point of the compass
 (C) the interior rooms are dominated by closely spaced, thick columns
 (D) the outside walls are low and shallow to allow the Nile to ceremonially flood the interior

3. The painting called the Last judgment of Hunefer shows the

 (A) eternal punishment proclaimed upon a damned soul
 (B) deceased being asked to account for the deeds in his life
 (C) might of the pharaoh in deciding life and death
 (D) rules of conduct imposed on the lowly and the mighty alike

4. Egyptian sculptors sometimes used sunken relief rather than bas-relief because

 (A) sunken reliefs highlight the contours of the surfaces being carved so that the columns appear to have images protruding from their surfaces
 (B) sunken reliefs are easier to carve, a necessity because Egyptians used soft bronze-age tools to carve into hard stones like graywacke
 (C) sunken reliefs act as supporting elements to sustain the weight of the lintels
 (D) sunken reliefs cast deep shadows so that the images can be read more clearly in the Egyptian sun

5. Which historical event is represented on the Palette of King Narmer?

 (A) The founding of the first Egyptian dynasty
 (B) The conquering of the Assyrians
 (C) The abandonment of the polytheistic Egyptian religion in favor of one god, Aton
 (D) The unification of Upper and Lower Egypt

Short Essay

Practice Question 6: Continuity and Change
Suggested Time: 15 minutes

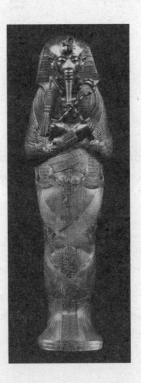

This is the inner coffin of King Tutankhamun from c. 1323 B.C.E.

Where in Egypt was this coffin found?

Explain the contextual reasons this site was chosen for the burial of this coffin.

How does this site differ from the context of ancient Egyptian Old Kingdom burials?

Using *at least two* specific details, discuss how this work is part of a tradition of pharaonic burial.

ANSWERS EXPLAINED

Multiple-Choice

1. **(D)** Images of scribes were placed in tombs to attend to the pharaoh's needs in the after-life. Whereas all of the other choices indicate how pharaohs used scribes, this sculpture of a seated scribe had the specific purpose of being placed in a tomb so that the ka could be accommodated, if necessary.

2. **(C)** There are thick round circles in a grid pattern on the ground plan which represent columns placed very closely together.

3. **(B)** This painting is a Last Judgment scene, in which the deceased's soul is weighed against a feather to see if he is pure enough to face the gods.

4. **(D)** Sunken relief sculpture is no easier or more difficult to carve than any other sculpture no matter what tools are being used or what materials are being carved. Sunken reliefs do not enhance a structural function, nor do they protrude from the surface. However, in the severe Egyptian summer months, sunken reliefs cast shadows that more dramatically highlight the features of the relief sculpture.

5. **(D)** The Palette of King Narmer symbolically represents a conflation of all the episodes leading to the unification of Upper and Lower Egypt.

Short Essay Rubric

Task	Point Value	Key Points in a Good Response
Where in Egypt was this coffin found?	1	The coffin was found in a tomb in the Valley of the Kings in Egypt.
Explain the contextual reasons this site was chosen for the burial of this coffin.	1	Answers could include: ■ This was the traditional burial ground for Egyptian kings. ■ The valley was naturally protected by cliffs against grave robbers. ■ The cliffs and tombs could be easily dug from the rock here.
How does this site differ from the context of ancient Egyptian Old Kingdom burials?	1	Answers could include: ■ It is a tomb rather than a pyramid. ■ The coffin was buried in a tomb in a vast valley, as opposed to a pyramid field. ■ The coffin was buried in a small suite of rooms underground rather than in a chamber in the center of a pyramid.
Using *at least two* specific details, discuss how this work is part of a tradition of pharaonic burial.	2	Answers could include: ■ Elaborate funerary ceremonies; 143 objects found with the body. ■ Gold symbolizes eternity; used extensively throughout the tomb. ■ Holds a crook and a flail, symbols of Osiris. ■ Above the head are symbols of Upper and Lower Egypt: the cobra and the falcon. ■ Idealization of facial features of the king.

Greek Art

4

TIME PERIOD	
Greek Archaic Art	600–480 B.C.E.
Greek Classical Art	480–323 B.C.E.
Greek Hellenistic Art	323–30 B.C.E.

ENDURING UNDERSTANDING: The culture, beliefs, and physical settings of a region play an important role in the creation, subject matter, and siting of works of art.

Learning Objective: Discuss how the culture, beliefs, or physical setting can influence the making of a work of art. (For example: the Parthenon)

Essential Knowledge:

- Ancient Greek art was primarily produced in what is today Greece, Turkey, and Italy.
- Greek art is studied chronologically according to changes in style.
- Greek culture is rich in written literature: i.e., epics, poetry, dramas.
- Greek art is known for its idealization and harmonious proportions, both in sculpture and in architecture.

ENDURING UNDERSTANDING: Art making is influenced by available materials and processes.

Learning Objective: Discuss how material, processes, and techniques influence the making of a work of art. (For example: Niobod Krater)

ENDURING UNDERSTANDING: Cultural interaction through war, trade, and travel can influence art and art making.

Learning Objective: Discuss how works of art are influenced by cultural interaction. (For example: Anavysos Kouros)

Essential Knowledge:

- There is an active exchange of artistic ideas throughout the Mediterranean.
- Ancient Greek objects were influenced by Egyptian and Near Eastern works.

ENDURING UNDERSTANDING: Art and art making can be influenced by a variety of concerns including audience, function, and patron.

Learning Objective: Discuss how art can be influenced by audience, function, and/or patron. (For example: *Winged Victory of Samothrace*)

Essential Knowledge:

■ Ancient Greek art is influenced by civic responsibility and the polytheism of its religion.

ENDURING UNDERSTANDING: Art history is best understood through an evolving tradition of theories and interpretations.

Learning Objective: Discuss how works of art have had an evolving interpretation based on visual analysis and interdisciplinary evidence. (For example: Plaque of the Ergastines)

Essential Knowledge:

■ The study of art history is shaped by changing analyses based on scholarship, theories, context, and written records.

■ Greek art has had an important impact on European art, particularly since the eighteenth century.

■ Greek writing contains some of the earliest contemporary accounts about art and artists.

HISTORICAL BACKGROUND

The collapse of Aegean society around 1100 B.C.E. left a vacuum in the Greek world until a reorganization took place around 900 B.C.E. in the form of city-states. Places like Sparta, Corinth, and Athens defined Greek civilization in that they were small, competing political entities that were united only in language and the fear of outsiders.

In the fifth century B.C.E. the Persians threatened to swallow Greece, and the city-states rallied behind Athens' leadership to expel them. This was accomplished, but not before Athens itself was destroyed in 480 B.C.E. After the Persians were effectively neutralized, the Greeks then turned, once again, to bickering among themselves. The worst of these internal struggles happened during the Peloponnesian War (431–404 B.C.E.) when Athens was crushed by Sparta. Without an effective core, Greek states continued to struggle for another century.

This did not end until the reign of Alexander the Great, who, in the fourth century B.C.E., briefly united Macedonians and Greeks, by establishing a mighty empire that eventually toppled the Persians. Because Alexander died young and left no clear successor, his empire crumbled away soon after his death. The remnants of Greek civilization lasted a few hundred years more, until it was eventually absorbed by Rome.

Patronage and Artistic Life

So many names of artists have come down to us that it is tempting to think that Greek artists achieved a distinguished status hitherto unknown in the ancient world. Artists signed their work, both as a symbol of accomplishment and as a bit of advertisement. Greek potters and painters signed their vases, usually in a formula that resembles "so and so made it" or "so and so decorated it."

Many artists were theoreticians as well as sculptors or architects. **Polykleitos** wrote a famous (no longer existing) book on the canon of human proportions. **Iktinos** wrote on the nature of ideal architecture. Phidias, who was responsible for the artistic program on the Acropolis, supervised hundreds of workers in a mammoth workshop and yet still managed to construct a complex with a single unifying artistic expression. This was a golden age for artists, indeed.

GREEK SCULPTURE

There are three ways in which Greek sculpture stands as a departure from the civilizations that have preceded it:

1. Greek sculpture is unafraid of nudity. Unlike the Egyptians, who felt that nudity was debasing, the Greeks gloried in the perfection of the human body. At first, only men are shown as nude; gradually women are also depicted, although there is a reluctance to fully accept female nudity, even at the end of the Greek period.
2. Large Greek marble sculptures are cut away from the stone behind them. Large-scale bronze works were particularly treasured; their lighter weight made compositional experiments more ambitious.
3. Greek art in the Classical and Hellenistic periods use **contrapposto**, which is a relaxed way of standing with knees bent and shoulders tilted. The immobile look of Egyptian art is replaced by a more informal and fluid stance, enabling the figures to appear to move.

Greek Archaic Sculpture

What survives of Greek Archaic art is limited to grave monuments, such as **kouros** and **kore** figures, or sculpture from Greek temples. Marble is the stone of choice, although Greek works survive in a variety of materials: bronze, limestone, terra cotta, wood, gold—even iron. Sculpture was often painted, especially if it were to be located high on the temple façade. Backgrounds are highlighted in red; lips, eyes, hair, and drapery are routinely painted. Sculpture often has metallic accessories: thunderbolts, harps, and various other attributes.

Bronze sculpture is hollow and made in the lost-wax process, call **cire perdue**. Eyes are inlaid with stone or glass, and lips, nipples, and teeth could be made of copper or silver highlights.

Kouros and **kore** figures stand frontally, bolt upright, and with squarish shoulders. Hair is knotted, and the ears are a curlicue. Figures are cut free from the stone as much as possible, although arms are sometimes attached to thighs. As in Egyptian works, kouros figures have one foot placed in front of the other, as if they were in mid-stride. The shins have a neat crease down the front, as Egyptian works do. To give the figures a sense of life, most kouros and kore figures smile.

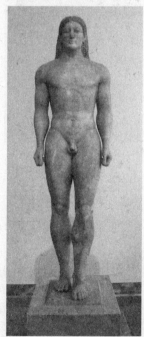

Figure 4.1: Anavysos Kouros, Archaic Greek, c. 530 B.C.E., marble with remnants of paint, National Archaeological Museum, Athens

Anavysos Kouros, Archaic Greek, c. 530 B.C.E., marble with remnants of paint, National Archaeological Museum, Athens (Figure 4.1)

Form

- Emulates the stance of Egyptian sculpture but is nude; arms and legs are largely cut free from the stone.
- Rigidly frontal.
- Freestanding and able to move; in contrast, many Egyptian works are reliefs or are attached to the stone.
- Hair is knotted and falls in neatly braided rows down the back.
- Some paint survives, some of it encaustic, which would have given the sculpture greater life.
- "Archaic smile" meant to enliven the sculpture.

Function

- Grave marker, replacing huge vases of the Geometric period.
- Sponsored by an aristocratic family.

Content
- Not a real portrait but a general representation of the dead.
- Named after a young military hero, Kroisos; inscription at base identifies him: "Stand and grieve at the tomb of Kroisos, the dead, in the front line slain by the wild Ares."

Content Area Ancient Mediterranean, Image 27

Web Source *https://www.namuseum.gr/en/collection/archaiki-periodos/*

- **Cross-Cultural Comparisons for Essay Question 1: Idealization**
 - Power figure (Figure 27.6)
 - Staff god (Figure 28.5a)
 - Donatello, *David* (Figure 15.5)

Peplos Kore, from the Acropolis, Archaic Greek, c. 530 B.C.E., marble and painted details, Acropolis Museum, Athens (Figure 4.2)

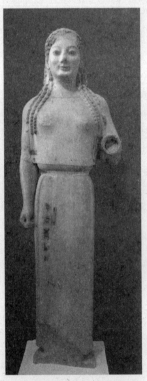

Figure 4.2: Peplos Kore, from the Acropolis, Archaic Greek, c. 530 B.C.E., marble and painted details, Acropolis Museum, Athens

Form
- Hand emerges into the viewer's space, breaks out of the mold of static Archaic statues.
- Indented waist.
- Breasts revealed beneath drapery.
- Rounded and naturalistic face.
- Much of the encaustic paint still remains, animating the face and hair.
- Broken hand was fitted into the socket and probably held an attribute; she may have been a goddess.

Context
- She is named for the peplos, thought to be one of the four traditional garments she is wearing.

Theory
- Recent theory proposes that she is the goddess, either Athena or Artemis; the figure is now missing arrows and a bow in her hand, and she may have worn a metal diadem on her head.

Content Area Ancient Mediterranean, Image 28

Web Source *http://theacropolismuseum.gr/en/content/korai-acropolis*

- **Cross-Cultural Comparisons for Essay Question 1: Human Figure in Greek Art**
 - *Winged Victory of Samothrace* (Figure 4.8)
 - Seated boxer (Figure 4.10)
 - Victory adjusting her sandal (Figure 4.6)

Greek Classical Sculpture

Classical sculpture is distinct from Archaic in the use of **contrapposto**, that is, the fluid body movement and relaxed stance that was unknown in freestanding sculpture before this. In addition, forms became highly idealized; even sculptures depicting older people have heroic bodies. In the fifth century B.C.E., this heroic form was defined by **Polykleitos**, a sculptor whose **canon** of proportions of the human figure had far-reaching effects. Polykleitos wrote that the head should be one-seventh of the body. He also favored a heavy musculature with a body expressing alternating stances of relaxed and stressed muscles. Thus, on his *Spear Bearer* (450–440 B.C.E.) (Figure 4.3), the right arm and the left leg are flexed, and the left arm and right leg are relaxed.

The crushing of Athens during the Peloponnesian War had a dramatic impact on the arts, which turned away from the idealizing canon of the fifth century B.C.E. In the Late Classical period of the fourth century B.C.E., gods were sculpted in a more humanized way. Praxiteles, the greatest sculptor of his age, carved figures with a sensuous and languorous appeal, and favored a lanky look to the bodies. Hallmarks of fourth-century work include heads that are one-eighth of the body and a sensuous S-curve to the frame.

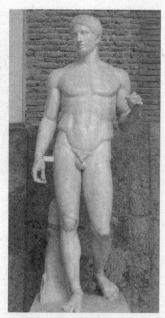

Figure 4.3: Polykleitos, *Doryphoros* (*Spear Bearer*), original: c. 450–440 B.C.E., Roman marble copy of a Greek bronze original, National Archaeological Museum, Naples

Polykleitos, *Doryphoros* (*Spear Bearer*), original: c. 450–440 B.C.E., Roman marble copy of a Greek bronze original, National Archaeological Museum, Naples (Figure 4.3)

Form
- Blocky solidity.
- Closed stance.
- Broad shoulders, thick torso, muscular body.
- Idealized body; contrapposto.
- Body is both tense and relaxed: left arm and right leg are relaxed, right arm and left leg are tense.

Content
- Warrior and athlete.
- Hand once held a spear.
- Movement is restrained; ideal Spartan body.
- Averted gaze; he does not recognize the viewer's admiration.
- Contemplative gaze.

Context
- Greek name: *Doryphoros.*
- Represents Polykleitos's ideal masculine figure.
- Considered a canon for classical body types; the general rule for beauty and form, probably linked to a no longer existing treatise by the artist.

History
- Marble Roman copy of a bronze Greek original.
- Found in Pompeii in a place for athletic training, perhaps for inspiration for athletes.

Content Area Ancient Mediterranean, Image 34

Web Source *http://collections.artsmia.org/art/3520/the-doryphoros-italy*

- **Cross-Cultural Comparisons for Essay Question 1: Human Figure**
 - Female deity from Nukuoro (Figure 28.2)
 - Shiva as Lord of Dance (Figure 23.6)
 - Braque, *The Portuguese* (Figure 22.6)

Helios, horses, and Dionysus (Heracles?), c. 438–432 B.C.E., marble, British Museum, London (Figure 4.4)

Form
- Greek Classical art; contrapposto.
- Figures seated in the left-hand corner of the east pediment of the Parthenon (Figure 4.16a).
- Sculptures comfortably sit in the triangular space of the pediment.

Function
- Part of the east pediment of the Parthenon.
- This grouping contains figures who are present at the birth of Athena, which is the main topic at the center of pediment—now lost.

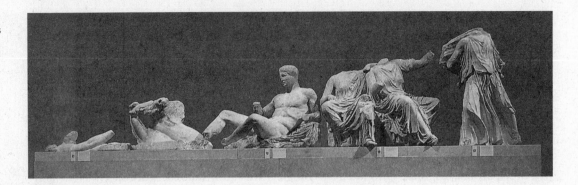

Figure 4.4: Helios, horses, and Dionysus (Heracles?), c. 438–432 B.C.E., marble, British Museum, London

Content

■ Left: the sun god, Helios, bringing up the dawn with his horses; the male nude is Dionysus, god of wine, and he is lounging.

■ Two seated figures may be the goddesses Demeter and Persephone, reacting to the birth of Athena.

Context

■ Part of the Parthenon sculptures, also called the Elgin Marbles.

■ Phidias acted as the chief sculptor of the workshop.

Content Area Ancient Mediterranean, Image 35

Web Source *https://artsandculture.google.com/asset/figure-thought-to-be-of-dionysos-from-the-east-pediment-of-the-parthenon/XgE6C-9WfO4Dbw*

■ **Cross-Cultural Comparisons for Essay Question 1: Sculpture on Architectural Monuments**

 – Churning of the Ocean of Milk (Figure 23.8c)

 – Royal Portals at Chartres (Figure 12.6)

 – Last Judgment, Sainte-Foy, Conques (Figure 11.6)

Plaque of the Ergastines, c. 447–438 B.C.E., marble, Louvre, Paris (Figure 4.5)

Form

■ Isocephalism: the tradition of depicting heads of figures on the same level.

■ Figures stand in contrapposto.

■ Carved in high relief, which reflects placement; the more three-dimensional the relief, the better it could be seen from below.

Content

■ Six ergastines, young women in charge of weaving Athena's peplos, are greeted by two priests.

Figure 4.5: Plaque of the Ergastines, c. 447–438 B.C.E., marble, Louvre, Paris

Context

■ Part of a frieze from the Parthenon that depicts some 360 figures (Figure 4.16b).

■ Scene from the Panathenaic Frieze depicting the Panathenaic Procession, held every four years to honor Athena.

■ This is the first time in Greek art that human events are depicted on a temple.

■ The scene contains a religious procession of women dressed in contemporary drapery and acting nobly.

- The procession began at the Dipylon Gate, passed through the agora, and ended at the Parthenon.
- Athenians placed a new peplos on an ancient statue of Athena.

Theory

- New theory: Not the Panathenaic procession but the story of the legendary Athenian king Erechtheus, who sacrificed one of his daughters to save the city of Athens; told to do so by the Oracle of Delphi.

Content Area Ancient Mediterranean, Image 35

Web Source *http://www.louvre.fr/en/oeuvre-notices/plaque-ergastines*

- **Cross-Cultural Comparisons for Essay Question 1: Relief Sculpture**
 - Churning of the Ocean of Milk (Figure 23.8c)
 - *Coyolxauhqui* (Figure 26.5b)
 - Lintel 25 of Structure 23 from Yaxchilán (Figure 26.2b)

Figure 4.6: Victory adjusting her sandal, from the Temple of Athena Nike, c. 410 B.C.E., marble, Acropolis Museum, Athens

Victory adjusting her sandal, from the Temple of Athena Nike, c. 410 B.C.E., marble, Acropolis Museum, Athens (Figure 4.6)

Form

- Graceful winged figure modeled in high relief.
- Deeply incised drapery lines reveal body; wet drapery.

Context

- Part of the balustrade on the Temple of Athena Nike, a war monument (Figure 4.17).
- One of many figures on the balustrade; not a continuous narrative but a sequence of independent scenes.
- The importance of military victories was stressed in the images on the Acropolis.

Web Source *http://www.theacropolismuseum.gr/en/content/temple-athena-nike*

- **Cross-Cultural Comparisons for Essay Question 1: Figure in Motion**
 - Shiva as Lord of Dance (Figure 23.6)
 - Nio guardian figure (Figures 25.1c, 25.1d)
 - Churning of the Ocean of Milk (Figure 23.8c)

Attributed to Kallimachos, Grave stele of Hegeso, c. 410 B.C.E., marble and paint, National Archaeological Museum, Athens (Figure 4.7)

Form

- Classical period of Greek art.
- Use of contrapposto in the standing figure.
- Jewelry painted in, not visible.
- Architectural framework.
- Text includes name of the deceased.

Function

- Grave marker.
- In Geometric and Archaic periods, Greeks used kraters and kouroi to mark graves; in the Classical period, stelae were used.

Figure 4.7: Attributed to Kallimachos, Grave stele of Hegeso, c. 410 B.C.E., marble and paint, National Archaeological Museum, Athens

Content

- Commemorates the death of Hegeso; an inscription identifies her and her father.
- Genre scene: Hegeso examines a piece of jewelry from a jewelry box handed to her by a standing servant; may represent her dowry.
- Standing figure has a lower social station, placed before a seated figure.

Context

- Erected in the Dipylon cemetery in Athens.
- Attributed to the sculptor Kallimachos.

Content Area Ancient Mediterranean, Image 36

Web Source *https://www.namuseum.gr/en/collection/klasiki-periodos-2/*

- **Cross-Cultural Comparisons for Essay Question 1: Funerary Markers and Materials**
 - Taj Mahal (Figures 9.17a, 9.17b)
 - *Sarcophagus of the Spouses* (Figure 5.4)
 - Tutankhamun's Tomb (Figure 3.11)

Greek Hellenistic Sculpture

Hellenistic sculptors offer a wider range of realistic modeling and a willingness to show more movement than their classical colleagues. Figures have a great variety of expression from sadness to joy. Themes untouched before, such as childhood, old age, despair, anger, and drunkenness, are common subjects in Hellenistic art. To be certain, there are still Hellenistic beauties, but the accent is on a variety of expressions sweeping across the range of human emotion. Moreover, sculptors carve with greater flexibility, employing negative space more freely. The viewer is meant to walk around a Hellenistic sculpture and see it from many sides; hence, the work is often not meant to be placed against a wall.

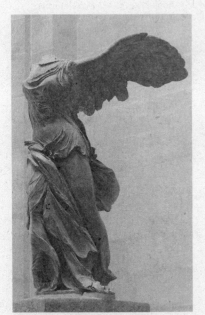

Figure 4.8: *Winged Victory of Samothrace*, Hellenistic Greek, c. 190 B.C.E., marble, Louvre, Paris

Winged Victory of Samothrace, **Hellenistic Greek, c. 190 B.C.E., marble, Louvre, Paris (Figure 4.8)**

Form

- Monumental figure.
- Dramatic twist and contrapposto of the torso.
- Wet drapery look imitates water playing on the wet body.
- Illusion of wind on the body.

Function

- Meant to sit on a fountain representing a figurehead on a boat; the fountain would splash water around the figure.

Content

- Large heroic figure of Nike placed above the marble prow of a naval vessel.
- Nike is wearing several garments, some of which are folded inside out to show the force of the wind.
- It has been suggested that Nike held a trumpet, a wreath, or a fillet in her right hand. However, the hand found in Samothrace in 1950 has an open palm and two outstretched fingers, suggesting that she was not holding anything and was simply holding her hand up in a gesture of greeting.

Context

- Probably made to commemorate a naval victory in 191 B.C.E.; Nike is the goddess of victory.
- The boat at the base is an ancient battleship with oar boxes and traces of a ram.

History

- Found in 1863 in situ on Samothrace.
- Reassembled in the Louvre Museum in Paris and placed at the top of a grand staircase.
- Only one wing was found; the other is a mirror image.
- Only one breast was found; the other is a reconstruction.
- The right hand has been found, but it cannot be attached because no arms have been found.

Content Area Ancient Mediterranean, Image 37

Web Source *http://focus.louvre.fr/en/winged-victory-samothrace*

- **Cross-Cultural Comparisons for Essay Question 1: Location**
 - Smithson, *Spiral Jetty* (Figure 22.26)
 - Dome of the Rock (Figures 9.12a, 9.12b)
 - Lanzón Stone (Figure 26.1b)

Athena, from the Great Altar of Zeus and Athena at Pergamon, Hellenistic Greek, c. 175 B.C.E., marble, Pergamon Museum, Berlin (Figure 4.9)

Form

- Deeply carved figures overlap one another; masterful handling of spatial illusion; figures break into the viewer's space from the frieze.
- Dramatic intensity of figures and movement; heroic musculature.

Function

- Gigantomachy on the base of the Pergamon Altar (Figure 4.18a) illustrates the victories of the goddess Athena, who is worshipped at the altar.

Content

- Describes the battle between the gods and the giants; the giants, depicted as helpless, are dragged up the stairs to worship the gods.
- Athena grabs Alkyoneos by the hair and drags him up the stair to worship Zeus.
- Nike, on the right, crowns Athena in victory.
- Gaia, the earth goddess, looks on in horror and pleads for the fate of her sons, the giants.

Context

- The gods' victory over the giants offers a parallel to Alexander the Great's defeat of the Persians.
- Also acts as an allegory of a Greek military victory by Eumenes II.

Content Area Ancient Mediterranean, Image 38

Web Source *http://contentdm.lib.byu.edu/cdm/ref/collection/Civilization/id/772*

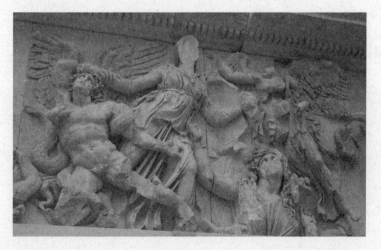

Figure 4.9: Athena, from the Great Altar of Zeus and Athena at Pergamon, Hellenistic Greek, c. 175 B.C.E., marble, Pergamon Museum, Berlin

- **Cross-Cultural Comparisons for Essay Question 1: Relief Sculpture**
 - Narmer Palette (Figure 3.4)
 - Anthropomorphic stele (Figure 1.2)
 - Pyxis of al-Mughira (Figure 9.4)

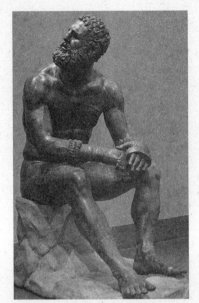

Figure 4.10: Seated boxer, Hellenistic Greek, c. 100 B.C.E., bronze, National Roman Museum, Rome

Seated boxer, Hellenistic Greek, c. 100 B.C.E., bronze, National Roman Museum, Rome (Figure 4.10)

Form
- Older man, past his prime, looks defeated.
- Smashed nose; lips sunken in suggesting broken teeth.
- Cauliflower ears.
- Nude fighter; hands wrapped in leather bands.
- Figure evinces sadness, stoicism and determination.

Function
- May have been a good luck charm for athletes; evidence of toes worn away from being touched.

Materials
- Rare surviving Hellenistic bronze.
- Blood, denoted in copper, drips from his face and onto his right arm and thigh.
- Copper used to highlight his lips and nipples, the straps on his leather gloves, and the wounds on his head.

Context
- May have been part of a group or perhaps a single sculpture, the head turned to face an unseen opponent.
- Found in a Roman bath in Rome.

Content Area Ancient Mediterranean, Image 41

Web Source *http://metmuseum.org/blogs/now-at-the-met/features/2013/the-boxer*

- **Cross-Cultural Comparisons for Essay Question 1: Individual and Society**
 - Goya, *And There's Nothing to Be Done* (Figure 20.2)
 - Kirchner, *Self-Portrait as a Soldier* (Figure 22.3)
 - Munch, *The Scream* (Figure 21.11)

GREEK ARCHITECTURE

Like the Egyptians, the Greeks designed their temples to be the earthly homes of the gods. Also like the Egyptians, the Greeks preferred limited access to the deity. This is one reason why such grand temples had doors that were removed from public view. In fact, architecturally the front and back of Greek temples look almost identical; only the sculptural ornament is different. When Greeks came to worship they congregated at a temple near the building. Interiors of temples held huge statues whose forbidding presence allowed only those with appropriate credentials to enter.

There are three types of Greek temples: **Doric**, **Ionic**, and **Corinthian** (Figure 4.11). Greeks in mainland Greece and in the places they settled, like Sicily, preferred the

Doric Capital Ionic Capital Corinthian Capital

Figure 4.11: Greek orders of columns

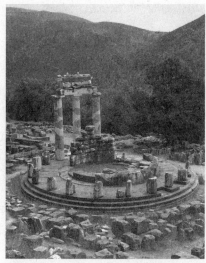

Figure 4.12: A tholos, a circular shrine

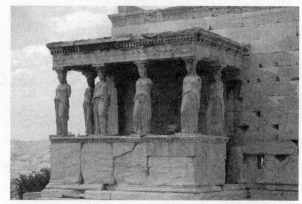

Figure 4.13: Caryatids act as columns holding up a building

Doric style, with its simplified capitals and columns with tapered **shafts** that sit, without a base, directly on the floor of the temple. **Doric** temples have unadorned **architraves** and alternating **trigylphs** and **metopes**, the latter depicting episodes from Greek mythology. Greek island architects preferred the **Ionic** style, with its volute-like capitals, columns that sit on bases, and **friezes** of sculpture placed along the **entablature**. Later, the **Corinthian** order was introduced, in which the capitals have leaves and the straight columns have bases that transition to the floor. The different orders of Greek architecture were occasionally freely mixed, as in the case of the **Parthenon**, where a Doric temple has Ionic features, like a frieze, introduced on the inside.

Elaborate Greek temple complexes were placed on a high hill, or **acropolis**, overlooking the city. Gateways, called **propylaea**, prepared the visitor for his or her entrance into the complex.

Greek temple architecture shows a reliance on few forms and develops these. However, there are two innovations of note. The first is the circular shrine, called a **tholos** (Figure 4.12), which represents perfection to the geometry-minded Greeks. The second is the introduction of columns carved as figures, the female version of which are called **caryatids** (Figure 4.13). These columns have to be carefully executed because the weight of the building rests on the thin points of a body's structure: the neck and the legs. This means that all caryatids have long hair and solid gowns in order to stabilize the building above.

Besides temples, the Greeks built a number of other important buildings, such as shopping centers and theaters. The theaters are marvels of construction, possessing incredible acoustics, especially considering that the performances were held in the open air. Some 12,000 people seated at the theater at Epidauros could hear every word, even if they were seated 55 rows back.

Except for the rare **tholos** buildings, Greek temples are rectangular and organized on an inventive, although rigid, set of geometric principles, which tantalized Greek thinkers and philosophers. Temples are built with the post-and-lintel system in mind, the columns never too widely set apart. The columns completely surround the temple core in a design called a **peristyle**. **Pediments**, which are seated over the tops of columns, contain sculpture representing the heroic deeds of the god or goddess housed inside. A **cornice** separates the upper and lower parts of a Greek temple (Figure 4.14).

The doors are set back from the façade, sometimes by two rows of columns, so that little light could enter these generally windowless buildings. This increases the sense of mystery about the interior, where few could go and the deity serenely reigned.

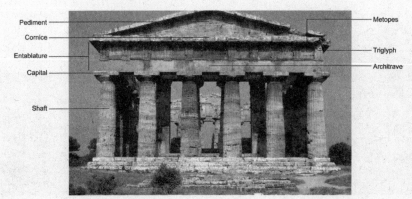

Figure 4.14: Parts of a Doric Greek temple

Athenian Agora, Archaic through Hellenistic Greek, 600–150 B.C.E., Athens, Greece (Figure 4.15)

Function

■ A plaza at the base of the Acropolis in Athens with commercial, civic, religious, and social buildings where ceremonies took place.

■ Setting for the Panathenaic Festival, ceremonies, and parades to honor Athena.

■ The Panathenaic Way cuts through along a hilly terrain from the northwestern to the southeastern corners.

Content

■ Surrounding the plaza were important buildings, including:

– a bouleuterion, a chamber used by a council of 500 citizens, called a boule, who were chosen by lot to serve for one year.

– a tholos, a round structure manned by a group of senators 24 hours a day for emergency meetings; served as a dining hall where the prytaneis (executives) of the boule often met.

– Several stoas. A stoa is a covered walkway with columns on one side and a wall on the other.

Content Area Ancient Mediterranean, Image 26

Web Source *http://www.agathe.gr/*

■ **Cross-Cultural Comparisons for Essay Question 1: Large Public Rituals**

– Presentation of Fijian mats and tapa cloths to Queen Elizabeth II (Figure 28.10)

– Aka elephant mask (Figure 27.12)

– The Kaaba (Figure 9.11a)

Figure 4.15: Athenian Agora, Archaic through Hellenistic Greek, 600–150 B.C.E., Athens, Greece

1 Peristyle Court
2 Mint
3 Enneacrounos
4 South stoa
5 Heliaea
6 Strategeion
7 Colonos Agoraios
8 Tholos
9 Agora stone
10 Monument of the Eponymous Heroes
11 Old Bouleuterion
12 New Bouleuterion
13 Temple of Hephaestus (Hephaestion)
14 Temple of Apollo Patroos
15 Stoa of Zeus
16 Altar of the Twelve Gods
17 Royal stoa
18 Temple of Aphrodite Urania
19 Stoa of Hermes
20 Stoa poikile

Iktinos and Kallikrates, The Parthenon, 447–410 B.C.E., Athens, Greece (Figures 4.16a and 4.16b)

Form

- Greek predilection for algebra and geometry is omnipresent in the design of this building: parts can be expressed as $x = 2y + 1$; thus, there are 17 columns on the side (x) and 8 columns in the front (y), and the ratio of the length to the width is 9:4. Proportions are the same for the cella.
- Unusually light interior had two windows in the cella.
- Floor curves upward in the center of the façade to drain off rainwater and to deflect appearance of sagging at the ends.
- Since the columns at the ends are surrounded by light, they are made thicker so as to look the same as the other columns.
- Ionic elements in a Doric temple: the rear room contains Ionic capitals, and the frieze on interior is Ionic.

Function

- Interior built to house a massive statue of Athena, to whom the building was dedicated; also included the treasure of the Delian League.
- The statue, made of gold and ivory over a wooden core, no longer exists.

Context

- Constructed under the leadership of Pericles after the Persian sack of Athens in 480 B.C.E. destroyed the original acropolis.
- Pericles used the extra funds in the Persian war treasury to build the Acropolis; Greek allies were furious that the funds were not returned to them.

History

- Built as a Greek temple dedicated to Athena, the patroness of Athens.
 - According to the story, Athena and Poseidon vied for control over Athens, and offered gifts to the populace to entice them (this story is recounted on the west pediment of the Parthenon).
 - Poseidon made salt water spring from the ground on the acropolis.
 - Athena made an olive tree grow on the site.
- The sacred sites in which these deeds are associated are in the Erechtheum, a temple adjacent to the Parthenon, including the marks of Poseidon's trident, the salt water well, and the sacred olive tree.
- After the Greek period, the Parthenon became a Greek Orthodox church and then a Roman Catholic church dedicated to Mary.
- In the Islamic period, it was converted to a mosque.
- Destroyed by the Venetians in an attack against the Turks.
- Half of the sculptures were removed to England by Lord Elgin in the nineteenth century.

Content Area Ancient Mediterranean, Image 35

Web Source http://whc.unesco.org/en/list/404

- **Cross-Cultural Comparisons for Essay Question 1: Classical Influence on Later Buildings**
 - Jefferson, Monticello (Figures 19.5a, 19.5b)
 - Porta, Il Gesù (Figure 16.6a)
 - Venturi, House in New Castle County (Figures 22.27a, 22.27b)

Figure 4.16a: Iktinos and Kallikrates, Acropolis, c. 447–410 B.C.E., marble, Athens, Greece

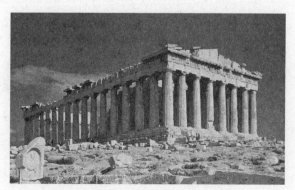

Figure 4.16b: Iktinos and Kallikrates, the Parthenon, 447–410 B.C.E., Athens, Greece

Figure 4.17: Kallikrates, Temple of Athena Nike, 427–424 B.C.E., marble, Athens, Greece

Kallikrates, Temple of Athena Nike, 427–424 B.C.E., marble, Athens, Greece (Figure 4.17)

Form

- Amphiprostyle: having four columns in the front and four in the back.
- Ionic temple.

Function

- Built to commemorate the Greek victory over the Persians in the Battle of Marathon; Nike is the goddess of victory.
- Once contained a figure of Nike inside.

Context

- Many images of victory on the temple.
- Cf. Victory adjusting her sandal (Figure 4.6) sculpted on a balustrade or railing that once framed the building.

Content Area Ancient Mediterranean, Image 35

Web Source *http://greatbuildings.com/buildings/Temple_of_Athena_Nike.html*

Great Altar of Zeus and Athena at Pergamon, Asia Minor (present-day Turkey), Hellenistic Greece, c. 175 B.C.E., marble, Pergamon Museum, Berlin (Figures 4.18a and 4.18b)

Form

- Altar is on an elevated platform at the top of a dramatic flight of stairs.
- A frieze 7.5 feet high and more than 400 feet long wraps around the monument.
- Ionic columns frame the monument.

Function

- Altar dedicated to Zeus and Athena.
- Cf. Athena (Figure 4.9) on the gigantomachy around the base of the altar.

Context

- Conscious effort to be in dialogue with the Panathenatic frieze on the Parthenon.

Figure 4.18a: Great Altar of Zeus and Athena at Pergamon, Asia Minor (present-day Turkey), Hellenistic Greece, c. 175 B.C.E., marble, Pergamon Museum, Berlin

- Parallels made between the Pergamon victories over the barbarians in a recent war, Alexander the Great's defeat of the Persians, and the gods' defeat of the giants in mythology.

Content Area Ancient Mediterranean, Image 38

Web Source *http://www.smb.museum/en/museums-institutions/antikensammlung/collection-research/3d-model-of-the-pergamon-altar.html*

Figure 4.18b: Plan of the Altar of Zeus and Athena at Pergamon, Asia Minor (present day Turkey), Greek Hellenistic, c. 175 B.C.E.

GREEK POTTERY

Much of what is known about Greek painting comes from pottery, which survives in surprising quantities, even though mural painting has almost totally disappeared. Professional pottery had been practiced in Greece from its origins in Aegean society throughout the entire span of the Greek period. Some vessels are everyday items; others serve as tomb monuments. Massive kraters have holes at the bottom so that when libations are poured liquid could run out the bottom of the pot and onto the grave itself. Pots that were used for these purposes often have a scene of the deceased lying on a bier surrounded by mourners. Chariots and warriors complete the grieving procession.

Form followed function in Greek pottery. Most pots were designed for a particular purpose and were so shaped. The portable **amphora** stored provisions like oil or wine with an opening large enough to admit a ladle. The **krater** was a bowl for mixing water and wine because the Greeks never drank their wine straight. A kylix, with its wide mouth and shallow dimensions, was a drinking cup, ideal for the display of scenes on the relatively flat bottom.

Painters wrote a myriad of inscriptions that were sometimes literally addressed to the viewer of the pot, saying things like "I greet you." Inscriptions could explain the narrative scene represented, or identify people or objects. The underside of vases usually indicated the selling transaction of the pot.

In the Archaic period, artists painted in a style called **black figure**, which emphasized large figures drawn in black on the red natural surface of the clay. Other colors would burn in the high temperature of the **kiln**, so after the pot had been fired, details were added in highlighting colors. The bright glazing of Greek pottery gives the surface a lustrous shine. At the end of the Archaic period, **red-figure** vases were introduced by Andokides; in effect, they are the reversal of black figure style pots. The backgrounds were painted in black, and the natural red of the clay detailed the forms.

Archaic pottery has the same stiffness and monumentality of Archaic sculpture. Achievements in Classical sculpture, such as **contrapposto**, were paralleled in classical pottery as well. Similarly the dynamic movements of the Hellenistic period were reflected in Greek Hellenistic pottery.

Niobid Painter, Niobides Krater, Classical Greek, 460–450 B.C.E., clay, red-figure technique with white highlights, Louvre, Paris (Figures 4.19a and 4.19b)

Form

- First time in vase painting that isocephalism (the tradition of depicting heads of figures on the same level) has been jettisoned.
- May have been the influence of wall paintings, although almost no Greek wall paintings survive. Written sources detail how numerous figures were placed at various levels in complex compositions.

Figure 4.19a: Niobid Painter, Niobides Krater, Classical Greek, 460–450 B.C.E., clay, red-figure technique with white highlights, Louvre, Paris

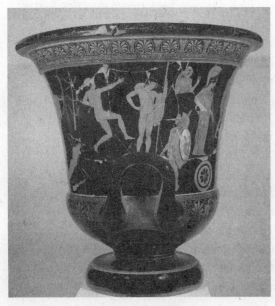

Figure 4.19b: Lateral view of Figure 4.19a

Technique
- Red-figure ware.

Function
- Ceremonial krater; practical kraters were used for mixing water and wine or storing liquids.

Context
- Called the Niobides Krater because the killing of Niobe's children is depicted on one side.
 - Niobe, who had seven sons and seven daughters, bragged about her fertility to the god Leto, who had only two children.
 - Leto's two children, Apollo and Artemis, sought revenge by killing Niobid's fourteen.
 - Niobid is punished for her hubris.
 - Niobe's children are slaughtered.
- On the other side of the vase, the story is the subject of scholarly debate.
 - One theory is that it represents Herakles in the center surrounded by heroes in arms and Athena (on the left).
 - Another theory is that the warriors of Marathon are depicted placing themselves before a sculpture of Herakles seeking protection in an upcoming battle.

History
- Found in Orvieto, Italy; many Greek vases found in Etruscan tombs.

Content Area Ancient Mediterranean, Image 33

Web Source *http://www.louvre.fr/en/oeuvre-notices/attic-red-figure-calyx-krater-known-niobid-krater*

- **Cross-Cultural Comparisons for Essay Question 1: Ceramics**
 - Beaker with ibex motifs (Figure 1.10)
 - The David Vases (Figure 24.11)
 - Martínez, Black-on-black ceramic vessel (Figure 26.14)

GREEK PAINTING

Alexander Mosaic **from the House of Faun,**
Republican Roman copy of c. 100 B.C.E., mosaic,
National Archaeological Museum, Naples
(Figure 4.20)

Figure 4.20: *Alexander Mosaic* from the House of Faun, Republican Roman copy of c. 100 B.C.E., mosaic, National Archaeological Museum, Naples

Form
- Crowded with nervous excitement.
- Extremely complex interweaving of figures; spatial illusionism through foreshortening, chiaroscuro, reflection in shield.

Technique
- Use of tesserae instead of previously used pebbles.
- Tesserae allow for greater flexibility and more complex compositions and shadings.

Function
- Roman floor mosaic, found in a house in Pompeii, based on an original Greek mural (?) painting.

Content
- Alexander, at left: young, brave, forthright, assured of success, wears helmet.
- Alexander pierces the body of an enemy with his spear without so much as a glance at his victim.
- Alexander's widened eye is trained on Darius.
- Darius, in center right on chariot: horrified, weakly cedes the victory; his charioteer commands the horses to make their escape.
- Darius looks stunned as his brother, Oxyanthres, is stabbed, the brother portrayed here as sacrificing himself to save the king.
- The dying man's right hand is still gripping his weapon, as though he wished to pull it out of his body, but his body is already collapsing onto the bloody corpse of his black horse.

Theories
- Perhaps a copy of a mural made by Piloxenos of Eretria for King Cassander.
- Perhaps made by Helen of Egypt, one of the few female Greek artists whose name has come down to us.

Content Area Ancient Mediterranean, Image 40

Web Source *http://alexandermosaik.de/en/*

- **Cross-Cultural Comparisons for Essay Question 1: Battle and Glory**
 - Narmer Palette (Figure 3.4)
 - *Bayeux Tapestry* (Figure 11.7a)
 - Delacroix, *Liberty Leading the People* (Figure 20.4)

VOCABULARY

Acropolis: literally, a "high city," a Greek temple complex built on a hill over a city (Figure 4.16a)

Agora: a public plaza in a Greek city where commercial, religious, and societal activities are conducted (Figure 4.15)

Amphiprostyle: having four columns in the front and rear of a temple

Amphora: a two-handled ancient Greek storage jar

Architrave: a plain, unornamented lintel on the entablature (Figure 4.14)

Athena: Greek goddess of war and wisdom; patron of Athens

Canon: a body of rules or laws; in Greek art, the ideal mathematical proportion of a figure

Caryatid (male: **atlantid**): a building column that is shaped like a female figure (Figure 4.13)

Cella: the main room of a temple where the god is housed

Contrapposto: a graceful arrangement of the body based on tilted shoulders and hips and bent knees (Figure 4.3)

Corinthian: an order of ancient Greek architecture similar to the Ionic, except that the capitals are carved in tiers of leaves (Figure 4.11)

Cornice: a projecting ledge over a wall (Figure 4.14)

Doric: an order of ancient Greek architecture that features grooved columns with no grooved bases and an upper story with square sculpture called metopes (Figure 4.11)

Encaustic: a type of painting in which colors are added to hot wax to affix to a surface

Entablature: the upper story of a Greek temple (Figure 4.14)

Frieze: a horizontal band of sculpture (Figure 4.5)

Gigantomachy: a mythical ancient Greek war between the giants and the Olympian gods (Figure 4.9)

In situ: a Latin expression that means that something is in its original location

Ionic: an order of Greek architecture that features columns with scrolled capitals and an upper story with sculptures that are in friezes (Figure 4.11)

Isocephalism: the tradition of depicting heads of figures on the same level (Figure 4.5)

Kiln: an oven used for making pottery

Kouros (female: **kore**): an archaic Greek sculpture of a standing youth (Figures 4.1 and 4.2)

Krater: a large ancient Greek bowl used for mixing water and wine (Figure 4.19)

Metope: a small relief sculpture on the façade of a Greek temple (Figure 4.14)

Mosaic: a decoration using pieces of stone, marble, or colored glass, called **tesserae**, that are cemented to a wall or a floor (Figure 4.20)

Nike: ancient Greek goddess of victory (Figure 4.8)

Niobe: the model of a grieving mother; after boasting of her fourteen children, jealous gods killed them

Panathenaic Way: a ceremonial road for a procession built to honor Athena during a festival (Figure 4.15)

Pediment: the triangular top of a temple that contains sculpture (Figure 4.14)

Peplos: a garment worn by women in ancient Greece, usually full length and tied at the waist (Figure 4.2)

Peristyle: a colonnade surrounding a building or enclosing a courtyard (Figure 4.16b)

Portico: an entranceway to a building having columns supporting a roof

Propylaeum (plural: **propylaea**): a gateway leading to a Greek temple

Relief sculpture: sculpture that projects from a flat background. A very shallow relief sculpture is called a **bas-relief** (pronounced: bah-relief) (Figure 4.5)

Shaft: the body of a column (Figure 4.14)

Stele (plural: **stelae**): an upright stone slab used to mark a grave or a site (Figure 4.7)

Stoa: an ancient Greek covered walkway having columns on one side and a wall on the other (Figure 4.15)

Tholos: an ancient Greek circular building (Figure 4.12)

Trigylph: a projecting grooved element alternating with a metope on a Greek temple (Figure 4.14)

Zeus: king of the ancient Greek gods; known as Jupiter to the Romans; god of the sky and weather

SUMMARY

The Greeks have had such a powerful influence on history that we have dubbed their art "classical," a word that means, among many other things, a standard of authority.

Greek temples are typically surrounded by an imposing set of columns that embrace the cella where the god is housed. The temple itself is often set apart from the rest of the city, sometimes located on an adjoining hill called an acropolis. Greek theaters, like the temples, are built of cut stone carefully carved into an important site.

Greek sculpture and pottery (little wall painting survives) are divided into a number of periods. Greek Archaic art is known for its bolt upright figures and animating smiles. The Classical period is characterized by the use of contrapposto, a figure placed in a relaxed pose and standing naturally. Fifth century B.C.E. art is known for its idealized body types; however, more humanizing expressions characterize fourth century B.C.E. work.

The last phase, called Hellenistic, shows figures with a greater range of expression and movement. Often sculptures look beyond themselves, at an approaching enemy perhaps, or into the face of an unseen wind.

Whatever the period, Greek art has provided a standard against which other classicizing trends in art history have been measured.

PRACTICE EXERCISES

Multiple-Choice

1. The Niobides Krater is the earliest known piece of Greek pottery

 (A) to show the Niobides myth
 (B) to be done in red-figure style
 (C) to not have figures arranged in isocephalism
 (D) to be influenced by wall painting

2. To emphasize realism seen in the Seated boxer, the artist used

 (A) gold to symbolize the boxer's victory over his opponents
 (B) ivory to highlight the tousled nature of his hair during combat
 (C) copper to indicate wounds on the hands and other parts of the body
 (D) blood to give a sense of the physical combat of boxing

3. Helios, horses, and Dionysos is a sculptural group placed on the pediment of the Parthenon because these figures

 (A) helped Athena defeat Neptune
 (B) were witnesses to Athena's birth
 (C) are associated with the Athenian king, Erechtheus
 (D) were part of the Panathenaic procession

4. The function of the Anavysos Kouros is to

(A) mark the grave of a dead athlete
(B) worship a Greek god
(C) celebrate a military victory
(D) honor athletes from the Olympics

5. The Anavysos Kouros has in common with Egyptian sculpture its

(A) nudity
(B) elongated anatomy
(C) contrapposto
(D) stance

Short Essay

Practice Question 4: Contextual Analysis
Suggested Time: 15 minutes

This work is the Parthenon, built by Iktinos and Kallikrates between 447–432 B.C.E.

Where was the Parthenon built?

Describe *at least two* reasons why the Parthenon was built on this site.

Using specific contextual evidence, explain how the site influenced the choice of both the materials *and* the imagery.

1. **C** 2. **C** 3. **B** 4. **A** 5. **D**

ANSWERS EXPLAINED

Multiple-Choice

1. **(C)** All of the statements about the Niobides Krater are true, but only (C) is the first time a vase depicts figures arranged without their heads lined up in isocephalism.

2. **(C)** There are a number of copper highlights on the work, the most visible being the wounds on the hands of the boxer.

3. **(B)** Helios, horses, and Dionysos were witnesses to Athena's birth; therefore, they belong on the pediment of a temple dedicated to her.

4. **(A)** As an inscription at the base indicates, this sculpture was meant to honor a dead athlete.

5. **(D)** Both the Anavysos Kouros and Egyptian sculptures such as King Menkaura and queen have the same stance, with one foot placed before the other, even as the torso remains rigid.

Short Essay Rubric

Task	Point Value	Key Points in a Good Response
Where was the Parthenon built?	1	Athens, Greece *or* The Acropolis in Athens
Describe *at least two* reasons why the Parthenon was built on this site.	2; 1 point each	Answers could include: ■ The site of the Acropolis is associated with Athena's victory over Poseidon for dominance over Athens. ■ The site has a commanding view of the city of Athens, the way Athena would have a commanding view over the inhabitants. ■ The site is a monumental and visible expression of the cultural and political dominance of Athens over Greek or foreign rivals. ■ It was also built on the site of an earlier temple destroyed by the Persians.
Using specific contextual evidence, explain how the site influenced the choice of both the materials *and* the imagery.	1 point for materials; 1 point for imagery	Answers could include: ■ Marble is a permanent material that expresses endurance and beauty. ■ Marble glistens in the sun, making the temple more noticeable and impressive. ■ The story of the conflict between Athena and Poseidon is spelled out on the west pediment of the Parthenon. ■ The Panathenaic frieze recounts the procession held every four years to honor Athena. ■ Other sculptures illustrate moments in the life of Athena, including her birth.

Etruscan Art

5

10th century B.C.E. to c. 270 B.C.E.
Height: 7th–6th centuries B.C.E.

ENDURING UNDERSTANDING: The culture, beliefs, and physical settings of a region play an important role in the creation, subject matter, and siting of works of art.

Learning Objective: Discuss how the culture, beliefs, or physical setting can influence the making of a work of art. (For example: Tomb of the Triclinium)

Essential Knowledge:

- Etruscan art was produced in central Italy.
- Etruscan art is studied as a unit, rather than by individual city-states.
- Etruscan art evinces a long tradition of epic storytelling.

ENDURING UNDERSTANDING: Art making is influenced by available materials and processes.

Learning Objective: Discuss how material, processes, and techniques influence the making of a work of art. (For example: *Sarcophagus of the Spouses*)

Essential Knowledge:

- Etruscan art reflects influences from other ancient traditions.

ENDURING UNDERSTANDING: Cultural interaction through war, trade, and travel can influence art and art making.

Learning Objective: Discuss how works of art are influenced by cultural interaction. (For example: Apollo from Veii)

Essential Knowledge:

- There is an active exchange of artistic ideas throughout the Mediterranean.
- Etruscan works of architecture and sculpture were influenced by their Greek counterparts.

ENDURING UNDERSTANDING: Art and art making can be influenced by a variety of concerns including audience, function, and patron.

Learning Objective: Discuss how art can be influenced by audience, function, and/or patron. (For example: *Sarcophagus of the Spouses*)

Essential Knowledge:

- Etruscan art expresses republican values.
- Etruscan art shows evidence of large public monuments.

ENDURING UNDERSTANDING: Art history is best understood through an evolving tradition of theories and interpretations.

Learning Objective: Discuss how works of art have had an evolving interpretation based on visual analysis and interdisciplinary evidence. (For example: Tomb of the Triclinium)

Essential Knowledge:

- Etruscan art is defined by contemporary Roman observers as well as by modern archaeological efforts.
- Little survives of the Etruscan written record.

HISTORICAL BACKGROUND

The Etruscans are the people who lived in Italy before the arrival of the Romans. Although they heavily influenced the Romans, their language and customs were different. The ravages of time have destroyed much of what the Etruscans accomplished, but fortunately their sophisticated tombs in huge **necropoli** still survive in sufficient numbers to give us some idea of Etruscan life and art. Eventually the Romans swallowed Etruscan culture whole, taking from it what they could use.

ETRUSCAN ARCHITECTURE

Much of what is known about the Etruscans comes from their tombs, which are arranged in densely packed **necropoli** throughout the Italian region of Tuscany, an area named for the Etruscans. Most tombs are round structures with a door leading to a large interior chamber that is brightly painted to reflect the interior of an Etruscan home. These tombs frequently have symbols of the Etruscan lifestyle on their walls. Entire families, with their servants, are often buried in one tomb.

Little is known about Etruscan temples, except what can be gleaned from the Roman architect Vitruvius, who wrote about them extensively. Superficially, they seem to be inspired by Greek buildings, with their pediments and columns, and the cella behind the porch. However, Etruscan buildings were made of wood and **mud brick**, not stone. Moreover, there is a flight of stairs leading up to the principal entrance, not a uniform set of steps surrounding the whole building. Sculptures were placed on the rooftops, unlike in Greek temples, to announce the presence of the deity within.

Temple of Minerva, 510–500 B.C.E., mud brick or tufa (volcanic rock) and wood, Veii (near Rome), Italy (Figures 5.1a and 5.1b)

Form

- Little architecture survives; this model is drawn from descriptions by Vitruvius, a Roman architect of the first century B.C.E.
- Temple raised on a podium; defined visible entrance.
- Deep porch places doorways away from the steps.

Function

- Temple dedicated to the goddess Minerva, the Etruscan equivalent to the Greek Athena.

Materials

- Temple made of mud brick and wood, perishable materials.

Context

- Steps in front direct attention to the deep porch; entrances emphasized.
- Three doors represent three gods; interior divided into three spaces.
- Etruscan variation of Greek capitals, called the Tuscan order (Figure 5.2).
- Inspired by Greek architecture, but different:
 - Columns are unfluted and made of wood, not marble as in Greece.
 - Pediments are made of wood and contain no sculpture, as in Greece.
 - Etruscan columns were spaced further apart than Greek columns because they were made of lighter material.
 - Etruscans used sculpture made of terra cotta rather than stone on their roofs; columns are unfluted, made of wood, not marble as in Greece.

Content Area Ancient Mediterranean, Image 31

Web Source https://books.google.co.uk/books?id=wOezNYCGLc4C&printsec=frontcover#v=onepage&q&f=false

- **Cross-Cultural Comparisons for Essay Question 1: Ancient Temples**
 - Parthenon (Figure 4.16a)
 - Pantheon (Figure 6.11a)
 - Mortuary temple of Hatshepsut (Figure 3.9a)

Figure 5.1a: Reconstruction drawing of the façade of the Temple of Minerva, 510–500 B.C.E., mud brick or tufa (volcanic rock) and wood, Veii (near Rome), Italy

Figure 5.1b: Ground plan of the Temple of Minerva

Figure 5.2: Tuscan capital

ETRUSCAN PAINTING

What survives of Etruscan painting is funerary, done on the walls and ceilings of tombs—some 280 painted chambers are still extant. Brightly painted frescoes reveal a world full of cheerful Etruscans celebrating, dancing, eating, and playing musical instruments. Much of the influence is probably Greek, but even less Greek painting from this period survives, so it is hard to draw firm parallels.

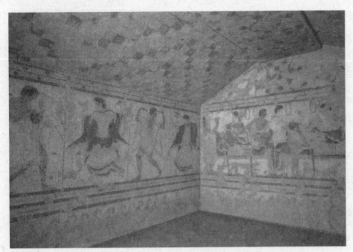

Figure 5.3: Tomb of the Triclinium. c. 480–470 B.C.E., tufa and fresco, Tarquinia, Italy

Tomb of the Triclinium, c. 480–470 B.C.E., tufa and fresco, Tarquinia, Italy (Figure 5.3)

Form

- Ancient convention of men painted in darker colors than women.
- Polychrome checkerboard pattern on ceiling; circles may symbolize time; pattern may reflect motifs on fabric tents erected for funeral banquets.

Function

- Painted tomb in an Etruscan necropolis.

Content

- Funerals seen as moments in which to celebrate the life of the deceased.
- Dancing figures play musical instruments in a festive celebration of the dead.
- Trees spring up between the main figures, and shrubbery grows beneath the reclining couches—perhaps suggesting a rural setting.

Context

- Banqueting couples recline while eating in the ancient manner.
- Named after a triclinium, an ancient Roman dining table, which appears in the fresco.

Content Area Ancient Mediterranean, Image 32

Web Source http://whc.unesco.org/en/list/1158/video

- **Cross-Cultural Comparisons for Essay Question 1: Fresco murals**
 - Arena Chapel (Figure 13.1b)
 - Sistine Chapel (Figure 16.2a)
 - House of the Vettii (Figures 6.7a, 6.7b)

ETRUSCAN SCULPTURE

Etruscans preferred terra cotta, **stucco**, and bronze for their sculpture; on occasion, stonework was introduced. Terra cotta sculptures were modeled rather than carved. The firing of large-scale works in a kiln betrays great technological prowess.

Most Etruscan sculpture shows an awareness of Greek Archaic art, although the comparisons go only so far. In Greece, kouros figures were carved as stoic and proud, with an occasional smile to give life. For the Etruscans, whose terra cotta work was brilliantly painted, figures move dynamically in space, aware of the world around them. Both cultures emphasized the broad shoulders of men and a stylization of the hair; however, the Etruscans avoided nudity.

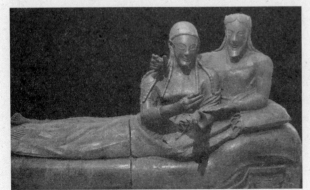

Figure 5.4: *Sarcophagus of the Spouses*, c. 520 B.C.E., terra cotta, Museo Nazionale di Villa Giulia, Rome

Sarcophagus of the Spouses, **c. 520 B.C.E., terra cotta, Museo Nazionale di Villa Giulia, Rome (Figure 5.4)**

Form

- Full-length portraits.
- Great concentration on the upper bodies, less on the legs.
- Bodies make an unnatural L-shape at the waist.
- Broad shoulders, knotted hair, and simple anatomical details.

Function

- Sarcophagus of a married couple, whose ashes were placed inside, or perhaps a large urn used for the ashes of the dead.

Technique

- Large terra cotta construction made in four separate pieces and joined together.

Content

- Both once held objects in their hands—perhaps the man held an egg to symbolize life after death; other theories suggest the woman is holding a bottle of perfume or a pomegranate.
- The couple reclines against wineskins that act as cushions; the wineskins allude to the ceremony of sharing wine at funerary rituals.

Context

- Depicts ancient tradition of reclining while eating; men and women ate together, unlike in ancient Greece.
- Symbiotic relationship: the man has a protective arm around the woman and the woman feeds the man, reflecting the high standing women had in Etruscan society.

Content Area Ancient Mediterranean, Image 29

Web Source *http://www.louvre.fr/en/oeuvre-notices/sarcophagus-spouses*

- **Cross-Cultural Comparisons for Essay Question 1: Funerary Monuments**
 - Grave stele of Hegeso (Figure 4.7)
 - Mortuary temple of Hatshepsut (Figure 3.9a)
 - Army of Emperor Shi Huangdi (Figure 24.8a)

Master sculptor Vulca, *Apollo from Veii*, c. 510 B.C.E., terra cotta, Museo Nazionale di Villa Giulia, Rome (Figure 5.5)

Form

- Figure has spirit, strides quickly forward.
- Archaic Greek smile.
- Meant to be seen from below.
- Tightly fitting garment.
- Hair in knots, dangles down around shoulders.
- Originally brightly painted.

Materials

- Masterpiece of terra cotta casting.

Context

- Unlike Greek sculpture, which appears in pediments and is made of stone, Etruscans prefer terra cotta figures that are mounted on roof lines.
- One of four large figures that once stood on the roof of the temple at Veii.
- Part of a scene from Greek mythology involving the third labor of Hercules; Apollo looks directly at Hercules, an important figure in Etruscan religion.
- May have been carved by Vulcan of Veii, the most famous Etruscan sculptor of the age.

Content Area Ancient Mediterranean, Image 31

Web Source *http://www.metmuseum.org/toah/hd/etru/hd_etru.htm*

- **Cross-Cultural Comparisons for Essay Question 1: The Figure in Motion**
 - Shiva as Lord of Dance (Figure 23.6)
 - Nio guardian figures (Figures 25.1c, 25.1d)
 - Running horned woman (Figure 1.9)

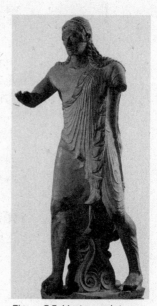

Figure 5.5: Master sculptor Vulca, *Apollo from Veii*, c. 510 B.C.E., terra cotta, Museo Nazionale di Villa Giulia, Rome

VOCABULARY

Necropolis (plural: **necropoli**): a large burial area; literally, a "city of the dead"

Stucco: a fine plaster used for wall decorations or moldings

Terra cotta: a hard ceramic clay used for building or for making pottery (Figures 5.4 and 5.5)

Triclinium: a dining table in ancient Rome that has a couch on three sides for reclining at meals

Tufa: a porous rock similar to limestone

Tumulus (plural: **tumuli**): an artificial mound of earth and stones placed over a grave

Tuscan order: an order of ancient architecture featuring slender, smooth columns that sit on simple bases; no carvings on the frieze or in the capitals (Figure 5.2).

SUMMARY

The Etruscans were a people who occupied central Italy before the arrival of the Romans—indeed, the region Tuscany is named for them. The remains of their civilization can be gleaned from written sources of later historians like Vitruvius or from what was buried in their expansive necropoli.

The Etruscans erected large mound-shaped tombs that contained a single large room in which the deceased were interred. The wall murals and stucco designs on the interior of the tombs are thought to parallel the interior of Etruscan homes. Large sarcophagi, made of terra cotta, were placed within the tomb, usually containing the ashes of the deceased. The style of these works betrays a knowledge of Archaic Greek works from around the same time.

The Etruscans were eventually overwhelmed by the Romans, who continued to employ Etruscan artists well into the Roman Republic.

PRACTICE EXERCISES

Multiple-Choice

Questions 1 and 2 refer to the image below.

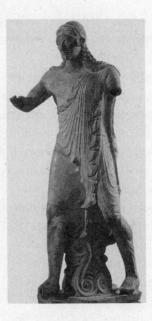

1. The sculpture of *Apollo from Veii* is inspired by ancient Greek works like kouroi figures, but differs from their Greek Archaic contemporaries in that

(A) Etruscan works have a smile that adds a lifelike quality to the sculpture
(B) Greek works are life-size
(C) Greek works have a more firmly articulated body
(D) Etruscan works move in space more dramatically

2. The *Apollo from Veii* was probably originally placed

(A) in a city square as a commemoration
(B) in a cemetery as a grave marker
(C) on a temple roof as part of a reenactment of a mythological story
(D) in a government building as a guiding spirit

———————————————

3. In addition to the Etruscans, which of the following cultures also placed tombs in tumuli?

(A) Egyptian
(B) Korean
(C) Persian
(D) Aztec

4. Etruscan art is unique for its time in its

(A) use of painted terra cotta
(B) ability to show contrapposto in large-scale sculpture
(C) tradition of depicting men and women together in a funerary monument
(D) painting of stone sculpture to give a work its lifelike quality

5. Etruscan tombs have fresco paintings that show

(A) funerary banquets
(B) mythological scenes
(C) historical panoramas
(D) Last Judgment scenes

Short Essay

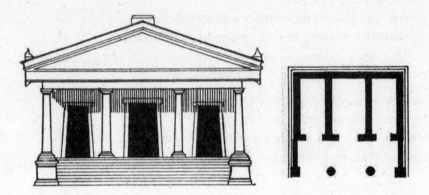

This is the reconstructed façade and ground plan of the Temple of Minerva from Veii, Italy, built around 510–500 B.C.E.

Temples like these were influenced by temple construction from ancient Greece. Identify an ancient Greek temple.

Using *at least two* specific details, analyze how the ancient Greek temple influenced construction of the Etruscan temple.

Using specific details, discuss how Etruscan temples differ from Greek temples both in construction *and* function.

ANSWER KEY

1. **D** 2. **C** 3. **B** 4. **C** 5. **A**

ANSWERS EXPLAINED

Multiple-Choice

1. **(D)** Etruscan works stride forward rather than stand at attention like kouroi from Archaic Greece.

2. **(C)** Sculptures like these were placed on the roofs of buildings, indicating important moments in mythological stories.

3. **(B)** Etruscan art is found in tumuli, like the gold and silver crown from the Silla Kingdom in Korea.

4. **(C)** The *Sarcophagus of the Spouses* showcases the Etruscan novelty of depicting a relative parity between the sexes.

5. **(A)** Etruscan tombs, like those of the Triclinium in Tarquinia, Italy, depict people celebrating the life of the deceased with a funerary banquet.

Short Essay Rubric

Task	Point Value	Key Points in a Good Response
Identify an ancient Greek temple.	1	Parthenon in Athens, Greece, by Iktinos and Kallikrates, c. 447–424 B.C.E., marble or Temple of Athena Nike by Kallikrates, c. 425 B.C.E., marble, Athens, Greece
Using *at least two* specific details, analyze how the ancient Greek temple influenced construction of the Etruscan temple.	1 point for each detail	Answers could include: ■ Greek elements of construction: pediment, columns, stairs, outdoor porch. ■ Held a cult statue. ■ Main room with subsidiary rooms. ■ Decorated with sculpture. ■ Both used to worship gods.
Using specific details, discuss how Etruscan temples differ from Greek temples both in construction...	1	Answers could include: ■ Made of wood, mud brick, and tufa; not marble as in Greek buildings. ■ Sculpture made of terra cotta, not marble as in Greek buildings. ■ Four-column front, not eight or more as in Greek buildings. ■ Walls around sides and back differ from columns all around the building in Greek buildings. ■ Capitals done in the Tuscan order, not Doric or Ionic as in the Greek buildings.
...*and* function.	1	Answers could include: ■ Flight of stairs in the front, not all around the sides as in Greek buildings, indicating a clearly marked entrance. ■ Interior porch leads to three chambers, indicating a different function for each, not one chamber as in Greek buildings. ■ Building sits on a raised podium commanding attention.

Content Areas:
Ancient Mediterranean, 3500 B.C.E.–300 C.E.
Petra: West and Central Asia, 500 B.C.E.–1980 C.E.

Roman Art

6

TIME PERIOD: 753 B.C.E.–FIFTH CENTURY C.E.

Legendary founding of Rome by Romulus and Remus	753 B.C.E.
Roman Republic	509–27 B.C.E.
Roman Empire	27 B.C.E.–410 C.E.

ENDURING UNDERSTANDING: The culture, beliefs, and physical settings of a region play an important role in the creation, subject matter, and siting of works of art.

Learning Objective: Discuss how the culture, beliefs, or physical setting can influence the making of a work of art. (For example: the Pantheon)

Essential Knowledge:

- Roman art was produced in the Mediterranean basin from 753 B.C.E. to 337 C.E.
- Roman art can be subdivided into the following periods: Republican, Early Imperial, Late Imperial, and Late Antique.
- Roman culture is rich in written literature: i.e., epics, poetry, dramas.

ENDURING UNDERSTANDING: Art making is influenced by available materials and processes.

Learning Objective: Discuss how material, processes, and techniques influence the making of a work of art. (For example: the Colosseum)

Essential Knowledge:

- Roman art reflects influences from other ancient traditions.
- Roman architecture reflects ancient traditions as well as technological innovations.

ENDURING UNDERSTANDING: Cultural interaction through war, trade, and travel can influence art and art making.

Learning Objective: Discuss how works of art are influenced by cultural interaction. (For example: Augustus of Prima Porta)

Essential Knowledge:

- There is an active exchange of artistic ideas throughout the Mediterranean.
- Roman works were influenced by Greek objects. In fact, many Hellenistic works survive as Roman copies.

ENDURING UNDERSTANDING: Art and art making can be influenced by a variety of concerns including audience, function, and patron.
Learning Objective: Discuss how art can be influenced by audience, function, and/or patron. (For example: Head of a Roman patrician)

Essential Knowledge:

■ Ancient Roman art is influenced by civic responsibility and the polytheism of its religion.
■ Roman art first shows republican and then imperial values.
■ Roman architecture shows a preference for large public monuments.

ENDURING UNDERSTANDING: Art history is best understood through an evolving tradition of theories and interpretations.
Learning Objective: Discuss how works of art have had an evolving interpretation based on visual analysis and interdisciplinary evidence. (For example: Pentheus Room)

Essential Knowledge:

■ The study of art history is shaped by changing analyses based on scholarship, theories, context, and written records.
■ Roman art has had an important impact on European art, particularly since the eighteenth century.
■ Roman writing contains some of the earliest contemporary accounts about art and artists.

HISTORICAL BACKGROUND

From hillside village to world power, Rome rose to glory by diplomacy and military might. The effects of Roman civilization are still felt today in the fields of law, language, literature, and the fine arts.

According to legend, Romulus and Remus, abandoned twins, were suckled by a she-wolf, and later established the city of Rome on its fabled seven hills. At first the state was ruled by kings, who were later overthrown and replaced by a Senate. The Romans then established a democracy of a sort, with magistrates ruling the country in concert with the Senate, an elected body of privileged Roman men.

Variously well-executed wars increased Rome's fortunes and boundaries. In 211 B.C.E., the Greek colony of Syracuse in Sicily was annexed. This was followed, in 146 B.C.E., by the absorption of Greece. The Romans valued Greek cultural riches and imported boatloads of sculpture, pottery, and jewelry to adorn the capital. Moreover, a general movement took hold to reproduce Greek art by establishing workshops that did little more than make copies of Greek sculpture.

Civil war in the late Republic caused a power vacuum that was filled by Octavian, later called Augustus Caesar, who became emperor in 27 B.C.E. From that time, Rome was ruled by a series of emperors as it expanded to faraway Mesopotamia and then retracted to a shadow of itself when it was sacked in 410 C.E.

The single most important archaeological site in the Roman world is the city of Pompeii, which was buried by volcanic ash from Mount Vesuvius in 79 C.E. In 1748, systematic excavation—actually more like fortune hunting—was begun. Because of Pompeii, we know more about daily life in Rome than we know about any other ancient civilization.

Patronage and Artistic Life

The Roman state and its wealthiest individuals were the major patrons of the arts. They could be known to spend lavishly on themselves and their homes, but they also felt a dedication to the general good and generously patronized public projects as well.

The homes of wealthy Romans, such as the ones that survive at Pompeii, were stage sets in which the influential could demonstrate their power and privilege. Elaborate social rituals inspired Romans to build their houses in order to impress and entertain. Consequently, Romans designed lavishly appointed interiors containing everything from finely executed fresco paintings to marble plumbing fixtures. Thus the interiors were grand domestic spaces that announced the importance of the owner. Artists, considered low members of the social scale, were treated poorly. Many were slaves who toiled in anonymity.

ROMAN ARCHITECTURE

The Romans were master builders. Improving upon nascent architectural techniques, they forged great roads and massive aqueducts as an efficient way of connecting their empire and making cities livable. Their temples were hymns to the gods and symbols of civic pride. Their arenas awed spectators both by their size and their engineering genius.

The Romans understood the possibilities of the arch, an architectural device known before but little used. Because arches could span huge spaces, they do not need the constant support of the post-and-lintel system. Each wedge-shaped stone of a Roman arch is smaller at the bottom and wider at the top. This seemingly simple development allowed a stable arch to stand indefinitely because the wider top could not pass through the narrower bottom. Mortar is not needed because the shape of stones in the arch supports the structure unaided. Buildings without mortar are built in a technique known as **ashlar masonry**.

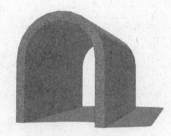

Figure 6.1: Barrel vault

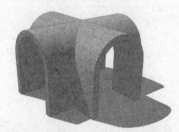

Figure 6.2: Groin vault

Roman architects understood that arches could be extended in space and form a continuous tunnel-like construction called a **barrel vault** (Figure 6.1). When two barrel vaults intersect, a larger, more open space is formed, called a **groin vault** (Figure 6.2). The latter is particularly important because the groin vault could be supported with only four corner **piers,** rather than requiring a continuous wall space that a barrel vault needed (Figure 6.3). The spaces between the arches on the piers are called **spandrels** (Figure 6.4).

Arches and vaults make enormous buildings possible, like the **Colosseum** (72–80 C.E.) (Figure 6.8), and they also make feasible vast interior spaces like the **Pantheon** (118–125 C.E.) (Figures 6.11a and 6.11b). Concrete walls are very heavy. To prevent the weight of a dome from cracking the walls beneath it, **coffers** (Figure 6.5) are carved into ceilings to lighten the load.

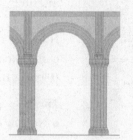

Figure 6.3: Piers

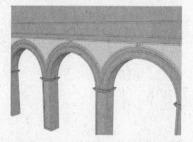

Figure 6.4: Spandrels are in the light areas

The Romans used concrete in constructing many of their oversized buildings. Although not their invention, once again they made this technique workable, using it initially as filler in buildings and then as the main support element. Romans thought that concrete was aesthetically displeasing, so although its flexibility and low cost were desirable, concrete was cloaked with another material, like marble, which seemed more attractive.

Figure 6.5: Coffers

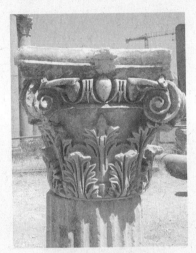

Figure 6.6: Composite capital

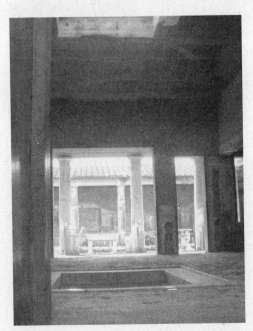

Figure 6.7a: Atrium, House of the Vettii, Imperial Roman, 2nd century B.C.E.–1st century C.E., rebuilt c. 67–79 C.E., cut stone and fresco, Pompeii, Italy

Much is known about Roman domestic architecture, principally because of what has been excavated at Pompeii. The exteriors of Roman houses have few windows, keeping the world at bay. A single entrance is usually flanked by stores which face the street. Stepping through the doorway one enters an open-air courtyard called an **atrium**, which has an **impluvium** to capture rainwater. Private bedrooms, called **cubicula**, radiate around the atrium. The atrium provides the only light and air to these windowless, but beautifully decorated, rooms.

The Romans placed their intimate rooms deeper into the house. Eventually another atrium, perhaps held up by columns called a **peristyle**, provided access to a garden flanked by more cubicula.

Grander Roman buildings, such as the **Colosseum** (Figures 6.8a and 6.8b) and the **Pantheon** (Figure 6.11) use concrete, arches, and the various kinds of vaulting techniques to achieve grand and spacious effects.

The center of the Roman business world was the **forum**, a large public square framed by the principal civic buildings. The gods needed to be worshipped and appeased; therefore, the focus of all fora is the temple dedicated to the locally favorite god. Around the sides of the forum are bath houses, markets, and administrative buildings dealing with life's everyday essentials.

Although the Romans sometimes use Greek and Etruscan columns in their architecture, they are just as likely to use adapted forms that were inspired by their earlier counterparts. **Composite columns** first seen in the Arch of Titus have a mix of Ionic (the volute) and Corinthian (the leaf) motifs in the capitals. **Tuscan columns** as seen on the Colosseum are unfluted with severe Doric-style capitals (Figure 5.2). Both columns are raised on large pedestals to diminish the size of the viewers and increasing their sense of awe.

Greek architecture remained a strong influence throughout Roman history. It was common for Roman temples to be fronted by Greek porches of columns and pediments, as in the **Pantheon**, even if the core of the building was completely Roman with its yawning domed interior.

House of the Vettii, Imperial Roman, 2nd century B.C.E.–1st century C.E., rebuilt c. 67–79 C.E., cut stone and fresco, Pompeii, Italy (Figures 6.7a and 6.7b)

Form
- Narrow entrance to the home sandwiched between several shops.
- Large reception area called the atrium, which is open to the sky and has a catch basin called an impluvium in the center; rooms called cubicula radiate around the atrium.
- Peristyle garden in rear with fountain, statuary, and more cubicula; this is the private area of the house.
- Axial symmetry of house; someone entering the house can see through to the peristyle garden in the rear.
- Exterior of house lacks windows; interior lighting comes from the atrium and the peristyle.

Function

- Private citizen's home in Pompeii, originally built during the Republic with early imperial additions.

Context

- Two brothers owned the house; both were freedmen who made their money as merchants.
- Extravagant home symbolized the owners' wealth.
- After the earthquake of 62 A.D., many wealthy Romans left Pompeii, leading to the rise of the "nouveau riche."
- See Pentheus Room (Figure 6.13).

Content Area Ancient Mediterranean, Image 39

Web Source *http://web.mit.edu/course/21/21h.405/www/vettii/sources.html*

- **Cross-Cultural Comparisons for Essay Question 1: Domestic Spaces**
 - Wright, Fallingwater (Figure 22.16a)
 - Venturi, House in New Castle County (Figure 22.27a)
 - Alberti, Palazzo Rucellai (Figure 15.2)

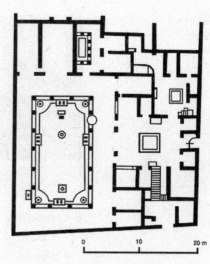

Figure 6.7b: House of the Vettii plan

The Colosseum (Flavian Amphitheater), Imperial Roman, 72–80 C.E., stone and concrete, Rome (Figures 6.8a and 6.8b)

Function

- Stadium meant for wild and dangerous spectacles—gladiator combat, animal hunts, naval battles—but not, as tradition suggests, religious persecution.

Form

- Accommodated 50,000 spectators.
- Concrete core, brick casing, travertine facing.
- 76 entrances and exits circle the façade.
- Interplay of barrel vaults, groin vaults, arches.
- Façade has engaged columns: first story is Tuscan, second story is Ionic, third story is Corinthian, and the top story is flattened Corinthian; each thought of as lighter than the order below.
- Above the squared windows at the top level are small brackets meant to hold flagstaffs; these staffs are the anchors for a retractable canvas roof, called a velarium, used to protect the crowd on hot days.
- Sand (hence the term: arena) was placed on the floor to absorb the blood; occasionally the sand was dyed red.
- Hypogeum, the subterranean part of an ancient building, can be seen in Figure 6.8b.

Context

- Real name is the Flavian Amphitheater; the name Colosseum comes from a colossal statue of Nero that used to be adjacent.
- The building illustrates what popular entertainment was like for ancient Romans.
- Entrances and staircases were separated by marble and iron railings to keep the social classes separate; women and the lower classes sat at the top level.
- Much of the marble was pulled off in the Middle Ages and repurposed.

Content Area Ancient Mediterranean, Image 44

Web Source *http://www.bbc.co.uk/history/ancient/romans/colosseum_01.shtml*

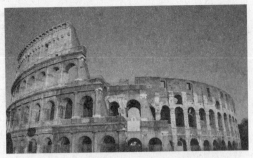

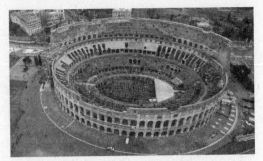

Figure 6.8a: The Colosseum (Flavian Amphitheater), Imperial Roman, 72–80 C.E., stone and concrete, Rome

Figure 6.8b: The Colosseum, aerial view

- **Cross-Cultural Comparisons for Essay Question 1: Civic Spaces**
 - Hadid, MAXXI (Figures 29.2a, 29.2b)
 - Athenian Agora (Figure 4.15)
 - Mies van der Rohe, Seagram Building (Figure 22.18)

CONTENT AREA FOR PETRA: WEST AND CENTRAL ASIA

Most art history texts place Petra in the Roman period. The College Board, however, puts Petra in a content area called West and Central Asia.

Treasury and Great Temple of Petra, Jordan, Nabataean Ptolemaic and Roman, c. 400 B.C.E.–100 C.E., cut rock, Jordan (Figures 6.9a, 6.9b, and 6.9c)

Context
- Petra was a central city of the Nabataeans, a nomadic people, until Roman occupation in 106 C.E.
 - The city was built along a caravan route.
 - They buried their dead in the tombs cut out of the sandstone cliffs.
 - Five hundred royal tombs in the rock, but no human remains found; burial practices are unknown; tombs are small.
 - The city is half built, half carved out of rock.
 - The city is protected by a narrow canyon entrance.
- The Roman emperor Hadrian visited the site and named it after himself: Hadriane Petra.

Content Area West and Central Asia, Image 181

Figure 6.9a: Petra, 400 B.C.E.–100 C.E., cut rock, Jordan

- **Cross-Cultural Comparisons for Essay Question 1: City Planning**
 - Forum of Trajan (Figures 6.10a, 6.10b, 6.10c)
 - Persepolis (Figures 2.6a, 2.6b)
 - Hadid, MAXXI (Figures 29.2a, 29.2b)

Great Temple of Petra, Jordan

Content

- Approached through a monumental gateway, called a propylaeum, and a grand staircase that leads to a colonnade terrace in the lower precincts.
- A second staircase leads to the upper precincts.
- A third staircase leads to the main temple.

Form

- Nabataean concept and Roman features such as Corinthian columns.
- Monuments carved in traditional Nabataean rock-cut cliff walls.
- Lower story influenced by Greek and Roman temples but with unusual features:
 - Columns not proportionally spaced.
 - Pediment does not cover all columns, only the central four.
 - Upper floor: broken pediment with a central tholos.
 - Combination of Roman and indigenous traditions.
- Greek, Egyptian, and Assyrian gods on the façade.
- Interior: one central chamber with two flanking smaller rooms.

Figure 6.9b: Treasury at Petra, Nabataean Ptolemaic and Roman, early 2nd century, cut rock, Jordan

Function

- In reality, it was a tomb, not a "treasury," as the name implies.

Content Area West and Central Asia, Image 181

Web Source *http://whc.unesco.org/en/list/326/*

Figure 6.9c: Great Temple, at Petra, Nabataean Ptolemaic and Roman, early 2nd century, cut rock, Jordan

Apollodorus of Damascus, Forum of Trajan, 106–112 C.E., brick and concrete, Rome, Italy (Figure 6.10a)

Form

- Large central plaza flanked by stoa-like buildings on each side.
- Originally held an equestrian monument dedicated to Trajan in the center.

Function

- Part of a complex that included the Basilica of Ulpia (Figure 6.10b), Trajan's markets (Figure 6.10c), and the Column of Trajan (Figure 6.16).

Figure 6.10a: Apollodorus of Damascus, Forum of Trajan, 106–112 C.E., brick and concrete, Rome, Italy

Context

- Built with booty collected from Trajan's victory over the Dacians.

Content Area Ancient Mediterranean, Image 45

Web Source *https://penelope.uchicago.edu/~grout/encyclopaedia_romana/imperialfora/trajan/forumtrajani.html*

Figure 6.10b: Apollodorus of Damascus, Basilica of Ulpia, c. 112 C.E., brick and concrete, Rome, Italy

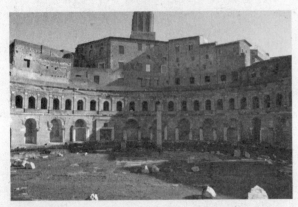

Figure 6.10c: Trajan Markets, 100–112 C.E., brick and concrete, Rome, Italy

Apollodorus of Damascus, Basilica of Ulpia, c. 112 C.E., brick and concrete, Rome, Italy (Figure 6.10b)

Form

- Grand interior space (385 feet by 182 feet) with two apses.
- Nave is spacious and wide.
- Double colonnaded side aisles.
- Second floor had galleries or perhaps clerestory windows.
- Timber roof 80 feet across.
- Basilican structure can be traced back to Greek stoas.

Function

- Law courts held here; apses were a setting for judges.

Context

- Said to have been paid for by Trajan's spoils taken from the defeat of the Dacians.
- Ulpius was Trajan's family name.

Content Area Ancient Mediterranean, Image 45

Web Source http://archive1.village.virginia.edu/spw4s/ RomanForum/GoogleEarth/AK_GE/AK_HTML/CB-007.html

- **Cross-Cultural Comparisons for Essay Question 1: Buildings with a Central Nave**
 - Santa Sabina (Figure 7.3b)
 - Hall of Mirrors (Figure 17.3d)
 - Westminster Hall (Figure 12.5)

Trajan Markets, 106–112 C.E., brick and concrete, Rome, Italy (Figure 6.10c)

Form

- Semicircular building held several levels of shops.
- Main space is groin vaulted; barrel vaulted area with the shops.

Function

- Multilevel mall.
- Original market had 150 shops.

Materials

- Use of exposed brick indicates a more accepted view of this material, which formerly was thought of as being unsuited to grand public buildings.

Content Area Ancient Mediterranean, Image 45

Web Source http://www.history.com/topics/ancient-history/ ancient-rome/videos/trajan-market

- **Cross-Cultural Comparisons for Essay Question 1: Shopping**
 - Sullivan, Carson, Pirie, Scott and Company Building (Figure 21.14a)

Pantheon, Imperial Roman, 118–125 C.E., concrete with stone facing, Rome, Italy (Figures 6.11a and 6.11b)

Form

Exterior

- Corinthian-capital porch in front of this building.

Figure 6.11a: Pantheon, Imperial Roman, 118–125 C.E., concrete with stone facing, Rome, Italy

- Façade has two pediments, one deeply recessed behind the other; it is difficult to see the second pediment from the street.

Interior

- Interior contains slightly convex floor for water drainage.
- Square panels on floor and in coffers contrast with roundness of walls; circles and squares are a unifying theme.
- Coffers may have been filled with rosette designs to simulate stars.
- Cupola walls are enormously thick: 20 feet at base.
- Thickness of walls is thinned at the top; coffers take some weight pressure off the walls.
- Oculus, 27 feet across, allows for air and sunlight; sun moves across the interior much like a spotlight.
- Height of the building equals its width; the building is based on the circle; a hemisphere.
- Walls have seven niches for statues of the gods.
- Triumph of concrete construction.
- Was originally brilliantly decorated.

Function

- Traditional interpretation: it was built as a Roman temple dedicated to all the gods.
- Recent interpretation: it may have been dedicated to a select group of gods and the divine Julius Caesar and/or used for court rituals.
- It is now a Catholic church called Santa Maria Rotonda.

Context

- Inscription on the façade: "Marcus Agrippa, son of Lucius, having been consul three times, built it."
- The name Pantheon is from the Greek meaning "all the gods" or "common to all the gods."
- Originally had a large atrium before it; originally built on a high podium; modern Rome has risen up to that level.
- Interior symbolized the vault of the heavens.

Content Area Ancient Mediterranean, Image 46

Web Source *http://www.greatbuildings.com/buildings/Pantheon.html*

- **Cross-Cultural Comparisons for Essay Question 1: Houses of Worship**
 - Chartres Cathedral (Figures 12.4a, 12.4b)
 - Angkor Wat (Figure 23.8a)
 - Templo Mayor (Figure 26.5a)

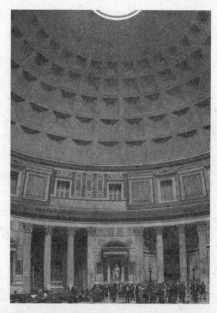

Figure 6.11b: Pantheon, 118–125 C.E., concrete with stone facing, Rome, Italy

Figure 6.12a: Figure seen in foreshortening

ROMAN PAINTING

Interior wall paintings, created to liven up generally windowless Roman **cubicula**, were frescoed with mythological scenes, landscapes, and city plazas. Mosaics were favorite floor decorations—stone kept feet cool in summer. **Encaustics** from Egypt provided lively individual portraits of the deceased.

Murals were painted with some knowledge of **linear perspective**—spatial relationships in landscape paintings appeared somewhat consistent. **Orthogonals** recede to multiple **vanishing points** in the distance. Sometimes, to present an object in the far distance, an artist used **atmospheric perspective**, a technique that employs cool pastel colors to create the illusion of deep recession. Figures were painted in **foreshortening** (Figures 6.12a, 6.12b), where they are seen at an oblique angle and seem to recede into space.

Figure 6.12b: Figure seen in foreshortening

So much Pompeian wall painting survives that an early history of Roman painting can be reconstructed.

- First Pompeian Style is characterized by painted rectangular squares meant to resemble marble facing.
- Second Pompeian Style had large mythological scenes and/or landscapes dominating the wall surface. Painted stucco decoration of the First Style appears beneath in horizontal bands.
- Third Pompeian Style is characterized by small scenes set in a field of color and framed by delicate columns of tracery.
- Fourth Pompeian Style combine elements from the previous three: The painted marble of the First Style is at the base; the large scenes of the Second Style and the delicate small scenes of the Third Style are intricately interwoven. The frescos from the **Pentheus Room** (Figure 6.13) are from the Fourth Style.

Figure 6.13: Pentheus Room, Imperial Roman, 62–79 C.E., fresco, Pompeii, Italy

Pentheus Room, Imperial Roman, 62–79 C.E., fresco, Pompeii, Italy (Figure 6.13)

Function
- Triclinium: a dining room in a Roman house.

Context
- Main scene is the death of the Greek hero Pentheus.
- Pentheus opposed the cult of Bacchus and was torn to pieces by women, including his mother, in a Bacchic frenzy; two women are pulling at his hair in this image.
- Punishment of Pentheus is eroticized; central figure with arms outstretched; exposed nakedness of his body.
- Architecture is seen through painted windows; imaginary landscape.
- This painting opens the room with the illusion of windows and a sunny cityscape beyond.
- See House of the Vettii (Figures 6.7a, 6.7b).

Content Area Ancient Mediterranean, Image 39

Web Source *https://onlinelibrary.wiley.com/doi/pdf/10.1111/j.1468-0424.2012.01697.x*

Alexander Mosaic, **Roman mosaic copy of a Greek original, found in Pompeii:** *see under* **Greek Art, Figure 4.20**

ROMAN SCULPTURE

The Romans erected commemorative arches to celebrate military victories. Sculpture was applied to the surface to animate the architecture as well as to recount the story of Roman victories. A combination of painted relief and freestanding works was integrated into a coherent didactic program. Later arches used works from contemporary artists, as well as sculptures removed from arches of previous emperors, some two hundred years older. In this way the glory of the past was linked to the accomplishments of the present.

Another Roman innovation was the hollowed-out column with banded narrative relief sculptures spiraling around the exterior. The first, the Column of Trajan (112 C.E.) (Figure 6.16), had an entrance at the base, from which the visitor could ascend a spiral staircase and emerge onto a porch, where Trajan's architectural accomplishments would be revealed in all their glory. A statue of the emperor, which no longer exists, crowned the ensemble. The banded

reliefs tell the story of Trajan's conquest of the Dacians. The spiraling turn of the narratives made the story difficult to read; scholars have suggested a number of theories that would have made this column, and works like it, legible to the viewer.

Republican Sculpture

Republican **busts** of noblemen, called **veristic** sculptures, are strikingly and unflatteringly realistic, with the age of the sitter seemingly enhanced. This may have been a form of idealization: Republicans valued virtues such as wisdom, determination, and experience, which these works seem to possess.

Republican full-length statues concentrate on the heads, some of which are removed from one work and placed on another. The bodies were occasionally classically idealized, symbolizing valor and strength. The Romans had great respect for ancestors: Figures can sometimes be seen holding busts of their ancestors in their hands as a sign of their patrician heritage.

Head of a Roman patrician, Republican Roman, c. 75–50 B.C.E., marble, Museo Torlonia, Rome (Figure 6.14)

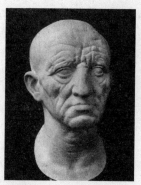

Figure 6.14: Head of a Roman patrician, Republican Roman, c. 75–50 B.C.E., marble, Museo Torlonia, Rome

Form
- Extremely realistic face, called a veristic portrait.

Function
- Funerary context; funerary altars adorned with portraits, busts, or reliefs and cinerary urns.
- Tradition of wax portrait masks in funeral processions of the upper class to commemorate their history.
- Portraits housed in family shrines honoring deceased relatives.

Context
- Realism of the portrayal shows influence of Greek Hellenistic art and late Etruscan art.
- Bulldog-like tenacity of features; overhanging flesh; deep crevices in face.
- Full of experience and wisdom—traits Roman patricians would have desired.
- Features may have been exaggerated by the artist to enhance adherence to Roman Republican virtues such as stoicism, determination, and foresight.
- Busts are mostly of men, often depicted as elderly.

Content Area Ancient Mediterranean, Image 42

Web Source *http://www.metmuseum.org/toah/hd/ropo/hd_ropo.htm*

- **Cross-Cultural Comparisons for Essay Question 1: Portraits**
 - *Mblo* (Figure 27.7)
 - Portrait of Sin Sukju (Figure 24.6)
 - Sherman, *Untitled #228*, from the History Portraits series (Figure 29.10)

Imperial Sculpture

While busts of senators conveyed the gruff virtues of Republican Rome, emperors, whose divinity descended from the gods themselves, were portrayed differently. Here, inspiration came from Classical Greece, and Roman sculptors adopted the contrapposto, ideal proportions, and heroic poses of Greek statuary. Forms became less individualized, iconography more associated with the divine.

At the end of the Early Imperial period, a stylistic shift begins to take place that transitions into the Late Imperial style. Perhaps reflecting the dissolution and anarchy of the Roman state, the classical tradition, so willingly embraced by previous emperors, is slowly abandoned by Late Imperial artists. Compositions are marked by figures that lack individuality and are crowded tightly together. Everything is pushed forward on the picture plane, as depth and recession were rejected along with the classicism they symbolize. Proportions are truncated—contrapposto ignored; bodies are almost lifeless behind masking drapery. Emperors are increasingly represented as military figures rather than civilian rulers.

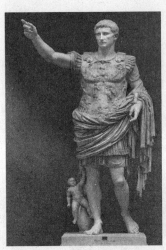

Figure 6.15: Augustus of Prima Porta, Imperial Roman, early 1st century c.e., marble, Vatican Museum, Rome

Augustus of Prima Porta, Imperial Roman, early 1st century c.e., marble, Vatican Museums, Rome (Figure 6.15)

Form

- Contrapposto.
- References Polykleitos's *Doryphoros* (Figure 4.3).
- Characteristic of works depicting Augustus is the part in the hair over the left eye and two locks over the right.
- Heroic, grand, authoritative ruler; over life-size scale.
- Back not carved; figure meant to be placed against a wall.
- Oratorical pose.

Function and Original Context

- Found in the villa of Livia, Augustus's wife; may have been sculpted to honor him in his lifetime or after his death (Augustus is barefoot like a god, not wearing military boots).
- May have been commissioned by Emperor Tiberius, Livia's son, whose diplomacy helped secure the return of the eagles; thus it would serve as a commemoration of Augustus and the reign of Tiberius.

Content

- Idealized view of the Roman emperor, not an individualized portrait.
- Confusion between God and man is intentional; in contrast with Roman Republican portraits.
- Standing barefoot indicates he is on sacred ground.
- On his breastplate are a number of gods participating in the return of Roman standards from the Parthians; Pax Romana.
- Breastplate indicates he is a warrior; judges' robes show him as a civic ruler.
- He may have carried a sword, pointing down, in his left hand.
- His right hand is in a Roman orator pose; perhaps it held laurel branches.
- At base: Cupid on the back of a dolphin—a reference to Augustus's divine descent from Venus; perhaps also a symbol of Augustus's naval victory over Mark Antony and Cleopatra.
- May be a copy of a bronze original, which probably did not have the image of Cupid.

Content Area Ancient Mediterranean, Image 43

Web Source *http://www.museivaticani.va/content/museivaticani/en/collezioni/musei/braccio-nuovo/Augusto-di-Prima-Porta.html*

- **Cross-Cultural Comparisons for Essay Question 1: Power and Authority**
 - *Ndop* (Figure 27.5a)
 - Lindauer, *Tamati Waka Nene* (Figure 28.7)
 - Houdon, *George Washington* (Figure 19.7)

Column of Trajan, 113 c.e., marble, Rome (Figure 6.16)

Form

- A 625-foot narrative cycle (128 feet high) wrapped around the column tells the story of Trajan's defeat of the Dacians; this is the earliest example of this kind of structure.
- Crowded composition.
- Base of the column has an oak wreath, the symbol of victory.
- Low relief; few shadows to cloud what must have been a very difficult object to view in its entirety.

Function

- Visitors who entered the column were meant to wander up the interior spiral staircase to the viewing platform at the top where a heroic nude statue of the emperor was placed (since replaced with a sculpture of Saint Peter).
- Base contains the burial chamber of Trajan and his wife, Plotina, whose ashes were placed in golden urns in the pedestal.

Technique

- Roman invention of a tall hollowed out column with an interior spiral staircase.

Content

- 150 episodes, 2,662 figures, 23 registers—continuous narrative.
- Scenes on the column depict the preparation for battle, key moments in the Dacian campaign, and many scenes of everyday life (i.e., transportation, religious ceremonies, construction techniques).
- Trajan appears 58 times in various roles: commander, statesman, ruler, etc.

Context

- Stood in Trajan's Forum at the far end surrounded by buildings.
- Scholarly debate over the way it was meant to be viewed.
- A viewer would be impressed with Trajan's accomplishments, including his forum and his markets.
- Two Roman libraries containing Greek and Roman manuscripts flanked the column.

Content Area Ancient Mediterranean, Image 45

Web Source *http://www.nationalgeographic.com/ trajan-column/article.html*

- **Cross-Cultural Comparisons for Essay Question 1: Narrative in Art**
 - *Bayeux Tapestry* (Figures 11.7a, 11.7b)
 - *Night Attack on the Sanjô Palace* (Figures 25.3a, 25.3b)
 - Walker, *Darkytown Rebellion* (Figure 29.21)

Figure 6.16: Column of Trajan, 113 c.e., marble, Rome, Italy

Ludovisi Battle Sarcophagus, Late Imperial Roman, c. 250 c.e., marble, National Roman Museum, Rome (Figure 6.17)

Form

- Extremely crowded surface with figures piled atop one another; horror vacui.
- Abandonment of classical tradition in favor of a more animated and crowded space.
- Figures lack individuality.

Figure 6.17: Ludovisi Battle Sarcophagus, Late Imperial Roman, c. 250 c.e., marble, National Roman Museum, Rome

Function

■ Interment of the dead; rich carving suggests a wealthy patron with a military background.

Technique

■ Very deep relief with layers of figures.

■ Complexity of composition with deeply carved undercutting.

Content

■ Roman army trounces bearded and defeated barbarians.

■ Romans appear noble and heroic while the Goths are ugly.

■ Romans battling "barbaric" Goths in the Late Imperial period.

■ Youthful Roman general appears center top with no weapons, the only Roman with no helmet, indicating that he is invincible and needs no protection; he controls a wild horse with a simple gesture.

Context

■ Confusion of battle is suggested by congested composition.

■ Rome at war throughout the third century.

■ So called because in the seventeenth century it was in Cardinal Ludovisi's collection in Rome.

Content Area Ancient Mediterranean, Image 47

Web Source for Roman sarcophagi *http://www.metmuseum.org/TOAH/hd/rsar/hd_rsar.htm*

■ **Cross-Cultural Comparisons for Essay Question 1: Relief Sculpture**

– Churning of the Ocean of Milk (Figure 23.8c)

– Last Judgment, Sainte-Foy, Conques (Figure 11.6a)

– Code of Hammurabi (Figures 2.4a, 2.4b)

VOCABULARY

Ashlar masonry: carefully cut and grooved stones that support a building without the use of concrete or other kinds of masonry

Atrium (plural: **atria**)**:** a courtyard in a Roman house or before a Christian church

Basilica: in Roman architecture, a large axially planned building with a nave, side aisles, and apses (Figure 6.10b)

Bust: a sculpture depicting the head, neck, and upper chest of a figure (Figure 6.14)

Coffer: in architecture, a sunken panel in a ceiling (Figure 6.5)

Composite column: one that contains a combination of volutes from the Ionic order and acanthus leaves from the Corinthian order

Continuous narrative: a work of art that contains several scenes of the same story painted or sculpted in continuous succession (Figure 6.16)

Contrapposto: a graceful arrangement of the body based on tilted shoulders and hips and bent knees (Figure 6.15)

Cubiculum (plural: **cubicula**)**:** a Roman bedroom flanking an atrium; in Early Christian art, a mortuary chapel in a catacomb

Cupola: a small dome rising over the roof of a building; in architecture, a cupola is achieved by rotating an arch on its axis

Encaustic: an ancient method of painting that uses colored waxes burned into a wooden surface

Foreshortening: a visual effect in which an object is shortened and turned deeper into the picture plane to give the effect of receding in space (Figures 6.12a, 6.12b)

Forum (plural: **fora**): a public square in a Roman city (Figure 6.10a)

Fresco: a painting technique that involves applying water-based paint onto a freshly plastered wall. The paint forms a bond with the plaster that is durable and long-lasting (Figure 6.13)

Horror vacui: (Latin for a "fear of empty spaces") a type of artwork in which the entire surface is filled with objects, people, designs, and ornaments in a crowded, sometimes congested way (Figure 6.17)

Impluvium: a rectangular basin in a Roman house that is placed in the open-air atrium in order to collect rainwater (Figure 6.7b)

Keystone: the center stone of an arch that holds the others in place

Oculus: a circular window in a church, or a round opening at the top of a dome (Figure 6.11b)

Peristyle: an atrium surrounded by columns in a Roman house (Figure 6.10a)

Perspective: depth and recession in a painting or a relief sculpture. Objects shown in **linear perspective** achieve a three-dimensionality in the two-dimensional world of the picture plane. Lines, called **orthogonals**, draw the viewer back in space to a common point, called the **vanishing point**. Paintings, however, may have more than one vanishing point, with orthogonals leading the eye to several parts of the work. Landscapes that give the illusion of distance are in **atmospheric** or **aerial perspective**

Pier: a vertical support that holds up an arch or a vault (Figure 6.3)

Spandrel: a triangular space enclosed by the curves of arches (Figure 6.4)

Triclinium: a dining table in ancient Rome that has a couch on three sides for reclining at meals; or a room containing a triclinium (Figure 6.13)

Tuscan order: an order of ancient architecture featuring slender, smooth columns that sit on simple bases.; no carvings on the frieze or in the capitals (Figure 6.8a)

Vault: a roof constructed with arches. When an arch is extended in space, forming a tunnel, it is called a **barrel vault** (Figure 6.1). When two barrel vaults intersect at right angles, it is called a **groin vault** (Figure 6.2)

Veristic: sculptures from the Roman Republic characterized by extreme realism of facial features (Figure 6.14)

SUMMARY

Art was used to emphasize the power of the state in a society in which empire building was a specialty. Monumental buildings and sculptures graced the great cities of the Roman world. The introduction of new methods of vaulting and the use of new construction materials, like concrete, enabled the Romans to build structures that not only had impressive exteriors but also had unparalleled interiors of great spaciousness.

Much is known about Roman art because of the destruction of the city of Pompeii by the volcanic explosion of Vesuvius in 79 C.E. Remains of Roman paintings betray some knowledge of linear perspective and foreshortening. Frescoes dominate the walls of elaborate villas in this seaside resort.

The Romans greatly admired Greek sculpture and were inspired by it throughout their history; indeed, much is known about Greek art from Roman copies that survive. Republican veristic works were influenced by Hellenistic Greek art; Imperial sculptures are modeled more on the Greek Classical age. Even though Roman sculpture retained a grandeur until the end of the Empire, it increasingly took on a military character, as in works such as the Ludovisi Battle Sarcophagus.

Multiple-Choice

1. Which of the following statements is true of both the Ludovisi Battle Sarcophagus and Athena Battling Alkyoneos from the Great Altar of Zeus and Athena at Pergamon?

 (A) They celebrate the victory of the gods over the giants.

 (B) They illustrate the conquest of barbarians.

 (C) They depict everyday events.

 (D) They show the defeat of Christian armies.

2. The form of the Augustus of Prima Porta is intended to recall

 (A) the majesty of Egyptian pharaohs as seen in works like King Menkaura and queen

 (B) the idealization of the human form as seen in Greek classical sculptures such as the *Doryphoros*

 (C) the formal quality of Greek archaic sculptures like the Anavysos Kouros

 (D) the Roman Republican veristic sculptures, such as the Head of a Roman patrician

3. Which of the following works is a Roman copy of a Greek original?

 (A) Seated boxer

 (B) *Winged Victory of Samothrace*

 (C) Peplos Kore

 (D) *Alexander Mosaic*

4. An atrium, such as the one seen in the House of Vettii, supplies light and air into the private spaces of a Roman home. Atria can also function as

 (A) spaces conducive to family religious ceremonies

 (B) courtyards to conduct business in a more comfortable private setting

 (C) places to gather rainwater for household use

 (D) outdoor bedrooms in a protected space

5. The Column of Trajan had many functions, including

 (A) being the centerpiece of buildings in a Roman racetrack

 (B) being used as a large sundial to indicate the time of day

 (C) acting as the Emperor Trajan's tomb

 (D) recounting the military victory of Emperor Trajan against the Greeks

Short Essay

Question 6: Continuity and Change
Suggested Time: 15 minutes

This is the Treasury at Petra, Jordan, dated between c. 400 B.C.E. and 100 C.E.

What was the function of this building?

What aspects of the site reflect its ancient Nabataean roots?

Although built in the Roman period, it shows Greek influence. Using *at least two* examples, explain which elements of the building were inspired by Greek architecture.

How has the design adapted the Greek elements in a nontraditional way to create a new architectural design?

ANSWER KEY

1. **B** 2. **B** 3. **D** 4. **C** 5. **C**

ANSWERS EXPLAINED

Multiple-Choice

1. **(B)** The Ludovisi Battle Sarcophagus illustrates a Roman victory over barbarians. The sculpture of Athena Battling Alkyoneos shows the victory of the gods over the giants. By implication, the Greeks were meant to see themselves as heroes over the barbarians who tried to conquer their land.

2. **(B)** Augustus of Prima Porta is a Roman work whose idealization, contrapposto, and human form express a parallel with the works of the Greek Classical period, particularly the *Doryphoros*.

3. **(D)** The *Alexander Mosaic* is a Roman copy of a Greek original, probably a fresco, that was found on the floor of a Roman villa at Pompeii.

4. **(C)** Interior atria often had impluvia, or basins, that were used to capture rainwater for household use.

5. **(C)** The Column of Trajan had many functions, including acting as a tomb for the emperor and as a glorification of his military victories against the Dacians, not the Greeks. It also was the centerpiece in a vast complex of buildings that was built in central Rome, but did not sit in the center of a racetrack. It did not tell time by acting as the point in a sundial.

Short Essay Rubric

Task	Point Value	Key Points in a Good Response
What was the function of this building?	1	Although named a "treasury," the building was actually a tomb.
What aspects of the site reflect its ancient Nabataean roots?	1	Answers could include: ■ Rock-cut tombs carved into cliff walls. ■ Combination of gods from Greece, Egypt, and Assyria. ■ Adaptation of Roman architectural forms interpreted in free way.
Using *at least two* examples, explain which elements of the building were inspired by Greek architecture.	2	Answers could include: ■ Columns supporting an entablature. ■ Pediment over the columns. ■ Greek tholos structure. ■ Door set back behind columns. ■ Placement of sculpture in niches.
How has the design adapted the Greek elements in a nontraditional way to create a new architectural design?	1	Answers could include: ■ Uneven and asymmetrical placement of columns. ■ Tholos located on second story. ■ Broken pediment on second story.

Content Area: Early Europe and Colonial Americas, 200–1750 C.E.

Late Antique Art

7

ENDURING UNDERSTANDING: The culture, beliefs, and physical settings of a region play an important role in the creation, subject matter, and siting of works of art.

Learning Objective: Discuss how the culture, beliefs, or physical setting can influence the making of a work of art. (For example: Catacomb of Priscilla)

Essential Knowledge:

- Late Antique art falls within the medieval artistic tradition.
- Late Antique art is influenced by the needs of Christian worship.
- Late Antique art is known for its avoidance of naturalistic forms.

ENDURING UNDERSTANDING: Cultural interaction through war, trade, and travel can influence art and art making.

Learning Objective: Discuss how works of art are influenced by cultural interaction. (For example: Santa Sabina)

Essential Knowledge:

- Late Antique art is heavily influenced by ancient art forms.
- Late Antique art has many regional variations.

ENDURING UNDERSTANDING: Art and art making can be influenced by a variety of concerns including audience, function, and patron.

Learning Objective: Discuss how art can be influenced by audience, function, and/or patron. (For example: Santa Sabina)

Essential Knowledge:

- Connections with the divine are illustrated through iconography.

ENDURING UNDERSTANDING: Art history is best understood through an evolving tradition of theories and interpretations.

Learning Objective: Discuss how works of art have had an evolving interpretation based on visual analysis and interdisciplinary evidence. (For example: Orant fresco)

Essential Knowledge:

- Late Antique art is generally studied chronologically.
- Contextual information comes from written records that are religious or civic.

HISTORICAL BACKGROUND

Christianity, in the first century C.E., was founded by Jesus Christ, whose energetic preaching and mesmerizing message encouraged devoted followers like Saints Peter and Paul to spread the message of Christian faith and forgiveness across the Roman world through active missionary work. Influential books and letters, which today make up the New Testament, were powerful tools that fired the imagination of everyone from the peasant to the philosopher.

Literally an underground religion, Christianity had to hide in the corners of the Roman Empire to escape harsh persecutions, but the number of converts could not be denied, and gradually the Christians became a majority. With Constantine's triumph at the Milvian Bridge in 312 C.E. came the Peace of the Church. Constantine granted restitution to Christians of state-confiscated property in the 313 C.E. Edict of Milan, which also granted religious toleration throughout the Empire. Constantine also favored Christians for government positions and constructed a series of religious buildings honoring Christian sites. Christianity was well on its way to becoming a state religion, with Emperor Constantine's blessing.

After emerging from the shadows, Christians began to build churches of considerable merit to rival the accomplishments of pagan Rome. However, pagan beliefs were by no means eradicated by the stroke of a pen, and ironically paganism took its turn as an underground religion in the Late Antique period.

Patronage and Artistic Life

It was not easy being a Christian in the first through third centuries. Persecutions were frequent; most of the early popes, including Saint Peter, were martyred. Those artists who preferred working for the more lucrative official government were blessed with great commissions in public places. Those who worked for Christians had to be satisfied with private church houses and burial chambers.

Most Christian art in the early centuries survives in the catacombs, buried beneath the city of Rome and other places scattered throughout the Empire. Christians were mostly poor—society's underclass. Artists imitated Roman works, but sometimes in a sketchy and unsophisticated manner. Once Christianity became recognized as an official religion, however, the doors of patronage sprang open. Christian artists then took their place alongside their pagan colleagues, eventually supplanting them.

EARLY CHRISTIAN ART

Christianity is an intensely narrative religion deriving its images from the various books of the New Testament. Christians were also inspired by parallel stories from the Old Testament or Hebrew Scriptures, and they illustrated these to complement Christian ideology. Since there are no written accounts of what the men and women of the Bible looked like, artists recreated the episodes by relying on their imagination. The following episodes from the New Testament are most often depicted:

- *The Annunciation*: The Angel Gabriel announces to Mary that she will be the virgin mother of Jesus (Figure 14.1).
- *The Visitation*: Mary visits her cousin Elizabeth to tell her the news that she is pregnant with Jesus. Because she is elderly, Elizabeth's announcement of her own pregnancy is greeted as a miracle. Elizabeth gives birth to Saint John the Baptist.

- *Christmas* or *the Nativity*: The birth of Jesus in Bethlehem. Mary gives birth in a stable; her husband, Joseph, is her sole companion. Soon after, angels announce the birth to shepherds.
- *Adoration of the Magi*: Traditionally, three kings, who are also astrologers, are attracted by a star that shines over Jesus's manger. They come to worship him and present gifts.
- *Massacre of the Innocents*: After Jesus is born, King Herod issues an order to execute all male infants in the hope of killing him. His family takes him to safety in an episode called *The Flight into Egypt*.
- *Baptism of Jesus*: John the Baptist, Jesus's cousin, baptizes him in the Jordan River. Jesus's ministry officially begins.
- *Calling of the Apostles*: Jesus gathers his followers, including Saint Matthew and Saint Peter, as his ministry moves forward (Figure 17.5).
- *Miracles*: To prove his divinity, Jesus performs a number of miracles, like multiplying loaves and fishes, resurrecting the deceased Lazarus, and changing water into wine at the Wedding at Cana.
- *Giving the Keys*: Sensing his own death, Jesus gives Saint Peter the keys to the kingdom of heaven, in effect installing him as the leader when he is gone, and therefore the first pope.
- *Transfiguration*: Jesus transfigures himself into God before the eyes of his apostles; this is the high point of his ministry.
- *Palm Sunday*: Jesus enters Jerusalem in triumph, greeted by throngs with palm branches.
- *Last Supper*: Before Jesus is arrested, he has a final meal with his disciples in which he institutes the Eucharist—that is, his body and blood in the form of bread and wine; at this meal he reveals that he knows that one of his apostles, Judas, has betrayed him for 30 pieces of silver (Figure 16.1).
- *Crucifixion*: After a brief series of trials, Jesus is sentenced to death for sedition. He is crowned with thorns, whipped with lashes, and forced to carry his cross through the streets of Jerusalem. At the top of a hill called Golgotha he is nailed to the cross and left to die (Figure 14.4a).
- *Deposition/Lamentation/Entombment/Pieta*: Jesus's body is removed from the cross by his relatives, cleaned, mourned over, and buried (Figures 12.7, 13.1, and 16.5).
- *Resurrection*: On Easter Sunday, three days later, Jesus rises from the dead. On Ascension Day he goes to heaven.

Also important are four author portraits of the Evangelists, who are the writers of the principal books, or gospels, of the New Testament. These books are arranged in the order in which it was traditionally believed they were written: Matthew, Mark, Luke, and John. Evangelist portraits appear often in medieval and Renaissance art, each associated with an attribute:

- Matthew: angel or a man
- Mark: lion
- Luke: ox or calf (Figure 10.2b)
- John: eagle

These attributes derive from the Bible (Ezekiel 1:5–14; Revelations 4:6–8) and were assigned to the four evangelists by great philosophers of the early church such as Saint Jerome.

Catacomb paintings, like the ones at **Priscilla** (Figure 7.1) from the fourth century, show a sensitivity toward artistic programs rather than random images. Jesus always maintains a

Figure 7.1a: Greek Chapel in the Catacomb of Priscilla, Late Antique Europe, 200–400, excavated tufa and fresco, Rome, Italy

position of centrality and dominance, but grouped around him are images that are carefully chosen either as Old Testament prefigurings or as subsidiary New Testament events. Early Christians learned from ancient paintings to frame figures in either **lunettes** or niches.

When Christianity was recognized as the official religion of the Roman Empire in 380 C.E., Christ was no longer depicted as the humble Good Shepherd; instead he took on imperial imagery. His robes become the imperial purple and gold, his crook a staff, his halo a symbol of the sun-king.

Unlike Roman mosaics, which are made of rock, Christian mosaics are often of gold or precious materials and faced with glass. Christian mosaics glimmer with the flickering of mysterious candlelight to create an otherworldly effect.

Catacomb of Priscilla, Late Antique Europe, 200–400, excavated tufa and fresco, Rome, Italy (Figures 7.1a, 7.1b, 7.1c)

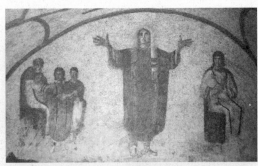

Form and Function

■ Catacombs are passageways beneath Rome that extend for about 100 miles and contain the tombs of 4 million dead.
■ They contain the tombs of seven popes and many early Christian martyrs.
■ The Priscilla catacomb has some 40,000 burials.

Context

■ Called Priscilla because she was the donor of the land for her family's burial. It was then opened up to Christians.
■ Greek Chapel (Figure 7.1a):
 – Named for two Greek inscriptions painted on the right niche.
 – Three niches for sarcophagi.
 – Lower portions done in the first Pompeian style of painting with imitation marble paneling enriching the surface.

Figure 7.1b: Orant fresco in the Catacomb of Priscilla, 200–400, excavated tufa and fresco, Rome, Italy

– Upper portions decorated with paintings in later Pompeian styles: sketchy painterly brushstrokes.
– Contains scenes of Old and New Testament stories.
 • Old Testament scenes show martyrs sacrificing for their faith.
 • New Testament scenes show miracles of Jesus.
■ Orant fresco (Figure 7.1b):
 – Fresco over a tomb niche set over an arched wall; cemetery of a family vault.
 – Central figure stands with arms outstretched in prayer; perhaps the same woman seen three times.
 • Figure is compact, dark, and set off from a light background with terse angular contours and emphatic gestures.
 • Figure prays for salvation in heaven.
 • Deeply set eyes—windows to the soul—staring upward implore God's deliverance.

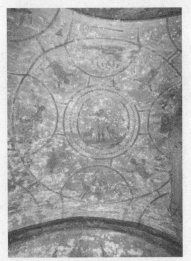

Figure 7.1c: Good Shepherd fresco in the Catacomb of Priscilla, 200–400, excavated tufa and fresco, Rome, Italy

 – Left: painting of a teacher with children, or the image of a couple being married with a bishop.
 – Right: mother and child, perhaps Mary with Christ or the Church.

- Good Shepherd fresco (Figure 7.1c):
 - Parallels between Old and New Testament stories feature prominently in Early Christian art; Christians see this as a fulfillment of the Hebrew scriptures; shows Christian interest in adapting aspects of the Hebrew scriptures in their own context.
 - Restrained portrait of Christ as a Good Shepherd, a pastoral motif in ancient art going back to the Greeks.
 - Symbolism of the Good Shepherd: rescues individual sinners in his flock who stray.
 - Stories of the life of the Old Testament Prophet Jonah often appear in the lunettes; Jonah's regurgitation from the mouth of a big fish is seen as prefiguring Christ's resurrection.
 - Peacocks in lunettes symbolize eternal life; quails symbolize earthly life; Christ is seen as a bridge between these worlds.

Content Area Early Europe and Colonial Americas, Image 48

Web Source *http://www.catacombepriscilla.com/index_en.html*

- **Cross-Cultural Comparisons for Essay Question 1: Ceiling paintings**
 - Sistine Chapel ceiling (Figure 16.2a)
 - Gaulli, *Triumph of the Name of Jesus* (Figure 17.6)

EARLY CHRISTIAN ARCHITECTURE

Under the city of Rome can be found a hundred miles of **catacombs**, sometimes five stories deep, with millions of interred bodies. Christians, Jews, and pagans used these burial grounds because they found this a cheaper alternative to aboveground interment. Finding the Roman practice of cremation repugnant, Christians preferred burial because it symbolized Jesus's, as well as their own, rising from the dead—body and soul.

Catacombs were dug from the earth in a maze of passageways that radiated out endlessly from the starting point. The poor were placed in **loculi**, which were holes cut in the walls of the catacombs meant to receive the bodies of the dead. Usually the bodies were folded over to take up less room. The wealthy had their bodies blessed in mortuary chapels, called **cubicula**, and then often placed in extravagant sarcophagi.

After the Peace of the Church in 313 C.E., Christians understood how they could adapt Roman architecture to their use. Basilicas, with their large, groin-vaulted interiors and impressive naves, were meeting places for the influential under the watchful gaze of the emperor's statue. Christians reordered the basilica, turning the entrance to face the far end instead of the side, and focused attention directly on the priest, whose altar (meaning "high place") was elevated in the **apse**. The clergy occupied the perpendicular aisle next to the apse, called the **transept**. Male worshippers stood in the long main aisle called the **nave**; females stood in the side aisles with partial views of the ceremony. In this way, Christians were inspired by Jewish communities in which this gender division was standard.

A **narthex**, or vestibule, was positioned as a transitional zone in the front of the church. An atrium was constructed in front of the building, framing the façade. Atria also housed the *catechumens*, those who expressed a desire to convert to Christianity but had not yet gone through the initiation rites. They were at once inside the church precincts but outside the main building. On occasion this overall design had the symbolic effect of turning the church into a cross shape.

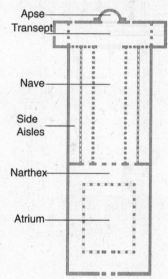

Apse
Transept
Nave
Side Aisles
Narthex
Atrium

Figure 7.2: Early Christian basilica. Some basilicas do not have a transept and have only one side aisle on either side of the nave.

Early Christian art has a "love/hate" relationship with its Roman predecessors. On the one hand, these were the people who mercilessly cemented Christians into giant flowerpots, covered them with tar, ignited them, and used them to light the streets at night. On the other hand, this was the world they knew: the grandeur, the excitement, the eternal quality suggested by mythical Rome.

Early Christian art shows an adaptation of Roman elements—taking from their predecessors the ideas that best expressed Christianity, and using the remnants of their monuments to embellish the new faith. In this way, Christianity, like most religions, expressed dominance over the older forms of worship by forcing pagan architectural elements, like columns, to do service to a new faith. **Santa Sabina** (Figures 7.3a, 7.3b, and 7.3c) employed a number of Roman columns from pagan temples. This type of reuse of architectural or sculptural elements is called **spolia**.

Early Christian churches come in two types, both inspired by Roman architecture: **centrally planned** and **axially planned** buildings. The exteriors of both church structures avoided decoration and sculpture that recall the façade of pagan temples.

The more numerous axially planned buildings, like **Santa Sabina**, had a long nave focusing on an apse. The nave, used for processional space, was usually flanked by side aisles. The first floor had columns lining the nave; the second floor contained a space decorated with mosaics; and the third floor had the **clerestory**, the window space. Early Christian **basilicas** have thin walls supporting wooden roofs with coffered ceilings (Figure 7.3b).

Centrally planned buildings were inspired by Roman buildings such as the Pantheon. The altar was placed in the middle of the building beneath a dome ringed with windows. Men stood around the altar, women in the side aisle, called an **ambulatory**.

Santa Sabina, Late Antique Europe, 422–432, brick, stone, and wooden roof, Rome, Italy
(Figures 7.3a, 7.3b, 7.3c)

Form
- Three-aisled basilica culminating in an apse; no transept.
- Long, tall, broad nave; axial plan.
- Windows not made of glass, but selenite, a type of transparent and colorless gypsum.
- Flat wooden roof; coffered ceiling; thin walls support a light roof.

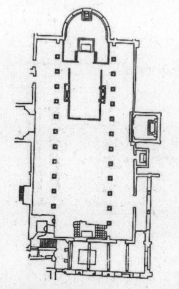

Figure 7.3c: Ground plan of Santa Sabina

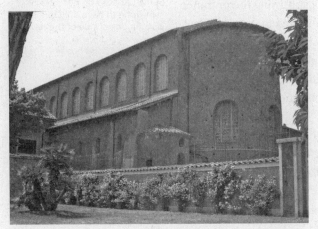

Figure 7.3a: Rear and flank exterior of Santa Sabina, Late Antique Europe, 422–432, brick, stone, and wooden roof, Rome, Italy

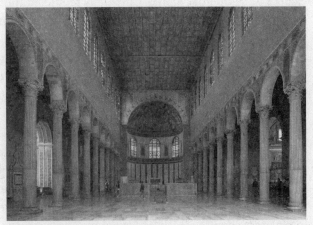

Figure 7.3b: Nave of Santa Sabina

Function

- Early Christian parish church.
- As in the Jewish tradition, men and women stood separately; the men stood in the main aisle, the women in the side aisles with a partial view.

Context

- Spolia: tall slender columns taken from the Temple of Juno in Rome, erected on this site; a statement about the triumph of Christianity over paganism.
- Bare exterior, sensitively decorated interior—represents the Christian whose exterior may be gross, but whose interior soul is beautiful.
- Built by Peter of Illyria.

Patronage

- According to an inscription in the narthex, the basilica was founded by Pope Celestine I (422–432).

Content Area Early Europe and Colonial Americas, Image 49

Web Source http://metmuseum.org/art/metpublications/Age_of_Spirituality_Late_Antique_ and_Early_Christian_Art_Third_to_Seventh_Century, pp. 266, 656–657

- **Cross-Cultural Comparisons for Essay Question 1: Ground Plans of Religious Structures**
 - Angkor Wat (Figure 23.8e)
 - Great Stupa (Figure 23.4d)
 - Great Mosque at Córdoba (Figure 9.14e)

VOCABULARY

Ambulatory: a passageway around the apse or altar of a church

Apse: the endpoint of a church where the altar is located (Figure 7.2)

Atrium (plural: **atria**): a courtyard in a Roman house or before a Christian church (Figure 7.2)

Axial plan (Basilican plan, Longitudinal plan): a church with a long nave whose focus is the apse; so-called because it is designed along an axis (Figure 7.3)

Basilica: In Christian architecture, an axially planned church with a long nave, side aisles, and an apse for the altar (Figure 7.3)

Catacomb: an underground passageway used for burial (Figure 7.1a)

Central plan: a church having a circular plan with the altar in the middle

Clerestory: the third, or window, story of a church

Coffer: in architecture, a sunken panel in a ceiling

Cubicula: small underground rooms in catacombs serving as mortuary chapels

Gospels: the first four books of the New Testament that chronicle the life of Jesus

Loculi: openings in the walls of catacombs to receive the dead

Lunette: a crescent-shaped space, sometimes over a doorway, that contains sculpture or painting

Narthex: the closest part of the atrium to the basilica, it serves as vestibule, or lobby, of a church (Figure 7.2)

Nave: the main aisle of a church (Figure 7.2)

Orant figure: a figure with its hands raised in prayer (Figure 7.1b)

Spolia: in art history, the reuse of architectural or sculptural pieces in buildings generally different from their original contexts

Transept: an aisle in a church perpendicular to the nave, where the clergy originally stood (Figure 7.2)

SUMMARY

Christianity was an underground religion for the first three hundred years of its existence. The earliest surviving artwork produced by Christians was buried in the catacombs far from the average Roman's view.

Imagery for Christian objects was derived from Roman precedents. Classical techniques such as fresco and mosaic flourished under Christian patronage, as did Roman figural compositions sometimes employing contrapposto. Moreover, Roman centrally and axially planned buildings found new life in Christian churches.

PRACTICE EXERCISES

Multiple-Choice

1. Construction of buildings like Santa Sabina relies on construction principles learned in the

 (A) Basilica Ulpia
 (B) Pantheon
 (C) Colosseum
 (D) Hagia Sophia

2. The painters of the catacombs preferred the fresco technique because

 (A) oil paint does not blend well on wall surfaces
 (B) mosaics were unavailable during this period
 (C) fresco forms a permanent bond with the wall
 (D) Christians have used fresco since Egyptian times

3. The Good Shepherd is an image in Early Christian catacombs that has its origins in the Bible, but pictorially the images are inspired by

 (A) Greek images of shepherding
 (B) Roman belief in agrarian virtues
 (C) Muslim cultivation of extensively planned gardens
 (D) prehistoric cave paintings of people and their animals

4. The division of painted spaces in the Good Shepherd fresco in the Catacombs of Priscilla is influenced by

 (A) Roman wall paintings as seen in the House of the Vettii
 (B) Greek vase painting as seen in the Niobides Krater
 (C) Greek friezes as seen in the Great Altar of Zeus and Athena at Pergamon
 (D) Etruscan wall paintings as seen in the Tomb of the Triclinium

5. After the catacombs in Rome were closed, legends grew around them that they were

 (A) haunted spaces
 (B) used to hide from Roman persecution
 (C) exclusively for the Roman elite
 (D) not really there, only the subject of legends

Short Essay

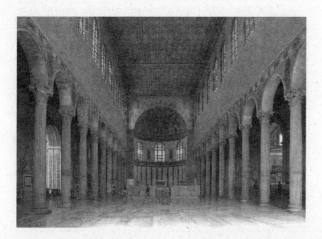 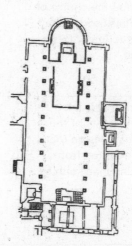

The images above show the interior and the ground plan of the church of Santa Sabina in Rome.

Describe the choice of materials used in the construction of this church.

Describe *at least two* elements of the Christian design that were adapted from non-Christian sources.

Using both the photograph *and* the ground plan, analyze how the design of the building is meant to accommodate the needs of Christian religious ceremonies.

ANSWER KEY

1. **A** 2. **C** 3. **A** 4. **A** 5. **B**

ANSWERS EXPLAINED

Multiple-Choice

1. **(A)** The Basilica Ulpia and other Roman basilicas formed a general inspiration for Christian churches.

2. **(C)** Christians did not exist in the Egyptian period. Oil painting was invented much later in the Renaissance. Mosaics were available, but were very expensive. Fresco forms a permanent bond with the wall surfaces, and was comparatively easy to use.

3. **(A)** The Good Shepherd image is inspired by a story from the Bible, but it has its pictorial roots in the shepherding image dating back to the Greeks.

4. **(A)** Roman paintings, such as the ones in the House of the Vettii, are separated by lines that define the wall spaces.

5. **(B)** Legends grew up about the catacombs that Christians, who were persecuted under the Romans, used them for hideaways. In truth, everyone in the ancient world knew where they were, so no one would have escaped by hiding there.

Short Essay Rubric

Task	Point Value	Key Points in a Good Response
Describe the choice of materials used in the construction of this church.	1	Answers could include: ■ Wooden roof allowed for thinner walls in contrast to stone roofs that required heavier walls. ■ Windows not made of glass but of selenite, a type of transparent and colorless gypsum.
Describe *at least two* elements of the Christian design that were adapted from non-Christian sources.	2	Answers could include: ■ Spolia: tall slender columns taken from the Temple of Juno in Rome, erected on this site; a statement about the triumph of Christianity over paganism. ■ Wooden roof similar to those in Roman basilicas. ■ Building made of brick and stone as in Roman buildings.
Using both the photograph *and* the ground plan, analyze how the design of the building is meant to accommodate the needs of Christian religious ceremonies.	2; 1 point for photograph and 1 point for ground plan	Answers could include: ■ Christians worship congregationally facing a priest. Photograph and ground plan indicate placement of altar. ■ Long nave for congregation; rounded apse sites the altar and highlights the priest. ■ As in the Jewish tradition, men and women stood separately; the men stood in the main aisle, the women in the side aisles with a partial view. Ground plan indicates placement of aisles.

Byzantine Art

8

TIME PERIOD

Early Byzantine	500–726
Iconoclastic Controversy	726–843
Middle and Late Byzantine	843–1453, and beyond

ENDURING UNDERSTANDING: The culture, beliefs, and physical settings of a region play an important role in the creation, subject matter, and siting of works of art.

Learning Objective: Discuss how the culture, beliefs, or physical setting can influence the making of a work of art. (For example: Hagia Sophia)

Essential Knowledge:

- Byzantine art is a medieval tradition.
- Byzantine art is inspired by the requirements of Christian worship.
- Byzantine art avoids naturalism and incorporates text into its images.

ENDURING UNDERSTANDING: Art and art making can be influenced by a variety of concerns including audience, function, and patron.

Learning Objective: Discuss how art can be influenced by audience, function, and/or patron. (For example: *Vienna Genesis*)

Essential Knowledge:

- Works of art were often displayed in religious and royal settings.
- Surviving architecture is mostly religious.
- Often there were reactions against figural imagery.

ENDURING UNDERSTANDING: Art history is best understood through an evolving tradition of theories and interpretations.

Learning Objective: Discuss how works of art have had an evolving interpretation based on visual analysis and interdisciplinary evidence. (For example: Justinian and Theodora panels from San Vitale)

Essential Knowledge:

- The study of art history is shaped by changing analyses based on scholarship, theories, context, and written records.
- Contextual information comes from written records that are religious or civic.

HISTORICAL BACKGROUND

The term "Byzantine" would have sounded strange to residents of the Empire—they called themselves Romans. The Byzantine Empire was born from a split in the Roman world that occurred in the fifth century, when the size of the Roman Empire became too unwieldy for one ruler to manage effectively. The fortunes of the two halves of the Roman Empire could not have been more different. The western half dissolved into barbarian chaos, succumbing to hordes of migrating peoples. The eastern half, founded by Roman Emperor Constantine the Great at Constantinople (modern-day Istanbul), flourished for one-thousand years beyond the collapse of its western counterparts. Culturally different from their Roman cousins, the Byzantines spoke Greek rather than Latin, and promoted orthodox Christianity, as opposed to western Christianity, which was centered in Rome.

The porous borders of the Empire expanded and contracted during the Middle Ages, reacting to external pressures from invading armies, seemingly coming from all directions. The Empire had only itself to blame: The capital, with its unparalleled wealth and opulence, was the envy of every other culture. Its buildings and public spaces awed ambassadors from around the known world. Constantinople was the trading center of early medieval Europe, directing traffic in the Mediterranean and controlling the shipment of goods nearly everywhere.

Icon production was a Byzantine specialty (Figure 8.8). Devout Christians attest that **icons** are images that act as reminders to the faithful; they are not intended to actually be the sacred persons themselves. However, by the eighth century, Byzantines became embroiled in a heated debate over icons; some even worshipped them as idols. In order to stop this practice, which many considered sacrilegious, the emperor banned all image production. Not content with stopping images from being produced, iconoclasts smashed previously created works. Perhaps the iconoclasts were inspired by religions, such as Judaism and Islam, which discouraged images of sacred figures for much the same reasons. The unfortunate result of this activity is that art from the Early Byzantine period (500–726) is almost completely lost. The artists themselves fled to parts of Europe where iconoclasm was unknown and Byzantine artists welcome. This so-called Iconoclastic Controversy serves as a division between the Early and Middle Byzantine art periods.

Despite the early successes of the iconoclasts, it became increasingly hard to suppress images in a Mediterranean culture such as Byzantium that had such a long tradition of creating paintings and sculptures of gods, going back to before the Greeks. In 843, iconoclasm was repealed and images were reinstated. This meant that every church and monastery had to be redecorated, causing a burst of creative energy throughout Byzantium.

Medieval Crusaders, some more interested in the spoils of war than the restoration of the Holy Land, conquered Constantinople in 1204, setting up a Latin kingdom in the east. Eventually the Latin invaders were expelled, but not before they brought untold damage to the capital, carrying off to Europe precious artwork that was simultaneously booty and artistic inspiration. The invaders also succeeded in permanently weakening the Empire, making it ripe for the Ottoman conquest in 1453. Even so, Late Byzantine artists continued to flourish both inside what was left of the Empire and in areas beyond its borders that accepted orthodoxy. A particularly strong tradition was established in Russia, where it remained until the 1917 Russian Revolution ended most religious activity. Even rival states, like Sicily and Venice, were known for their vibrant schools of Byzantine art, importing artists from the capital itself.

Patronage and Artistic Life

The church and state were one in the Byzantine Empire, so that many of the greatest works of art were commissioned, in effect, by both institutions at the same time. Monasteries were particularly influential, commissioning a great number of works for their private spaces. Interiors of Byzantine buildings were crowded with religious works competing with each other for attention.

A strong court atelier developed around a royal household interested in luxury objects. This atelier specialized in extravagant works in ivory, manuscripts, and precious metals.

Individual artists worked with great piety and felt they were executing works for the glory of God. They rarely signed their names, some feeling that pride was a sin. Many artists were monks, priests, or nuns whose artistic production was an expression of their religious devotion and sincerity.

BYZANTINE ARCHITECTURE

Byzantine architecture shows great innovation, beginning with the construction of the **Hagia Sophia** in 532 in Istanbul (Figures 8.3a, 8.3b, and 8.3c). The architects, Anthemius of Tralles and Isidorus of Miletus (actually a mathematician and a physicist rather than true architects), examined the issue of how a round dome, such as the one built for the Pantheon in Rome (Figure 6.11), could be placed on flat walls. Their solution was the invention of the **pendentive** (Figure 8.1), a triangle-shaped piece of masonry with the dome resting on one long side, and the other two sides channeling the weight down to a pier below. A pendentive allows the dome to be supported by four piers, one in each corner of the building. Since the walls between the piers do not support the dome, they can be opened up for greater window space. Thus the Hagia Sophia has walls of windows that flank the building on each side, unlike the Pantheon, which lacks windows, having only an oculus in the dome.

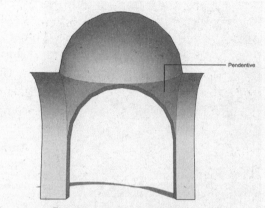
Figure 8.1: A dome supported by pendentives

Middle and Late Byzantine architects introduced a variation on the pendentive called the **squinch** (Figure 8.2). Although fulfilling the same function as a pendentive, that is, transitioning the weight of a dome onto a flat rather than a rounded wall, a squinch can take a number of shapes and forms, some corbelling from the wall behind, others arching into the center space. Architects designed pendentives and squinches so that artists could later use these broad and protruding surfaces as painted spaces.

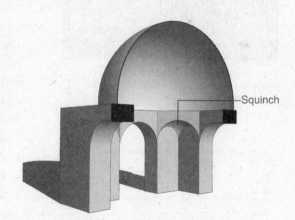
Figure 8.2: A dome supported by squinches

The Hagia Sophia's dome is composed of a set of ribs meeting at the top. The spaces between those ribs do not support the dome and are opened for window space. The Hagia Sophia has forty windows around the base of the dome, forming a great circle of light (or halo) over the congregation.

A further innovation in the Hagia Sophia involves its ground plan (Figure 8.3c). Churches in the Early Christian era concentrate on one of two forms: the circular building containing a centrally planned apse and the longer basilica with an axially planned nave facing an

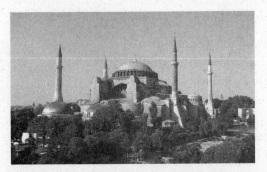

Figure 8.3a: Anthemius of Tralles and Isidorus of Miletus, Hagia Sophia, 532–537, brick and ceramic elements, with stone and mosaic veneer, Constantinople (Istanbul)

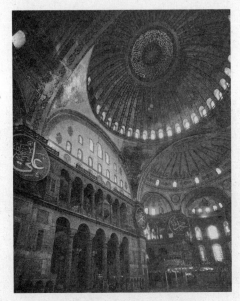

Figure 8.3b: Anthemius of Tralles and Isidorus of Miletus, Hagia Sophia, 532–537, Constantinople (Istanbul)

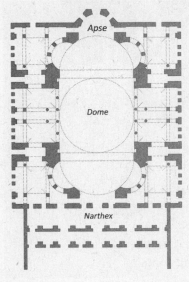

Figure 8.3c: Ground plan of Hagia Sophia

altar. The Hagia Sophia shows a marriage of these two forms, with the dome emphasizing a centrally planned core and the long nave directing focus toward the apse.

Except for the Hagia Sophia, Byzantine architecture is not known for its size. Buildings in the Early period (500–726) have plain exteriors made of brick or concrete. In the Middle and Late periods (843–1453), the exteriors are richly articulated with a provocative use of various colors of brick, stone, and marble, often with contrasting vertical and horizontal elements. The domes are smaller, but there are more of them, sometimes forming a cross shape.

Interiors are marked by extensive use of variously colored marbles on the lower floors and mosaics or frescoes in the elevated portions of the buildings. Domes tend to be low rather than soaring, having windows around the base. Interior arches reach into space, creating mysterious areas clouded by half-lights and shimmering mosaics. These buildings usually set the domes on more elevated drums.

Greek Orthodox tradition dictates that important parts of the Mass take place behind a curtain or screen. In some buildings this screen is composed of a wall of icons called an **iconostasis**.

Anthemius of Tralles and Isidorus of Miletus, Hagia Sophia, 532–537, brick and ceramic elements, with stone and mosaic veneer, Constantinople (Istanbul) (Figures 8.3a, 8.3b, and 8.3c)

Form

- Exterior: plain and massive with little decoration.
- Interior:
 - Combination of centrally and axially planned church.
 - Arcade decoration: walls and capitals are flat and thin and richly ornamented.
 - Capitals diminish classical allusions; surfaces contain deeply cut acanthus leaves.
 - Cornice unifies space.
 - Large fields for mosaic decoration; at one time there were four acres of gold mosaics on the walls.
 - Many windows punctuate wall spaces.
- Dome: the first building to have a dome supported by pendentives.
 - Altar at end of nave, but emphasis placed over the area covered by the dome.
 - Large central dome, with 40 windows at base symbolically acting as a halo over the congregation when filled with light.

Function

- Originally a Christian church; Hagia Sophia means "holy wisdom."
- Built on the site of another church that was destroyed during the Nike Revolt in 532.
- Converted to a mosque in the fifteenth century; minarets added in the Islamic period.
- Converted into a museum in 1935.

Context

- Marble columns appropriated from Rome, Ephesus, and other Greek sites.
- Patrons were Emperor Justinian and Empress Theodora, who commissioned the work after the burning of the original building in the Nike Revolt.

Content Area Early Europe and Colonial Americas, Image 52

Web Source *https://www.ktb.gov.tr/EN-113776/ayasofya-hagia-sophia.html*

- **Cross-Cultural Comparisons for Essay Question 1: Buildings that Have Changed Use**
 - Parthenon (Figure 4.16b)
 - Pantheon (Figures 6.11a, 6.11b)
 - Great Mosque at Córdoba (Figures 9.14a, 9.14b, 9.14c, 9.14d, 9.14e)

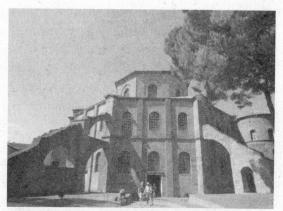

Figure 8.4a: San Vitale, Early Byzantine Europe, 526–547, brick, marble, and stone veneer, Ravenna, Italy

San Vitale, Early Byzantine Europe, 526–547, brick, marble, and stone veneer, Ravenna, Italy (Figures 8.4a, 8.4b, and 8.4c)

Form

- Eight-sided church.
- Plain exterior; porch added later, in the Renaissance.
- Large windows for illuminating interior designs.
- Interior has thin columns and open arched spaces.
- Dematerialization of the mass of the structure.
- Combination of axial and central plans.
- Spolia: bricks taken from ruined Roman buildings reused here.
- Martyrium design: circular plan in an octagonal format.

Function

- Christian church.

Context

- Mysterious space symbolically connects with the mystic elements of religion.
- Banker Julianus Argentarius financed the building of San Vitale.

Content Area Early Europe and Colonial Americas, Image 51

Web Source *http://www.ravennamosaici.it/?lang=en*

- **Cross-Cultural Comparisons for Essay Question 1: Buildings with Circular Plans**
 - Pantheon (Figures 6.11a, 6.11b)
 - Dome of the Rock (Figures 9.12a, 9.12b)
 - Mosque of Selim II (Figures 9.16a, 9.16b, 9.16c)

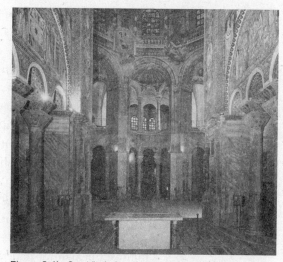

Figure 8.4b: San Vitale interior, 526–547, Ravenna, Italy

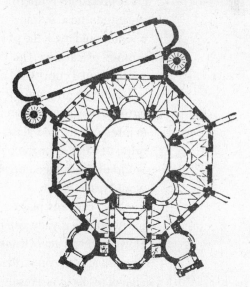

Figure 8.4c: San Vitale plan, 526–547, Ravenna, Italy

BYZANTINE PAINTING

The most characteristic work of Byzantine art is the **icon**, a religious devotional image usually of portable size and hanging in a place of honor either at home or in a religious institution. An icon has a wooden foundation covered by preparatory undercoats of paint, sometimes composed of such things as fish glue

or putty. Cloth is placed over this base, and successive layers of stucco are gently applied. A perforated paper sketch is placed on the surface, so that the image can be traced and then gilded and painted. The artist then applies varnish to make the icon shine, as well as to protect it, because icons are often touched, handled, and embraced. The faithful were encouraged to kiss icons and burn votive candles beneath them; as a result, icons have become blackened by candle soot and incense, their frames singed by flames. Consequently, many icons have been repainted and no longer have their original surface texture.

Icons were paraded in religious processions on feast days, and sometimes exhibited on city walls in times of invasion. Frequently they were believed to possess spiritual powers, and they held a sacred place in the hearts of Byzantine worshippers.

Byzantine painting is marked by a combination of the classical heritage of ancient Greece and Rome with a more formal and hieratic medieval style. Artists are trained in one tradition or the other, and it is common to see a single work of art done by a number of artists, some inspired by the classical tradition, and others by medieval formalism. **The Virgin (Theotokos) and Child between Saints Theodore and George** (Figure 8.8) shows both traditions.

Those artists who were classically trained used a painterly brushstroke and an innovative way of representing a figure—typically from an unusual angle. These artists employed soft transitions between color areas and showed a more relaxed figure stance.

Those trained in the medieval tradition favored frontal poses, symmetry, and almost weightless bodies. The drapery is emphasized, so there is little effort to reveal the body beneath. Perspective is unimportant because figures occupy a timeless space, marked by golden backgrounds and heavily highlighted halos.

Whatever the tradition, Byzantine art, like all medieval art, avoids nudity whenever possible, deeming it debasing. Nudity also had a pagan association, connected with the mythological religions of ancient Greece and Rome.

One of the glories of Byzantine art is its jewel-like treatment of manuscript painting. The manuscript painter had to possess a fine eye for detail, and so was trained to work with great precision, rendering minute details carefully. Byzantine manuscripts are meticulously executed; most employ the same use of gold seen in icons and mosaics. Because so few people could read, the possession of manuscripts was a status symbol, and libraries were true temples of learning. The *Vienna Genesis* (Figures 8.7a and 8.7b) is an excellent example of the sophisticated court style of manuscript painting.

Byzantine art continues the ancient traditions of fresco and mosaic painting, bringing the latter to new heights. Interior church walls are covered in shimmering tesserae made of gold, colored stones, and glass. Each piece of tesserae is placed at an odd angle to catch the flickering of candles or the oblique rays of sunlight; the interior then resembles a vast glittering world of floating golden shapes, perhaps echoing what the Byzantines thought heaven itself would resemble.

Court customs play an important role in Byzantine art. Purple, the color usually reserved for Byzantine royalty, can be seen in the mosaics of Emperor Justinian and Empress Theodora. However, in an act of transference, purple is sometimes used on the garments of Jesus himself. Custom at court prescribed that courtiers approach the emperor with their hands covered as a sign of respect. As a result, nearly every figure has at least one hand covered before someone of higher station, sometimes even when he or she is holding something. **Justinian** himself (Figure 8.5), in his famous mosaic in San Vitale, holds a **paten** with his covered hand.

Facial types are fairly standardized. There is no attempt at psychological penetration or individual insight: Portraits in the modern sense of the word are unknown. Continuing a tradition from Roman art, eyes are characteristically large and wide open. Noses tend to be long

and thin, mouths short and closed. The Christ Child, who is a fixture in Byzantine art, is more like a little man than a child, perhaps showing his wisdom and majesty. Medieval art generally labels the names of figures the viewer is observing, and Byzantine art is no exception.

Typically, most paintings have flattened backgrounds, often with just a single layer of gold to symbolize an eternal space. This becomes increasingly pronounced in the Middle and Late Byzantine periods in which figures stand before a monochromatic of golden opulence, perhaps illustrating a heavenly world.

Justinian Panel, c. 547, mosaic from San Vitale, Ravenna (Figure 8.5)

Content

- Emperor Justinian, as the central image, dominates all; emperor's rank indicated by his centrality, halo, fibula, and crown.
- To his left the clergy, to his right the military.
- Dressed in royal purple and gold.
- Divine authority symbolized by the halo; Justinian is establishing religious and political control over Ravenna.

Form

- Symmetry, frontality.
- Slight impression of procession forward.
- Figures have no volume; they seem to float and yet step on each other's feet.
- Minimal background: green base at feet; golden background indicates timelessness.

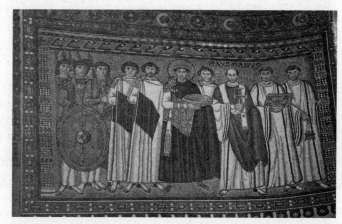

Figure 8.5: Justinian Panel, c. 547, mosaic from San Vitale, Ravenna

Function

- Justinian holds a paten, or plate, for the Eucharist; participating in the service of the Mass almost as if he were a celebrant—his position over the altar enhances this reference.
- Justinian appears as head of church and state; regent of Christ on earth.

Context

- Archbishop Maximianus is identified; he is the patron of San Vitale.
- XP or Chi Rho, the monogram of Christ, on soldier's shield shows them as defenders of the faith, or Christ's soldiers on earth.

Content Area Early Europe and Colonial Americas, Image 51

- **Cross-Cultural Comparisons for Essay Question 1: Mosaics**
 - *Alexander Mosaic* (Figure 4.20)
 - Dome of the Rock interior (Figure 9.12b)

Theodora Panel, c. 547, mosaic from San Vitale, Ravenna (Figure 8.6)

Content

- Empress Theodora stands in an architectural framework holding a chalice for the Mass and is about to go behind the curtain.

Form

- Slight displacement of absolute symmetry with Empress Theodora; she plays a secondary role to her husband.
- She is simultaneously frontal and moving to our left.
- Figures are flattened and weightless; barely a hint of a body can be detected beneath the drapery.

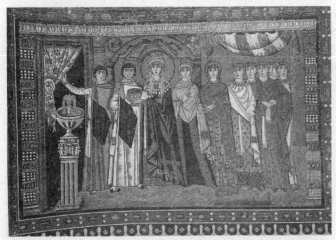

Figure 8.6: Theodora Panel, c. 547, mosaic from San Vitale, Ravenna

Function

- She holds a chalice for the wine; participating in the service of the Mass almost as if she were a celebrant.
- She is juxtaposed with Emperor Justinian on the flanking wall; both figures hold the sacred items for the Mass.

Context

- Richly robed empress and ladies at court.
- The three Magi, who bring gifts to the baby Jesus, are depicted on the hem of her dress. This reference draws parallels between Theodora and the Magi.

Content Area Early Europe and Colonial Americas, Image 51

Web Source *http://employees.oneonta.edu/farberas/ARTH/arth212/san_vitale.html*

- **Cross-Cultural Comparisons for Essay Question 1: Role of Women in Positions of Power**
 - Kneeling statue of Hatshepsut (Figure 3.9b)
 - Presentation of Fijian mats and tapa cloths to Queen Elizabeth II (Figure 28.10)
 - Olowe of Ise, veranda post of enthroned king and senior wife (Figure 27.14)

Vienna Genesis, **Early Byzantine Europe, early 6th century, illuminated manuscript, tempera, gold, and silver on purple vellum, Austrian National Library, Vienna (Figures 8.7a and 8.7b)**

Form

- Lively, softly modeled figures.
- Classical training of the artists: contrapposto, foreshortening, shadowing, perspective, classical allusions.
- Shallow settings.
- Fluid movement of decorative figures.
- Richly colored and shaded.
- Two rows linked by a bridge or a pathway.
- Text placed above illustrations, which are on the lower half of the page.
- Continuous narrative.

Context

- First surviving illustrations of the stories from Genesis.
- Genesis stories are done in continuous narrative with genre details.
- Written in Greek.
- Partial manuscript: 48 of 192 (?) illustrations survive.

Materials and Origin

- Manuscript painted on vellum.
- Written in silver script, now oxidized and turned black.
- Origin uncertain: a scriptorium in Constantinople? Antioch?
- Perhaps done in a royal workshop; purple parchment is a hallmark of a royal institution.

Rebecca and Eliezer at the Well

- Genesis 24: 15–61.

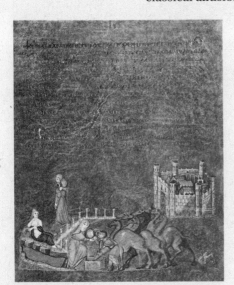

Figure 8.7a: Rebecca and Eliezer at the Well, from the *Vienna Genesis*, Early Byzantine Europe, early 6th century, illuminated manuscript, tempera, gold, and silver on purple vellum, Austrian National Library, Vienna

- Rebecca, shown twice, emerges from the city of Nahor with a jar on her shoulder to go down to the spring.
- She quenches the thirst of a camel driver, Eliezer, and his camels.
- Colonnaded road leads to the spring.
- Roman water goddess personifies the spring.

Jacob Wrestling the Angel

- Genesis 32: 22–31.
- Jacob takes his two wives, two maids, and eleven children and crosses a river; the number of children is abbreviated.
- At night Jacob wrestles an angel.
- The angel strikes Jacob on the hip socket.
- Classical influence in the Roman-designed bridge, but medieval influence in the bridge's perspective: i.e., the shorter columns are placed in the nearer side of the bridge and the taller columns behind the figures.

Content Area Early Europe and Colonial Americas, Image 50

Web Source *http://metmuseum.org/art/metpublications/Age_of_Spirituality_Late_Antique_and_Early_Christian_Art_Third_to_Seventh_Century* p. 458 ff.

- **Cross-Cultural Comparisons for Essay Question 1: Narrative**
 - *Night Attack on the Sanjô Palace* (Figures 25.3a, 25.3b)
 - Last judgment of Hunefer (Figure 3.12)
 - Churning of the Ocean of Milk (Figure 23.8c)

Figure 8.7b: Jacob Wrestling the Angel, from the *Vienna Genesis*, Early Byzantine Europe, early 6th century, illuminated manuscript, tempera, gold, and silver on purple vellum, Austrian National Library, Vienna

Virgin (Theotokos) and Child between Saints Theodore and George, Early Byzantine Europe, 6th or early 7th centuries, encaustic on wood, Monastery of Saint Catherine, Mount Sinai, Egypt (Figure 8.8)

Function

- Icon placed in a medieval monastery for devotional purposes.

Content and Form

- Virgin and Child centrally placed; firmly modeled.
 - Mary as Theotokos, mother of God.
 - Mary looks beyond the viewer as if seeing into the future.
 - Christ child looks away, perhaps anticipating his crucifixion.
- Saints Theodore and George flank Virgin and Child.
 - Warrior saints.
 - Stiff and hieratic.
 - Directly stare at the viewer; engage the viewer directly.
- Angels in background look toward heaven.
 - Painted in a classical style with brisk brushwork in encaustic, a Roman tradition.
 - Turned toward the descending hand of God, which comes down to bless the scene.
- Because the three groups are in very different styles, it has been assumed that they were painted by three different artists.

Context

- Pre–Iconoclastic Controversy icon, location in the Sinai and encaustic places it near Roman-Egyptian encaustic painted portraits.

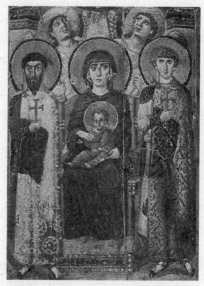

Figure 8.8: Virgin (Theotokos) and Child between Saints Theodore and George, Early Byzantine Europe, 6th or early 7th centuries, encaustic on wood, Monastery of Saint Catherine, Mount Sinai, Egypt

Content Area Early Europe and Colonial Americas, Image 54

Web Source *https://www.sinaimonastery.com/index.php/en/treasures/icons*

■ **Cross-Cultural Comparisons for Essay Question 1: A Work of Art Done by Many Artists**
- Terra cotta warriors (Figures 24.8a, 24.8b)
- Parthenon (Figures 4.16a, 4.16b)
- Koons, *Pink Panther* (Figure 29.9)

VOCABULARY

Axial plan (Basilican plan, Longitudinal plan): a church with a long nave whose focus is the apse, so-called because it is designed along an axis

Cathedral: the principal church of a diocese, where a bishop sits (Figure 8.3a)

Central plan: a church having a circular plan with the altar in the middle

Chalice: a cup containing wine, used during a Christian service (Figure 8.6)

Codex (plural: **codices**): a manuscript book (Figures 8.7a and 8.7b)

Continuous narrative: a work of art that contains several scenes of the same story painted or sculpted in continuous succession (Figure 8.7)

Cornice: a projecting ledge over a wall (Figure 8.3b)

Encaustic: a type of painting in which colors are added to hot wax to affix to a surface. (Figure 8.8)

Eucharist: the bread sanctified by the priest at the Christian ceremony commemorating the Last Supper

Genesis: first book of the Bible that details Creation, the Flood, Rebecca at the Well, and Jacob Wrestling the Angel, among other episodes (Figures 8.7a and 8.7b)

Icon: a devotional panel depicting a sacred image (Figure 8.8)

Iconoclastic controversy: the destruction of religious images in the Byzantine Empire during the eighth and ninth centuries.

Iconostasis: a screen decorated with icons, which separates the apse from the transept of a church

Illuminated manuscript: a manuscript that is hand decorated with painted initials, marginal illustrations, and larger images that add a pictorial element to the written text (Figures 8.7a and 8.7b)

Martyrium (plural: **martyria**): a shrine built over a place of martyrdom or a grave of a martyred Christian saint

Mosaic: a decoration using pieces of stone, marble or colored glass, called **tesserae**, that are cemented to a wall or a floor (Figures 8.5 and 8.6)

Paten: a plate, dish, or bowl used to hold the Eucharist at a Christian ceremony (Figure 8.5)

Pendentive: a construction shaped like a triangle that transitions the space between flat walls and the base of a round dome (Figure 8.1)

Squinch: the polygonal base of a dome that makes a transition from the round dome to a flat wall (Figure 8.2)

Theotokos: the Virgin Mary in her role as the Mother of God (Figure 8.8)

XP: the Christian monogram made up of the Greek letters *khi* and *rho*, the first two letters of *Khristos*, the Greek form of Christ's name (Figure 8.5)

SUMMARY

The Eastern half of the Roman Empire lived for another one thousand years beyond the fall of Rome under a name we today call Byzantine. The Empire produced lavish works of art for a splendid court that resided in Constantinople—one of the most resplendent cities in history.

Byzantine art specialized in a number of diverse art forms. Walls were covered in shimmering gold mosaic that reflected a heavenly world of great opulence. Icons that were sometimes thought to have spiritual powers were painted of religious figures. Ivories were carved with consummate precision and skill.

Byzantine builders invented the pendentive, first seen at the Hagia Sophia. However, in later buildings the squinch was preferred.

The death of the Empire in 1453 did not mean the end of Byzantine art. Indeed, a second life developed in Russia, in eastern Europe, and in occupied Greece lasting into the twentieth century.

PRACTICE EXERCISES

Multiple-Choice

1. Interior mosaic decoration is different in Late Antique and Byzantine buildings than in that of the ancient world in that

 (A) ancient mosaicists used large blocks of stone rather than miniature pieces called tesserae.
 (B) tiles were made from glass, whereas Byzantine tiles were made of metal
 (C) tiles depicted animals and vegetable forms; Byzantine mosaics depict people
 (D) tiles are colored in flat pastel shades; Byzantine tiles glow with a use of gold and sparkling colors

Questions 2 and 3 refer to the following images.

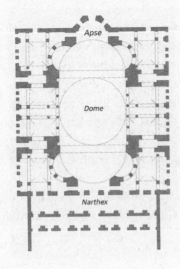

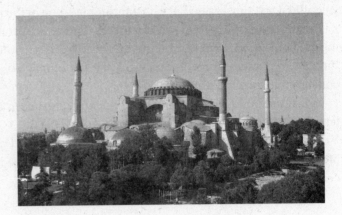

2. The ground plan of the Hagia Sophia suggests that

(A) columns are used as decorative patterning rather than as internal supports

(B) it is a combination of a central and a basilican plan

(C) the mihrab faces Mecca

(D) the Roman basilican type has been altered to create side aisles

3. Later additions to the original construction of this church included

(A) enlargement of windows

(B) development of rib vaults

(C) installation of underground catacombs

(D) addition of minarets

4. The mosaics of Justinian and Theodora have been placed in San Vitale

(A) to commemorate a state visit by the Emperor and Empress

(B) as a thank you for helping to construct the building

(C) to symbolize their semidivine status as participants in the Mass

(D) because they were declared saints after they died

5. After the fall of the Byzantine Empire in 1453, its artistic tradition was carried on in

(A) Turkey

(B) Russia

(C) Austria

(D) Spain

Short Essay

Practice Question 4: Contextual Analysis
Suggested Time: 15 minutes

The illustrations below are pages from the *Vienna Genesis:* Rebecca and Eliezer at the Well on the left and Jacob Wrestling the Angel on the right.

What is the written source of the images in this manuscript?

Describe *at least two* elements of the work that indicate an imperial or royal patronage.

The scenes have a number of motifs taken from classical art. Using specific details, analyze *how* these settings are incorporated into the text.

The scenes have a number of motifs taken from classical art. Using specific details, analyze *why* these settings are incorporated into the text.

1. **D** 2. **B** 3. **D** 4. **C** 5. **B**

ANSWERS EXPLAINED

Multiple-Choice

1. **(D)** Byzantine mosaics are characterized by their glowing golden colors; Roman and Greek mosaicists use pastel colors.

2. **(B)** The Hagia Sophia was constructed as a combination of the central plan (dome sitting on pendentives) and a basilican plan (long nave terminating at an apse).

3. **(D)** The minarets were added by the Muslims when the building was turned into a mosque.

4. **(C)** There is no evidence that either Justinian or Theodora ever visited or financially supported San Vitale. Even though they wear halos, they were never declared saints after their death. Their presence and their halos suggest a semidivine presence at services.

5. **(B)** After the fall of the Byzantine Empire, the Byzantine artistic tradition was carried on in Russia.

Short Essay Rubric

Task	Point Value	Key Points in a Good Response
What is the written source of the images in this manuscript?	1	The manuscript source is the Book of Genesis, Chapters 24 and 32, or more generally, the Hebrew Scriptures.
Describe *at least two* elements of the work that indicate an imperial or royal patronage.	2	Answers could include: ■ Work done on vellum, a luxurious, expensive product. ■ Painted with silver ink (now oxidized and turned black). ■ Purple parchment is a hallmark of a royal institution.
The scenes have a number of motifs taken from classical art. Using specific details, analyze *how* these settings are incorporated into the text.	1	Answers could include: ■ Classical training of the artists: contrapposto, foreshortening, shadowing, perspective. ■ In Rebecca: – Roman water goddess personifies the spring. – Colonnaded road leads to the spring. ■ In Jacob: – Roman-style bridge.
The scenes have a number of motifs taken from classical art. Using specific details, analyze *why* these settings are incorporated into the text.	1	Answers could include: ■ The Byzantines called themselves Romans and saw themselves as continuing in this tradition. ■ Classical style references the antique world and great epic moments in ancient history.

Content Areas: Early Europe and Colonial Americas, 200–1750 C.E.
West and Central Asia, 500 B.C.E–1980 C.E.
Taj Mahal: South, East, and Southeast Asia, 300 B.C.E.–1980 C.E.

Islamic Art

9

TIME PERIOD: 630 C.E. TO THE PRESENT

ENDURING UNDERSTANDING: The culture, beliefs, and physical settings of a region play an important role in the creation, subject matter, and siting of works of art.

Learning Objective: Discuss how the culture, beliefs, or physical setting can influence the making of a work of art. (For example: the Kaaba)

Essential Knowledge:

- Islamic art is a part of the medieval artistic tradition.
- In the Islamic period, scientific and mathematical experimentation was prioritized.
- Islamic art incorporates text.
- Islamic artists created ceramics and metalwork that are particularly well-regarded.
- Islamic textiles include silk and wool used for tapestries and carpets.
- Islamic manuscripts are written on paper, cloth, or vellum.
- Islamic art favors a two-dimensional approach to painting, emphasizing geometric designs and organic forms.

ENDURING UNDERSTANDING: Cultural interaction through war, trade, and travel can influence art and art making.

Learning Objective: Discuss how works of art are influenced by cultural interaction. (For example: *Baptistère de Saint Louis*)

Essential Knowledge:

- There is an active exchange of artistic ideas throughout the Middle Ages.
- There is a great influence of Roman, Early Medieval, and Byzantine art on Islamic art.
- Islamic art has a strong calligraphic tradition.
- Even though Islamic art is produced over a wide geographic area, it has a number of shared similarities and characteristics.
- There is a strong pilgrimage tradition in Islam.

ENDURING UNDERSTANDING: Art and art making can be influenced by a variety of concerns including audience, function, and patron.

Learning Objective: Discuss how art can be influenced by audience, function, and/or patron. (For example: Pyxis of al-Mughira)

Essential Knowledge:

- Works of art were often displayed in religious or court settings.
- Architecture is mostly religious.
- Often great works of Islamic art were created for royal and wealthy patrons.

ENDURING UNDERSTANDING: Art history is best understood through an evolving tradition of theories and interpretations.

Learning Objective: Discuss how works of art have had an evolving interpretation based on visual analysis and interdisciplinary evidence. (For example: The Ardabil Carpet)

Essential Knowledge:

- The study of art history is shaped by changing analyses based on scholarship, theories, context, and written records.
- Contextual information comes from written records that are religious or civic.
- Islamic art created for religious purposes is not figural.
- Mosque architecture contains no figural imagery, but it does have geometric, calligraphic, and organic decoration.
- In a secular context, Islamic art is sometimes figural especially in manuscript painting.

HISTORICAL BACKGROUND

The Prophet Muhammad's powerful religious message resonated deeply with Arabs in the seventh century, and so by the end of the Umayyad Dynasty in 750 C.E., North Africa, the Middle East and parts of Spain, India, and Central Asia were converted to Islam or were under the control of Islamic dynasties. The Islamic world expanded under the Abbasid Caliphate, which ruled a vast empire from their capital in Baghdad. After the Mongol sack of Baghdad in 1258, the Islamic world split into two great cultural divisions, the East, consisting of South and Central Asia, Iran, and Turkey; and the West, which included the Near East and the Arabic peninsula, North Africa, parts of Sicily and Spain.

Islam exists in two principal divisions, Shiite and Sunni, each based on a differing claim of leadership after Muhammad's death. Even though millions practice and continue to share a similar faith, there is great diversity in Islamic religious and artistic traditions.

Patronage and Artistic Life

Major artistic movements in the Islamic world are the result of patronage by secular and religious rulers and the social elite. Other objects much valued today, such as textiles, metalwork, and ceramics were produced for the art market, both at home and abroad.

One of the most popular art forms in the Islamic world is **calligraphy**, which is based upon the Arabic script and varies in form depending on the period and region of its production. Calligraphy is considered to be the highest art form in the Islamic world as it is used to transmit the texts revealed from God to Muhammad. Calligraphers therefore were the most respected Islamic artists. Most early artists were humble handmaidens to the art form—and to God—therefore many remained anonymous. However, by the fourteenth and fifteenth centuries, writing examples are signed or attributed to specific calligraphers. Even royalty dabbled in calligraphy, raising the art form to new heights. Apprenticeships were exacting, making students master everything including the manufacture of ink and the correct posture for sitting while writing.

ISLAMIC PAINTING AND SCULPTURE

Islamic art features three types of patterns—**arabesques**, **calligraphy**, and **tessellation** (Figures 9.1, 9.2, and 9.3, respectively)—used on everything from great monuments to simple earthenware plates; sometimes all three are used on the same item.

Favorite arabesque motifs include acanthus and split leaves, scrolling vines, spirals, wheels, and zigzags. Calligraphy is highly specialized, and comes in a number of recognized scripts, including **Kufic**. The Arabic alphabet has 28 letters from 17 different shapes, and is written from right to left. Arabic numerals, however, are written left to right as they are in the West. **Kufic** is highly distinguished, and has been reserved for official texts, indeed has been the traditional, but not the only, script for the **Qur'an**. It has evolved into a highly ornamental style, and therefore is difficult for the average reader to decipher. Tessellations, or the repetition of geometric designs, demonstrate the Islamic belief that there is unity in multiplicity. Their use can be found on objects as disparate as open metalwork and stone decorations. Perforated ornamental stone screens, called **jali**, were a particular Islamic specialty.

All of these designs, no matter how complicated, were achieved with only a straightedge and a compass. Islamic mathematicians were thinkers of the highest order; geometric elements reinforced their idea that the universe is based on logic and a clear design. Patterns seem to radiate from a central point, although any point can be thought of as the start. These patterns are not designed to fit a frame, rather to repeat until they reach the edge, and then by inference go beyond that.

Islamic textiles, carpets in particular, are especially treasured. Elaborate prayer rugs, often bearing the mihrab motif, are placed on mosque floors to provide a clean and comfortable spot for the worshipper to kneel on. Royal factories made elaborate carpets, in which it was usual to have hundreds of knots per square inch. In tribal villages, women were often the manufacturers of smaller carpets with designs created by either the knotting or the flat-weave technique.

Islamic art is intellectual, refined, and decorative; it contains no strong emotions and no pathos, but exhibits serene harmony.

Although the Qur'an does not ban images, there is an active tradition in many Islamic countries to avoid religious imagery whenever possible. Some societies strictly adhere to the prohibition, others allow floral designs and animal motifs, still others disregard the traditional ban.

Figure 9.1: Arabesque

Figure 9.2: Islamic calligraphy with arabesque

Figure 9.3: Tessellation

Pyxis of al-Mughira, Umayyad, 968, ivory, Louvre, Paris (Figure 9.4)

Form
- Horror vacui.
- Vegetal and geometric motifs.

Material
- Intricately carved container made from elephant ivory.

Function
- Container for expensive aromatics, sometimes also used to hold jewels, gems, or seals.
- Gift for the caliph's younger son.

Content
- Four polylobed medallion scenes showing pleasure activities of the royal court: hunting, falconry, sports, music.

Context
- Calligraphic inscription in Arabic names the owner, asks for Allah's blessings, and includes the date of the pyxis.
- From Muslim Spain.

Figure 9.4: Pyxis of al-Mughira, Umayyad, 968, ivory, Louvre, Paris

Cross-Cultural Comparisons for Essay Question 1: Luxury Items

- Ruler's feather headdress (Figure 26.6)
- Merovingian looped fibulae (Figure 10.1)
- Basin (*Baptistère de Saint Louis*) (Figure 9.6)

Figure 9.5: Folio from a Qur'an, Arab, North Africa or Near East, Abbasid, 8th–9th century, ink, color, and gold on parchment, Pierpont Morgan Library, New York

Folio from a Qur'an, Arab, North Africa or Near East, Abbasid, 8th–9th century, ink, color, and gold on parchment, Pierpont Morgan Library, New York (Figure 9.5)

Form

- The title of each chapter is scripted in gold.
- Script is rigidly aligned in strong horizontal letters well-spaced apart in brown ink.
- Kufic script: strong uprights and long horizontals.
- Great clarity of text is important because several readers read a book at once, some at a distance.
- Arabic reads right to left.
- Consonants are scripted, vowels are indicated by dots or markings around the other letters.
- The diacritical markings of short diagonal lines and red dots indicate vocalizations.
- Pyramids of six gold discs mark the ends of *ayat* (verses).

Function

- The Qur'an is the Muslim holy book.

Context

- Qur'ans were compiled and codified in the mid-seventh century; however, the earliest surviving Qur'an is from the ninth century.
- Calligraphy is greatly prized in Qur'anic texts; elaborate divine words needed the best artists.
- Illustrated is the heading of sura 29 (*al-'Ankabūt*, or "The Spider") in gold.
- The text indicates that those who believe in protectors other than Allah are like spiders who build flimsy homes.

- **Cross-Cultural Comparisons for Essay Question 1: Calligraphy**
 - *Book of Lindisfarne* (Figure 10.2c)
 - *Night Attack on the Sanjô Palace* (Figures 25.3a, 25.3b)
 - *Vienna Genesis* (Figures 8.7a, 8.7b)

Figure 9.6: Muhammad ibn al-Zain, Basin (*Baptistère de Saint Louis*), 1320–1340, brass inlaid with gold and silver, Louvre, Paris

Muhammad ibn al-Zain, Basin (*Baptistère de Saint Louis*), 1320–1340, brass inlaid with gold and silver, Louvre, Paris (Figure 9.6)

Function

- Original use: ceremonial hand washing; perhaps a banqueting piece.
- Later use: baptisms for the French royal family (association with Saint Louis is fictional); coats-of-arms originally on the work were reworked with French fleur-de-lys.

Content
- Signed by the artist six times.
- Hunting scenes alternate with battle scenes along the side of the bowl.
- Mamluk hunters and Mongol enemies.
- Bottom of bowl decorated with fish, eels, crabs, frogs, and crocodiles.

Patronage
- There is no patron or date identifying the work, although some scholars feel that the basin is connected to the amir Salar (d. 1310), whose image may be prominently depicted on one of the roundels; in that regard it may have been a gift from Salar to a sultan.
- Exquisite craftsmanship makes it likely that the work was done on commission for an important setting.

Content Area West and Central Asia, Image 188

Web Source https://learner.org/series/art-through-time-a-global-view/ceremony-and-society/basin-known-as-the-baptistere-of-saint-louis/

- **Cross-Cultural Comparisons for Essay Question 1: Works Reflecting a Cultural Diversity**
 - Miguel González, *Virgin of Guadalupe* (Figure 18.4)
 - Quick-to-See-Smith, *Trade* (Figure 29.12)
 - Kngwarreye, *Earth's Creation* (Figure 29.13)

Maqsud of Kashan, The Ardabil Carpet, 1539–1540, silk and wool, Victoria and Albert Museum, London (Figures 9.7a and 9.7b)

Function
- Prayer carpet used at a pilgrimage site of a Sufi saint.
- Huge carpet, one of a matching pair, from the funerary mosque of Shayik Safial-Din; probably made when the shrine was enlarged. The companion carpet is in the Los Angeles County Museum of Art.

Materials
- Wool carpet, woven by ten people, probably men; although women also did weaving in this period.
- The importance of the location and the size of the project indicate that men were entrusted with its execution.

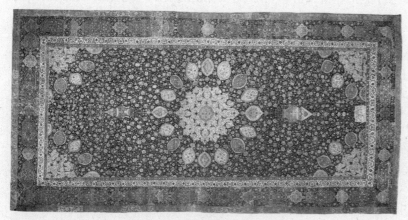

Figure 9.7a: Maqsud of Kashan, The Ardabil Carpet, 1539–1540, silk and wool, Victoria and Albert Museum, London

Figure 9.7b: Detail of 9.7a

Technique

■ Wool pile of 5,300 knots per 10 cm. sq.; allows for great detail.

Content

■ Medallion in center of carpet may represent the inside of a dome with 16 pendants.

■ Mosque lamps hang from two of the pendants; because one lamp is smaller than the other, the larger lamp is placed farther away so that it appears the same size as the smaller; some suggest that this is a deliberate flaw to reflect that God alone is perfect.

■ Corner squinches also have pendants completing the feeling of looking into a dome.

■ Inscription: "Except for thy threshold, there is no refuge for me in all the world. Except for this door there is no resting-place for my head. The work of the slave of the portal, Masqud Kashani," and the date, 946, in the Muslim calendar.

■ The word "slave" in the inscription has been variously interpreted, but generally it is agreed that he was not a slave in the literal sense, but someone who was charged with executing the carpet.

Context

■ World's oldest dated carpet.

Content Area West and Central Asia, Image 191

Web Source *https://www.vam.ac.uk/articles/the-ardabil-carpet*

■ **Cross-Cultural Comparisons for Essay Question 1: Textiles**

 – Hiapo (Figure 28.6)

 – *Bayeux Tapestry* (Figures 11.7a, 11.7b)

 – Ringgold, *Dancing at the Louvre* (Figure 29.11)

Persian Manuscripts

Persian painting descends from a rich and diverse heritage, including illustrated manuscripts from the western Islamic world and figural ceramics from pre-Mongol Iran. The Mongolian rulers who conquered Iran in 1258 introduced exotic Chinese painting to the Iranian court in the late Middle Ages. Persian manuscript paintings (sometimes called miniatures) gave a visual image to a literary plot, rendering a more enjoyable and easier-to-understand text. A number of diverse schools of manuscript painting were cultivated throughout Persia, some more, others less, under the spell of Chinese painting. Centuries after the Mongols, Chinese elements survive in the Asiatic appearance of figures, the incorporation of Chinese rocks and clouds, and the appearance of motifs such as dragons and chrysanthemums. Persian miniatures, in turn, influenced Mughal manuscripts in India.

Characteristics of many Persian manuscripts include a portrayal of figures in a relatively shadowless world, usually sumptuously dressed and occupying a richly decorative environment. Persian artists admire intricate details and multicolored geometric patterns. Space is divided into a series of flat planes. The marriage of text and calligraphy is especially stressed, as the words are often written with consummate precision in spaces reserved for them on the page.

The viewer's point of view shifts in a world perceived at various angles—sometimes looking directly at some figures, while also looking down at the floor and carpets. Artists depict a lavishly ornamented architectural setting with crowded compositions of doll-like figures distinguishable by a brilliant color palette.

Bahram Gur Fights the Karg, folio from the Great Il-Khanid
Shahnama, Islamic; Persian, c. 1330–1340, ink and opaque
watercolor, gold, and silver on paper, Harvard University Art Gallery,
Cambridge, Massachusetts (Figure 9.8)

Form
- Large painted surface area; calligraphy on the top and bottom
 frame the image.
- Areas of flat color.
- Spatial recession indicated by the overlapping planes.
- Atmospheric perspective seen in the light-bluish background.

Content
- Bahram Gur was an ancient Iranian king from the Sassanian dynasty.
- He represents the ideal king; wears a crown and a golden halo.
- Mongol artists of Persia sought to link themselves to great ancient
 Persian heroes shown as Mongol horsemen.
- A karg is a kind of unicorn or horned wolf he fought during his trip
 to India.
- Cross-cultural influences: Bahram Gur wears a garment of
 European fabric; Chinese landscape conventions can be seen in the
 background; these aspects connect the painting with trade along
 the Silk Road.

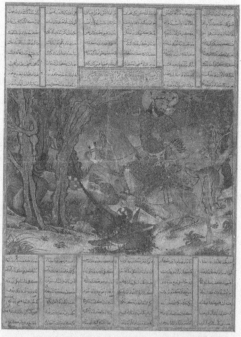

Figure 9.8: *Bahram Gur Fights the Karg*, folio from
the Great Il-Khanid *Shahnama*, Islamic; Persian, c.
1330–1340, ink and opaque watercolor, gold, and
silver on paper, Harvard University Art Gallery,
Cambridge, Massachusetts

Context
- Because of its lavish production, it is assumed to have been commissioned by a high-rank-
 ing member of the Ilkhanid court and produced at the court scriptorium as a chronicle of
 great Persian kings.
- A high point of Persian manuscripts; very lavish.
- The original story by Firdawsi was written around 1010.
- Folio from the text called the *Great Ilkhanid Shahnama,* or the *Book of
 Kings,* a Persian epic.
- Originally one of 280 folios by several different artists; 57 pages survive.

Content Area West and Central Asia, Image 189

Web Source *http://www.harvardartmuseums.org/art/169542*

- **Cross-Cultural Comparisons for Essay Question 1: Scenes of Conquering**
 - Athena from the Temple of Zeus (Figure 4.9)
 - Narmer Palette (Figure 3.4)
 - Ludovisi Battle Sarcophagus (Figure 6.17)

Sultan Muhammad, *The Court of Gayumars,* **from the Shah Tahmasp's**
Shahnama, **1522–1525, ink, opaque watercolor, and gold on paper,**
Aga Khan Museum, Toronto, Canada (Figure 9.9)

Form
- Large painted surface area; calligraphy diminished.
- Harmony between man and landscape.
- Minute details do not overwhelm the harmony of the scene.
- Very richly and decoratively painted with vibrant colors.
- Minute scale suggest the use of fine brushes, perhaps of squirrel hairs.

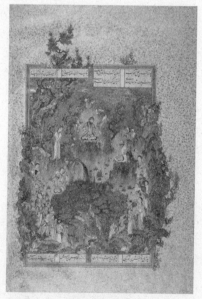

Figure 9.9: Sultan Muhammad, *The Court
of Gayumars*, from the Shah Tahmasp's
Shahnama, 1522–1525, ink, opaque
watercolor, and gold on paper, Aga Khan
Museum, Toronto, Canada

Content

■ This excerpt shows the first king of Iran, Gayumars, enthroned before his community, ruling from a mountaintop.

■ During his reign, men learned how to prepare food and prepare leopard skins as clothing; wild animals are shown as meek and submissive.

■ On left, his son Siyamak; on right, his grandson Hushang.

■ His court appears in a semicircle below him; court attire includes the wearing of leopard skins.

■ The angel Surush tells Gayumars that his son will be murdered by the Black Div, son of the demon Ahriman; his death will be avenged by Hushang, who will rescue the Iranian throne.

Context

■ Persian manuscript.

■ The original story by Firdawsi was written around 1010.

■ Folio from the text called the *Great Ilkhanid Shahnama* or the *Book of Kings*, a Persian epic.

■ Produced for the Safavid ruler of Iran, Shah Tahmasp I, who saw himself as part of a proud tradition of Persian kings.

■ Whole book contains 258 illustrated pages.

Content Area West and Central Asia, Image 190

Web Source *https://agakhanmuseum.org/collection/artifact/court-of-kayumars-akm165*

■ **Cross-Cultural Comparisons for Essay Question 1: Court Ruler**

– Bichitr, *Jahangir Preferring a Sufi Shaikh to Kings* (Figure 23.9)

– Presentation of Fijian mats and tapa cloths to Queen Elizabeth II (Figure 28.10)

– Velázquez, *Las Meninas* (Figure 17.7)

ISLAMIC ARCHITECTURE

All mosques are oriented toward Mecca because Muslims must pray five times a day facing the holy city. The **qiblah**, or direction, to Mecca is marked by the **mihrab** (Figure 9.10), an empty niche, which directs the worshipper's attention.

To remind the faithful of the times to pray, great **minarets** (Figure 9.16a) are constructed in every corner of the Muslim world, from which the call to prayer is recited to the faithful. Minarets are composed of a base, a tall shaft with an internal staircase, and a gallery from which **muezzins** call people to prayer. Galleries are often covered with canopies to protect the occupants from the weather.

Figure 9.10: A mihrab

Mosques come in many varieties. The most common designs are either the hypostyle halls like the **Great Mosque at Córdoba** (eighth–tenth centuries) (Figures 9.14a–9.14e) or the unified open interior as the **Mosque of Selim II** (1568–1575) (Figures 9.16a–9.16c). The focus of all prayer is the mihrab, which points the direction to Mecca.

The Mosque of Selim II has a unified central core with a brilliant dome surmounting a centrally organized ground plan. Works like this were inspired by Byzantine architecture. The domes of mosques and tombs employ squinches, which in Islamic hands can be made to form an elaborate orchestration of suspended facets called **muqarnas**.

In Iran mosques evolved around a centrally placed courtyard. Each side features a half-dome open at one end called an **iwan**. The Great Mosque in Isfahan, Iran (Figure 9.13) might be the first example of this architectural arrangement.

The Kaaba, Islamic and Pre-Islamic monument; rededicated by Muhammad in 631–632, multiple renovations; granite masonry, covered with silk curtain, and calligraphy in gold and silver-wrapped thread, Mecca, Saudi Arabia (Figures 9.11a and 9.11b)

Function
- Mecca is the spiritual center of Islam; this is the most sacred site in Islam.
- A large mosque surrounds the Kaaba.
- Destination for those making the hajj, or spiritual pilgrimage, to Mecca.
- Pilgrims circumambulate the Kaaba counterclockwise seven times.

Materials
- The Kaaba is made of granite; the floor is made of marble and limestone.
- The Kaaba is covered by textiles; the cloth is called the Kiswa and is changed annually.

Context
- Kaaba means cube in Arabic; the Kaaba is cube-like in shape.
- Kaaba said to have been built by Ibrahim (Abraham, in the Western tradition) and Ishamel for God
- Existing structure encases the black stone in the eastern corner, the only part of the original structure by Ibrahim that survives.
- Has been repaired and reconstructed many times since Muhammad's time.

Content Area West and Central Asia, Image 183

Web Source http://archnet.org/sites/3790

- **Cross-Cultural Comparisons for Essay Question 1: Buildings Built on Important Sites**
 - Dome of the Rock (Figures 9.12a, 9.12b)
 - Lin, Vietnam Veterans Memorial (Figure 29.4a)
 - Tutankhamun's Tomb (Figure 3.11)

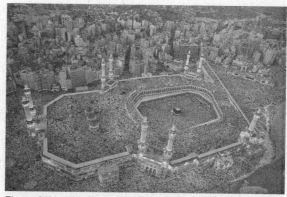

Figure 9.11a: The Kaaba, Islamic and Pre-Islamic monument; rededicated by Muhammad in 631–632, multiple renovations; granite masonry, covered with silk curtain, and calligraphy in gold and silver-wrapped thread, Mecca, Saudi Arabia

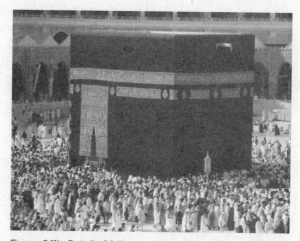

Figure 9.11b: Detail of 9.11a

Dome of the Rock, Islamic, Umayyad, 691–692, with multiple renovations, stone masonry and wood roof decorated with glazed ceramic tile, mosaics, and gilt aluminum and bronze dome, Jerusalem (Figures 9.12a and 9.12b)

Form
- Domed wooden octagon.
- Influenced by centrally planned buildings (cf. Santa Costanza and the Pantheon, Figure 6.11c).
- Columns are spolia taken from Roman monuments.

Function
- Pilgrimage site for the faithful.
- Not a mosque; its original function has been debated.

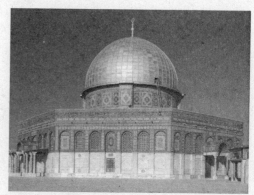

Figure 9.12a: Dome of the Rock, Islamic, Umayyad, 691–692, with multiple renovations, stone masonry and wood roof decorated with glazed ceramic tile, mosaics, and gilt aluminum and bronze dome, Jerusalem

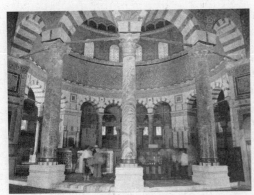
Figure 9.12b: Interior of the Dome of the Rock

Context

- This building houses several sacred sites:
 - The place where Adam was born.
 - The site in which Abraham nearly sacrificed Isaac.
 - The place where Muhammad ascended to heaven (as described in the Qu'ran).
 - The place where the Temple of Jerusalem was located.
- Meant to rival the Christian church of the Holy Sepulcher in Jerusalem, although it was inspired by its domed rotunda.
- Arabic calligraphy on the mosaic decoration urges Muslims to embrace Allah as the one God and indicates that the Christian notion of the Trinity is an aspect of polytheism.
- Oldest surviving Qur'an verses; first use of Qur'an verses in architecture; one of the oldest Muslim buildings.
- Erected by Abd al-Malik, caliph of the Umayyad Dynasty.

Content Area West and Central Asia, Image 185

Web Source *http://archnet.org/sites/2814*

- **Cross-Cultural Comparisons for Essay Question 1: Domes**
 - Taj Mahal (Figures 9.17a, 9.17b)
 - Pantheon (Figures 6.11a, 6.11b)
 - Hagia Sophia (Figures 8.3a, 8.3b)

Great Mosque (Masjid-e Jameh), Islamic: Persian: Seljuk, Il-Khanid, Timurid, and Safavid Dynasties, c. 700 additions and restorations in the 14th, 18th, and 20th centuries, stone, brick, wood, plaster, ceramic tile, Isfahan, Iran (Figures 9.13a, 9.13b, 9.13c, and 9.13d)

Form

- Large central rectangular courtyard surrounded by a two-story arcade.
- Typical of Muslim architecture is to have one large arch flanked by two stories of smaller arches (cf. the Taj Mahal, Fig. 9.17a).
- The qibla iwan is the largest and most decorative; its size indicates the direction to Mecca.
- Southern iwan is an entry for a private space used by the sultan and his retinue; its dome is adorned by decorative tiles; this contains the main mihrab of the mosque.

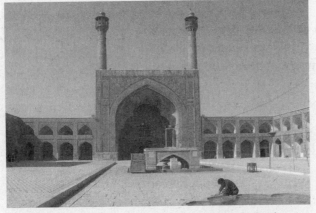
Figure 9.13a: Great Mosque (Masjid-e Jameh), Islamic: Persian: Seljuk, Il-Khanid, Timurid, and Safavid Dynasties, c. 700 additions and restorations in the 14th, 18th, and 20th centuries, stone, brick, wood, plaster, ceramic tile, Isfahan, Iran

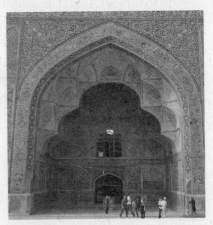
Figure 9.13b: Detail of 9.13a

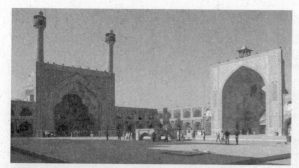
Figure 9.13c: Courtyard of 9.13a

Figure 9.13d: Mihrab (prayer room) of the Great Mosque (Masjid-e Jameh)

- Muqarnes: an ornamental and intricate vaulting placed on the underside of arches.
- Elaborately decorated mihrab on the interior points the direction to Mecca; the elaborateness reflects the fact that this is the holiest section of the shrine.

Function
- Muslim mosque.
- Each side of the courtyard, or sahn, has a centrally placed iwan; may be the first mosque to have this feature.
- Iwans have different roles, reflecting their size and ornamentation.

Context
- Iwan originally seen in palace architecture; used here for the first time to emphasize the sanctuary.
- This mosque is nestled in an urban center; many gates give access.
- The mosque's outside walls share support with other buildings.

Content Area West and Central Asia, Image 186
Web Source http://archnet.org/sites/1621

- **Cross-Cultural Comparisons for Essay Question 1: Houses of Worship**
 - Chartres Cathedral (Figures 12.4a, 12.4b, 12.4c)
 - Great Stupa at Sanchi (Figures 23.4a, 23.4b)
 - White Temple and its ziggurat (Figures 2.1a, 2.1b)

Great Mosque, Umayyad Dynasty, 785-786, 8th–10th centuries, stone masonry, Córdoba, Spain (Figures 9.14a, 9.14b, 9.14c, 9.14d, and 9.14e)

Form
- Double-arched columns, brilliantly articulated in alternating bands of color.
- Light and airy interior.

Figure 9.14a: Great Mosque, aerial view, Umayyad Dynasty, begun 785–786, stone masonry, Córdoba, Spain

Figure 9.14b: Flank view of Great Mosque, Córdoba, Spain

Figure 9.14c: Detail of façade of 9.14a

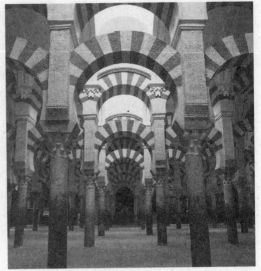

Figure 9.14d: Great Mosque, Umayyad Dynasty, 785-786, stone masonry, Córdoba, Spain

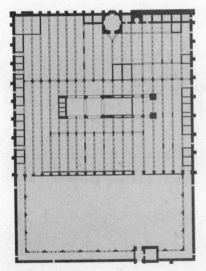

Figure 9.14e: Ground plan for Great Mosque, Córdoba, Spain

- Horseshoe-shaped arches derived from the Visigoths of Spain.
- Hypostyle mosque: no central focus, no congregational worship.
- Elaborately carved doorways signal principle entrances into the mosque and contrast with unadorned walls that otherwise flank the mosque.

Function
- Muslim mosque.

History
- The site was originally a Roman temple dedicated to Janus, then a Visigothic church, and then the mosque was built.
- Columns are spolia from ancient Roman structures.
- After a Christian reconquest, the center of the mosque was used for a church.
- Original wooden ceiling replaced by vaulting after Spanish reconquest.

Context
- Complex dome with elaborate squinches was built over the mihrab; it was inspired by Byzantine architecture.
- Horseshoe-shaped arches were inspired by Visigothic buildings in Spain.
- Relatively short columns made ceilings low; doubling of arches enhances interior space, perhaps influenced by the Roman aqueduct in Mérida, Spain.
- Kufic calligraphy on walls and vaults.
- Original patron: Abl al Rahman.

Content Area Early Europe and Colonial Americas, Image 56

Web Source http://www.mezquitadecordoba.org/en/history-mosque-cordoba.asp

- **Cross-Cultural Comparisons for Essay Question 1: Architectural Plans**
 - Sullivan, Carson, Pirie, Scott and Company Building (Figure 21.14c)
 - Chartres Cathedral (Figure 12.4c)
 - Temple of Amun-Re (Figure 3.8c)

Alhambra, Nasrid Dynasty, 1354–1391, whitewashed adobe stucco, wood, tile, paint, and gilding, Granada, Spain (Figures 9.15a, 9.15b, 9.15c, and 9.15d)

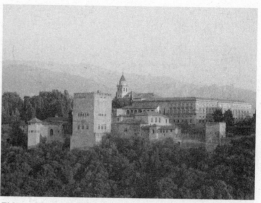

Form

- Light, airy interiors; fortress-like exterior.
- Contains palaces, gardens, water pools, fountains, courtyards.
- Small, low-bubbling fountains in each room contribute to cool temperatures in the summer.
- Inspired by the Charbagh gardens from Persia.

Function

- Palace of the Nasrid sultans of southern Spain.
- The Alcazaba (Arab for fortress) is the oldest section and is visible from the exterior.
- The Alcazaba is a double-walled fortress of solid and vaulted towers containing barracks, cisterns, baths, houses, storerooms, and a dungeon.

Context

- Built on a hill overlooking the city of Granada.

Content Area Early Europe and Colonial Americas, Image 65

Web Source http://archnet.org/sites/2547

Figure 9.15a: Alhambra, Nasrid Dynasty, 1354–1391, whitewashed adobe stucco, wood, tile, paint, and gilding, Granada, Spain

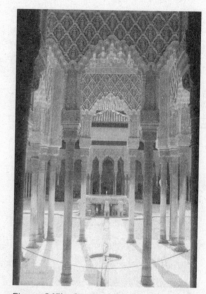

Court of the Lions (Figure 9.15b)

Form

- Thin columns support heavy roofs; a feeling of weightlessness.
- Intricately patterned and sculpted ceilings and walls.
- Central fountain supported by 12 protective lions; animal imagery permitted in secular monuments.
- Parts of the walls are chiseled through to create vibrant light patterns within.

Context

- Built by Muhammad V between 1370 and 1391.
- Palaces follow the tradition of western Islamic palace design: rooms arranged symmetrically around rectangular courtyards.
- The courtyard is divided into four parts, each symbolizing one of the four parts of the world. Each part of the world is therefore irrigated by a water channel that symbolizes the four rivers of Paradise.
- The courtyard is an architectural symbol of Paradise combining its gardens, water, and columns in a unified expression.

Content Area Early Europe and Colonial Americas, Image 65

Figure 9.15b: Court of the Lions (See page 216.)

Hall of the Sisters (Figure 9.15c)

Form

- Sixteen small windows are placed at the top of hall; light dissolves into a honeycomb of stalactites hanging from the ceiling.
- Five thousand muqarnas, carved in stucco onto the ceiling, refract light.
- Abstract patterns, abstraction of forms.
- Highly sophisticated and refined interior.

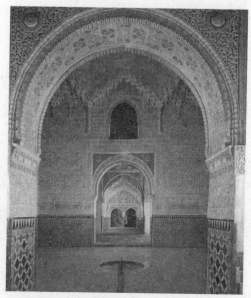

Figure 9.15c: Hall of the Sisters, Alhambra, Spain

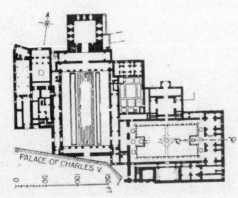

Figure 9.15d: Plan of the Alhambra, Granada, Spain

Context

- Perhaps used as a music room or for receptions.
- The hall is so named because of two big twin marble flagstones placed on the floor. In between these flagstones is a small fountain and a short canal from which water flows to the Court of the Lions (Figure 9.15b).
- The hall was built by order of Mohammed V.

Content Area Early Europe and Colonial Americas, Image 65

- **Cross-Cultural Comparisons for Essay Question 1: Interiors**
 - House of the Vettii (Figure 6.13)
 - Wright, Fallingwater (Figure 22.16b)
 - Hall of Mirrors, Versailles (Figure 17.3d)

Sinan, Mosque of Selim II, 1568–1575, brick and stone, Edirne, Turkey (Figures 9.16a, 9.16b, and 9.16c)

Form

- Extremely thin soaring minarets.
- Abundant window space makes for a brilliantly lit interior.
- Octagonal interior, with eight pillars resting on a square set of piers.
- Squinches decorated with muqarnas transition the round dome to the huge piers below.
- Smaller half-domes in the corners support the main dome and transition the space to a square ground plan.
- Decorative display of Iznik mosaic and tile work.

Function

- Mosque part of a complex, including a hospital, school, and library.

Context

- Inspired by Hagia Sophia (Figure 8.3a), but a centrally planned building.

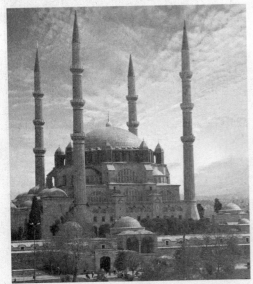

Figure 9.16a: Sinan, Mosque of Selim II, 1568–1575, brick and stone, Edirne, Turkey

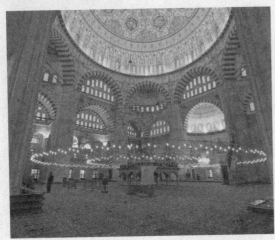

Figure 9.16b: Sinan, Mosque of Selim II, interior

Figure 9.16c: Ground plan of Sinan, Mosque of Selim II

- Open airy interior contrasts with conventional mosques that have partitioned interiors.
- Sinan was chief court architect for the Ottoman emperor Suleyman the Magnificent (r. 1520–1566).

Content Area Early Europe and Colonial Americas, Image 84

Web Source http://www.3dmekanlar.com/en/selimiye-mosque-2.html

- **Cross-Cultural Comparisons for Essay Question 1: Domes**
 - Pantheon (Figures 6.11a, 6.11b)
 - Dome of the Rock (Figures 9.12a, 9.12b)
 - Hagia Sophia (Figures 8.3a, 8.3b, 8.3c)

Content Area: South, East, and Southeast Asia, 300 B.C.E.–1980 C.E.

Taj Mahal, c. 1632–1653, stone masonry and marble with inlay of precious and semi-precious stones, gardens, Agra, India (Figures 9.17a and 9.17b)

Masons, marble workers, mosaicists, and decorators working under the supervision of Ustad Ahmad Lahori, architect of the emperor.

Form
- Symmetrical harmony of design.
- Typical Islamic feature of one large central arch flanked by two smaller arches.
- Square plan with chamfered corners.
- Onion-shaped dome rises gracefully from the façade.
- Small kiosks around dome lessen severity.
- Intricate floral and geometric inlays of colored stone.
- Minarets act like a picture frame, directing the eye of the viewer and sheltering the monument.
- Texts from the Qu'ran cover surface.
- Motifs of flowering plants, carved into the walls of the structure, may have been inspired by engravings in European herbals.

Function
- Built as the tomb of Mumtaz Mahal, Shah Jahan's wife; the shah was interred next to her after his death.

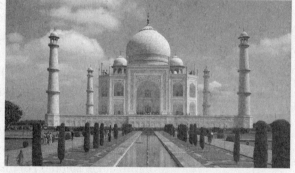

Figure 9.17a: Taj Mahal, c. 1632–1653, stone masonry and marble with inlay of precious and semi precious stones; gardens, Agra, India

Context
- Translated to mean "crown palace."
- Named for Mumtaz Mahal, deceased wife of Shah Jahan, who died while giving birth to her 14th child.
- Part of a larger ensemble of buildings.
- Grounds represent a vast funerary garden, the gardens found in heaven in the Islamic tradition.
- Taj Mahal reflected in the Charbagh garden (that is, a garden that is rectangular and based on the four gardens of Paradise mentioned in the Qu'ran).
- Different from other Mongol buildings in its extensive use of white marble, which was generally reserved for interior spaces; white marble contrasts with the red sandstone of the flanking buildings.
- Influence of Hindi texts in which white is seen as a symbol of purity for priests and red for warriors; the Taj Mahal is white marble but the surrounding buildings are red sandstone.

Figure 9. 17b: Interior of Taj Mahal, Agra, India

Theory

- May have been built to salute the grandeur of the Shah Jahan and his royal kingdom, as much as to honor his wife's memory.
- Alternate theory suggests that this is a symbolic representation of a Divine Throne on the Day of Judgment.

Content Area South, East, and Southeast Asia, Image 209

Web Source *http://www.history.com/topics/taj-mahal*

- **Cross-Cultural Comparisons for Essay Question 1: Gardens**
 - Versailles (Figure 17.3e)
 - Kusama, *Narcissus Garden* (Figures 22.25a, 22.25b)
 - Ryoan-ji (Figures 25.2a, 25.2b, 25.2c)

VOCABULARY

Arabesque: a flowing, intricate, and symmetrical pattern deriving from floral motifs (Figure 9.1)

Calligraphy: decorative or beautiful handwriting (Figure 9.2)

Charbagh: a rectangular garden in the Persian tradition that is based on the four gardens of Paradise mentioned in the Qur'an

Hajj: an Islamic pilgrimage to Mecca that is required of devout Muslims as one of the five pillars of Islam

Hypostyle: a hall that has a roof supported by a dense thicket of columns (Figure 9.14d)

Illuminated manuscript: a manuscript that is hand-decorated with painted initials, marginal illustrations, and larger images that add a pictorial element to the written text (Figure 9.8)

Iwan: a rectangular vaulted space in a Muslim building that is walled on three sides and open on the fourth (Figure 9.13a)

Jali: perforated ornamental stone screens in Islamic art

Kufic: a highly ornamental Islamic script (Figure 9.5)

Madrasa: a Muslim school or university often attached to a mosque

Mausoleum: a building, usually large, that contains tombs (Figure 9.17a)

Mecca, Medina: Islamic holy cities; Mecca is the birthplace of Muhammad and the city all Muslims turn to in prayer; Medina is where Muhammad was first accepted as the Prophet, and where his tomb is located

Mihrab: a central niche in a mosque, which indicates the direction to Mecca (Figure 9.10)

Minaret: a tall, slender column used to call people to prayer (Figure 9.13a)

Minbar: a pulpit from which sermons are given

Mosque: a Muslim house of worship (Figure 9.14a)

Muezzin: an Islamic official who calls people to prayer traditionally from a minaret

Muhammad (570?–632): The Prophet whose revelations and teachings form the foundation of Islam

Muqarna: a honeycomb-like decoration often applied in Islamic buildings to domes, niches, capitals, or vaults. The surface resembles intricate stalactites (Figure 9.15c)

Pyxis (pronounced "pick-sis"): a small cylinder-shaped container with a detachable lid used to contain cosmetics or jewelry (Figure 9.4)

Qibla: the direction toward Mecca which Muslims face in prayer

Qur'an: the Islamic sacred text, dictated to the Prophet Muhammad by the Angel Gabriel

Sahn: a courtyard in Islamic architecture (Figure 9.13c)

Shahnama, or ***The Book of Kings:*** a long epic poem written by the Persian poet Firdawsi between c. 977 and 1010 C.E.; the national epic of Iran (Figure 9.9)

Squinch: the polygonal base of a dome that makes a transition from the round dome to a flat wall (Figure 9.16b)

Tessellation: decoration using polygonal shapes with no gaps (Figure 9.3)

Voussoirs (pronounced "vo͞o-swar"): a wedge-shaped stone that forms the curved part of an arch; the central voussoir is called a **keystone** (Figure 9.14d)

SUMMARY

Although not specifically banned by the Qur'an, a traditional prohibition against figural art dominates much of the Islamic movement. This did not prove to be an impediment for Muslim artists, who formed an endless creative expression of abstract designs based on calligraphy, arabesques, and tessellations. Figural art occurs mostly in Persian manuscripts that depict lavishly costumed courtiers recreating famous stories from Arabic literature.

Islamic architecture borrows freely from Byzantine, Sassanian, and Early Christian sources. Mosques all have niches, called mihrabs, which direct the worshipper's attention to Mecca. Religious symbolism dominates mosques, but is also richly represented in secular buildings such as tombs or palaces.

PRACTICE EXERCISES

Multiple-Choice

Questions 1–3 refer to this picture of a basin.

1. The decoration on the basin called the *Baptistère de Saint Louis* is noted for its use of

 (A) mixed media

 (B) contrapposto

 (C) horror vacui

 (D) encaustic

2. The original function of the basin called the *Baptistère de Saint Louis* was probably for

 (A) the baptisms of infants in the royal household

 (B) coronation rituals of royalty

 (C) retelling mythological stories of the ancient past

 (D) washing hands during official ceremonies

3. The importance of the item is alluded to in the

 (A) rich material used to create it
 (B) depiction of royal family members and their entourage
 (C) use of lions and peacocks as royal symbols
 (D) purple color which symbolized royalty

4. How has the Great Mosque at Córdoba been altered by Christians after the reconquest of Spain?

 (A) The interior arches were taken down to make a vast unified space.
 (B) The mihrab was destroyed and an altar was placed in its stead.
 (C) The interior was reroofed using European vaulting techniques.
 (D) The building was turned into a church and then back into a mosque again.

5. The Kufic script used in Islamic calligraphy is read in the same direction as which of the following works?

 (A) The Golden Haggadah
 (B) *The Book of Lindisfarne*
 (C) *The Vienna Genesis*
 (D) The *Bayeux Tapestry*

Long Essay

Practice Question 2: Visual and Contextual Analysis
Suggested Time: 25 minutes

In Islamic and Indian art, artists often use a combination of abstract, calligraphic, and/or figural design to recount stories from the past.

Select and completely identify an Islamic or Indian work of art that combines abstract, calligraphic, and/or figural art. You may choose one from the suggested list below or any other relevant work.

Explain how the artist used a combination of designs to recount stories in Islamic and Indian manuscripts.

In your answer, make sure to:

- Accurately identify the work you have chosen with *at least two* identifiers beyond those given.
- Respond to the question with an art historically defensible thesis statement.
- Support your claim with *at least two* examples of visual and/or contextual evidence.
- Explain how the evidence that you have supplied supports your thesis.
- Use your evidence to corroborate or modify your thesis.

Court of Gaymars
Bahram Gur Fights the Karg
Jahangir Preferring a Sufi Shaikh to Kings

ANSWERS EXPLAINED

Multiple-Choice

1. **(C)** All of the surfaces on the basin are covered with decoration. The definition of horror vacui (Latin for "fear of empty spaces") suggests that artists intentionally filled the whole surface with patterns, as is the case with this basin.

2. **(D)** Originally this basin functioned as a bowl probably for washing hands during ceremonies. It was later brought into the French royal court and used for baptisms.

3. **(A)** The basin is made of brass, inlaid with gold and silver—rich items indicating court patronage.

4. **(C)** After Spain was reconquered from the Moors in 1492, this building had its original wooden ceiling removed, and European-style vaulting was installed.

5. **(A)** Kufic script is read right to left, the way Hebrew is. The Golden Haggadah is written in Hebrew.

Long Essay Rubric

Task	Point Value	Key Points in a Good Response
Accurately identify the work you have chosen with *at least two* identifiers beyond those given.	1	*Gayumars:* Sultan Muhammad, Shah Tahmasp's *Shahnama*, 1522–1525, ink, opaque watercolor, and gold on paper *Bahram Gur:* Great Il-Khanid *Shahnama* c. 1330–1340, ink and opaque watercolor, gold and silver on paper *Jahangir:* Bichitr, c. 1620, watercolor, gold, and ink on paper
Respond to the question with an art historically defensible thesis statement.	1	The thesis statement must be an art historically sound claim that responds to the question and does not merely restate it. The thesis statement should come at the beginning of the argument and be at least one, preferably two sentences. For example: *The Court of Gayumars* shows the combination of multiple decorative elements to recount the ancient Persian story of a king enthroned before his community. The figural designs visually tell the story of Gayumars; this is complemented by the calligraphy above and below the main illustration and the abstract designs that fill the otherwise empty sections of the page.
Support your claim with *at least two* examples of visual and/or contextual evidence.	2	*Two* visual or contextual examples are needed here. For these examples, part of the evidence could involve a discussion of the stories being told, and how they are illustrated by the artist, and/or the direct relationship of the text to the image.
Explain how the evidence that you have supplied supports your thesis.	1	Good responses link the evidence you have provided with the main thesis statement. In these examples, one could discuss how the combination of figural, abstract, and calligraphic decoration represents a union of the visual arts that is typical of Islamic and Indian art.
Use your evidence to corroborate or modify your thesis.	1	This point is earned when a student demonstrates a depth of understanding, in this case of manuscripts from this part of the world. The student must demonstrate multiple insights on a given subject. For example, the student could discuss how calligraphy was the highest art form in Islam; in hand-painted manuscripts of the Qu'ran the words are elegantly painted—there are no illustrations. Some Muslims prefer no illustrations of any type in their artwork, which sets apart Persian and Indian works.

Content Area: Early Europe and Colonial Americas, 200–1750 c.e.

Early Medieval Art

TIME PERIOD: 450–1050		
Merovingian Art	481–714	France
Hiberno-Saxon Art	6th–8th centuries	British Isles

ENDURING UNDERSTANDING: The culture, beliefs, and physical settings of a region play an important role in the creation, subject matter, and siting of works of art.

Learning Objective: Discuss how the culture, beliefs, or physical setting can influence the making of a work of art. (For example: *Lindisfarne Gospels*)

Essential Knowledge:

- Early Medieval art is a part of the medieval artistic tradition.
- In the Early Medieval period, royal courts emphasized the study of theology, music, and writing.
- Early Medieval art avoids naturalism and emphasizes stylistic variety. Text is often incorporated into Early Medieval artworks.

ENDURING UNDERSTANDING: Cultural interaction through war, trade, and travel can influence art and art making.

Learning Objective: Discuss how works of art are influenced by cultural interaction. (For example: Saint Luke portrait page from the *Lindisfarne Gospels*)

Essential Knowledge:

- There is an active exchange of artistic ideas throughout the Middle Ages.
- There is a great influence of Roman art on Early Medieval art.

ENDURING UNDERSTANDING: Art and art making can be influenced by a variety of concerns including audience, function, and patron.

Learning Objective: Discuss how art can be influenced by audience, function, and/or patron. (For example: Merovingian looped fibulae)

Essential Knowledge:

- Works of art were often displayed in religious or court settings.
- Surviving architecture is mostly religious.

ENDURING UNDERSTANDING: Art history is best understood through an evolving tradition of theories and interpretations.

Learning Objective: Discuss how works of art have had an evolving interpretation based on visual analysis and interdisciplinary evidence. (For example: Cross-carpet page from *The Lindisfarne Gospels*)

Essential Knowledge:

- The study of art history is shaped by changing analyses based on scholarship, theories, context, and written records.
- Contextual information comes from written records that are religious or civic.

HISTORICAL BACKGROUND

In the year 600, almost everything that was known was old. The great technological breakthroughs of the Romans were either lost to history or beyond the capabilities of the migratory people of the seventh century. This was the age of mass migrations sweeping across Europe, an age epitomized by the fifth-century king, Attila the Hun, whose hordes were famous for despoiling all before them.

Certainly Attila was not alone. The Vikings from Scandinavia, in their speedy boats, flew across the North Sea and invaded the British Isles and colonized parts of France.

Other groups, like the notorious Vandals, did much to destroy the remains of Roman civilization. So desperate was this era that historians named it the "Dark Ages," a term that more reflects our knowledge of the times than the times themselves.

However, stability in Europe was reached at the end of the eighth century when a group of Frankish kings, most notably Charlemagne, built an impressive empire whose capital was centered in Aachen, Germany.

Patronage and Artistic Life

Monasteries were the principal centers of learning in an age when even the emperor, Charlemagne, could read, but not write more than his name. Therefore, artists who could both write and draw were particularly honored for the creation of manuscripts.

The modern idea that artists should be original and say something fresh or new in each work is a notion that was largely unknown in the Middle Ages. Scribes copied great works of ancient literature, like the Bible or medical treatises; they did not record contemporary literature or folk tales. Scribes were expected to maintain the wording of the original, while illustrators painted important scenes, keeping one eye on traditional approaches, and another on his or her own creative powers. Therefore, the text of a manuscript is generally an exact copy of a continuously recopied book; the illustrations allow the artist some freedom of expression.

EARLY MEDIEVAL ART

One of the great glories of medieval art is the decoration of manuscript books, called **codices**, which were improvements over ancient scrolls both for ease of use and durability. A codex was made of resilient antelope or calf hide, called **vellum**, or sheep or goat hide, called **parchment**. These hides were more durable than the friable papyrus used in making ancient scrolls. Hides were cut into sheets and soaked in lime in order to free them from oil and hair. The skin was then dried and perhaps chalk was added to whiten the surface. Artisans then prepared the skins by scraping them down to an even thickness with a sharp knife; each page had to

be rubbed smooth to remove impurities. The hides were then folded to form small booklets of eight pages. Parchment was so valued as a writing surface that it continued to be used for manuscripts even after paper became standard.

The backbone of the hide was arranged so that the spine of the animal ran across the page horizontally. This minimized movement when the hide dried and tried to return to the shape of the animal, perhaps causing the paint to flake.

Illuminations were painted mostly by monks or nuns who wrote in rooms called **scriptoria**, or writing places, that had no heat or light, to prevent fires. Vows of silence were maintained to limit mistakes. A team often worked on one book; scribes copied the text and illustrators drew capital letters as painters illustrated scenes from the Bible. Eventually, the booklets were sewn together to create a manuscript.

Manuscript books had a sacred quality. This was the word of God, and had to be treated with appropriate deference. The books were covered with bindings of wood or leather, and gold leaf was lavished on the surfaces. Finally, precious gems were inset on the cover.

A spectacular hoard of medieval gold and silverwork was discovered on a farm in Shropshire, England, in 2009. This find is so large that it has forced scholars to reconsider everything that is known about the Anglo-Saxon kingdoms of medieval Britain.

Objects are done in the **cloisonné technique**, with **horror vacui** designs featuring **animal style** decoration. Interlace patternings are common. Images enjoy an elaborate symmetry, with animals alternating with geometric designs. Most of the objects that survive are portable.

MEROVINGIAN ART

The Merovingians were a dynasty of Frankish kings who, according to tradition, descended from Merovech, chief of the Salian Franks. Power was solidified under Clovis (reigned 481–511) who ruled what is today France and southwestern Germany. The Frankish custom of dividing property among sons when a father died led to instability because Clovis's four male descendants fought over their patrimony. With the constant division of land after a king's death, Merovingian history became marked by internal struggles and civil wars.

Even so, court life and art production could be quite splendid. Merovingian rulers treated their kingdom as private property and exploited its wealth as much as possible, spending lavishly on themselves.

Royal burials supply almost all our knowledge of Merovingian art. A wide range of metal objects were interred with the dead, including personal jewelry items like brooches, discs, pins, earrings, and bracelets. Garment clasps, called fibulae, were particular specialties. They were often inlaid with hard stones, like garnets, and were made using chasing and cloisonné techniques.

Figure 10.1: Merovingian looped fibulae, early medieval Europe, mid-6th century, silver gilt worked in filigree with semiprecious stones, inlays of garnets and other stones, Musee d'Archeologie Nationale, Saint-Germain-en-Laye, France

Merovingian looped fibulae, early medieval Europe, mid-6th century, silver gilt worked in filigree with semiprecious stones, inlays of garnets and other stones, Musee d'Archeologie Nationale, Saint-Germain-en-Laye, France (Figure 10.1)

Form

- Zoomorphic elements: fish and bird, possibly Christian or pagan symbols.
- Highly abstracted forms derived from the classical tradition.

Function

- Fibula: a pin or brooch used to fasten garments; showed the prestige of the wearer.
- Small portable objects.

Technique

- Cloisonné and chasing techniques.

Context

- Found in a grave.
- Probably made for a woman.

Content Area Early Europe and Colonial Americas, Image 53

Web Source *https://art.thewalters.org/detail/11727/bow-fibula/*

- **Cross-Cultural Comparisons for Essay Question 1: Zoomorphic Elements**
 - Beaker with ibex motifs (Figure 1.10)
 - Buk (mask) (Figure 28.9)
 - Aka elephant mask (Figure 27.12)

HIBERNO SAXON ART

Figure 10.2a: Cross-carpet page from the Book of Matthew from *The Book of Lindisfarne*, early medieval Europe, c. 700, illuminated manuscript, ink, pigments, and gold on vellum, British Library, London

Hiberno Saxon art refers to the art of the British Isles in the Early Medieval period; Hibernia is the ancient name for Ireland. The main artistic expression is illuminated manuscripts, of which a particularly rich collection still survives.

Hiberno Saxon art relies on complicated interlace patterns in a frenzy of **horror vacui**. The borders of these pages harbor animals in stylized combat patterns, sometimes called the **animal style**. Each section of the illustrated text opens with huge initials that are rich fields for ornamentation. The Irish artists who worked on these books had an exceptional handling of color and form, featuring a brilliant transference of polychrome techniques to manuscripts.

Lindisfarne Gospels, **early medieval Europe, c. 700, illuminated manuscript, ink, pigments, and gold on vellum, British Library, London (Figures 10.2a, 10.2b, and 10.2c)**

Function

- The first four books of the New Testament, used for services and private devotion.

Materials

- Manuscript made from 130 calfskins.

Content

- Evangelist portraits come first, followed by a carpet page (so called because it resembles a carpet). These pages are followed by the opening of the gospel with a large series of capital letters.

Context

- Written by Eadrith, bishop of Lindisfarne.
- Unusual in that it is the work of an individual artist and not a team of scribes.
- Written in Latin with annotations in English between the lines; some Greek letters.
 - Latin script is called half-uncial.
 - English added around 970; it is the oldest surviving manuscript of the Bible in English.
 - English script called Anglo-Saxon miniscule.

Figure 10.2b: Saint Luke portrait page from *Lindisfarne Gospels*, early medieval Europe, c. 700, illuminated manuscript, ink, pigments, and gold on vellum, British Library, London

Figure 10.2c: Saint Luke incipit page from *Lindisfarne Gospels*, early medieval Europe, c. 700, illuminated manuscript, ink, pigments, and gold on vellum, British Library, London

- Uses Saint Jerome's translation of the Bible, called the Vulgate.
- Colophon at end of the book discusses the making of the manuscript.
- Made and used at the Lindisfarne Priory on Holy Island, a major religious center that housed the remains of Saint Cuthbert.

Content Area Early Europe and Colonial Americas, Image 55

Web Source http://www.bl.uk/turning-the-pages/

Cross-carpet page from the *Book of Matthew* from *The Book of Lindisfarne*

Form

- Cross depicted on a page with horror vacui decoration.
- Dog-headed snakes intermix with birds with long beaks.
- Cloisonné style reflected in the bodies of the birds.
- Elongated figures lost in a maze of S shapes.
- Symmetrical arrangement.
- Black background makes patterning stand out.

Context

- Mixture of traditional Celtic imagery and Christian theology.

Content Area Early Europe and Colonial Americas, Image 55

Saint Luke portrait page from *The Book of Lindisfarne*

Context

- The traditional symbol associated with Saint Luke is the calf (a sacrificial animal).
- Identity of the calf is acknowledged in the Latin phrase "imago vituli."
- Saint Luke is identified by Greek words using Latin characters: "Hagios Lucas." There is also Greek text.

- Saint Luke is heavily bearded, which gives weight to his authority as an author, but he appears as a younger man.
- Saint Luke sits with legs crossed holding a scroll and a writing instrument.
- Influenced by classical author portraits.

Content Area Early Europe and Colonial Americas, Image 55

Saint Luke incipit page from *The Book of Lindisfarne*

Content

- This page is called "Incipit," meaning it depicts the opening words of Saint Luke's gospel: "Quoniam Quidem…"
- Numerous Celtic spiral ornaments are painted in the large Q; step patterns appear in the enlarged O.
- Naturalistic detail of a cat in the lower right corner; it has eaten eight birds.
- Incomplete manuscript page; some lettering not filled in.

Content Area Early Europe and Colonial Americas, Image 55

- **Cross-Cultural Comparisons for Essay Question 1: Manuscripts**
 - Golden Haggadah (Figures 12.10a, 12.10b, 12.10c)
 - *Bahram Gur Fights the Karg* (Figure 9.8)
 - Folio from the Qur'an (Figure 9.5)

VOCABULARY

Animal style: a medieval art form in which animals are depicted in a stylized and often complicated pattern, usually seen fighting with one another (Figure 10.2a)

Chasing: to ornament metal by indenting into a surface with a hammer (Figure 10.1)

Cloissonné: enamelwork in which colored areas are separated by thin bands of metal, usually gold or bronze (Figure 10.1)

Codex (plural: **codices**): a manuscript book (Figure 10.2a)

Colophon: 1) a commentary on the end panel of a Chinese scroll, 2) an inscription at the end of a manuscript containing relevant information on its publication

Fibula (plural: **fibulae**): a clasp used to fasten garments (Figure 10.1)

Gospels: the first four books of the New Testament that chronicle the life of Jesus Christ (Figure 10.2b)

Horror vacui: (Latin, meaning "fear of empty spaces") a type of artwork in which the entire surface is filled with objects, people, designs, and ornaments in a crowded, sometimes congested way (Figure 10.2a)

Illuminated manuscript: a manuscript that is hand decorated with painted initials, marginal illustrations, and larger images that add a pictorial element to the written text (Figures 10.2a, 10.2b, and 10.2c)

Parchment: a writing surface made from animal skins; particularly fine parchment made of calf skin is called **vellum** (Figures 10.2a, 10.2b, and 10.2c)

Scriptorium (plural: **scriptoria**): a place in a monastery where monks wrote manuscripts

Zoomorphic: having elements of animal shapes

SUMMARY

The political chaos resulting from the Fall of Rome set in motion a period of migrations. The unifying force in Europe was Christianity, whose adherents established powerful centers of learning, particularly in places like Ireland.

Artists concentrated on portable objects that intermixed the animal style of Germanic art with horror vacui and strong interlacing patterns.

Fibulae and other personal jewelry became a sign of status and wealth.

PRACTICE EXERCISES

Multiple-Choice

1. The *Lindisfarne Gospels* shows classical influence in its

 (A) animals depicted in margins
 (B) figures shown in contrapposto
 (C) use of Latin
 (D) interlace patterning with interweaving forms

2. A fibula can be seen worn in which of the following images?

 (A) *Sarcophagus of the Spouses*
 (B) Augustus of Prima Porta
 (C) Justinian from San Vitale
 (D) Head of a Roman patrician

3. The Merovingian looped fibula shows horror vacui, cloisonné, and chasing techniques common in which of the following traditions?

 (A) Roman
 (B) Byzantine
 (C) Greek
 (D) Celtic

4. Zoomorphic designs, as seen in the *Lindisfarne Gospels*, are similar to those found on

 (A) Camelid sacrum in the shape of a canine
 (B) Anthropomorphic stele
 (C) Jade *cong* from Liangzhu, China
 (D) Tlatilco female figure

5. Gospel books

 (A) are biographies of Jesus
 (B) foretell the coming of Jesus
 (C) discuss apocalyptic visions of the Last Judgment
 (D) are letters written by saints after the death of Jesus

Short Essay

Practice Question 4: Contextual Analysis
Suggested Time: 15 minutes

These are two pages from the *Lindisfarne Gospels.*

What was the original historical or religious context for this work? Describe *at least two* contextual elements.

Describe how the original context influenced the choice of both the materials *and* the imagery in this work.

What aspects of this work show an understanding of cross-cultural connections?

ANSWERS EXPLAINED

Multiple-Choice

1. **(C)** Both (A) and (D) are Celtic inspirations in *The Book of Lindisfarne.* Choice (B) would be correct except that there is no trace of contrapposto in the drawing of this book. The book is written in Latin, a classical language.

2. **(C)** Justinian wears a fibula in the Byzantine mosaics in San Vitale.

3. **(D)** Merovingian looped fibulae show a decline in the classical tradition in Western Europe. Byzantine, Greek, and Roman art are aspects of the classical tradition. Celtic art from Northern Europe developed separately and is from a different tradition.

4. **(C)** Zoomorphic designs, those having elements of animal shapes, are seen in the jade *cong* from Liangzhu, China.

5. **(A)** The four gospels books are, among other things, biographies of the life of Jesus.

Short Essay Rubric

Task	Point Value	Key Points in a Good Response
What was the original historical or religious context for this work? Describe *at least two* contextual elements.	2	Answers could include: ■ This gospel book was used for private devotion or for public services. ■ Made and used at the Lindisfarne Priory on the Holy Island, a major religious community that housed the shrine of Saint Cuthbert. ■ Written by Eadrith, bishop of Lindisfarne; unusual in that it was done by an individual rather than a workshop.
Describe how the original context influenced the choice of both the materials *and* the imagery in this work.	2	Answers could include: ■ Materials (gold on vellum) indicate a sumptuously illustrated book. ■ Materials reflect the sacredness of the subject and the reverence in which it is held. ■ Imagery includes Saint Luke as bearded (indicating his philosophical status as a great thinker). ■ The traditional sacrificial animal, the calf, hovers over Saint Luke as his symbol. ■ Luke appears as an author in the midst of writing on a scroll; the calf holds a completed book.
What aspects of this work show an understanding of cross-cultural connections?	1	Answers could include: ■ Latin writing. ■ Classical author portraits. ■ Margins written in English. ■ Interlace patterning of Celtic origin. ■ Greek words written in Latin characters.

Romanesque Art

TIME PERIOD: 1050–1150, SOME OBJECTS DATE AS EARLY AS 1000 AND AS LATE AS 1200

To nineteenth-century art historians, Romanesque architecture looked like a derivative of ancient Roman art, and they titled the period "Romanesque," or "in the Roman manner." Although there are some superficial resemblances in the roundness of architectural forms, the Romanesque period is very different from its namesake.

ENDURING UNDERSTANDING: The culture, beliefs, and physical settings of a region play an important role in the creation, subject matter, and siting of works of art.

Learning Objective: Discuss how the culture, beliefs, or physical setting can influence the making of a work of art. (For example: Church of Sainte-Foy)

Essential Knowledge:

- Romanesque art is a part of the medieval artistic tradition.
- In the Romanesque period, royal courts emphasized the study of theology, music, and writing.
- Romanesque art avoids naturalism and emphasizes stylistic variety. Text is often incorporated into artwork from this period.

ENDURING UNDERSTANDING: Cultural interaction through war, trade, and travel can influence art and art making.

Learning Objective: Discuss how works of art are influenced by cultural interaction. (For example: Reliquary of Sainte-Foy)

Essential Knowledge:

- There is an active exchange of artistic ideas throughout the Middle Ages.
- There is a great influence of Roman, Early Medieval, and Islamic art on Romanesque art.

ENDURING UNDERSTANDING: Art and art making can be influenced by a variety of concerns including audience, function, and patron.

Learning Objective: Discuss how art can be influenced by audience, function, and/or patron. (For example: *Bayeux Tapestry*)

Essential Knowledge:

- Works of art were often displayed in religious or court settings.
- Existing architecture is mostly religious.

ENDURING UNDERSTANDING: Art history is best understood through an evolving tradition of theories and interpretations.

Learning Objective: Discuss how works of art have had an evolving interpretation based on visual analysis and interdisciplinary evidence. (For example: *Bayeux Tapestry*)

Essential Knowledge:

■ The study of art history is shaped by changing analyses based on scholarship, theories, context, and written record.

■ Contextual information comes from written records that are religious or civic.

HISTORICAL BACKGROUND

By 1000, Europe had begun to settle down from the great migration that characterized the Early Medieval period. Wandering seafarers like the Vikings were Christianized, and their descendants colonized Normandy, France, and southern Italy and Sicily. Islamic incursions from Spain and North Africa were neutralized; in fact, Europeans began a counterinvasion of Muslim lands called the Crusades. The universal triumph of Christianity in Europe with the pope cast as its leader was a spiritual empire not unlike the Roman secular one.

Even though Europeans fought with equal ardor among themselves, enough stability was reached so that trade and the arts could flourish; cities, for the first time in centuries, expanded. People began to crisscross Europe on religious pilgrimages to Rome and even Jerusalem. The most popular destination was the shrine dedicated to Saint James in the northwestern Spanish town of Santiago de Compostela. A magnificent Romanesque cathedral was built as the endpoint of western European pilgrimages.

The journey to Santiago took perhaps a year or longer to make. Shrines were established at key points along the road, so that pilgrims could enjoy additional holy places, many of which still survive today. This pilgrimage movement, with its consequent building boom, is one of the great revitalizations in history.

Patronage and Artistic Life

Medieval society centered on feudalism, which can be expressed as a symbiotic relationship between lords and peasants. Peasants worked the land, sustaining all with their labor. Lords owned the land, and they guaranteed peasants security. Someplace between these stations, artists lived in what eventually became a middle class. Painting was considered a higher calling compared to sculpture or architecture because painters worked less with their hands.

Women were generally confined to the "feminine arts" such as ceramics, weaving, or manuscript decoration. Powerful and wealthy women (queens, abbesses, and so on) were active patrons of the arts, sponsoring the construction of nunneries or commissioning illuminated manuscripts. Hrotswitha of Gandersheim, a nun, wrote plays that were reminiscent of Roman playwrights and poets. One of the most brilliant people of the period was Hildegard von Bingen, who was a renowned author, composer, and patroness of the arts.

Although Christian works dominate the artistic production of the Romanesque period, a significant number of beautifully crafted secular works also survives. The line between secular and religious works in medieval society was not so finely drawn, as objects for one often contain symbolism of the other.

The primary focus of medieval architecture is on the construction of castles, manor houses, monasteries, and churches. These were conceived not by architects in the modern sense of the word, but by master builders, who oversaw the whole operation from designing

the building to contracting the employees. These master builders were often accompanied by master artists, who supervised the artistic design of the building.

ROMANESQUE ARCHITECTURE

Cathedrals were sources of civic pride as well as artistic expression and spiritual devotion. Since they sometimes took hundreds of years to build and were extremely expensive, great care was lavished on their construction and maintenance. Church leaders sought to preserve structures from the threat of fire and moved away from wood to stone roofs. Those that were originally conceived with wood were sometimes retrofitted. This revival of structures entirely in stone is one reason for the period's name, "Romanesque."

But stone caused problems. It is heavy—which means that the walls have to be extra thick to sustain the weight of the roof. Windows are small, so that there are as few holes in the walls as possible. The interiors are correspondingly dark. To bring more light into the buildings, the exterior of the windows are often narrow and the interior of the window wider—this way the light would come in through the window and ricochet off its thick walls and appear more luminous. However, the introduction of stained glass darkened attempts at lightening the interiors.

To help support the roofs of these massive buildings, master builders designed a new device called the **rib vault** (Figure 11.1). At first, these ribs were decorative moldings placed on top of groin vaults, but eventually they became a new way of looking at roof support. While they do not carry its full weight, they help channel the stresses of its load down to the walls and onto the massive piers below, which serve as functional buttresses. Rib vaults also open up the ceiling spaces more dramatically, allowing for larger windows to be placed in the clerestory. During construction, rib vaults were the first part of the roof to be built, the stones in the spaces between were added later (Figure 11.1).

Besides the advantage of being fireproof, stone has several other positive properties. It is easy to maintain, durable, and generally weatherproof. It also conducts sound very well, so that medieval music, characterized by Gregorian chant, could be performed, enabling even those in the rear of these vast buildings to hear the service.

The basic unit of medieval construction is called the **bay**. This spatial unit contains an arch on the first floor, a triforium with smaller arches on the second, and windows in a clerestory on the third. The bay became a model for the total expression of the cathedral—its form is repeated throughout the building to render an artistic whole (Figure 11.2).

In order to accommodate large crowds who came to Romanesque buildings during feast days or for pilgrimages, master builders designed an addition to the east end of the building, called an **ambulatory**, a feature that was also present in Early Christian churches. This walkway had the benefit of directing crowds around the church without disturbing the ceremonies taking place in the apse. Chapels were placed at measured

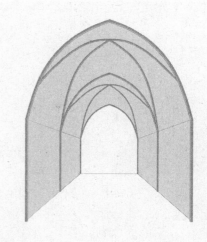

Figure 11.1: Rib vaults

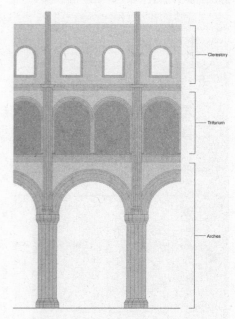

Figure 11.2: A bay is a vertical section of a church often containing arches, a triforium, and a clerestory.

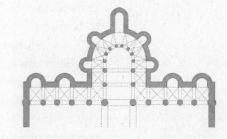

Figure 11.3: An ambulatory is the passageway that winds around an apse. Romanesque buildings often have chapels that radiate from them. Ambulatories can be found in buildings as early as the Early Christian period.

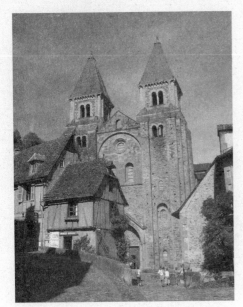

Figure 11.4a: Church of Sainte-Foy, Romanesque Europe, c. 1050–1130, stone, Conques, France

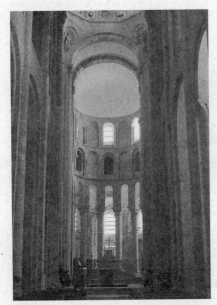

Figure 11.4b: Nave of Church of Sainte-Foy

intervals around the ambulatory so that pilgrims could admire the displays of relics and other sacred items housed there. The ambulatory at Saint. Sernin (Figure 11.3) is a good example of how they work in this context.

After six hundred years of relatively small buildings, Romanesque architecture with its massive display of cut stone comes as a surprise. The buildings are characterized as being uniformly large, displaying monumentality and solidity. Round arches, often used as **arcades**, are prominent features on façades. Concrete technology, a favorite of the ancient Romans, was forgotten by the tenth century.

Interiors are dark; façades are sometimes punctured with round oculus-type windows.

Although some buildings were built with wood ceilings, the tendency outside Italy is to use Roman stone-vaulting techniques, such as the barrel and groin vault to cover the interior spaces as at **Sainte-Foy** (Figure 11.4b). However, later buildings employ rib-covered groin vaults to make interiors seem taller and lighter.

Italian buildings have separate bell towers called **campaniles** to summon people to prayer. Northern European buildings incorporate this tower into the fabric of the building often over the crossing.

Church of Sainte-Foy, Romanesque Europe, c. 1050–1130, stone, Conques, France (Figures 11.4a and 11.4b)

Form
- Church built to handle the large number of pilgrims: wide transepts, large ambulatory with radiating chapels.
- Massive heavy interior walls, unadorned.
- No clerestory; light provided by windows over the side aisles and galleries.
- Barrel vaults in nave, reinforced by transverse arches.
- Cross-like ground plan, called a Latin cross.

Function
- Christian church built along the pilgrimage road to Santiago de Compostela, a popular pilgrimage center for the worship of the relics of Saint James.
- Radiating chapels housed relics of the saints.

Content Area Early Europe and Colonial Americas, Image 58
Web Source https://www.tourisme-conques.fr/en/en-conques/st-foy-abbey-church
- **Cross-Cultural Comparisons for Essay Question 1: Pilgrimages**
 - Great Stupa, Sanchi (Figures 23.4a, 23.4b, 23.4c, 23.4d, 23.4e)
 - Kaaba (Figures 9.11a, 9.11b)
 - Bamiyan Buddha (Figures 23.2a, 23.2b)

ROMANESQUE SCULPTURE AND PAINTING

Large-scale stone sculpture was generally unknown in the Early Medieval period—its revitalization is one of the hallmarks of the Romanesque. Sculptors took their inspiration from goldsmiths and other metal workers, but expanded the scale to almost life-size works.

Most characteristically, sculpture was placed around the portals of medieval churches so that worshippers could understand, among other things, the theme of a particular building (Figure 11.5). Small-scale works, such as ivories, wooden objects, and metalwork continued to flourish as they did in earlier periods.

Most of what we know about Romanesque painting comes from illuminated manuscripts and an occasional surviving ceiling or wall mural. Characteristically, figures tend to be outlined in black and then vibrantly colored. Gestures are emphatic; emotions are exaggerated—therefore, heads and hands are proportionally the largest features. Figures fill a blank surface rather than occupy a three-dimensional reality; hence they seem to float. Sometimes they are on tiptoe or glide across a surface, as they do in the ***Bayeux Tapestry***. People are most important; they dominate buildings that seem like props or stage sets in the background of most Romanesque illustrations.

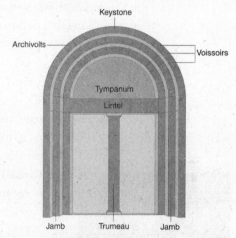

Figure 11.5: A Romanesque portal

Painted stone sculpture is a trademark of Romanesque churches. Capitals are elaborately, and often fancifully, carved with scenes from the Bible. The chief glory of Romanesque sculpture is the portal. These are works of so prominent a location that sculptors vied for the honor of carving in so important a site. As artists became famous for their work, towns competed to hire them. Some have prominently placed signatures that proclaim their glory.

Although there are regional variations, there are some broad characteristics that generally define Romanesque sculpture. Figures tend to have a flattened look with zigzagging drapery that often hides body form rather than defines it. Scale is carefully articulated, with a hierarchy of figures being presented according to their importance. Figures are placed within borders, usually using them as isolated frames for scenes to be acted out in. They rarely push against these frames, preferring to be defined by them.

Smaller, independent sculptures were also produced at this time. Among the most significant are **reliquaries** (Figure 11.6c) that contain venerated objects, like the bones of saints; they are richly adorned and highly prized.

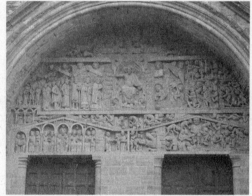

Figure 11.6a: Last Judgment, 1050–1130, stone and paint, Sainte-Foy, Conques

Last Judgment, 1050–1130, stone and paint, Sainte-Foy, Conques (Figures 11.6a and 11.6b)

Form
- Largest Romanesque tympanum.
- 124 figures densely packed together; originally richly painted.

Function
- Last Judgment cautions pilgrims that life is transitory and one should prepare for the next life.
- Subject of the tympanum reminds pilgrims of the point of their pilgrimage.

Content
- Christ, as a strict judge, divides the world into those going to heaven and those going to hell.
 - Christ is depicted with a welcoming right hand, a cast down left hand.
 - Christ sits in a mandorla.

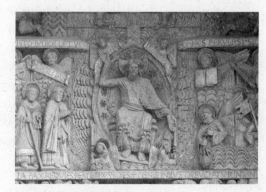

Figure 11.6b: Detail of 11.6a

- A dividing line runs vertically through the cross in the middle of the composition.
- The Archangel Michael and the devil are at Christ's feet, weighing souls.
- Hell, with the damned, is on the right.
- People enter the church on the right as sinners and exit on the left as saved; the right door has sculptures of the damned and the left door has images of the saved.
- The figures of the saved move toward Christ, Mary, and Saint Peter; local abbots and monks follow Charlemagne, the legendary benefactor of the monastery, who is led by the hand.
- Paradise, at the lower level, is portrayed as the heavenly Jerusalem.
- Sainte Foy interceded for those enslaved by the Muslims in Spain—she herself appears kneeling before a giant hand of God.
- On the right lower level, the devil presides over a chaotic tangle of tortured condemned sinners.
- Inscription on lintel: "O Sinners, change your morals before you might face a cruel judgment."
- Hieratic scale may parallel one's status in a feudal society.

Content Area Early Europe and Colonial Americas, Image 58

Web Source *https://www.tourisme-conques.fr/en/en-conques/the-tympanum*

- **Cross-Cultural Comparisons for Essay Question 1: Last Judgment Scenes**
 - Giotto, Arena Chapel (Figure 13.1b)
 - Michelangelo, Sistine Chapel (Figure 16.2e)
 - Last judgment of Hunefer (Figure 3.12)

Reliquary of Sainte-Foy, gold, silver, gemstones, and enamel over wood, 9th century, with later additions, Sainte-Foy, Conques (Figure 11.6c)

Form
- Child saint's skull is housed in the rather mannish-looking enlarged head.
- Jewels, gems, and crown added over the years by the faithful, as acts of devotion.
- Facial expression is haughty and severe.

Function
- Reliquary of a young girl martyred in the early fourth century.

Context
- Sainte Foy (or Faith) probably died as a martyr to the Christian faith during the persecutions in 303 under Emperor Diocletian; she was tortured over a brazier; she refused to sacrifice to the Roman gods in a pagan ritual.
- Saint Foy, triumphant over death, looking up and over the viewer's head.

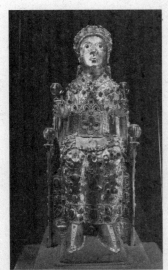

Figure 11.6c: Reliquary of Sainte-Foy, gold, silver, gemstones, and enamel over wood, 9th century with later additions, Sainte-Foy, Conques

- Relics of her body were stolen from a nearby town and enthroned in Conques in 866.
- One of the earliest large-scale sculptures in the Middle Ages.

Content Area Early Europe and Colonial Americas, Image 58

Web Source *https://www.tourisme-conques.fr/en/en-conques/the-treasure*

- **Cross-Cultural Comparisons for Essay Question 1: Art as a Container**
 - Reliquary guardian figure (Figure 27.13)
 - Great Stupa (Figure 23.4a)
 - *Nkisi n'kondi* (Figure 27.6)

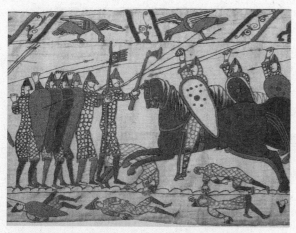

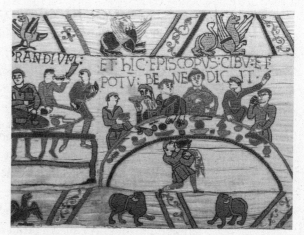

Figure 11.7a: Cavalry attack from the *Bayeux Tapestry*, Romanesque Europe (English or Norman), c. 1066–1080, embroidery on linen, Bayeux Tapestry Museum, Bayeux, France

Figure 11.7b: First meal from the *Bayeux Tapestry*

The *Bayeux Tapestry*, Romanesque Europe (English or Norman), 1066–1080, embroidery on linen, Bayeux Tapestry Museum, Bayeux, France (Figures 11.7a and 11.7b)

Form
- Color used in a decorative, although unnatural, manner—different parts of a horse are colored variously.
- Neutral background of unpainted fabric.
- Flat figures; no shadows.

Content
- Tells the story (in Latin) of William the Conqueror's conquest of England at the Battle of Hastings in 1066.
- The story, told from the Norman point-of-view, emphasizes the treachery of Harold of England, who breaks his vow of loyalty and betrays William by having himself crowned.
- More than 600 people, 75 scenes.
- Fanciful beasts in upper and lower registers.
- Borders sometimes comment on the main scenes or show scenes of everyday life (bird hunting, farming, even pornography).

Function
- Uncertainty over how this work was meant to be displayed, perhaps in a cathedral hung from the pillars in the nave or hung in a hall along a wall.

Technique
- Tapestry is a misnomer; actually, it's an embroidery.
- Probably designed by a man and executed by women.

Patronage
- Commissioned by Bishop Odo, half-brother to William the Conqueror.

Context
- Continues the narrative tradition of medieval art; 230 feet long.
- Narrative tradition goes back to the Column of Trajan (Figure 6.16).

Content Area Early Europe and Colonial Americas, Image 59

Web Source http://www.bayeuxmuseum.com/en/

- **Cross-Cultural Comparisons for Essay Question 1: Battle Scenes**
 - Ludovisi Battle Sarcophagus (Figure 6.17)
 - *Night Attack on the Sanjô Palace* (Figures 25.3a, 25.3b)
 - Delacroix, *Liberty Leading the People* (Figure 20.4)

VOCABULARY

Abbey: a monastery for monks, or a convent for nuns, and the church that is connected to it (Figure 11.4a)

Ambulatory: a passageway around the apse of a church (Figure 11.3)

Apse: the end point of a church where the altar is (Figure 11.3)

Arcade: a series of arches supported by columns. When the arches face a wall and are not self-supporting, they are called a **blind arcade**

Archivolt: a series of concentric moldings around an arch (Figure 11.5)

Axial plan (Basilican plan, Longitundinal plan): a church with a long nave whose focus is the apse, so-called because it is designed along an axis (Figure 11.4b)

Baptistery: in medieval architecture, a separate chapel or building generally in front of a church used for baptisms

Bay: a vertical section of a church that is embraced by a set of columns and is usually composed of arches and aligned windows (Figure 11.2)

Campanile: a bell tower of an Italian building

Cathedral: the principal church of a diocese, where a bishop sits

Clerestory: the window story of a church (Figure 11.2)

Compound pier: a gathering of engaged shafts around a pier (Figure 11.4b)

Continuous Narrative: a work of art that contains several scenes of the same story painted or sculpted in continuous succession (Figures 11.7a and 11.7b)

Embroidery: a woven product in which the design is stitched into a premade fabric (Figures 11.7a and 11.7b)

Gallery: a passageway inside or outside a church that generally is characterized by having a colonnade or arcade (Figure 11.4b)

Jamb: the side posts of a medieval portal (Figure 11.5)

Last Judgment: in Christianity, the judgment before God at the end of the world (Figure 11.6a)

Mandorla: (Italian for "almond") an almond-shaped circle of light around the figure of Christ or Buddha (Figure 11.6a)

Narthex: the vestibule, or lobby, of a church

Portal: a doorway. In medieval art they can be significantly decorated (Figure 11.5)

Radiating chapel: a chapel that extends out in a radial pattern from an apse or an ambulatory (Figure 11.3)

Reliquary: a vessel for holding a sacred relic. Often reliquaries took the shape of the objects they held. Precious metals and stones were the common material (Figure 11.6c)

Rib vault: a vault in which diagonal arches form riblike patterns. These arches partially support a roof, in some cases forming a web-like design (Figure 11.1)

Tapestry: a woven product in which the design and the backing are produced at the same time on a device called a **loom**

Transept: an aisle in a church perpendicular to the nave

Transverse arch: an arch that spans an interior space connecting opposite walls by crossing from side to side (Figure 11.4b)

Triforium: A narrow passageway with arches opening onto a nave, usually directly below a clerestory (Figure 11.2)

Trumeau (plural: **trumeaux**): the central pillar of a portal that stabilizes the structure. It is often elaborately decorated (Figure 11.5)

Tympanum (plural: **tympana**): a rounded sculpture placed over the portal of a medieval church (Figure 11.6a)

Vault: a roof constructed with arches; when an arch is extended in space, forming a tunnel, it is called a **barrel vault**; when two barrel vaults intersect at right angles, it is called a **groin vault**

Voussoir (pronounced "vōō-swar"): a wedge-shaped stone that forms the curved part of an arch. The central voussoir is called a **keystone** (Figure 11.5)

SUMMARY

In a way, the monumentality, rounded arches, and heavy walls of Roman architecture are reflected in the Romanesque tradition. However, the liturgical purpose of Romanesque buildings, their use of ambulatories and radiating chapels and their dark interiors give these churches a religious feeling quite different from their Roman predecessors.

Romanesque builders reacted to the increased mobility of Europeans, many of whom were now traveling on pilgrimages, by enlarging the size of their buildings. As Romanesque art progresses, increasingly sophisticated vaulting techniques are developed. Hallmarks of the Romanesque style include thick walls and piers that give the buildings a monumentality and massiveness lacking in Early Medieval art.

Most great Romanesque sculpture was done around the main portals of churches, usually on themes related to the Last Judgment and the punishment of the bad alongside the salvation of the good. French sculptors carved energetic and elongated figures that often look flattened against the surface of the stone. Although regional variations are common, most Romanesque sculpture is content within the frame of the work it is conceived in, and rarely presses against the sides or emerges forward.

Although religious themes dominate Romanesque art, occasionally works of secular interest, like the *Bayeux Tapestry*, were created.

PRACTICE EXERCISES

Multiple-Choice

1. The subject matter in the *Bayeux Tapestry* is most similar to

 (A) scenes from the *Vienna Genesis*
 (B) the Temple of Zeus and Athena at Pergamon
 (C) the Niobides Krater
 (D) the Column of Trajan

2. Pilgrims entering Romanesque churches such as Sainte-Foy were expected to

(A) walk to the chapels in the rear where the relics were housed
(B) worship around a centrally planned altar where services would be held
(C) travel to the top of the bell towers to ceremonially ring the bells
(D) place offerings at the foot of a statue of Jesus

3. The scene over the doorway of the Church of Sainte-Foy of the Last Judgment shows the damned condemned to hell on the right and the saved rising to heaven on the left because

(A) in the middle are those who were noncommittal about religion and salvation
(B) one enters the church as a sinner on the right but emerges saved on the left
(C) in the Christian tradition, the damned are unwelcome in church
(D) a parallel is drawn between sinners who must use the right door and saints who must use the left door

4. The Reliquary of Sainte-Foy and the Reliquary Figure (*byeri*) are similar in that they

(A) are both meant to ward off evil
(B) are both male figures in the shape of females
(C) both held skulls of important deceased people
(D) are both part of an extensive pilgrimage site for many to come to

5. Romanesque architecture can be characterized as

(A) small, intimate, and warm
(B) soaring, vertical, and uplifting
(C) thick, heavy, and massive
(D) irregular, unbalanced, and asymmetrical

Short Essay

Practice Question 4: Contextual Analysis
Suggested Time: 15 minutes

This is the Romanesque church at Sainte-Foy.

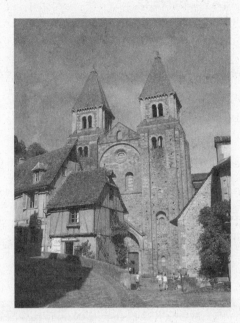 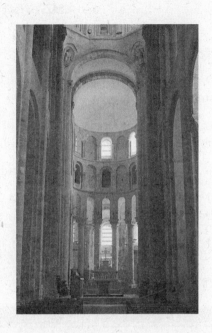

Why was this church built?

Discuss how the design of this church reflects its symbolic *and* practical functions.

Analyze how *at least two* contextual elements contributed to a religious experience for medieval Christians.

ANSWERS EXPLAINED

Multiple-Choice

1. **(D)** Both the *Bayeux Tapestry* and the Column of Trajan have narrative retellings of real historical events.

2. **(A)** Pilgrims treasured seeing relics of the saints, which were placed in chapels in the ambulatory around the altar of a church.

3. **(B)** One enters the church a sinner and leaves absolved of sins.

4. **(C)** Both reliquary figures hold skulls. The Sainte-Foy holds one within the head of the saint; the Reliquary Figure holds one in a container he is resting on.

5. **(C)** Romanesque architecture is thick, heavy, and massive, and often very dark.

Short Essay Rubric

Task	Point Value	Key Points in a Good Response
Why was this church built?	1	Answers could include: ■ To house the relics of Sainte-Foy. ■ To be a pilgrimage site along the road to Santiago de Compostela.
Discuss how the design of this church reflects its symbolic *and* practical functions.	1: symbolic function 1: practical function	Answers could include: ■ Church is nestled amid other buildings downtown, symbolically mixing with the people. ■ Long nave, wide transept, and ambulatory used to accommodate large numbers of pilgrims. ■ Long nave used for processions. ■ Large ambulatory around the altar allows for a free flow of pilgrims to the various chapels, and relics on display. ■ Cross-like ground plan reflects the crucifixion of Jesus.
Analyze how *at least two* contextual elements contributed to a religious experience for medieval Christians.	2	Answers could include: ■ Lack of nave windows contributes to a dark interior, which symbolizes the mysteries of the Christian faith. ■ Sculpture on the façade of the *Last Judgment* warns pilgrims of the dangers of hell and encourages them toward salvation. ■ Stone walls enhance the echo effect that characterized medieval chanting.

Gothic Art

> ## TIME PERIOD: 1140–1400,
> ## UP TO 1550 IN SOME SECTIONS OF EUROPE

ENDURING UNDERSTANDING: The culture, beliefs, and physical settings of a region play an important role in the creation, subject matter, and siting of works of art.

Learning Objective: Discuss how the culture, beliefs, or physical setting can influence the making of a work of art. (For example: Notre Dame de la Belle Verriere)

Essential Knowledge:

- Gothic art is a part of the medieval artistic tradition.
- In the Gothic period, royal courts emphasized the study of theology, music, and writing.
- Gothic art avoids naturalism and emphasizes stylistic variety. Text is often incorporated into artwork from this period.

ENDURING UNDERSTANDING: Cultural interaction through war, trade, and travel can influence art and art making.

Learning Objective: Discuss how works of art are influenced by cultural interaction. (For example: the Golden Haggadah)

Essential Knowledge:

- There is an active exchange of artistic ideas throughout the Middle Ages.
- There is a great influence of Roman, Early Medieval, and Islamic art on Gothic art.

ENDURING UNDERSTANDING: Art and art making can be influenced by a variety of concerns including audience, function, and patron.

Learning Objective: Discuss how art can be influenced by audience, function, and/or patron. (For example: Blanche of Castile and Louis IX)

Essential Knowledge:

- Works of art were often displayed in religious or court settings.
- Surviving architecture is mostly religious.

ENDURING UNDERSTANDING: Art history is best understood through an evolving tradition of theories and interpretations.

Learning Objective: Discuss how works of art have had an evolving interpretation based on visual analysis and interdisciplinary evidence. (For example: Great Portals of Chartres)

Essential Knowledge:

- The study of art history is shaped by changing analyses based on scholarship, theories, context, and written records.
- Contextual information comes from written records that are religious or civic.

HISTORICAL BACKGROUND

The beginning of the Gothic period cannot be dated precisely, although the place of its creation, Paris, can. The change in thinking that we call "Gothic" is the result of a number of factors:

1. An era of peace and prosperity in the region around Paris, owing to an increasingly centralized monarchy, new definition of the concepts of "king" and "kingship," together with the peaceful succession of kings from 987 to 1328.
2. Increasing growth and wealth of cities and towns, encouraged by the sale of royal charters that bound the cities to the king rather than to local lords and the increased wealth of the king.
3. The gradual development of a money economy in which cities played a role in converting agricultural products to goods and services.
4. The emergence of the schools in Paris as the intellectual center of western Europe that brought together the teachers and scholars who transformed western thinking by changing the way questions were asked and by arguing using logic.

The Late Gothic period is marked by three crucial historical events:

1. The Hundred Years' War between France and England (1337–1453). This conflict devastated both countries socially and economically, and left vast regions of France ruined.
2. The Babylonian Captivity (1304–1377). French popes moved the headquarters of the Christian church to Avignon, France, creating a spiritual crisis that had far-reaching effects on European society, and on Rome in particular. With the popes away, there was little reason to maintain Saint Peter's; indeed Rome itself began to decay. When the pope finally returned to Rome in 1377, a schism developed as rival popes set up competing claims of authority, none of which was resolved until 1409. This did much to undermine the authority of the church in general.
3. The Black Death of 1348. This was the greatest cataclysm in human history: A quarter to a third of the world perished in a misdiagnosed pulmonary plague. The consequences for art history were enormous; in many towns there were not enough living to bury the dead: Consequently, architecture came to a standstill. Artists interpreted the plague as a punishment from God, thus painting became conservative and began to look backward to earlier styles. Europe spent generations recovering from the plague's devastating effects.

Patronage and Artistic Life

Master builders coordinated hundreds of laborers and artisans—masons, stonecutters, sculptors, haulers, carpenters—in the building of a cathedral. Indeed, the cathedral was the public works project of its day, keeping the local economies humming and importing artists as needed from everywhere.

Similarly, manuscripts were organized by a chef d'atelier who was responsible for establishing an overall plan or vision of a book so that the workshop could execute his or her designs. A scribe copied the text, but in so doing left room for decorative touches, such as initials, borders, and narrative scenes. Embellishments were added by artists who could express themselves more fully than scribes, who had to stick to the text. Artists often rendered fanciful designs to an initial or a border. Lastly, a bookbinder had the manuscript bound.

GOTHIC ARCHITECTURE

Gothic architecture developed advances made in the Romanesque:

1. The rib vault. Invented at the end of the Romanesque period, and became the standard vaulting practice of the Gothic period.
2. Bays. The Romanesque use of repeated vertical elements in bays also became standard in the Gothic period.
3. The rose window. Begun as an oculus on the façade of Romanesque buildings, the rose window becomes an elaborate circular feature that opens up wall spaces by allowing more light in through the façade and transepts.
4. The pointed arch. First seen in Islamic Spain, this arch directs thrusts down to the floor more efficiently than rounded arches. More fanciful "S" shaped arches, called **ogee** arches, are developed at this time (Figure 12.3).

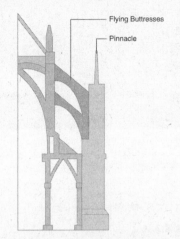

Figure 12.1: Flying buttress and pinnacle on a Gothic cathedral

What is new in the Gothic period is the **flying buttress** (Figure 12.1). These stone arches support a roof by having the weight bypass the walls and travel down to piers outside the building. This enabled the building to be opened up for more window space and to display more stained glass. Most important, flying buttresses also help to stabilize the building, preventing wind stresses from damaging these very vertical and narrow structures.

Ground plans of Gothic buildings denote innovations in the east end, or **chevet** (Figure 12.2). Increasingly elaborate ceremonies called for a larger space to be introduced between the transept and the apse, called the **choir**. While allowing for greater clergy participation, it also had the side effect of removing the public further from the main altar and keeping the ceremony at arm's length.

Another innovation is the introduction of decorative **pinnacles** (Figure 12.1) on the roof of Gothic churches. Long thought to be mere ornaments on flying buttresses, pinnacles are now understood to be essential architectural components that act as stabilizing forces in a wind storm.

Gothic buildings are tall and narrow, causing the worshipper to look up upon entering. The architecture, therefore, reinforces the religious symbolism of the building.

French Gothic buildings tend to be nestled downtown, surrounded by other buildings, and rising above the city landscape as a point of civic and religious pride. In sort of a competition, each town built successively taller buildings, seeking to outdo its neighbors.

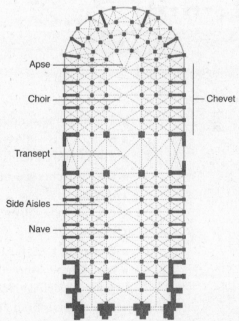

Figure 12.2: Plan of Notre Dame, Paris

Figure 12.3: Ogee arches

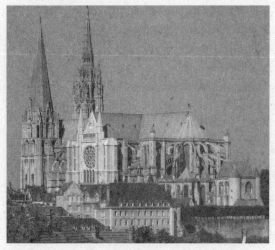

Figure 12.4a: Chartres Cathedral flank, Gothic Europe, c. 1145–1155, reconstructed 1194–1220, limestone and stained glass, Chartres, France

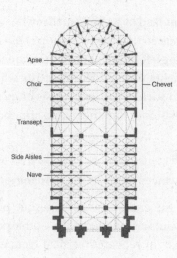

Figure 12.4b: Chartres Cathedral façade

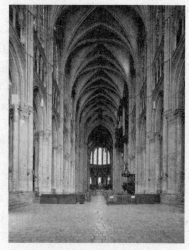

Figure 12.4c: Chartres Cathedral interior

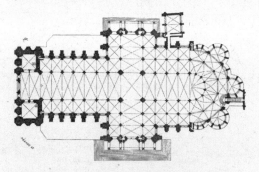

Figure 12.4d: Chartres Cathedral ground plan

Chartres Cathedral, Gothic Europe, c. 1145–1155, reconstructed 1194–1220, limestone and stained glass, Chartres, France (Figures 12.4a, 12.4b, 12.4c, and 12.4d)

Form

- The first church to have flying buttresses as part of the original design; earlier churches retrofitted flying buttresses after the building was constructed.
- The tall vertical nature of the interior pulls the viewer's eyes up to the ceiling and symbolically to heaven; rib vaulting increases the ceiling's vertical thrust.
- Lancets and spires add to the verticality of the building.
- The dark, mysterious interior increases a spiritual feeling.
- Stained glass enlivens the interior surfaces of the church (see Figure 12.8).
- The façade contains a gallery of Old Testament figures above a rose window.
- Enlarged chevet accommodates elaborate church ceremonies.

Function

- Christian church dedicated to the Virgin Mary; a Marian shrine.

Context

- Started in 1145; fire in 1194 forced reconstruction of everything except the façade.
- Mary's tunic, worn at Jesus's birth, is its most sacred relic; its escape from a fire in 1194 was seen as a signal to rebuild the cathedral.
- Right spire is from 1160; left spire is Late Gothic (1507–1513), a style more elaborate and decorative called Flamboyant Gothic.
- Importance of the church reflected in the speed of construction: 27 years.
- Each wing of the cathedral faces a cardinal direction of the compass:
 - The west wing is the entrance, facing sunset and symbolizing the end of the world.
 - The north wing has stained-glass windows that symbolize the past.
 - The south wing has stained-glass windows that symbolize the present world depicted in the New Testament.
 - The east wing has the apse and altar, located where the sun rises.
- Part of a complex that included a school, a bishop's palace, and a hospital.

Content Area Early Europe and Colonial Americas, Image 60
Web Source *http://whc.unesco.org/en/list/81/*

■ **Cross-Cultural Comparisons for Essay Question 1:**
Church Ground Plans that Indicate Their Function
- San Vitale (Figure 8.4c)
- San Carlo alle Quattro Fontane (Figure 17.2c)
- Santa Sabina (Figure 7.3c)

Westminster Hall, 1097–1099; ceiling 1390s, stone and wood,
London, England (Figure 12.5)

Form

■ Bare walls were probably decorated with tapestries.
■ Windows placed high up, surrounded by Romanesque arches.
■ Hammerbeam style roof; made of oak; beams curve to
 meet in the center of the ceiling like a corbelled arch.

Function

■ Meant for grand ceremonial occasions: coronations, feasts.
■ Later used as a law court to dispense justice.

Context

■ Started under William II (r. 1087–1100) as the largest hall in England at the time.
■ Roof remodeled under Richard II (r. 1377–1399).
■ Original roof has been replaced; there is debate over how the roof was vaulted, perhaps
 with beams that came down to the floor, denoting a main aisle and two side aisles.
■ Richard II also placed six statues of kings at one entrance, along with his emblems.
■ When the old Houses of Parliament were burned to the ground, this remaining build-
 ing was the last vestige of the medieval parliament, and served as inspiration for the new
 Houses of Parliament (Figure 20.1a).

Content Area Later Europe and Americas, Image 112
Web Source *http://www.parliament.uk/about/living-heritage/building/palace/westminsterhall/*

■ **Cross-Cultural Comparisons for Essay Question 1: Wooden Roofs on Stone Structures**
- Mosque at Córdoba, Spain, original construction (Figure 9.14a)
- Santa Sabina, Rome (Figure 7.3a)
- Basilica of Ulpia, Rome (Figure 6.10b)

Figure 12.5: Westminster Hall, 1097–1099; ceiling 1390s, stone
and wood, London, England

GOTHIC SCULPTURE

Although Romanesque buildings had sculpture on the portals and on parts of building façades,
its role was subsidiary to architecture. In the Gothic period, sculpture begins to emerge more
forcefully on church façades.

Saint-Denis (c. 1140–1144) was the first building to have statue columns on the jambs, now
mostly destroyed. Although still attached to the columns, jamb figures have rounded volumes
that set them apart from their architectural background. The statue columns at the **Great West**
Portals at Chartres (1145–1155) (Figure 12.6) appear to imitate the verticality of the church
itself, but contain a robust three-dimensionality lacking in the Romanesque period.

There is also a change in the subject matter from the Romanesque to the Gothic portals.
Romanesque sculptural programs stress the Last Judgment and the threat of being damned to
hell. Gothic sculpture concentrates on the possibility of salvation; the believer is empowered
with the choice of salvation.

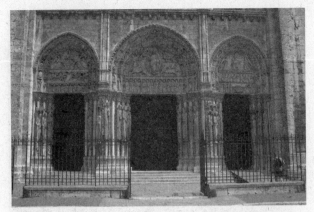

Figure 12.6: Great Portals of the West Façade, 1145–1155, limestone, Chartres Cathedral, Chartres, France

In Romanesque sculpture, figures are flattened into the wall space of tympana or jambs, being content to be defined by that space. In Gothic sculpture, the statue columns progress away from the wall, building a space seemingly independent of the wall surface. The **Great West Portals of Chartres** (Figure 12.6) begin this process by bringing figures forward, although they are still columnar.

As Gothic art advances, the sculptures become increasingly three-dimensional and freestanding. In the thirteenth century, the figures are defining their own space, turning to one another with humanizing expressions and engaging in a narrative interplay.

By the fourteenth century, Gothic sculpture and painting develops a courtly S-curve to the bodies.

Great Portals of the West Façade, 1145–1155, limestone, Chartres Cathedral, Chartres, France (Figure 12.6)

Form
- Jamb statues stand in front of the wall, almost fully rounded; cf. Romanesque figures, which are flat against the surface.
- Upright, rigid, elongated figures reflect the vertical columns behind and the vertical nature of the cathedral itself.
- Figures wear rich courtly dress with vertical folds.
- The robes are almost hypnotic in their concentric composition; cf. Romanesque nervous excitement to drapery.
- Heads: serene; slightly heavy eyes; benevolent; humanized faces.
- Heads are lined up in a row, but the feet are of different lengths.

Function
- These portals were used by church hierarchy, not commoners, as the entry to the church.

Context
- Called Royal Portals because the jamb sculptures depict kings and queens from the Old Testament; connection is being made between the French and biblical royalty.
- Three portals linked by lintels and 24 capitals that contain the life of Christ:
 - Left tympanum: Christ before he takes on mortal form.
 - Central tympanum: Christ as Judge of the World, no menacing Last Judgment as at Conques (Figure 11.6a); Christ surrounded by symbols of the evangelists.
 - Right tympanum: Mary as Queen of Heaven; scenes from her life; Mary with the Christ Child in her lap symbolizing her as the throne of wisdom.
- Scholasticism stressed in the image of Mary as the throne of wisdom (*sedes sapientiae*) holding Jesus, in the right tympanum; the seven liberal arts taught at medieval universities are personified in the archivolts of the right tympanum.
- Originally 24 statues (19 survive).

Content Area Early Europe and Colonial Americas, Image 60
- **Cross-Cultural Comparisons for Essay Question 1: Architectural sculpture**
 - Helios, horses, and Dionysos (Heracles?) (Figure 4.4)
 - Last Judgment, Sainte-Foy, Conques (Figure 11.6a)
 - Lintel 25, Yaxchilán (Figure 26.2b)

Röttgen Pietà, late medieval Europe, 1300–1325, painted wood, Rheinisches Landesmuseum, Bonn, Germany (Figure 12.7)

Form

- Christ emaciated, drained of all blood, all tissue, all muscle.
- Originally vividly painted, some paint survives.

Function

- An Andachtsbild, used in church for services or in a procession.

Context

- Horror of the crucifixion is made manifest.
- This work shows the humanizing of religious themes; Mary as a grieving, very human mother displaying compassion and emotion.
- Christ's blood is depicted in grape-like drops, a reference to Christ as a "mystical vineyard."
- The imagery asks the viewer to concentrate on the Eucharist: the body and blood of Jesus Christ.

Content Area Early Europe and Colonial Americas, Image 62

Web Source *http://metmuseum.org/toah/works-of-art/2001.78/*

- **Cross-Cultural Comparisons for Essay Question 1: Images of Suffering**
 - Coyolxauhqui Stone (Figure 26.5b)
 - Seated boxer (Figure 4.10)
 - Kollwitz, *Memorial Sheet for Karl Liebknecht* (Figure 22.4)

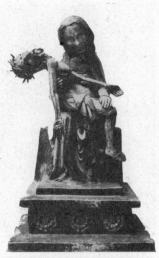

Figure 12.7: *Röttgen Pietà*, late medieval Europe, 1300–1325, painted wood, Rheinisches Landesmuseum, Bonn, Germany

GOTHIC PAINTING

Stained-glass has existed for centuries; the earliest surviving examples are from the seventh century in England. It became an industry in the Gothic period. Craftsmen made the glass, while glaziers cut the big panels into the desired shapes, wrapping the leading around them. Details (i.e., facial expressions or folds of drapery) were then painted on the glass before it was refired and then set into the window frame.

Stained-glass windows became the illustrations of a sophisticated theological program. Generally, larger images of saints appeared in the clerestory so that they could be read from the floor. Narratives appeared in side aisle windows where they could be read more clearly at a closer distance.

Illuminated manuscripts continue to be important, some seeking to emulate the luminous colors of stained-glass windows. Forms have borders much like the leading of windows, and are painted in brilliant colors.

Notre Dame de la Belle Verriere, "Our Lady of the Beautiful Window," c. 1170, stained glass, Chartres Cathedral (Figure 12.8)

Function

- Part of a lancet stained-glass window in Chartres Cathedral.

Context

- Mary is crowned Queen of Heaven with the Christ Child on her lap; she is depicted as the throne of wisdom.
- Light acts as a manifestation of the divine; shades of color patterns play across the gray stone of the cathedral.

Figure 12.8: Notre Dame de la Belle Verriere, c. 1170, stained glass, Chartres Cathedral

Figure 12.9a: Scenes from the Apocalypse, from a *Bible moralisée*, Gothic Europe, c. 1226–1234, illuminated manuscript, ink, tempera, and gold leaf on vellum, Cathédral, Toledo

- Bands across the surface are typical of Early Gothic stained glass.
- Undamaged by the fire of 1194; blue framing added when it was reset with framing angels on either side of the main scene, which contrasts the two styles of stained glass in the same window.

Content Area Early Europe and Colonial Americas, Image 60

Web Source *http://www.medievalart.org.uk/Chartres/030a_pages/Chartres_Bay030a_key.htm*

- **Cross-Cultural Comparisons for Essay Question 1: Transparency and Reflection**
 - Kusama, *Narcissus Garden* (Figures 22.25a, 22.25b)
 - Mies van der Rohe, Seagram Building (Figure 22.18)
 - Versailles, Hall of Mirrors (Figure 17.3d)

Scenes from the Apocalypse, from a *Bible moralisée (Moralized Bible)*, Gothic Europe, c. 1226–1234, illuminated manuscript, ink, tempera, and gold leaf on vellum, Cathedral, Toledo (Figure 12.9a)

Form

- Eight medallions; format derives from the stained-glass windows.
- Luminosity of text a reflection of stained-glass windows; strong black outlining of forms.
- Two vertical columns of four painted scenes.
- Modeling is minimal.

Function

- Moralized Bible.

Content

- Each scene has a text with a summary of the event depicted in the roundel.
- Old and New Testament scenes are paired as complementing one another.

Context

- Done for the royal court at Paris.

Content Area Early Europe and Colonial Americas, Image 61

Web Source *http://ica.themorgan.org/manuscript/page/6/77422*

- **Cross-Cultural Comparisons for Essay Question 1: Gold**
 - Golden Stool (Figure 27.4)
 - Ogat Korin, *White and Red Plum Blossoms* (Figures 25.4a, 25.4b)
 - Gold and jade crown (Figure 24.10)

Figure 12.9b: Dedication Page with Blanche of Castile and Louis IX of France, 1226–1234, illuminated manuscript, ink, tempera, and gold leaf on vellum, Morgan Library, New York

Dedication Page with Blanche of Castile and Louis IX of France, 1226–1234, illuminated manuscript, ink, tempera, and gold leaf on vellum, Morgan Library, New York (Figure 12.9b)

Context and Interpretation

Content

- Top left: Blanche of Castile, mother and regent to the king; her gestures indicate her dominant role at this time.
 - Since she is a widow, she is wearing a white widow's wimple.
- Top right: teenage king Louis IX; beardless, enthroned, holding a bird surmounting fleur-de-lis scepter in his right hand and a round object, possibly a seal matrix, in his left hand.

- Bottom: older monk dictates to younger scribe; younger scribe is drawing circles as seen in Scenes from the Apocalypse (Figure 12.9a).

Content Area Early Europe and Colonial Americas, Image 61

Web Source *http://ica.themorgan.org/manuscript/page/8/77422*

JEWISH ART

Although Jews almost universally ban images in temples today, their ancient and medieval ancestors did not always follow this prohibition. Perhaps they were inspired by episodes in the Old Testament that mention incidents in which images could be valid; for example, in Exodus 25: 18–22, God orders Moses to install two cherubim above the Arc of the Covenant in the Holy of Holies.

Jews living in the Greco-Roman world were also influenced by pagan artists who created sweeping narratives of the heroic deeds of their gods. This is perhaps why there are a few ancient synagogues that have illustrations of episodes from the Old Testament. In the Middle Ages, wealthy Jewish patrons often commissioned luxury objects like illuminated manuscripts the same way their Christian or Muslim neighbors would. Jewish patrons often used Christian painters to decorate important sacred books, mostly for personal use.

Golden Haggadah (The Plagues of Egypt, Scenes of Liberation, and Preparation for Passover), late medieval Spain, c. 1320, illuminated manuscript, pigments and gold leaf on vellum, British Library, London (Figures 12.10a, 12.10b, 12.10c, 12.10d)

Form
- Style similarities to French Gothic manuscripts in the handling of space, architecture, figure style, facial/gestural expression, and the manuscript medium itself.
- 56 miniatures; gold leaf background.

Function and Content
- A Haggadah is a book that illustrates the story of the Jewish exodus from Egypt under Moses and its subsequent celebration.
- It contains a narrative cycle of events from the books of Genesis and Exodus.
- It is to be read at a Passover Seder.
- This Haggadah was used primarily at home, therefore avoiding the more stringent restriction against holy images in a synagogue.

Context
- Haggadah means "narration"; fulfills the Jewish requirement to tell the story of the Jewish escape from Egypt as a reminder of God's mercy.
- Haggadot (plural) are generally the most lavishly painted of Jewish manuscripts.
- The book is read right to left according to the manner of Hebrew texts.

Figure 12.10a: Golden Haggadah: The Plagues of Egypt
Upper right: plague of frogs initiated here by Moses, not Aaron as depicted in the Bible
Upper left: plague of lice: Pharaoh and his magicians are covered with lice
Lower left: Moses looks on as Pharaoh is attacked by wild beasts
Lower right: plague on livestock

Figure 12.10b: Golden Haggadah: Scenes of Liberation
Upper right: Plague and death of the first-born Egyptian child
Upper left: Pharaoh orders Israelites to leave Egypt
Lower right: Egyptians dressed in medieval armor attack the Israelites
Lower left: Israelites safely cross the Red Sea; Egyptians drown

Figure 12.10c: Golden Haggadah: Preparation for Passover
Upper right: Miriam, Moses's sister, holds a tambourine decorated with an Islamic motif and is joined by maidens dancing and playing contemporary musical instruments
Upper left: master of the house, sitting under a canopy, orders the distribution of *matzah* (unleavened bread) and *haroset* (sweetmeats) to the children
Lower right: a family prepares the house for Passover; women clean and the man searches for leaven
Lower left: people are preparing for Passover: sheep are being slaughtered and utensils are being purified

Figure 12.10d: detail of Figure 12.10c. Family prepares the house for Passover; women clean, and the man searches for leaven.

- Two unknown artists, probably Christian, illustrated the Golden Haggadah; a Jewish scribe wrote the Hebrew script.
- Painted around the Barcelona area of Spain.

Content Area Early Europe and Colonial Americas, Image 64

Web Source *http://www.bl.uk/turning-the-pages/?id=47111807-4e9a-43de-be65-96f49c3d623c&type=book*

- **Cross-Cultural Comparisons for Essay Question 1: Works as Part of a Series**
 - Rubens, *Henri IV Receives the Portrait of Marie de' Medici,* from the Marie de' Medici Cycle (Figure 17.8)
 - Lawrence, *The Migration of the Negro, Panel no. 49* (Figure 22.19)
 - Giotto, *Lamentation* from the Arena Chapel (Figures 13.1b, 13.1c)

VOCABULARY

Andachtsbild: an image used for private contemplation and devotion (Figure 12.7)

Apocalypse: the last book of the Christian Bible, sometimes called Revelations, which details God's destruction of evil and consequent raising to heaven of the righteous (Figure 12.9a)

Bay: a vertical section of a church that is embraced by a set of columns and is usually composed of arches and aligned windows (Figure 11.2)

Chevet: the east end of a Gothic church (Figure 12.2)

Choir: a space in a church between the transept and the apse for a choir or clergymen (Figure 12.2)

Close: an enclosed garden-like area around a cathedral

Compound pier: a pier that appears to be a group or gathering of smaller piers put together (Figure 12.4c)

Flying buttress: a stone arch and its pier that support a roof from a pillar outside the building. Flying buttresses also stabilize a building and protect it from wind sheer (Figure 12.1)

Haggadah (plural: **Haggadot):** literally, "narration"; specifically, a book containing the Jewish story of Passover and the ritual of the Seder (Figures 12.10a, 12.10b, and 12.10c)

Hammerbeam: a type of roof in English Gothic architecture, in which timber braces curve out from walls and meet high over the middle of the floor (Figure 12.5)

Lancet: a tall narrow window with a pointed arch usually filled with stained glass (Figure 12.8)

Moralized Bible: a Bible in which the Old and New Testament stories are paralleled with one another in illustrations, text, and commentary (Figures 12.9a and 12.9b)

Ogee arch: an arch formed by two S-shaped curves that meet at the top (Figure 12.3)

Passover: an eight day Jewish festival that commemorates the exodus of Jews from Egypt under the leadership of Moses. So-called because an avenging angel of the Lord knew to "pass over" the homes of Jews who, in order to distinguish their houses from those of the pagan Egyptians, had sprinkled lamb's blood over their doorways, thus preserving the lives of their first-born sons

Pietà: a painting or sculpture of a crucified Christ lying on the lap of his grieving mother, Mary (Figure 12.7)

Pinnacle: a pointed sculpture on piers or flying buttresses (Figure 12.1)

Portal: a doorway. In medieval art they can be significantly decorated (Figure 12.6)

Rib vault: a vault in which diagonal arches form riblike patterns; these arches partially support a roof, in some cases forming a weblike design (Figure 12.4c)

Rose window: a circular window, filled with stained glass, placed at the end of a transept or on the façade of a church (Figure 12.4b)

Seder: a ceremonial meal celebrated on the first two nights of Passover that commemorates the Jewish flight from Egypt as told in the Bible; marked by a reading of the Haggadah

Spire or **Steeple:** a tall pointed tower on a church (Figure 12.4b)

Triforium: a narrow passageway with arches opening onto a nave, usually directly below a clerestory (Figure 11.2)

SUMMARY

A century of peace and prosperity brought architectural greatness to Northern France, where the Gothic style of architecture exploded on the scene around 1140. New buildings were built with great verticality, pointed arches, and large expanses of stained-glass windows. The introduction of flying buttresses made taller and thinner buildings possible.

Gothic portal sculpture became more humanized than its Romanesque counterparts, stressing salvation and resurrection rather than judgment and fear. Figures are still attached to the wall space, but are more three-dimensional. As Gothic sculpture progresses, the body is increasingly revealed beneath the drapery.

Multiple-Choice

1. The cathedral at Chartres is typical of Gothic churches in that it

 (A) contains references to classical architecture
 (B) has an oculus to admit light
 (C) uses flying buttresses to stabilize tall naves
 (D) provides a separate space for coronations

2. Christian worshippers at Chartres had their attention drawn to

 (A) the relics displayed in the crypt
 (B) the mihrab pointing the way to Mecca
 (C) the royal tombs that line the side aisles
 (D) the apse, which was elevated from the nave

3. The great portal of the west façade of Chartres is similar to the Lamassu of ancient Assyria in that they

 (A) are both guardian figures protecting what is inside
 (B) are both attached to the walls behind the figure
 (C) both have the faces of the religious leaders of their day, forming a divine connection with the earthly
 (D) both show a military presence to frighten the viewer

4. The architectural achievement that, in part, makes Gothic buildings so tall and yet so stable is the use of

 (A) rib vaults
 (B) stained-glass windows
 (C) a dome on pendentives
 (D) ashlar masonry

5. Perpendicular Gothic is a style of architecture unique to

 (A) Spain
 (B) France
 (C) Germany
 (D) England

Long Essay

Practice Question 1: Comparison
Suggested Time: 35 minutes

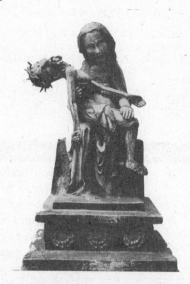

This work is the *Röttgen Pietà*, 1300–1325, painted wood.

This work shows an image of suffering and pain.

Select and completely identify another work of art that shows suffering and pain. You may choose a work listed below or any other work of your choice.

For each work, discuss *at least two* reasons *why* the figures are shown suffering.

Analyze the relationship between how these objects are depicted *and* the function they were supposed to have.

Explain *at least one* difference on how each work conveys suffering.

Coyolxauhqui "She of the Golden Bells"
Memorial Sheet for Karl Liebknecht
Giotto, *Lamentation*

ANSWERS EXPLAINED

Multiple-Choice

1. **(C)** Flying buttresses were first introduced at Notre Dame in Paris and were used to stabilize naves that were getting increasingly tall.

2. **(D)** In order for the altar to be seen more effectively in a darkened church, it was generally elevated above the floor of the nave.

3. **(B)** Both the Lamassu and the great portals at Chartres are attached to the walls behind them and, therefore, are not entirely freestanding.

4. **(A)** Rib vaults stabilize the stone roofs and help pass pressure down to the walls below. Gothic buildings do not have domes, and ashlar masonry is rarely used. Stained-glass windows do not have a supporting function in a building.

5. **(D)** Perpendicular, a form of Late Gothic architecture, is unique to England. Westminster Hall is Perpendicular Gothic.

Long Essay Rubric

Task	Point Value	Key Points in a Good Response
Select and completely identify another work of art that shows suffering and pain.	1	Answers could include: ■ *Coyolxauhqui*, "She of the Golden Bells," 1409 (?), volcanic stone. ■ *Memorial Sheet for Karl Liebknecht*, 1919–1920, woodcut. ■ Giotto, *Lamentation*, from the Arena Chapel, 1305–1306, fresco.
For each work discuss *at least two* reasons *why* the figures are shown suffering.	1 point for each work	For *Röttgen Pietà*, answers could include: ■ Crucifixion is a bloody and painful death. ■ Emphasis on the physical suffering. ■ In compliance with the biblical account. For Coyolxauhqui, answers could include: ■ Represents the dismembered moon goddess who is placed at the base of the two pyramids of Tenochtitlán. ■ Coyolxauhqui and her many brothers plotted the death of her mother, Coatlicue, who became pregnant after tucking a ball of feathers down her bosom. When Coyolxauhqui chopped off Coatlicue's head, a child popped out of the severed body fully grown, and he dismembered Coyolxauhqui, who fell dead at the base of the shrine. For *Memorial Sheet for Karl Liebknecht*, answers could include: ■ In 1919 Liebknecht was shot to death during a Communist uprising in Berlin called the Spartacus Revolt (named for the slave who led a revolt against the Romans in 73 B.C.E.). For the *Lamentation*, answers could include: ■ Biblical figures seen grieving over the body of Jesus. ■ Emphasis on the human drama of seeing a son murdered in a humiliating way during a public spectacle. ■ In compliance with the biblical account.

Task	Point Value	Key Points in a Good Response
Analyze the relationship between how these objects are depicted *and* the function they were supposed to have.	Each reason earns 1 point; total 4 points	For *Röttgen Pietà*, answers could include: ■ An andachtsbild, used for church devotion, services, or in processions. ■ Grapelike drops of Christ's blood are a reference to Christ as a "mystical vineyard." For Coyolxauhqui, answers could include: ■ Aztecs sacrificed people and then threw them down the steps of the temple dismembered, as Huitzilopochtli did to Coyolxauhqui. ■ Relationship between the death and decapitation of Coyolxauhqui and the sacrifice of enemies at the top of Aztec pyramids. For *Memorial Sheet for Karl Liebknecht*, answers could include: ■ Karl Liebknecht was among the founders of the Berlin Spartacus League, which became the German Communist Party. ■ Exposed the brutality of the ruling party and the stifling of dissent. ■ Meant to make the drama of this event personal and emotional to the viewer. ■ Use of woodcut technique makes the print readily available; thus the image can have a maximum impact among many people. For the *Lamentation*, answers could include: ■ Part of a series of paintings depicting the life of Christ. ■ Reality of the subject made the viewer feel closer to the biblical account. ■ Brought the biblical story into focus as a human and dramatic event.
Explain *at least one* difference on how each work conveys suffering.	1	Answers could include: ■ The *Röttgen Pietà* is different from the others in that it is smaller in scale, and therefore can be carried in processions and all can share in the suffering of Jesus. ■ Coyolxauhqui shows a direct relationship between what happened to her and the sacrifices the Aztecs performed in front of this work. ■ The *Memorial Sheet for Karl Liebknecht* is a secular work that references Christian iconography. ■ The *Lamentation* is part of a larger series of works and is best understood in the context of the whole.

Gothic Art in Italy

TIME PERIOD: 1250–1400

ENDURING UNDERSTANDING: The culture, beliefs, and physical settings of a region play an important role in the creation, subject matter, and siting of works of art.

Learning Objective: Discuss how the culture, beliefs, or physical setting can influence the making of a work of art. (For example: Giotto, *Lamentation*)

Essential Knowledge:

- Gothic art is a part of the medieval artistic tradition.
- In the Gothic period, royal courts emphasized the study of theology, music, and writing.
- Gothic art avoids naturalism and emphasizes stylistic variety. Text is often incorporated into artwork from this period.

ENDURING UNDERSTANDING: Cultural interaction through war, trade, and travel could influence art and art making.

Learning Objective: Discuss how works of art are influenced by cultural interaction.

Essential Knowledge:

- There is an active exchange of artistic ideas throughout the Middle Ages.
- There is a great influence of Roman, Early Medieval, and Islamic art on Gothic art.

ENDURING UNDERSTANDING: Art and art making can be influenced by a variety of concerns including audience, function, and patron.

Learning Objective: Discuss how art can be influenced by audience, function, and/or patron. (For example: The Arena or Scrovegni Chapel)

Essential Knowledge:

- Works of art were often displayed in religious or court settings.
- Surviving architecture is mostly religious.

ENDURING UNDERSTANDING: Art history is best understood through an evolving tradition of theories and interpretations.

Learning Objective: Discuss how works of art have had an evolving interpretation based on visual analysis and interdisciplinary evidence.

Essential Knowledge:

- The study of art history is shaped by changing analyses based on scholarship, theories, context, and written records.
- Contextual information comes from written records that are religious or civic.

HISTORICAL BACKGROUND

Italy did not exist as a unified entity the way it does today. The peninsula was divided into a spectrum of city-states, some quite small, ruled by an assortment of princes, prelates, and the occasional republic, like Venice. Citizens identified themselves as Sienese or Florentines, not as Italians. The varied topography and differences in the local dialects of the Italian language often made the distinction from one state to another even more profound. Sometimes, as in the case of modern Sicilian, the linguistic differences are enough to be classified as a separate language.

Few things seem more complicated to the modern viewer than Italian medieval politics, characterized as it is by routinely shifting allegiances that break into splinter groups and reform into new alliances. Those who lost power were either killed or driven from their city. Sometimes they regrouped and returned for revenge. Add to this military interventions from outside forces, such as the Holy Roman Empire or France, and medieval Italy becomes a complicated network of splintering associations.

With such instability it is a wonder that any works of art were completed, but this behavior does explain why many pieces come down to us in fragmentary condition, and why artists who were favored by one monarch may not have completed a work when another ruler came to power.

Patronage and Artistic Life

Medieval artists worked within an elaborate network called the guild system, in which artwork was regulated as an industry like any other. Guilds were artist associations that determined, among other things, how long apprenticeships should take, how many apprentices an artist could have, and what the proper route would be for an artist trying to establish him- or herself on his or her own. However, female artists were rare, because apprentices lived with their teacher, creating a situation unthinkable for females.

After a successful internship, former apprentices entered the guild as mature artists and full members. The guild helped to regulate commissions as well as ensure that not too many people entered the field, a situation that would have driven down prices. The guild system remained in effect until replaced by the free-market approach that took hold in the eighteenth century.

Artistic patronage was particularly strong among preaching orders of friars, such as the Franciscans, the devoted followers of Saint Francis of Assisi, and the Dominicans, the faithful followers of Saint Dominic de Guzman. Coalescing early in the thirteenth century, both groups abstained from material concerns and committed themselves to helping the poor and the sick. Since the Dominicans stressed teaching, they were instrumental in commissioning narrative pulpits and altarpieces for their churches so that the faithful could learn important Christian tenets. The Franciscan mother church in Assisi has a program of frescoes unequaled in **trecento** art, in part devoted to the life of the charismatic Saint Francis.

Italian citizens had a strong devotional attachment to their local church, sometimes being buried inside. Families commissioned artists to decorate private chapels, occasionally with members of the family serving as models in a religious scene. If a family could not afford a whole chapel, they perhaps could sponsor a sculpture or an altarpiece. Analogously, rulers, church leaders, and civic-minded institutions led by laypersons commissioned works for public display, using them to legitimize their reign or express their public generosity.

The modern approach to art, as a business run by professionals, has its origins in the Late Gothic period. Contracts between artists and patrons were drawn up, bookkeeping records of transactions between the two were maintained, and artists self-consciously and confidently began signing works more regularly. Artists' signatures indicate their rising status—a radical break from the general anonymity in which earlier medieval artists had toiled—and a self-conscious need publicly to associate their names with works of art of which they were particularly proud.

ITALIAN GOTHIC PAINTING

The trend in Gothic sculpture is to liberate works from the wall, allowing them to occupy space independent of their architectural framework. Concurrently, Italian painting of the Late Gothic period is characterized by large scale panels that stand on their own.

Wall paintings in the Middle Ages emphasize the flatness of the wall surface, encouraging artists to produce compositions that are frontal and linear. Late Gothic artists prefer to shade figures convincingly and reach for a three-dimensional reality.

At first, artists accepted Byzantine formulas for pictorial representation, referred to as the **maniera greca or Italo-Byzantine**. Subsequent Florentine painters, however, particularly under the guidance of **Giotto** and his followers, began to move away from this tradition and toward a different concept of reality that substantiated masses and anchored figures to ground lines. Through expressive faces and meaningful gestures, emotions become more palpable and dynamic. Florentine painting dares to experiment with compositional arrangements, moving the focus away from the center of the painting.

Unknown architect, Arena (Scrovegni) Chapel, c. 1303, brick, Padua, Italy (Figure 13.1a)

Figure 13.1a: Unknown architect, Arena (Scrovegni) Chapel, c. 1303, brick, Padua, Italy

Context
- The Arena Chapel was built by an unknown architect over an ancient Roman arena—hence the name.
- It is also called the Scrovegni Chapel after the name of the patron, Enrico Scrovegni.
- It was built to expiate the sin of usury through which Scrovegni's father amassed a fortune; shows the rise of patronage from the European business class.
- Some narrative scenes illustrate biblical episodes of ill-gotten gains.
- The life of Christ appears on one side of the chapel, the life of Mary on the other.

Content Area Early Europe and Colonial Americas, Image 63
- **Cross-Cultural Comparisons for Essay Question 1: Fresco Interiors**
 - Pentheus Room (Figure 6.13)
 - Sistine Chapel (Figure 16.2a)
 - Tomb of the Triclinium (Figure 5.3)

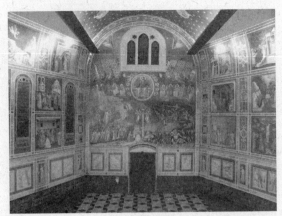

Figure 13.1b: Giotto, *Last Judgment* from the Arena Chapel, 1305, fresco, Padua, Italy

Giotto, *Last Judgment* from the Arena Chapel, 1305, fresco, Padua, Italy (Figure 13.1b)

Content

- Christ as judge, coming at the end of the world.
- Heavenly powers are arranged in an organized chorus; heads aligned in a row.
- Twelve apostles are arranged symmetrically around Christ.
- Cross at bottom center divides the saved from the damned.
- On the side of the saved is Enrico Scrovegni in his role as donor presenting a model of the church to angels.
- At right is the devil, who eats and excretes sinners.
- Those guilty of usury or money-related sins like prostitution are particularly noted.

Content Area Early Europe and Colonial Americas, Image 63

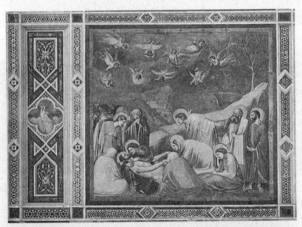

Figure 13.1c: Giotto, *Lamentation* from the Arena Chapel, 1305, fresco, Padua, Italy

Giotto, *Lamentation* from the Arena Chapel, 1305, fresco, Padua, Italy (Figure 13.1c)

Form

- Shallow stage; figures occupy a palpable space pushed forward toward the picture plane.
- Diagonal cliff formation points to main action daringly placed in lower left-hand corner.
- Modeling indicates direction of light; light falls from above right.
- Figures seen from the back isolate the main action.

Content

- *Lamentation* shows scenes of Jesus's followers mourning his death. Usually the scene contains Mary, Saint John, and Mary Magdalene.
- Saint John throws his hands back—recalling his iconographical symbol as an eagle; Mary Magdalene cradles Jesus's feet; Mary holds Jesus's head.
- At left is the Old Testament scene of Jonah being swallowed by the whale and returning to life, a parallel with the New Testament scene of Christ dying and rising from the dead.
- Range of emotions: heavy sadness, quiet resignation, flaming outbursts, despair.
- Sadness of scene emphasized by grieving angels.
- Leafless tree echoes the theme of death in the painting; also represents the tree of the knowledge of good and evil in the Garden of Eden, which dies after Adam and Eve are expelled; a dead tree also symbolizes the wood of the cross Jesus was crucified on.
- Christians believe Jesus sacrificed himself, in part, to expiate the expulsion from the Garden of Eden.

Content Area Early Europe and Colonial Americas, Image 63

Web Source http://employees.oneonta.edu/farberas/arth/arth213/arenachapel.html

- **Cross-Cultural Comparisons for Essay Question 1: Pathos**
 - Seated boxer (Figure 4.10)
 - Kollwitz, *Memorial Sheet for Karl Liebknecht* (Figure 22.4)
 - Abakanowicz, *Androgyn III* (Figure 29.7)

VOCABULARY

Lamentation: scenes that show Jesus's followers mourning his death. Usually the scene contains Mary, Saint John, and Mary Magdalene (Figure 13.1c)

Last Judgment: in Christianity, the judgment before God at the end of the world (Figure 13.1b)

Maniera greca: (Italian for "Greek manner") a style of painting based on Byzantine models that was popular in Italy in the twelfth and thirteenth centuries

Tempera: a type of paint employing egg yolk as the binding medium that is noted for its quick drying rate and flat opaque colors

Trecento: the 1300s, or fourteenth century, in Italian art

SUMMARY

It is not degrading to trecento artists to say that Late Gothic art in Italy is a bridge period between the Middle Ages and the Renaissance. Italian artists were inspired by Roman works, broke away from Byzantine traditions, and established strong schools of painting in the trecento. Florentine artists like Giotto concentrate on mass and solidity, often using shading to create the suggestion of three dimensions.

PRACTICE EXERCISES

Multiple-Choice

Questions 1 and 2 refer to the image below.

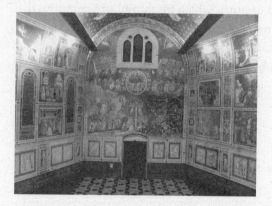

1. Among the innovations seen in this work is the artist's

 (A) combination of fresco, tempera, and oil paint, which allowed for greater detail
 (B) affinity for human emotions in Christian subject matter
 (C) ability to paint works in a series
 (D) referencing of Old and New Testament scenes side by side

2. The scene in the back of the Arena Chapel over the main door is the same scene depicted in

 (A) the tympanum of the Church of Sainte-Foy, Conques
 (B) the Great Portal, west façade, Chartres
 (C) the Golden Haggadah
 (D) Blanche of Castile and Louis IX of France in a moralized Bible

3. The artistic revival known as the Renaissance began with painters like Giotto and was stimulated in part by the

 (A) use of stained glass, which had fallen into disuse
 (B) building of Gothic cathedrals
 (C) preaching of the Franciscans
 (D) discovery of the ancient city of Pompeii

4. The fresco technique can be characterized by

 (A) use of rich colors, containing warm and vibrant hues
 (B) a permanence that will last as long as the wall surface remains untouched
 (C) a glowing iridescence that makes the surface resemble shimmering mosaics
 (D) a rapid technique without the use of preliminary drawings or preparatory studies

5. Enrico Scrovegni, the patron of the Arena Chapel, had the building built and decorated to

 (A) expiate the sin of usury, which his family had committed
 (B) honor the memory of Saint Francis of Assisi
 (C) commemorate the Virgin of Guadalupe
 (D) house the tombs of his family and his descendants

Long Essay

Practice Question 1: Comparison
Suggested Time: 35 minutes

The illustration below is the *Lamentation* by Giotto from the Arena Chapel, dated around 1305.

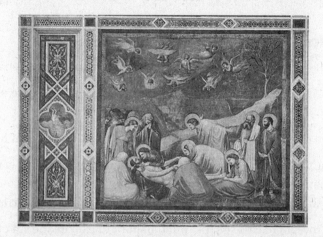

Identify the scene in the margin on the left.

Using *at least two* specific examples, discuss how the secondary scene adds to or completes the meaning of the main scene in this work.

Select and completely identify another work of art that shows a secondary scene that represents a reflection on the main scene in a work of art. You may choose a work listed below or any other work of your choice.

Using *at least two* specific examples, discuss how the secondary scene adds to or completes the meaning of the principal scene in your chosen work.

Discuss how each scene functions in the original context of each work.

Campin and workshop, Annunciation Triptych
Grünewald, Isenheim altarpiece

ANSWERS EXPLAINED

Multiple-Choice

1. **(B)** Giotto's innovations include painting figures with profoundly human expressions.

2. **(A)** Both the Arena Chapel and the tympanum of Sainte-Foy have scenes of the Last Judgment.

3. **(C)** Franciscan preaching was an important element in the revival of Renaissance art.

4. **(B)** Frescoes are water-based paints that are more muted than rich, warm, or iridescent. Artists used many preparatory sketches and preliminary drawings to create these carefully designed works. The fresco will generally last as long as the wall it is attached to lasts.

5. **(A)** Enrico Scrovegni had the chapel built, in part, to expiate the sin of usury. His father amassed a considerable fortune at this practice, and Scrovegni felt the need to atone.

Long Essay Rubric

Task	Point Value	Key Points in a Good Response
Identify the scene in the margin on the left.	1	The scene on the left is of Jonah and the Whale, from the Book of Jonah in the Old Testament.
Using *at least two* specific examples, discuss how the secondary scene adds to or completes the meaning of the principal scene in this work.	2	Answers could include: ■ Jonah is swallowed by a whale, but later comes out of the whale's belly and is reborn. ■ Jesus died on the cross but rose from the dead three days later—a New Testament reflection on the Old Testament story. ■ In a sense they are both reborn; hence the parallel of the Old and New Testament scenes.
Select and completely identify another work of art that shows a secondary scene that represents a reflection on the main scene in a work of art.	1	Answers could include: ■ Campin (or workshop), Annunciation Triptych, 1425–1428, oil on wood. ■ Grünewald, Isenheim altarpiece, 1512–1516, oil on panel.

Task	Point Value	Key Points in a Good Response
Using *at least* two specific examples, discuss how the secondary scene adds to or completes the meaning of the principal scene in your chosen work.	2	For the Annunciation Triptych, answers could include: ■ In the left panel, the donors, middle-class people, kneel before the holy scene; a door leads directly into the main room. ■ In the left scene, the enclosed garden and the rose bush are symbols of Mary. ■ The right panel depicts Joseph at work in his carpentry shop; he is often shown removed from the main scene because he is Mary's husband, but not Jesus's father. ■ Symbols in the right scene include, among other things, a mousetrap, which symbolizes capturing the devil. For the Isenheim altarpiece, answers could include: ■ The altarpiece was placed in a hospital for the treatment of ergotism, the effects of which are visible in Christ's body, including amputation of an arm, symbolized by the opening of the altarpiece which cuts his arm. ■ Amputation of Christ's legs in the predella scene indicates another amputation. ■ A disease called Saint Anthony's fire was treated at this hospital. It explains why Saint Anthony is placed on the right panel of the first view. ■ Saint Sebastian, on the left panel, is a martyr who died because of wounds.
Discuss how each scene functions in the original context of each work.	2	For the *Lamentation*, answers could include: ■ Part of the Arena Chapel. Each main scene is an episode from the life of Christ and Mary. Each main scene is flanked by a coordinating scene from the Old Testament. For the Annunciation altarpiece, answers could include: ■ This is a devotional work that is meant for private worship, hence the more intimate scale. The depiction of the donors in the wings indicates, among other things, their piety and devotion to Christianity. For the Isenheim altarpiece, answers could include: ■ Placement of this painting, with its scenes of suffering, in a hospital would open up a direct dialogue between Christ and the patient. ■ Ultimately, the painting seeks to reassure people that there is a better life awaiting them.

Renaissance in Northern Europe

14

TIME PERIOD: 1400–1600

ENDURING UNDERSTANDING: The culture, beliefs, and physical settings of a region play an important role in the creation, subject matter, and siting of works of art.

Learning Objective: Discuss how the culture, beliefs, or physical setting can influence the making of a work of art. (For example: Cranach, *Allegory of Law and Grace*)

Essential Knowledge:

- Renaissance art is generally the art of Western Europe.
- Renaissance art is influenced by a number of concerns, including the art of the classical world, Christianity, a greater respect for naturalism, and formal artistic training.
- The Reformation and the Counter-Reformation created a division in European art between the northern artists who were generally Protestant and the southern artists who were generally Catholic. In the north, religious art was deemphasized and still life, genre, landscape, and portraiture increased in popularity. In the south, religious art continued to be important, in addition to an emphasis on naturalism, dynamic compositions, and pageantry.

ENDURING UNDERSTANDING: Cultural interaction through war, trade, and travel can influence art and art making.

Learning Objective: Discuss how works of art are influenced by cultural interaction. (For example: Dürer, *Adam and Eve*)

Essential Knowledge:

- There are the beginnings of global commercial and artistic networks.

ENDURING UNDERSTANDING: Art making is influenced by available materials and processes.

Learning Objective: Discuss how material, processes, and techniques influence the making of a work of art. (For example: Cranach, *Allegory of Law and Grace*)

Essential Knowledge:

- The period is dominated by an experimentation of visual elements, i.e., atmospheric perspective, a bold use of color, creative compositions, and an illusion of naturalism.

ENDURING UNDERSTANDING: Art and art making can be influenced by a variety of concerns including audience, function, and patron.

Learning Objective: Discuss how art can be influenced by audience, function, and/or patron. (For example: Van Eyck, *Arnolfini Portrait*)

Essential Knowledge:

- There is a more pronounced identity of the artist in society; the artist has more structured training opportunities.

ENDURING UNDERSTANDING: Art history is best understood through an evolving tradition of theories and interpretations.

Learning Objective: Discuss how works of art have had an evolving interpretation based on visual analysis and interdisciplinary evidence. (For example: Van Eyck, *Arnolfini Portrait*)

Essential Knowledge:

- Renaissance art is studied in chronological order.
- There is a large body of primary source material housed in libraries and public institutions.

HISTORICAL BACKGROUND

The prosperous commercial and mercantile interests in the affluent trading towns of Flanders stimulated interest in the arts. Emerging capitalism was visible everywhere, from the first stock exchange established in Antwerp in 1460 to the marketing and trading of works of art. Cities vied with one another for the most sumptuously designed cathedrals, town halls, and altarpieces—in short, the best Europe had to offer.

Political and religious turmoil began with the Reformation, which is traditionally dated to 1517 when a German monk and scholar named Martin Luther nailed a list of his complaints to the doors of All Saints Church in Wittenberg, Germany. Perhaps unknowingly, he began one of the greatest upheavals in European history, causing a split in the Christian faith and political turmoil that would last for centuries. Those countries that were Christian the shortest period of time (Germany, Scandinavia, and the Netherlands) became Protestant. Those with longer Christian traditions (Spain, Italy, Portugal, and Poland) remained Catholic.

With a Protestant wave of anti-Catholic feeling came an iconoclastic movement attacking paintings and sculptures of holy figures, which only a short while before were considered sacred. Calvinists, in particular, were staunchly opposed to what they saw as blasphemous and idolatrous images; they spearheaded the iconoclastic movement.

Patronage and Artistic Life

The conflict between Protestant iconoclasm and Catholic images put artists squarely in the middle. On the one hand, the Church was an excellent source of employment; on the other, what if the contentions of the Protestants were true?

Many, like **Dürer**, tried to resolve the issue by either turning to other types of painting, like portraits, or by seeking a middle road by playing down religious ecstasies or the lives of the saints. Protestants thought that God could be reached directly through human intercession, so paintings of Jesus, when permitted, were direct and forceful. Catholics wanted intermediaries, such as Mary, the saints, or the priesthood to direct their thoughts, so those images were more permissible to them. However, Catholics always insisted that a sculpture of Mary was just a reminder of the figure one was praying to. Idolatry was not endorsed.

The Northern European economy can be characterized by a capitalist market system that flourished due to expansive trade across the Atlantic. This brought with it a parallel emphasis on buying and selling works of art as commodities. New technologies in printmaking made artists internationally popular, and more courted than ever before.

NORTHERN RENAISSANCE PAINTING

One of the most important inventions in the last thousand years, if not history, is the development of movable type by Johann Gutenberg. The impact was enormous. This device could mass produce books, make them available to almost anyone, and have them circulated on a wide scale.

However, mechanically printed books looked cheap and artificial to those who were used to having their books handmade over the course of years, as the **Golden Haggadah** (Figure 12.10a) did for the super-wealthy patrons. Gutenberg's first book, the Bible, was printed mechanically, but the decorative flourishes—mostly initial letters before each chapter—were hand painted by calligraphers. Meanwhile, a similar mechanical process gave birth to the print, first as a **woodcut**, then as an **engraving**, and later as an **etching**. Prints were mass produced and relatively inexpensive, since the artist made a prototype that was reprinted many times. Although each print was individually cheaper than a painting, the artist made his profit on the number of reproductions. Indeed, fame could spread more quickly with prints, because these products went everywhere, whereas paintings were in the hands of single owners.

The second important development in the fifteenth century was the widespread use of oil paint. Prior to this, wall paintings were done in fresco and panel paintings in tempera. Oil paint was developed as an alternative in a part of Europe in which fresco was never that popular.

Oil paint produces exceptionally rich colors, having the notable ability to accurately imitate natural hues and tones. It can generate enamel-like surfaces and sharp details. It also preserves well in wet climates, retaining its luster for a long time. Unlike tempera and fresco, oil paint is not quick drying and requires time to set properly, thereby allowing artists to make changes onto what they previously painted. With all these advantages, oil paint has emerged as the medium of choice for most artists since its development in Flanders in the Early Renaissance.

The great painted altarpieces of medieval art were the pride of accomplished painters whose works were on public view in the most conspicuous locations. Italian altarpieces from the age of Giotto tend to be flat paintings that stand directly behind an altar, often with gabled tops.

Alternatively, Northern European altarpieces are often cupboards rather than screens, with wings that open and close, folding neatly into one another. The large central scene is the most important, sometimes carved rather than painted; sculpture was considered a higher art form. Small paintings such as the **Annunciation Triptych** of 1425–1428 (Figure 14.1) were designed for portability. Larger works were meant to be housed in an elaborate Gothic frame that enclosed the main scenes. Sometimes the frame alluded to the architecture of the building in which the painting resided.

Altarpieces usually have a scene painted on the outside, visible during the week. On Sundays, during key services, the interior of the altarpiece is exposed to view. Particularly elaborate altarpieces may have had a third view for holidays.

Northern European artists were heavily influenced by International Gothic Painting, a courtly elegant art form, begun by Italian artists such as Simone Martini in the fourteenth century. This style of painting features thin, graceful figures that usually have an S-shaped curve

as does Late Gothic sculpture. Natural details abound in small bits of reality that are carefully rendered. Costumes are splendidly depicted with the latest fashions and most stylish fabrics. Gold is used in abundance to indicate the wealth of the figures and the patrons who sponsored these works. Architecture is carefully rendered, frequently with the walls of buildings opened up so that the viewer can look into the interior. International Gothic paintings often have elaborate frames that match the sumptuous painting style.

Regardless of whether artists worked in the International Gothic tradition, Northern European painters generally continued the practice of opening up wall spaces to see into rooms as in the **Annunciation Triptych** (Figure 14.1). Typically, figures are encased in the rooms they occupy, rather than being proportional to their surroundings. Ground lines tilt up dramatically, as do table tops and virtually any flat surface. High horizons are the norm. Although symbolism can be seen in virtually any work of art in any art historical period, it seems to be particularly a part of the fabric of Northern European painting. Items that appear casually placed as a bit of naturalism can be construed as part of a symbolic network of interpretations existing on several important levels. Scholars have spilled a great deal of ink in decoding possible readings of important works.

Northern European art during the sixteenth century is characterized by the assimilation of Italian Renaissance ideas into a Northern European context. Michelangelo was enormously popular in Northern Europe, even though he never went there, and only one of his works did. However, many other Italian artists made the journey, including the elderly Leonardo da Vinci.

Northern European painting had a fondness for nature unknown in Italian art—whether it is seen in sweeping Alpine landscape views or the study of a rabbit or even a clump of earth. Landscapes, no matter how purely represented, generally have a trace of human involvement, sometimes shown by the presence of buildings or farms, or the rendering of small people in an overwhelming setting.

Northern artists continued to use high horizon lines that enabled a large area of the work to be filled with earthbound details. In general, there is a reluctance to use linear perspective in paintings, although atmospheric perspective is featured in landscapes.

Robert Campin workshop, Annunciation Triptych (also called Merode Altarpiece), 1427–1432, oil on wood, Metropolitan Museum of Art, New York (Figure 14.1)

Form
- Triptych, or three-paneled altarpiece.
- Meticulous handling of paint; intricate details are rendered through the use of oil paint.
- Steep rising of the ground line; figures too large for the architectural space they occupy.

Function
- Meant to be in a private home for personal devotion.

Technique
- Oil paint gives the surface a luminosity and shine.
- Oil allows for layers of glazes that render soft shadows.
- Oil can also be erased with turpentine, allowing for changes and corrections.

Content
- Left panel: donors, middle-class people kneeling before the holy scene.
 - Messenger appears at the gate to an enclosed garden.

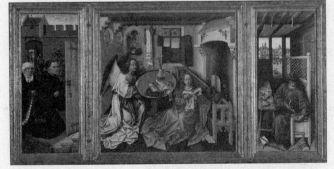

Figure 14.1: Robert Campin workshop, Annunciation Triptych (also called Merode Altarpiece), 1425–1428, oil on wood, Metropolitan Museum of Art, New York

- Center panel: Annunciation taking place in an everyday Flemish interior.
 - Symbolism
 - Towels and water represent Mary's purity; water is a baptism symbol.
 - Flowers have three buds, symbolizing the Trinity; the unopened bud represents the unborn Jesus.
 - Mary is seated on a kneeler near the floor, symbolizing her humility.
 - Mary blocks the fireplace, the entrance to hell.
 - The candlestick symbolizes Mary holding Christ in the womb.
 - The Holy Spirit with a cross comes in through the window, symbolizing the divine birth.
 - Humanization of traditional themes: no halos, domestic interiors, view into a Flemish cityscape.
- Right panel: Joseph is working in his carpentry workshop; the mousetraps on the window-sill and the workbench symbolize the capturing of the devil.
 - The mousetraps on the bench and in the shop window opening onto the street are thought to allude to references in the writings of Saint Augustine identifying the cross as the devil's mousetrap.

Context
- Unusually, the main panel was not commissioned.
- Wings were commissioned when the main panel was purchased; the donor portrait was added at this time.
- After the donor's marriage in the 1430s, the wife and messenger were added, which accounts for the rather squeezed-in look of the donor's wife.

Content Area Early Europe and Colonial Americas, Image 66

Web Source *http://www.metmuseum.org/art/collection/search/470304*

- **Cross-Cultural Connections: Images of the Virgin Mary**
 - González, *Virgin of Guadalupe* (Figure 18.4)
 - Lippi, *Madonna and Child with Two Angels* (Figure 15.3)
 - Virgin (Theotokos) and Child between Saints Theodore and George (Figure 8.8)

Jan van Eyck, *Arnolfini Portrait*, 1434, oil on wood, National Gallery, London (Figure 14.2)

Form
- Meticulous handling of oil paint; great concentration of minute details.
- Linear perspective, but upturned ground plane and two horizon lines unlike contemporary Italian Renaissance art.
- Great care is taken in rendering elements of a contemporary Flemish bedroom.

Theories
- Traditionally assumed to be the wedding portrait of Giovanni Arnolfini and his wife.
- It may be a memorial to a dead wife, who could have died in childbirth.
- It may represent a betrothal.
- Arnolfini may be conferring legal and business privileges on his wife during an absence.
- The painting may have been meant as a gift for the Arnolfini family in Italy. It had the purpose of showing the prosperity and wealth of the couple depicted.

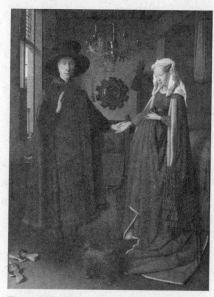

Figure 14.2: Jan van Eyck, *Arnolfini Portrait*, 1434, oil on wood, National Gallery, London

Context

- Symbolism of weddings:
 - The custom of burning a candle on the first night of a wedding.
 - Shoes are cast off, indicating that the couple is standing on holy ground.
 - The groom is in a promising pose.
 - The dog symbolizes fidelity.
- Two witnesses in the convex mirror; perhaps the artist himself, since the inscription reads "Jan van Eyck was here 1434."
- The woman pulls up her dress to symbolize childbirth, although most likely she is not pregnant; the gesture may simply be a fashion of the time.
- Statue of Saint Margaret, patron saint of childbirth, appears on the bedpost.
- The man is standing near the window, symbolizing his role as someone who makes his way in the outside world; the woman appears further in the room to emphasize her role as a homemaker.
- Wealth is displayed in the opulent furnishings, the elaborate clothing, and the importing of fresh oranges from southern Europe.

Content Area Early Europe and Colonial Americas, Image 68

Web Source *http://www.nationalgallery.org.uk/paintings/jan-van-eyck-the-arnolfini-portrait*

- **Cross-Cultural Comparisons for Essay Question 1: Couples in Art**
 - King Menkaura and queen (Figure 3.7)
 - Veranda post (Figure 27.14)
 - Justinian Panel and Theodora Panel (Figures 8.5 and 8.6)

Albrecht Dürer, *Adam and Eve*, 1504, engraving, Metropolitan Museum of Art, New York (Figure 14.3)

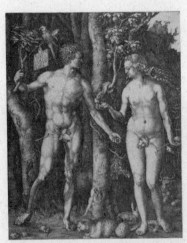

Figure 14.3: Albrecht Dürer, *Adam and Eve*, 1504, engraving, Metropolitan Museum of Art, New York

Form

- Influenced by classical sculpture; Adam looks like the *Apollo Belvedere*, and Eve looks like *Medici Venus*.
- Italian massing of forms, which he learned from his Italian trips.
- Ideal image of humans before the Fall of Man (Genesis 3).
- Contrapposto of figures from the Italian Renaissance, in turn also based on classical Greek art.
- Northern European devotion to detail.

Content

- Four humors are represented in the animals: cat (choleric, or angry), rabbit (sanguine, or energetic), elk (melancholic, or sad), ox (phlegmatic, or lethargic); the four humors were kept in balance before the Fall of Man; the humors fell out of balance after the successful temptation of the serpent.
- The mouse represents Satan.
- The parrot is a symbol of cleverness.
- Adam tries to dissuade Eve; he grasps the mountain ash, a tree from which snakes recoil.

Context

- Prominent placement of the artist's signature indicates the rising status of his occupation.

Content Area Early Europe and Colonial Americas, Image 74

Web Source *http://www.metmuseum.org/toah/works-of-art/19.73.1/*

■ **Cross-Cultural Comparisons for Essay Question 1: The Human Figure**
 - Polykleitos, *Spear Bearer* (Figure 4.3)
 - Botticelli, *Birth of Venus* (Figure 15.4)
 - Braque, *The Portuguese* (Figure 22.6)

Matthias Grünewald, Isenheim altarpiece, 1512–1516, oil on wood, Musée d'Unterlinden, Colmar (Figures 14.4a and 14.4b)

Context

■ Placed in a monastery hospital where people were treated for Saint Anthony's fire, or ergotism—a disease caused by ingesting a fungus that grows on rye flour.

■ The name of the disease explains the presence of Saint Anthony in the first view and in the third.

■ Theme: healing through salvation and faith; Saint Sebastian (left) was saved after being shot by arrows; Saint Anthony (right) survived torments by devils and demons.

■ Those suffering in the hospital were brought before this image, which symbolized heroism, sacrifice, and martyrdom.

■ Ergotism causes convulsions and gangrene.

First view

■ A scene of the crucifixion is in the center:
 - Surrounded by a symbolically dark background.
 - Christ's body is dead with decomposing flesh emphasized as inspired by the writings by the mystic Saint Bridget.
 - Christ's arms are almost torn from their sockets.
 - The body is lashed and whipped.
 - The agony of the body is unflinchingly shown and acts as a symbol for the agony of ergotism.

■ A lamb holds a cross, a common symbol for Christ, who is called the Lamb of God.

■ A chalice catching the lamb's blood parallels the chalice used to hold wine—the blood of Christ—during the Mass.

■ The crucified body of Christ would have paralleled the raising of the sacramental bread called the Eucharist.

■ A swooning Mary is dressed like the nuns who worked in the hospital.

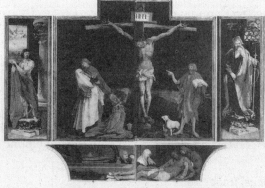

Figure 14.4a: Matthias Grünewald, Isenheim altarpiece, first view, 1512–1516, oil on wood, Musée d'Unterlinden, Colmar

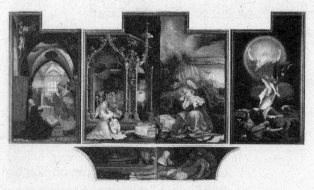

Figure 14.4b: Matthias Grünewald, Isenheim altarpiece, second view, 1512–1516, oil on wood, Musée d'Unterlinden, Colmar

- When panels open to reveal the next scene, Christ is amputated. Patients suffering from ergotism often endured amputation.
- Amputation also in the predella: Christ's legs seem amputated below the kneecap.

Second view

- Marian symbols: the enclosed garden, closed gate, rosebush, rosary.
- Christ rises from the dead, on the right; his rags changed to glorious robes; he shows his wounds, which do not harm him now.
- Message to patients: earthly diseases and trials will vanish in the next world.

Third view

- Saint Anthony in the right panel has oozing boils, a withered arm, and a distended stomach: symbols of ergotism (this view is not illustrated on the AP exam).

Content Area Early Europe and Colonial Americas, Image 77

Web Source *https://www.learner.org/series/art-through-time-a-global-view/cosmology-and-belief/isenheim-altarpiece-exterior/*

- **Cross-Cultural Comparisons for Essay Question 1: Pathos**
 - Seated boxer (Figure 4.10)
 - Munch, *The Scream* (Figure 21.11)
 - Kollwitz, *Memorial Sheet for Karl Liebknecht* (Figure 22.4)

Lucas Cranach the Elder, *Allegory of Law and Grace*, c. 1530, woodcut and letterpress (Figure 14.5)

Function

- Designed using the woodcut technique to make the image available to the masses.
- Its purpose was to contrast the benefits of Protestantism versus the perceived disadvantages of Catholicism.

Figure 14.5: Lucas Cranach the Elder, *Allegory of Law and Grace*, c. 1530, woodcut and letterpress

- Influential image of the Protestant Reformation; text appears in the people's language: German, and not the church language: Latin.

Context

- Protestantism: the faithful achieve salvation by God's grace; guidance can be achieved using the Bible.
- Meant to reflect the Lutheran ideas about salvation.
- Done in consultation with Martin Luther, a leader in the Protestant movement.
- *Left:* Last Judgment
 - Moses holds the Ten Commandments.
 - The Ten Commandments represent the Old Law, Catholicism.
 - The Law of Moses is not enough; it is not enough to live a good life.
 - A skeleton chases a man into hell.
- *Right:* Figure bathed in Christ's blood
 - Faith in Christ alone is needed for salvation.
 - Symbolically, the barren branches of the tree on the left side contrast with the full bloom on the right.

Content Area Early Europe and Colonial Americas, Image 79

Web Source *http://pitts.emory.edu/exhibits/exhibitcatalogs/LGCatalogFinal.pdf*

- **Cross-Cultural Comparisons for Essay Question 1: Ideas and Rebellion**
 - Lawrence, *The Migration of the Negro, Panel no. 49* (Figure 22.19)
 - Michel Tuffery, *Pisupo Lua Afe* (Corned Beef 2000) (Figure 29.16)
 - Neshat, *Rebellious Silence* (Figure 29.14)

Pieter Bruegel the Elder, *Hunters in the Snow*, 1565, oil on wood, Art History Museum, Vienna (Figure 14.6)

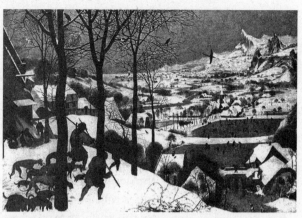

Figure 14.6: Pieter Bruegel the Elder, *Hunters in the Snow*, 1565, oil on wood, Art History Museum, Vienna

Form

- Alpine landscape; typical winter scene inspired by the artist's trips across the Alps to Italy.
- Strong diagonals lead the eye deeper into the painting.
- Figures are peasant types, not individuals.
- Landscape has high horizon line with panoramic views, a Northern European tradition.
- Extremely detailed.

Function

- One of a series of six paintings representing the labors of the months—this winter scene is November/December.
- Placed in a wealthy Antwerp merchant's home.
- Patrons were wealthy individuals of high status; Bruegel's paintings offered them a view of the world of the peasants.

Context

- Hunters have had little success in the winter hunt; dogs are skinny and hang their heads.
- Peasants in the sixteenth century were regarded as buffoons or figures of fun; Bruegel does not give them individuality but does treat them with respect.

Content Area Early Europe and Colonial Americas, Image 83

Web Source *http://metmuseum.org/toah/hd/brue/hd_brue.htm*

- **Cross-Cultural Comparisons for Essay Question 1: Hardship**
 - Turner, *Slave Ship* (Figure 20.5)
 - Courbet, *Stone Breakers* (Figure 21.1)
 - Stieglitz, *The Steerage* (Figure 22.8)

VOCABULARY

Altarpiece: a painted or sculpted panel set on an altar of a church

Annunciation: in Christianity, an episode in the Book of Luke 1:26–38 in which Angel Gabriel announces to Mary that she would be the Virgin Mother of Jesus (Figure 14.1)

Donor: a patron of a work of art, who is often seen in that work (Figure 14.1 left panel)

Engraving: a printmaking process in which a tool called a **burin** is used to carve into a metal plate, causing impressions to be made in the surface. Ink is passed into the crevices of the plate and paper is applied. The result is a print with remarkable details and finely shaded contours (Figure 14.3)

Etching: a printmaking process in which a metal plate is covered with a ground made of wax. The artist uses a tool to cut into the wax to leave the plate exposed. The plate is then submerged into an acid bath, which eats away at the exposed portions of the plate. The plate

is removed from the acid, cleaned, and ink is filled into the crevices caused by the acid. Paper is applied and an impression is made. Etching produces the finest detail of the three types of early prints (Figure 17.9)

Oil paint: a paint in which pigments are suspended in an oil-based medium. Oil dries slowly allowing for corrections or additions; oil also allows for a great range of luster and minute details (Figure 14.2)

Polyptych: a many-paneled altarpiece

Predella: The base of an altarpiece that is filled with small paintings, often narrative scenes (Figures 14.4a and 14.4b)

Reformation: a division in western Christianity in which reformers broke away from the Catholic Church and formed a series of Protestant movements. It is considered to have started with the publication of the Ninety-five Theses by Martin Luther in 1517

Triptych: a three-paneled painting or sculpture (Figure 14.1)

Woodcut: a printmaking process by which a wooden tablet is carved into with a tool, leaving the design raised and the background cut away (very much as how a rubber stamp looks). Ink is rolled onto the raised portions, and an impression is made when paper is applied to the surface. Woodcuts have strong angular surfaces with sharply delineated lines (Figure 14.5)

SUMMARY

Northern European art from the fifteenth century is dominated by monumental altarpieces prominently erected in great cathedrals. Flemish artists delight in symbolically rich compositions that evoke a visually enticing experience along with a religiously sincere and intellectually challenging interpretation. The Flemish emphasis on minute details does not minimize the total effect. The introduction of oil paint provides a new luminous glow to Northern European works.

The invention of movable type brought about a revolution in the art world. Instead of producing individual items, artists could now make multiple images whose portability and affordability would ensure their widespread fame.

The achievements of Italian Renaissance painters had a profound effect on their Northern European counterparts in the sixteenth century. The monumentality of forms, particularly in the works of Michelangelo, were of great interest to Northern European artists, who traveled to Italy in great numbers. Even so, most Northern painters continued their own tradition of meticulously painting details, high horizon lines, and colorful surfaces that characterize their art.

The civil unrest that was an outgrowth of the Reformation caused many churches to be violated as works of art were smashed and destroyed because they were thought to be pagan. Protestants in general sought more austere church interiors in reaction against the perceived lavishness of their Catholic counterparts.

Multiple-Choice

Questions 1 and 2 refer to this image.

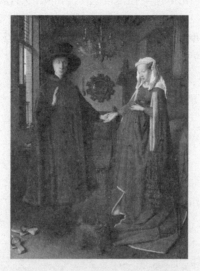

1. This work is both signed and dated, showing the growing status of artists. Which of the following works are also signed?

 (A) Basin (*Baptistère de Saint Louis*)
 (B) Virgin (Theotokos) and Child between Saints Theodore and George
 (C) *Lamentation* by Giotto
 (D) *Last Supper* by Leonardo da Vinci

2. This painting has been traditionally thought of as a wedding portrait. Which of the following has been interpreted as a wedding symbol?

 (A) The burning candle, a custom on the first night of a wedding
 (B) The inscription on the rear wall, which makes clear that a wedding contract has been signed
 (C) The man's fur coat, which is a typical garment for weddings
 (D) The convex mirror, which reflects God's blessing on this event

3. Altarpieces in Northern Europe during the Renaissance were different from their Italian counterparts in that the northern works

 (A) are painted in tempera; Italian artists preferred oil
 (B) rely on classical forms, which Italian artists rejected
 (C) specialize in religious works, which Italian artists avoided
 (D) fold closed as if they were cupboards; Italian works have one large dominant panel that does not fold closed

4. Woodcuts, such as Cranach's *Allegory of Law and Grace*, enabled

 (A) the artist to reach a wider audience with his ability to mass produce images
 (B) the collector to display works that were resistant to fading and peeling
 (C) the artist to use color in printmaking; before, only black and white was possible
 (D) the artist for the first time to represent a scene three-dimensionally

5. Albrecht Dürer's engraving of *Adam and Eve* references works of classical art for the forms of the two figures because it shows them as

 (A) pagan and corrupt
 (B) idealized before the Fall of Man
 (C) saintly and holy
 (D) concerned only about their physical appearance

Short Essay

Practice Question 5: Attribution
Suggested Time: 15 minutes

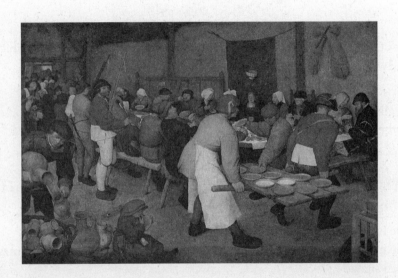

Attribute this painting to the artist who painted it.

Using *at least two* specific details, justify your attribution by describing relevant similarities between this work and a work in the required course content.

Using *at least two* specific details, explain *why* these visual elements are characteristic of this artist.

1. **A** 2. **A** 3. **D** 4. **A** 5. **B**

ANSWERS EXPLAINED

Multiple-Choice

1. **(A)** The Basin (*Baptistère de Saint Louis*) is signed (six times!) by Muhammad ibn al-Zain.

2. **(A)** All of the choices appear in the painting, but only the burning candle reflects a marriage custom.

3. **(D)** Northern works such as the Annunciation Triptych and the Isenheim altarpiece come in many sections and fold closed. Italian altarpieces tend to have one large scene that remains always viewable.

4. **(A)** Woodcuts made cheap mass-produced images available for a fraction of the cost of paintings. This enabled an artist's reputation to spread very quickly.

5. **(B)** Dürer is representing people before the Fall of Man, and therefore perfect as God originally created them. It was after they sinned that their bodies became mortal and corruptible.

Short Essay Rubric

Task	Point Value	Key Points in a Good Response
Attribute this painting to the artist who painted it.	1	Pieter Bruegel the Elder
Using *at least two* specific details, justify your attribution by describing relevant similarities between this work and a work in the required course content.	2	The work in the required course content is *Hunters in the Snow*. Answer could include: ■ Peasants in everyday activities. ■ Very detailed paintings. ■ Strong receding diagonals. ■ Gruff, but picturesque, view of country life. ■ No central focus.
Using *at least two* specific details, explain *why* these visual elements are characteristic of this artist.	2	Answers could include: ■ Rejection of Italian Renaissance ideals in art, including: – Not interested in symmetry and balance. – No classical idealization of forms. ■ Bruegel gives the impression of the immediate and spontaneous; a moment in time. ■ Bruegel has an affinity for genre scenes and landscapes. ■ Bruegel's extensive use of oil painting enables the artist to render great details and a luminous shine to his surfaces.

Content Area: Early Europe and Colonial Americas, 200–1750 C.E.

Early Renaissance in Italy: Fifteenth Century

15

TIME PERIOD: 1400–1500

The Early Renaissance takes place in the courts of Italian city-states:
Ferrara, Florence, Mantua, Naples, Rome, Venice, and so on.

ENDURING UNDERSTANDING: The culture, beliefs, and physical settings of a region play an important role in the creation, subject matter, and siting of works of art.

Learning Objective: Discuss how the culture, beliefs, or physical setting can influence the making of a work of art. (For example: Donatello, *David*)

Essential Knowledge:

- Renaissance art is generally the art of Western Europe.
- Renaissance art is influenced by the art of the classical world, Christianity, a greater respect for naturalism, and formal artistic training.

ENDURING UNDERSTANDING: Cultural interaction through war, trade, and travel can influence art and art making.

Learning Objective: Discuss how works of art are influenced by cultural interaction.

Essential Knowledge:

- There are the beginnings of global commercial and artistic networks.

ENDURING UNDERSTANDING: Art making is influenced by available materials and processes.

Learning Objective: Discuss how material, processes, and techniques influence the making of a work of art. (For example: Donatello, *David*)

Essential Knowledge:

- The period is dominated by an experimentation of visual elements, i.e., atmospheric perspective, a bold use of color, creative compositions, and an illusion of naturalism.

ENDURING UNDERSTANDING: Art and art making can be influenced by a variety of concerns including audience, function, and patron.

Learning Objective: Discuss how art can be influenced by audience, function, and/or patron. (For example: Botticelli, *Birth of Venus*)

Essential Knowledge:

- There is a more pronounced identity of the artist in society; the artist has more structured training opportunities.

ENDURING UNDERSTANDING: Art history is best understood through an evolving tradition of theories and interpretations.

Learning Objective: Discuss how works of art have had an evolving interpretation based on visual analysis and interdisciplinary evidence.

Essential Knowledge:

- Renaissance art is studied in chronological order.
- There is a large body of primary source material housed in libraries and public institutions.

HISTORICAL BACKGROUND

Italian city-states were controlled by ruling families who dominated politics throughout the fifteenth century. These princes were lavish spenders on the arts, and great connoisseurs of cutting-edge movements in painting and sculpture. Indeed, they embellished their palaces with the latest innovative paintings by artists such as **Lippi** and **Botticelli**. They commissioned architectural works from the most pioneering architects of the day. Competition among families and city-states encouraged a competition in the arts, each state and family seeking to outdo the other.

Princely courts gradually turned their attention away from religious subjects to more secular concerns, in a spirit today defined as **humanism**. It became acceptable, in fact encouraged, to explore Italy's pagan past as a way of shedding light on contemporary life. The exploration of new worlds, epitomized by the great European explorers, was mirrored in a new growth and appreciation of the sciences, as well as the arts.

Patronage and Artistic Life

The influence of the patrons of this period can be seen in a number of ways, including such things as specifying the amount of gold lavished on an altarpiece or which family members the artist was required to prominently place in the foreground of a painting. It was also customary for great families to have a private chapel in the local church dedicated to their use. Artists would often be asked to paint murals in these chapels to enhance the spirituality of the location.

EARLY RENAISSANCE ARCHITECTURE

Renaissance architecture depends on order, clarity, and light. The darkness and mystery, indeed the sacred sense of Gothic cathedrals, was deemed barbaric. In its place were created buildings with wide window spaces, limited stained glass, and vivid wall paintings.

Although all buildings need mathematics to sustain the engineering principles inherent in their design, Renaissance buildings seem to stress geometric designs more demonstrably than most. Harmonies were achieved by a system of ideal proportions learned from an architectural treatise by the Roman Vitruvius. The ratios and proportions of various elements of the interior

of Florentine Renaissance churches were interpreted as expressions of humanistic ideals. The Early Christian past was recalled in the use of unvaulted naves with coffered ceilings.

Thus, the crossing is twice the size of the nave bays, the nave twice the width of the side aisles, and the side aisles twice the size of side chapels. Arches and columns take up two-thirds of the height of the nave, and so on. This logical expression is often strongly delineated by the floor patterns in the nave, in which white and gray marble lines demarcate the spaces, as at Brunelleschi's **Pazzi Chapel** (Figures 15.1a and 15.1b).

Florentine palaces, such as Alberti's **Palazzo Rucellai** (Figure 15.2), have austere dominating façades that rise three stories from street level. Usually the first floor is reserved as public areas; business is regularly transacted here. The second floor rises in lightness, with a strong stringcourse marking the ceiling of one story and the floor of another. The third floor is capped by a heavy cornice in the style of a number of Roman temples.

Filippo Brunelleschi, Pazzi Chapel, Basilica di Santa Croce, designed 1423, built 1429–1461, masonry, Florence, Italy (Figures 15.1a and 15.1b)

Form

- Two barrel vaults on the interior; small dome over crossing; pendentives support dome; oculus in the center.
- Interior has a quiet sense of color with muted tones that is punctuated by glazed terra cotta tiles.
- Use of pietra serena (a grayish stone) in contrast to whitewashed walls accentuates basic design structure.
- Inspired by Roman triumphal arches.
- Ideal geometry in the plan of the building.

Function

- Chapter house: a meeting place for Franciscan monks; bench that wraps around the interior provides seating for meetings.
- Rectangular chapel with an apse and an altar attached to the church of Santa Croce, Florence.

Attribution

- Attribution of portico by Brunelleschi has been recently questioned; the building may have been designed by Bernardo Rossellino or his workshop.

Patronage

- Patrons were the wealthy Pazzi family, who were rivals of the Medici.
- The family coat-of-arms, two outward facing dolphins, is placed at the base of each pendentive on the interior.

Content Area Early Europe and Colonial Americas, Image 67

Web Source *http://www.sgira.org/hm/brun7.htm*

Figure 15.1a: Filippo Brunelleschi, Pazzi Chapel, Basilica di Santa Croce, 1429–1461, masonry, Florence, Italy

Figure 15.1b: Filippo Brunelleschi, Pazzi Chapel interior, Basilica di Santa Croce, 1429–1461, masonry, Florence, Italy

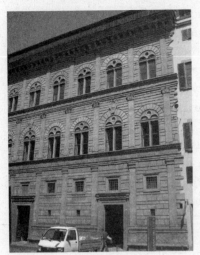

Figure 15.2: Leon Battista Alberti, Palazzo Rucellai, c. 1450, stone, masonry, Florence, Italy

■ **Cross-Cultural Comparisons for Essay Question 1: Personal Sacred Spaces**
 – Bernini, Cornaro Chapel (Figures 17.4a, 17.4b)
 – Giotto, Arena Chapel (Figures 13.1a, 13.1b, 13.1c)
 – Ryoan-ji (Figures 25.2a, 25.2b)

Leon Battista Alberti, Palazzo Rucellai, c. 1450, stone, masonry, Florence, Italy (Figure 15.2)

Form
■ Three horizontal floors separated by a strongly articulated stringcourse; each floor is shorter than the one below.
■ Pilasters rise vertically and divide the spaces into squarish shapes.
■ An emphasized cornice caps the building.
■ Square windows on the first floor; windows with mullions on the second and third floors.
■ Rejects rustication of earlier Renaissance palaces; used beveled masonry joints instead.
■ Benches on lower level connect the palazzo with the city.

Function
■ City residence of the Rucellai family.
■ The building format expresses classical humanist ideals for a residence: the bottom floor was used for business; the family received guests on the second floor; the family's private quarters were on the third floor; the hidden fourth floor was for servants.

Context
■ The articulation of the three stories links the building to the Colosseum levels, which have arches framed by columns: the first floor pilasters are Tuscan (derived from Doric); the second are Alberti's own invention (derived from Ionic); the third are Corinthian.
■ Original building:
 – Five bays on the left, with a central door.
 – Second doorway bay and right bay added later.
 – Eighth bay fragmentary: owners of house next door refused to sell, and the Palazzo Rucellai never expanded.

Patronage
■ Patron was Giovanni Rucellai, a wealthy merchant.
■ Rucellai coat-of-arms, a rampart lion, is placed over two second-floor windows.
■ Friezes contain Rucellai family symbols: billowing sails.

Content Area Early Europe and Colonial Americas, Image 70

Web Source *http://www.sgira.org/hm/alberti3.htm*

■ **Cross-Cultural Comparisons for Essay Question 1: Buildings in Urban Spaces**
 – Gehry, Guggenheim Museum Bilbao (Figures 29.1a, 29.1b)
 – Sullivan, Carson, Pirie, Scott and Company Building (Figure 21.14a)
 – Trajan's Market (Figure 6.10a)

FIFTEENTH-CENTURY ITALIAN PAINTING AND SCULPTURE

The most characteristic development of Italian Renaissance painting is the use of linear perspective, a technique some scholars say was known to the Romans. Other scholars have attributed its revitalization, if not invention, to **Filippo Brunelleschi**, who developed perspective while drawing the Florence Cathedral Baptistery in the early fifteenth century.

Some artists were fascinated with perspective, showing objects and people in proportion with one another, unlike medieval art which has people dominating compositions. Artists who were trained prior to this tradition were quick to see the advantages to linear perspective and incorporated it into their later works.

Later in the century, perspective becomes an instrument that some artists would use, or exploit, to create different artistic effects. The use of perspective to intentionally fool the eye, the **trompe l'oeil technique**, is an outgrowth of the ability of later fifteenth-century painters who employed it as one tool in an arsenal of techniques.

In the early part of the fifteenth century, religious paintings dominated, but by the end of the century, portraits and mythological scenes proliferated, reflecting humanist ideals and aspirations.

Interest in humanism and the rebirth of Greco-Roman classics also spurs an interest in authentic Greek and Roman sculptures. The ancients gloried in the nude form in a way that was interpreted by medieval artists as pagan. The revival of nudity in life-size sculpture is begun in Florence with **Donatello's** *David* (Figure 15.5), and continued throughout the century.

Nudity is one manifestation of an increased study of human anatomy. Drawings of people with heroic bodies are sketched in the nude and transferred into stone and bronze. Some artists show the intense physical interaction of forms in the twisting gestures and straining muscles of their works.

Fra Filippo Lippi, *Madonna and Child with Two Angels*, c. 1465, tempera on wood, Uffizi, Florence (Figure 15.3)

Content and Symbolism
- Symbolic landscape
 - Rock formations symbolize the Christian Church.
 - City near the Madonna's head is the Heavenly Jerusalem.
- Pearl motif: seen in headdress and pillow as products of the sea (in upper-left corner).
- Pearls used as symbols in scenes of the Incarnation of Christ.

Context
- Mary seen as a young mother.
- Model may have been the artist's lover.
- Landscape inspired by Flemish painting.
- Scene depicted as if in a window in a Florentine home.
- Humanization of a sacred theme; there is a sense of domestic intimacy.
- Lippi was a monk, as indicated by the word "Fra" that precedes his name; he was working in a Carmelite monastery under the patronage of the Medici.

Content Area Early Europe and Colonial Americas, Image 71
Web Source https://www.theguardian.com/culture/2004/feb/14/art
- **Cross-Cultural Comparisons for Essay Question 1: Virgin Mary**
 - Notre Dame de la Belle Verriere (Figure 12.8)
 - *Röttgen Pietà* (Figure 12.7)
 - Miguel González, *Virgin of Guadalupe* (Figure 18.4)

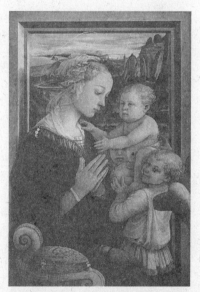

Figure 15.3: Fra Filippo Lippi, *Madonna and Child with Two Angels*, c. 1465, tempera on wood, Uffizi, Florence

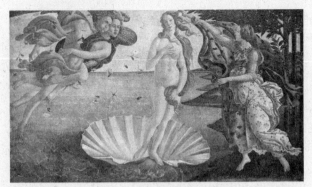

Figure 15.4: Sandro Botticelli, *Birth of Venus*, c. 1484–1486, tempera on canvas, Uffizi, Florence

Sandro Botticelli, *Birth of Venus*, c. 1484–1486, tempera on canvas, Uffizi, Florence (Figure 15.4)

Form

- Crisply drawn figures.
- Landscape flat and unrealistic; simple V-shaped waves.
- Figures float, not anchored to the ground.

Content

- Venus emerges fully grown from the foam of the sea with a faraway look in her eyes.
- Roses scattered before her; roses created at the same time as Venus, symbolizing that love can be painful.
- On the left: Zephyr (west wind) and Chloris (nymph).
- On the right: handmaiden rushes to clothe Venus.

Context

- Medici commission; may have been commissioned for a wedding celebration.
- Painting based on a popular court poem by the writer Poliziano, which itself is based on Homeric hymns and Hesiod's Theogony.
- A revival of interest in Greek and Roman themes can be seen in this work.
- Earliest full-scale nude of Venus in the Renaissance.
- Reflects emerging Neoplatonic thought.

Content Area Early Europe and Colonial Americas, Image 72

Web Source http://www.pbs.org/empires/medici/renaissance/botticelli.html

- **Cross-Cultural Comparisons for Essay Question 1: Classical References**
 - David, *The Oath of the Horatii* (Figure 19.6)
 - Raphael, *School of Athens* (Figure 16.3)
 - Dürer, *Adam and Eve* (Figure 14.3)

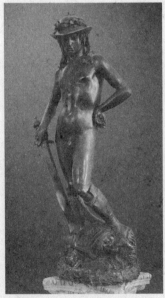

Figure 15.5: Donatello, *David*, c. 1440–1460, bronze, National Museum, Bargello, Florence

Donatello, *David*, c. 1440–1460, bronze, National Museum, Bargello, Florence (Figure 15.5)

Form

- First large bronze nude since antiquity.
- Exaggerated contrapposto of the body.
- Sleekness of the black bronze adds to the femininity of the work.
- Androgynous figure; homoerotic overtones.

Function

- Life-size work, probably meant to be housed in the Medici palace courtyard; not for public viewing.

Content

- The work depicts the moment after David slays the Philistine Goliath with a rock from a slingshot; David then decapitates Goliath with his own sword (1 Samuel 17).
- David contemplates his victory over Goliath, whose head is at his feet; David's head is lowered to suggest humility.
- Laurel on David's hat indicates he was a poet; the hat is a foppish Renaissance design.

Context

- David symbolizes Florence taking on larger forces with ease; perhaps Goliath would have been equated with the Duke of Milan.
- Nothing is known of its commission or patron, but it was placed in the courtyard of the Medici palace in Florence.
- Modern theory alleges that this is a figure of Mercury, and that the decapitated head is of Argo; Mercury is the patron of the arts and merchants, and therefore an appropriate symbol for the Medici.

Content Area Early Europe and Colonial Americas, Image 69

Web Source *http://www.pbs.org/empires/medici/renaissance/donatello.html*

- **Cross-Cultural Comparisons for Essay Question 1: Nudity**
 - Female deity from Nukuoro (Figure 28.2)
 - Seated boxer (Figure 4.10)
 - Ingres, *La Grande Odalisque* (Figure 20.3)

VOCABULARY

Bottega: the studio of an Italian artist

Chapter house: a building next to a church used for meetings (Figures 15.1a and 15.1b)

Humanism: an intellectual movement in the Renaissance that emphasized the secular alongside the religious. Humanists were greatly attracted to the achievements of the classical past, and stressed the study of classical literature, history, philosophy, and art

Madonna: the Virgin Mary, mother of Jesus Christ (Figure 15.3)

Mullion: a central post or column that is a support element in a window or a door (Figure 15.2)

Neoplatonism: a school of ancient Greek philosophy that was revived by Italian humanists of the Renaissance

Orthogonal: lines that appear to recede toward a vanishing point in a painting with linear perspective

Perspective: depth and recession in a painting or a relief sculpture. Objects shown in **linear perspective** achieve a three-dimensionality in the two-dimensional world of the picture plane. Lines, called **orthogonals**, draw the viewer back in space to a common point, called the **vanishing point**. Paintings, however, may have more than one vanishing point, with the orthogonals leading the eye to several parts of the work. Landscapes that give the illusion of distance are in an **atmospheric** or **aerial perspective**.

Pietra serena: a dark-gray stone used for columns, arches, and trim details in Renaissance buildings (Figure 15.1b)

Pilaster: a flattened column attached to a wall with a capital, a shaft, and a base (Figure 15.2)

Quattrocento: the 1400s, or fifteenth century, in Italian art

Trompe l'oeil: (French, meaning "fools the eye") a form of painting that attempts to represent an object as existing in three dimensions, and therefore resembles the real thing

Humanist courts of Renaissance Italy patronized artists who rendered both religious compositions and secular works. After 1450 it is common to see contemporary events, ancient mythology, or portraits of significant people take their place side by side with scenes of the Annunciation and Crucifixion.

Brunelleschi's development of one-point perspective revolutionized Italian painting. At first, artists faithfully used the formula in their compositions, creating realistic three-dimensional spaces on their surfaces. Later, painters used perspective as a tool to manipulate the viewer's impression of a particular scene.

Sculptors competed with the glory of ancient artists by creating monumental figures and equestrian images, and revived antiquity's interest in nudity and idealized human proportion.

Architecture was dominated by spatial harmony and light interiors that contrasted markedly with the mystical stained-glass-filled Gothic buildings.

PRACTICE EXERCISES

Multiple-Choice

1. Leon Battista Alberti's architectural style represents a scholarly interpretation of classical elements seen in buildings such as

 (A) the Mortuary temple of Hatshepsut
 (B) the Parthenon
 (C) the Column of Trajan
 (D) the Colosseum

Questions 2–4 refer to the following picture.

2. The nudity in Donatello's *David*

 (A) would have been considered heroic in Islamic art
 (B) is inspired by Gothic portal sculpture
 (C) references the ideal human proportions expressed in Polykleitos's canon
 (D) recalls the nudity of public sculptures from the ancient Mediterranean

3. The laurel wreath on the head of the *David* refers to his

 (A) oneness with nature
 (B) victory over Goliath
 (C) role as a shepherd
 (D) author of a book in the Bible

4. Before the creation of Donatello's *David*, large, public nude sculptures were not executed because

 (A) they represented the pagan world of mythological gods
 (B) artists were influenced by a general ban on images in Jewish art
 (C) they showed man in a primitive and bestial state
 (D) they were not suitable for women to view

5. Fra Filippo Lippi's *Madonna and Child with Two Angels* reflects the Renaissance's attitude toward a more

 (A) ethereal and heavenly vision of Mary and Jesus
 (B) formal and forbidding image of divine figures
 (C) human and approachable interpretation of heavenly figures
 (D) pagan and mythological approach to Christian imagery

Long Essay

Practice Question 2: Visual and Contextual Analysis
Suggested Time: 15 minutes

This work is Leon Battista Alberti's Palazzo Rucellai built c. 1450 of stone and masonry in Florence, Italy. It is a domestic structure.

Select and completely identify another building that is a domestic structure either from the suggested list below or any other relevant work.

Explain how each architect designed his or her building in relationship to the site around it.

In your answer, make sure to:

- Accurately identify the work you have chosen with *at least two* identifiers beyond those given.
- Respond to the question with an art historically defensible thesis statement.
- Support your claim with *at least two* examples of visual and/or contextual evidence.
- Explain how the evidence that you have supplied supports your thesis.
- Use your evidence to corroborate or modify your thesis.

Villa Savoye
House in New Castle County
Fallingwater

ANSWER KEY

1. **D** 2. **D** 3. **D** 4. **A** 5. **C**

ANSWERS EXPLAINED

Multiple-Choice

1. **(D)** The three floors with rounded arches interspersed by columns recalls an arrangement on the Colosseum in Rome.

2. **(D)** Greek and Roman cities are often characterized by a preponderance of large-scale heroic nude figures. Islamic art would have considered nudes as blasphemous and debasing. Gothic portal sculptures are typically entirely covered by drapery except for the extremities. This work does not have the ideal human proportions expressed by Polykleitos.

3. **(D)** David was a poet. The Book of Psalms is ascribed to his authorship.

4. **(A)** Nudity was associated with the pagan world; Christians sought to avoid association with pagan gods.

5. **(C)** The Renaissance was mostly interested in making human the divine image. This painting has a particularly affectionate view of a young mother as Mary, and a suitably human child accompanied by impish angels.

Long Essay Rubric

Task	Point Value	Key Points in a Good Response
Accurately identify the work you have chosen with *at least two* identifiers beyond those given.	1	Answers could include: ■ Le Corbusier, Villa Savoye, 1929, steel and reinforced concrete, Poissy-sur-Seine, France. ■ Venturi, Rauch, and Brown, House in New Castle County, 1978–1983, wood frame and stucco, Delaware. ■ Wright, Fallingwater, 1936–1939, reinforced concrete, sandstone, steel, and glass, Pennsylvania.
Respond to the question with an art historically defensible thesis statement.	1	The thesis statement must be an art historically sound claim that responds to the question and does not merely restate it. The thesis statement should come at the beginning of the argument and be at least one, preferably two sentences. For example, the Palazzo Rucellai and Fallingwater are both works that consider aspects of the surrounding environment into their designs. In the first case, the Palazzo Rucellai is in an urban environment, the building constructed downtown amid other buildings; in the second case, Fallingwater is designed in a rural setting with many natural features.
Support your claim with *at least two* examples of visual and/or contextual evidence.	2	*Two* visual *or* contextual examples are needed here. For these examples, part of the evidence could involve a discussion of the relationship of each work to the area around it. For example, the Palazzo Rucellai is meant to be imposing and symbolize the status of the family who lives there, and to advertise itself to fellow city dwellers. This status is suggested by the friezes that contain the Rucellai family symbols of a billowing sail, or their coat-of-arms. These symbols are meant to impress fellow citydwellers of the status of the family within.
Explain how the evidence that you have supplied supports your thesis.	1	Good responses link the evidence you have provided with the main thesis statement. For example, make sure you make a strong connection between aspects of the site (the waterfall, for example, in Fallingwater) with the respect for nature felt by the Kaufmanns and Wright, and the welcoming of nature into the home.
Use your evidence to corroborate or modify your thesis.	1	This point is earned when a student demonstrates a depth of understanding, in this case of domestic architecture. The student must demonstrate multiple insights on a given subject. For example, the student could discuss each building's function as a home as well as a monument to its owners.

Content Area: Early Europe and Colonial Americas, 200–1750 C.E.

High Renaissance and Mannerism

16

ENDURING UNDERSTANDING: The culture, beliefs, and physical settings of a region play an important role in the creation, subject matter, and siting of works of art.

Learning Objective: Discuss how the culture, beliefs, or physical setting can influence the making of a work of art. (For example: Leonardo da Vinci, *The Last Supper*)

Essential Knowledge:

- Renaissance art is generally the art of Western Europe.
- Renaissance art is influenced by the art of the classical world, Christianity, a greater respect for naturalism, and formal artistic training.

ENDURING UNDERSTANDING: Cultural interaction through war, trade, and travel can influence art and art making.

Learning Objective: Discuss how works of art are influenced by cultural interaction.

Essential Knowledge:

- There are the beginnings of global commercial and artistic networks.

ENDURING UNDERSTANDING: Art making is influenced by available materials and processes.

Learning Objective: Discuss how material, processes, and techniques influence the making of a work of art.

Essential Knowledge:

- The period is dominated by an experimentation of visual elements, i.e., atmospheric perspective, a bold use of color, creative compositions, and an illusion of naturalism.

ENDURING UNDERSTANDING: Art and art making can be influenced by a variety of concerns including audience, function, and patron.

Learning Objective: Discuss how art can be influenced by audience, function, and/or patron. (For example: Michelangelo, Sistine Chapel ceiling)

Essential Knowledge:

- There is a more pronounced identity and social status of the artist in society; the artist has more structured training opportunities.

ENDURING UNDERSTANDING: Art history is best understood through an evolving tradition of theories and interpretations.

Learning Objective: Discuss how works of art have had an evolving interpretation based on visual analysis and interdisciplinary evidence. (For example: Michelangelo, Sistine Chapel ceiling)

Essential Knowledge:

- Renaissance art is studied in chronological order.
- There is a large body of primary source material housed in libraries and public institutions.

HISTORICAL BACKGROUND

Italian city-states with their large bankrolls and small populations were easy pickings for Spain and France, as they began their advances over the Italian peninsula. Venice alone remained an independent power, with its incomparable fleet bringing goods and profits around the Mediterranean.

The High Renaissance flourished in the cultivated courts of princes, doges, and popes—each wanting to make his city-state greater than his neighbor's. Unfortunately, most of this came to a temporary halt with the sack of Rome in 1527—a six-month rape of the city that did much to undo the achievements of one of the most creative moments in art history. What emerged from the ruins of Rome was a new period, Mannerism, which took art on a different path.

When Martin Luther nailed his theses to the doors of a church in Wittenberg, Germany in 1517, he touched off a religious and political upheaval that had long-lasting repercussions throughout Europe. Even if this movement, called the Protestant Reformation, was treated as a heresy in Italy, it had a dramatic impact on Italian art. No longer was the High Renaissance sense of perfection a representation of the world as it is, or could ever be. Mannerist distortions were more appropriate in this highly contentious period. Indeed, the basic tenets of Mannerism concern the tension between the ideal, the natural, and the symmetrical against the real, the artificial, and the unbalanced.

The schism that the Reformation caused was met by a Catholic response, framed at the Council of Trent (1545–1563) and later termed the Counter-Reformation. At the Council a new order of priests was created, called the Jesuits, whose missionary activity and commitment to education is still visible around the world today. The Jesuits quickly saw the power of art as a teaching tool and a religious statement, and became great patrons of the arts.

The religious and political upheaval that characterized the sixteenth century was exemplified by the sacking of the city of Rome in 1527. The unpaid army of the Holy Roman Empire, after defeating the French troops in Italy, sought restitution in looting and pillaging the holy city. The desecration of Rome shook all Christendom, especially since it proved that its chief holy place could so easily fall victim to the undisciplined and the greedy.

Patronage and Artistic Life

Most Renaissance artists came from humble origins, although some like **Titian** and **Michelangelo** came from families of limited influence. Every artist had to join a trade guild, which sometimes made them seem equivalent to house painters or carpenters. Even so, artists could achieve great fame, so great that monarchs competed to have them in their employ. Francis I of France is said to have held the dying **Leonardo da Vinci** in his arms, Charles V of the Holy Roman Empire lavished praise upon **Titian**, and **Michelangelo** was called "divino" by his biographers.

The dominant patron of the era was Pope Julius II, a powerful force in European religion and politics. It was Julius's ambition that transformed the rather ramshackle medieval town of Rome into an artistic center and capital of the Renaissance. It was Julius's devotion to the arts that inspired **Raphael** and **Michelangelo** to do their greatest work.

The first permanent painting academy was established by Cosimo I of Florence in 1563; its function was to train artists and improve their status in society. The best artists, however, did not need academies, nor did they need patrons. Although some preferred to work for a duke and stay in his graces, the reality was that a duke usually did not have enough commissions to keep a painter occupied. Famous artists did not need this security, and most achieved success by keeping their important patrons satisfied. Michelangelo's relationship with Pope Julius II was successful in part because Julius became his preferred, although by no means his only, customer. Mannerist painters saw nothing about this situation worth changing.

HIGH RENAISSANCE PAINTING

Northern European artists discovered the durability and portability of canvas as a painting surface. This was immediately taken up in Venice, where the former backing of choice—wood—would often warp in damp climate. Since canvas is a material with a grainy texture, great care was made to prepare it in such a way as to minimize the effect the cloth would have on the paint. Canvas, therefore, had to be primed properly to make it resemble the enamel-like surface of wood. In modern art, the grainy texture is often maintained for the earthy feel it lends a painting.

Leonardo da Vinci used a painting technique known as **sfumato**, in which he rendered forms in a subtly soft way to create a misty effect across the painted surface. Sfumato has the effect of distancing the viewer from the subject by placing the subject in a hazy world removed from us.

Artists also employed **chiaroscuro**, which provides soft transitions between light and dark. Chiaroscuro often heightens modeling effects in a work by having the light define the forms.

Venetian artists, particularly **Titian**, increased the richness of oil-painted surfaces by applying **glazes**. Glazes had been used on pottery since ancient times, when they were applied to ceramics to give them a highly polished sheen. In painting, as in pottery, glazes are transparent so that the painted surface shows through. However, glazes subtly change colors by brightening them, much as varnish brightens wood.

In portrait painting, instead of profiles, which were popular in the quattrocento, three-quarter views became fashionable. This view minimizes facial defects that profiles enhance. With Leonardo da Vinci's *Mona Lisa*, portraits become psychological paintings. It was not enough for artists to capture likenesses; artists were expected to express the character of the sitter.

The idealization that characterizes **Raphael's** work becomes the standard High Renaissance expression. Raphael specialized in balanced compositions, warm colors, and ideally proportioned figures. He favored a triangular composition: The heavy bottom anchors forms securely and then yields to a lighter touch as the viewer's eye ascends.

Works like **Leonardo da Vinci's *The Last Supper*** (Figure 16.1) show a High Renaissance composition, with the key figure, in this case Jesus, in the center of the work, alone and highlighted by the window behind. The twelve apostles are grouped in threes, symmetrically balanced around Jesus, who is the focal point of the orthogonals. Even so, the work's formal structure does not dominate because the Biblical drama is rendered so effectively on the faces of the individuals.

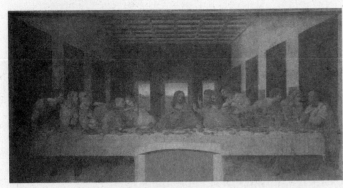
Figure 16.1: Leonardo da Vinci, *The Last Supper*, 1494-1498, tempera and oil, Santa Maria delle Grazie, Milan

Leonardo da Vinci, *The Last Supper*, 1494–1498, tempera and oil, Santa Maria delle Grazie, Milan (Figure 16.1)

Form

- Linear perspective; orthogonals of ceiling and floor point to Jesus.
- Apostles are grouped in sets of three
- Jesus is alone before a group of three windows, a symbol of the Trinity.
- A rounded pediment over Jesus's head acts as a symbolic halo; Leonardo subtlety suggests Jesus's divinity.

Function

- Painted for the refectory, or dining hall, of an abbey of friars.
- A relationship is drawn between the friars eating and a biblical meal.

Patronage

- Commissioned by the Sforza family of Milan for the refectory of a Dominican abbey.

Materials

- Leonardo experimented with a combination of paints to yield a greater chiaroscuro; however, the paints began to peel off the wall in Leonardo's lifetime. As a result, the painting has been restored many times and is a shadow of itself.

Content

- Great drama of the moment: Jesus says, "One of you will betray me" (Matthew 26:21); Jesus also blesses the bread and wine, creating a sacred Eucharist (Matthew 26:26–27).
- Various reactions on the faces of the apostles: surprise, fear, anger, denial, suspicion; anguish on the face of Jesus.
- Judas, the betrayer, falls back clutching his bag of coins; his face is symbolically in darkness.

Content

- The only Leonardo da Vinci work remaining in situ.

Content Area Early Europe and Colonial Americas, Image 73

Web Source https://whc.unesco.org/en/list/93/

- **Cross-Cultural Comparisons for Essay Question 1: Composition**
 - Justinian and Theodora (Figures 8.5, 8.6)
 - Basquiat, *Horn Players* (Figure 29.5)
 - Niobides Krater (Figures 4.19a and 4.19b)

Michelangelo, Sistine Chapel ceiling, 1508–1512, fresco, Vatican City, Italy (Figures 16.2a and 16.2b)

Form

- Masculine modeling of forms.
- Bold, direct, powerful narrative expression.

Function

- Function of the chapel: the place where new popes are elected and where papal services take place.
- Name derives from Pope Sixtus IV, who was the patron of the building's redesign between 1473 and 1481.

Content

- Michelangelo chose a complicated arrangement of figures for the ceiling, which broadly illustrates the first few chapters of Genesis in nine scenes, with accompanying Old Testament figures and antique sibyls—many based on antique sculptures; the Old Testament figures and antique sibyls foretell the coming of Christ, and they express a spirit of Neoplatonism.
- The grand and massive figures are meant to be seen from a distance, but also echo the grandeur of the Biblical narrative.
- 300 figures on the ceiling, with no two in the same pose; a tribute to Michelangelo's lifelong preoccupation with the male nude in motion.
- Enormous variety of expression.
- Painted cornices frame groupings of figures in a highly organized way.
- Many figures are done for artistic expression rather than to enhance the narrative; the ignudi, for example.

Context

- Sistine Chapel was erected in 1472 and painted by quattrocento masters, including Botticelli, Perugino, and Michelangelo's teacher, Ghirlandaio; Michelangelo's ceiling was added to these.
- Quattrocento paintings are of the life of Christ and the life of Moses; Michelangelo needed a different topic for the ceiling; he chose the cosmic theme of creation.
- Michelangelo's paintings are painted over the window level of the chapel as well as the ceiling.
- The chapel is dedicated to the Virgin Mary, as such the central panel on the ceiling depicts Eve, the archetype of Mary, who, according to tradition, began the redemption necessitated by the sin of Eve and Adam.
- Acorns, a motif on the ceiling, were inspired by the crest of the chapel's patron, Pope Julius II.

Content Area Early Europe and Colonial Americas, Image 75

Web Source *http://www.museivaticani.va/content/museivaticani/en/collezioni/musei/cappella-sistina.html*

- **Cross-Cultural Comparisons for Essay Question 1: Subdivided Compositions**
 - Golden Haggadah (Figure 12.10a, 12.10b, 12.10c)
 - Giotto, *Lamentation* (Figure 13.1c)
 - Pentheus Room (Figure 6.13)

Michelangelo, Delphic Sybil, c. 1508–1512, fresco, Sistine Chapel, Vatican City, Italy (Figure 16.2c)

Form and Content

- The sibyl wears a Greek-style turban.
- Her head is turned as if listening.

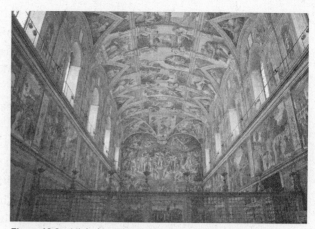
Figure 16.2a: Michelangelo, Sistine Chapel, 1508–1512, fresco, Vatican City, Italy

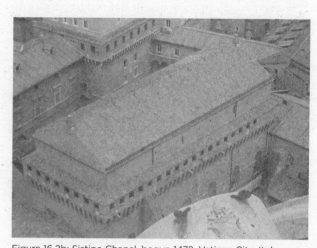
Figure 16.2b: Sistine Chapel, begun 1472, Vatican City, Italy

Figure 16.2c: Michelangelo, Delphic Sybil, c. 1508–1512, fresco, Sistine Chapel, Vatican City, Italy

- She has a sorrowful expression.
- There is a dramatic contrapposto positioning of the body.
- She holds the scroll containing her prophecy.
- She is a powerfully built female figure.

Context
- One of five sibyls (prophetesses) on the ceiling.
- Greco-Roman figures whom Christians believed foretold the coming of Jesus Christ.
- This shows a combination of Christian religious and pagan mythological imagery.

Content Area Early Europe and Colonial Americas, Image 75
- **Cross-Cultural Comparisons for Essay Question 1: Time and Memory**
 - Calendar Stone (Figure 26.5c)
 - *Lukasa* (memory board) (Figure 27.11)
 - Lin, Vietnam Veterans Memorial (Figures 29.4a, 29.4b)

Figure 16.2d: Michelangelo, The Flood, c. 1508–1512, fresco, Sistine Chapel, Vatican City, Italy

Michelangelo, The Flood, c. 1508–1512, fresco, Sistine Chapel, Vatican City, Italy (Figure 16.2d)

Form
- Sculptural intensity of the figure style.
- More than 60 figures are crowded into the composition.

Function
- One of the scenes on the Sistine Chapel ceiling.

Content
- Story details Noah and his family's escape from rising floodwaters, as told in Genesis 7.
- The few remaining survivors cling to mountain tops; their fate will be sealed.
- A man carrying his drowned son to safety will meet his son's fate as well.
- The ark in the background is the only safe haven.
- The salvation of the good (as opposed to God's destruction of the wicked) is stressed.

Content Area Early Europe and Colonial Americas, Image 75
- **Cross-Cultural Comparisons for Essay Question 1: The Power of Water**
 - Viola, *The Crossing* (Figure 29.18b)
 - Hokusai, the Great Wave (Figure 25.5)
 - Wright, Fallingwater (Figure 22.16a)

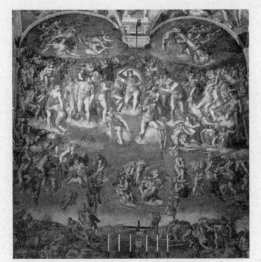

Figure 16.2e: Michelangelo, *Last Judgment,* fresco from the Sistine Chapel, 1536–1541, Vatican City, Italy

Michelangelo, *Last Judgment,* 1536–1541, fresco, Sistine Chapel, Vatican City, Italy (Figure 16.2e)

Form
- In contrast to the ceiling, there are no cornice divisions; it is one large space with figures greatly integrated.
- The Mannerist style is shown in the distortions of the body: elongations and crowded groups.

Function
- Last Judgment scenes are traditional on altar walls of chapels, although this was not the original choice of subject matter for the wall.

Patronage

■ Pope Paul III was the patron.

Context

■ The subject was chosen because of the turbulence in Rome after the sack of the city in 1521.

■ Counter-Reformation message: the true path to salvation is through the Catholic Church.

■ Spiraling composition is a reaction against the High Renaissance harmony of the Sistine Ceiling and reflects the disunity in Christendom caused by the Reformation.

■ In the spirit of the Counter-Reformation, the genitalia were painted over after Michelangelo's death.

Content

■ Four broad horizontal bands act as the unifying element:
 1. Bottom: dead rising on the left and the mouth of hell on the right.
 2. Second level: ascending elect, descending sinners, trumpeting angels.
 3. Third level: those risen to heaven are gathered around Jesus.
 4. Top lunettes: angels carrying the cross and the column, instruments used at Christ's death.

■ Christ, in center, gestures defiantly with right hand; complex pose.

■ Justice is delivered: the good rise, the evil fall.

■ Lower right-hand corner has figures from Dante's *Inferno*: Minos and Charon.

■ Saint Bartholomew's face is modeled on a contemporary critic. Saint Bartholomew holds his skin, a symbol of his martyrdom, but the skin's face is Michelangelo's, an oblique reference to critics who skinned him alive with their criticism. It may also represent Michelangelo's concern over the fate of his soul as expressed in his poetry.

Content Area Early Europe and Colonial Americas, Image 75

■ **Cross-Cultural Comparisons for Essay Question 1: Group Compositions**
 – Leonardo da Vinci, *The Last Supper* (Figure 16.1)
 – Rivera, *Dream of a Sunday Afternoon in the Almeda Park* (Figure 22.20)
 – Lam, *The Jungle* (Figure 22.12)

Raphael, *School of Athens*, 1509–1511, fresco, Apostolic Palace, Vatican City, Italy (Figure 16.3)

Form

■ Open, clear light uniformly spread throughout the composition.

■ Nobility and monumentality of forms parallel the greatness of the figures represented; figures gesture to indicate their philosophical thought.

■ Raphael's overall composition was influenced by Leonardo's *Last Supper* (Figure 16.1).

Patronage and Function

■ Commissioned by Pope Julius II to decorate his library.

■ This is one painting in a complex program of works that illustrate the vastness and variety of the papal library.

■ Painting originally called *Philosophy* because the pope's philosophy books were meant to be housed on shelving below.

Content and Context

■ Opposite this work is a Raphael painting called *La Disputà*, based on religion; religious books were placed below; parallels drawn between the two themes expressed in the paintings.

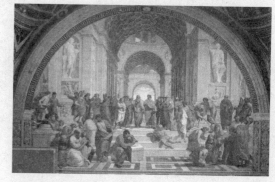

Figure 16.3: Raphael, *School of Athens*, 1509–1511, fresco, Apostolic Palace, Vatican City, Italy

- To the left of Philosophy is Apollo and the Muses on Parnassus, referencing literature.
- The building depicted in the background might reflect Bramante's plan for Saint Peter's; Bramante appears as the bald Euclid in the lower right.
- In the center are the two greatest figures in ancient Greek thought: Plato (with the features of Leonardo da Vinci) on the left pointing up, and Aristotle (perhaps with the features of the architect Giuliano da Sangallo) pointing out. Their gestures reflect their philosophies.
- On the left are those interested in the ideal (followers of Plato); on the right, those interested in the practical (followers of Aristotle).
- Raphael is on the extreme right with a black hat.
- Michelangelo, resting on the stone block writing a poem, represents the philosopher Heraclitus (inspired by the pose of Isaiah on the Sistine Chapel ceiling); the figure was added later and was not part of the original composition.

Content Area Early Europe and Colonial Americas, Image 76

Web Source *http://www.museivaticani.va/content/museivaticani/en/collezioni/musei/stanze-di-raffaello/stanza-della-segnatura.html*

- **Cross-Cultural Comparisons for Essay Question 1: Referencing the Past**
 - Smith, *Trade* (Figure 29.12)
 - Rodin, *Burghers of Calais* (Figure 21.15)
 - Barry and Pugin, Palace of Westminster (Houses of Parliament) (Figures 12.5a and 12.5b)

VENETIAN HIGH RENAISSANCE PAINTING

In contrast to the Florentines and Romans, whose paintings valued line and contour, the Venetians bathed their figures in a soft atmospheric ambiance highlighted by a gently modulated use of light. Bodies are sensuously rendered. While Florentines and Venetians both paint religious scenes, Florentines choose to see them as heroic accomplishments, whereas Venetians imbue their saints with a more human touch, setting them in bucolic environments that show a genuine interest in the beauty of the natural world. This natural setting is often called **Arcadian**.

The damp Venetian climate caused wooden paintings to warp and crack, frescoes to peel and flake. Artists opted for **canvas**, a more secure and lightweight surface that could maintain the integrity of a work for an indefinite period.

Titian, *Venus of Urbino*, 1538, oil on canvas, Uffizi, Florence (Figure 16.4)

Form
- Sensuous delight in the skin tones; layers of glazes produce rich, sonorous effect.

- Oil painted in layers; glazes achieve rich color.
- Complex spatial environment: figure placed forward on the picture plane, servants in middle space; open window with plants in background.

Content
- Venus looks at the viewer directly.
- Venus is reclining in an open space in a luxurious Venetian bedroom.
- Roses contribute to the floral motif carried throughout the work; roses with their thorns symbolize the beauty and problems of love.
- The dog may symbolize faithfulness.

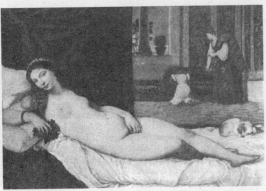
Figure 16.4: Titian, *Venus of Urbino*, 1538, oil on canvas, Uffizi, Florence

Context

- May not be Venus; may be a courtesan in the tradition of a female reclining nude.
- Cassoni: trunks intended for storage of clothing for a wife's trousseau seen in the background of the painting.
- May have been commissioned by the Duke of Urbino as a wedding painting.

Content Area Early Europe and Colonial Americas, Image 80

Web Source *www.titian.org/venus-of-urbino.jsp*

- **Cross-Cultural Comparisons for Essay Question 1: Female Reclining Nude**
 - Manet, *Olympia* (Figure 21.3)
 - Ingres, *La Grande Odalisque* (Figure 20.3)
 - Mutu, *Preying Mantra* (Figure 29.25)

MANNERIST PAINTING

Typical High Renaissance paintings have a perspective grid on a plaza that leads the eye to a central point (cf. *School of Athens*) (Figure 16.3). Mannerists chose to discard conventional theories of perspective by having the eye wander around a picture plane—as seen in **Pontormo's *Entombment*** (Figure 16.5)—or use perspective to create an interesting illusion. Although heavily indebted to High Renaissance forms, the Mannerist uses these as starting points to freely vary the ideals of the previous generation. It is the ability of the Mannerists to defy the conventional classical order and rationality that gives the style much of its appeal.

A new artistic subject, the **still life**, is born in the Mannerist period. Although understood as the lowest form of painting, it gradually becomes an accepted art form in seventeenth-century Holland. **Genre** paintings are also introduced, as scenes of everyday life become acceptable in finished works of art.

For many years scholars saw the demanding compositions of Mannerist paintings as crude reflections of High Renaissance art—the aftermath of a great period. But scholars have slowly come to realize that the unusual complexities and ambiguous spaces—the artifice—of Mannerist art is its most endearing quality. This is an intensely intellectual art form that is deliberately complex, seeking refinement in unusual compositions and contrived settings. The irrational spatial effects rely on an exaggeration of forms, obscure imagery, and symbolic enigmas whose consequence is puzzling, stimulating, and challenging. It is the calculated ambiguity of Mannerist painting that gives it its enduring value.

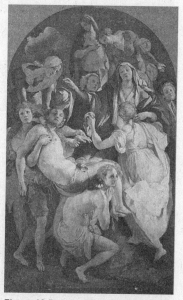

Jacopo da Pontormo, *Entombment of Christ*, 1525–1528, oil on wood, Santa Felicità, Florence (Figure 16.5)

Form

- Anticlassical composition.
- Linear bodies twisting around one another.
- In the center of the circular composition is a grouping of hands.
- Hands seem disembodied.
- No ground line for many figures; what is Mary sitting on?
- Elongation of bodies.
- Some androgynous figures.
- No weeping, just yearning.

Figure 16.5: Jacopo da Pontormo, *Entombment of Christ*, 1525–1528, oil on wood, Santa Felicità, Florence

- High-keyed colors, perhaps taking into account the darkness of the chapel the work is placed in.

Context

- The painting is called *Entombment of Christ*, although there is no tomb, just the carrying of Jesus's lifeless body.
- It is placed over the altar of a family chapel near the right front entrance of Santa Felicità in Florence.
- The composition and Mannerist style may reflect the instability in European politics brought on by the Protestant Reformation.
- There is a self-portrait on the extreme right of the painting.

Content Area Early Europe and Colonial Americas, Image 78

Web Source on Mannerism *http://www.metmuseum.org/toah/hd/zino/hd_zino.htm*

- **Cross-Cultural Comparisons for Essay Question 1: Scenes of Grief and Loss**
 - Giotto, *Lamentation* (Figure 13.1c)
 - Kollwitz, *Memorial Sheet for Karl Liebknecht* (Figure 22.4)

Figure 16.6a: Giacomo della Porta, Il Gesù façade, 1568–1584, brick and marble, Rome

Figure 16.6b: Giacomo da Vignola, Il Gesù nave, 16th century, Rome, Italy

MANNERIST ARCHITECTURE

Mannerist architecture invites us to question the use of classical vocabulary on a sixteenth-century building. Drawing on a wealth of antique elements, the Mannerist architect playfully engages the viewer in the reuse of these elements independent of their original function. These are commonly seen in works in which a bold interlocking of classical forms is arranged in a way to make us ponder the significance of ancient architecture in the Renaissance.

Giacomo della Porta, Il Gesù façade, 1568–1584, brick and marble, Rome (Figure 16.6a); nave by Giacomo da Vignola, 16th century (Figure 16.6b)

Form

 Façade:

- Column groupings, tympana, and pediment emphasize the central doorway.
- A slight crescendo of forms directs the viewer to the center.
- The two stories separated by a cornice; united by scrolls and a framing niche.
- The letters of Jesus's name (IHS) are over the central doorway in a cartouche.
- Patron: Cardinal Farnese has his name placed directly over the cartouche with Jesus's name.

 Interior:

- Interior has no aisles; meant for grand ceremonies.
- Ceiling painting (cf. Figure 17.6).

Function

- Principal church of the Jesuit order.

Context

- Jesuits are seen as the defenders of Counter-Reformation ideals.

Content Area Early Europe and Colonial Americas, Image 82
Web Source *https://www.britannica.com/biography/Giacomo-della-Porta*
- **Cross-Cultural Comparisons for Essay Question 1: Relationship of Façade to Interior**
 - Chartres Cathedral (Figure 12.4a, 12.4b, 12.4c)
 - Brunelleschi, Pazzi Chapel (Figure 15.1a, 15.1b)
 - Hadid, MAXXI (Figure 29.2b)

VOCABULARY

Arcadian: a simple rural and rustic setting used especially in Venetian paintings of the High Renaissance; named after Arcadia, a district in Greece to which poets and painters have attributed a rural simplicity and an idyllically untroubled world

Canvas: a heavy woven material used as the surface of a painting; first widely used in Venice (Figure 16.4)

Cassone (plural: **cassoni):** a trunk intended for storage of clothing for a wife's trousseau (Figure 16.4)

Chiaroscuro: a gradual transition from light to dark in a painting. Forms are not determined by sharp outlines, but by the meeting of lighter and darker areas (Figure 16.1)

Cinquecento: the 1500s, or sixteenth century, in Italian art

Entombment: a painting or sculpture depicting Jesus Christ's burial after his crucifixion (Figure 16.5)

Flood story: as told in Genesis 7 of the Bible, Noah and his family escape rising waters by building an ark and placing two of every animal aboard (Figure 16.2d)

Genre painting: painting in which scenes of everyday life are depicted

Glazes: thin transparent layers put over a painting to alter the color and build up a rich sonorous effect

Ignudi: nude corner figures on the Sistine Chapel ceiling (Figure 16.2c)

Last Supper: a meal shared by Jesus Christ with his apostles the night before his death by crucifixion (Figure 16.1)

Neoplatonism: a school of ancient Greek philosophy that was revived by Italian humanists of the Renaissance

Sfumato: a smoke-light or hazy effect that distances the viewer from the subject of a painting (Figure 16.1)

Sibyl: a Greco-Roman prophetess whom Christians saw as prefiguring the coming of Jesus Christ (Figure 16.2c)

Still life: a painting of a grouping of inanimate objects, such as flowers or fruit

SUMMARY

The Papal Court of Julius II commissioned some of the greatest works of Renaissance art to beautify the Vatican, including starting construction on the new Saint Peter's. Artists sought to rival the ancients with their accomplishments, often doing heroic feats like carving monumental sculptures from a single block of marble, or painting vast walls in fresco.

The Venetian school of painting was at its height during this period, realizing works that have a soft, sensuous surface texture layered with glazes. Sfumato and chiaroscuro are widely used to enhance this sensuous effect.

Mannerist artists broke the conventional representations of Italian Renaissance art by introducing intentionally distorted figures, acidy colors, and unusual compositions to create evocative and highly intellectual works of art that challenge the viewer's perceptions and ideals. Perspective was used as a tool to manipulate a composition into intriguing arrangements of spatial forms.

The questioning of artistic values extends to the types of paintings as well. Still lifes and genre paintings, long considered too low for sophisticated artists, make their first appearance.

Mannerist architects seek to combine conventional architectural elements in a refined and challenging interplay of forms. It is this ambiguity that gives Mannerism a fascination today.

PRACTICE EXERCISES

Multiple-Choice

Questions 1 and 2 refer to the image below.

1. The literary source for this work is

 (A) the New Testament
 (B) *The Odyssey*
 (C) the Qur'an
 (D) *The Metamorphosis*

2. This type of painting is a departure from High Renaissance painting in that it

 (A) relies on symbolism to convey its meaning
 (B) has exaggerated and elongated figures
 (C) is painted with a quick and visible brushstroke
 (D) is meant for private viewing rather than public display

3. Sixteenth-century Italian painting was revolutionary for the

(A) introduction of guilds, which organized the arts into professional groups
(B) patronage of preaching orders of friars such as the Franciscans and Dominicans, who stressed teaching
(C) introduction of a capitalist market system, which bought and traded works as commodities
(D) first permanent painting academy, which trained artists and improved their status in society

4. The Venetian High Renaissance differs from the Florentine High Renaissance in its great emphasis on

(A) foreshortening
(B) chiaroscuro
(C) warm and rich colors
(D) mythological scenes

5. Leonardo da Vinci's *Last Supper* provided a general inspiration for Raphael's *School of Athens*. This can be particularly seen in their use of

(A) strict symmetry, which adds balance to the composition
(B) self-portraits in discreet locations
(C) linear perspective, which creates a unified architectural framework
(D) contemporary faces placed on people from the past

Short Essay

Practice Question 3: Visual Analysis

Suggested Time: 15 minutes

This work is Raphael's *School of Athens* painted from 1509–1511.

Explain how Raphael created a sense of perspective in this work.

Using specific visual evidence, discuss *at least two* ways in which Raphael has placed emphasis on the figures in the center.

Explain *why* the emphasis has been placed on these figures and *what* the meaning of this emphasis is in relationship to the work as a whole.

ANSWER KEY

1. **A** 2. **B** 3. **D** 4. **C** 5. **C**

ANSWERS EXPLAINED

Multiple-Choice

1. **(A)** This painting is Pontormo's *Entombment of Christ*, a scene taken from the New Testament.

2. **(B)** This painting is different from High Renaissance art in that it shows a Mannerist delight in "mannered" figure styles: exaggerated and elongated poses.

3. **(D)** The first permanent painting academy was opened in Florence in 1563. It sought to train artists and improve their status in society.

4. **(C)** Venetian High Renaissance paintings, like those by Titian, are often painted in warm and rich colors.

5. **(C)** All of these characteristics are true of one or the other painting, but the only one that characterizes both works is the unified architectural setting based on linear perspective.

Short Essay Rubric

Task	Point Value	Key Points in a Good Response
Explain how Raphael created a sense of perspective in this work.	1	Answers could include: ■ Linear perspective brings our eye to the center of the composition. ■ Our eye is drawn to the middle by the sloping walls on the side of the painting and by the rising floor pavements at the bottom of the painting. ■ The sky-lit background behind the two central figures brings us deeper into the composition.
Using specific visual evidence, discuss *at least two* ways in which Raphael has placed emphasis on the figures in the center.	2	Answers could include: ■ The sky-lit background behind the two central figures highlights them; in contrast to the other figures, which are backed by walls and steps. ■ The lines of linear perspective in the painting point directly to the central figures. ■ The composition is basically symmetrical; in the center the two figures balance each other.
Explain *why* the emphasis has been placed on these figures...	1	Answers could include: ■ The two figures represent Aristotle and Plato, who are seen as the central figures in ancient philosophy. ■ In the Renaissance, people viewed Aristotle and Plato as the founders of philosophical thought. ■ The two differing views of philosophy are given equal weight as expressed by Aristotle and Plato's symmetry and balance.
...and *what* the meaning of this emphasis is in relationship to the work as a whole.	1	Answers could include: ■ Since Aristotle and Plato are seen as the central figures in ancient philosophy, they are centrally placed in the painting. ■ Aristotle and Plato had differing views of philosophy and their views are expressed in their gestures, the books they carry, and by the thinkers grouped on either side of them. ■ The faces of contemporaries are placed on the bodies of many of the figures, including Plato who is represented as Leonardo da Vinci. Da Vinci was thought to represent the greatest of modern thinkers.

Baroque Art

17

TIME PERIOD: 1600–1700

The term "Baroque" means "irregularly shaped" or "odd,"
a negative word that evolved in the eighteenth century to
describe the Baroque's departure from the Italian Renaissance.

ENDURING UNDERSTANDING: The culture, beliefs, and physical settings of a region play an important role in the creation, subject matter, and siting of works of art.
Learning Objective: Discuss how the culture, beliefs, or physical setting influence the making of a work of art. (For example: Gaulli, *Triumph of the Name of Jesus*)

Essential Knowledge:

- Baroque art can be found in New Spain.
- Baroque art still has a basis on classical formulas, but also has an interest in dynamic compositions and theatricality.

ENDURING UNDERSTANDING: Cultural interaction through war, trade, and travel can influence art and art making.
Learning Objective: Discuss how works of art are influenced by cultural interaction. (For example: Rubens, *Henri IV Receives the Portrait of Marie de' Medici*)

Essential Knowledge:

- There are the beginnings of global commercial and artistic networks.

ENDURING UNDERSTANDING: Art making is influenced by available materials and processes.
Learning Objective: Discuss how material, processes, and techniques influence the making of a work of art. (For example: Caravaggio, *The Calling of Saint Matthew*)

Essential Knowledge:

- The period is dominated by an experimentation of visual elements, i.e., atmospheric perspective, a bold use of color, creative compositions, and an illusion of naturalism.

ENDURING UNDERSTANDING: Art and art making can be influenced by a variety of concerns including audience, function, and patron.
Learning Objective: Discuss how art can be influenced by audience, function, and/or patron. (For example: Le Vau and Hardouin-Mansart, Versailles)

Essential Knowledge:

- There is a more pronounced identity of the artist in society; the artist has more structured training opportunities.

ENDURING UNDERSTANDING: Art history is best understood through an evolving tradition of theories and interpretations.

Learning Objective: Discuss how works of art have had an evolving interpretation based on visual analysis and interdisciplinary evidence. (For example: Vermeer, *Woman Holding a Balance*)

Essential Knowledge:

- Baroque art is studied in chronological order and by geographic region.
- There is a large body of primary source material housed in libraries and public institutions.

HISTORICAL BACKGROUND

In 1600, the artistic center of Europe was Rome, particularly at the court of the popes. The completion of Saint Peter's became a crusade for the Catholic Church, both as an evocation of faith and as a symbol of the Church on earth. By 1650, however, the increased power and influence of the French kings, first at Paris and then at their capital in Versailles, shifted the art world to France. While Rome still kept its allure as the keeper of the masterpieces for both the ancient world and the Renaissance, France became the center of modern art and innovation, a position it kept unchallenged until the beginning of World War II.

The most important political watershed of the seventeenth century was the Thirty Years' War, which ended in 1648. Ostensibly started over religion, and featuring a Catholic resurgence called the Counter-Reformation, the Thirty Years' War also had active political, economic, and social components as well. The war succeeded in devastating central Europe so effectively that economic activity and artistic production ground to a halt in this region for the balance of the seventeenth century.

The Counter-Reformation movement reaffirmed all the things the Protestant Reformation was against. Protestants were largely iconoclasts, breaking painted and sculpted images in churches; Catholics endorsed the place of images and were reinspired to create new ones. Protestants derided saints; Catholics reaffirmed the communion of saints and glorified their images. Protestants played down miracles; Catholics made them visible and palpable as in the *Ecstasy of Saint Teresa* (Figures 17.4a and 17.4b).

Patronage and Artistic Life

Even with all the religious conflict, the Catholic Church was still the greatest source of artistic commissions in the seventeenth century, closely followed by royalty and their autocratic governments. Huge churches and massive palaces had big spaces that needed to be filled with large paintings commanding high prices. However, artists were not just interested in monetary gain; many Baroque artists such as **Rubens** and **Bernini** were intensely religious people, who were acting out of a firm commitment to their faith as well as to their art. Credit must be given to the highly cultivated and farsighted patrons who allowed artists to flourish; Pope Urban VIII, for example, sponsored some of Bernini's best work.

BAROQUE ARCHITECTURE

Landscape architecture becomes an important artistic expression in the Baroque. Starting at **Versailles** (Figure 17.3e) and continuing throughout the eighteenth century, palaces are envisioned as the principal feature in an ensemble with gardens that are imaginatively arranged to enhance the buildings they framed. Long views are important. Key windows are viewing stations upon which gardens spread out before the viewer in an imaginatively orchestrated display that suggests man's control over his environment. Views look down extended avenues carpeted by lawns and embraced by bordering trees, usually terminating in a statue or a fountain. The purpose is to impress the viewer with a sense of limitlessness.

Baroque architecture relies on movement. Façades undulate, creating symmetrical cavities of shadow alternating with projecting pilasters that capture the sun. Emphasis is on the center of the façade with wave-like forms that accentuate the entrance. Usually entrances are topped by pediments or tympana to reinforce their importance. A careful interplay of concave and convex shapes marks the most experimental buildings by **Borromini**. Interiors are richly designed to combine all the arts; painting and sculpture service the architectural members in a choreographed ensemble. The aim of Baroque buildings is a dramatically unified effect.

Baroque architecture is large; it seeks to impress with its size and its elaborate ornamentation. In this regard, the Baroque style represents the imperial or papal achievements of its patrons—proclaiming their power and wealth. Buildings are erected at high points accessible by elaborately carved staircases, ones that spill out toward the spectator and change direction—and view—as they rise.

Carlo Maderno, Santa Maria della Vittoria, 1605–1620, Rome (Figure 17.1)

Form
- First story: six Ionic pilasters; emphasis placed on center of façade.
- Round and triangular pediments; broken pediments; swags and scrollwork.

Function
- Catholic church, originally dedicated to Saint Paul.

Context
- Rededicated to the Virgin Mary in gratitude for a military victory in Bohemia in 1620.
- The Turkish standards captured in the Siege of Vienna in 1683 are on display.
- Single wide nave
- One of the side chapels houses Bernini's *Ecstasy of Saint Teresa* (Figures 17.4a and 17.4b), with a window added to illuminate the sculptural group.

Content Area Early Europe and Colonial Americas, Image 89
Web Source http://romeartlover.it/Vasi148.htm

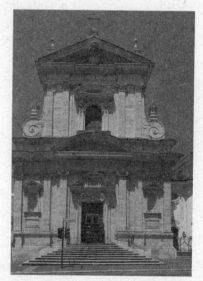

Figure 17.1: Carlo Maderno, Santa Maria della Vittoria, 1605–1620, Rome

Francesco Borromini, Saint Charles of the Four Fountains (San Carlo alle Quattro Fontane), 1638–1646, stone and stucco, Rome (Figures 17.2a, 17.2b, and 17.2c)

Form
- So named because it is on a street intersection in Rome with four fountains.

Exterior
- Unusually small site.

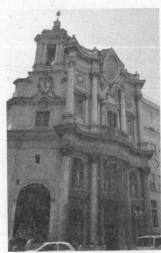

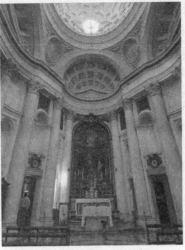

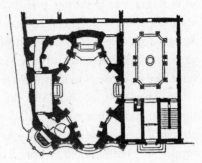

Figures 17.2a: Francesco Borromini, Saint Charles of the Four Fountains (San Carlo alle Quattro Fontane), 1638–1646, stone and stucco, Rome

Figure 17.2b: Francesco Borromini, interior of Saint Charles of the Four Fountains (San Carlo alle Quattro Fontane), 1638–1646, stone and stucco, Rome

Figure 17.2c: Francesco Borromini, plan of Saint Charles of the Four Fountains (San Carlo alle Quattro Fontane)

- The building is designed with alternating convex and concave patterns and undulating volumes in both the ground plan and on the façade.
- The façade higher than the rest of the building.

Interior
- The interior side chapels merge into a central space.
- The interior dome is oval shaped and coffered.
- The dome has an interconnection of different shapes that fit together seamlessly; they illustrate the Baroque admiration for multiplicity that resolves into a unified space.
- The walls are treated sculpturally; Baroque drama and complexity.
- Borromini worked in shades of white, avoided colors used in many other Baroque buildings.

Function
- It was built as part of a complex of monastic buildings for the Spanish Trinitarians, an order of religious dedicated to freeing Christian slaves.

Context
- Sculptures of Trinitarian saints are placed on the façade.
- Medallion on façade once held a fresco of the Trinity.
- Borromini worked on the building for free, giving him more artistic license.

Content Area Early Europe and Colonial Americas, Image 88

Web Source https://vimeo.com/135904560

- **Cross-Cultural Comparisons for Essay Question 1: Architectural Sculpture**
 - Temple of Amun-Re (Figures 3.8a, 3.8b, 3.8c)
 - Parthenon (Figures 4.4, 4.16b)
 - Lakshmana Temple (Figures 23.7a, 23.7b)

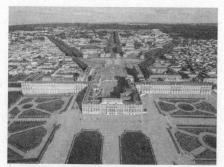

Figure 17.3a: Louis Le Vau and Jules Hardouin-Mansart, Versailles, begun 1669, masonry, stone, wood, iron, and gold leaf, Versailles, France

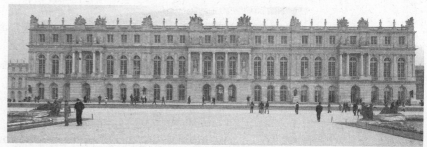

Figure 17.3b: Louis Le Vau and Jules Hardouin-Mansart, Versailles façade, begun 1669, masonry, stone, wood, iron, and gold leaf, Versailles, France

Figure 17.3c: Louis Le Vau and Jules Hardouin-Mansart, Versailles courtyard, begun 1669, masonry, stone, wood, iron, and gold leaf, Versailles, France

Figure 17.3d: Louis Le Vau and Jules Hardouin-Mansart, Versailles, Hall of Mirrors, begun 1669, masonry, stone, wood, iron, and gold leaf, sculpture: bronze and marble, Versailles, France

Figure 17.3e: Versailles gardens, begun 1669, Versailles, France

Louis Le Vau and Jules Hardouin-Mansart, Versailles, begun 1669, masonry, stone, wood, iron, and gold leaf; gardens, Versailles, France (Figures 17.3a–17.3e)

Function

- This is the palace of King Louis XIV and subsequent kings and their courts.
- The palace expresses the idea of the absolute monarch; the massive scale of the project is indicative of the massive power of the king.

Form and History

- Louis XIV reorganized and remodeled an existing hunting lodge into an elaborate palace.
- The center of the building is Louis XIV's bedroom, or audience chamber, from which all aspects of the design radiate like rays from the sun (hence Louis' sobriquet the Sun King).
- The building is centered in a vast garden and town complex that radiated from it.
- There is a subdued exterior decoration on the façade; the undulation of projecting members is understated.

Hall of Mirrors

- 240 feet long, facing the garden façade.
- Barrel-vaulted painted ceiling (paintings stress the military victories of Louis XIV; rooms that flank the Hall of Mirrors are thematically related, one of Peace and the other War).
- Light comes in from one side and ricochets off large panes of glass, the largest that could be made at the time.
- This is an example of a use of flickering light in an architectural setting.
- Mirrors were among the most expensive items manufactured in the seventeenth century—the Hall of Mirrors is an extravagant display of wealth.
- Mirrors were made exclusively in Venice at the time; workers had to be imported from Venice to make the mirrors, which conformed to the dictates that the decorations at Versailles had to be made in France.
- Hall of Mirrors used for court and state functions: embassies, births, and marriages were celebrated in this room.

- Subsequent history:
 - Used by Bismarck to declare William I as German emperor after the defeat of the French in the Franco-Prussian War in 1871.
 - Used reciprocally by the French after the defeat of the Germans in World War I to sign the Treaty of Versailles in 1919.

Gardens

- Classically and harmoniously arranged.
- Formal gardens near the palace; more wooded and less elaborate plantings farther from the palace.
- Baroque characteristics:
 - Large size.
 - Long vistas.
 - Terminal views in fountains and statuary.
 - Geometric plantings show control of nature.
- A mile-long canal crossed by another canal forms the main axis of the gardens; linked to the rising sun over the palace.
- Only the fountains near the palace were turned on all the time; others were turned on only when the king progressed through the gardens.
- Illustrates the belief that humans can organize and control nature to make a more refined experience.

Content Area Early Europe and Colonial Americas, Image 93

Web Source *http://en.chateauversailles.fr/homepage*

- **Cross-Cultural Comparisons for Essay Question 1: National Capitals**
 - Nan Madol (Figures 28.1a, 28.1b)
 - Great Zimbabwe (Figures 27.1a, 27.1b)
 - Forbidden City (Figures 24.2a, 24.2b, 24.2c, 24.2d)

BAROQUE PAINTING AND SCULPTURE

Baroque artists explored subjects born in the Renaissance but previously considered too humble for serious painters to indulge in. These subjects, still life, genre, and landscape painting, flourished in the seventeenth century as never before. While religious and historical paintings were still considered the highest form of expression, even great artists such as **Rembrandt** and **Rubens** painted landscapes and genre scenes. Still lifes were a specialty of the Dutch school.

Landscapes and still lifes exist not in and of themselves, but to express a higher meaning. Still lifes frequently contain a **vanitas** theme, which stresses the brevity of life and the folly of human vanity. Broad open landscapes feature small figures in the foreground acting out a Biblical or mythological passage. Genre paintings often had an allegorical commentary on a contemporary or historical issue.

Landscapes were never actual views of a particular site; instead they were composed in a studio from sketches done in the field. The artist was free to select trees from one place and put them with buildings from another. Landscape painters felt they had to reach beyond the visual into a world of creation that relies on the thoughtful combination of disparate elements to make an artistic statement.

Painters were fascinated by **Caravaggio's** use of **tenebrism**—even the greatest painters of the century experimented with it. The handling of light and shadow became a trademark of the Baroque, not only for painters, but for sculptors and architects as well. Northern artists

specialized in **impasto** brushwork, which created a feeling of spontaneity with a vibrant use of visible brushwork. Similarly, sculptors animated the texture of surfaces by variously polishing or abrading surfaces.

Painters like **Caravaggio** painted with an expressive sense of movement. Figures are dramatically rendered, even in what would appear to be a simple portrait. Light effects are key, as offstage sources illuminated parts of figures in a strong dark light contrast called **tenebroso**. Colors are descriptive and evocative. Inspiration comes from the Venetian Renaissance, and passes through **Caravaggio** and onto **Rubens** and his followers, who are called **Rubénistes**. Naturalists reject what they perceive as the contortions and artificiality of the Mannerists.

As in the other arts, Baroque sculpture stressed movement. Figures are caught in mid-motion, mouths open, with the flesh of one figure yielding to the touch of another. Some large works, particularly those by **Bernini**, were often meant to be placed in the middle of the floor or at a slight distance from a wall and be seen in the round. Sculptors employ negative space, carving large openings in a work so that the viewer can contemplate a multiplicity of angles. Marble is treated with a tactile sense: human skin given a high polish, angel wings shown with a feathery touch, animal skins reveal a coarser feel. Baroque sculptors found inspiration in the major works of the Greek Hellenistic period.

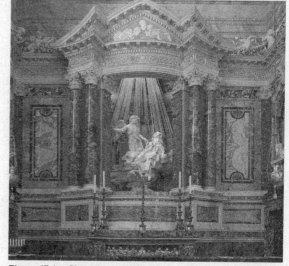

Figure 17.4a: Gian Lorenzo Bernini, Cornaro Chapel, *Ecstasy of Saint Teresa*, 1647–1652, marble, stucco, and gilt bronze, Santa Maria della Vittoria, Rome

Italian Baroque Art

Gian Lorenzo Bernini, *Ecstasy of Saint Teresa*, 1647–1652, marble, stucco and gilt bronze, Santa Maria della Vittoria, Rome (Figures 17.4a and 17.4b)

Form

- Marble is handled in a tactile way to reveal textures: skin is high gloss, feathers of angel are rougher, drapery is animated and fluid, clouds are roughly cut.
- Figures seem to float in space; the rays of God's light symbolically illuminate the scene from behind.
- Natural light is redirected onto the sculpture from a window hidden above the work.
- The work captures a moment in time—a characteristic of Baroque art.

Patronage

- Stage-like setting with the patrons, members of the Cornaro family, sitting in theater boxes looking on and commenting.

Function and Context

- Saint Teresa was canonized in 1622; a new saint at the time.
- This is a sculptural interpretation of Saint Teresa's diary writings, in which she tells of her visions of God, many involving an angel descending with an arrow and plunging it into her.
- Saint Teresa's pose suggests sexual exhaustion, a feeling that is consistent with her description of spiritual ecstasy in her diary entries.
- This is a Counter-Reformation work that illustrates the use of images to increase piety and devotion among the Catholic faithful.
- It is located inside Santa Maria della Vittoria (Figure 17.1).
- Cf. Visionary experience depicted in Lintel 25, Yaxchilán (Figure 26.2).

Figure 17.4b: Gian Lorenzo Bernini, *Ecstasy of Saint Teresa*, 1647–1652, marble, Santa Maria della Vittoria, Rome

Figure 17.5: Caravaggio, *Calling of Saint Matthew*, 1597–1601, oil on canvas, San Luigi dei Francesi, Rome

Content Area Early Europe and Colonial Americas, Image 89

Web Source *https://www.learner.org/series/art-through-time-a-global-view/dreams-and-visions/the-ecstasy-of-st-teresa/*

- **Cross-Cultural Comparisons for Essay Question 1: Use of Light and Dark**
 - Lanzón Stone (Figure 26.1b)
 - Court of the Lions (Figure 9.15b)
 - Pantheon (Figures 6.11a, 6.11b)

Caravaggio, *Calling of Saint Matthew*, 1597–1601, oil on canvas, San Luigi dei Francesi, Rome (Figure 17.5)

Function and Patronage

- One of three paintings illustrating the life of Saint Matthew in a chapel dedicated to him by the Contarelli family.

Form

- Diagonal shaft of light points directly to Saint Matthew, who points to himself as if unsure that Christ would select him.
- Light coming in from two sources on the right creates a tenebroso effect on the figures.
- Christ's pose is the inverse of Adam's on the Sistine Ceiling.
- Only a slight suggestion of a halo on Christ's head indicates sanctity of the scene.
- Foppishly dressed figures wear cutting-edge Baroque fashion.
- Figures placed on a shallow stage.
- Sensual figures, everyday people.
- Naturalist approach to the Baroque.

Context

- Matthew was a tax collector; hence he is seated at a table with coins being counted.
- Story taken from Matthew 9:9: "As Jesus went on from there, he saw a man named Matthew sitting at the tax collector's booth. 'Follow me,' he told him, and Matthew got up and followed him."
 - Two figures on the left are so concerned with counting the money they do not even notice Christ's arrival; symbolically their inattention (and by implication, everyone else's) to Christ deprives them of the opportunity he offers: eternal life.
 - Jesuit influence on Counter-Reformation Baroque art; the sensual or physical expression of faith as expressed in Saint Ignatius's Spiritual Exercises.

Content Area Early Europe and Colonial Americas, Image 85

Web Source *https://www.artble.com/artists/caravaggio/paintings/the_calling_of_saint_matthew*

- **Cross-Cultural Comparisons for Essay Question 1: Light Effects**
 - Viola, *The Crossing* (Figures 29.18a, 29.18b)
 - Walker, *Darkytown Rebellion* (Figure 29.21)
 - Notre Dame de la Belle Verriere (Figure 12.8)

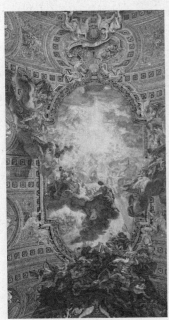

Figure 17.6: Giovanni Battista Gaulli, *Triumph of the Name of Jesus*, 1676–1679, fresco and stucco, Il Gesù, Rome

Giovanni Battista Gaulli, *Triumph of the Name of Jesus*, 1676–1679, fresco and stucco, Il Gesù, Rome (Figure 17.6)

Form and Content

- On the ceiling in the main nave of Il Gesù, Rome (Figure 16.6).
- In the center is the monogram of Jesus, IHS, in a brilliant sea of golden color.

- Figures tumble below the name; some are carved in stucco and enhance the three-dimensional effect.
- Some cast long shadows across the barrel vault.
- Some painted figures are not stucco, but maintain a vibrant three-dimensional illusion.
- It is as if the ceiling were opened to the sky and the figures are spiraling around Jesus's name.
- Depicted in the center are holy men and women.
- Around the rim are priests, soldiers, noblemen, and the Magi.
- Allegories of avarice, simony, heresy, and vanity occupy the lowest registers.
- Di sotto in sù.

Function

- A Last Judgment scene, placed over the barrel vault of the nave; cf. Last Judgment scenes placed on the walls of chapels (Sistine Chapel: Figure 16.2e; Arena Chapel: Figure 13.1b).
- Message to the faithful: the damned are cast into hell; the saved rise heavenward.

Context

- Inspired by Saint Paul's epistle to the Philippians 2:10: "That at the name of Jesus every knee should bow, of things in heaven, and things in earth, and things under the earth."
- There is the influence of Bernini's dramatic emotionalism in the style; Gaulli was Bernini's pupil.

Content Area Early Europe and Colonial Americas, Image 82

Web Source *http://artmuseum.princeton.edu/collections/objects/45004*

- **Cross-Cultural Comparisons for Essay Question 1: Ceiling Paintings**
 - Michelangelo, The Flood (Figure 16.2d)
 - Catacomb of Priscilla Good Shepherd (Figure 7.1c)
 - Lascaux Caves (Figure 1.8)

Spanish Baroque Art

Diego Velázquez, *Las Meninas*, 1656, oil on canvas, Prado, Madrid (Figure 17.7)

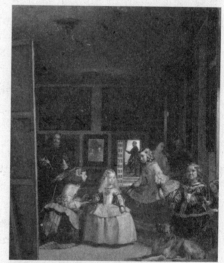

Figure 17.7: Diego Velázquez, *Las Meninas*, 1656, oil on canvas, Prado, Madrid

Content

- Portrait of the artist in his studio at work; he steps back from his very large canvas and looks at the viewer.
- Central is the Infanta Margharita of Spain with her meninas (attendants), a dog, a dwarf, and a midget. Behind are two chaperones in half-shadow. In the doorway is perhaps José Nieto, who was head of the queen's tapestry works (hence his hand on a curtain).
- The king and queen appear in a mirror. But what is the mirror reflecting?
 - Velázquez's canvas?
 - The king and queen perhaps standing in the viewer's space—is this why people have turned around?
 - Or is it reflecting a painting of the king and queen on the far wall of the room?
- What is the painter painting?
 - The royal family?
 - The Infanta?
 - A painting of this painting?
 - Us?
 - Ultimately, there is no answer, which expresses the Baroque fascination with exploring reality.

Form

- Alternating darks and lights draw the viewer deeper into the canvas; the mirror simultaneously reflects out into the viewer's space.
- Dappled effect of light on shimmering surfaces.
- Painterly brushstrokes seen in the sleeves of the Infanta and the hands of the artist.

Function

- Painting originally hung in King Philip IV's study.

Context

- Velázquez wears the cross of the Royal Order of Santiago, which elevated him to knighthood; this work seeks to establish painting as a noble occupation.
- Paintings on the back wall depict Minerva, goddess of wisdom and patroness of the arts.

Content Area Early Europe and Colonial Americas, Image 91

Web Source *https://www.museodelprado.es/en/the-collection/art-work/las-meninas/9fdc7800-9ade-48b0-ab8b-edee94ea877f*

- **Cross-Cultural Comparisons for Essay Question 1: Self-Portraits**
 - Mori, *Pure Land* (Figure 29.19)
 - Raphael, *School of Athens* (Figure 16.3)
 - Bichitr, *Jahangir Preferring a Sufi Shaikh to Kings* (Figure 23.9)

Flemish Baroque Art

Peter Paul Rubens, Marie de' Medici Cycle, 1621–1625, oil on canvas, Louvre, Paris (Figure 17.8)

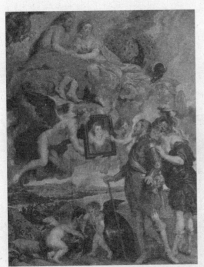

Figure 17.8: Peter Paul Rubens, *Henri IV Receives the Portrait of Marie de' Medici*, 1621–1625, oil on canvas, Louvre, Paris

Form

- Heroic gestures, demonstrative spiraling figures.
- Mellow intensity of color, inspired by Titian and Caravaggio.
- Sumptuous full-fleshed women.
- Splendid costumes suggest an opulent theatrical production.
- Allegories assist in telling the story and mix freely with historical people.

Function and Context

- 24 huge historical paintings allegorically retelling the life of Marie de' Medici, queen of France, wife of King Henry IV; the series also contains three portraits.
- Commissioned by Marie de' Medici, at the time the widow of Henry IV.
- The series was placed in Marie de' Medici's home in Paris, the Luxembourg Palace.

Henri IV Receives the Portrait of Marie de' Medici

- Henry IV is smitten by the portrait of his intended; the portrait is the center of a swirling composition.
- The portrait is held by Cupid (the god of love) and Hymen (the god of marriage).
- Mythological gods Jupiter (symbolized by an eagle) and Juno (symbolized by a peacock) look down from below; they are symbolic of marital harmony. They express their support.
- Royalty was considered demigods; the approval of mythological gods is in concert with their beliefs about themselves.
- This represents the tradition of portraits being exchanged before the marriage.
- They were actually married by proxy in 1600.

- Behind Henry is the personification of France:
 - France is a female figure with a masculine helmet and manly legs.
 - She whispers to Henry to choose love over war.

Content Area Early Europe and Colonial Americas, Image 86

Web Source *https://fds.duke.edu/db/attachment/2652*

Cross-Cultural Comparisons for Essay Question 1: Relationships
 - Klimt, *The Kiss* (Figure 21.12)
 - Veranda post (Figure 27.14)
 - Akhenaton, Nefertiti, and three daughters (Figure 3.10)

Dutch Baroque Art

While the Baroque is often associated with stately court art, it also flourished in mercantile Holland. Dutch paintings are harbingers of modern taste: landscapes, portraits, and genre paintings flourished; religious ecstasies, great myths, and historical subjects were avoided. In contrast to the massive buildings in other countries, Dutch houses are small and wall space scarce, so painters designed their works to hang in more intimate settings. Even though commerce and trade boomed, the Dutch did not want industry portrayed in their works. Ships are sailboats, not merchant vessels, which courageously braved the weather, not unloaded cargo. Animals are shown quietly grazing rather than giving milk or being shorn for wool. A featureless flat Dutch landscape is animated by powerful and evocative skies.

Dutch painting, however, has several things in common with the rest of European art. Most significantly, Dutch art features many layers of symbolism that provokes the viewer to intellectual consideration. Still life paintings, for example, are not the mere arrangement of inanimate objects, but a cause to ponder the fleeting nature of life. Stark church interiors often symbolized the triumph of Protestantism over Catholicism. Indeed, while Dutch art may seem outside the mainstream of the Baroque, it does have important parallels with contemporary art in the rest of Europe.

Rembrandt, *Self-Portrait with Saskia*, 1636, etching, Art Institute of Chicago, Chicago, Illinois (Figure 17.9)

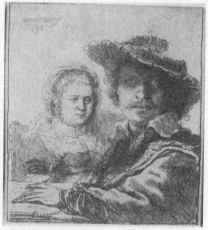

Figure 17.9: Rembrandt, *Self-Portrait with Saskia*, 1636, etching, Art Institute of Chicago, Chicago, Illinois

Content
- Rembrandt is seen drawing or perhaps making an etching.
- Saskia is seated deeper into the work, but is very noticeable because she is portrayed with a lighter touch.

Function
- Not for general sale but for private purposes.

Context
- The scene depicts the 30-year-old Rembrandt with his new bride.
- This is the only image of Rembrandt with his wife together in an etching.
- Images of Saskia are abundant in Rembrandt's output; she was a source of inspiration for him.
- Marital harmony; Saskia as a muse who inspires him.
- Characteristic of Rembrandt: they are wearing fanciful, not contemporary, dress.
- Saskia was the mother of four.
- Rembrandt's self-portraits included 50 paintings, 32 etchings, and 7 drawings.

Content Area Early Europe and Colonial Americas, Image 87

Web Source *http://www.artic.edu/aic/collections/artwork/58483*

- **Cross-Cultural Comparisons for Essay Question 1: Graphic Arts**
 - Dürer, *Adam and Eve* (Figure 14.3)
 - Cranach, *Allegory of Law and Grace* (Figure 14.5)
 - Kollwitz, *Memorial Sheet for Karl Liebknecht* (Figure 22.4)

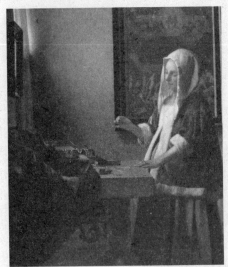

Figure 17.10: Johannes Vermeer, *Woman Holding a Balance*, c. 1664, oil on canvas, National Gallery of Art, Washington

Johannes Vermeer, *Woman Holding a Balance*, c. 1664, oil on canvas, National Gallery of Art, Washington (Figure 17.10)

Form and Content

- Light enters from the left, illuminating the figures and warmly highlighting textures and surfaces: the woman's garments, wooden table, marble checkerboard floor, jewelry, the painting, etc.
- A moment in time: stillness and timelessness.
- The woman is dressed in fine, fur-trimmed clothing.
- Geometric lines focus on a central point at the pivot of the balance.
- The figure seems unaware of the viewer's presence.
- Her pensive stillness suggests she may be weighing something more profound than jewelry.

Context

- A small number of Vermeer works are in existence.
- Except for two landscapes, Vermeer's works portray intimate scenes in the interior of Dutch homes.
- The viewer looks into a private world in which seemingly small gestures take on a significance greater than what first appears.
- A family member may have posed for the painting, perhaps Vermeer's wife, Caterina.

Theories

- Is it a genre scene or an allegory? Or both?
- A moment of weighing and judging.
- In the background is a painting of the Last Judgment, a time of weighing souls:
 - The woman is at a midpoint between earthly jewels and spiritual goals such as meditation and temperance.
 - The balance (scale) has nothing in it; pearls and coins on the table waiting to be measured; may be symbolic of a balanced state of mind.
 - The balancing reference perhaps relates to the unborn child.
 - This is Catholic subject matter in a Protestant country; Vermeer and his family were Catholic.
- Vanitas painting: gold should not be a false allure.
- Vermeer may have used a camera obscura.

Content Area Early Europe and Colonial Americas, Image 92

Web Source *http://www.nga.gov/content/ngaweb/Collection/art-object-page.1236.html*

- **Cross-Cultural Comparisons for Essay Question 1: Genre Scenes**
 - Grave stele of Hegeso (Figure 4.7)
 - Cassatt, *The Coiffure* (Figure 21.7)
 - *Bayeux Tapestry*, First Meal (Figure 11.7b)

Rachel Ruysch, *Fruit and Insects*, 1711, oil on wood, Uffizi, Florence (Figure 17.11)

Form

- Asymmetrical, artful arrangement.
- A finely detailed illustration of natural objects in a rural setting.

Content

- Not a depiction of actual flowers, but a construct of perfect specimens all in bloom at the same time.
- The artist probably used illustrations in botany textbooks as a basis for the painting.
- Wheat and grapes juxtaposed: may have been a reference to the Eucharist.

Context

- The artist's father was a professor of anatomy and botany as well as an amateur painter.
- The artist produced a number of such still lifes in woodland settings.
- Parallels Dutch interest in botany, and the growing of flowers for decorative and medicinal purposes.
- Flowers were symbols of wealth and status.

Content Area Early Europe and Colonial Americas, Image 96

Web Source https://www.britannica.com/biography/Rachel-Ruysch

- **Cross-Cultural Comparisons for Essay Question 1: Still Lifes**
 - Daguerre, *Still Life in Studio* (Figure 20.8)
 - Matisse, *Goldfish* (Figure 22.1)

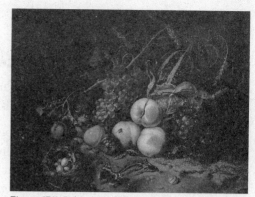

Figure 17.11: Rachel Ruysch, *Fruit and Insects*, 1711, oil on wood, Uffizi, Florence

VOCABULARY

Di sotto in sù: ("from the bottom up") a type of ceiling painting in which the figures seem to be hovering above the viewers, often looking down at us (Figure 17.6).

Genre painting: painting in which scenes of everyday life are depicted

Impasto: a thick and very visible application of paint on a painting surface

Still life: a painting of a grouping of inanimate objects, such as flowers or fruit (Figure 17.11)

Tenebroso/Tenebrism: a dramatic dark and light contrast in a painting (Figure 17.5)

Vanitas: a theme in still life painting that stresses the brevity of life and the folly of human vanity (Figure 17.11)

SUMMARY

The Baroque has always symbolized the grand, the majestic, the colorful, and the sumptuous in European art. While the work of Rubens and Bernini and the architecture of Versailles certainly qualify as this view of the Baroque, the period is equally famous for small Dutch paintings of penetrating psychological intensity and masterful interplays of light and shadow.

Illusion is a key element of the Baroque aesthetic. Whether it be the floating of Saint Teresa on a cloud or the trompe l'oeil ceilings of Roman palaces, the Baroque teases our imagination by stretching the limits of the space deep into the picture plane. The same complexity of thought is applied to intriguing and symbolic still lifes, known as vanitas paintings, or intricate groupings of figures such as *Las Meninas* (Figure 17.7).

The Baroque is characterized by a sense of ceaseless movement. Building façades undulate, sculptures are seen in the round, and portraits show sitters ready to speak or interact with the viewer. Naturalist painters, like Caravaggio, use dramatic contrasts of light and dark to highlight the movement of the figures.

The Baroque achieves a splendor through an energetic interaction reminiscent of Hellenistic Greek art, which serves as its original role model.

Multiple-Choice

1. The theatrical illusionism of Baroque works is similar to those seen in which of the following periods?

 (A) Roman Republic
 (B) Chinese Ming
 (C) Cambodian Khmer
 (D) Greek Hellenistic

2. Vanitas paintings are usually seen as symbolic elements in

 (A) still lifes, where they demonstrate the passing nature of human life
 (B) genre paintings, where they show the folly of human interactions
 (C) landscapes, where they stress the changing nature of the seasons
 (D) historical paintings, where they indicate the folly of greatness and triumph

3. An innovation seen in the architecture of Francesco Borromini is his

 (A) use of non-Western elements in his Catholic churches
 (B) massing of forms on a grand scale to achieve a powerful effect
 (C) use of gardens to enhance the setting of his buildings
 (D) creation of stone buildings that are not linear but curvilinear and undulating in form

4. Which of the following is the prime reason why Caravaggio's public and patrons found his art objectionable?

 (A) He copied directly from great masters of the Renaissance and was considered derivative rather than inventive.
 (B) He worked for discredited bishops, popes, and kings and was tainted by association.
 (C) He made saintly figures have earthly characteristics, which shocked church officials.
 (D) He showed the harsh glare of direct sunlight on his figures, which illuminated them in an uncompromising light.

5. The union of mythological gods and allegorical figures with real people as seen in the Peter Paul Rubens painting *Henri IV Receives the Portrait of Marie de' Medici* from the Marie de' Medici Cycle can also be seen in

 (A) Reliquary of Sainte-Foy
 (B) Code of Hammurabi
 (C) *Night Attack on the Sanjô Palace*
 (D) Rodin's *The Burghers of Calais*

Short Essay

Practice Question 6: Continuity and Change
Suggested Time: 15 minutes

This work is *Woman Holding a Balance* by Johannes Vermeer from 1664.

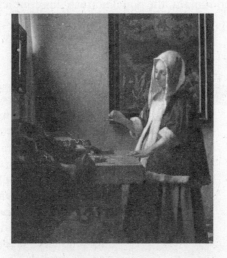

In this painting, Jan Vermeer is influenced by contemporary trends that are characteristic of Dutch painting in seventeenth-century Holland.

Describe specific characteristics of Dutch painting seen in this work.

Using *at least two* specific details, discuss the symbolic elements that could lead to an allegorical interpretation of this work.

Using *at least two* specific contextual details, discuss how this work reflects seventeenth-century Dutch society.

ANSWER KEY

1. **D** 2. **A** 3. **D** 4. **C** 5. **B**

ANSWERS EXPLAINED

Multiple-Choice

1. **(D)** Works like the *Winged Victory of Samothrace* show a theatrical illusionism, similar to that of Bernini's *Ecstasy of Saint Teresa.*

2. **(A)** Vanitas paintings are still lifes, generally still lifes that stand alone, although they can be part of larger compositions. They usually have symbols of the passing of time, like clocks, skulls, or hourglasses, which symbolize—among other things—the folly of human endeavor.

3. **(D)** Borromini's buildings, like San Carlo alle Quattro Fontane, show his interest in cutting stone into undulating and curvilinear forms.

4. **(C)** Caravaggio was famous for using models who were not glorious or saintly looking for images of angels, the Virgin Mary, and various saints.

5. **(B)** In the Code of Hammurabi, the god Shamash has contact with Hammurabi by literally handing him the code.

Short Essay Rubric

Task	Point Value	Key Points in a Good Response
Describe specific characteristics of Dutch painting seen in this work.	1	Answers could include: ■ It is not grand, large, or overwhelming but small and concentrated. ■ It does not have historical associations. ■ It is seemingly simple but asks the viewer to contemplate its meaning. ■ It is not theatrical but poignant. ■ The meaning is captured in a simple gesture and a moment suspended in time. ■ Genre scene. ■ Mercantile activity seen in a symbolic setting.
Using *at least two* specific details, discuss the symbolic elements that could lead to an allegorical interpretation of this work.	1 point for each symbolic element	Answers could include: ■ Weighing and judging. ■ Holds a balance or scales. ■ Pregnant woman. ■ Vanitas theme. ■ Symbolism of various objects. ■ Last Judgment in the painting in the background.
Using *at least two* specific contextual details, discuss how this work reflects seventeenth-century Dutch society.	1 point for each element of context	Answers could include: ■ Merchant activity of weighing goods. ■ Christian imagery of the judging and weighing of souls. ■ Deeper meaning seen in common activities of the time. ■ Lack of ostentation in dress, home, and environment reflects Dutch pragmatism. ■ Genre scenes can carry a higher meaning. ■ Lack of symbols of royalty or historical allusions; an anti-Spanish feeling.

Art of New Spain: Spanish Colonies in the Americas

18

TIME PERIOD: c. 1500–1820

ENDURING UNDERSTANDING: The culture, beliefs, and physical settings of a region play an important role in the creation, subject matter, and siting of works of art.

Learning Objective: Discuss how the culture, beliefs, or physical setting can influence the making of a work of art. (For example: Juárez, *Spaniard and Indian Produce a Mestizo*)

Essential Knowledge:

- Baroque art can be found in New Spain.
- Baroque art still has a basis on classical formulas, but also has an interest in dynamic compositions and theatricality.

ENDURING UNDERSTANDING: Cultural interaction through war, trade, and travel can influence art and art making.

Learning Objective: Discuss how works of art are influenced by cultural interaction. (For example: Frontispiece of the Codex Mendoza)

Essential Knowledge:

- There are the beginnings of global commercial and artistic networks.
- Art in New Spain shows a willingness to absorb European, Asian, and indigenous American influences.
- Art in New Spain has a generally Catholic character similar to the art of southern Europe.

ENDURING UNDERSTANDING: Art making is influenced by available materials and processes.

Learning Objective: Discuss how material, processes, and techniques influence the making of a work of art. (For example: Circle of the González family, Screen with the Siege of Belgrade and hunting scene)

Essential Knowledge:

- The period is dominated by an experimentation of visual elements, i.e., atmospheric perspective, a bold use of color, creative compositions, and an illusion of naturalism.

ENDURING UNDERSTANDING: Art and art making can be influenced by a variety of concerns including audience, function, and patron.

Learning Objective: Discuss how art can be influenced by audience, function, and/or patron. (For example: Circle of the González family, Screen with the Siege of Belgrade and hunting scene)

Essential Knowledge:

- There is a more pronounced identity of the artist in society; the artist has more structured training opportunities.

ENDURING UNDERSTANDING: Art history is best understood through an evolving tradition of theories and interpretations.

Learning Objective: Discuss how works of art have had an evolving interpretation based on visual analysis and interdisciplinary evidence. (For example: Juárez, *Spaniard and Indian Produce a Mestizo*)

Essential Knowledge:

- Baroque art is studied in chronological order and by geographic region.
- There is a large body of primary source material housed in libraries and public institutions.
- Traditional art history material favors European art; the art of New Spain is often sidelined. This material is being presented here in a more comprehensive approach that highlights the interconnections between the Americas and Europe.

HISTORICAL BACKGROUND

Following the news that Columbus landed in what is now the Bahamas in 1492, European powers immediately set upon a mission of conquest and colonization. Spanish and Portuguese adventurers occupied vast expanses of territory in an area we today call Latin America. The great Native American civilizations of the Aztecs and Inkas rapidly fell before the more technologically advanced and disease-bearing Europeans.

Within a short time, local populations were made to work for their European overlords, artists included. Some Native Americans married into the established Spanish hierarchy and produced children called **mestizos**.

The Spanish extracted much the New World had to offer: silver, gold, and new crops, like potatoes and corn. They also established a world wide trading empire in which ships slowly trekked across the Pacific connecting Mexico with Asia. These voyages, called the Manila Galleon, enabled trade vessels to make the four-month journey unimpeded. The Mexican market could boast Asian spices, ceramics, silks, ivory, and other precious items long before they became available in the colonial United States. Artistic life became enriched by the contact of East and West layered onto a Native American population.

Instability in Europe during the Napoleonic wars, however, inspired Spain's colonies to seek independence. As quickly as Spain gained her territories, she lost them to very capable generals like Simón Bolivar and José de San Martin. By 1822 most of Latin America was a patchwork of independent states; colonial rule was over.

Patronage and Artistic Life

The Spanish brought Roman Catholicism, a religion rich in imagery, to the New World. Ecclesiastical patrons sponsored an astonishing degree of high quality religious works. Unlike English colonists, the Spanish were not reluctant to use native artists. Works from New Spain combine Roman Catholicism with Native American traditions in a pictorial landscape that often uses new materials from Asia. Concurrently, English Protestants in what is now the United States limited their artistic interest to portraits.

In the beginning, the Spanish brought over late medieval artistic conventions that were often combined with provincial Renaissance works. Soon thereafter efforts were made to establish local schools that were inspired by the more current Baroque style. Many Mexican portraits show men dressed in the latest Madrid styles to prove they had aristocratic sensibilities.

The first center of European art in the Americas was established in Cusco, Peru. Spanish painters taught local Quechan and mestizo artists the newly imported style. In addition to religious images, patrons also were interested in portraits, as well other subjects current in European painting like historical paintings of battle scenes and Arcadian landscapes.

Painting in New Spain

Religious painting of the colonial Spanish era is generally marked by a combination of Old and New World skills. Spain contributed the oil technique and Catholic imagery to American painting. Native artists, working within their own traditions, showed less interest in European painting formulas such as perspective. They favored a flattened surface with earthen tones. This is particularly evident in the works of the Cusco School.

Many works of art were created anonymously, in service of religion rather than in service of the fame of the artist. Today it is oftentimes impossible to establish the name of the artist because the style of a given school is so closely united.

The Manila Galleon brought trade from Asia, and new materials as well, so it is not unusual to see works of Latin American art that use ivory, silk, or ceramics.

Frontispiece of the Codex Mendoza, Viceroyalty of New Spain, c. 1541–1542, ink and color on paper, Bodleian Library, Oxford University (Figure 18.1)

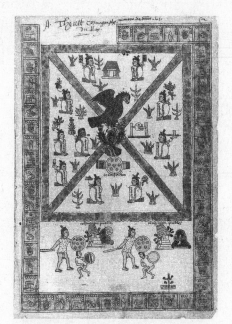

Figure 18.1: Frontispiece of the Codex Mendoza, c. 1541–1542, ink and color on paper, Bodleian Library, Oxford University

Content
- The main scene depicts the founding of Tenochtitlán; below is the conquest of Colhuacan and Tenayucan.
- Aztecs were told to found their city at the spot where an eagle was perched on a cactus growing from a rock—today this is the symbol used on the Mexican flag.
- An eagle landing on a cactus at the intersection of the two waterways commemorates the division of Tenochtitlán into four quarters.
- Enemy temples are on fire; Aztec warriors carry clubs and shields.
- Skulls represent sacrificial victims.
- There is a small representation of the Templo Mayor above the eagle.

Function
- The book was intended as a history of the Aztecs for Charles V of the Holy Roman Empire—although he never received it.
- Named after Antonio de Mendoza, viceroy of New Spain.

Context
- The book was created 20 years after the Spanish conquest.
- The book depicts Aztec rulers and daily life in Mexico to a European audience.
- The book uses glyphs created by Aztec artists that were later annotated in Spanish.

Content Area Early Europe and Colonial Americas, Image 81

Web Source http://publicdomainreview.org/collections/codex-mendoza-1542/

- **Cross-Cultural Comparisons for Essay Question 1: National Symbols**
 - Delacroix, *Liberty Leading the People* (Figure 20.4)
 - Golden Stool (Figure 27.4)
 - Quick-to-See-Smith, *Trade* (Figure 29.12)

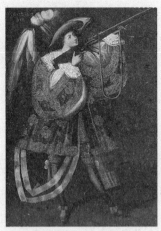

Figure 18.2: Master of Calamarca (La Paz School), *Angel with Arquebus, Asiel Timor Dei*, 17th century, oil on canvas, National Art Museum, La Paz, Bolivia

Master of Calamarca (La Paz School), *Angel with Arquebus, Asiel Timor Dei*, **17th century, oil on canvas, National Art Museum, La Paz, Bolivia (Figure 18.2)**

Content
- Latin inscription: Asiel, fear of God.
- The angel is depicted with an arquebus (a form of rifle) instead of a traditional sword.
- An arquebus is a state-of-the-art weapon brought by the Spanish to the New World.

Form
- The elongated hat with feathers is a feature of dress of Inkan nobility.
- Indigenous people favored gold embroidered on fabrics.
- Military poses are derived from European engravings of military exercises.
- The drapery is of a seventeenth-century Spanish-American aristocrat; rich costuming.
- The angel appears in an androgynous stance.
- Mannerist influence in the stiffness of the figure and dance-like pose.

Function
- Probably one in a series of angel drummers, buglers, standard bearers, and holders of swords.

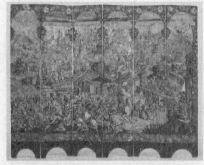

Figure 18.3a: Circle of the González family, Screen with the Siege of Belgrade, 1697–1701, tempera and resin on wood inlaid with mother-of-pearl, Brooklyn Museum, New York

Context
- A relationship is expressed between this kind of image and the winged warriors of pre-Columbian art.
- The work may have originated in the region around Lake Titicaca, in the Collao region of Peru.
- The Master of Calamarca may have been José López de los Ríos, a Bolivian painter.
- The feathered hat may reference Andean royalty.
- Guns were symbols of power and dominance over native American peoples and their beliefs.
- The painting is related to Spanish-American writings that allude to angels coming at the Last Judgment well-attired with feathered hats and carrying guns.

Content Area Early Europe and Colonial Americas, Image 90

Web Source *https://www.questia.com/magazine/1G1-6134023/the-angel-with-the-arquebus*

- **Cross-Cultural Comparisons for Essay Question 1: Guardian Figures**
 - Nio guardian figure (Figures 25.1c, 25.1d)
 - Lamassu (Figure 2.5)
 - Jayavarman VII as Buddha (Figure 23.8d)

Figure 18.3b: Circle of the González family, Screen with a hunting scene, 1697–1701, tempera and resin on wood inlaid with mother-of-pearl, Brooklyn Museum, New York

Circle of the González family, Screen with the Siege of Belgrade and a hunting scene, 1697–1701, tempera and resin on wood inlaid with mother-of-pearl, Brooklyn Museum, New York (Figures 18.3a and 18.3b)

Form
- Only known example of an artwork that combines biombos and enconchados.

Function and Patronage

- The screen was commissioned by José Sarmiento de Valladares, viceroy of New Spain.
- Displayed in Viceregal Palace in Mexico City.
- The screen was meant to divide a space into smaller areas; similar to Japanese screens in function.
- Only half of the screen is illustrated in the official image set; the other half is in Mexico City.

Context

- Two faces of the screen: one has a hunting scene, and the other has a war scene (the Siege of Belgrade).
- The hunting scene is suited to an intimate space for small receptions.
- The hunting scene is based on tapestry designs for the Medici, a great family of art patrons in Renaissance Italy; the design is derived from prints exported from Europe.
- The war scene is more suited for a grander room of political importance.
- The war scene depicts the contemporary event of the Great Turkish War (1683–1699); a Dutch print was used for inspiration.
- The war scene illustrates a scene of Hapsburg power.
- Lacquer-style imported works from Japan influenced the decorative floral elements and the landscape motifs.

Content Area Early Europe and Colonial Americas, Image 94

Web Source https://www.brooklynmuseum.org/opencollection/objects/207337

- **Cross-Cultural Comparisons for Essay Question 1: Screens**
 - Korin, *White and Red Plum Blossoms* (Figure 25.4a, 25.4b)

Miguel González, *Virgin of Guadalupe* (*Virgen de Guadalupe*), based on original Virgin of Guadalupe, Basilica of Guadalupe, Mexico City, 1698, oil on canvas on wood inlaid with mother-of-pearl, Los Angeles County Museum of Art, Los Angeles, California (Figure 18.4)

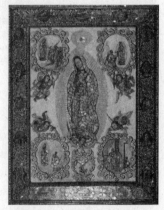

Figure 18.4: Miguel González, *Virgin of Guadalupe* (*Virgen de Guadalupe*), based on original Virgin of Guadalupe, Basilica of Guadalupe, Mexico City, 1698, oil on canvas on wood inlaid with mother-of-pearl, Los Angeles County Museum of Art, Los Angeles, California

Form

- The Virgin Mary is surrounded by four roundels that tell the story of the Virgin of Guadalupe.
- In the roundels there are depictions of her appearance to Juan Diego, and the moment the Virgin's image is revealed on his tunic.

Materials

- Brocade on Virgin's robes made of enconchados.
- Enconchado paintings often include ornate frames inspired by Japanese Nanban lacquer work.
- Enconchado paintings have a luminous and vibrant color patterning that enhance the other-worldly effect that this object represents.

Context

- The painting describes an event in which Mary appeared to Native Americans on a hill called Tepeyac, a shrine sacred to a pre-Columbian goddess.
- In 1531 Mary ordered a Native American convert, Juan Diego, to tell the local archbishop to build a sanctuary on this site; Mary addressed Juan Diego in Nuhuatl, his native tongue.
- Mary made the hilltop flower, and Juan Diego brought the flowers to the archbishop; Juan Diego's cloth revealed the Virgin's image.
- The Virgin of Guadalupe is the most revered symbol in Mexico and the patroness of New Spain.

- In Guadalupe images, Mary always stands on a crescent moon surrounded by sunrays with clouds behind her.
- An eagle perched on a cactus at bottom center is a symbol of Mexico today.
- Cf. Revelations 12:1: "A great sign appeared in heaven: a woman clothed with the sun, with the moon under her feet and a crown of twelve stars on her head."
- Image was in demand: many made for export around New Spain.

Content Area Early Europe and Colonial Americas, Image 95

Web Source *https://collections.lacma.org/node/222405*

- **Cross-Cultural Comparisons for Essay Question 1: Images of Mary**
 - Notre Dame de la Belle Verriere (Figure 12.8)
 - Lippi, *Madonna and Child with Two Angels* (Figure 15.3)
 - Virgin (Theotokos) and Child between Saints Theodore and George (Figure 8.8)

Figure 18.5: Attributed to Juan Rodríguez Juárez, *Spaniard and Indian Produce a Mestizo*, c. 1715, oil on canvas, Breamore House, Hampshire, United Kingdom

Attributed to Juan Rodríguez Juárez, *Spaniard and Indian Produce a Mestizo*, c. 1715, oil on canvas, Breamore House, Hampshire, United Kingdom (Figure 18.5)

Form
- A Spanish gentleman married an indigenous woman and produced a mestizo, who is carried on the back of a servant.
- Many Africans and Indians are rendered with Southern European features: slim noses, curly hair, almond-shaped eyes.

Function
- Spanish colonists commissioned these works to be sent abroad to show the caste system of the New World.
- Not considered art objects but illustrations of ethnic groups.

Context
- Panel from the first known series of casta paintings; may not have been a completed set.
- Spanish social hierarchy with the European ancestry at the top; sixteen different gradations on the social scale.
- Spanish blood linked to civilizing forces; wearing lavish costumes.
- Africans and Indians are rendered with respect; showing harmony and mixing of the classes.

Content Area Early Europe and Colonial Americas, Image 97

Web Source *https://www.brooklynmuseum.org/opencollection/objects/207338*

- **Cross-Cultural Comparisons for Essay Question 1: Meeting of Cultures**
 - Quick-to-See-Smith, *Trade* (Figure 29.12)
 - Bandolier bag (Figure 26.11)
 - Bichitr, *Jahangir Preferring a Sufi Shaikh to Kings* (Figure 23.9)

Content Area: Later Europe and Americas, 1750–1980 C.E.

Miguel Cabrera, Portrait of Sor Juana Inés de la Cruz, 1750, oil on canvas, Museo Nacional de Historia, Castillo de Chapultepec, Mexico (Figure 18.6)

Function
- Many portraits survive, but all images derive from a now-lost self-portrait.
- Painting was done for her admirers 55 years after Sor Juana Inés's death.

Content

- Portrayed seated in her library surrounded by symbols of her faith and her learning.
- She wears the habit of the religious order of the Hermits of Saint Jerome nuns of Mexico City; the habit includes the escudo—a framed vellum painting.
- Painting may have been inspired by the image of Saint Jerome seated at a desk.

Context

- Sor Juana Inés (Sister Juana Agnes), a child prodigy (1651–1695).
- She was a criollo woman who became a nun in 1669.
- A feminist culture survived in Mexican convents, where privileged nuns could live in comfort with servants and households.
- Sor Juana was a literary figure who wrote books that were widely read; she also wrote poetry and theatrical pieces, and maintained a great library.
- Sor Juana was instrumental in giving girls an education in a male-dominated world.

Content Area Later Europe and Americas, Image 99

Web Source *http://www.dartmouth.edu/~sorjuana/*

- **Cross-Cultural Comparisons for Essay Question 1: Portraits**
 - *Mblo* (Figure 27.7)
 - Portrait of Sin Sukju (Figure 24.6)
 - Smith, *Lying with the Wolf* (Figure 29.20)

Figure 18.6: Miguel Cabrera, Portrait of Sor Juana Inés de la Cruz, 1750, oil on canvas, Museo Nacional de Historia, Castillo de Chapultepec, Mexico

VOCABULARY

Biombos: folding freestanding screens (Figures 18.3a and 18.3b)

Casta paintings: paintings from New Spain showing people of mixed races (Figure 18.5)

Enconchados: shell-inlay paintings; tiny fragments of mother-of-pearl placed onto a wooden support and canvas and covered with a yellowish tint and thin glazes of paint (Figure 18.4)

Escudo: a framed painting worn below the neck in a colonial Spanish painting (Figure 18.6)

Mestizo: someone of mixed European and Native American descent (Figure 18.5)

Viceroy: a person appointed to rule a country as the deputy of the sovereign

SUMMARY

Spanish colonists combined European Baroque traditions with Native American labor and Asian imports to create a multi layered artistic experience. Patrons sponsored a wide range of subjects: religious images, portraits, painted screens, landscapes, and historical episodes. While many of the artistic formulas remain European in inspiration, the appeal of art from this period is its ability to wed disparate artistic experiences into a coherent whole.

Multiple-Choice

Questions 1–3 refer to the image below.

1. The formal quality of this work shows the influence of

 (A) Byzantine art in its extensive use of gold
 (B) Gothic art in its angularity and frontality
 (C) Mannerism in its awkwardness of poses
 (D) Rococo art in its light-hearted humor

2. This image of an angel differs from other angels in other contexts in that

 (A) the body is covered in drapery
 (B) this face looks human rather than divine
 (C) this angel is carrying a gun rather than a sword
 (D) there is no suggestion of an episode from the Bible being depicted

3. The materials used to create this work show the influence of

 (A) Aztec sculptures
 (B) Mayan frescoes
 (C) Aztec feather work
 (D) Spanish painting

4. The Codex Mendoza was created for

 (A) the Aztecs as an official account of their history
 (B) the Aztecs as a record of their civilization before the conquest by Spain
 (C) Antonio de Mendoza as a keepsake to remember his time spent in Mexico
 (D) Europeans to show them this history of the Aztecs

5. *The Virgin of Guadalupe* by Miguel González shows the influence of Asian art in its

 (A) use of exotic materials, such as mother-of-pearl

 (B) subject matter, which included the Chinese shrine at Guadalupe

 (C) Chinese calligraphy identifying the images

 (D) abstract formulae for depicting the human body

Long Essay

Practice Question 1: Comparison
Suggested Time: 35 minutes

This painting is attributed to Juan Rodríguez Juárez and is called *Spaniard and Indian Produce a Mestizo*. It was painted in 1715 and is an oil on canvas.

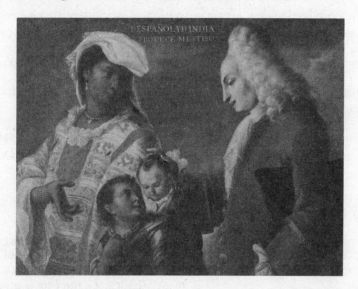

Many works of art illustrate cultural mores, stereotypes, and institutional biases, and comment on a contemporary situation.

Select and completely identify another work of art that represents cultural mores, stereotypes, or institutional biases. You may select a work from the list below or any other relevant work.

Identify the contemporary audience for *each* work.

Describe cultural mores, stereotypes, or institutional biases represented in *each* work.

Using *at least one* visual element, analyze the meaning of the cultural mores, stereotypes, or institutional biases of that work.

Using *at least one* contextual element, analyze the meaning of the cultural mores, stereotypes, or institutional biases of that work.

Discuss *at least one* difference in how *each work* communicates its message about a cultural mores, stereotype, or institutional bias.

 Head of a Roman patrician
 Pink Panther

ANSWERS EXPLAINED

Multiple Choice

1. **(C)** The stiff and awkward nature of the pose shows influence from Mannerist artists.

2. **(C)** It is not unusual for an angel to carry a weapon, like a sword. It is highly unusual for him to carry a gun. In traditional images, angels wear robes and are covered in drapery. Although they can be depicted acting out a biblical story, they are also commonly represented without a narrative. They can be depicted as either human or divine, or both.

3. **(D)** This work is an oil on canvas, the same technique as that used in Spain.

4. **(D)** The purpose of the Codex Mendoza is to show Europeans the life and history of the Aztec people.

5. **(A)** Exotic materials were brought from Asia through a shipping route called the Manila Galleon. Spanish artists were particularly attracted to the widespread use of mother-of-pearl, as seen in this screen.

Long Essay Rubric

Task	Point Value	Key Points in a Good Response
Select and completely identify another work of art that represents cultural mores, stereotypes, or institutional biases.	1	▪ Head of a Roman patrician: Marble, c. 75–50 B.C.E. (Since the title is given in the directions, you may not use it in your identification. You may also not use the term *Roman* as a cultural designation because that word is given in the title as well. Two other identifiers are required.) ▪ Jeff Koons, 1988, glazed porcelain, American, contemporary art; Since the title is given in the directions, you may not use it in your identification. Two other identifiers are required.
Identify the contemporary audience for *each work.*	2	For *Spaniard and Indian Produce a Mestizo:* ▪ Spanish colonists commissioned works to be sent abroad to show how the caste system of the New World works. For Head of a Roman patrician: ▪ Portraits housed in family shrines, honoring deceased relatives. ▪ Funerary altars were adorned with portraits, busts, or reliefs and cinerary urns. For *Pink Panther:* ▪ It has an American or an international audience in museums, galleries, and private collections.

Task	Point Value	Key Points in a Good Response
Describe cultural mores, stereotypes, or institutional biases represented in *each work*.	2	For *Spaniard and Indian Produce a Mestizo:* ■ Spanish social hierarchy with the European ancestry at the top; 16 different gradations of social scale. ■ Spanish blood linked to civilizing forces; wearing of lavish costumes. ■ Indians shown in harmony with the Spanish intervention in the New World. For Head of a Roman patrician: ■ Realism of the portrayal shows influence of Greek Hellenistic art and late Etruscan art and thus kinship with the values expressed in those civilizations. ■ Busts are mostly of men, often depicted as elderly; the wisdom of patrician men is praised and glorified. For *Pink Panther:* ■ It shows attitudes toward the objectification of women. ■ The world of kitsch is elevated to high art. ■ It reflects a commentary on celebrity romance, sexuality, commercialism, stereotypes, pop culture, and sentimentality.
Using *at least one* visual element, analyze the meaning of the cultural mores, stereotypes, or institutional biases of that work.	1	For *Spaniard and Indian Produce a Mestizo:* ■ Indians are rendered with respect; shows harmony and mixing of the classes. ■ Children treated with affection and love by the European fathers. ■ Indians rendered with Southern European features: slim noses, curly hair, almond-shaped eyes. For Head of a Roman patrician: ■ Bulldog-like tenacity of features; overhanging flesh; deep crevices in face. ■ Features show experience and wisdom—traits Roman patricians would have desired. For *Pink Panther:* ■ Artificially idealized female form: overly yellow hair, bright red lips, large breasts, pronounced red fingernails; overtly fake look. ■ Pink Panther, a cartoon character derived from a series of American movies; tender gesture.

Task	Point Value	Key Points in a Good Response
Using *at least one* contextual element, analyze the meaning of the cultural mores, stereotypes, or institutional biases of that work.	1	For *Spaniard and Indian Produce a Mestizo:* ■ Spanish are seen as a civilizing force in the New World. ■ Mixing of cultural traditions brings peace and harmony. ■ The Spanish recognize the existence of a caste system in the New World. ■ Indians take on a European code of behavior and dress, a willingness to mix with the Spanish. For Head of a Roman patrician: ■ Extremely realistic face, called a veristic portrait. ■ Wax portrait masks were traditionally used in funeral processions of the upper class to commemorate their history. ■ Features may have been exaggerated by the artist to enhance adherence to Roman Republican virtues. For *Pink Panther:* ■ It was part of a series called *Banality* at a 1988 show in the Sonnenbend Gallery in New York. ■ Critiques the banality of much of popular culture; modern art; women's objectification; the introduction of kitsch into high art; the questioning of what high art really is.
Discuss *at least one* difference in how *each work* communicates its message about a cultural more, stereotype, or institutional bias.	1	There are many differences. An obvious choice would be materials. Oil on canvas is a conventional format for European artists and expresses a cultural superiority over Native American art forms. Marble suggests permanence and monumentality. Porcelain is considered a lower type of artistic material, further contributing to Koons's commentary.

19

Rococo and Neoclassicism

▰▰▰▰▰▰▰▰▰▰▰▰▰▰▰▰

TIME PERIOD: ROCOCO: 1700–1750 AND BEYOND
NEOCLASSICISM: 1750–1815

The Rococo derives its name from a combination of the French *rocaille*,
meaning "pebble" or "shell," and the Italian *barocco*, meaning "baroque."
Thus, motifs in the Rococo were thought to resemble ornate shell or pebble work.

ENDURING UNDERSTANDING: The culture, beliefs, and physical settings of a region play an important role in the creation, subject matter, and siting of works of art.

Learning Objective: Discuss how the culture, beliefs, or physical setting can influence the making of a work of art. (For example: Jefferson, Monticello)

Essential Knowledge:

- Europe and the Americas experience great innovation in economics, industrialization, war, and migration. There is a strong advancement in social issues.
- The ideas of the Enlightenment and scientific inquiry affect the arts.

ENDURING UNDERSTANDING: Cultural interaction through war, trade, and travel can influence art and art making.

Learning Objective: Discuss how works of art are influenced by cultural interaction.

Essential Knowledge:

- Architecture is expressed in a series of revival styles.
- Artists are exposed to diverse, sometimes exotic, cultures as a result of colonial expansion.

ENDURING UNDERSTANDING: Art and art making can be influenced by a variety of concerns including audience, function, and patron.

Learning Objective: Discuss how art can be influenced by audience, function, and/or patron.
(For example: Houdon, *George Washington*)

Essential Knowledge:

- The Salon in Paris becomes important. Museums open and display art. Art sells to an ever-widening market.
- The importance of academies rises, as artistic careers become dependent on juried salons.
- Women artists become increasingly important.

ENDURING UNDERSTANDING: Art making is influenced by available materials and processes.

Learning Objective: Discuss how material, processes, and techniques influence the making of a work of art.

Essential Knowledge:

■ Artists use new media including photography, lithography, and mass production.

ENDURING UNDERSTANDING: Art history is best understood through an evolving tradition of theories and interpretations.

Learning Objective: Discuss how works of art have had an evolving interpretation based on visual analysis and interdisciplinary evidence. (For example: Wright of Derby, *A Philosopher Giving a Lecture on the Orrery*)

Essential Knowledge:

■ Art history as a science continues to be shaped by theories, interpretations, and analyses applied to the new art forms.

HISTORICAL BACKGROUND

Center stage in early-eighteenth-century politics was the European conquest of the rest of the world. The great struggles of the time took place among the colonial powers, who at first merely established trading stations in the lands they encountered, but later occupied distant places by layering new settlers, new languages, new religions, and new governments onto an indigenous population. At first, Europeans hoped to become wealthy by exploiting these new territories, but the cost of maintaining foreign armies soon began to outweigh the commercial benefits.

As European settlers grew wistful for home, they built Baroque- and Rococo-inspired buildings, imported Rococo fashions and garments, and made the New World seem as much like the Old World as they could.

In France, the court at Versailles began to diminish after the death of Louis XIV, leaving less power in the hands of the king and more in the nobility. Therefore, the Rococo departs from the Baroque interest in royalty, and takes on a more aristocratic flavor, particularly in the decoration of lavish townhouses that the upper class kept in Paris—not in Versailles.

The late eighteenth century was the age of the Industrial Revolution. Populations boomed as mass production, technological innovation, and medical science marched relentlessly forward. The improvements in the quality of life that the Industrial Revolution yielded were often offset by a new slavery to mechanized work and inhumane working conditions.

At the same time, Europe was being swept by a new intellectual transformation called the Enlightenment, in which philosophers and scientists based their ideas on logic and observation, rather than tradition and folk wisdom. Knowledge began to be structured in a deliberate way: Denis Diderot (1713–1784) organized and edited a massive 52-volume French encyclopedia in 1764, Samuel Johnson (1709–1784) composed the first English dictionary singlehandedly in 1755, and Jean-Jacques Rousseau discussed how a legitimate government was an expression of the general will in his 1762 *Social Contract*.

With all this change came political ferment—the late eighteenth century being a particularly transformational moment in European politics. Some artists, like David, were caught up in the turbulent politics of the time and advocated the sweeping societal changes that they thought the French Revolution espoused.

Patronage and Artistic Life

Rome was the place to be—to see the past. New artistic life was springing up all over Europe, leaving Rome as the custodian of inspiration and tradition, but not of progress. Italy's seminal position as a cultural cornucopia was magnified in 1748 by the discovery of the buried city of Pompeii. Suddenly genuine Roman works were being dug up daily, and the world could admire an entire ancient city.

The discovery of Pompeii inspired art theorist Johann Winckelmann (1717–1768) to publish *The History of Ancient Art* in 1764, which many consider the first art history book. Winckelmann heavily criticized the waning Rococo as decadent, and celebrated the ancients for their purity of form and crispness of execution.

Because of renewed interest in studying the ancients, art academies began to spring up around Europe and in the United States. Artists were trained in what the Academy viewed as the proper classical tradition—part of that training sent many artists to Rome to study works firsthand.

The French Academy showcased selected works by its members in an annual or biannual event called the **Salon**, so-called because it was held in a large room, the Salon Carrè, in the Louvre. Art critics and judges would scout out the best of the current art scene, and accept a limited number of paintings for public view at the Salon. If an artist received this critical endorsement, it meant his or her prestige greatly increased, as well as the value of his paintings.

The Salons had very traditional standards, insisting on artists employing a flawless technique with emphasis on established subjects executed with conventional perspective and drawing. History paintings, that is, those paintings dealing with historical, religious, or mythological subjects, were most prized. Portraits were next in importance, followed by landscapes, genre paintings, and then still lifes.

No education was complete without a **Grand Tour** of Italy. Usually under the guidance of a connoisseur, the tour visited cities like Naples, Florence, Venice, and Rome. It was here that people could immerse themselves in the lessons of the ancient world and perhaps collect an antiquity or two, or buy a work from a contemporary artist under the guidance of the connoisseur. The blessings of the Neoclassical period were firmly entrenched in the mind of art professionals and educated amateurs.

ROCOCO PAINTING

Rococo painting shuns straight lines, even in the frames of paintings. It is typical to have curved frames with delicate rounded forms in which the limbs of several of the figures spill over the sides so that the viewer is hard-pressed to determine what is painted and what is sculpted.

Rococo art is flagrantly erotic, sensual in its appeal to the viewer. The curvilinear characteristics of Rococo paintings enhance their seductiveness. Unlike the sensual paintings of the Venetian Renaissance, these paintings tease the imagination by presenting playful scenes of love and romance with overt sexual overtones.

Although the French are most noted for the Rococo, there were also active centers in England, central Europe, and Venice.

Rococo painting is the triumph of the Rubénistes over the Poussinistes. Artists, particularly those of Flemish descent like Watteau, were captivated by Rubens's use of color to create form and modeling.

Figures in Rococo painting are slender, often seen from the back. Their light frames are clothed in shimmering fabrics worn in bucolic settings like park benches or downy meadows. Gardens are rich with plant life and flowers dominate. Figures walk easily through forested glens and flowery copses, contributing to a feeling of oneness with nature reminiscent of the Arcadian paintings of the Venetian Renaissance. **Fête galante** painting features the aristocracy taking long walks or listening to sentimental love songs in garden settings.

Colors are never thick or richly painted; instead, **pastel** hues dominate. Some artists specialized in pastel paintings that possessed an extraordinary lifelike quality. Others transferred the spontaneous brushwork and light palette of pastels to oils.

By and large, Rococo art is more domestic than Baroque, meaning it is more for private rather than public display.

Figure 19.1: Jean-Honoré Fragonard, *The Swing*, 1767, oil on canvas, Wallace Collection, London

Jean-Honoré Fragonard, *The Swing*, 1767, oil on canvas, Wallace Collection, London (Figure 19.1)

Form
- Pastel palette; light brushwork.
- Figures are small in a dominant garden-like setting.
- Use of atmospheric perspective.
- Puffy clouds; rich vegetation; abundant flowers; sinuous curves.
- Symbolically a dreamlike setting.

Patronage and Content
- Commissioned by an unnamed "gentleman of the Court:" a painting of his young mistress on a swing; in an early version, a bishop is pushing the swing with the gentleman admiring his mistress's legs from below.
- In the finished painting, the older man is no longer a priest, a barking dog has been added, and Falconet's sculpture of Menacing Love comments on the story.
- The patron in the lower left looks up the skirt of a young lady who swings flirtatiously, boldly kicking off her shoe at a sculpture.
- The dog in the lower right corner, generally seen as a symbol of fidelity, barks in disapproval at the scene before him.

Context
- Fragonard answers the libertine intentions of his patron by painting in the Rococo style.
- Fragonard often used different styles at the same time, and he seems to have seen the Rococo as particularly appropriate for an erotic scene.
- An intrigue painting; the patron hides in a bower; the garden sculpture of Menacing Love asks the lady to be discreet and may be a symbol for the secret hiding of the patron.

Content Area Later Europe and Americas, Image 101

Web Source *https://www.wallacecollection.org/collection/les-hazards-heureux-de-lescarpolette-swing/*

- **Cross-Cultural Comparisons for Essay Question 1: Figures Set in a Landscape**
 - Fan Kuan, *Travelers among Mountains and Streams* (Figure 24.5)
 - Dürer, *Adam and Eve* (Figure 14.3)
 - Cotsiogo, Hide Painting of a Sun Dance (Figure 26.13)

Elisabeth Louise Vigée Le Brun, *Self-Portrait*, 1790, oil on canvas, Uffizi, Florence (Figure 19.2)

Figure 19.2: Elisabeth Louise Vigée Le Brun, *Self-Portrait*, 1790, oil on canvas, Uffizi, Florence

Form

- Light Rococo touch in the coloring.
- Inspired by the portraits of Rubens.

Context

- Forty self-portraits exist, all highly idealized.
- The artist was 45 when this was painted, but she appears much younger.
- Painted in Rome during the French Revolution when the artist was exiled for political reasons.
- The artist was granted admission to the male-dominated French Royal Academy through the influence of Marie Antoinette.
- The artist looks at the viewer as she paints a portrait of the French queen Marie Antoinette, who is rendered from memory since she was killed during the French Revolution.
- Subject in the painting looks admiringly upon the painter.

Content Area Later Europe and Americas, Image 105

Web Source https://catalog.hathitrust.org/Record/005721740

- **Cross-Cultural Comparisons for Essay Question 1: Individual, Status, and Society**
 - Augustus of Prima Porta (Figure 6.15)
 - Portrait of Sin Sukju (Figure 24.6)
 - *Mblo* (Figure 27.7)

EIGHTEENTH-CENTURY ENGLISH PAINTING

Freedom of expression swept through France and England at the beginning of the eighteenth century and found its fullest expression in the satires of Jonathan Swift's *Gulliver's Travels* and Voltaire's *Candide*. The visual arts responded by painting the first overt satires, the most famous of which are by the English painter **Hogarth**. Satirical paintings usually were done in a series to help spell out a story as in *Marriage à la Mode* (Figure 19.3). Afterward the paintings were transferred to prints, so that the message could be mass produced. Themes stem from exposing political corruption to spoofs on contemporary lifestyles. Hogarth knew that the pictorial would reach more people than the written, and he hoped to use his prints to didactically expose his audience to abuses in the upper class. Society had changed so much that by now those in power grew more tolerant of criticism so as to allow satirical painting to flourish, at least in England. Today, the political cartoon is the descendant of these satirical prints.

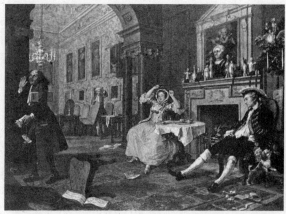

Figure 19.3: William Hogarth, *The Tête à Tête* from *Marriage à la Mode*, c. 1743, oil on canvas, National Gallery, London

William Hogarth, *The Tête à Tête* from *Marriage à la Mode*, c. 1743, oil on canvas, National Gallery, London (Figure 19.3)

Marriage à la Mode

Form

- Richly decorated rooms painted in brilliant color.
- Myriad of details; each detail adds to the symbolism in the work.
- Elements of French Rococo style used to indict those who are flattered in French art.

Function
- Highly satiric paintings about a decadent English aristocracy and those who would have liked to buy their way into it.
- A series of six narrative paintings; later turned into a series of prints.

Context
- Second of six scenes in a suite of paintings called *Marriage à la Mode*.

The Tête-à-Tête
- Shortly after the marriage each partner has been pursing pleasures without the other.
- The husband has been out all night with another woman (the dog sniffs suspiciously at another bonnet); the broken sword means he has been in a fight and probably lost (and may also be a symbol for sexual inadequacy).
- The wife has been playing cards all night, the steward indicating by his expression that she has lost a fortune at a card game called whist; he holds nine unpaid bills in his hand (one was paid by mistake, further illustrating their carelessness).
- The painting over the mantlepiece is a symbolic depiction of Cupid among the ruins.
- A turned-over chair indicates that the violin player made a hasty retreat when the husband came home.

Content Area Early Europe and Colonial Americas, Image 98

Web Source *http://www.nationalgallery.org.uk/paintings/william-hogarth-marriage-a-la-mode-2-the-tete-a-tete*

- **Cross-Cultural Comparisons for Essay Question 1: Elements of Humor**
 - Jeff Koons, *Pink Panther* (Figure 29.9)
 - Michel Tuffery, *Pisupo Lua Afe (Corned Beef 2000)* (Figure 29.16)
 - Honoré Daumier, *Nadar Raising Photography to the Height of Art* (Figure 21.2)

Figure 19.4: Joseph Wright of Derby, *A Philosopher Giving a Lecture on the Orrery*, 1763–1765, oil on canvas, Derby Museum and Art Gallery, Derby, U.K.

Joseph Wright of Derby, *A Philosopher Giving a Lecture on the Orrery*, 1763–1765, oil on canvas, Derby Museum and Art Gallery, Derby, U.K. (Figure 19.4)

Form
- One of a series of candlelight pictures by Wright; inspired by Caravaggio's use of tenebrism.
- Clearly drawn and sharply delineated portraits of individuals.

Content
- An orrery is an early form of a planetarium, imitating the motion of the solar system.
- The lamp in the center represents the sun; it is blocked by the silhouette of a figure.
- All ages of man are represented by the mixed group of middle-class people in attendance.
- Some curious, some contemplative, some in wonder, some fascinated.
- The philosopher is based loosely on a portrait of Isaac Newton; he is demonstrating an eclipse.
- The philosopher stops to clarify a point for the note-taker on the left.

Context
- Influenced by a provincial group of intellectuals called the Lunar Society, who met once a month to discuss current scientific discoveries and developments.
- To complete the celestial theme, each face in the painting is an aspect of the phases of the moon.

- Illustrates the eighteenth-century period called the Enlightenment and the democratization of knowledge.

Content Area Later Europe and Americas, Image 100

Web Source *http://www.tms.org/pubs/journals/jom/0706/byko-0706.html*

- **Cross-Cultural Comparisons for Essay Question 1: Knowledge**
 - Bichitr, *Jahangir Preferring a Sufi Shaikh to Kings* (Figure 23.9)
 - Cabrera, Portrait of Sor Juana Inés de la Cruz (Figure 18.6)

NEOCLASSICAL ARCHITECTURE

The best Neoclassical buildings were not dry adaptations of the rules of ancient architecture, but a clever revision of classical principles onto a modern framework. While many buildings had the outward trappings of Roman works, they were also efficiently tailored to living in the eighteenth century.

Ancient architecture came to Europe distilled through the books written by the Renaissance architect Andrea Palladio, and reemphasized by the classicizing works of Inigo Jones. From these sources Neoclassicists learned about symmetry, balance, composition, and order. Greek and Roman columns, with their appropriate capitals, appeared on the façades of most great houses of the period, even in the remote hills of Virginia. Pediments crown entrances and top windows. Domes grace the center of homes, often setting off gallery space. The interior layout is nearly or completely symmetrical, with rectangular rooms mirroring one another on either side of the building. Each room is decorated with a different theme, some inspired by the ancient world, others with a dominant color in wallpaper or paint.

Thomas Jefferson, Monticello, 1768–1809, brick, glass, stone, and wood, Charlottesville, Virginia (Figures 19.5a and 19.5b)

Form
- Monticello is a brick building with stucco applied to the trim to give the effect of marble.
- It appears to be a one-story building with a dome, but the balustrade hides a modest second floor.
- The octagonal dome functions as an office or retreat.
- The rooms generally have a symmetrical design.
- Tall French doors and windows allow air circulation in hot Virginia summers.
- Jefferson was concerned with saving space: very narrow spiral staircases; beds in alcoves or in walls between rooms.

Function
- Chief building on Jefferson's plantation, supported by slave labor.

Context
- Monticello is "little mountain" in Italian, sited on a hilltop in Virginia.
- Inspired by books by the Italian Renaissance architect Palladio and by Roman ruins Jefferson saw in France.
- The design is also impacted by eighteenth-century French buildings in Paris.

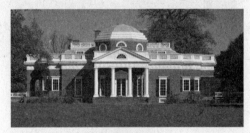

Figures 19.5a and 19.5b: Thomas Jefferson, Monticello, 1768–1809, brick, glass, stone, and wood, Charlottesville, Virginia

- Illustrates the Roman Republican goals of equality and democracy expressed in this adaptation of Roman architectural themes.

Content Area Later Europe and Americas, Image 102

Web Source http://whc.unesco.org/en/list/442/

- **Cross-Cultural Comparisons for Essay Question 1: Classical Revival**
 - Houdon, *George Washington* (Figure 19.7)
 - Donatello, *David* (Figure 15.5)
 - Alberti, Palazzo Rucellai (Figure 15.2)

NEOCLASSICAL PAINTING

Stories from the great epics of antiquity spoke meaningfully to eighteenth-century painters. Mythological or Biblical scenes were painted with a modern context in mind. The retelling of the story of the Horatii would be a dry academic exercise if it did not have the added implication of self-sacrifice for the greater good. A painting like this was called an **exemplum virtutis**.

Even paintings that did not have mythological references had subtexts inviting the viewer to take measure of a person, a situation, and a state of affairs.

Compositions in Neoclassical paintings were symmetrical, with linear perspective leading the eye into a carefully constructed background. The most exemplary works were marked by invisible brushwork and clarity of detail.

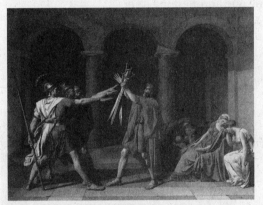

Figure 19.6: Jacques-Louis David, *The Oath of the Horatii*, 1784, oil on canvas, Louvre, Paris

Jacques-Louis David, *The Oath of the Horatii*, 1784, oil on canvas, Louvre, Paris (Figure 19.6)

Form
- Male forms are vigorous, powerful, animated, emphatic, angular; symbolically they are figures of action.
- Female forms are soft and rounded, displaying "feminine" emotion; symbolically they are figures of inaction or reaction.
- Gestures are sweeping and unified.
- Figures are pushed to the foreground.
- Neoclassical drapery and tripartite composition.
- Not neoclassical in its Caravaggio-like lighting and un-Roman architectural capitals.

Patronage
- Painted under royal patronage, Louis XVI.
- The artist presented the finished canvas in his studio in Rome in 1785 and at the Paris Salon later that year—on both occasions to acclaim.

Content
- Story of three Roman brothers (the Horatii) who do battle with three other brothers (the Curiatii—not painted) from the nearby city of Alba; they pledge their fidelity to their father and to Rome.
- One of the three women on right is a Horatii engaged to one of the Curiatii brothers; another woman is the sister of the Curiatii brothers and wife of the eldest Horatii.

Context
- Exemplum virtutis.
- David presents this episode as an example of patriotism and stoicism, which should override family relationships.

- Influenced by Enlightenment philosophers, such as Diderot, who advocated the painting of moral subjects.
- Emulated Grand Style of French painting of the seventeenth century.

Content Area Later Europe and Americas, Image 103

Web Source *http://www.louvre.fr/en/oeuvre-notices/oath-horatii*

- **Cross-Cultural Comparisons for Essay Question 1: Historicism**
 - Rivera, *Dream of a Sunday Afternoon in the Alameda Park* (Figure 22.20)
 - Shonibare, *The Swing* (after Fragonard) (Figure 29.22)
 - Sherman, *Untitled #228* (Figure 29.10)

NEOCLASSICAL SCULPTURE

Before the Industrial Revolution, bronze was the most expensive and most highly prized sculptural medium. Mass production of metal made possible by factories in England and Germany caused the price of bronze to fall, while simultaneously causing the price of marble to rise. Stonework relied on manual labor, a cost that was now going up. Because it was felt that the ancients preferred marble, it still seemed more desirable possessing an authoritative appeal. It was also assumed that the ancients preferred an unpainted sculpture, because the majority of marbles that have come down to us have lost their color.

The recovery of artifacts from Pompeii increasingly inspired sculptors to work in the classical medium. This reached a fever pitch with the importation of the Parthenon sculptures, the Elgin Marbles, to London, where they were eventually purchased by the state and ensconced in the Neoclassical British Museum. Sculptors like **Houdon** saw the Neoclassical style as a continuance of an ancient tradition.

Sculpture, while deeply affected by classicism, also was mindful of the realistic likeness of the sitter. Sculptors moved away from figures wrapped in ancient robes to more realistic figural poses in contemporary drapery. Classical allusions were secondary influences. Still, Neoclassical sculpture was carved from white marble with no paint added, the way it was felt the ancients worked.

Jean-Antoine Houdon, *George Washington*, 1788–1792, marble, State Capitol, Richmond, Virginia (Figure 19.7)

Form and Content
- Washington is dressed as an eighteenth-century gentleman with a Revolutionary War uniform.
- Military associations minimized: he wears only epaulettes on his shoulders; the sword is cast to the side.
- Naturalistic details: the missing button on his jacket and the tightly buttoned vest around a protruding stomach.
- Seen as a man of vision and enlightenment.
- Stance inspired by Polykleitos's *Doryphoros* (Figure 4.3) linking Washington's actions with the greatness of the past.

Materials
- Marble, appreciated for its durability and luster, was used to associate the figure of Washington with the great sculptures of the Renaissance and the ancient world.

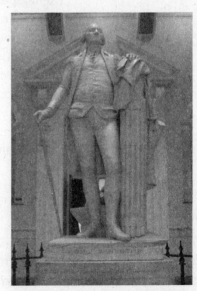

Figure 19.7: Jean-Antoine Houdon, *George Washington*, 1788–1792, marble, State Capitol, Richmond, Virginia

Function and Patronage

- Commissioned by the Virginia legislature to stand at the center of the state capitol in Richmond, which was designed by Jefferson.
- Meant to commemorate the central position of Washington in the founding of American independence.
- Installed in 1796, the year Washington published his farewell address.

Symbolism

- The badge of Cincinnatus is on his belt: Washington was a gentleman-farmer who left Mount Vernon to take up the American cause much as Cincinnatus from the Roman Republic left his farm to command Roman armies and then returned to the farm.
- Washington leans on the Roman fasces: a group of rods bound together on the top and the bottom; the 13 rods symbolize the 13 colonies united in a cause.
- Washington leans on the 13 colonies, from which he gets his support.
- Arrows between the rods likely refer to Native Americans or the idea of America as wild frontier.
- Plow behind Washington symbolizes his plantation as well as the planting of a new world order.

Content Area Later Europe and Americas, Image 104

Web Source *https://edu.lva.virginia.gov/online_classroom/shaping_the_constitution/doc/ washington*

- **Cross-Cultural Comparisons for Essay Question 1: Rulers**
 - King Menkaura and queen (Figure 3.7)
 - Lindauer, *Tamati Waka Nene* (Figure 28.7)
 - Augustus of Prima Porta (Figure 6.15)

VOCABULARY

Academy: an institution whose main objectives include training artists in an academic tradition, ennobling the profession, and holding exhibitions

Exemplum virtutis: a painting that tells a moral tale for the viewer (Figure 19.6)

Fête galante: an eighteenth-century French style of painting that depicts the aristocracy walking through a forested landscape

Grand Tour: in order to complete their education young Englishmen and Americans in the eighteenth century undertook a journey to Italy to absorb ancient and Renaissance sites

Pastel: a colored chalk that when mixed with other ingredients produces a medium that has a soft and delicate hue

Salon: a government-sponsored exhibition of artworks held in Paris in the eighteenth and nineteenth centuries

SUMMARY

The early eighteenth century saw the shift of power turn away from the king and his court at Versailles to the nobles in Paris. The royal imagery and rich coloring of Baroque painting was correspondingly replaced by lighter pastels and a theatrical flair. Fragonard's lighthearted compositions, called *fête galantes*, were symbolic of the aristocratic taste of the period.

Partly inspired by the French Rococo, English painters and patrons delighted in satirical painting, reflecting a more relaxed attitude in the eighteenth century toward criticism and censorship.

The aristocratic associations of the Rococo caused the style to be reviled by the Neoclassicists of the next generation, who thought that the Rococo style was decadent and amoral. Even so, the Rococo continued to be the dominant style in territories occupied by Europeans in other parts of the world—there it symbolized a cultured and refined view of the world in the midst of perceived pagans.

Intellectuals influenced by the Enlightenment were quick to reject the Rococo as decadent, and espoused Neoclassicism as a movement that expressed the "Liberty, Equality, and Fraternity" of the French Revolution. Moreover, the discovery of Pompeii and the writings of Johann Winckelmann, the first art historian, did much to revive interest in the classics and use them as models for the modern experience.

PRACTICE EXERCISES

Multiple-Choice

1. *The Swing* by Jean-Honoré Fragonard is similar to other Rococo paintings in that it

 (A) uses tenebrism to sharply contrast dark and light
 (B) is concerned with the classical ideals of Polykleitos
 (C) is innovative and experimental in painting techniques
 (D) uses a pastel palette

2. The structure of Monticello is heavily influenced by Thomas Jefferson's

 (A) trip to Spain to study Renaissance architecture
 (B) work as an archaeologist uncovering the ancient ruins of Pompeii
 (C) study of books on architecture by the Italian architect Palladio
 (D) friendship with George Washington, whose architectural theories were widely respected

3. The columns and the pediment of Monticello are meant to recall the

 (A) ancient Egyptian pharaohs and their expression of eternity
 (B) Greek gods and their mythological stories
 (C) Roman Republic and its governmental ideals
 (D) Gothic churches and their spirituality

4. Jacques-Louis David's *The Oath of the Horatii* is based on an ancient Roman story, but the painting technique owes a great deal to

 (A) Peter Paul Rubens
 (B) Caravaggio
 (C) Johannes Vermeer
 (D) Jacopo Pontormo

5. William Hogarth's satiric paintings are a reflection of a movement in the eighteenth century called

 (A) the Enlightenment
 (B) Naturalism
 (C) the Industrial Revolution
 (D) the Grand Tour

Short Essay

Practice Question 5: Attribution
Suggested Time: 15 minutes

Attribute this painting to the artist who painted it.

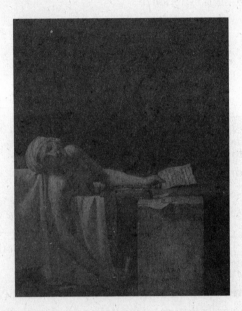

Using *at least two* specific details, justify your attribution by describing relevant similarities between this work and a work in the required course content.

Using *at least two* specific details, explain *why* these visual elements are characteristic of this artist.

1. **D** 2. **C** 3. **C** 4. **B** 5. **A**

ANSWERS EXPLAINED

Multiple-Choice

1. **(D)** Rococo paintings can be characterized by their soft, delicate, pastel color schemes.

2. **(C)** Jefferson possessed copies of Palladio's books on architecture.

3. **(C)** Jefferson felt that the Roman Republic embodied the spirit of democracy.

4. **(B)** The dark/light contrast called tenebrism is associated with artists like Caravaggio. David's mysteriously darkened background in *The Oath of the Horatii* is indebted to this artist.

5. **(A)** European painting was affected by the Enlightenment. For the first time, artists experienced a new freedom to lampoon political and social conventions in a public way. All the other choices are events that took place in the eighteenth century but don't apply to this question.

Short Essay Rubric

Task	Point Value	Key Points in a Good Response
Attribute this painting to the artist who painted it.	1	Jacques-Louis David
Using *at least two* specific details, justify your attribution by describing relevant similarities between this work and a work in the required course content.	2	The work in the required course content is David, *The Oath of the Horatii,* 1784, oil on canvas, Neoclassicism. Two specific details could include: ■ Greco-Roman imagery. ■ Classical compositions. ■ Antique drapery. ■ Firm, robust, idealized figures. ■ Minimum of extraneous detail. ■ Tenebrism.
Using *at least two* specific details, explain *why* these visual elements are characteristic of this artist.	2	Answers could include: ■ David was an advocate of the French Revolution, which was seen as a mythical and critical moment in politics. ■ David used the ancient world to reflect on the contemporary world. ■ David's style of Neoclassicism was a rejection of the previous Rococo style, which was linked to the aristocracy. ■ Both works indicate a dedication to patriotic causes.

Romanticism

20

TIME PERIOD: 1789–1848

The French Revolution of 1789 and the European revolts of 1848 form
a neat, although not completely accurate, boundary for Romanticism.

ENDURING UNDERSTANDING: The culture, beliefs, and physical settings of a region play an important role in the creation, subject matter, and siting of works of art.

Learning Objective: Discuss how the culture, beliefs, or physical setting can influence the making of a work of art. (For example: Barry and Pugin, Palace of Westminster)

Essential Knowledge:

- Europe and the Americas experience great innovation in economics, industrialization, war, and migration. There is a strong advancement in social issues.
- Artists in the Romantic period interpreted Enlightenment values in a new light.

ENDURING UNDERSTANDING: Cultural interaction through war, trade, and travel can influence art and art making.

Learning Objective: Discuss how works of art are influenced by cultural interaction. (For example: Ingres, *La Grande Odalisque*)

Essential Knowledge:

- Architecture is expressed in a series of revival styles.
- Artists are exposed to diverse, sometimes exotic, cultures as a result of colonial expansion.

ENDURING UNDERSTANDING: Art and art making can be influenced by a variety of concerns including audience, function, and patron.

Learning Objective: Discuss how art can be influenced by audience, function, and/or patron. (For example: Delacroix, *Liberty Leading the People*)

Essential Knowledge:

- Commercial galleries become important. Museums open and display art. Art sells to an ever-widening market.
- The Salon in Paris retains its leading role in the display of art.
- Women artists become increasingly important.

ENDURING UNDERSTANDING: Art making is influenced by available materials and processes.

Learning Objective: Discuss how material, processes, and techniques influence the making of a work of art. (For example: Daguerre, *Still Life in Studio*)

Essential Knowledge:

■ Architecture is affected by new materials and new modes of construction.

■ Artists use new media including photography, lithography, and mass production.

ENDURING UNDERSTANDING: Art history is best understood through an evolving tradition of theories and interpretations.

Learning Objective: Discuss how works of art have had an evolving interpretation based on visual analysis and interdisciplinary evidence. (For example: Delacroix, *Liberty Leading the People*)

Essential Knowledge:

■ Audiences and patrons were often hostile to art made in this period. Art history as a science continues to be shaped by theories, interpretations, and analyses applied to these new art forms.

HISTORICAL BACKGROUND

The revolutionary spirit of casting off oppressors and installing "Liberty, Equality, and Fraternity" created a dynamic for freedom not just in France, but throughout Europe, and in North and South America as well. However, the French Revolution itself, even though well-intentioned, devolved into the chaos of the Reign of Terror and eventually the Napoleonic Wars.

Nonetheless, the philosophical powers that were unleashed by these revolutionary impulses had long-term positive effects on European life, which are embodied in the Romantic spirit. Romantics espoused social independence, freedom of individual thought, and the ability to express oneself openly. This was manifest not only in the political battles of the day, but also in the societal changes in general education, social welfare, and a newfound expression in the arts. As a reaction against the Enlightenment, the Romantics would argue that you should trust your heart, not your head.

Patronage and Artistic Life

The Romantic artist was a troubled genius, deeply affected by all around him or her—temperamental, critical, and always exhausted. Seeking pleasure in things of greatest refinement, or adventures of audacious daring, the Romantic was a product of the extremes of human endeavor. **Turner**, for example, liked to be tied to the deck of a ship in a storm so that he could bring a greater sense of the **sublime** to his paintings.

Stereotypically, Romantic artists were loners who fought for important causes. **Delacroix** painted a number of great political paintings, and **Goya** understood that human folly exists on the side of the villain and the hero alike.

Romantics enjoyed a state of melancholy, that is, a gloomy, depressed, and pensive mindset that is soberly thoughtful. This can be seen in a series of nineteenth-century portraits. Romantics also championed the antihero, a protagonist who does not have the typical characteristics of a hero, often shunning society and rarely speaking, but capable of great heroic deeds.

The greatest artistic invention of the period was the development of photography. Since this was a new art form, there were no academies, no salons, and no schools from which to

learn the craft. Even so, the mechanical nature of the camera prejudiced the public against viewing photographs as works of art. Anyone with a camera and a how-to book could open a photo shop. Because of photography's universality, and because there were no preconceived notions about photographers creating great art, marginalized populations, including women, easily entered the field. Some of the most important advances in the history of photography were made by these groups; it was the first instance of equal opportunity in the arts.

REVIVAL ARCHITECTURE

Nineteenth-century architecture is characterized by a revival of nearly every style of the past. Historicism and yearning for past ideals fueled a reliance on the old, the tried, and the familiar.

There was symbolism in this. The Middle Ages represented a time when religion was more devout and sincere, and life was more centered around faith. Modern living, it was felt, was corrupted by the Industrial Revolution. People were so nostalgic for medieval ruins that when there were none handy, they had ruins built so that Romantic souls could ponder the loss of civilization.

Medieval art may have been the favorite theme to revive, but it was by no means the only one. Egyptian, Islamic, and even Baroque architecture was updated and grafted onto structures that had no connection with their original inspiration. Bath houses in England are done in the Islamic style; opera houses in Paris are Baroque; office buildings in the United States are Gothic; a monument to George Washington in Washington, D.C., is an Egyptian obelisk.

The use of iron in architecture, which started in the Neoclassical period, became more important in the Romantic. Architects concerned with reviving past architectural styles like Gothic or Romanesque used ironwork, but hid it under the skin of the building. More adventuresome architects used stone on the exterior, but were unafraid of iron as an exposed structural element on the interior. Progressive architects found the elegance and malleability of ironwork irresistible, especially when combined with walls of glass.

Charles Barry and Augustus Pugin, Palace of Westminster (Houses of Parliament), 1840–1870, limestone, masonry, and glass, London (Figures 20.1a and 20.1b)

Function
- The building holds the two chambers of the United Kingdom's government: the House of Commons and the House of Lords; today the House of Lords is largely a ceremonial body.

Form
- Enormous structure of 1,100 rooms, 100 staircases, 2 miles of corridors.
- It is a modern office building cloaked in medieval clothes.
- Barry, a classical architect, accounts for the regularity of plan.
- Pugin, a Gothic architect, added Gothic architectural touches to the structure.

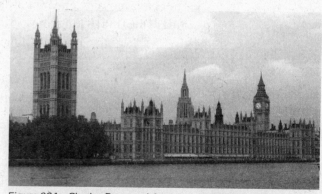

Figure 20.1a: Charles Barry and Augustus Pugin, Palace of Westminster (Houses of Parliament), 1840–1870, limestone, masonry, and glass, London

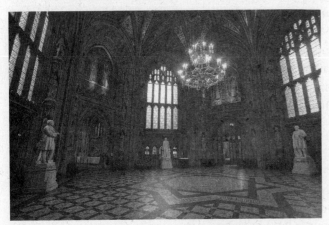

Figure 20.1b: Central lobby of the Houses of Parliament

- The profusion of Gothic ornament (pinnacles, spires, vertical thrust) is greater than would appear in an original Gothic building.
- Modern adaptation of a Gothic building includes innovations like air ventilation shafts.

Context
- Competition held in 1835 for a new Houses of Parliament after the old one burned down in 1834.
- There were 97 entrants: 91 in the Perpendicular Gothic style and 6 in the Elizabethan style; these styles were thought to be native English styles suitable for a new capitol building.
- Big Ben is a clock tower; in a sense a village clock for all of England.
- The building is a reaction against art as a mass-produced product of the Industrial Revolution; it has a hand-crafted look.

Content Area Later Europe and Americas, Image 112

- **Cross-Cultural Comparisons for Essay Question 1: Government Centers**
 - Nan Madol (Figures 28.1a, 28.1b)
 - Versailles (Figures 17.3a, 17.3b, 17.3c)
 - Forbidden City (Figures 24.2a, 24.2b, 24.2c, 24.2d)

Central Lobby
- Situated between the House of Commons and the House of Lords.
- Meant to be a space where constituents can meet their member of Parliament.
- The metal grilles on the doorways were originally in the House of Commons and marked off the spots where women could be seated to watch Parliament; now they are symbols of the suffrage movement.
- The grilles, originally installed to ensure that members of Parliament were not distracted by the sight of women watching them at work, were finally removed permanently from the gallery and placed in the Central Lobby following a vote in the House of Commons in August 1917.
- The central octagonal space contains statues of the kings and queens of England and Scotland.
- Four large mosaics, one over each doorway; in each mosaic a saint represents a different area of the United Kingdom:
 - England: Saint George.
 - Scotland: Saint Andrew.
 - Wales: Saint David.
 - Northern Island: Saint Patrick.

Westminster Hall (Figure 20.1c)
- When the old Houses of Parliament burned to the ground, this hall survived and became the last vestige of the medieval parliament building.
- Perpendicular Gothic style of Westminster Hall inspired the design of the Houses of Parliament.
- See Figure 12.5, page 261.

Web Source *http://www.parliament.uk/about/living-heritage/building/palace/*

Figure 20.1c: Westminster Hall, 1097–1099; ceiling 1390s, stone and wood, London, England

ROMANTIC PAINTING

Artists were impressed by the **sublime** in art. What the Enlightenment saw as ordered, symmetrical, logical, and scientific—and therefore beautiful—the Romantics viewed with disdain.

Artists wanted to create the fantastic, the unconscious, the haunted, and the insane. Some visited asylums and depicted their residents. Others painted the underside of the subconscious state a hundred years before Freud.

Photography had an enormous impact on painters. Some fled painting, feeling that their efforts could not match the precision and speed of a photograph. Others more wisely saw that pictures could be a great aid in a painter's work, from hiring a model to capturing a landscape. Painters eventually learned that photography was a new art form that was not in competition with the long-standing tradition of painting.

Artists, like everyone else, were caught up in European and American revolutions. The fight for Greek independence was particularly galvanizing for European intellectuals. Political paintings became important, expressing the artist's solidarity with a social movement or a political position. **Delacroix** and **Goya** are among many who create memorable political compositions.

Even landscape painting had a political agenda. No longer content to paint scenes for their physical beauty or artistic arrangement, landscape painters needed to make a contemporary statement. Perhaps the paintings were expressions against the Industrial Revolution, or as in the case of **Cole**, an answer to criticism on how Americans had polluted their land.

Francisco de Goya, *And There's Nothing to Be Done (Y no hai remedio)*, from *The Disasters of War (Les Desastres de la Guerra)*, Plate 15, 1810–1823 (published 1863), etching, drypoint, burin, and burnishing, Metropolitan Museum of Art, New York (Figure 20.2)

Disasters of War
Context
- Original title: "Fatal Consequences of Spain's Bloody War with Bonaparte and Other Emphatic Caprices."
- Artwork was critical of the French occupation of Spain and the subsequent Spanish rulers.
- Influenced by Spain's continuous warfare.
- Eighty etchings and aquatints.
- Published in 1863, 35 years after the artist's death.
- Explores themes of war, famine, and politics.

Technique
- Goya used a combination of etching and drypoint.
- Etching gives the work fine details.
- Drypoint is added to the metal etched plate. The rough burr at the sides of the incised lines yield a velvety black tone in the print.
- The effect is a very rich black and white surface.

And There's Nothing to Be Done
- Bitterly ironic and sardonic.
- Guns at very close-range point toward the victims, assumedly Spanish patriots, who will be summarily killed by French soldiers.

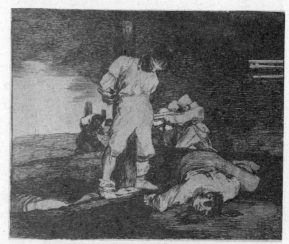

Figure 20.2: Francisco de Goya, *And There's Nothing to Be Done (Y no hai remedio)*, from *The Disasters of War (Les Desastres de la Guerra)*, Plate 15, 1810–1823 (published 1863), etching, drypoint, burin, and burnishing, Metropolitan Museum of Art, New York

- The mangled body on the ground accentuates the sense of despair.
- Are civilians or soldiers being shot? Ambiguity intentional.
- Central figure is seen in a Christ-like pose.
- Compositional elements reference Goya's painting called *The Third of May 1808*.

Content Area Later Europe and Americas, Image 106

Web Source *http://metmuseum.org/toah/works-of-art/32.62.17/*

- **Cross-Cultural Comparisons for Essay Question 1: War and Remembrance**
 - Lin, Vietnam Veterans Memorial (Figures 29.4a and 29.4b)
 - *Bayeux Tapestry* (Figures 11.7a and 11.7b)
 - *Alexander Mosaic* (Figure 4.20)

Jean-Auguste-Dominique Ingres, *La Grande Odalisque*, 1814, oil on canvas, Louvre, Paris (Figure 20.3)

Form

- Inconsistent arrangement of limbs: rubbery arm, elongated back, odd placement of leg, one arm longer than other.
- Mannerist-like elegant distrortions.
- Raphael-like face.
- Not a traditional frontal nude (cf. Titian, Figure 16.4).

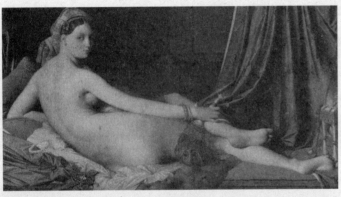

Figure 20.3: Jean-Auguste-Dominique Ingres, *La Grande Odalisque*, 1814, oil on canvas, Louvre, Paris

Patronage and Reception

- Commissioned by Caroline Murat, Napoleon's sister, Queen of Naples.
- Exhibited at the Salon of 1819; the critics did not understand Ingres's style; he was criticized for his disregard for anatomical reality, a trait that set him apart from his teacher, Jacques-Louis David.

Context

- Turkish elements: incense burner, peacock fan, tapestry-like turban, hashish pipe; expresses an exoticism; Orientalism was a form of exoticism.
- Heavily influenced by Italian Mannerism in the figure style (cf. Pontormo, Figure 16.5); perhaps the decorative motifs were influenced by Persian illuminated manuscripts (Figure 9.9).

Content Area Later Europe and Americas, Image 107

Web Source *http://www.louvre.fr/en/oeuvre-notices/une-odalisque*

- **Cross-Cultural Comparisons for Essay Question 1: Female Figure**
 - Tlatilco female figure (Figure 1.5)
 - Neshat, *Rebellious Silence* (Figure 29.14)
 - *Pwo* mask (Figure 27.8)

Eugène Delacroix, *Liberty Leading the People*, 1830, oil on canvas, Louvre, Paris (Figure 20.4)

Form

- Strong pyramidical structure.
- Red/white/blue (colors of the French flag) echo throughout the painting.

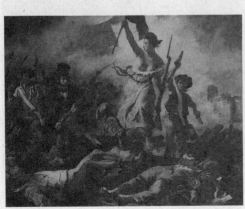

Figure 20.4: Eugène Delacroix, *Liberty Leading the People*, 1830, oil on canvas, Louvre, Paris

Content

- Liberty, with breast exposed and wearing no shoes, charges symbolically over the barricades.
- Liberty wears a red Phrygian cap, worn in the ancient world by freed slaves; portrayed as rebellious, vibrant, and fiery; she references the French Revolution of 1789.
- Notre Dame Cathedral is seen through the smoke on the far right; the French tricolor is raised on its tower.
- The Parisian landmark of Notre Dame is mixed in with the true historical event and the allegorical and symbolic figures.

Context

- The painting symbolically depicts the July Revolution of 1830; Liberty with the French tricolor in her hand marches over the barricades to overthrow government soldiers.
- The painting memorializes the overthrow of the French government of Charles X, the last Bourbon king of France, in favor of the "citizen king" Louis-Philippe.
- The child with pistols symbolizes the role of students in the revolt; the middle class is represented by a man with a top hat and carrying a rifle; the lower classes are symbolized by the man at extreme left with a sword in his hand and a pistol in his belt.

History

- Exhibited at the Salon of 1831 and then acquired by the French state; not exhibited publicly for twenty-five years because of its subversive message.

Content Area Later Europe and Americas, Image 108

Web Source http://www.louvre.fr/en/oeuvre-notices/july-28-liberty-leading-people

- **Cross-Cultural Comparisons for Essay Question 1: National Symbols**
 - King Menkaura and queen (Figure 3.7)
 - *Chairman Mao en Route to Anyuan* (Figure 24.7)
 - Golden Stool (Figure 27.4)

Joseph Mallord William Turner, *Slave Ship (Slavers Throwing Overboard the Dead and Dying, Typhoon Coming On)*, 1840, oil on canvas, Museum of Fine Arts, Boston (Figure 20.5)

Form

- Color expresses emotions.
- Rapid brushwork.
- Recognizable forms—the ship, the hands, the chains—are reduced in size and pale in comparison with the mightiness of the turbulent seascape.
- The bloody sunset acts as a symbol of the scene taking place.
- Use of the sublime enhances dramatic impact.

Context

- Exhibited at the Royal Academy in 1840, with an excerpt from Turner's own poem called "The Fallacies of Hope:"

> "Aloft all hands, strike the top-masts and belay;
> Yon angry setting sun and fierce-edged clouds
> Declare the Typhon's coming.
> Before it sweeps your decks, throw overboard
> The dead and dying—ne'er heed their chains
> Hope, Hope, fallacious Hope!
> Where is thy market now?"

Figure 20.5: Joseph Mallord William Turner, *Slave Ship (Slavers Throwing Overboard the Dead and Dying, Typhoon Coming On)*, 1840, oil on canvas, Museum of Fine Arts, Boston

- Based on a true story, an event in 1781 in which a slave ship, the *Zong*, sailed for the Americas full of slaves.
- The slaves were insured against accidental drowning, but not insured against sickness; a policy instituted to force captains to treat slaves humanely.
- Knowing that he would not collect insurance money on sick and dying slaves, the captain cast them overboard.
- Turner's painting was inspired by an account of the scandal published in a book by Thomas Clarkson, which had been reprinted in 1839.
- England freed the slaves in 1833 by an act of Parliament, however, there were exceptions, which were not addressed until 1843.
- Nature responds to the inhumanity of the slave trade.

Content Area Later Europe and Americas, Image 111

Web Source *http://www.mfa.org/collections/object/slave-ship-slavers-throwing-overboard-the-dead-and-dying-typhoon-coming-on-31102*

- **Cross-Cultural Comparisons for Essay Question 1: Artistic Renderings of Historical Events**
 - Walker, *Darkytown Rebellion* (Figure 29.21)
 - *Chairman Mao en Route to Anyuan* (Figure 24.7)
 - Lawrence, *Migration of the Negro, No. 49* (Figure 22.19)

Figure 20.6: Thomas Cole, *The Oxbow* (*The View from Mount Holyoke, Northampton, Massachusetts, after a Thunderstorm*), 1836, oil on canvas, Metropolitan Museum of Art, New York

Thomas Cole, *The Oxbow (The View from Mount Holyoke, Northampton, Massachusetts, after a Thunderstorm),* 1836, oil on canvas, Metropolitan Museum of Art, New York (Figure 20.6)

Form
- Actual view in Massachusetts.
- Landscape divided into two clearly contrasting areas: the Romantic landscape on the left and the Classical landscape on the right.
- On the right, man's touch is light: cultivated fields, boats drifting down the river.

Function
- Painted as reply to a British book that alleged that Americans had destroyed a wilderness with industry.
- Painted for an exhibit at the National Academy of Design; hence the unusually large size.

Context
- Illustrates the nineteenth-century American belief in Manifest Destiny.
- Cole is the founder of the Hudson River School.
- Cole's self-portrait can be seen in the foreground in a dense forest.
- The wild landscape includes broken trees and a storm: the sublime.
- Cole at the center of the composition, between the two worlds expressed in the painting; challenges Americans to be good stewards of the land.

Content Area Later Europe and Americas, Image 109

Web Source *http://metmuseum.org/toah/works-of-art/08.228/*

- **Cross-Cultural Comparisons for Essay Question 1: Nature**
 - Korin, *White and Red Plum Blossoms* (Figures 25.4a, 25.4b)
 - Su-nam, *Summer Trees* (Figure 29.6)
 - Ryoan-ji (Figures 25.2a, 25.2b, 25.2c)

THE DEVELOPMENT OF PHOTOGRAPHY

Experiments in photography go back to the seventeenth century, when artists used a device called a **camera obscura** (Figure 20.7) to focus images in a box so that artists could render accurate copies of the scene before them. Gradually, photosensitive paper was introduced that could replicate the silhouette of an object when exposed to light. These objects were called **photograms**, which yielded a primitive type of photography that captured outlines of objects and little else.

Figure 20.7: Camera obscura

Modern photography was invented in two different places at the same time: France and England. The French version, called the **daguerreotype** after its inventor Louis Daguerre, was a single image that is characterized by a sharp focus and great clarity of detail. Englishman William Talbot invented the **calotype**, which, though at first inferior in quality to the French version, was less costly to make and had an accompanying negative that could generate an unlimited number of copies from the original. Both men showed their inventions to scientific conventions in January 1839.

Photography spread quickly, and technological advances followed almost as fast. For example, shutter speeds were made faster so that sitters could pose for pictures without blurring, and the cameras themselves became increasingly portable and user-friendly. The advantages to photography were obvious to everyone: It went everywhere a person could go, capturing and illustrating everything from the exotic to the commonplace.

Louis-Jacques-Mande Daguerre, *Still Life in Studio,* **1837, daguerreotype, French Photographic Society, Paris (Figure 20.8)**

Form

- Photograph reproduces a variety of textures: fabric, wicker, plaster, framed print, etc.
- Inspired by painted still lifes, such as vanitas paintings.

Context

- New art form proclaimed while referencing older art forms.
- Daguerreotypes have a shiny surface and a sharp eye for detail.
- No negative; therefore, copies could not be made.
- Long exposure times required.
- Produced on a metallic surface; photos have a glossy finish.

Content Area Later Europe and Americas, Image 110

Web Source http://www.metmuseum.org/toah/hd/dagu/hd_dagu.htm

- **Cross-Cultural Comparisons for Essay Question 1: Still Lifes**
 - Ruysch, *Fruit and Insects* (Figure 17.11)
 - Matisse, *Goldfish* (Figure 22.1)

Figure 20.8: Louis-Jacques-Mande Daguerre, *Still Life in Studio,* 1837, daguerreotype, French Photographic Society, Paris

VOCABULARY

Calotype: a type of early photograph, developed by William H. F. Talbot that is characterized by its grainy quality. A calotype is considered the forefather of all photography because it produces both a positive and a negative image

Camera obscura: (Latin, meaning "dark room") a box with a lens which captures light and casts an image on the opposite side (Figure 20.7)

Caprice: usually a work of art that is an architectural fantasy; more broadly any work that has a fantasy element (Figure 20.2)

Daguerreotype: a type of early photograph, developed by Louis Daguerre that is characterized by a shiny surface, meticulous finish, and clarity of detail. Daguerreotypes are unique photographs; they have no negative (Figure 20.8)

Drypoint: an engraving technique in which a steel needle is used to incise lines in a metal plate. The rough burr at the sides of the incised lines yields a velvety black tone in the print (Figure 20.2)

Odalisque: a woman slave in a harem (Figure 20.3)

Photogram: an image made by placing objects on photosensitive paper and exposing them to light to produce a silhouette

School: a group of artists who share the same philosophy, work around the same time, but not necessarily together

The sublime: any cathartic experience from the catastrophic to the intellectual that causes the viewer to marvel in awe, wonder, and passion (Figure 20.5)

SUMMARY

A spirited cultural movement called Romanticism inspired artists to move beyond former boundaries and express themselves as individuals. Romantic artists introduce new subjects such as grand political canvases, the world of the unconscious, and the awesome grandeur of nature.

Romantics were influenced by the invention of photography, which was used by some artists as a tool for preserving such things as a model's pose or a mountain landscape. Photography's immediacy and realistic impact made it a sensation from its inception, causing the art form to spread quickly among all classes of people.

Early-nineteenth-century architects sought to revive former artistic styles and graft them onto modern buildings. It is common to see an office building, like the Houses of Parliament, wrapped in Gothic clothes. This yearning for the past is a reaction against the mechanization of the Industrial Revolution and a way of life that seemed to have permanently passed from the scene.

PRACTICE EXERCISES

Multiple-Choice

1. *La Grande Odalisque* by Jean-Auguste-Dominique Ingres from 1814 was inspired by

 (A) a deep use of spatial recession formulated in the High Renaissance
 (B) political controversy raging in Europe over the question of slavery
 (C) a figure style reminiscent of Italian Mannerism
 (D) a brushstroke used in the Rococo

2. *Liberty Leading the People* by Eugène Delacroix depicts in allegorical terms a moment from the

 (A) French Revolution of 1789
 (B) American Revolution of 1776
 (C) Parisian uprising of 1830
 (D) Franco-Prussian War of 1870

3. The *Slave Ship* by Joseph M. W. Turner is based on

 (A) the novels of Herman Melville
 (B) the sinking of the French frigate *The Medusa*
 (C) events related to the eighteenth-century ship called the *Zong*
 (D) the American Civil War and the passage of the Emancipation Proclamation

4. Thomas Cole's paintings have historical allusion to contemporary issues concerning

 (A) slavery in the American South
 (B) Manifest Destiny
 (C) the building of the railroads and their effect on American culture
 (D) the treatment of American Indians as anthropological specimens

5. Photography was practiced by marginalized communities, women and minorities, at its earliest stage of development because

 (A) the French salons gave their consent for minorities to practice what they considered an inferior artform
 (B) the price of the materials to produce photographs was carefully regulated by the governments of Europe
 (C) patrons insisted on female photographers because they were less threatening
 (D) as there were no academies or art studios for photography, there were no institutions that could ban minorities.

Long Essay

Practice Question 1: Comparison
Suggested Time: 15 minutes

This work is Joseph Turner's *The Slave Ship (Slavers Throwing Overboard the Dead and Dying, Typhoon Going On)*, 1840, oil on canvas.

This work, like many works of art, is intended to recreate a scene from the historical past to comment on the present.

Select and completely identify another work of art that represents the historical past. You may choose a work from the list or any other relevant work.

Identify the contemporary historical context for *both* works.

Describe the original historical context of *both* works.

Using visual elements, analyze the meaning of the historical event for a contemporary audience.

Using contextual elements, analyze the meaning of the historical event for a contemporary audience.

Discuss *at least one* difference in how *each* work communicates its message about the relationship between the historical event and a contemporary audience.

Olmec-style mask
Siege of Belgrade

ANSWER KEY

1. **C** 2. **C** 3. **C** 4. **B** 5. **D**

ANSWERS EXPLAINED

Multiple-Choice

1. **(C)** Elongated figures, often in complex poses, such as those seen in the works of Pontormo, generally influenced Ingres's approach to painting the human form.

2. **(C)** *Liberty Leading the People* depicts the Parisian uprising of 1830, which installed Louis-Philippe as "Citizen King" of France.

3. **(C)** *Slave Ship* depicts the journey of an actual ship, the *Zong*, which traveled to the New World laden with slaves. The slaves were insured against accidental drowning, but they weren't insured against sickness. Knowing that he would not collect insurance money on sick and dying slaves, the captain cast them overboard.

4. **(B)** The notion of Manifest Destiny, that it was in the United States' interests to expand across the North American continent, is expressed in many of Cole's works.

5. **(D)** Because photography is mechanical, it was looked down upon by the art establishment, which did not accept it as a true art form. As a result, minorities were able to practice it because there were no official salons or academies to keep them out.

Long Essay Rubric

Task	Point Value	For *The Slave Ship*, answers could include:
Select and completely identify another work of art that represents the historical past. You may choose a work from the list or any other relevant work.	—	—
Identify the contemporary historical context for *both* works.	1 point for *The Slave Ship*	Although slavery had been repealed throughout the British Empire, contemporary Englishmen were concerned about the abuses of a slavery system and its after effects.
Describe the original historical context of *both* works.	1 point for *The Slave Ship*	■ This work is based on an event in 1781 in which a slave ship, the *Zong*, sailed for the Americas full of slaves. ■ The slaves were insured against accidental drowning but not insured against sickness, a policy instituted to force the captain to treat slaves humanely. ■ Knowing that he could not collect insurance money on sick and dying slaves, the captain cast them overboard.
Using visual elements, analyze the meaning of the historical event for a contemporary audience.	1 point for *The Slave Ship*	■ Symbolism is found in the blood-red sky and the bloody waters. ■ Hands, chains, sharks, and legs appearing in the foreground signal death by drowning and from devouring fish. ■ These visual symbols represent the guilt that slavery has passed on to a generation of the British public. ■ The ship seems to be sinking under the weight of its guilt.
Using contextual elements, analyze the meaning of the historical event for a contemporary audience.	1 point for *The Slave Ship*	■ Turner's painting was inspired by an account of the scandal published in a book by Thomas Clarkson, which had been reprinted in 1839. ■ England abolished slavery in 1833 by an act of Parliament; however, there were exceptions, which were not addressed until 1843.
Discuss *at least one* difference in how *each* work communicates its message about the relationship between the historical event and a contemporary audience.	1 point shared with the other work	*The Slave Ship* is oil on canvas, exhibited at the Royal Academy in 1840, owned by an art critic John Ruskin. This work was for an audience of elites about a subject they would have been sympathetic toward.

Task	Point Value	For the Olmec-style mask, answers could include:	For the Siege of Belgrade, answers could include:
Select and completely identify another work of art that represents the historical past. You may choose a work from the list or any other relevant work.	1 point for the Olmec mask *or* the Siege of Belgrade	Jadeite, Art of the Americas (Two identifications are needed for a complete response.)	Circle of the González family, Screen with the Siege of Belgrade and a hunting scene, 1697–1701, tempera and resin on wood inlaid with mother-of-pearl. (Two identifications are needed for a complete response.)
Identify the contemporary historical context for *both* works.	1 point for the Olmec mask *or* the Siege of Belgrade	Aztec rulers saw the great ancient Olmec civilization as a precursor.	■ The Siege of Belgrade is a contemporary event of the Great Turkish War (1683–1699). ■ A Dutch print was used for inspiration. ■ The scene illustrates Hapsburg power.
Describe the original historical context of *both* works.	1 point for the Olmec mask *or* the Siege of Belgrade	The Olmec mask was found on the site of the Templo Mayor (Main Temple) in Tenochtitlán, Mexico City, Mexico.	The Siege of Belgrade was commissioned by José Sarmiento de Valladares, viceroy of New Spain, and was displayed in the Viceregal Palace in Mexico City; it was seen by members of the royal court and visiting dignitaries.
Using visual elements, analyze the meaning of the historical event for a contemporary audience.	1 point for the Olmec mask *or* the Siege of Belgrade	Aztecs would have admired the physical characteristics of these works: ■ Frowns ■ Pugnacious faces ■ Heavy-lidded eyes ■ Protective headgear ■ Curled lips	■ Scenes of warfare, military prowess, and advanced warfare techniques are on display. ■ The nobleness of the cause is illustrated in the vast sweep of the action.
Using contextual elements, analyze the meaning of the historical event for a contemporary audience.	1 point for the Olmec mask *or* the Siege of Belgrade	■ The Olmecs represented an ancient civilization whose glories reflected on their own empire. ■ The Aztecs collected works of ancient art; they saw themselves reflected in the "virtues" of other ancient civilizations. ■ When ancient works were not available, the Aztecs made copies of Olmec works.	■ The reach of Hapsburg power is worldwide. ■ The strength of Hapsburg's arms can subdue any enemy. ■ Battles in distant places can have an effect on contemporary politics half a world away.

Task	Point Value	For the Olmec-style mask, answers could include:	For the Siege of Belgrade, answers could include:
Discuss *at least one* difference in how *each* work communicates its message about the relationship between the historical event and a contemporary audience.	1 point shared with the other work	This work is a jadeite sculpture that would have evoked a historical past of great glory. The Aztecs saw themselves as a reflection of that glory. The audience would have been very sympathetic with the values expressed in this work.	This work is a functional object that would have been placed in a room to divide the spaces. It is made of richly imported materials, and therefore would show the wealth and worldliness of its owners. Like the other works, it was exhibited to a sympathetic audience who believed in these values.

Late-Ninteenth-Century Art

TIME PERIOD: 1848–1900

Movement	Dates
Realism	1848–1860s
Impressionism	1872–1880s
Post-Impressionism	1880s–1890s
Symbolism	1890s
Art Nouveau	1890s–1914

ENDURING UNDERSTANDING: The culture, beliefs, and physical settings of a region play an important role in the creation, subject matter, and siting of works of art.

Learning Objective: Discuss how the culture, beliefs, or physical setting can influence the making of a work of art. (For example: Sullivan, Carson, Pirie, Scott and Company Building)

Essential Knowledge:

- Europe and the Americas experience great innovation in economics, industrialization, war, and migration. There is a strong advancement in social issues.
- The avant-garde emerges as artists express themselves in various new movements.
- Marx and Darwin had philosophies that affected the world.

ENDURING UNDERSTANDING: Cultural interaction through war, trade, and travel can influence art and art making.

Learning Objective: Discuss how works of art are influenced by cultural interaction. (For example: Gauguin, *Where Do We Come From? Where Are We? Where Are We Going?*)

Essential Knowledge:

- Architecture is expressed in a series of revival styles.
- Artists are exposed to diverse, sometimes exotic, cultures as a result of colonial expansion.

ENDURING UNDERSTANDING: Art and art making can be influenced by a variety of concerns including audience, function, and patron.

Learning Objective: Discuss how art can be influenced by audience, function, and/or patron. (For example: Rodin, *The Burghers of Calais*)

Essential Knowledge:

- Commercial galleries become important. Museums open and display art. Art sells to an ever-widening market.

- Artists work for private and public institutions to a sometimes-critical public.
- The importance of academies diminishes, and many artists work without patronage.
- Women artists become increasingly important.

ENDURING UNDERSTANDING: Art making is influenced by available materials and processes.
Learning Objective: Discuss how material, processes, and techniques influence the making of a work of art. (For example: Sullivan, Carson, Pirie, Scott and Company Building)

Essential Knowledge:

- Architecture is affected by new materials and new modes of construction.
- Artists use new media including photography, lithography, and mass production.

ENDURING UNDERSTANDING: Art history is best understood through an evolving tradition of theories and interpretations.
Learning Objective: Discuss how works of art have had an evolving interpretation based on visual analysis and interdisciplinary evidence. (For example: Munch, *The Scream*)

Essential Knowledge:

- Audiences and patrons were often hostile to art made in this period. Art history as a science continues to be shaped by theories, interpretations, and analyses applied to these new art forms.

HISTORICAL BACKGROUND

The year 1848 was busy. Europe was shaken by revolutions in Sicily, Venice, Germany, Austria, and Lombardy—each challenging the old order and seeking to replace aristocracies with democracies. In France, Louis-Philippe, the great victor of the Revolution of 1830 and self-styled "Citizen King," faced internal pressure and deposed himself. He was soon replaced by Napoleon III, who led France down a path of belligerency culminating in the Franco-Prussian War of 1870. When the dust cleared, the Germans were masters of continental Europe, but by that time everyone had had enough of turmoil, and settled down for a generation of peace.

Social reformers were influenced by a concept called **positivism** promulgated by Auguste Comte (1798–1857). This theory allowed that all knowledge must come from proven ideas based on science or scientific theory. Comte said that only tested concepts can be accepted as truths. Key nineteenth-century thinkers like Charles Darwin (1809–1882) and Karl Marx (1818–1883) added to the spirit of positivism by exploring theories about human evolution and social equality. These efforts shook traditional thinking and created a clamor in intellectual circles. New inventions such as telephones, motion pictures, bicycles, and automobiles shrank the world by opening communication to a wider audience.

Artists understood these powerful changes by exchanging traditional beliefs for the "**avant-garde**," a word coined at this time. The academies, so carefully set up in the eighteenth century, were abandoned in the late nineteenth century. Artists used the past for inspiration, but rejected traditional subject matter. Gone are religious subjects, aristocratic portraits, history paintings, and scenes from the great myths of Greece and Rome. Instead the spirit of **modernism** prevailed, artists chose to represent peasant scenes, landscapes, and still lifes. Systematic and scientific archaeology began during this period as well, with excavations in Greece, Turkey, and Egypt.

Patronage and Artistic Life

Even though most artists wanted to exhibit at the Salon of Paris, many found the conservative nature of the jury to be stifling, and began to look elsewhere for recognition. Artists whose

works were rejected by the Salon, such as **Courbet** or **Manet**, set up oppositional showcases, achieving fame by being antiestablishment. The Impressionist exhibitions of the 1870s and 1880s fall into this category.

One of the greatest changes in the marketing of art came about with the emergence of the art gallery. Here was a more comfortable viewing experience than the Salon: No great crowds, no idly curious—just the art lover with a dealer in tastefully appointed surroundings. Galleries featured carefully selected works of art from a limited number of artists, and were not the artistic impluvia that the Salon had become.

Paul Cézanne cultivated the persona of the struggling and misunderstood artist. He fought the conventional aspirations of his family, escaped to a bohemian lifestyle, and worked for years without success or recognition. The more he suffered, and the cruder he grew, the more people were attracted to him and found his artwork intriguing. He was one of the first to exploit the stereotype of the artist as rebel. Other artists followed suit: Gauguin escaped to Tahiti, van Gogh to the south of France.

European artists were greatly influenced by an influx of Japanese art, particularly their highly sophisticated prints of genre scenes or landscapes. These broke European conventional methods of representation, but were still sophisticated and elegant. Japanese art relies on a different sense of depth, enhancing a flatness that dominates the background. Subjects appear at odd angles or on a tilt. This interest in all things Japanese was called **Japonisme**.

Painters felt that the artificial atmosphere of the studio inhibited artistic expression. In a movement that characterizes Impressionism, called **plein-air**, artists moved their studio outdoors seeking to capture the effects of atmosphere and light on a given subject.

A new creative outlet for printmakers was the invention of **lithography** in 1798. Great Romantic artists such as Delacroix and Goya saw the medium's potential and made effective prints. By the late nineteenth century, those politically inclined, such as **Daumier**, used the lithography to critique society's ills. Others, like **Toulouse-Lautrec**, used the medium to mass-produce posters of the latest Parisian shows.

REALISM

Courbet's aphorism "Show me an angel, and I'll paint one" sums up the Realist philosophy. Inspired by the **positivism** movement, Realist painters believe in painting things that one could experience with the five senses, which often translated into painting the lower classes in their environment. Usually peasants are depicted with reverence, their daily lives touched with a basic honesty and sincerity thought to be missing among the middle and upper classes. They are shown at one with the earth and the landscape; brown and ochre are the dominant hues.

Gustave Courbet, *The Stone Breakers*, 1849, oil on canvas, formerly in Gemäldgalerie, Dresden, destroyed in 1945 (Figure 21.1)

Figure 21.1: Gustave Courbet, *The Stone Breakers*, 1849, oil on canvas, formerly in Gemäldgalerie, Dresden, destroyed in 1945

Content
- Peasants are breaking stones down to rubble to be used for paving.
- Poverty emphasized.
- The figures are born poor, will remain poor their whole lives.
- No idealization of peasant life or of the working poor.

Form
- Large massive figures dominate the composition; a style usually reserved for mythic figures in painting.
- Thick heavy paint application.

- Browns and ochres are dominant hues reflecting the drudgery of peasant life.
- Concentration on the main figures; little in the foreground or background to detract from them.

Function
- Submitted to the Salon of 1850–1851.
- Large size of painting usually reserved for grand historical paintings; this work elevates the commonplace into the realm of legend and history.

Context
- Reaction to labor unrest of 1848, which demanded better working conditions.
- Reflects a greater understanding of those who spend their entire lives in misery; cf. Dickens's novels.
- Courbet's words: "I stopped to consider two men breaking stones on the highway. It's rare to meet the most complete expression of poverty, so an idea of a picture came to me on the spot. I made an appointment with them at my studio for the next day.... On the one side is an old man, seventy.... On the other side is a young fellow...in his filthy tattered shirt. Alas, in labor such as this, one's life begins that way, and it ends the same way."

Content Area Later Europe and Americas, Image 113

Web Source http://19thcenturyart-facos.com/artwork/stone-breakers

- **Cross-Cultural Comparisons for Essay Question 1: Genre Scenes**
 - Vermeer, *Woman Holding a Balance* (Figure 17.10)
 - Bruegel, *Hunters in the Snow* (Figure 14.6)
 - Cassatt, *The Coiffure* (Figure 21.7)

Honoré Daumier, *Nadar Raising Photography to the Height of Art*, 1862, lithograph, Brooklyn Museum, Brooklyn, New York (Figure 21.2)

Content
- Nadar often took his balloon over Paris to photograph scenes from above.
- Daumier was a satiric artist who portrayed political and social events with a critical eye.

Function
- Originally appeared in a journal, *Le Boulevard*, as a mass-produced lithograph.

Context
- The print satirizes the claims that photography can be a "high art;" irony implied in title.

 - Nadar was famous for taking aerial photos of Paris beginning in 1858.
 - The work was executed after a court decision in 1862 that determined that photographs could be considered works of art; this is Daumier's commentary.
 - Presents Nadar as a silly photographer; in his excitement to get a daring shot he almost falls out of his balloon and loses his hat.
 - Photography used as a military tool: Nadar's balloon reused in the 1870 siege of Paris.
 - Every building has the word "Photographie" on it; foreshadows modern surveillance photographs, drones with cameras, Google Earth.

Content Area Later Europe and Americas, Image 114

Web Source http://bir.brandeis.edu/handle/10192/3674

- **Cross-Cultural Comparisons for Essay Question 1: Humor in Art**
 - Hogarth, *The Tête à Tête* (Figure 19.3)
 - Fragonard, *The Swing* (Figure 19.1)
 - Duchamp, *Fountain* (Figure 22.9)

Figure 21.2: Honoré Daumier, *Nadar Raising Photography to the Height of Art*, 1862, lithograph, Brooklyn Museum, Brooklyn, New York

Édouard Manet, *Olympia*, 1863, oil on canvas, Musée d'Orsay, Paris (Figure 21.3)

Form and Content

- Olympia's frank, direct, uncaring, and unnerving look startled viewers.
- The figure is cold and uninviting; no mystery, no joy.
- No idealization of the female nude.
- The maid delivers flowers from an admirer; a cat responds to our entry into the room.
- Simplified modeling; active brushwork.
- Stark contrast of colors.

Figure 21.3: Édouard Manet, *Olympia*, 1863, oil on canvas, Musée d'Orsay, Paris

Reception

- Exhibited at the Salon of 1865; created a scandal.

Context

- Olympia was a common prostitute name of the time.
- A mistress was common to upper-class Parisian men, often sympathetically portrayed in contemporary literature, but never so brazenly depicted as in this painting.
- The painting is inspired by Titian's *Venus of Urbino* (Figure 16.4) and seen as a modern commentary on the classical feminine nude.
- This painting is a reaction to academic art that was based on Renaissance and classical ideals.
- Images of prostitutes and black women are not new with this painting, but Manet creates a dialogue between the nude prostitute and the clothed black servant, named Laure, which brings up issues of sexuality, racism, and stereotypes.

Content Area Later Europe and Americas, Image 115

Web Source *http://www.musee-orsay.fr/en/collections/works-in-focus/search/commentaire_id/olympia-7087.html*

- **Cross-Cultural Comparisons for Essay Question 1: Female Form**
 - Ingres, *La Grande Odalisque* (Figure 20.3)
 - Titian, *Venus of Urbino* (Figure 16.4)
 - de Kooning, *Woman, I* (Figure 22.21)

Jose María Velasco, *The Valley of Mexico from the Hillside of Santa Isabel* (*El Valle de México desde el Cerro de Santa Isabel*), 1882, oil on canvas, National Art Museum, Mexico City (Figure 21.4)

Form

- Dramatic perspective; small human figures.
- The painting depicts Tepeyac and offers a sweeping view of the Valley of Mexico, the basilica of the Lady of Guadalupe, as well as Mexico City and two volcanoes in the distance.
- The work glorifies the Mexican countryside as well as emerging industrialism with the depiction of the train.
- The artist as a keen observer of nature: rocks, foliage, clouds, waterfalls.

Figure 21.4: Jose María Velasco, *The Valley of Mexico from the Hillside of Santa Isabel* (*El Valle de México desde el Cerro de Santa Isabel*), 1882, oil on canvas, National Art Museum, Mexico City

Context

- The artist was primarily an academic landscape painter.
- Velasco specialized in broad panoramas of the Valley of Mexico.
- He rejected the realist landscapes of Courbet; he preferred the romantic landscapes of Turner.
- The artist settled in Villa Guadalupe with an overview of the Valley of Mexico.

Content Area Later Europe and Americas, Image 118

Web Source *https://www.wikiart.org/en/jose-maria-velasco*

- **Cross-Cultural Comparisons for Essay Question 1: Landscape and Nature**
 - Cole, *The Oxbow* (Figure 20.6)
 - Korin, *White and Red Plum Blossoms* (Figures 25.4a, 25.4b)
 - Su-nam, *Summer Trees* (Figure 29.6)

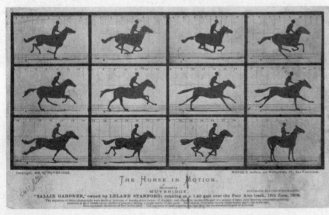

Figure 21.5: Eadweard Muybridge, *The Horse in Motion*, 1878, albumen print

Eadweard Muybridge, *The Horse in Motion*, 1878, albumen print (Figure 21.5)

Patronage

- Hired by Leland Stanford (the founder of Stanford University) to settle a bet to see if a horse's four hooves could be off the ground at the same time during a natural gallop.

Technique

- The photographer used a device called a zoopraxiscope to settle the bet.
- Cameras snap photos at evenly spaced points along a track, giving the effect of things happening in sequence.
- For the time, it was very fast shutter speeds, nearly 1/2000th of a second.
- Photography now advanced enough that it can capture moments the human eye cannot.
- These motion studies bridge the gap between still photography and motion pictures.

Content

- One photograph with sixteen separate images of a horse galloping.
- Images could be played in sequence to simulate motion pictures.

Content Area Later Europe and Americas, Image 117

Web Source *https://sites.utexas.edu/ransomcentermagazine/2013/05/22/eadweard-muybridge/*

- **Cross-Cultural Comparisons for Essay Question 1: Multiple Images**
 - Terra cotta warriors (Figures 24.8a, 24.8b)
 - Warhol, *Marilyn Diptych* (Figure 22.23)
 - Christo and Jeanne-Claude, *The Gates* (Figures 29.3a, 29.3b)

IMPRESSIONISM

Impressionism is a true modernist movement symbolized by the **avant-garde** artists who spearheaded it. Relying on the transient, the quick and the fleeting, Impressionist brushstrokes seek to capture the dappling effects of light across a given surface. The knowledge that shadows contain color, that times of day and seasons of the year affect the appearance of objects—these are the basic tenets of Impressionism. Often working in **plein-air**, Impressionists use a spectacular color range, varying from subtle harmonies to stark contrasts of brilliant hues.

Impressionists concentrate on landscape and still-life painting, imbuing them with an urban viewpoint, even when depicting a country scene. Some make the human figure in movement a specialty, others, like **Monet**, eventually abandon figure painting altogether.

The influence of Japanese art cannot be underestimated. Artists like **Cassatt** were struck by the freedom that Japanese artists used to show figures from the back, or solid blocks of color without gradations of hues. Others signed their names in a Japanese anagram and imitated the flatness and off-center compositional qualities Japanese prints typically have.

Impressionism originally prided itself on being both antiacademic and antibourgeois; ironically, today it is the hallmark of bourgeois taste.

Claude Monet, *The Saint-Lazare Station*, 1877, oil on canvas, Musée d'Orsay, Paris (Figure 21.6)

Figure 21.6: Claude Monet, *The Saint-Lazare Station*, 1877, oil on canvas, Musée d'Orsay, Paris

Form

- Effects of steam, light, and color; not really about the machines or travelers.
- Subtle gradations of light on the surface.
- Forms dissolve and dematerialize; color overwhelms the forms.
- Figures are painted in a sketchy way with brief brushstrokes.

Content

- The painting depicts the interior of a train station in Paris; a modern marvel of engineering.
- Trains were propelled by steam; accent on the energy of the steam rather than the train that produces it.

History

- Exhibited at the Impressionist exhibition of 1877.

Context

- One of a series depicting this train station.
- Monet is famous for painting a series of paintings on the same subject at different times of day and days of the year.
- Originally meant to be hung together for effect: *Haystacks* were his first group to hang this way.
- Shows modern life in Paris with great industrial iron output.
- New view of a modern city that reflects Haussmann's redesign of Paris.

Content Area Later Europe and Americas, Image 116

Web Source http://www.musee-orsay.fr/en/collections/works-in-focus/search/commentaire_id/la-gare-saint-lazare-7080.html

- **Cross-Cultural Comparisons for Essay Question 1: Oil Painting**
 - Pontormo, *Entombment of Christ* (Figure 16.5)
 - Caravaggio, *Calling of Saint Matthew* (Figure 17.5)
 - de Kooning, *Woman, I* (Figure 22.21)

Mary Cassatt, *The Coiffure*, 1890–1891, drypoint and aquatint, Metropolitan Museum of Art, New York (Figure 21.7)

Form

- No posing or acting; the figures possess a natural charm.
- Cassatt's work possesses a tenderness foreign to other Impressionists.

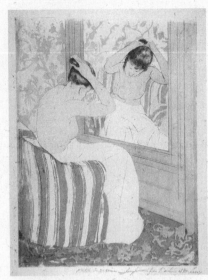

Figure 21.7: Mary Cassatt, *The Coiffure*, 1890–1891, drypoint and aquatint, Metropolitan Museum of Art, New York

- The figures are from everyday life.
- Pastel color scheme.
- The work contains contrasting sensuous curves of the female figure with straight lines of the furniture and wall.
- Japanese influence:
 - Decorative charm.
 - Japanese hair style.
 - Japanese point of view: figure seen from the back.
 - Graceful lines of the neck.

Function

- Part of a series of ten prints exhibited together at a Paris gallery in 1891.

Technique

- Drypoint and aquatint.
- Drypoint yields soft dense lines.
- Aquatint is generally used with engravings like drypoint; it also yields flat colored areas on a print.

Context

- Cassatt's world is filled with women; women as independent and not needing men to complete themselves; women who enjoy the company of other women.
- The mother and child theme is a specialty of Cassatt.
- She is among the first Impressionist artists seen in the United States of America.
- She acted as an advisor to wealthy American collectors as to what Impressionist works to buy.

Content Area Later Europe and Americas, Image 121

Web Source *https://www.metmuseum.org/art/collection/search/371957*

- **Cross-Cultural Comparisons for Essay Question 1: Domestic Scenes**
 - Vermeer, *Woman Holding a Balance* (Figure 17.10)
 - Velázquez, *Las Meninas* (Figure 17.7)
 - Grave stele of Hegeso (Figure 4.7)

POST-IMPRESSIONISM

While the Impressionists stressed light, shading, and color, the Post-Impressionists—that is, those painters of the next generation—moved beyond these ideals to combine them with an analysis of the structure of a given subject. **Paul Cézanne**, the quintessential Post-Impressionist, said that he wished to "make Impressionism something solid and durable, like the art of the museums." It is common for Post-Impressionists to move toward abstraction in their work, and yet seemingly paradoxically retaining solid forms, exploring underlying structure, and preserving traditional elements such as perspective.

Vincent van Gogh, *Starry Night*, 1889, oil on canvas, Museum of Modern Art, New York (Figure 21.8)

Form

- Thick, short brushstrokes.
- Heavy application of paint called impasto.
- Parts of the canvas can be seen through the brushwork; artist need not fill in every part of the surface.

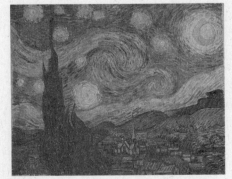

Figure 21.8: Vincent van Gogh, *Starry Night*, 1889, oil on canvas, Museum of Modern Art, New York

- Strong left-to-right wave-like impulse in the work broken only by the tree and the church steeple.
- The tree looks like green flames reaching into a sky that is exploding with stars over a placid village.

Context

- The mountains in the distance are the ones that Van Gogh could see from his hospital room in Saint-Rémy; steepness exaggerated.
- Combination of images: Dutch church, crescent moon, Mediterranean cypress tree.
- Cypresses were often associated with cemeteries.
- Landscape painting was popular in the late nineteenth century as a reaction to the industrialization of cities.

Content Area Later Europe and Americas, Image 120

Web Source *https://www.moma.org/learn/moma_learning/vincent-van-gogh-the-starry-night-1889*

- **Cross-Cultural Comparisons for Essay Question 1: Landscape**
 - Kngwarreye, *Earth's Creation* (Figure 29.13)
 - Fan Kuan, *Travelers among Mountains and Streams* (Figure 24.5)
 - Cole, *The Oxbow* (Figure 20.6)

Paul Gauguin, *Where Do We Come From? What Are We? Where Are We Going?*, 1897–1898, oil on canvas, Museum of Fine Arts, Boston (Figure 21.9)

Content

- The story of life, read right to left.
- Right: birth, infant, and three adults—the beginning of life.
- Center: mid life; picking of the fruit of the world.
- Left: death (a figure derived from a Peruvian mummy exhibited in Paris, cf. *The Scream* Figure 21.11); the old woman seems resigned.
- The blue idol with arms half-raised represents "The Beyond."
- The figures in foreground represent Tahiti and an Eden-like paradise; background figures are anguished, darkened figures.

Context

- Title of the painting poses more questions than it answers.
- Gauguin thought the painting was a summation of his artistic and personal expression.

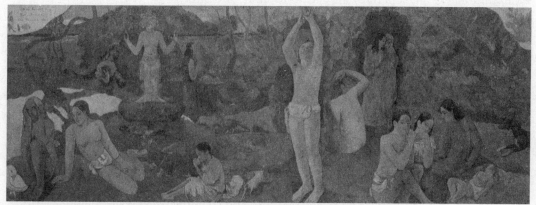

Figure 21.9: Paul Gauguin, *Where Do We Come From? What Are We? Where Are We Going?*, 1897–1898, oil on canvas, Museum of Fine Arts, Boston

- Painted during his second stay in Tahiti between 1895–1901.
- Gauguin suffered from poor health and poverty, obsessed by thoughts of death.
- He learned of the death of his daughter, Aline, in April 1897 and was deeply shaken; he was determined to commit suicide and have this painting be his artistic last will and testament.

Influences
- Many nontraditional influences:
 - Egyptian figures used for inspiration.
 - Japanese prints in the solid fields of color and unusual angles.
 - Tahitian imagery in the Polynesian idol.
- A rejection of Greco-Roman influence.

Content Area Later Europe and Americas, Image 123

Web Source *http://www.mfa.org/collections/object/where-do-we-come-from-what-are-we-where-are-we-going-32558*

- **Cross-Cultural Comparisons for Essay Question 1: European Encounters with the World**
 - Frontispiece of the Codex Mendoza (Figure 18.1)
 - Bandolier bag (Figure 26.11)
 - Rodriguez, *Spaniard and Indian Produce a Mestizo* (Figure 18.5)

Figure 21.10: Paul Cézanne, *Mont Saint-Victoire*, 1902–1904, oil on canvas, Philadelphia Museum of Art, Philadelphia

Paul Cézanne, *Mont Saint-Victoire* (Figure 21.10), 1902–1904, oil on canvas, Philadelphia Museum of Art, Philadelphia

Form
- Used perspective through juxtaposing forward warm colors with receding cool colors.
- Cézanne had contempt for flat painting; wanted rounded and firm objects, but ones that were geometric constructions made from splashes of undiluted color.
- Not a momentary glimpse of atmosphere, as in the Impressionists, but a solid and firmly constructed mountain and foreground.
- The landscape is seen from an elevation.
- Cézanne's landscapes rarely contain humans.
- Three horizontal sections divide the painting, connected by a complex series of diagonals that bring your eye back.
- The viewer is invited to look at space, but not enter.
- Cézanne allows blank parts of the canvas to shine through.
- Broad brushstrokes dominate the painted surface.

Context
- One of 11 canvases of this view painted near his studio in Aix in the south of France; the series dominates Cézanne's mature period.
- Not the countryside of Impressionism; more interested in geometric forms rather than dappled effects of light.

Content Area Later Europe and Americas, Image 125

Web Source *http://www.philamuseum.org/collections/permanent/102997.html*

- **Cross-Cultural Comparisons for Essay Question 1: Interpretations of the Natural World**
 - Su-nam, *Summer Trees* (Figure 29.6)
 - Hokusai, *Under the Wave off Kanagawa,* also known as the Great Wave (Figure 25.5)
 - Silver and gold maize cobs, Inka (Figure 26.7)

SYMBOLISM

As a reaction against the literal world of Realism, Symbolist artists felt that the unseen forces of life, the things that are deeply felt rather than merely seen, were the guiding influences in painting. Symbolists embraced a mystical philosophy in which the dreams and inner experiences of an artist's life became the source of inspiration. Hence, Symbolists vary greatly in their painting styles from the very flat primitive quality of a work by Rousseau to the expressionistic swirls of **Munch's** art.

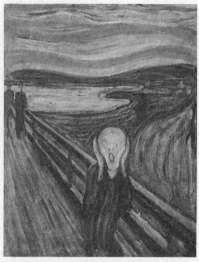

Figure 21.11: Edvard Munch, *The Scream*, 1893, tempera and pastels on cardboard, National Gallery, Oslo

Edvard Munch, *The Scream*, 1893, tempera and pastels on cardboard, National Gallery, Oslo (Figure 21.11)

Form and Content
- The figure walks along a wharf; boats are at sea in the distance.
- Long, thick brushstrokes swirl around the composition.
- The figure cries out in a horrifying scream; the landscape echoes his emotions.
- Discordant colors symbolize anguish.
- Emaciated, twisting stick figure with skull-like head.

Function
- Painted as part of a series called *The Frieze of Life;* a semi autobiographical succession of paintings.

Context
- Said to have been inspired by an exhibit of a Peruvian mummy in Paris.
- The work prefigures Expressionist art.
- The work is influenced by Art Nouveau swirling patterns.

Content Area Later Europe and Americas, Image 122

Web Source http://www.bbc.co.uk/programmes/b00rbmrx

- **Cross-Cultural Comparisons for Essay Question 1: Individual and Society**
 - *Chairman Mao en Route to Anyuan* (Figure 24.7)
 - Neshat, *Rebellious Silence* (Figure 29.14)
 - Salcedo, *Shibboleth* (Figure 29.26)

ART NOUVEAU

Art Nouveau developed in a few artistic centers in Europe—Brussels, Barcelona, Paris, and Vienna—and lasted from about 1890 to the outbreak of World War I in 1914. Art Nouveau seeks to eliminate the separation among various artistic media and combine them into one unified experience. Thus, an Art Nouveau building was designed, furnished, and decorated by the same artist or artistic team as an integrated whole.

Stylistically, Art Nouveau relies on vegetal and floral patterns, complexity of design, and undulating surfaces. Straight lines are avoided; the accent is on the curvilinear. Designers particularly enjoy using elaborately conceived wrought ironwork for balconies, fences, railings, and structural elements.

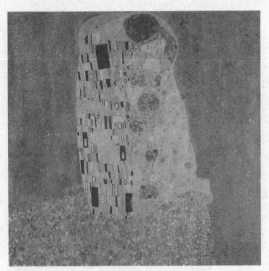

Figure 21.12: Gustav Klimt, *The Kiss*, 1907–1908, oil and gold leaf on canvas, Austrian Gallery, Vienna

Gustav Klimt, *The Kiss*, 1907–1908, oil and gold leaf on canvas, Austrian Gallery, Vienna (Figure 21.12)

Form

- Little of the human form is actually seen: two heads four hands, two feet.
- The bodies are suggested under a sea of richly designed patterning.
- The work is spaced in an indeterminate location against a flattened background.

Context

- The male figure is composed of large rectangular boxes; the female figure is composed of circular forms.
- The work suggests all-consuming love; passion; eroticism.
- The use of gold leaf is reminiscent of Byzantine mosaics (Figure 8.5).
- The work is influenced by gold applied to medieval illuminated manuscripts (Figure 12.9b).
- Part of a movement called the Vienna Succession, which broke away from academic training in schools at that time.

Content Area Later Europe and Americas, Image 128

Web Source *https://blog.artsper.com/en/a-closer-look/art-analysis-the-kiss-by-klimt/*

- **Cross-Cultural Comparisons for Essay Question 1: Couples**
 - Akhenaton, Nefertiti, and three daughters (Figure 3.10)
 - *Sarcophagus of the Spouses* (Figure 5.4)
 - Van Eyck, *Arnolfini Portrait* (Figure 14.2)

LATE-NINETEENTH-CENTURY ARCHITECTURE

The movement toward skeletal architecture increased in the late nineteenth century. Architects and engineers worked in the direction of a curtain wall, that is, a building that is held up by an interior framework, called a **skeleton**, the exterior wall being a mere curtain made of glass or steel that keeps out the weather.

The emphasis is on the vertical. Land values soar in modern cities, and architects respond by building up. Buildings emphasized their verticality by using tall pilasters and setting back windows behind them. Architects insisted their buildings were works of art, and covered them in traditional terra cotta or ironwork.

Figure 21.13: Chicago windows on Daniel Burnham's Reliance Building, 1890–1894, Chicago

During this period, the greatest advances in architecture were made by the Chicago School, formed shortly after the Great Fire burned much of the city to the ground in 1871. This disaster exposed not only the faults of building downtown structures out of wood, but also demonstrated the weaknesses of iron, which melts and bends under high temperatures. What survived quite nicely is building ceramic, especially when steel or iron is wrapped in terra cotta casings. This became the mainstay of Chicago buildings built in the late nineteenth century, such as **Carson, Pririe, Scott and Company** (Figure 21.14). These buildings demanded open and wide window spaces for light and air, as well as allowing passersby to admire window displays. Thus, the Chicago window was developed with a central immobile windowpane flanked by two smaller double-hung windows that opened for ventilation (Figure 21.13).

The single most important development in the history of early modern architecture is the invention of the elevator by Elisha Otis. This made buildings of indefinite height a reality.

Louis Sullivan, Carson, Pirie, Scott and Company Building, 1899–1903, iron, steel, glass, and terra cotta, Chicago (Figures 21.14a, 21.14b, and 21.14c)

Form
- Horizontal emphasis on the exterior mirrors the continuous flow of floor space on the interior.
- The exterior is covered in decorative terra cotta tiles; original interior ornamentation elaborately arranged around lobby areas, hallways, elevator; interior ornamentation now lost.
- The architect designed maximum window areas to admit light, but also to make displays visible from the street.
- Nonsupportive role of exterior walls; held up by an interior framework.
- Open ground plan allows for free movement of customers and goods.

Function
- A department store on a fashionable street in Chicago.

Context
- Some historical touches exist in the round entrance arches and the heavy cornice at the top of the building.
- Cast iron decorative elements transformed the store into a beautiful place to buy beautiful things.
- Shows the influence of Art Nouveau in decorative ironwork on the entrance.
- Sullivan motto: "Form follows function."

Content Area Later Europe and Americas, Image 124

Web Source *https://www.nps.gov/nr/travel/chicago/c9.htm*

- **Cross-Cultural Comparisons for Essay Question 1: City Planning**
 - Gehry, Guggenheim Museum Bilbao (Figures 29.1a, 29.1b)
 - Trajan Markets (Figure 6.10c)
 - Mies van der Rohe and Johnson, Seagram Building (Figure 22.18)

LATE-NINETEENTH-CENTURY SCULPTURE

Late-nineteenth-century sculpture, symbolized by **Rodin**, visibly represented the imprint of the artist's hand on a given work. Most works were hand molded first in clay, and then later cast in bronze or cut in marble, usually by a workshop. The sculptor then put finishing touches on a work he or she conceived, but never executed. The physical imprint of the hand is analogous to the visible brushstroke in Impressionist painting.

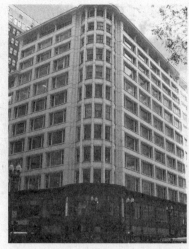

Figure 21.14a: Louis Sullivan, Carson, Pirie, Scott and Company Building, 1899–1903, iron, steel, glass, and terra cotta, Chicago

Figure 21.14b: Louis Sullivan, Carson, Pirie, Scott and Company Building, detail of main entrance

Figure 21.14c: Louis Sullivan, Carson, Pirie, Scott and Company Building, plan

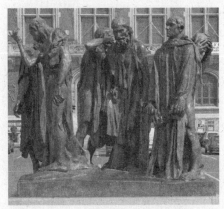

Figure 21.15: Auguste Rodin, *The Burghers of Calais*, 1884–1895, bronze, Calais, France

Auguste Rodin, *The Burghers of Calais*, 1884–1895, bronze, Calais, France (Figure 21.15)

Function and Reception

- Commissioned by the town of Calais in 1885 to commemorate six burghers who offered their lives to the English king in return for saving their besieged city during the Hundred Years' War in 1347.
- Town council of Calais said it was inglorious; they wanted a single allegorical figure.
- In 1895, more than 10 years after Rodin presented the first maquette, it was installed at the entrance of the Jardin du Front Sud, on a pedestal designed by the city architect Decroix, with an octagonal iron gate around it.
- Rodin resented this installation and wanted the work mounted on a very low, "but impressive," base on the Place d'Armes in the center of Calais.
- Meant to be placed on the ground so that people could see it close up.

Context

- Rodin's direct literary source is Jean Froissart (ca. 1333–1410) who described how King Edward of England demanded the six citizens to appear before him bareheaded, only dressed with a sackcloth, with a rope around their necks and the keys to the town in their hands. He wanted them to sacrifice their lives for their town.
- The English king was impressed by the self-sacrifice and allowed the citizens to live.
- Parallels between Paris besieged during the Franco-Prussian War of 1870 and Calais besieged by the English in 1347.

Form

- Figures sculpted individually and then arranged as the artist thought best.
- Rodin concentrates on the figures' misery, doubt, and internal conflict.
- Each has a different emotion: some fearful, or resigned, or forlorn.
- Figures suffer from privation; they are weak and emaciated.
- The men are placed on an equal level, symbolizing their uniform sacrifice.
- The central figure is Eustache de Saint-Pierre, who has large, swollen hands and a noose around his neck, ready for his execution.
- Details are reduced to emphasize an overall impression.

Content Area Later Europe and Americas, Image 119

Web Source *http://www.rodin-web.org/works/1884_burghers.htm*

- **Cross-Cultural Comparisons for Essay Question 1: Public Sculpture**
 - Christo and Jeanne-Claude, *The Gates* (Figures 29.3a, 29.3b)
 - Kneeling statue of Hatshepsut (Figure 3.9b)
 - Bamiyan Buddha (Figures 23.2a and 23.2b)

VOCABULARY

Aquatint: a kind of print that achieves a watercolor effect by using acids that dissolve onto a copper plate (Figure 21.7)

Avant-garde: an innovative group of artists who generally reject traditional approaches in favor of a more experimental technique

Caricature: a drawing that uses distortion or exaggeration of someone's physical features or apparel in order to make that person look foolish (Figure 21.2)

Drypoint: an engraving technique in which a steel needle is used to incise lines in a metal plate. The rough burr at the sides of the incised lines yields a velvety black tone in the print (Figure 21.7)

Japonisme: an attraction for Japanese art and artifacts that were imported into Europe in the late nineteenth century

Lithography: a printmaking technique that uses a flat stone surface as a base. The artist draws an image with a special crayon that attracts ink. Paper, which absorbs the ink, is applied to the surface and a print emerges

Modernism: a movement begun in the late nineteenth century in which artists embraced the current at the expense of the traditional in both subject matter and in media. Modernist artists often seek to question the very nature of art itself

Plein-air: painting in the outdoors to directly capture the effects of light and atmosphere on a given object (Figure 21.6)

Positivism: a theory that expresses that all knowledge must come from proven ideas based on science or scientific theory; a philosophy promoted by French philosopher Auguste Comte (1798–1857)

Skeleton: the supporting interior framework of a building

Zoopraxiscope: a device that projects sequences of photographs to give the illusion of movement (Figure 21.5)

SUMMARY

The late nineteenth century is known for a series of art movements, one following quickly upon another: Realism, Impressionism, Post-Impressionism, Symbolism, and Art Nouveau. Each movement expresses a different philosophy demonstrating the richness and diversity of artistic expression in this period.

Realism relied on the philosophy of positivism, which made paintings of mythological and religious scenes seem not only outdated but archaic. Many Impressionist artists painted outdoors, seeking to draw inspiration from nature. Post-Impressionists explored the underlying structural foundation of images, and laid the groundwork for much of modern art. Symbolists drew upon personal visions to create works resembling a dreamworld. Lastly, Art Nouveau was a stylish and creative art form that put emphasis on sinuous shapes and curvilinear forms.

The late nineteenth century saw a revival of sculpture under the command of Auguste Rodin, who molded works in clay giving them a very tactile quality.

The direction of late-nineteenth-century architecture was vertical. Architects responded to increased land values and advances in engineering by designing taller and thinner. For the first time in history, cities began to be defined by their skylines, which rose dramatically in downtown areas.

Multiple-Choice

1. Late-nineteenth-century avant-garde European painting had a fascination for

 (A) trains, canals, and other forms of modern transportation
 (B) Chinese jades and bronzes
 (C) imported African masks
 (D) historical and religious subjects done on commission

2. Painters achieved fame in the mid-nineteenth century by having their works

 (A) realize success at the Salons of Paris
 (B) photographed for posterity
 (C) enter royal collections
 (D) shipped to eager buyers in non-Western countries

3. Manet's *Olympia* horrified contemporary critics as well as the public because

 (A) the central figure was a prostitute, which was new in art history
 (B) the inclusion of a black woman was bold and experimental
 (C) it relied on the Renaissance view of formal composition, and that was deemed outdated
 (D) it depicted the main figure as shameless and defiant in her role

4. Eadweard Muybridge's experiments enabled him to

 (A) draw onto a negative to create special effects
 (B) freeze the action of a fast-moving object
 (C) introduce color for the first time in a world of black-and-white photography
 (D) make multiple copies from a single negative

5. Post-Impressionist artists differed from the Impressionists a generation earlier by rejecting the Impressionist use of

 (A) everyday people and situations in their work
 (B) paintings in a series
 (C) the transitory effect of changing atmospheric conditions
 (D) solid massing of forms

Short Essay

Practice Question 5: Attribution
Suggested Time: 15 minutes

Attribute this painting to the artist who painted it.

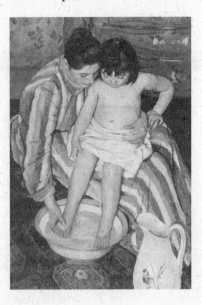

Using *at least two* specific details, justify your attribution by describing relevant similarities between this work and a work in the required course content.

Using *at least two* specific details, explain *why* these visual elements are characteristic of this artist.

ANSWERS EXPLAINED

Multiple-Choice

1. **(A)** Historical and religious paintings were out of fashion; trains, canals and other forms of transportation were in. The interest in African and Chinese art happens in the twentieth century.

2. **(A)** Without success at the Paris salon, an artist's career could not go anywhere.

3. **(D)** Both prostitutes and black women have appeared in art history before, so there was nothing shocking about this. This painting uses a Renaissance notion of composition in that it references Titian's *Venus of Urbino*. What is new is the representation of the prostitute in a bold and confrontational manner rather than as a secretive and demure individual.

4. **(B)** A zoopraxiscope freezes the motion of a fast-moving person, animal, or object, and presents images in a sequence.

5. **(C)** Post-Impressionists wanted to return to a solid form of representation; therefore, they rejected Impressionists' interest in the transitory and the fleeting.

Short Essay Rubric

Task	Point Value	Key Points in a Good Response
Attribute the painting to the artist who painted it.	1	Mary Cassatt
Using *at least two* specific details, justify your attribution by describing relevant similarities between this work and a work in the required course content.	2	The work in the required course content is Mary Cassatt, *The Coiffure*, 1890–1891, drypoint and aquatint. Two specific details could include: ■ Tenderness foreign to other Impressionists. ■ Pastel color scheme. ■ No posing or acting; figures possess a natural charm. ■ Unusual point of view.
Using *at least two* specific details, explain why these visual elements are characteristic of this artist.	2	Answers could include Mary Cassatt's interest in: ■ A world filled with women: women as independent and not needing men to complete their lives; women who enjoy the company of other women. ■ Japonisme: decorative charm; coiffure of the woman; point of view seen from the back or from above; simple decorative color patterns; Japanese-style furniture in the room.

Early- and Mid-Twentieth-Century Art

22

TIME PERIOD: 1900–1980

Movement	Dates	Major Artists
Fauvism	c. 1905	Matisse
Expressionism	1905–1930s	Kollwitz
▪ The Bridge	1905	Kirchner
▪ The Blue Rider	1911	Kandinsky
Cubism	1907–1930s	Picasso, Braque
Constructivism	1914–1920s	Stepanova
Dada	1916–1925	Duchamp
De Stijl	1917–1930s	Mondrian
Mexican Muralists	1920s–1930s	Rivera
International Style	1920s–1930s	Le Corbusier
Surrealism	1924–1930s	Kahlo, Oppenheim, Lam
Harlem Renaissance	1930s	Lawrence
Abstract Expressionism	Late 1940s–1950s	de Kooning
Pop Art	1955–1960s	Warhol, Oldenburg
Color Field Painting	1960s	Frankenthaler
Happenings	1960s	Kusama
Site Art	1970s–1990s	Lin, Smithson
Postmodern	1975–today	Venturi

ENDURING UNDERSTANDING: The culture, beliefs, and physical settings of a region play an important role in the creation, subject matter, and siting of works of art.

Learning Objective: Discuss how the culture, beliefs, or physical setting can influence the making of a work of art. (For example: Wright, Fallingwater)

Essential Knowledge:

- Europe and the Americas experience great innovations in economics, industrialization, war, and migration. There is a strong advancement in social issues.
- The avant-garde emerges as artists express themselves in various new movements.
- Freud and Einstein had philosophies that affected the world.

ENDURING UNDERSTANDING: Cultural interaction through war, trade, and travel can influence art and art making.

Learning Objective: Discuss how works of art are influenced by cultural interaction. (For example: Stieglitz, *The Steerage*)

Essential Knowledge:

- Artists are exposed to diverse, sometimes exotic, cultures as a result of colonial expansion.

ENDURING UNDERSTANDING: Art and art making can be influenced by a variety of concerns including audience, function, and patron.

Learning Objective: Discuss how art can be influenced by audience, function, and/or patron. (For example: Kusama, *Narcissus Garden*)

Essential Knowledge:

- Commercial galleries become important. Museums open and display art. Art sells to an ever-widening market.
- Artists work for private and public institutions to a sometimes-critical public.
- The importance of academies disappears, and many artists work without patronage.
- Women artists become increasingly important.

ENDURING UNDERSTANDING: Art making is influenced by available materials and processes.

Learning Objective: Discuss how material, processes, and techniques influence the making of a work of art. (For example: Smithson, *Spiral Jetty*)

Essential Knowledge:

- Architecture is affected by new materials and new modes of construction.
- Artists use new media including photography, lithography, and mass production. Artists also create new monumental works, such as earthworks, as well as ready-made objects.

ENDURING UNDERSTANDING: Art history is best understood through an evolving tradition of theories and interpretations.

Learning Objective: Discuss how works of art have had an evolving interpretation based on visual analysis and interdisciplinary evidence. (For example: Duchamp, *Fountain*)

Essential Knowledge:

- Audiences and patrons were often hostile to art made in this period. Art history as a science continues to be shaped by theories, interpretations, and analyses applied to new art forms.

HISTORICAL BACKGROUND

With the cataclysmic events of World War I and World War II, as well as the Great Depression, one would never suspect that the early twentieth century was an intensely creative period in the arts. But in nearly every artistic venue—literature, music, dance, and the fine arts—artistic expression flourished. Some movements fed on these very cataclysms for inspiration, others sought to escape the visceral world. For a complex set of reasons—including new technologies, new freedom to express race and gender identities, and the collapse of traditional patronage—the twentieth century proved to be one of the most creative periods in art history.

Patronage and Artistic Life

Early-twentieth-century art was sponsored by extremely cultivated and intellectual patrons who were members of the avant-garde. They saw art as a way to embrace the modern spirit in a cultured way. These influential patrons, like Gertrude Stein, promoted great artists through their sponsorship and connections.

New to the art world is the patronage of museums. It has become standard for a great museum to hire the finest architectural firms to handle expansion projects and turn the museum into a work of art in its own right. Museums also commission works of sculpture and painting from contemporary artists to be showcased in their public spaces.

Not all modern art, however, was greeted with enthusiasm. The **Armory Show** of 1913, which introduced modern art to American audiences, was generally reviled by American audiences. **Picasso's** *Les Demoiselles d'Avignon* (Figure 22.5) horrified the public. **Duchamp's** *Fountain* (Figure 22.9) even upset the promoters of the gallery who were supposed to allow anyone to be able to exhibit, provided he or she paid the six-dollar admission fee.

One of the results of World War II was the abandonment of Paris as the art capital of the world, a position it had retained since about 1650. New York, the financial and cultural capital of the United States, took over that position, in part because that is where so many fleeing Europeans settled, and in part because it had an active artistic community that was unafraid of experimentation. Mondrian, Duchamp, and Kandinsky moved to New York, not so much to continue their work, most of which was well behind them, but to galvanize modern American artists in what has been called The New York School. **De Kooning** and **Frankenthaler** settled here to do their most impressive works.

EARLY- AND MID-TWENTIETH-CENTURY ART

All of the characteristic painter's tools of expression were under question in the early twentieth century. Color was not only used to describe a setting or an artist's impression, but also to evoke a feeling and challenge the viewer. Perspective was generally discarded, or violently tilted for dramatic impact. Compositions were forcefully altered in a new and dynamic way.

Most radically, the introduction of pure form, **abstraction**, became the feature of modern art. Actually, abstract art has always existed, usually in marginal areas of works of art, sometimes in frames or as decorative designs. New is the placement of the abstract form directly in the center of the composition—a statement averring that abstraction has a meaning independent of realistically conveyed representations.

Artists moved beyond the traditional oil-on-canvas approach to great art, and were inspired by **photomontage** and **collage**, techniques formerly relegated to children's art. Such fervent experimentation led Europeans to draw inspiration from African cultures, hitherto ignored or labeled as primitive. Europeans were stimulated by African artists' ability to create works in geometric, even abstract, terms, unafraid of a lack of conventional reality. This freedom of expression inspired Europeans to rethink traditional representations, sometimes by writing their thoughts down in artistic manifestos, which served as a call to arms for their movement.

The Armory Show, named after the building in New York where it was held, was mounted in 1913 to introduce Americans to the current trends in European art. Many contemporary artists, such as Duchamp and Picasso, were showcased in America for the first time. The show also exhibited prominent American artists.

The adventurous spirit that epitomizes modern painting and architecture also characterizes modern sculpture. Artists used new materials, such as plastic, and new formats, such as

collages, to create dynamic compositions. Artists also dangled metal shapes from a ceiling and called them **mobiles**.

In the Dada movement, artists saw a found object and turn it into a work of art. These **ready-mades** became works of art simply because the artist said they were.

Fauvism

Fauvism is an art movement that debuted in 1905 at Salon d'Automne in Paris. It was so named because a critic, Louis Vauxcelles, thought that the paintings looked as if they were created by "Wild Beasts." Fauvism was inspired by Post-Impressionist painters like Gauguin and Van Gogh, whose work was exhibited in Paris around this time. Fauves stressed a painterly surface with broad flat areas of violently contrasting color. Figure modeling and color harmonies were suppressed so that expressive effects could be maximized. Fauvism all but died out by 1908.

Figure 22.1: Henri Matisse, *Goldfish*, 1912, oil on canvas, Pushkin Museum of Art, Moscow, Russia

Henri Matisse, *Goldfish*, 1912, oil on canvas, Pushkin Museum of Art, Moscow, Russia (Figure 22.1)

Form
- Strong contrasts of color.
- Thinly applied colors; the white of the canvas shows through.
- Energetic, painterly brushwork.
- Broad patches of color anticipate color-field painting later in the century.

Content
- Still-life painting.
- Compare to Ruysch, *Fruits and Insects* (Figure 17.11), and Daguerre, *Still Life in Studio* (Figure 20.8).

Context
- May have been in response to a trip in Morocco, where Matisse noted how the local population would daydream for hours, gazing into goldfish bowls. Form, color, and subject matter were inspired by this trip.
- Admired the relaxed and contemplative lifestyle of the Moroccans, which symbolized a meditative state of mind and a sense of paradise lost to Europeans.
- May have been influenced by the decorative quality of Asian art and diverse cultures from North Africa.

Content Area Later Europe and Americas, Image 131

Web Source http://www.henrimatisse.org/goldfish.jsp

- **Cross-Cultural Comparisons for Essay Question 1: Color**
 - Kngwarreye, *Earth's Creation* (Figure 29.13)
 - Dedication Page of Blanche of Castile and Louis IX (Figure 12.9b)
 - Mori, *Pure Land* (Figure 29.19)

Expressionism

Inspired by the Fauve movement in Paris, a group of German artists in Dresden gathered around **Kirchner** and formed Die Brüke, **The Bridge**, in 1905, so named because they saw themselves as a bridge from traditional to modern painting. They emphasized the same Fauve

ideals expressed in violent juxtapositions of color, which so purposely roused the ire of critics and the public.

A second Expressionist group, called **Der Blaue Reiter**, **The Blue Rider**, formed in Munich, Germany, in 1911. This group (so named because of an affection the founders had for horses and the color blue) began to forsake representational art and move toward abstraction. Highly intellectual, and filled with theories of artistic representation, artists like **Kandinsky** saw abstraction as a way of conceiving the natural world in terms that went beyond representation. Kandinsky's theories were best expressed in his influential essay, *Concerning the Spiritual in Art*, which outlined his theories on color and form for the modern movement.

Vassily Kandinsky, *Improvisation 28* **(second version), 1912, oil on canvas, Guggenheim Museum, New York (Figure 22.2)**

Figure 22.2: Vassily Kandinsky, *Improvisation 28* (second version), 1912, oil on canvas, Guggenheim Museum, New York

Form

- Strongly articulated use of black lines.
- Colors seem to shade around line forms.

Content

- Using schematic means, Kandinsky depicts cataclysmic events on the left (boat and waves—a deluge, a serpent, a cannon) and a sense of spiritual salvation on the right (a couple embrace, a candle, a church on a hill).

Context

- Kandinsky wanted the viewer to respond to a painting the way one would to an abstract musical composition: a concerto, a sonata, a symphony.
- The artist felt that sound and color were linked; for example, it was possible to hear color.
- He used words such as "composition" and "improvisation" in the titles of his works, words associated with musical composition.
- Kandinsky's works have a relationship to atonal music, which was evolving at this time.
- Movement toward abstraction; representational objects suggested rather than depicted.

Content Area Later Europe and Americas, Image 132

Web Source *https://www.guggenheim.org/artwork/1861*

- **Cross-Cultural Comparisons for Essay Question 1: Composition**
 - David, *The Oath of the Horatii* (Figure 19.6)
 - Ringgold, *Dancing at the Louvre* (Figure 29.11)
 - Giotto, *Lamentation* (Figure 13.1c)

Ernst Ludwig Kirchner, *Self-Portrait as a Soldier*, **1915, oil on canvas, Allen Memorial Art Museum, Oberlin College, Oberlin, Ohio (Figure 22.3)**

Figure 22.3: Ernst Ludwig Kirchner, *Self-Portrait as a Soldier*, 1915, oil on canvas, Allen Memorial Art Museum, Oberlin College, Oberlin, Ohio

Form

- Nightmarish quality.
- Colors are nonrepresentational but symbolic, chosen to provide a jarring impact.
- Expressive quality of horrified facial features and grim surroundings.
- Tilted perspective moves things closer to the picture plane.

- Main figure has a drawn face, with a cigarette hanging loosely from his lips.
- The eyes are unseeing and empty, without pupils; the iris reflects the blue of his uniform.
- The bloody stump of a hand represents losses in war, loss of the artist's ability to paint, his creativity, his artistic vision, and his inspiration.
- Sharp angular lines reinforce a sense of violence and anxiety.

Context
- Kirchner became an "unwilling volunteer," a driver in the artillery in World War I, to avoid being drafted into the infantry.
- He is wearing the uniform of his field artillery regiment.
- He was declared unfit for service; he had lung problems and weakness and suffered a mental breakdown—there is scholarly debate as to whether he faked these ailments to avoid service.
- This self-portrait was painted during a recuperation period.
- His life was plagued by drug abuse, alcoholism, and then paralysis.
- The artist feared that war would destroy his creative powers.

Content Area Later Europe and Americas, Image 133

Web Source http://www.oberlin.edu/amam/Kirchner_SelfPortrait.htm

- **Cross-Cultural Comparisons for Essay Question 1: Self-Portraits**
 - Rembrandt, *Self-Portrait with Saskia* (Figure 17.9)
 - Vigée Le Brun, *Self-Portrait* (Figure 19.2)
 - Kahlo, *The Two Fridas* (Figure 22.11)

Figure 22.4: Käthe Kollwitz, *Memorial Sheet for Karl Liebknecht*, 1919–1920, woodcut, Private Collection

Käthe Kollwitz, *Memorial Sheet for Karl Liebknecht*, 1919–1920, woodcut, Private Collection (Figure 22.4)

Form
- Stark black and white of the woodcut used to magnify the grief.
- Human grief dominates.

Patronage
- Family of Liebknecht asked Kollwitz to memorialize him.

Technique
- Wood-block print.
- Kollwitz used this technique to reinforce the emotions depicted in the scene.
- She liked the "primitive" quality that wood-block prints could render.

Context
- Liebknecht was among the founders of the Berlin Spartacus League, which became the German Communist Party.
- In 1919, Liebknecht was shot to death during a Communist uprising in Berlin called the Spartacus Revolt (named for the slave who led a revolt against the Romans in 73 B.C.E.).
- Liebknecht was held to be a martyr in the Communist cause.
- There are no political references in the woodcut.
- Themes of war and poverty dominate the artist's oeuvre.
- She often emphasized the theme of women grieving over dead children; her son died in World War I; the artist then became a socialist.
- References to the *Lamentation* (cf. Giotto, Figure 13.1c).

Content Area Later Europe and Americas, Image 134
Web Source *https://www.moma.org/collection/works/71889*

- **Cross-Cultural Comparisons for Essay Question 1: Memorials**
 - Taj Mahal (Figures 9.17a, 9.17b)
 - The Sphinx and the Pyramids (Figure 3.6a)
 - Giotto, *Lamentation* (Figure 13.1c)

Cubism

Cubism was born in the studio of **Pablo Picasso**, who in 1907 revealed the first Cubist painting, *Les Demoiselles d'Avignon* (Figure 22.5). Perhaps influenced by the simple geometries of African masks, then the rage in Paris, Picasso was inspired to break down the human form into angles and shapes, achieving a new way of looking at the human figure from many sides at once. This use of multiple views shows parts of a face, for example, from a number of angles. Cubism is dominated by wedges and facets that are sometimes shaded to simulate depth.

The first phase of Cubism, from 1907–1912, called **Analytical**, was highly experimental, showing jagged edges and sharp multifaceted lines. The second phase, after 1912, called **Synthetic Cubism**, was initially inspired by collages and found objects and featured flattened forms. The last phase, **Curvilinear Cubism**, in the 1930s, was a more flowing rounded response to the flattened and firm edges of Synthetic.

Pablo Picasso, *Les Demoiselles d'Avignon*, 1907, oil on canvas, Museum of Modern Art, New York (Figure 22.5)

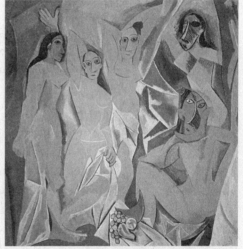

Figure 22.5: Pablo Picasso, *Les Demoiselles d'Avignon*, 1907, oil on canvas, Museum of Modern Art, New York

Content
- Depicts five prostitutes in a bordello in Avignon Street in Barcelona, each posing for a customer.
- Poses are not traditionally alluring but awkward, expressionless, and uninviting.

Form
- The three on the left are more conservatively painted; the two on right more radical; reflects a dichotomy in Picasso.
- Multiple views are expressed at the same time.
- Depth is limited, but ambiguous and ever shifting.
- The painting has semitransparent passages.

Context
- This is the first cubist work, influenced by late Cézanne and perhaps African masks (faces on the right) and ancient Iberian sculpture (figure on the left).
- Influenced by Gauguin's so-called Primitivism.

Content Area Later Europe and Americas, Image 126
Web Source *https://www.moma.org/collection/works/79766*

- **Cross-Cultural Comparisons for Essay Question 1: Group Compositions**
 - Velázquez, *Las Meninas* (Figure 17.7)
 - Basquiat, *Horn Players* (Figure 29.5)
 - Sultan Muhammad, *Court of the Gayumars* (Figure 9.9)

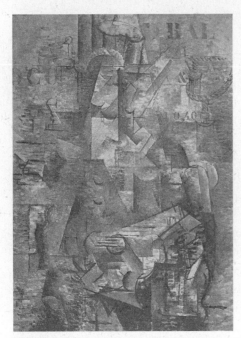

Figure 22.6: Georges Braque, *The Portuguese*, 1911, oil on canvas, Art Museum, Basel, Switzerland

Georges Braque, *The Portuguese*, 1911, oil on canvas, Art Museum, Basel, Switzerland (Figure 22.6)

Form
- Braque rejected naturalistic and conventional painting.
- Fractured forms; breaking down of objects into smaller forms.
- Clear-edged surfaces at the front of the picture plane, not recessed in space.
- Nearly monochrome.

Context
- Analytical Cubism; Braque worked in concert with Pablo Picasso to develop this style.
- This is not a portrait of a Portuguese musician, but rather an exploration of shapes.
- The only realistic elements are the stenciled letters and numbers; perhaps they suggest a dance hall poster behind the guitarist, a café-like atmosphere.

Content Area Later Europe and Americas, Image 130

Web Source https://www.artsy.net/artwork/georges-braque-the-portuguese

- **Cross-Cultural Comparisons for Essay Question 1: Image and Word**
 - Sultan Muhammad, *Court of the Gayumars* (Figure 9.9)
 - Bichitr, *Jahangir Preferring a Sufi Shaikh to Kings* (Figure 23.9)
 - Basquiat, *Horn Players* (Figure 29.5)

Constantin Brancusi, *The Kiss*, original 1907–1908, stone, Philadelphia Museum of Art, Philadelphia (Figure 22.7)

Form
- Symbolic, almost Cubist rendering of the male and female bodies.
- Simplified carving.
- Intertwined and enveloped figures.
- Interlocked forms; fused bodies.
- Two eyes become one, almost Cyclops-like.
- Rough surface contributes to a feeling of naturalism; this is an artistic break from the high-polish effect of past sculpture.

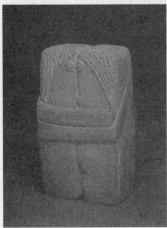

Figure 22.7: Constantin Brancusi, *The Kiss*, original 1907–1908, stone, Philadelphia Museum of Art, Philadelphia

Patronage
- Requested by John Quinn, Brancusi's patron in New York, who admired the small plaster version of *The Kiss* in the collection of the artist Walter Pach.

Context
- Brancusi worked in Rodin's studio; cf. Rodin's *The Kiss*.
- This is the fourth stone version of this subject:
 - First version was one of Brancusi's earliest efforts at stone carving (Craiova Art Museum, Romania).
 - Second version (a plaster cast) was exhibited at the Armory Show.
 - Third version used as a tombstone in Montparnasse Cemetery in Paris over the body of a suicide victim: a young Russian anarchist.
 - The artist was asked by a friend of the deceased, who had jilted her, for a marker for her grave.
 - The artist said take what you want; he took this work.
- There may be many more undocumented versions.

Photo-Secession

From 1902 through 1917 Alfred Stieglitz's gallery, called Gallery 291, was the most progressive gallery in the United States, showcasing photographs as works of art beside avant-garde European paintings and modern American works.

Alfred Stieglitz, *The Steerage,* **1907, photogravure, Private Collection (Figure 22.8)**

Form

- Interested in compositional possibilities of diagonals and lines acting as framing elements.
- Diagonals and framing effects of ladders, sails, steam pipes, etc.
- Stieglitz photographed the world as he saw it; he arranged little, and allowed people and events to make their own compositions.
- Influenced by experimental European painting; compared with a Cubist drawing by Picasso, Cubist-like in arrangement of shapes and tonal values.

Content

- Steerage: the part of a ship reserved for passengers with the cheapest tickets.
- Depicts the poorest passengers on a ship traveling from the United States to Europe in 1907; they were allowed out for air for a limited time.
- Some may have been people turned away from entrance to the United States; more likely, they were artisans whose visas had expired and were returning home.

Context

- The work depicts social divisions in society.
- Published in October 1911 in *Camera Work*.

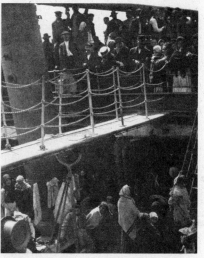

Figure 22.8: Alfred Stieglitz, *The Steerage*, 1907, photogravure, Private Collection

Dada

Dada, a nonsense word that literally means "hobby horse," is a term directed at a movement in Zurich, Cologne, Berlin, Paris, and New York from 1916 to 1925. Disillusioned by the useless slaughter of World War I, the Dadaists rejected conventional methods of representation and the conventional manner in which they were exhibited. Oil and canvas were abandoned. Instead, Dadaists accepted **ready-mades** as an art form, and often did their work on glass. Dadaists challenged the relationship between words and images, often incorporating words prominently in their works. The meaning of Dada works is frequently contingent on location or accident. If a glass should shatter, as a few did, it was hailed as an enhancement, acknowledging the hand of chance in this achievement. In sum, Dada accepts the dominance of the artistic concept over the execution.

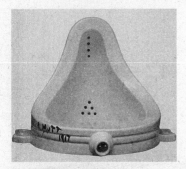

Figure 22.9: Marcel Duchamp, *Fountain*, original 1917, this version 1950, readymade glazed sanitary china with black paint, Philadelphia Museum of Art, Pennsylvania

Marcel Duchamp, *Fountain*, original 1917, this version 1950, readymade glazed sanitary china with black paint, Philadelphia Museum of Art, Pennsylvania (Figure 22.9)

Form

- Ready-made sculpture; actually a found object that Duchamp deemed to be a work of art.
- Signed by the "artist," R. Mutt, a pun on the Mutt and Jeff comic strip and Mott Iron Works.
- Item purchased from a sanitary-ware supplier and submitted to the Society of Independent Artists, a group that Duchamp helped to found.

Function and History

- Entered in an unjuried show, the work was refused—narrowly voted out by the organizers.
- Thought to be indecent, not fit to show women.
- Duchamp resigned in protest.
- It is not fully understood why Duchamp resigned; it may have come from his experience exhibiting an earlier work *Nude Descending a Staircase No. 2* to the Salon des Indépendants in Paris; although the work was illustrated in the show's catalog, Duchamp was asked to remove it a few days before the opening.
- He removed the object but felt betrayed; said it was a turning point in his life.
- *Fountain* can be seen as an experimental replay by Duchamp, testing the commitment of the new American Society to freedom of expression and tolerance of new conceptions about art.

Context

- The title is a pun: a fountain spouts liquid, a urinal collects it.
- The placing of the urinal upside down is an added irony.
- The rotation of *Fountain* may symbolize seeing something familiar from a new perspective.
- The original is now lost; Duchamp oversaw the "remaking" of a few models in 1964.

Content Area Later Europe and Americas, Image 144

Web Source *http://www.tate.org.uk/art/artworks/duchamp-fountain-t07573*

- **Cross-Cultural Comparisons for Essay Question 1: Recycling Objects into Art**
 - Camelid sacrum (Figure 1.1)
 - Tuffery, *Pisupo Lua Afe* (*Corned Beef 2000*) (Figure 29.16)
 - Quick-to-See-Smith, *Trade* (Figure 29.12)

Surrealism

Inspired by the psychological studies of Freud and Jung, Surrealists sought to represent an unseen world of dreams, subconscious thoughts, and unspoken communication. Starting with the theories of Andre Breton in 1924, the movement went in two directions: The abstract tradition of **biomorphic** and suggestive forms, and the veristic tradition of using reality-based subjects put together in unusual ways. Those who seek to understand the inscrutable world of Surrealism by looking at a painting's title will find themselves even more confused than when they started. Surrealism is meant to puzzle, challenge, and fascinate; its sources are in mysticism, psychology, and the symbolic. It is not meant to be clearly understood and didactic.

Meret Oppenheim, *Object (Le Dejéuner en fourrure),* **1936, fur-covered cup, saucer, and spoon, Museum of Modern Art, New York (Figure 22.10)**

Form

■ An assemblage.

Context

■ Said to have been done in response to Picasso's claim that anything looks good in fur; Oppenheim said to respond, "Even this cup and saucer?"

■ Erotic overtones.

■ Combination of unalike objects: fur-covered teacup, saucer, and spoon. The tea cup was purchased at a department store; the fur is the pelt of a Chinese gazelle.

Figure 22.10: Meret Oppenheim, *Object (Le Dejéuner en fourrure),* 1936, fur-covered cup, saucer, and spoon, Museum of Modern Art, New York

■ A contrast of textures: fur delights the touch, not the taste; cups and spoons are meant to be put in the mouth.

■ Oppenheim did not title the work, but the Surrealist critic, Andre Breton, called the piece *Le Déjeneur en fourrure,* or *Luncheon in Fur,* a title that references Édouard Manet's *Luncheon on the Grass (Le Déjeneur sur l'herbe)* as well as the erotic novel by Leopold von Sacher-Masoch called *Venus in Furs.*

■ Chosen by visitors to a Surrealist show in New York as the quintessential Surrealist work of art.

■ Because fame came to Oppenheim so young (she was twenty-two when she produced this work), it inhibited her growth as an artist.

Content Area Later Europe and Americas, Image 138

Web Source *https://www.moma.org/collection/works/80997?locale=en*

■ **Cross-Cultural Comparisons for Essay Question 1: Traditional Objects Reused**

– Weiwei, *Sunflower Seeds* (Figure 29.27)

– Ringgold, *Dancing at the Louvre* (Figure 29.11)

– Bing, *Book from the Sky* (Figure 29.8)

Frida Kahlo, *The Two Fridas,* **1939, oil on canvas, Museum of Modern Art, Mexico City (Figure 22.11)**

Content

■ On the left: Kahlo is dressed as a Spanish lady in white lace, linking her to a European heritage.

■ On the right: Kahlo dressed as a Mexican peasant—the stiffness and provincial quality of Mexican folk art was a direct inspiration for the artist.

■ Behind is a barren landscape; two figures sit against a wildly active sky.

Context

■ There is a juxtaposition to two self-portraits.

Figure 22.11: Frida Kahlo, *The Two Fridas,* 1939, oil on canvas, Museum of Modern Art, Mexico City

■ Kahlo's two hearts are joined together by veins that are cut by scissors at one end and lead to a portrait of her husband, artist Diego Rivera, at the other; painted at the time of their divorce.

■ The vein acts as an umbilical cord; symbolism: Rivera as both husband and son.

■ Blood on her lap suggests many abortions and miscarriages; also, surgeries related to her health issues.

■ Kahlo rejected the label Surrealism for her artwork.

Content Area Later Europe and Americas, Image 140
Web Source *http://www.pbs.org/weta/fridakahlo/worksofart/*

- **Cross-Cultural Comparisons for Essay Question 1: Self-Portraits**
 - Bichitr, *Jahangir Preferring a Sufi Shaikh to Kings* (Figure 23.9)
 - Rembrandt, *Self-Portrait with Saskia* (Figure 17.9)
 - Vigée Le Brun, *Self-Portrait* (Figure 19.2)

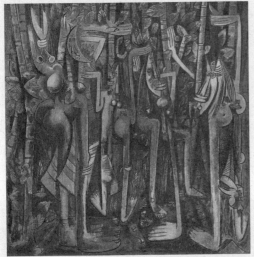

Figure 22.12: Wifredo Lam, *The Jungle*, 1943, gouache on paper mounted on canvas, The Museum of Modern Art, New York

Wifredo Lam, *The Jungle*, 1943, gouache on paper mounted on canvas, The Museum of Modern Art, New York (Figure 22.12)

Form

- Crescent-shaped faces suggest African masks and the god Elegua.
- Rounded backs, thin arms and legs, pronounced hands and feet.
- Long vertical lines suggest sugarcane, which is grown in fields, not jungles.

Context

- Cuban-born artist whose career took him to Europe and the United States.
- The artist was interested in Cuba's mixture of Hispanic and African cultures.
- This work was "intended to communicate a psychic state."
- The work addresses the history of slavery in colonial Cuba.
- Influences include African sculpture; Cubist works; Surrealist paintings (Lam was a member of the Surrealist movement in Paris).
- The painting contrasts a Cuban landscape with a tourist image of Cuba as a tropical paradise.

Content Area Later Europe and Americas, Image 142
Web Source *https://www.moma.org/collection/works/34666*

- **Cross-Cultural Comparisons for Essay Question 1: Art Inspired from Diverse Cultural Traditions**
 - Petra (Figures 6.9a, 6.9b)
 - Golden Haggadah (Figures 12.10a, 12.10b, 12.10c)
 - Kngwarreye, *Earth's Creation* (Figure 29.13)

Constructivism

Constructivists experimented with new architectural materials and assembled them in a way devoid of historical reference. Beginning in 1914, Stepanova and others saw the new Russia as an idealistic center removed from historical reference and decoration. Influenced by the Cubists, Constructivists designed buildings with no precise façades. Emphasis was placed on the dramatic use of the materials used to create the project. Constructivists were particularly influenced by the modern industrial complexes that dominated human employment in the early twentieth century.

Varvara Stepanova, Illustration from *The Results of the First Five-Year Plan*, 1932, photomontage, Museum of the Revolution, Moscow, Russia (Figure 22.13)

Form and Function

- Graphic art for political and propaganda purposes; a photomontage.
- Red color dominates—the color of Communist Soviet Union.

- A large portrait of Lenin dominates; although deceased, his image is used to stimulate patriotism.
- Masses of people below illustrate the popularity of the Five-Year Plan.
- CCCP (Союз Советских Социалистических Республи) is a Russian abbreviation for the Soviet Union.

Context
- Stepanova was one of the main figures in the Russian avant-garde movement.
- Influenced by Cubism and Futurism.
- Five-Year Plan:
 - Soviet practice of increasing agricultural and industrial output in five years.
 - Launched in 1928, considered complete in 1932.
 - Emphasis on growth of heavy industry rather than consumer goods.
 - Huge increases in electrical output (dominant industrial symbol in the work).
 - The failures of the five-year plan are overlooked in this representation (famine, extreme poverty, political oppression); instead it is a propaganda statement of the virtues of the Stalinist state.

Content Area Later Europe and Americas, Image 137

Web Source http://www.tate.org.uk/learn/online-resources/glossary/c/constructivism

- **Cross-Cultural Comparisons for Essay Question 1: Social Commentary**
 - Delacroix, *Liberty Leading the People* (Figure 20.4)
 - Neshat, *Rebellious Silence* (Figure 29.14)
 - Walker, *Darkytown Rebellion* (Figure 29.21)

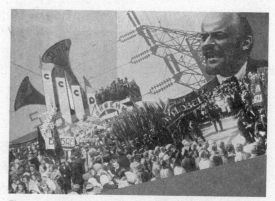

Figure 22.13: Varvara Stepanova, Illustration from *The Results of the First Five-Year Plan*, 1932, photomontage, Museum of the Revolution, Moscow, Russia

De Stijl

De Stijl, a movement symbolized by the Dutch painter **Mondrian**, reached its height between 1917 and the 1930s. At its purest, De Stijl paintings are completely abstract; even the titles make no reference to nature. They are painted on a white background and use black lines to shape the rectangular spaces. Only the three primary colors are used: red, yellow, and blue, and they are painted without modulation. Lines can only be placed perpendicularly—diagonals are forbidden. Mondrian called this artistic style **neoplasticism**.

Piet Mondrian, *Composition with Red, Blue and Yellow*, 1930, oil on canvas, Kunsthaus, Zurich (Figure 22.14)

Form
- Only primary colors used—red, yellow, and blue—plus the neutral colors, white and black.
- Severe geometry of form; only right angles; grid-like forms.
- No shading of colors.

Context
- The artist is interested in the material properties of paint, not naturalistic depictions.
- The artist expresses ideas using abstract elements—that is, line and color.
- Influenced by Cubism.

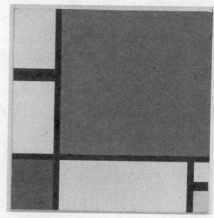

Figure 22.14: Piet Mondrian, *Composition with Red, Blue and Yellow*, 1930, oil on canvas, Kunsthaus, Zurich

Content Area Later Europe and Americas, Image 136

Web Source *http://www.tate.org.uk/learn/online-resources/glossary/d/de-stijl*

- **Cross-Cultural Comparisons for Essay Question 1: Composition**
 - Su-nam, *Summer Trees* (Figure 29.6)
 - Navigation chart (Figure 28.3)
 - Martínez, Black-on-black ceramic vessel (Figure 26.14)

EARLY- AND MID-TWENTIETH-CENTURY ARCHITECTURE

Early-twentieth-century architecture is marked by a complete embrace of technological advances. **Ferroconcrete** construction, particularly in Europe, allowed for new designs employing skeleton frameworks and glass walls. The **cantilever** (Figure 22.15) helped push building elements beyond the solid structure of the skeletal framework.

In general, architects avoided historical associations: There are few columns and fewer flying buttresses. Architects prefer clean sleek lines that stress the building's underlying structure and emphasize the impact of the machine and technology.

Figure 22.15: Cantilever

The Prairie Style

The Prairie School of architecture concerns a group of architects working in Chicago from 1900 to 1917, of which **Frank Lloyd Wright** is the most famous. They rejected the idea that buildings should be done in historic styles of architecture; however, they insisted that they should be in harmony with their site. Wright employed complex irregular plans and forms that seemed to reflect the abstract shapes of contemporary painting: Rectangles, triangles, squares, and circles. Stylized botanical shapes were particularly prized. Wright used **cantilever** construction to have porches and terraces extend out from the main section of a structure (Figure 22.15). Cantilevers give the impression of forms hovering over open space, held up by seemingly weightless anchors.

The organic qualities of the materials—concrete with pebble aggregate, sand-finished stucco, rough-hewn lumber, and natural woods—were believed to be the most beautiful. The horizontal nature of the prairie is stressed in the alignment of these houses. Although **Fallingwater** was designed well after the Prairie School peaked, it still reflects many of the same characteristics.

Frank Lloyd Wright, Fallingwater, 1936–1939, reinforced concrete, sandstone, steel, and glass, Bear Run, Pennsylvania (Figures 22.16a, 22.16b, and 22.16c)

Form

- Cantilevered steel-supported porches extend over a waterfall.
- The accent is on horizontal lines—as opposed to the verticality of much of twentieth-century architecture.
- The architecture is in harmony with the site.

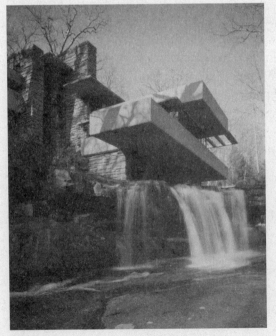

Figure 22.16a: Frank Lloyd Wright, Fallingwater, 1936–1939, Bear Run, Pennsylvania

Figure 22.16b: Frank Lloyd Wright, Fallingwater, living room

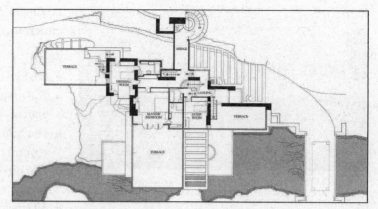

Figure 22.16c: Frank Lloyd Wright, Fallingwater, site plan

- The living room contains a glass curtain wall around three of the four sides; the building embraces the woods around it.
- The floor of the living room and the walls of building are made from the stone of the area.
- The hearth (physically and symbolically) is the center of the house, an outcropping of natural stones surrounds it.
- The interior shows a suppression of space devoted to hanging a painting; Wright wanted the architecture to dominate.
- The ground plan and design is irregular and complex.
- Only two colors used: light ochre for the concrete and Cherokee red for the steel.

Context
- Late expression of Prairie School ideas.

Function and Patronage
- Weekend retreat for the Kaufmann family, who owned a department store in Pittsburgh, Pennsylvania.

Content Area Later Europe and Americas, Image 139

Web Source *http://www.fallingwater.org/*

- **Cross-Cultural Comparisons for Essay Question 1: Homes**
 - Jefferson, Monticello (Figures 19.5a, 19.5b)
 - Ryoan-ji (Figures 25.2a, 25.2b, 25.2c)
 - House of the Vettii (Figures 6.7a, 6.7b)

The International Style

Le Corbusier's dictum that a house should be a "machine for living" sums up the International Style from the 1920s to the 1950s. Greatly influenced by the streamlined qualities of the Bauhaus, the International Style celebrates the clean spacious white lines of a building's façade. The internal structure is a skeleton system which holds the building up from within and allows great planes of glass to wrap around the walls using **ferroconcrete** construction. A key characteristic is the lack of architectural ornament and an avoidance of sculpture and painting applied to exterior surfaces.

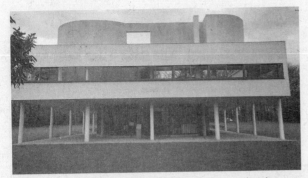

Figure 22.17a: Le Corbusier, Villa Savoye, 1929, steel and reinforced concrete, Poissy-sur-Seine, France

Le Corbusier, Villa Savoye, 1929, steel and reinforced concrete, Poissy-sur-Seine, France (Figures 22.17a, 22.17b)

Form

- Boxlike horizontal quality; an abstraction of a house.
- The main part of the house is lifted off the ground by narrow pilotis—thin freestanding posts.
- The house appears to float on pilotis; allows air to circulate around the base of the house.
- The turning circular carport on the bottom floor enables family members to enter the house directly from their car.
- All space is utilized, including the roof, which acts as a patio.
- The roof terraces bring the outdoors into the house.
- Subtle colors: white on exterior symbolizes modern cleanliness and healthful living.
- Open interior is free of many walls.
- Some furniture is built into the walls.
- Ribbon windows wind around the second floor.
- Streamlined look.
- Living spaces that are surrounded by glass face an open courtyard-type setting on the second floor.

Function and Patronage

- A three-bedroom country house with servants' quarters on the ground floor.
- Built in suburban Paris as a retreat for the wealthy.
- Patrons: Pierre and Emilie Savoye.

Context

- No historical ornamentation.

Content Area Later Europe and Americas, Image 135

Web Source http://greatbuildings.com/buildings/villa_savoye.html

- **Cross-Cultural Comparisons for Essay Question 1: Houses**
 - House of the Vettii (Figures 6.7a, 6.7b)
 - Alberti, Palazzo Rucellai (Figure 15.2)
 - Wright, Fallingwater (Figures 22.16a, 22.16b, and 22.16c)

Figure 22.17b: Le Corbusier, Villa Savoye, 1929, steel and reinforced concrete, Poissy-sur-Seine, France

Ludwig Mies van der Rohe and Philip Johnson, Seagram Building, 1954–1958, steel frame with glass curtain wall and bronze, New York (Figure 22.18)

Function

- 38-story corporate headquarters of the Seagram Liquor Company.

Form

- Bronze veneer gives the skyscraper a monolithic look; bronze is maintained yearly to keep the same color.
- Set back from Park Avenue on a wide plaza balanced by reflecting pools.
- Interplay of vertical and horizontal accents.
- Mullions stress the verticality of the internal frame.

Context

- Minimalist architecture.
- Monolith style expresses corporate power.
- Mies's saying of "Less is more" can be seen in this building with its great simplicity, geometry of design, and elegance of construction.

Figure 22.18: Ludwig Mies van der Rohe and Philip Johnson, Seagram Building, 1954–1958, New York

- Mies also said, "God is in the details;" truthful buildings express their structure, not hide it.
- Steel and glass skyscrapers and curtain wall construction became the model after World War II.
- A triumph of the International Style of architecture.

Content Area Later Europe and Americas, Image 146

Web Source *http://www.375parkavenue.com/*

- **Cross-Cultural Comparisons for Essay Question 1: Glass and Steel**
 - Sullivan, Carson, Pirie, Scott and Company Building (Figure 21.14)
 - Hadid, MAXXI (Figure 29.2)
 - Le Corbusier, Villa Savoye (Figure 22.17)

The Harlem Renaissance

In the early twentieth century African-Americans moved in great numbers to a New York City neighborhood called Harlem. This migration, and its subsequent infusion of talent, created a deep cultural center that reached its fullest expression in painting, theater, music, writing, and photography. The movement began after World War I, and reached its peak in the 1920s and early 1930s, but its influence extended well into the later twentieth century. The movement's general themes, which extended across the arts, include racial pride, civil rights, and the influence of slavery on modern culture.

Jacob Lawrence, *The Migration of the Negro, Panel no. 49*, casein tempera on hardboard, 1940–1941, Museum of Modern Art, New York (Figure 22.19)

Form

- The work illustrates the collective African-American experience; therefore, there is little individuality in the figures.
- Forms hover in large spaces.
- Angularity of forms.
- Tilted tabletops show the surface of the table.
- Flat, simple shapes.
- Unmodulated colors.
- Collective unity achieved by painting one color across many panels before going on to the next color; overall color unity in the series unites each painting.

Content

- This scene involves a public restaurant in the North; segregation emphasized by the yellow poles that zigzag down the center.
- Whites appear haughty and self-engrossed.
- African-Americans appear faceless; forms reveal their bodies and personalities.

Context

- One of a series of 60 paintings that depicts the migration of African-Americans from the rural South to the urban North after World War I.
- Negroes escaping the economic privation of the South.
- Narrative painting in an era of increasing abstraction.
- Cinematic movement of views of panels: some horizontal and others vertical.

Figure 22.19: Jacob Lawrence, *The Migration of the Negro, Panel no. 49*, casein tempera on hardboard, 1940–1941, Museum of Modern Art, New York

- Influenced by the Italian masters of the fourteenth and fifteenth centuries; used tempera paint.
- The Phillips Collections in Washington, D.C., and the Museum of Modern Art in New York bought the collection and it was split. The Phillips took the odd-numbered paintings; the Museum of Modern Art has the even-numbered ones.

Content Area Later Europe and Americas, Image 141

Web Source *http://www.phillipscollection.org/collection/migration-series*

- **Cross-Cultural Comparisons for Essay Question 1: Social Criticism**
 - Salcedo, *Shibboleth* (Figure 29.26)
 - Smith, *Lying with the Wolf* (Figure 29.20)
 - Quick-to-See-Smith, *Trade* (Figure 29.12)

Mexican Muralists

A major revival of Mexican art took place in the 1920s and 1930s by artists whose training was in the age-old tradition of fresco painting. Using large murals that all could see and appreciate, the Mexican Muralists usually promoted a political or a social message. These didactic paintings have an unmistakable meaning rendered in an easy-to-read format. The themes generally promote the labor and struggle of the working classes, and usually have a socialist agenda.

Diego Rivera, *Dream of a Sunday Afternoon in the Alameda Park*, 1947–1948, fresco, Museo Mural Diego Rivera, Mexico City (Figure 22.20)

Form

- 50-foot-long fresco, 13 feet high.
- Horror vacui; didactic painting.
- Colorful painting.
- Revival of fresco painting, a Mexican specialty.

Placement

- Originally in the lobby of the Hotel del Prado.
- After a 1985 earthquake destabilized the hotel, the fresco was placed in a museum adjacent to Alameda Park, Mexico City's first city park—built on the grounds of an Aztec marketplace.

Content

- Three eras of Mexican history depicted from left to right:
 - Conquest and colonization of Mexico by the Spanish.
 - Porfirio Diaz dictatorship.
 - Revolution of 1910 and the modern world.

Figure 22.20: Diego Rivera, *Dream of a Sunday Afternoon in the Alameda Park*, 1947–1948, fresco, Museo Mural Diego Rivera, Mexico City

- Depicts a who's who of Mexican politics, culture, and leadership:
 - Sor Juana (Figure 18.6), in nun's habit, at left center.
 - Benito Juárez, five-term president of Mexico, left at top.
 - General Santa Ana handing the keys of Mexico to General Winfield Scott.
 - Emperor Maximilian and Empress Carlota.
 - José Marti, father of Mexican independence (tipping his hat).
 - General Porfirio Díaz, with medals, asleep.
 - A police officer ordering a family out of an elitist park.
 - Francisco Madero, a martyred president.
 - José Posaro, artist and Rivera hero.
- Rivera is in the center, at age ten, holding hands with Caterina ("Death") and dreaming of a perfect love (Kahlo is behind him holding a yin/yang symbol—a symbol of Kahlo and Rivera's relationship).

Content Area Later Europe and Americas, Image 143

Web Source http://www.nytimes.com/1987/01/04/arts/rivera-mural-in-mexico-awaits-its-new-shelter.html

- **Cross-Cultural Comparisons for Essay Question 1: Historicism**
 - Delacroix, *Liberty Leading the People* (Figure 20.4)
 - Raphael, *School of Athens* (Figure 16.3)
 - Olmec-style mask (Figure 26.5d)

Abstract Expressionism

Sometimes called **The New York School**, Abstract Expressionism of the 1950s is the first American avant-garde art movement. It developed as a reaction against artists like **Mondrian**, who took the Minimalist approach to abstraction. Abstract Expressionists seek a more active representation of the hand of the artist on a given work. Hence, **action painting** is a big component of Abstract Expressionism.

Willem de Kooning, *Woman, I,* 1950–1952, oil on canvas, Museum of Modern Art, New York (Figure 22.21)

Form
- Ferocious woman with great fierce teeth and huge eyes.
- Large, bulbous breasts satirize women who appear in magazine advertising; smile said to be influenced by an ad of a woman selling Camel cigarettes.
- Jagged lines create an overpowering image.
- The smile is a cut out of a female smile from a magazine advertisement.
- Blank stare; frozen grin.
- Ambiguous environment: vagueness, insecurity.
- Thick and thin black lines dominate.

Context
- Combination of stereotypes; ironic comment on the banal and artificial world of film and advertising.
- Commentary on the female form in art history.

Figure 22.21: Willem de Kooning, *Woman, I*, 1950–1952, oil on canvas, Museum of Modern Art, New York

- Is she aggressive? Or have aggressions been committed against her? Or both?
- One of a series of six paintings on this theme.
- Influenced by everything from paleolithic goddesses to pin-up girls.

Content Area Later Europe and Americas, Image 145

Web Source https://www.moma.org/collection/works/79810

- **Cross-Cultural Comparisons for Essay Question 1: Images of Women**
 - Manet, *Olympia* (Figure 21.3)
 - Titian, *Venus of Urbino* (Figure 16.4)
 - Neshat, *Rebellious Silence* (Figure 29.14)

Color Field Painting

Color field painting lacks the aggression of Abstract Expressionism. It relies on subtle tonal values that are often variations of a monochromatic hue. With **Frankenthaler** the images are mysteriously hovering in an ambiguous space. Other artists have a more clear-cut definition of forms with lines descending through the composition. Color field painting was popular in the 1960s.

Figure 22.22: Helen Frankenthaler, *The Bay*, 1963, acrylic on canvas, Detroit Institute of Arts, Detroit, Michigan

Helen Frankenthaler, *The Bay*, 1963, acrylic on canvas, Detroit Institute of Arts, Detroit, Michigan (Figure 22.22)

Form
- Painted directly on an unprimed canvas; canvas absorbs the paint more directly.
- Use of runny water-based acrylic paint.
- Soak-stained technique.
- Use of landscape as a starting point, a basis for imagery in the works.
- The two-dimensionality of the canvas is accentuated.

Context and Interpretation
- Artist worked in the avant-garde New York School at mid-century.

Content Area Later Europe and Americas, Image 149

Web Source https://www.dia.org/art/collection/object/bay-45380

- **Cross-Cultural Comparisons for Essay Question 1: Nature**
 - Su-nam, *Summer Trees* (Figure 29.6)
 - Hokusai, the Great Wave (Figure 25.5)
 - Bruegel, *Hunters in the Snow* (Figure 14.6)

Pop Art

Pop, or Popular, Art is a term coined by an English critic in 1955 about a movement that gathered momentum in the 1950s and then reached its climax in the 1960s. It draws on materials of the everyday world, items of mass popular culture like consumer goods or famous singers—the Pop artist saw no distinction between "high" art or the design of mass-produced items. It glorifies, indeed magnifies, the commonplace, bringing the viewer face to face with everyday reality. Most Pop artists proclaim that their art is not satirical, although sometimes this is hard to believe given the images they used and the scale used to display them. It is generally thought that Pop Art is a reaction against Abstract Expressionism.

Andy Warhol, *Marilyn Diptych*, 1962, oil, acrylic, silkscreen enamel on canvas, Tate Gallery, London (Figure 22.23)

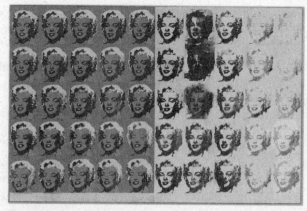

Figure 22.23: Andy Warhol, *Marilyn Diptych*, 1962, oil, acrylic, silkscreen enamel on canvas, Tate Gallery, London

Form and Content

- Marilyn Monroe's public face appears sequentially as if on a roll of film.
- Fifty images from a film still from a movie, *Niagara* (1953).
- Social characteristics magnified: brilliance of blonde hair, heavily applied lipstick, seductive expression.
- Private persona of the individual submerged beneath the public face.
- Marilyn's public face appears highlighted by bold, artificial colors.
- Left, in color, represents her in life; right, in black and white, represents her in death; work done four months after her tragic death.
- Repetition of faces reflects the repetition of the number of times Marilyn appeared before the public; sometimes overexposed, sometimes underexposed.

Materials and Technique

- Silkscreen printing technique applies photographic images in rectangular shapes onto a canvas background.
- Silkscreen diminishes the role of shading and emphasizes broad planes and unmodulated color.
- Diptych format suggests almost a religious presence.

Context

- Cult of celebrity; Monroe was a famous movie star of the 1950s.
- Private persona of Marilyn submerged beneath the public face(s).
- Repeated imagery drains the image of Monroe of meaning.
- Reproduction of many denies the concept of the unique work of art.

Content Area Later Europe and Americas, Image 147

Web Source *http://www.tate.org.uk/art/artworks/warhol-marilyn-diptych-t03093*

- **Cross-Cultural Comparisons for Essay Question 1: Human Identity**
 - Tlatilco female figurine (Figure 1.5)
 - Rodriguez, *Spaniard and Indian Produce a Mestizo* (Figure 18.5)
 - Neshat, *Rebellious Silence* (Figure 29.14)

Claes Oldenburg, *Lipstick (Ascending) on Caterpillar Tracks*, 1969–1974, cor-ten steel, steel, aluminum, and cast resin, painted with polyurethane enamel, Yale University, New Haven, Connecticut (Figure 22.24)

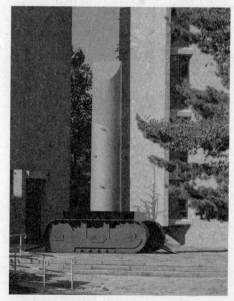

Figure 22.24: Claes Oldenburg, *Lipstick (Ascending) on Caterpillar Tracks*, 1969–1974, cor-ten steel, steel, aluminum, and cast resin, painted with polyurethane enamel, Yale University, New Haven, Connecticut

Function

- First installed, secretly, on Beinecke Plaza, New Haven, in 1969.
- Intended as a platform for public speakers; rallying point for anti-Vietnam-era protests.

Materials

■ Sculpture made of inexpensive and perishable materials (plywood tracks and an inflatable vinyl balloon tip).

■ Refurbished with steel and aluminum; reinstalled in 1974 in front of Morse College, at Yale—not its original location.

Context

■ Tank-shaped platform base with lipstick ascending—antiwar symbolism.

■ Male and female forms unite: themes of death, power, desire, and sensuality.

■ First monumental sculpture by Oldenburg.

Content Area Later Europe and Americas, Image 150

Web Source *http://oldenburgvanbruggen.com/largescaleprojects/lipstick.htm*

Artist's Website *http://oldenburgvanbruggen.com/*

■ **Cross-Cultural Comparisons for Essay Question 1: War and Battle Commemorations**

– Column of Trajan (Figure 6.16)

– Lin, Vietnam Veterans Memorial (Figures 29.4a, 29.4b)

– Siege of Belgrade (Figures 18.3a, 18.3b)

HAPPENINGS

The word "happening" was coined in the late 1950s to describe an act of performance art that is initially planned, but involves spontaneity, improvisation, and often audience participation. Happenings continue today in various formats, including Flash Mobs, Improvisational Theater, and Performance Art.

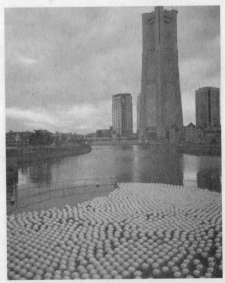

Figure 22.25a: Yayoi Kusama, *Narcissus Sea*, 2010, mirror balls, this installation at Yokohama Triennale entitled "Narcissus Sea."

Yayoi Kusama, *Narcissus Garden*, first seen in 1966, installation of mirror balls, Venice (Figures 22.25a and 22.25b)

Function and History

■ The artist originally featured the work as an uninvited participant in the 1966 Venice Biennale.

■ Fifteen hundred large, mirrored, plastic balls were placed on a lawn under a sign that said "Your Narcissism for Sale."

■ The viewer is reflected seemingly into infinity in the mirrored surfaces.

■ The artist offered the balls for sale for 1,200 lire ($2 each) as a commentary on the commercialism and vanity of the current art world.

■ The installation later moved to water, where the floating balls reflect the natural environment—and the viewers—around the work; water placement makes a stronger connection to the ancient myth.

■ Balls move with the currents of the water and wind, reflecting organically made, ever-changing viewpoints.

■ The installation has been exhibited in many places around the world, both in water and in dry spaces

Context

■ *Narcissus Garden* references the ancient myth of Narcissus, a young man who is so enraptured by his image in reflecting water that he stares at it indefinitely until he becomes a flower.

- There is a deeper meaning today as *Narcissus Garden* references modern obsessions with selfies and uploaded images on social media.
- Kusama is an internationally renowned Japanese-born artist:
 - Got her start showing large works of art featuring huge polka dots.
 - One of the foremost innovators of Happenings.
 - Works in a wide variety of media, including installations.

Content Area Later Europe and Americas, Image 148

Artist's Website *http://www.yayoi-kusama.jp/*

- **Cross-Cultural Comparisons for Essay Question 1: Human Identity and Image**
 - Sherman, *Untitled #228* (Figure 29.10)
 - Wall plaque from Oba's palace (Figure 27.3)
 - Narmer Palette (Figures 3.4a and 3.4b)

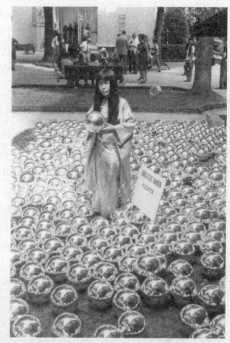

Figure 22.25b: Yayoi Kusama, *Narcissus Garden*, artist sells balls at the Venice Biennale, 1966

Site Art

Sometimes called Earth Art, Site Art is dependent on its location to render full meaning. Often works of Site Art are temporary, as in the works of **Christo** and **Jeanne-Claude**. Other times the works remain, but need the original environment intact in order for it to be fully understood. Such items are often called **earthworks**. Site Art dates from the 1970s and is still being done today.

Robert Smithson, *Spiral Jetty*, 1970, earthwork: mud, precipitated salt crystals, rocks, water coil, Great Salt Lake, Utah (Figure 22.26)

Form
- A coil of rock placed in a part of the Great Salt Lake that is in an extremely remote and inaccessible area.
- The artist liked the site because of the blood-red color of the water, which is due to the presence of bacteria and algae that live in the high-salt content.

Material
- The artist used a tractor to move basalt from the adjacent hillside to create the jetty.

Context
- Upon walking on the jetty, the twisting and curling path changes the viewer's view from every angle.
- A jetty is usually a pier extending into the water; here it is transformed into a curl of rocks sitting silently in a vast, empty wilderness.
- The coil is an image seen in North American earthworks—cf. Great Serpent Mound, Ohio (Figure 26.4)—as well as in petroglyphs and Anasazi pottery.
- The work reflects emerging views of the environmental movement; Earth Day was inaugurated in 1970.
- Smithson wanted nature to have its effect on the jetty (sometimes it is submerged, sometimes it is visible).

Content Area Later Europe and Americas, Image 151

Artist's Website *http://robertsmithson.com/*

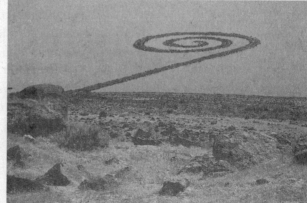

Figure 22.26: Robert Smithson, *Spiral Jetty*, 1970, earthwork: mud, precipitated salt crystals, rocks, water coil, Great Salt Lake, Utah

- **Cross-Cultural Comparisons for Essay Question 1: Spirals and Circular Constructions**
 - Christo and Jeanne-Claude, *The Gates* (Figures 29.3a, 29.3b)
 - Great Serpent Mound (Figure 26.4)
 - Stonehenge (Figures 1.12a, 1.12b)

POSTMODERN ARCHITECTURE

Postmodern architecture, generally thought to emerge in the late 1970s and early 1980s, sees the achievements of the International Style as cold and removed from the needs of modern cities with their cosmopolitan populations. Postmodernists see nothing wrong with incorporating ornament, traditional architectural expressions, and references to past styles in a modern context. Philip Johnson, himself a contributor to the International Style, as well as someone who worked on the Seagram Building (Figure 22.18), began the shift away to a Postmodern ideal with the AT&T building.

Figure 22.27a: Robert Venturi, John Rauch, and Denise Scott Brown, House in New Castle County, 1978–1983, wood frame and stucco, Delaware

Figure 22.27b: Music Room of House in New Castle County

Robert Venturi, John Rauch, and Denise Scott Brown, House in New Castle County, 1978–1983, wood frame and stucco, Delaware (Figures 22.27a and 22.27b)

Form
- The façade contains an arch inside a pediment form.
- A squat, bulging Doric colonnade is asymmetrically placed.
- The columns are actually flat rather than the traditionally round forms.
- The drainpipe at the left bisects the outermost column.
- The flattened forms on the interior arches echo the exterior flat columns.
- The interior forms reflect a craftsman's hand in curved, cutting elements.

Function
- The house was designed for a family of three.
- For the wife, a musician, a music room was created with two pianos, an organ, and a harpsichord.
- For the husband, a bird-watcher, large windows were installed facing the woods.

Context
- Postmodern mix of historical styles.
- Rural location in low hills, grassy fields of Delaware.
- Venturi's comment on the International style: "Less is a bore."

Content Area Later Europe and Americas, Image 152

Artist's Website *http://www.venturiscottbrown.org/*

- **Cross-Cultural Comparisons for Essay Question 1: Homes**
 - Jefferson, Monticello (Figures 19.5a, 19.5b)
 - Alberti, Palazzo Rucellai (Figure 15.2)
 - Le Corbusier, Villa Savoye (Figure 22.17)

VOCABULARY

Abstract: works of art that may have form, but have little or no attempt at pictorial representation (Figure 22.14)

Action painting: an abstract painting in which the artist drips or splatters paint onto a surface like a canvas in order to create the work

Assemblage: a three-dimensional work made of various materials such as wood, cloth, paper, and miscellaneous objects

Biomorphism: a movement stressing organic shapes that hint at natural forms

Cantilever: a projecting beam that is attached to a building at one end, but suspended in the air at the other (Figure 22.15)

Collage: a composition made by pasting together different items onto a flat surface

Color field painting: a style of abstract painting characterized by simple shapes and monochromatic color

Documentary photography: a type of photography that seeks social and political redress for current issues by using photographs as a way of exposing society's faults

Earthwork: a large outdoor work in which the earth itself is the medium (Figure 22.26)

Ferroconcrete: steel reinforced concrete; the two materials act together to resist building stresses

Happening: an act of performance art that is intially planned but involves spontaneity, improvisation, and often audience participation

Harlem Renaissance: a particularly rich artistic period in the 1920s and 1930s that is named after the African-American neighborhood in New York City where it emerged. It is marked by a cultural resurgence by African-Americans in the fields of painting, writing, music, and photography

Installation: a temporary work of art made up of assemblages created for a particular space, like an art gallery or a museum (Figure 22.25b)

Mobile: a sculpture made of several different items that dangle from a ceiling and can be set into motion by air currents

Neoplasticism: a term coined by Piet Mondrian to describe works of art that contain only primary and neutral colors and only straight, vertical, or horizontal lines intersecting at right angles

Photomontage: The technique of creating an image by combining photographs, sometimes with other materials, to form a unified image (Figure 22.13)

Ready-made: a commonplace or found object selected and exhibited as a work of art

Silkscreen: a printing technique that passes ink or paint through a stenciled image to make multiple copies (Figure 22.23)

Venice Biennale: a major show of contemporary art that takes place every other year in various venues throughout the city of Venice; begun in 1895 (Figure 22.25b)

SUMMARY

Early modern art is characterized by the birth of radical art movements. Avant-garde artists, with the help of their progressive patrons, broke new ground in rethinking the traditional figure, and in the use of color as a vehicle of expression rather than description.

Artists moved in many directions; for example, abstract art was approached in entirely different ways by artists as diverse as Kandinsky and Mondrian. Other artists, such as Brancusi, come close to the abstract form, using representational ideas as a starting point. Still others, such as Surrealists, see conventional painting as a beginning, but expanded their horizons immediately after that.

Modern architects embrace new technology, using it to cantilever forms over open space, imitate the machine aesthetic of Art Deco, or espouse the complete artistic concept of the Bauhaus. Whatever the motivations, modern architecture is dominated by clear, clean, simple lines, paralleling some of the advances made in painting and sculpture.

PRACTICE EXERCISES

Multiple-Choice

1. Robert Smithson's works, like *Spiral Jetty*, were inspired by

 (A) Surrealist paintings
 (B) Aztec temple structures and complexes
 (C) Buddhist stupas and toranas
 (D) American Indian earthworks

2. The *Memorial Sheet for Karl Liebknecht* commemorates a moment in the

 (A) Franco-Prussian War of 1980
 (B) Communist uprising in 1919
 (C) erection of the Berlin Wall in 1961
 (D) collapse of the Stock Market in 1929

3. Cuban artist Wifredo Lam sought to combine his Hispanic heritage with

 (A) flat areas of color used in Japanese prints
 (B) facial designs inspired by African masks
 (C) abstract patterning popularized by painters of the New York School
 (D) found objects used by the Dadists

4. Alfred Stieglitz's photographs have been compared to

 (A) Surrealist paintings because of their odd juxtapositions
 (B) Cubist paintings because of the tonal values and the arrangement of shapes
 (C) Impressionist paintings because of their atmospheric effects
 (D) Realist paintings because of the concentration on the plight of the hard-working poor

5. Constructivists were highly influenced by

 (A) political unrest in Germany as a result of World War I
 (B) social ferment in the African-American community in Harlem, New York
 (C) the rise of the industrial complex in Russia that Communists saw as a way toward a modern state
 (D) the philosopher André Breton and the organizing principles of Surrealist art

Short Essay

Practice Question 3: Visual Analysis
Suggested Time: 15 minutes

This work is Yayoi Kusama's *Narcissus Sea*.

 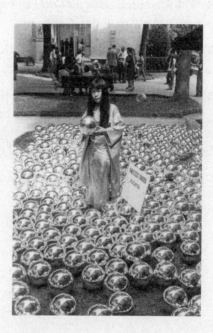

Where was the original version of this work first shown?

How is this work, as seen here, different from the prior installation?

Discuss why this work caused a scandal when it was first shown.

Using specific visual evidence, discuss *at least two* examples of how the media used in this work has created a variety of interpretations.

ANSWERS EXPLAINED

Multiple-Choice

1. **(D)** The circular patterns seen in such earthworks as Great Serpent Mound formed a general inspiration for Smithson's works.

2. **(B)** The *Memorial Sheet for Karl Liebknecht* commemorates a moment in the Communist uprising in 1919 in Berlin, Germany.

3. **(B)** Cuban artist Wifredo Lam was influenced by African masks. Cuban ancestry is a mixture of European and African heritages, and his work often mirrors that combination.

4. **(B)** The development of Cubism is simultaneous with Stieglitz's experiments in photography. There is a strong parallel between Cubism's refined artistic palette and the subtle tonal shades in Stieglitz's photographs. Moreover, there is a comparison between Cubism's sharp angles and thoughtful compositional varieties in Stieglitz.

5. **(C)** Constructivism was a Russian movement that celebrated the rise of the industrial complex in the service of the state.

Short Essay Rubric

Task	Point Value	Key Points in a Good Response
Where was the original version of this work first shown?	1	The artist originally featured the work as a nonparticipant in the 1966 Venice Biennale.
How is this work, as seen here, different from the prior installation?	1	Answers could include: ■ The initial installation was on grass; most subsequent installations have been on water. ■ The initial installation had the artist present selling the balls; subsequent installations have not had balls for sale, and the artist has not been present. ■ The initial installation was done as a commentary on the Venice Biennale and on the art world in general; subsequent installations have carried a broader message.
Discuss why this work caused a scandal when it was first shown.	1	Answers could include: ■ 1,500 large, mirrored, stainless steel balls placed on a lawn under a sign that said, "Your Narcissism for Sale." ■ Artist offered the balls for sale for 1,200 lire ($2 dollars each) as a commentary on the commercialism and vanity of the current art world. ■ The artist was not invited to participate in the official biennale, but came anyway.
Using specific visual evidence, discuss *at least two* examples of how the media used in this work has created a variety of interpretations.	2	Answers could include: ■ *Narcissus Garden* references the ancient myth of Narcissus, a young man who is so enraptured by his image in reflecting water that he stares at it indefinitely until he becomes a flower. ■ This installation was later moved to water, where the floating balls reflect the natural environment—and the viewers; water placement makes a stronger connection to the ancient myth. ■ Balls move with the current of the water and wind, reflecting ever-changing viewpoints. ■ The installation has been exhibited in many places around the world, both in water and in dry spaces.

Content Areas: South, East, and Southeast Asia, 300 B.C.E.–1980 C.E.
West and Central Asia, 500 B.C.E.–1980 C.E.

Indian and Southeast Asian Art

23

TIME PERIOD: FROM ANCIENT TIMES TO THE PRESENT

ENDURING UNDERSTANDING: Art making is influenced by available materials and processes.

Learning Objective: Discuss how material, processes, and techniques influence the making of a work of art. (For example: Bichitr, *Jahangir Preferring a Sufi Sheik to Kings*)

Essential Knowledge:

- The art of India is some of the oldest in the world with the longest continuous tradition.
- Indian artists employ a wide range of materials including ceramics and metal.
- Distinctive to India is the development of Buddhist stupas.
- Indian art extensively employs stone and wood carving.
- Indian art specializes in wall and manuscript painting.
- Tapestry is an Indian specialty.

ENDURING UNDERSTANDING: The culture, beliefs, and physical settings of a region play an important role in the creation, subject matter, and siting of works of art.

Learning Objective: Discuss how the culture, beliefs, or physical setting can influence the making of a work of art. (For example: Lakshmana Temple)

Essential Knowledge:

- The Indus Valley civilizations were among the most advanced for their time.
- Cultural centers in India became the home of great civilizations and dynasties.
- Some of the world's greatest philosophies and religions developed in India.
- Early Indian religions often separated the cosmic from the earthly realm. All the religions in this area (i.e., Hinduism and Buddhist) adopted this world view.
- The Indian religions generated unique artistic expressions, such as the Buddhist stupa and the Hindu temple.
- Buddhism, Hinduism, and Jainism are image-friendly religions.

ENDURING UNDERSTANDING: Art and art making can be influenced by a variety of concerns including audience, function, and patron.

Learning Objective: Discuss how art can be influenced by audience, function, and/or patron. (For example: Jowo Rinpoche)

Essential Knowledge:

- Indian art has a rich tradition of depicting mythical and historical subjects.
- Architecture is generally religious.

ENDURING UNDERSTANDING: Cultural interaction through war, trade, and travel can influence art and art making.

Learning Objective: Discuss how works of art are influenced by cultural interaction. (For example: Bichitr, *Jahangir Preferring a Sufi Sheik to Kings*)

Essential Knowledge:

- Asian art is influenced by global trends, and in turn influences global trends.
- Trade routes connected Asia with the world.
- Other religions such as Christianity and Islam have had a dramatic impact on the arts in India.

ENDURING UNDERSTANDING: Art history is best understood through an evolving tradition of theories and interpretations.

Learning Objective: Discuss how works of art have had an evolving interpretation based on visual analysis and interdisciplinary evidence. (For example: Angkor Wat)

Essential Knowledge:

- Art history as a science is subject to differing interpretations and theories that change over time.

HISTORICAL BACKGROUND

The fertile Indus and Ganges valleys were too great a temptation for outsiders, and thus the history of India has become a history of invasions and assimilations. But those who invaded came to stay, and so Indian life today is a layering of disparate populations to create a cosmopolitan culture. There are eighteen official languages in India—Hindi, the one foreigners think of as the national language, is spoken natively by only 20 percent of the population. Along with Hindus and Muslims, there are many concentrations of Jains, Buddhists, Christians, and Sikhs, as well as myriad tribal religions. Geographically, India has enormous range as well, from the world's tallest mountains to vast deserts and tropical forests. This is one of the most diverse countries on earth.

Patronage and Artistic Life

The arts play a critical role in Indian life. Most rulers have been extremely generous patrons, commissioning great buildings, sculptures, and murals to enhance civic and religious life, as well as their own glory. The interconnectiveness of the arts in India is crucial to understanding Indian artistic life. Monuments are conceived as a combination of the arts; the artists who work on them carry out their work at the behest of an artist who acts as a team leader with a single artistic vision. Thus, Indian monuments have a surprising uniformity of style. The design of religious art and architecture may have also been determined by a priest or other religious advisor, who ensured that proportions and iconography of monuments agreed with descriptions supplied in canonical texts and diagrams.

Much as in the European tradition, artists were trained as apprentices in workshops. The process was comprehensive; the artist learned everything from how to make a brush to how to create intricate miniatures or vast murals. Indians are highly organized in their approach to artistic training.

BUDDHIST PHILOSOPHY AND ART

Still practiced today as the dominant religion of Southeast Asia, Buddhism is a spiritual force that teaches individuals how to cope in a world full of misery. The central figure, Buddha (563–483 B.C.E.), who is not a god, rejected the worldly concerns of life at a royal court, and sought fulfillment traveling the countryside and living as an ascetic.

In Buddhism, life is believed to be full of suffering that is compounded by an endless cycle of birth and rebirth. The aim of every Buddhist is to end this cycle and achieve oneness with the supreme spirit, which involves a final release or extinguishing of the soul. This can only happen by accumulating spiritual merit through devotion to good works, charity, love of all beings, and religious fervor.

Buddhist art has a rich cultural iconography. Some of the most common symbols include:

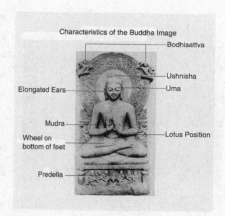

Figure 23.1: Principal characteristics of the Buddha

- The Lion: a symbol of Buddha's royalty
- The Wheel: Buddha's law
- Lotus: a symbol of Buddha's pure nature. The lotus grows in swamps, but mud slides off its surface.
- Columns surrounded by a wheel: Buddha's teaching
- Empty Throne: Buddha, or a reminder of a Buddha's presence.

There is a surprising uniformity in the way in which Buddhas are depicted, given that they were produced over thousands of years and across thousands of miles. Typically Buddhas have a compact pose with little negative space (Figure 23.1). They are often seated, although standing and lying down are occasional variations. When seated, a Buddha is usually posed in a lotus position with the balls of his feet turned straight up, and a wheel marking on the souls of the feet is prominently displayed.

The treatment of drapery varies from region to region. In Central India, Buddhist drapery is extremely tight-fitting, and resting on one shoulder with folds slanting diagonally down the chest. In Gandhara, a region that spreads across northwest India, Pakistan, and Afghanistan, Buddhist figures wear heavy robes that cover both shoulders, similar to a Roman toga, showing a Hellenistic influence.

Buddhas are generally frontal, symmetrical, and have a nimbus, or halo, around their heads. Helpers, called **bodhisattvas**, are usually near the Buddha, sometimes attached to the nimbus.

Buddhas' moods are many, but most have a detached, removed quality that suggests meditation. Buddhas' actions and feelings are revealed by hand gestures called **mudras**.

The head has a top knot, or **ushnisha**, and the hair has a series of tight-fitting curls. Extremely long ears dangle almost to his shoulders. A curl of hair called an **urna** appears between his brows. His rejection of courtly life explains his disdain for personal jewelry.

Beneath statues of Buddha there usually is a base or a **predella**, which can include donor figures and may have an illustration of one of his teachings or a story from his life.

Buddhist art also depicts distinctive figures called **yakshas** (males) and **yakshis** (females), which are nature spirits that appear frequently in Indian popular religion. Their appearance in Buddhist art indicates their incorporation into the Buddhist pantheon. The females often stand in an elaborate dance-like poses, almost nude, with their breasts prominently displayed. The depiction of yakshas accentuates male characteristics such as powerful shoulders and arms.

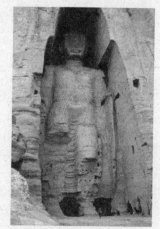

Figure 23.2a: Buddha from Bamiyan, Gandharan, 400–800, destroyed 2001, cut rock with plaster and polychrome paint, Afghanistan

Buddha from Bamiyan, Gandharan, 400–800, destroyed 2001, cut rock with plaster and polychrome paint, Afghanistan (Figures 23.2a and 23.2b)

Form and Content
- First colossal Buddhas.
- Two huge standing Buddhas, one 175 feet tall, the other 115 feet tall.

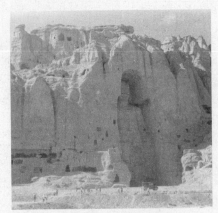

Figure 23.2b: Buddha from Bamiyan, oblique view

- Smaller Buddha: Sakyamuni, the historical Buddha.
- Larger Buddha: Vairocana, the universal Buddha.
- Niche shaped like a halo—or mandorla—around the body.
- Buddhas originally covered with pigment and gold.
- Cave galleries weave through the cliff face; some contain wall paintings and painted images of the seated Buddha.

Function

- Pilgrimage site linked to the Silk Road.
- Pilgrims can walk through the cave galleries into passageways that lead to the level of the Buddha's shoulders.
- Legs are carved in the round; originally pilgrims were able to circumambulate.
- Caves were part of a vast complex of Buddhist monasteries, chapels, and sanctuaries.

Context

- Located near one of the largest branches of the Silk Road.
- Bamiyan, situated at the western end of the Silk Road, was a trading and religious center.
- These Buddhas served as models for later large-scale rock-cut images in China.
- Destroyed by the Taliban in an act of iconoclasm in March 2001.

Content Area West and Central Asia, Image 182

Web Source http://whc.unesco.org/en/list/208

- **Cross-Cultural Comparisons for Essay Question 1: Monumental Sculpture**
 - Lamassu (Figure 2.5)
 - Great Sphinx (Figure 3.6a)
 - Longmen Caves (Figure 24.9a)

Figure 23.3: Jowo Rinpoche enshrined in the Jokhang Temple, Yarlung Dynasty, believed to have been brought to Tibet in 641, gilt metals with semiprecious stones, pearls, and paint; various offerings, Lhasa, Tibet

Jowo Rinpoche enshrined in the Jokhang Temple, Yarlung Dynasty, believed to have been brought to Tibet in 641, gilt metals with semiprecious stones, pearls, and paint; various offerings, Lhasa, Tibet (Figure 23.3)

History

- Statue thought to have been blessed by the Buddha himself; believed to have been crafted in India during his lifetime; said to have his likeness.
- Believed to have been brought to Tibet in 641.
- Temple founded in 647 by the first ruler of a unified Tibet.
- Disappeared in 1960s during China's Cultural Revolution.
- In 1983, the lower part was found in a rubbish heap and the upper part in Beijing; restored in 2003.
- Enshrined in the Jokhang Temple, Tibet's earliest and foremost Buddhist temple.

Function

- Served as a proxy for the Buddha after his departure from this world.
- Often decorated, clothed, and presented with offerings.

Context

- Depiction of Buddha Sakyamuni as a young man around the age of twelve.
- Most sacred and important Buddhist image in Tibet.
- Jowo means "lord," Khang means "house."

Content Area West and Central Asia, Image 184

Web Source for Buddhist Art http://www.metmuseum.org/toah/hd/budd/hd_budd.htm
■ **Cross-Cultural Comparisons for Essay Question 1: Sacred Images**
- Moai (Figure 28.11)
- *Apollo from Veii* (Figure 5.5)
- Reliquary of Sainte-Foy (Figure 11.6c)

BUDDHIST ARCHITECTURE

The principal place of early Buddhist worship is the **stupa**, a mound-shaped shrine that has no interior. A stupa is a reliquary; worshippers gain spiritual merit through being in close proximity to its contents. A staircase leads the worshipper from the base to the drum. Buddhists pray while walking in a clockwise or easterly direction, that is, the direction of the sun's course. Because of its distinctive shape, that of a giant hemisphere, and because one walks and prays with the sun, the stupa has cosmic symbolism. It is also conceived as being a symbol of Mt. Meru, the mountain that lies at the center of the world in Buddhist cosmology and serves as an axis connecting the earth and the heavens.

Stupas, like one at **Sanchi** (Figure 23.4a), have a central mast of three umbrellas at the top of the monument, each umbrella symbolizing the three jewels of Buddhism: the Buddha, the Law, and the Community of Monks. The square enclosure around the umbrellas symbolizes a sacred tree surrounded by a fence.

Four **toranas**, at the cardinal points of the compass, act as elaborate gateways to the structure.

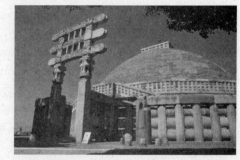

Great Stupa, Buddhist, Mauyra, late Sunga Dynasty, 300 B.C.E.–100 C.E., stone masonry, sandstone on dome, Sanchi, Madhya Pradesh, India (Figures 23.4a, 23.4b, 23.4c, 23.4d, 23.4e)

Function
■ Pilgrimage site.
■ A Buddhist shrine, mound shaped and faced with dressed stone containing the relics of the Buddha.
■ The worshipper circumambulates the stupa clockwise along the base of the drum; circular motion suggests the endless cycle of birth and rebirth.

Figure 23.4a: Great Stupa, Buddhist, Mauyra, Late Sunga Dynasty, 300 B.C.E.-100 C.E., stone masonry, sandstone on dome, Sanchi, Madhya Pradesh, India

Figure 23.4b: Interior ambulatory

Figure 23.4c: North Gate, or Torana

Figure 23.4d: Great Stupa plan

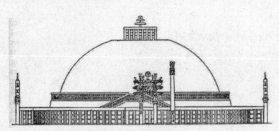

Figure 23.4e: Great Stupa elevation

Form

- Three umbrellas at the top represent Buddha, Buddha's law, and monastic orders.
- A railing at the crest of the mound surrounds the umbrellas, symbolically representing a sacred tree.
- Double stairway at the south end leads from base to drum, where there is a walkway for circumambulation.
- Originally painted white.
- Hemispherical dome is a replication of the dome of heaven. Seated Buddha from second level from the Later Gupta period.

Toranas

- Four toranas, or gateways, at cardinal points of the compass, grace the entrances.
- The orientation of the toranas (east, south, west, and north) and the direction of ritualistic circumambulation correspond with the direction of the sun's course: from sunrise to zenith, sunset, and nadir.
- Torana: richly carved scenes on the architraves:
 - Buddha does not appear himself but is symbolized by an empty throne or a tree under which he meditated.
 - Some of these reliefs may also represent the sacred sites where Shakyamuni Buddha visited or taught others about the jataka stories or past lives of the Buddha.
 - Horror vacui of composition.
 - High-relief sculpture.
 - Pre-Buddhist Yakshi figures symbolize fertility.

Context

- Donors' names are carved into the monument: 600 inscriptions reveal the project was funded by women as well as men, common people as well as monks.

Content Area South, East, and Southeast Asia, Image 192

Web Source http://sanchi.org/sanchi-great-stupa.html

- **Cross-Cultural Comparisons for Essay Question 1: Integration of Sculpture and Architecture**
 - Angkor Wat (Figures 23.8a, 23.8b, 23.8c, 23.8d)
 - Parthenon (Figures 4.5, 4.6)
 - Mortuary temple of Hatshepsut (Figure 3.9a)

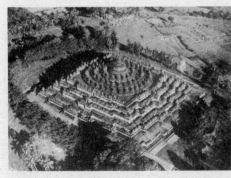

Figure 23.5a: Borobudur Temple, Sailendra Dynasty, c. 750–842, volcanic stone masonry, Central Java, Indonesia

Borobudur Temple, Sailendra Dynasty, c. 750–842, volcanic stone masonry, Central Java, Indonesia (Figures 23.5a, 23.5b, and 23.5c)

Form

- Pyramid in form; aligned with the four cardinal points of the compass.
- Square-shaped plan with four entry points.
- Rubble faced with carved volcanic stone.
- Built on a low hill rising above a wide plain.

Content

- This massive Buddhist monument contains 504 life-size Buddhas, 1,460 narrative relief sculptures on 1,300 panels 8,200 feet long.
- 72 openwork stupas containing a Buddha, each with a preaching mudra.
- Six identical square terraces are placed one atop the other, like steps; three smaller circular terraces are placed on top; the lowest level functions as the base of the structure, with a

square floor plan; the second level recedes 23 feet from the edge of the base so that the space is wide enough for processions.

- Each terrace is a level of enlightenment.
- On the top is an enclosed stupa.
- Divided into three sections, representing three levels of Buddhist cosmology:
 - *Base:* represents the lowest level of experience; those who are aligned with their desires on Earth; the world of desire and negative impulses; sculptures here show the deeds of self-sacrifice practiced by the Buddha in his previous births and the story of his last incarnation as Prince Siddhartha.
 - *Body:* five terraces in which people abandon their earthly desires; this is the world of forms—people have to control these negative impulses; sculptures here show the pilgrimage of the young man, Sudhana, who sets out in search of the Ultimate Truth.
 - *Superstructure:* an area that represents a formless world, in which a person experiences reality in its purest stage, where the physical world and worldly desire are expunged.

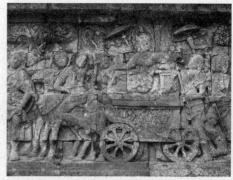

Figure 23.5b: Borobudur Temple: Queen Maya riding a horse carriage retreating to Lumbini to give birth to Prince Siddhartha Gautama

Function

- A place of pilgrimage.
- Built as a stupa.

Context

- Meant to be circumambulated on each terrace; six concentric square terraces topped by three circular tiers with a great stupa at the summit.
- Iconographically complex and intricate; many levels of meaning.

Content Area South, East, and Southeast Asia, Image 198

- **Cross-Cultural Comparisons for Essay Question 1: Pilgrimage Sites**
 - Church of Sainte-Foy, Conques (Figures 11.4a, 11.4b)
 - the Kaaba (Figures 9.11a, 9.11b)
 - Great Stupa (Figures 23.4a, 23.4b)

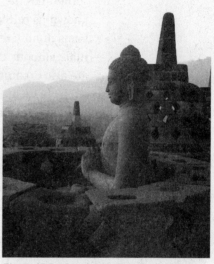

Figure 23.5c: Borobudur Temple, Buddha

Queen Maya riding a horse carriage retreating to Lumbini to give birth to Prince Siddhartha Gautama

- Densely packed scene; horror vacui.
- The queen is majestic and at rest before giving birth.
- Ready to give birth to her son, Prince Siddhartha Gautama, the Buddha.
- She is brought to the city in a great ceremonial procession.

Web Source http://borobudurpark.com/

- **Cross-Cultural Comparisons for Essay Question 1: Relief Sculpture**
 - Plaque of the Ergastines (Figure 4.5)
 - Wall plaque from Oba's palace (Figure 27.3)
 - Ludovisi Battle Sarcophagus (Figure 6.17)

HINDU PHILOSOPHY AND ART

To outsiders, Hinduism is a bewildering religion with myriad sects, each devoted to the worship of one of its many gods. The complexity and multiplicity of the practices and beliefs associated with Hinduism are evident in the name of the religion, which is an umbrella term meaning, "the religions of Hindustan (India)." Folk beliefs exist side by side with sophisticated

philosophical schools. However, all forms of Hinduism concentrate on the infinite variety of the divine, whether it is expressed in the gods, in nature, or in other human beings. Those who proclaim to be orthodox Hindus accept the Vedic texts as divine in origin, and many maintain aspects of the Vedic social hierarchy, which assigns a caste of ritual specialists, known as Brahmins, to officiate between the gods and humankind.

As in the case of Buddhism, every Hindu is to lead a good life through prayer, good deeds, and religious devotion, because only in that way can he or she break the cycle of reincarnation. **Shiva** (Figure 23.6) is one of the principal Hindu deities, who periodically dances the world to destruction and rebirth. Other important deities include Brahma, the creator god; Vishnu, the preserver god; and the great goddesses who are manifest as peaceful consorts, like Laksmi and Parvati.

HINDU SCULPTURE

Temple sculpture is a complete integration with the architecture to which it is attached—sometimes the buildings are thought of as a giant work of sculpture. Pairs of divine couples, known as **mithuna**, appear upon the exterior and doorways of some temples. Sexual allusions dominate and are expressed with candor, but not obscenity. Hindu sculptures accentuate sinuous curves and the lines of the body. Dance poses are common. Temple surfaces are also ornamented with organic and geometric designs, including lateral bands that depict subjects such as lotus flowers, temple bells, and strings of pearls.

Images placed in the "womb" of the temple are idols in that they are invoked with the essence of divinity that the figure represents. To touch the image is to touch the god himself or herself; few can do this. Instead the image is treated with the utmost respect and deference, and is occasionally exposed to public viewing. Worshippers experience the divine through actively seeing the invoked image, an experience known as **darshan** and performing **puja**, a ritual offering to the deity, which is mediated by temple priests.

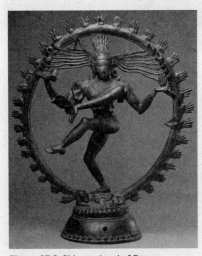

Figure 23.6: Shiva as Lord of Dance (Nataraja), Hindu, India (Tamil Nadu), Chola Dynasty, c. 11th century C.E., cast bronze, Metropolitan Museum of Art, New York

Shiva as Lord of Dance (Nataraja), Hindu, India (Tamil Nadu), Chola Dynasty, c. 11th century C.E., cast bronze, Metropolitan Museum of Art, New York (Figure 23.6)

Form
- Shiva has four hands.
- One hand sounds the drum that he dances to; another carries a flame of destruction; the other two offer the abhaya mudra, a gesture that allays fear.
- Epicene quality showing an idealized, nearly nude, male figure.
- Flying locks of hair terminate in rearing cobra heads.
- Often depicted in a flaming nimbus, vigorously dancing with one foot on a dwarf, the Demon of Ignorance.
- Fire around Shiva represents the borders of the Hindu cosmos; covered with flowers when carried in processions.

Function
- The sculpture becomes the receptacle for the divine spirit when people pray before it; therefore, the sculpture is royally treated with gifts, food, and incense.
- The sculpture can be bathed and clothed.
- A hole is at the bottom of the sculpture for the placement of a pole so that it can be used in processions and covered by flowers.

Context
- Shiva periodically destroys the universe so that it can be reborn again.

- He unfolds the universe out of the drum held in one of his right hands; he preserves it by uplifting his other right hand in a gesture indicating "do not be afraid."
- Shiva has a third eye barely suggested between his other two eyes; he once burned the god Kama with this eye.
- The message is that belief in Shiva can achieve salvation.
- The distribution of this figure due to the patronage of a queen, Mahadevi.

Content Area South, East, and Southeast Asia, Image 202

Web Source *http://metmuseum.org/art/collection/search/39328*

- **Cross-Cultural Comparisons for Essay Question 1: Divine Judgments**
 - Last judgment of Hunefer (Figure 3.12)
 - Last Judgment, Sainte-Foy, Conques (Figure 11.6a)
 - Gaulli, *Triumph of the Name of Jesus* (Figure 17.6)

HINDU ARCHITECTURE

The Hindu temple is not a hall for congregational worship; instead it is the residence of a god. The temples are solidly built with small interior rooms, just enough space for a few priests and individual worshippers. At the center is a tiny interior cella that is called the "Womb of the World" where the sacred statue invoked with the main deity is placed. Although Indians knew the arch, they preferred corbelled-vaulting techniques to create a cave-like look on the inside. Thick walls protect the deity from outside forces. An antechamber, where ceremonies are prepared, precedes the **cella**, and a **hypostyle** hall is visible from the outside where congregants can participate. Hindu temples are constructed amid a temple complex that includes subsidiary buildings.

In northern India, temples have a more vertical character, with large towers setting the decorative scheme, and other subsidiary towers imitating the shape but at various scales. Placed on high pedestals, temples have a sense of grandeur as they command the countryside. Major temples form "temple cities" in south India, where layers of concentric gated walls surround a network of temples, shrines, pillared halls, and colonnades. The Hindu temples found in Cambodia are based upon a pyramidal plan with a central shrine surrounded by subshrines and enclosed walls.

Temple exteriors are covered with sculpture, almost in a feverish frenzy to crowd every blank spot on the surface.

Lakshmana Temple, Hindu, Chandella Dynasty, 930–950, sandstone, Khajuraho, India (Figures 23.7a, 23.7b, 23.7c, 23.7d)

Form
- The temple is placed on a high pedestal, or plinth, to be seen from a distance. It appears like rising peaks of a mountain range.
- Compact proportions.

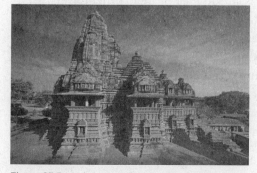

Figure 23.7a: Lakshmana Temple, Hindu, Chandella Dynasty, 930–950, sandstone, Khajuraho, India

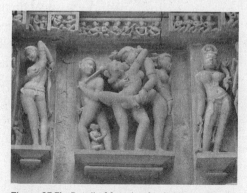

Figure 23.7b: Detail of façade of Lakshmana Temple

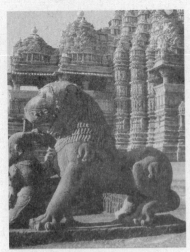

Figure 23.7c: Detail of Lakshmana Temple

- East/west axis: it receives direct rays from the rising sun.
- The building is a series of shapes that build to become a large tower; complicated intertwining of similar forms called a shikara.
- In the center is the "embryo" room containing the shrine.
- The embryo, called a garbha griha, is very small with only space enough for a limited number of people. It is meant for individual—not congregational—worship.

Materials
- Ashlar masonry; made of fine sandstone.

Sculpture
- Bands of horizontal moldings unite the temple.
- The sculpture on the surface harmoniously integrates with the architecture.
- The figures are sensuous with revealing clothing.
- Erotic poses symbolize regeneration.
- Sexuality is frankly expressed.

Function
- It is a Hindu temple grouped with a series of other temples in Khajuraho.
- The temple is dedicated to Vishnu.

Patron
- Yashovarman, a leader in the Chandella Dynasty, built the temple to legitimize his rule; completed by his son, Dharga, after his death.

Context
- Worshippers move in a clockwise direction starting at the staircase to circumambulate the temple.

Figure 23.7d: Plan of Lakshmana Temple

Content Area South, East, and Southeast Asia, Image 200

Web Source for Hindu Art http://www.metmuseum.org/toah/hd/hind/hd_hind.htm

- **Cross-Cultural Comparisons for Essay Question 1: Ashlar Masonry**
 - Parthenon (Figure 4.16b)
 - Persepolis (Figures 2.6a, 2.6b)
 - Petra (Figures 6.9a, 6.9b, 6.9c)

Figure 23.8a: Angkor Wat, Hindu, Angkor Dynasty, c. 800–1400, stone masonry, sandstone, Cambodia

Angkor, the temple of Angkor Wat, and the city of Angkor Thom, Hindu, Angkor Dynasty, c. 800–1400, stone masonry, sandstone, Cambodia (Figures 23.8a, 23.8b, 23.8c, 23.8d, 23.8e)

Form
- Main pyramid is surrounded by four corner towers; a temple-mountain.
- Corbelled gallery roofs; influenced by the Indian use of corbelled vaulting.
- The entire complex is made of stone; most surfaces are carved and decorated.
- Horror vacui of sculptural reliefs.
- Sculpture in rhythmic dance poses; repetition of shapes.

Function

- Dedicated to Vishnu; most sculptures represent Vishnu's incarnations.
- May have been intended to serve as the king's mausoleum.
- Hindu temples functioned primarily as the home of the god.

Patronage

- Angkor Wat was the capital of medieval Cambodia, built by King Suryavarman II.
- The complex was built by successive kings, who installed various deities in the complex.
- The kings often identified themselves with the gods they installed.

Context

- The complex has a mixed Buddhist/Hindu character.
- Mountain-like towers symbolize the five peaks of Mount Meru, a sacred mountain said to be the center of the spiritual and physical universe in both Buddhism and Hinduism.

Content Area South, East, and Southeast Asia, Image 199

- **Cross-Cultural Comparisons for Essay Question 1: Water and Art**
 - Versailles Gardens (Figure 17.3e)
 - Kusama, *Narcissus Garden* (Figures 22.25a, 22.25b)
 - Alhambra (Figure 9.15b)
- **Churning of the Ocean of Milk**
 - The story is from the Hindu religion.
 - The story involves the churning of the ocean of the stars to obtain Amrita, the nectar of immortal life.
 - Both the gods (devas) and the devils (asuras) churn the ocean to guarantee themselves immortality.
 - To churn the ocean, they used the Serpent King, Vasuki.
 - This bas-relief at Angkor Wat depicts devas and asuras churning the Ocean of Milk.
 - Vishnu wraps a serpent around Mount Mandara; the mountain rotates around the sea and churns it.
- **Jayavarman VII as Buddha, Khmer king, reigned c.1181–1218**
 - Most famous and powerful Khmer monarch.
 - Patron of Angkor Thom.
 - Heavily influenced by his two wives, who were sisters; after his first wife's death he married her sister.
 - Jayavarman was devoted to Buddhism, although these monuments show a mixture of Buddhist and Hindu iconography.

Content Area South, East, and Southeast Asia, Image 199

Web Source http://whc.unesco.org/en/list/668/

- **Cross-Cultural Comparisons for Essay Question 1: Gardens**
 - Versailles Gardens (Figure 17.3e)
 - Ryoan-ji (Figures 25.2a, 25.2b, 25.2c)
 - Kusama, *Narcissus Garden* (Figures 22.25a, 22.25b)

Figure 23.8b: South Gate of Angkor Thom

Figure 23.8c: Churning of the Ocean of Milk

Figure 23.8d: Jayavarman VII as Buddha

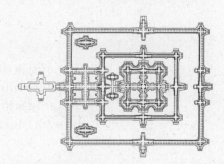

Figure 23.8e: Angkor Wat plan

PAINTING

Indians excel at painting miniatures, illustrations done with watercolor on paper, used either to illuminate books or as individual leaves kept in an album. One of the most famous schools of Indian painting is the Rajput School, which enjoyed illustrating Hindu myths and legends, especially the life of Krishna. Care is also lavished on individual portraits, which were done with immediacy and freshness.

As in most Indian art, compositions tend to be both crowded and colorful. Perspective is tilted upward so that the surface of objects, like tables or rugs, can be seen in their entirety. Floral patterns contribute to the richness of expression. Figures are painted with great delicacy and generally seem small compared to the landscape around them. They have a doll-like character that adds to the fairy-tale-like nature of the stories being illustrated.

Characteristics of Indian painting include a heightened and intense use of color, with black lines outlining figures. Humans have a wide range of emotion; figures often gesticulate wildly. Nature is seen as friendly and restorative. Few names of Indian artists have come down to us; the works are generally anonymous, even among the greatest masters.

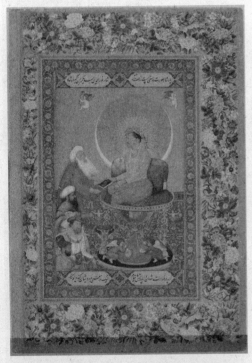

Figure 23.9: Bichitr, *Jahangir Preferring a Sufi Shaikh to Kings*, c. 1620, watercolor, gold, and ink on paper, Freer Gallery of Art, Washington, D.C.

Bichitr, *Jahangir Preferring a Sufi Shaikh to Kings*, c. 1620, watercolor, gold, and ink on paper, Freer Gallery of Art, Washington, D.C. (Figure 23.9)

Content

- Jahangir is the source of all light; he is surrounded by a halo of the sun and moon.
- Jahangir is near the end: seated on an hourglass throne; sands of time running out.
- Jahangir wears a single pearl as a devotion to an eleventh century saint.
- Sufi Sheik is handed a book by Jahangir, or perhaps the holy man is handing Jahangir the book—the book is placed on a cloth so that the sheik does not touch Jahangir.
- The sheik was the superintendent of the shrine at Ajmer, where Jahangir lived from 1613–1616.
- Holy men are placed above and rank higher than all others; the painting is thought to represent the importance of spiritual life over worldly power.
- The Ottoman sultan (not a real portrait) is placed higher than James I, but shows deference to Jahangir.
- James I of England is in the lower left-hand corner; less important than Jahangir, as his position implies; the portrait based on a diplomatic gift probably by artist John de Critz, given by ambassador Sir Thomas Roe.
- The artist, a Hindu, holds a miniature with two horses and an elephant—perhaps gifts from his patron.
- The artist is in lower left-hand corner; he symbolically signs his name on the footstool beneath Jahangir.

Quotations

- Quotation, in frame: "Though outwardly shahs stand before him, he fixes his gazes on dervishes."
- Angels wish Jahangir a long life by writing on the hourglass, "O Shah, may the span of your life be a thousand years."

Context

- Jahangir had many artists follow him wherever he went; he wanted everything recorded.
- He sought to bring together things from distant lands.
- Cross-cultural influences from Europe: a Renaissance carpet is in the background; figures of small cherubs are copied from European paintings; there is a halo behind Jahangir.
- Great interest in the Mughal court for European allegorical portraits, techniques, and motifs.

Content Area South, East, and Southeast Asia, Image 208

Web Source *www.freersackler.si.edu/object/F1942.15a/*

- **Cross-Cultural Comparisons for Essay Question 1: Works that Show Western Influence**
 - Cotsiogo, Painted elk hide (Figure 26.13)
 - Cabrera, Sor Juana Inés de la Cruz (Figure 18.6)
 - Lindauer, *Tamati Waka Nene* (Figure 28.7)

VOCABULARY

Ashlar masonry: carefully cut and grooved stones that support a building without the use of concrete or other kinds of masonry (Figure 23.7a)

Bas-relief: a very shallow relief sculpture (Figure 23.5b)

Bodhisattva: a deity who refrains from entering nirvana to help others

Buddha: a fully enlightened being. There are many Buddhas, the most famous of whom is Sakyamuni, also known as Gautama or Siddhartha (Figure 23.5c)

Cella: the main room of a temple, where the god is housed

Darshan: in Hinduism, the ability of a worshipper to see a deity and the deity to see the worshipper

Garbha griha: a "womb chamber," the inner room in a Hindu temple that houses the god's image

Horror vacui: (Latin, meaning "fear of empty spaces") a type of artwork in which the entire surface is filled with objects, people, designs, and ornaments in a crowded and sometimes congested way (Figure 23.5b)

Hypostyle: a hall with a roof supported by a dense thicket of columns

Iconoclasm: the destruction of religious images that are seen as heresy (Figure 23.2)

Mandorla: (Italian, meaning "almond") an almond-shaped circle of light around the figure of Christ or Buddha (Figure 23.2a)

Mithuna: in India, the mating of males and females in a ritualistic, symbolic, or physical sense (Figure 23.7b)

Mudra: a symbolic hand gesture in Hindu and Buddhist art (Figure 23.1)

Nirvana: an afterlife in which reincarnation ends and the soul becomes one with the supreme spirit

Puja: a Hindu prayer ritual

Sakyamuni: the historical Buddha, named after the town of Sakya, Buddha's birthplace (Figure 23.3)

Shikara: a bee-hive shaped tower on a Hindu temple (Figure 23.7a)

Shiva: the Hindu god of creation and destruction (Figure 23.6)

Stupa: a dome-shaped Buddhist shrine (Figure 23.4a)

Torana: a gateway near a stupa that has two upright posts and three horizontal lintels. They are usually elaborately carved (Figure 23.4c)

Urna: a circle of hair on the brows of a deity, sometimes represented as focal point (Figure 23.1)

Ushnisha: a protrusion at the top of the head, or the top knot of a Buddha (Figure 23.1)

Vairocana: the universal Buddha, a source of enlightenment; also known as the Supreme Buddha who represents "emptiness," that is, freedom from earthly matters to help achieve salvation (Figure 23.2a)

Vishnu: the Hindu god worshipped as the protector and preserver of the world (Figure 23.8c)

Wat: a Buddhist monastery or temple in Cambodia (Figure 23.8a)

Yakshi (masculine: **yaksha**)**:** female and male figures of fertility in Buddhist and Hindu art

SUMMARY

The diversity of the Indian subcontinent is reflected in the wide range of artistic expression one finds there. Indians typically unify the arts, so that one large monument is realized as a single creative expression involving painting, sculpture, and architecture.

Buddhist images dominate early Indian art. Buddha himself is often depicted in a meditative state, with his various mudras revealing his inner thoughts. Hindu sculptures feature a myriad of gods, with Shiva as the most dominant. Both Buddhist and Hindu temples are mound-shaped, the Buddhist works being a large, solid hemisphere, and the Hindu a sculpted mountain with a small interior.

Both Hindu and Buddhist art are marked by horror vacui, forms piled one atop the other in crowded compositions.

Multiple-Choice

Questions 1–3 refer to these images.

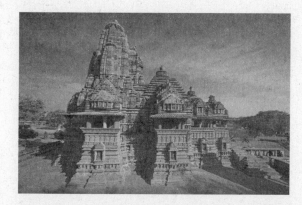 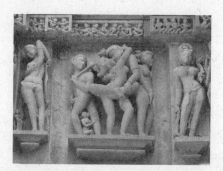

1. The Lakshmana Temple is a Hindu temple that has a narrow interior because

 (A) it symbolizes the embryo of the world, as if in its very womb
 (B) vaulting techniques were unknown
 (C) the narrow passageway symbolizes the journey to salvation
 (D) the interior darkness symbolizes the evil in the world

2. Erotic sculptures on the outside of the temple connote

 (A) inspiration
 (B) regeneration
 (C) subjugation
 (D) intolerance

3. The highly carved exterior is similar to the complex at

 (A) Borobudur, Java
 (B) Persepolis, Iran
 (C) Todai-ji, Japan
 (D) Ryoan-ji, Japan

4. Shiva as Lord of Dance depicts an episode of divine judgment in which Shiva

 (A) warns the living that judgment day is coming

 (B) judges those who have died and will be sent to heaven or hell

 (C) destroys the universe so that it can be reborn again

 (D) comforts the weak and disciplines the strong

5. The Bamiyan Buddhas were destroyed in 2001 in an act of

 (A) iconography

 (B) impluvium

 (C) isocephalism

 (D) iconoclasm

Short Essay

Practice Question 3: Visual Analysis

Suggested Time: 15 minutes

This work is *Shah Shuja Enthroned with Maharaja Gaj Singh of Marvar* by Bichitr.

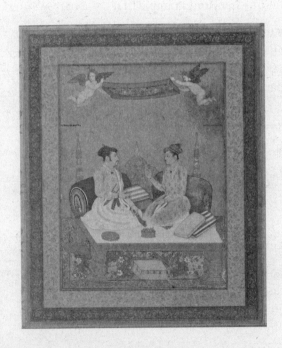

Describe *at least two* visual characteristics of this work.

Using specific visual evidence, explain *at least two* techniques that Bichitr used that are part of Indian portrait tradition.

Discuss how this work references works of art in the Western tradition.

1. **A** 2. **B** 3. **A** 4. **C** 5. **D**

ANSWERS EXPLAINED

Multiple-Choice

1. **(A)** The interiors of Hindu temples are characterized by small rooms that contain the god; they are called the "embryo" of the world and are meant to suggest the very center of existence, among many other things.

2. **(B)** The erotic sculptures are done with frankness to symbolize regeneration. They are not done to be lurid or sinful.

3. **(A)** Borobudur has many sculptures, both in relief and free standing, wrapped around its exterior.

4. **(C)** Shiva periodically dances the world to destruction and rebuilds it so that it can start afresh.

5. **(D)** Iconoclasm is defined as the destruction of images. The Bamiyan Buddhas were blown up because they were considered false idols.

Short Essay Rubric

Task	Point Value	Key Points in a Good Response
Describe *at least two* visual characteristics of this work.	2	Answers could include: ■ Work is framed in an elaborate border. ■ There is a tilted perspective: we look directly at the main figures, but they sit on a raised platform that we look down upon. ■ The colors are rich and vibrant. ■ Extensive use of gold to indicate material richness and status of the figures. ■ Words written in Indian script.
Using specific visual evidence, explain *at least two* techniques that Bichitr used that are part of Indian portrait tradition.	2	Answers could include: ■ Work done in watercolor. ■ Figures seated in an Asian-style pose. ■ Main figures are sumptuously dressed indicating their wealth and position. ■ Great attention paid to richly illustrated fabrics. ■ Great attention paid to minute details, but not at the expense of the overall scene.
Discuss how this work references works of art in the Western tradition.	1	Answers could include: ■ Putti carry a canopy over the heads of the seated figures. ■ Putti have Western-style wings and wear Western-style crowns.

Chinese and Korean Art

24

ENDURING UNDERSTANDING: Art making is influenced by available materials and processes.

Learning Objective: Discuss how material, processes, and techniques influence the making of a work of art. (For example: Terra cotta warriors)

Essential Knowledge:

- The art of China is some of the oldest in the world with the longest continuous tradition.
- Chinese artists employ a wide range of materials including ceramics and metal.
- Distinctive to China is the development of monochrome ink painting and the pagoda.
- Chinese art extensively employs stone and wood carving.
- Calligraphy was considered the highest art form in China.
- Silk weaving is an important Chinese art form.
- Elaborate floral and animal-inspired artwork is a Chinese specialty.

ENDURING UNDERSTANDING: The culture, beliefs, and physical settings of a region play an important role in the creation, subject matter, and siting of works of art.

Learning Objective: Discuss how the culture, beliefs, or physical setting can influence the making of a work of art. (For example: Funeral banner of Lady Dai)

Essential Knowledge:

- Ancient Chinese civilizations were very advanced for their time.
- Shared cultural ideas throughout Asia stimulated artistic production.
- Some of the world's greatest philosophies and religions developed in China.
- Figural subjects are common in Chinese painting.
- Daoism and Confucianism, both Chinese philosophies, explore the interconnected nature that people have with the spiritual and natural world.

ENDURING UNDERSTANDING: Art and art making can be influenced by a variety of concerns including audience, function, and patron.

Learning Objective: Discuss how art can be influenced by audience, function, and/or patron. (For example: *Chairman Mao en Route to Anyuan*)

Essential Knowledge:

- Chinese art featured a counterculture approach called the literati.
- Chinese architecture is generally religious.

ENDURING UNDERSTANDING: Cultural interaction through war, trade, and travel can influence art and art making.

Learning Objective: Discuss how works of art are influenced by cultural interaction. (For example: Longmen Caves)

Essential Knowledge:

- Asian art is influenced by global trends, and in turn influences global trends.
- Trade routes connected Asia with the world.

ENDURING UNDERSTANDING: Art history is best understood through an evolving tradition of theories and interpretations.

Learning Objective: Discuss how works of art have had an evolving interpretation based on visual analysis and interdisciplinary evidence. (For example: Gold and jade crown)

Essential Knowledge:

- Art history as a science is subject to differing interpretations and theories that change over time.

HISTORICAL BACKGROUND

Although Chinese culture seems monolithic to those in the West, China has the size and population of Europe, with the same ethnic diversity and the same number of languages. To speak in general terms of Chinese art, therefore, has the same validity as speaking in general terms about European art.

To make such a diverse subject more manageable, Chinese art is divided into historical periods named after the families who ruled China for vast stretches of time. These families, united by blood and tradition, formed dynasties, and their impact on Chinese culture has been enormous.

The first ruler of a united China was Emperor **Shi Huangdi**, who reigned in the third century B.C.E. He not only unified China politically, but was also responsible for codifying written Chinese, standardizing weights and measures, and establishing a uniform currency. Moreover, he started the famous Great Wall and began his majestic tomb. While historians have taken a more critical look at Shi Huangdi's accomplishments, his insistence on government promotion based on achievement rather than family connections had far-reaching effects on Chinese society.

Dynastic fortunes reached their greatest height during the Tang Dynasty (618–906 C.E.). Brilliant periods were also achieved under the Yuan of Kublai Khan (1215–1294) and the Ming Dynasty (1368–1644), which built the **Forbidden City** (Figure 24.2).

A particularly long-lasting and artistically rich period in Korea was formed during the Silla Dynasty (57 B.C.E.–935 C.E.). Silla rulers united with the Tang Dynasty to solidify territorial gains on the Korean peninsula. They later waged a successful war to expel the Chinese who had intended to form puppet governments throughout Korea. Silla rulers established a royal burial ground in present-day Gyeongju. The largest tomb measures over 260 feet in diameter and 400 feet long, and contains a wide array of imperial gold regalia, jewelry, pottery, and metalwork.

East Asia has been marked by a great deal of turbulence in the twentieth century. The Qing Dynasty collapsed in 1911, replaced by a chaotic rule under the Republic of China. The Japanese invasion in the 1930s caused more upheaval, as did the eventual triumph of

the communist forces under Mao Tse-tung in 1949. Peace still did not settle over China since internal struggles, such as the Cultural Revolution and the Great Leap Forward, ended up being political motives to enforce purges and persecutions.

Similarly in Korea, occupation by Japan left great scars on the Korean physical and mental landscape. The 1945 Japanese collapse left Korea as a nation divided in two. The subsequent Korean War achieved little—the country lay in ruins, and is still divided roughly the same way it was before the war. Today South Korea has a vibrant economy and is a world leader in many scientific and economic related fields. North Korea, however, remains economically stagnant.

Patronage and Artistic Life

Calligraphy is the central artistic expression in traditional China, standing as it does at a midpoint between poetry and painting. Those who wanted important state positions had to pass a battery of exams that included calligraphy. Even emperors were known to have been accomplished calligraphers, painters, and poets. Standard written Chinese is often at variance with the more cursive or running script used in paintings, some of which is so artistically rendered that modern Chinese readers cannot decipher it. Rather than letters, which are used in European languages, Chinese employs characters, each of which represents a word or an idea. Therefore, the artistic representation of a word inherently carries more meaning than a creatively written individual letter in English.

Artists worked under the patronage of religion or the state, although a counterculture was developed by a group called the **literati** who painted for themselves, eschewing public commissions and personal fame. These artists produced paintings of a highly individualized nature, not caring what the world at large would think.

At first the Korean language was written with adapted Chinese characters called **hanja**. A native alphabet was invented in 1444 during the reign of Kong Sejong, a king of the Joseon Dynasty. However, many Koreans preferred to remain loyal to the Chinese script, seeing the native writing as common and therefore for the uneducated. During the twentieth century, standard Korean began to adopt the native script as its own. Today, it is more likely to be written in a western style—that is, horizontally and from left to right—in contrast to other Asian scripts.

CHINESE PHILOSOPHIES

Daoism and **Confucianism**, the two great philosophies of ancient China, dominate all aspects of Chinese art, from the original artistic thought to the final execution. Dao, meaning "the Way," can be characterized as a religious journey that allows the pilgrim to wander meaningfully in search of self-expression. It was begun by Laozi (604–531 B.C.E.), a philosopher who believed in escaping society's pressures, achieving serenity, and working toward a oneness with nature. Daoists emphasize individual expression and strongly embrace the philosophy of doing unto others. The yin and the yang are well-known Daoist symbols (Figure 24.3c).

The great Chinese philosopher Confucius (551–479 B.C.E.) wrote about behavior, relationships, and duty in a series of precepts called *The Analects*. Built on a system of mutual respect, the Confucian model presents an ideal man whose attributes include loyalty, morality, generosity, and humanity. An important ingredient in Confucianism is respect for traditional values.

CHINESE ARCHITECTURE

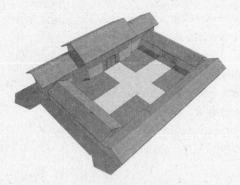

Figure 24.1: Chinese courtyard-style residence with the principal structure on the north side facing south.

The design of the stupa, a Buddhist building associated with India, moved eastward with missionaries along the Great Silk Road, transforming itself into the **pagoda** when it reached China. Built for a sacred purpose, the pagoda characteristically has one design that is repeated vertically on each level, each smaller than the design below it. In this way, pagodas achieve substantial height through a repetition of forms.

The exterior walls of a courtyard style residence (Figure 24.1) kept the crowded outside world away and framed an atrium in which family members resided in comparative tranquility. In harmony with Confucian thought, elders were to be honored and so were to live in a suite of rooms on the warmer north end of the courtyard. Children lived in the wings, servants in the south end. The southeast corner usually functioned as an entrance, and the southwest as a lavatory.

This courtyard-style arrangement is reflected on a massive scale in the **Forbidden City**. The emperor's seat is in the Hall of Supreme Harmony, itself on the north end of a courtyard; the throne faces south. The entire Forbidden City is a rectangular grid with its southern entrance and its high walls keeping the concerns of the multitude at a safe distance.

The Chinese, both in the Forbidden City and in less lavish projects, used wood for their principal building material. Tiled roofs seem to float over structures with eaves that hang away from the wall space and curve up to allow light in and keep rain out. Walls protect the interior from the weather, but do not support the building. Instead, support comes from an interior fabric of wooden columns that are grooved together rather than nailed. Corbeled brackets are used to transition the tops of columns to the swinging eaves. Wooden architecture is painted both to preserve the wood and enhance artistic effect.

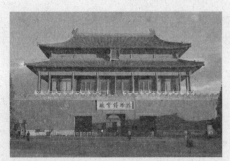

Figure 24.2a: Forbidden City, 15th century and later, stone masonry, marble, brick, wood, and ceramic tile, Beijing, China

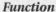

Figure 24.2b: Front Gate of the Forbidden City

Forbidden City, 15th century and later, Ming Dynasty, stone masonry, marble, brick, wood, ceramic tile, Beijing, China (Figures 24.2a, 24.2b, 24.2c, 24.2d)

Form

- Largest and most complete Chinese architectural ensemble in existence.
- 9,000 rooms.
- Walls were built 30 feet high to keep outside people out and those inside in.
- Each corner of the rectangular plan has a tower representing one of the four corners of the world.
- The focus is on the Hall of Supreme Harmony, the throne room and seat of power; it is a wooden structure made with elaborately painted beams; meant for grand ceremonies.
- Yellow tile roofs and red painted wooden beams placed on marble foundations unify the structures in the Forbidden City into an artistic whole; yellow is the emperor's color.

Function

- The emperor's palace; the seat of Chinese power: the capital of the empire during the Ming and Qing Dynasties.

- Originally built to consolidate the emperor's power.
- Ceremonies took place in the Hall of Supreme Harmony for the new year, the winter solstice, and the emperor's birthday.
- The Hall of Supreme Harmony is the largest building in the complex.

Context

- Called "Forbidden" in that no one could enter or leave the inner sanctuaries without official permission.
- The throne room was placed symbolically at the center.
- The emperor is associated with the dragon: sits on a dragon throne, wears dragon-themed robes.
- Animals and figures on the roof were placed to ward off fire and evil spirits.
- The surrounding wall of the Forbidden City is characteristic of a Chinese city: privacy within provides protection and reflects the containment aspect of Chinese culture.
- Mandate of Heaven: heaven bestows a mandate on the emperor, who rules with divine blessing as the Son of Heaven; as a result, his Forbidden City was a reflection of heaven itself.

Content Area South, East, and Southeast Asia, Image 206

Web Source *http://whc.unesco.org/en/list/439*

- **Cross-Cultural Comparisons for Essay Question 1: Centers of Power**
 - Versailles (Figure 17.3a)
 - Nan Madol (Figures 28.1a, 28.1b)
 - Barry and Pugin, Houses of Parliament (Figures 20.1a, 20.1b)

Figure 24.2c: Hall of Supreme Harmony

Figure 24.2d: Plan of Forbidden City

CHINESE AND KOREAN PAINTING

East Asian painting appears in many formats, including album leaves, fans, murals, and scrolls. Scrolls come in two formats: The handscroll (Figure 24.3a), which is horizontal and can be read on a desk or table, and the hanging scroll (Figure 24.3b), which is supported by a pole or hung for a time on a wall and unraveled vertically. No scrolls were allowed on permanent view in a home—they were something to be admired, studied, and analyzed, not hung for mere decorative qualities. Scrolls were stored away in specifically designed cabinets.

Handscrolls are read right to left. Although paper is sometimes used as a painting surface, silks are preferred and specially chosen by the artist for their color and texture to evoke a mood. The silk is then attached to wooden dowels and secured at the ends. When the scrolls are unwound, a title panel first appears, much like the title page in a book. As the scroll is carefully unrolled a section at a time, the viewer encounters both text and painting intertwined. Square red markings, made by artistically rendered seals, identify either the artist or the owners of the painting. In Chinese art, it is considered acceptable to comment on a work by writing poetry in praise of what has been read or seen. The commentaries are written on the last panel, called the **colophon**.

Landscape paintings are highly prized in Chinese art. Like European paintings of the same date, they do not seek to represent a particular forest or mountain, but reflect an artistic construct yielding a philosophical idea. Typically, some parts of a painting are empty and barren, suggesting openness and space. Other parts

Figure 24.3a: A Chinese handscroll read right to left. It starts with the title panel, moves to the main scene, and ends with a colophon.

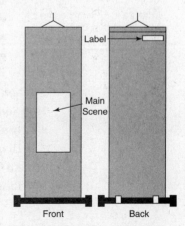

Figure 24.3b: A Chinese hanging scroll with the main scene on the front and the title on the top back.

Figure 24.3c: Yin and yang

are crowded, almost impenetrable. This intertwining of crowded and empty spaces is a reflection of the Daoist theory of **yin** and **yang** (Figure 24.3c), in which opposites flow into one another.

Another specialty is **porcelain**. Subtle and refined vase shapes are combined with imaginative designs to create works of art that appear to be utilitarian, but are actually objects that stand alone. To achieve maximum gloss and finish, sophisticated glazing techniques are applied to the surface. Glazing has the added benefit of protecting the vase from wear.

The Literati

Some artists rejected the restrictive nature of court art and developed a highly individualized style. These artists, called **literati**, worked as painters, furniture makers, and landscape architects, as well as in other fields. The literati were often scholars rather than professional artists, and by tradition did not sell their works, but gave them to friends and connoisseurs.

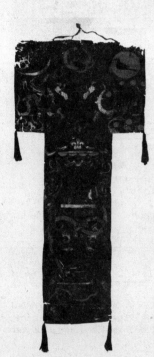

Figure 24.4: Funeral banner of Lady Dai (Xin Zhui), Han Dynasty, 180 B.C.E., painted silk, Hunan Provincial Museum, Changsha

Funeral banner of Lady Dai (Xin Zhui), Han Dynasty, 180 B.C.E., painted silk, Hunan Provincial Museum, Changsha (Figure 24.4)

Form and Content
- Painted in three distinct sections:
 - Top: Heaven, with the crescent moon at left and the legend of the ten suns at right.
 - In the center, two seated officers guard the entrance to the heavenly world.
 - Middle: Earth, with Lady Dai in the center on a white platform about to make her journey to heaven with the walking stick that was found in her tomb.
 - Mourners and assistants appear by her side.
 - Dragons' bodies are symbolically circled through a bi in a yin and yang exchange.
 - Bottom: the underworld; symbolically low creatures frame the underworld scene: fish, turtles, dragon tails; tomb guardians protect the body.

Function
- The T-shaped silk banner covered the inner coffin which contained the intact body of Lady Dai in a tomb.
- It was probably carried in a procession to the tomb, and then placed over the body to speed its journey to the afterlife.

Context
- Lady Dai died in 168 B.C.E. in the Hunan province during the Han Dynasty.
- The tomb found with more than 100 objects in 1972.
- Yin symbols on the left of the banner; Yang symbols at right; the center mixes the two philosophies; Daoist elements.

Content Area South, East, and Southeast Asia, Image 194

Web Source http://61.187.53.122/collection.aspx?id=1348&lang=en

- **Cross-Cultural Comparisons for Essay Question 1: Fabric Arts**
 - Hiapo (Figure 28.6)
 - All-T'oqapu tunic (Figure 26.10)
 - Ringgold, *Dancing at the Louvre* (Figure 29.11)

Fan Kuan, *Travelers among Mountains and Streams,* **c. 1000, ink and colors on silk, National Palace Museum, Taipei, Taiwan (Figure 24.5)**

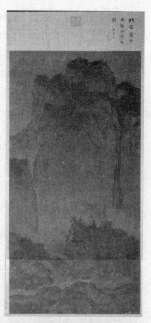

Form and Content

■ Very complex landscape.

■ Different brushstrokes describe different kinds of trees: coniferous, deciduous, etc.

■ The long waterfall on the right is balanced by a mountain on the left; the waterfall accents the height of the mountain; embodying the essence of a place rather than likeness.

■ Not a pure landscape: donkeys laden with firewood are driven by two men; a small temple appears in the forest; people seen as small and insignificant in a vast natural world.

■ Mists, created by ink washes, silhouette the roof of the temple.

Function

■ Hanging scroll; meant to be studied and appreciated, not hung permanently.

Context

■ The artist isolated himself away from civilization to be with nature and to study it for his landscapes; this reflects a Daoist philosophy.

■ The work contains elements of Daoism, Buddhism, and Confucianism.

■ This might be the artist's only surviving work; his signature is hidden in the bushes on the lower right.

Content Area South, East, and Southeast Asia, Image 201

Web Source *http://www.comuseum.com/painting/masters/fan-kuan/travelers-among-mountains-and-streams/*

Figure 24.5: Fan Kuan, *Travelers among Mountains and Streams*, c. 1000, ink and colors on silk, National Palace Museum, Taipei, Taiwan

■ **Cross-Cultural Comparisons for Essay Question 1: Figures Set in Landscape**

– Cole, *The Oxbow* (Figure 20.6)

– Breughel, *Hunters in the Snow* (Figure 14.6)

– Circle of the Gonzalez family, Screen with the Siege of Belgrade and hunting scene (Figure 18.3b)

Portrait of Sin Sukju, 1417–1475, Imperial Bureau of Painting, 15th century hanging scroll, ink and color on silk (Figure 24.6)

Form

■ Hanging scroll.

Function

■ May have served as a focus for ancestral rituals after death.

■ May have hung in a private setting in a family shrine; hence the emphasis on the rank badge.

■ Served as a reminder to his descendants of Sin Sukju's status in Korean society.

Materials

■ Painting on silk was a highly desired and a greatly esteemed product.

Context

■ Korean prime minister (1461–1464 and 1471–1475); scholar and soldier, involved in creating the modern Korean alphabet.

Figure 24.6: Portrait of Sin Sukju, 1417–1475, Imperial Bureau of Painting, 15th century hanging scroll, ink and color on silk

■ The portrait was made when he was a second-grade civil officer: insignia, or rank badge, designed with clouds and a wild goose.

■ Korean portraits emphasize how the subject made a great contribution to the country and how the spirit of loyalty to king and country was valued by Confucian philosophy.

- Repainted over the years, especially in 1475, when Sin Sukju died, as an act of reverence for a departed ancestor.

Content Area South, East, and Southeast Asia, Image 205

Web Source *http://koreaarthistory.weebly.com/traditional-paintings.html*

- **Cross-Cultural Comparisons for Essay Question 1: Painting Technique**
 - Campin, Annunciation Triptych (Figure 14.1)
 - Rivera, *Dream of a Sunday Afternoon in the Alameda Park* (Figure 22.20)
 - Smith, *Lying with the Wolf* (Figure 29.20)

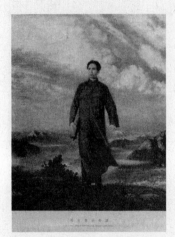

Figure 24.7: *Chairman Mao en Route to Anyuan*, artist unknown, based on an oil painting by Liu Chunhua, 1969, color lithograph, Private Collection

Chairman Mao en Route to Anyuan, **artist unknown, based on an oil painting by Liu Chunhua, 1969, color lithograph, Private Collection (Figure 24.7)**

Form

- Mao rises above a landscape that contains a power line as a symbol of industrialization.
- Iconic representation of the great leader's career.
- Poster-like; vivid colors, dramatic, and with obvious political message.

Function

- Done as propaganda: Mao appears youthful, heroic, and idealized.
- May be the most reproduced image ever made: 900,000,000 copies were generated.

Context

- Painted during the Cultural Revolution of 1966–1976; high art was dismissed as feudal or bourgeois; art was created to be of service to the state.
- Based on an oil painting by Liu Chunhua, which first appeared at the Beijing Museum of the Revolution in 1967.
- This type of art was done anonymously; individual artistic fame was seen as countercultural in a collectivist society.

- A moment in the 1920s; Mao on his way to Anyuan to lead a miners' strike.
- Mao worked for reforms for miners; supported a local strike for better wages, working conditions, and education.
- For many people, this action formed a permanent bond with the Communist Party.

Content Area South, East, and Southeast Asia, Image 212

Web Source *https://www.learner.org/series/art-through-time-a-global-view/conflict-and-resistance/chairman-mao-en-route-to-anyuan/*

- **Cross-Cultural Comparisons for Essay Question 1: Non-Western Works Using Western Ideas**
 - Bandolier bag (Figure 26.11)
 - Lindauer, *Tamati Waka Nene* (Figure 28.7)
 - Frontispiece of the Codex Mendoza (Figure 18.1)

CHINESE SCULPTURE

China is a monumental civilization that has produced large-scale sculpture as a sign of grandeur. Enormous scale, without sacrificing artistic integrity, is a typical Chinese characteristic epitomized by the terra cotta army of **Shi Huangdi** (Figures 24.8a and 24.8b) and the huge **seated Buddha at Longmen** (Figure 24.9a). The Chinese have created a dazzling number of sculptures cut from the rock in situ, a technique probably imported from India.

At the same time, Chinese sculpture is known for intricately designed miniature objects. Those made of jade are especially prized for their beauty; they are durable and polished to a high shine in a matte green-gray color.

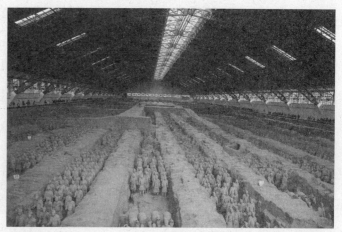

Figure 24.8a: Terra cotta warriors from the mausoleum of the first Qin emperor of China, Qin Dynasty, painted terra cotta, c. 221–209 B.C.E., Lintong, China

Terra cotta warriors from the mausoleum of the first Qin emperor of China, Qin Dynasty, painted terra cotta, c. 221–209 B.C.E., Lintong, China (Figures 24.8a and 24.8b)

Form

- About 8,000 terra cotta warriors, 100 wooden chariots, 2 bronze chariots, 30,000 weapons.
- Soldiers are 6-feet tall—taller than the average person of the time; some are fierce, some proud, some confident; actually held metal weapons.
- Originally colorfully painted.
- Tomb oriented north–south.
- The tomb has a rectangular double-walled enclosure.

Function

- Tomb of Emperor Shi Huangdi, founder of the first unified Chinese empire.

Context

- The work represents a Chinese army marching into the next world.
- Each soldier's face is unique and expresses the army's ethnic diversity.
- Daoism is seen in the individualization of each soldier despite their numbers.
- This is an early form of mass production, alluding to the power of the state.
- Discovered in 1974.

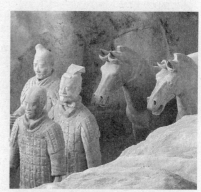

Figure 24.8b: Terra cotta warriors

Content Area South, East, and Southeast Asia, Image 193

Web Source http://whc.unesco.org/pg.cfm?cid=31&id_site=441

- **Cross-Cultural Comparisons for Essay Question 1: Intentionally Buried Works**
 - Tomb of Tutankhamun (Figure 3.11)
 - Catacomb of Priscilla (Figure 7.1a)
 - Tomb of the Triclinium (Figure 5.3)

Longmen Caves, 493–1127, Tang Dynasty, limestone, Luoyang, China (Figures 24.9a, 24.9b, and 24.9c)

Form

- The Buddha is arranged as if on an altar of a temple, deeply set into the rock face.
- Vairocana Buddha is flanked by monk attendants, bodhisattvas, and guardians; perhaps a portrait of Wu Zetian.
- The figures have elongated legs and exaggerated poses.
- Sculptures and reliefs are carved from the existing rock—some colossal, some small.
- Realistic musculature of the heavenly guardians (Figure 24.9b) shows them as able protectors and defenders of the faith.

Patronage

- Inscription states that Empress Wu Zetian was the principal patroness of the site and that she used her private funds to finance the project.

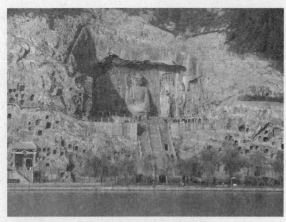

Figure 24.9a: Longmen Caves with Vairocana Buddha, 493–1127, Tang Dynasty, limestone, Luoyang, China

Figure 24.9b: Longmen Caves detail

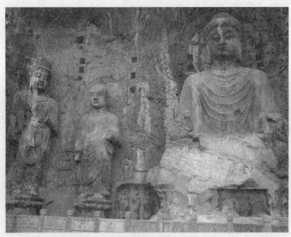

Figure 24.9c: Longmen Caves detail

Context

- More than 2,300 caves and niches are carved along the banks of the Yi River.
- Documents attest that 800,000 people worked on the site; they produced 110,000 Buddhist stone statues, more than 60 stupas, and 2,800 inscriptions on steles.

Content Area South, East, and Southeast Asia, Image 195

Web Source *http://whc.unesco.org/en/list/1003*

- **Cross-Cultural Comparisons for Essay Question 1: Grand Outdoor Sculpture**
 - Great Altar of Zeus and Athena at Pergamon (Figures 4.18a, 4.18b)
 - Bamiyan Buddha (Figure 23.2)
 - Moai (Figure 28.11)

Figure 24.10: Gold and jade crown, Three Kingdoms period, Silla Kingdom, 5th–6th century, metalwork, National Museum of Korea, South Korea

Gold and jade crown, Three Kingdoms period, Silla Kingdom, 5th–6th century, metalwork, National Museum of Korea, Seoul, South Korea (Figure 24.10)

Function

- Crown is very lightweight and therefore had limited use—maybe for ceremonial occasions or perhaps only for burial.

Context

- Stylized geometric shapes symbolize trees.
- Antler forms influenced by shamanistic practices in Siberia.
- Uncovered from a royal tomb in Gyeongju, Korea; from the Silla Dynasty.

Content Area South, East, and Southeast Asia, Image 196

Web Source *http://www.metmuseum.org/exhibitions/listings/2013/koreas-golden-kingdom*

- **Cross-Cultural Comparisons for Essay Question 1: Metalwork**
 - Merovingian looped fibulae (Figure 10.1)
 - Golden Stool (Figure 27.4)
 - El Anatsui, *Old Man's Cloth* (Figure 29.23)

PORCELAIN

Almost every world culture has a tradition of ceramics, few as fine as those from China. Originally most ceramics were made by the **coiling** method, in which clay was rolled onto a long, flat surface so that it resembles a long cord. The cords were wrapped around themselves creating a sculpture, sometimes of considerable size. To remove the appearance of the coils, the edges were often smoothed out with the artist's hands or an instrument.

Later the clay was placed on a round tray and made to revolve using a pedal; this began the invention of the **potter's wheel**. The process of making pottery on a wheel is called **throwing**. The potter uses his or her hands to shape the pottery as it revolves.

Yuan Dynasty (1279–1368) vases have a distinctive blue and white color. The cobalt used to make the iridescent blue was imported from Iran and greatly prized by the Chinese.

The David Vases, Yuan Dynasty, 1351, white porcelain with cobalt-blue underglaze, British Museum, London (Figure 24.11)

Figure 24.11: The David Vases, Yuan Dynasty, 1351, white porcelain with cobalt-blue underglaze, British Museum, London

Form and Content
- The blue color was imported from Iran; Chinese expansion into western Asia made the cobalt blue available.
- The vases were modeled after bronzes of the same type.
- The necks and feet of the vases contain leaves and flowers.
- They have elephant-head-shaped handles.
- Central section: Chinese dragons with traditional long bodies and beards; dragons have scales and claws, and are set in a sea of clouds.

Function
- Made for the altar of a Daoist temple along with an incense burner, which has not been found; a typical altar set.
- Site heavily damaged during the twentieth century.

Materials
- Made of Jingdezhen porcelain, the same materials found in Ai Weiwei's *Sunflower Seeds* (cf. Figure 29.27).

Context
- One of the most important examples of Chinese blue and white porcelain in existence.
- A dedication is written on the side of the neck of the vessels; believed to be the earliest known blue-and-white porcelain dedication.
- Inscription on one of the vases: "Zhang Wenjin, from Jingtang community, Dejiao village, Shuncheng township, Yushan county, Xinzhou circuit, a disciple of the Holy Gods, is pleased to offer a set comprising one incense-burner and a pair of flower vases to General Hu Jingyi at the Original Palace in Xingyuan, as a prayer for the protection and blessing of the whole family and for the peace of his sons and daughters. Carefully offered on an auspicious day in the Fourth Month, Eleventh year of the Zhizheng reign."
- Named after Sir Percival David, a collector of Chinese art.

Content Area South, East, and Southeast Asia, Image 204

Web Source *https://www.britishmuseum.org/research/collection_online/collection_object_details.aspx?objectId=3181344&partId=1*

- **Cross-Cultural Comparisons for Essay Question 1: Porcelain and Ceramic**
 - Martínez, Black-on-black ceramic vessel (Figure 26.14)
 - Niobides Krater (Figures 4.19a, 4.19b)
 - Terra cotta warriors (Figures 24.8a, 24.8b)

VOCABULARY

Bi: a round ceremonial disk found in ancient Chinese tombs; characterized by having a circular hole in the center, which may have symbolized heaven

Bodhisattva: a deity who refrains from entering nirvana to help others (Figure 24.9c)

Coiling: a method of creating pottery in which a rope-like strand of clay is wrapped and layered into a shape before being fired in a kiln

Colophon: a commentary on the end panel of a Chinese handscroll; an inscription at the end of a manuscript containing relevant information on its publication (Figure 24.3a)

Confucianism: a philosophical belief begun by Confucius that stresses education, devotion to family, mutual respect, and traditional culture

Daoism: a philosophical belief begun by Laozi that stresses individual expression and a striving to find balance in one's life

Hanja: Chinese characters used in Korean script with a Korean pronunciation

Literati: a sophisticated and scholarly group of Chinese artists who painted for themselves rather than for fame and mass acceptance. Their work is highly individualized

Pagoda: a tower built of many stories. Each succeeding story is identical in style to the one beneath it, only smaller. Pagodas typically have dramatically projecting eaves that curl up at the ends

Porcelain: a ceramic made from clay that when fired in a kiln produces a product that is hard, white, brittle, and shiny

Potter's wheel: a device that usually has a pedal used to make a flat circular table spin, so that a potter can create pottery

Throwing: molding clay forms on a potter's wheel

Vairocana: the universal Buddha, a source of enlightenment; also known as the Supreme Buddha who represents "emptiness," that is, freedom from earthly matters to help achieve salvation (Figure 24.9c)

Yin and yang: complementary polarities. The yin is a feminine symbol that has dark, soft, moist, and weak characteristics. The yang is the male symbol that has bright, hard, dry, and strong characteristics (Figure 24.3c)

SUMMARY

The great Chinese philosophies of Daoism and Confucianism dominate the fine arts, as well as all intellectual thought in China. They express the relationship of buildings to one another in courtyard-style residences from the most humble to the Forbidden City. They also articulate a relationship of the forms in Chinese painting.

Chinese artists apprenticed under a master and worked under a system of patronage controlled by religion or government. A powerful minority, the literati, deliberately chose to walk away from traditional artistic venues and cultivate a more individualized type of art.

Chinese art has a penchant for the monumental and the grand, epitomized by the Great Wall, the Colossal Buddhas, and the Tomb of Shi Huangdi. Considerable attention, however, is paid to smaller items such as delicate porcelains, finely cut jade figures, and laquered wooden objects.

Multiple-Choice

1. The tomb of the Terra cotta warriors from the first Qin emperor of China has more than 8,000 soldiers who are

 (A) alike to show their uniformity in protecting the emperor
 (B) unpainted to contrast with the colorful image of the emperor more forcefully
 (C) subtly different to show their ethnic diversity of China
 (D) from every social class, gender, and age in China

Questions 2–4 refer to this image.

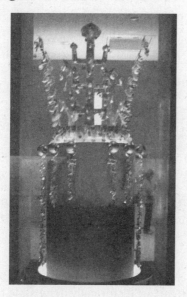

2. This Korean crown was found

 (A) in a royal sanctuary placed with other religious objects
 (B) on the head of a large sculpture of Buddha
 (C) in a royal tomb buried in a mound
 (D) in Japan, given as a diplomatic gift to the Japanese emperor

3. It is assumed that the crown was probably not meant to be worn because

 (A) the gold is too precious and would have been easily stolen
 (B) gold is a soft metal that could be easily bent if worn
 (C) the gold applied here is extremely thin and fragile
 (D) the whole crown was too heavy to be worn comfortably

4. The uprights probably symbolized

 (A) a distinctive royal lineage of a "family tree" that came from the gods to the wearer
 (B) a stylized tree with antler forms that denoted spiritual power
 (C) everlasting peace achievable through the gods and the divinely appointed emperor
 (D) the riches of an earthly kingdom reflecting the glory of an eternal world

5. Which of the following Chinese art forms inspired contemporary artwork?

 (A) Chinese music as seen in *Horn Players*
 (B) Chinese porcelains as seen in *Pink Panther*
 (C) Chinese photography as seen in *Rebellious Silence*
 (D) Chinese writing as seen in *A Book from the Sky*

Long Essay

Practice Question 2: Visual and Contextual Analysis
Suggested Time: 25 minutes

As a faith, Buddhism has often had a strong impact on the art of Asia.

Select and completely identify a work of Buddhist art from the list below, or any other relevant work from Asia.

Explain how artists or architects have constructed Buddhist monuments to reflect the imagery and practice of the Buddhist faith as seen in the work you have selected.

In your answer, make sure to:

- Accurately identify the work you have chosen with *at least two* identifiers beyond those given.
- Respond to the question with an art historically defensible thesis statement.
- Support your claim with *at least two* examples of visual and/or contextual evidence.
- Explain how the evidence that you have supplied supports your thesis.
- Use your evidence to corroborate or modify your thesis.

Great Stupa at Sanchi
Longmen Caves
Todai-ji

ANSWERS EXPLAINED

Multiple-Choice

1. **(C)** Each of the figures is subtly different to depict various ethnic features in different regions of China. There are no women, or old or young people.

2. **(C)** The crown was found in a tumulus, or burial mound.

3. **(C)** The gold is extremely thin and very fragile; it was meant only for limited occasions or mostly likely burial.

4. **(B)** The uprights symbolize a stylized tree reaching up to the sky. They have connections with spiritual forces.

5. **(D)** Xu Bing's *A Book from the Sky* contains references to traditional Chinese art, book-making, and calligraphy, although much of the calligraphy is made up.

Long Essay Rubric

Task	Point Value	Key Points in a Good Response
Accurately identify the work you have chosen with *at least two* identifiers beyond those given.	1	■ For the Great Stupa at Sanchi: Madhya Pradesh, India, late Sunga Dynasty, c. 300 B.C.E.–100 C.E.; stone masonry, sandstone on dome. ■ For Longmen Caves: Laoyang, China, Tang Dynasty, 493–1127 C.E., limestone. ■ For Todai-ji: Nara, Japan, various artists including sculptors Unkei and Keikei as well as the Kei School, 743, rebuilt c. 1700, bronze and wood (sculpture) wood with ceramic-tile roofing (architecture).
Respond to the question with an art historically defensible thesis statement.	1	The thesis statement must be an art historically sound claim that responds to the question and does not merely restate it. The thesis statement should come at the beginning of the argument and be at least one, preferably two sentences. For example: The Longmen Caves represent an extensive Buddhist monument that is composed of 2,300 caves and niches dedicated to the worship of Buddha. The main focus is a huge sculpture of Buddha that is set on an altar-like pedestal.
Support your claim with *at least two* examples of visual and/or contextual evidence.	2	*Two* visual *or* contextual examples are needed to supply the necessary evidence. Part of the evidence could involve a discussion of how the artist has rendered stories about Buddha, or how the stupa functions in Buddhist worship, or how Buddhist shrines are constructed in Japan.
Explain how the evidence that you have supplied supports your thesis.	1	Good responses link the evidence you have provided with the main thesis statement. With these examples, you could discuss how patronage has played a role in the artists' rendering of the Buddha image or a Buddhist shrine.
Use your evidence to corroborate or modify your thesis.	1	This point is earned when a student demonstrates a depth of understanding, in this case of Buddhist monuments. The student must demonstrate multiple insights on a given subject. For example, you could discuss how Asian artists have manifested the image of Buddha in different ways and yet have remained true to the overall Buddhist tradition.

Content Area: South, East, and Southeast Asia, 300 B.C.E.–1980 C.E.

Japanese Art

TIME PERIOD: 1789–1848

ENDURING UNDERSTANDING: Art making is influenced by available materials and processes.

Learning Objective: Discuss how material, processes, and techniques influence the making of a work of art. (For example: Hokusai, the Great Wave)

Essential Knowledge:

- The art of Japan is some of the oldest in the world with the longest continuous tradition.
- Distinctive to Japan is the development of rock gardens, teahouses, and wood-block printing.
- Japanese architecture uses natural materials such as wood and stone.
- Calligraphy is highly prized in Japan.
- Elaborate floral and animal-inspired artwork is a Japanese specialty.

ENDURING UNDERSTANDING: The culture, beliefs, and physical settings of a region play an important role in the creation, subject matter, and siting of works of art.

Learning Objective: Discuss how the culture, beliefs, or physical setting can influence the making of a work of art. (For example: Dry garden at Ryoan-ji)

Essential Knowledge:

- Ancient Japanese civilizations were very advanced for their time.
- Shared cultural ideas throughout Asia stimulated artistic production.
- Figural subjects are common in Japanese painting.
- Zen rock gardens and ink paintings were popular in Japan.

ENDURING UNDERSTANDING: Art and art making can be influenced by a variety of concerns including audience, function, and patron.

Learning Objective: Discuss how art can be influenced by audience, function, and/or patron. (For example: Ogata Korin, *White and Red Plum Blossoms*)

Essential Knowledge:

- Japanese art featured a counterculture approach that highlighted the achievements of nonprofessional artists with new types of subject matter.
- Architecture is generally religious.

ENDURING UNDERSTANDING: Cultural interaction through war, trade, and travel can influence art and art making.

Learning Objective: Discuss how works of art are influenced by cultural interaction. (For example: Great Buddha at Todai-ji)

Essential Knowledge:

■ Asian art is influenced by global trends, and in turn influences global trends.

■ Trade routes connected Asia with the world.

■ Buddhism was imported from Korea and China and was widely popular in part because of courtly patronage.

ENDURING UNDERSTANDING: Art history is best understood through an evolving tradition of theories and interpretations.

Learning Objective: Discuss how works of art have had an evolving interpretation based on visual analysis and interdisciplinary evidence. (For example: Nio guardian figures)

Essential Knowledge:

■ Art history as a science is subject to differing interpretations and theories that change over time.

HISTORICAL BACKGROUND

Japan is one of the few countries in the world that has never been successfully invaded by an outside army. There are those who have tried, like the Mongols in 1281, whose fleet was destroyed by a typhoon called a kamikaze, or divine wind, and there are those who have defeated the Japanese without invading, like the Allies in World War II, who never landed a force on the four principal islands, until the war was over.

Because of the relatively sheltered nature of the Japanese archipelago, and the infrequency of foreign interference, Japan has a greater proportion of its traditional artistic patrimony than almost any other country in the world. It was Commodore Perry who opened Japan, to outside influence in 1854. One by-product of Perry's intervention was the shipment of **ukiyo-e** prints to European markets, first as packing material and then in their own right. They achieved enduring fame in nineteenth-century Europe and America, but were looked down upon by the upper classes in Japan, who were more than willing to send them off for export.

Patronage and Artistic Life

Japanese artists worked on commission, some for the royal court, others in the service of religion. Masters ran workshops with a range of assistants—the tradition in Japan usually marking this as a family-run business with the eldest son inheriting the trade. Assistants learned from the ground up, making paper and ink, for example. The master created the composition by brushing in key outlines and his assistants worked on the colors and details.

Painting is highly esteemed in Japan. Aristocrats of both sexes not only learned to paint, but became distinguished in the art form.

ZEN BUDDHISM

Zen is a school of Buddhism that is deeply rooted in all East Asian societies, and was imported from China in the late twelfth century. It had a particularly great impact on the art of Japan, where the Zen philosophy was warmly embraced.

Zen adherents reject worldliness, the collection of goods for their own sake, and physical adornment. Instead, the Zen world is centered on austerity, self-control, courage, and loyalty. Meditation is key to enlightenment; for example, samurai warriors reach deeply into themselves to perform acts of bravery and great physical endurance.

Zen teaches through intuition and introspection, rather than through books and scripture. Warriors as well as artists were quick to adopt a Zen philosophy.

THE JAPANESE TEA CEREMONY

The tea ceremony is a ritual of greater importance than it at first seems to the Westerner. The simple details, the crude vessels, the refined tea, the uncomplicated gestures—these alluring items are all part of a seemingly casual, but in fact, highly sophisticated tea ceremony that endures because of its minimalism. Teahouses have bamboo and wooden walls with floor mats of woven straw. Everything is carefully arranged to give the sense of straightforwardness and delicacy.

Visitors enter through a low doorway—symbolizing their humbleness—into a private setting. Rectangular spaces are broken by an unadorned alcove that houses a Zen painting done in a free and monochromatic style, selected to enhance an intimate atmosphere of warm and dark spaces.

Participants sit on the floor in a small space usually designed for about five people, and drink tea. The ceremony requires four principles: Purity, harmony, respect, and tranquility. All elements of the ceremony are proscribed, even the purification ritual of hand washing and the types of conversation allowed.

JAPANESE ARCHITECTURE AND SCULPTURE

The austerity of **Zen** philosophy can be most readily seen in the simplicity of architectural design that dominates Japanese buildings. A traditional structure is usually a single story, made of wood, and meant to harmonize with its natural environment. The wood is typically undressed—the fine grains appreciated by the Japanese. Because wood is relatively light, the pillars could be placed at wide intervals to support the roof, opening the interior most dramatically to the outdoors.

Floors are raised above the ground to reduce humidity by allowing the air to circulate under the building. Eaves are long to generate shady interiors in the summer, and steeply pitched to allow the quick runoff of rain and snow.

Interiors have mobile spaces created by sliding screens, which act as room dividers, by changing its dimensions at will. Particularly lavish homes may have gilded screens, but most are of wooden materials. The floors are overlaid with removable straw mats.

A principal innovation in Japanese design is the Zen garden, which features meticulous arrangements of raked sand circling around prominently placed stones and plants (Figure 25.2b). Each garden suggests wider vistas and elaborate landscapes. Zen gardens contain no water, but the careful placement of rocks often suggests a cascade or a rushing stream. Ultimately these gardens serve for spiritual refreshment, a place of contemplation and rejuvenation.

There is a deep respect for the natural world in Japanese thought. The native religion, Shintoism, believes in the sacredness of spirits inherent in nature. In a heavily forested and rocky terrained country like Japan, wood becomes the natural choice for building, and stone for Zen gardens.

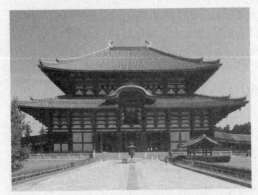
Figure 25.1a: Todai-ji, 743, rebuilt c. 1700, wood with ceramic tile roofing, Nara, Japan

Todai-ji, 743, rebuilt c. 1700, wood with ceramic tile roofing, Nara, Japan (Figure 25.1a)

Various artists including sculptors Unkei and Keikei, as well as the Kei school.

Form
- A two-story building with long, graceful eaves hanging over the edges: the eaves protect the interior from the sun and rain.
- Seven external bays on the façade.

Function
- This is the original center of the Buddhist faith in Japan, from which ancillary temples around the country were served.
- The building expresses an imperial and political authority combined with religious overtones.
- It served as a center for the training of scholar monks, who studied Buddhist doctrines.

Context
- The name Great Eastern Temple refers to its location on the eastern edge of the city of Nara, Japan (called Daibutuden).
- The temple is noted for its colossal sculpture of seated Vairocana Buddha.
- The temple and Buddha have been razed several times during military unrest.
- The Buddha is influenced by monumental Chinese sculptures (cf. Longmen Caves, Figures 24.9a, 24.9b, 24.9c).

Content Area South, East, and Southeast Asia, Image 197

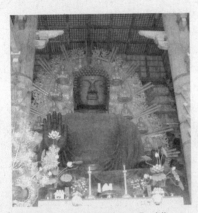
Figure 25.1b: Todai-ji, Great Buddha, base 8th century, upper portion including head 12th century, bronze

Great Buddha, base 8th century, upper portion including head 12th century, bronze (Figure 25.1b)

- Largest metal statue of Buddha in the world.
- Monumental feat of casting.
- Emperor Shōmu embraced Buddhism and erected sculpture as a way of stabilizing Japanese population during a time of economic crisis.
- Mudra: right hand means "do not fear"; left hand means "welcome."

Content Area South, East, and Southeast Asia, Image 197

- **Cross-Cultural Comparisons for Essay Question 1: Images of Buddha Across Asia**
 - Bamiyan Buddha (Figure 23.2)
 - Jowo Rinpoche (Figure 23.3)
 - Longmen Caves (Figures 24.9a, 24.9b, 24.9c)

Nio guardian figures, c. 1203, wood, by Unkei (Figures 25.1c and 25.1d)

- They are placed on either side of the Todai-ji south gate.
- The sculptures are a series of complexly joined woodblock pieces.
- Masculine, frightening figures that protect the Buddha derived from Chinese guardian figures such as those at Luoyang.
- Fierce, forbidding looks and gestures.
- Intricate swirling drapery.

Content Area South, East, and Southeast Asia, Image 197

Figure 25.1c: Nio guardian figure, c. 1203, wood, by Unkei

Figure 25.1d: Nio guardian figure, c. 1203, wood, by Unkei

Great South Gate, 1181–1203, wood with ceramic tile roofing (Figure 25.1e)

- This is the main gate of Todai-ji.
- Nandaimon: great south gate, with five bays—three central bays for passing and two outer bays that are closed.
- The two stories are the same size: unusual in Japanese architecture (usually the upper story is smaller).
- Deep eaves are supported by the six-stepped bracket complex, which rise in tiers with no bracketed arms.
- The roof is supported by huge pillars.
- Unusual in that it has no ceiling; the roof is exposed from below.
- Overall effect is of proportion and stateliness.

Content Area South, East, and Southeast Asia, Image 197

Web Source http://www.todaiji.or.jp/english/

- **Cross-Cultural Comparisons for Essay Question 1: Entrances**
 - Great Portal, Chartres (Figure 12.6)
 - North Gate of the Great Stupa (Figure 23.4c)
 - Front Gate of the Forbidden City (Figure 24.2b)

Figure 25.1e: Great South Gate, 1181–1203, wood with ceramic tile roofing

Ryoan-ji, Muromachi period, c. 1480, current design 18th century, rock garden, Kyoto, Japan (Figures 25.2a, 25.2b, 25.2c)

- Garden as a microcosm of nature.
- Zen dry garden:
 - Gravel represents water; gravel is raked in wavy patterns daily by monks.
 - Rocks represent mountain ranges.
 - Asymmetrical arrangement.
 - The garden is bounded on two sides by a low, yellow wall.
 - Fifteen rocks arranged in three groups interpreted as:
 - Islands in a floating sea.
 - Mountain peaks above clouds.
 - Constellations in the sky.
 - A tiger taking her cubs across a stream.

Figure 25.2a: Ryoan-ji, Muromachi period, c. 1480, current design 18th century, wet garden, Kyoto, Japan

Figure 25.2b: Ryoan-ji, dry garden

Figure 25.2c: Ryoan-ji, plan

- – Meant to be viewed from a veranda in a nearby building, the abbot's residence.
- – From no viewpoint is the entire garden viewable at once.
- – Garden served as a focus for meditation; in a sense, a garden entered by the mind.
- ■ Wet garden:
 - – Contains a teahouse.
 - – Seemingly arbitrary in placement, the plants are actually placed in a highly organized and structured environment symbolizing the natural world.
 - – Water symbolizes purification; used in rituals.

Content Area South, East, and Southeast Asia, Image 207

Web Source *http://www.ryoanji.jp/smph/eng/*

- ■ **Cross-Cultural Comparisons for Essay Question 1: People and Nature**
 - – Weiwei, *Sunflower Seeds* (Figure 29.27)
 - – Velasco, *Valley of Mexico* (Figure 21.4)
 - – Turner, *Slave Ship* (Figure 20.5)

JAPANESE PAINTING AND PRINTMAKING

Chinese painting techniques and formats were popular in Japan as well, so it is common to see the Japanese as masters of the handscroll, the hanging scroll, and the decorative screen.

Characteristics of the Japanese style include elevated viewpoints, diagonal lines, and depersonalized faces.

A Japanese specialty is **haboku** or **ink-splashed** painting that involved applying in a free and open style that gives the illusion of being splashed on the surface. The preponderance of Chinese imagery and painting techniques caused a reaction in Japan, as artists and patrons sought to find a national voice, independent of other Asian traditions. **Yamato-e**, developed in the twelfth century, features tales from Japanese history and literature depicted usually in long narrative scrolls. There is a depersonalization of figures in yamato-e works, often with just a line to indicate the eyes and mouth, and many times the nose is missing or just suggested. Strong diagonals dominate compositions that feature buildings with their roofs missing so we can see inside. Clouds are used to divide compositions into sections so they become more manageable to the viewer.

Genre painting from the seventeenth to the nineteenth centuries was dominated by **ukiyo-e**, a term that means "pictures of the floating world." The word "floating" is meant in the Buddhist sense of the passing or transient nature of life; therefore ukiyo-e works depict scenes of everyday life or pleasure: festivals, theater (i.e., the kabuki), domestic life, geishas, brothels, and so on. Ukiyo-e is most famously represented in wood-block prints, although it can be found on scrolls and painted screens.

Ukiyo-e was immensely popular; millions of prints were sold to the middle class during its heyday, usually put between 1658 and 1858. Although disdained by the Japanese upper classes for being popular, they won particular affection in Europe and in the Americas as an example of innovative Japanese art.

Printmaking was a collaborative process between the artist and the publisher. The publisher determined the market, dictated the subject matter and style, and employed the wood-block carver and the printer. At first, all prints were in black and white, but the popularity encouraged experimentation, and a two-color system was introduced in 1741.

By 1765, a polychrome print was created, and while this made the product more time-consuming to create and therefore more expensive, it was wildly popular and sold enthusiastically. Colors are subtle and delicate, and separated by black lines. Each color was applied one at a time, requiring a separate step in the printmaking process. This made the steps complicated with precise alignments critical to a successful print. Suzuki Harunobu was the first successful ukiyo-e artist in the polychrome tradition. **Hokusai** explored the relationship of ukiyo-e and landscape painting.

Western artists were taken with ukiyo-e prints. They particularly enjoyed the flat areas of color, the largely unmodulated tones, the lack of shadows, and the odd compositional angles, with figures occasionally seen from behind. Forms are often unexpectedly cut off and cropped by the frame of the work. The Western interest in realistic subject matter found agreement in ukiyo-e prints.

Figure 25.3a: *Night Attack on the Sanjô Palace*, Kamakura period, c. 1250–1300, handscroll (ink and color on paper), Museum of Fine Arts, Boston.

Night Attack on the Sanjô Palace, **Kamakura period, c. 1250–1300, Handscroll (ink and color on paper), Museum of Fine Arts, Boston (Figures 25.3a and 25.3b)**

Figure 25.3b: *Night Attack on the Sanjô Palace*, detail

Form
- A narrative work that is read from right to left as the scroll is unrolled.
- Point of view: one looks down from above onto the scene, which takes place in Kyoto.
- Strong diagonals emphasize movement and action.
- Swift, active brushstrokes.
- Depersonalized figures; many with only one stroke for the eyes, ears, and mouth.
- Tangled mass of forms accentuated by Japanese armor.
- Final scene: lone archer leads the escape from the burning palace with the Japanese commander behind him.

Function
- Hand scroll, meant to be read and studied, not meant to be placed on permanent display.

Context
- Military rule in Japan from 1185 on had an interest in the code of the warrior; reflected in the large quantity of war-related literature and paintings.
- Scroll depicts a coup staged in 1159 as Emperor Go-Shirakawa is taken prisoner.
- Burning of the imperial palace at Sanjô in Kyoto as rebel forces try to seize power by capturing a retired emperor.
- Imperial palace in flames; rebels force the emperor to board a cart waiting to take him into captivity.
- Rebels kill those opposed and place their heads on sticks and parade them as trophies.
- Painted a hundred years after the civil war depicted in the scene.
- Unrolls like a film sequence; as one unrolls, time advances.

Content Area South, East, and Southeast Asia, Image 203

Web Source *http://learn.bowdoin.edu/heijiscroll/*

Ogata Korin, *White and Red Plum Blossoms*, 1710–1716, ink, watercolor, and gold leaf on paper, MOA Museum of Art, Atami, Japan (Figures 25.4a and 25.4b)

Form

■ A stream cuts rhythmically through the scene; swirls in the paint surface indicate water currents.

■ White plum blossoms on left; red on right.

■ The artist worked in vivid colors or ink monochrome on gold ground.

■ This work has more abstracted and simplified forms than the compositions of Ogata's predecessors.

■ Old tree on left is balanced by new tree on right.

Function

■ Japanese screen, usually used to separate spaces in a room.

Context

■ Japanese rinpa style named for Ogata (*Rin*, for Ko-rin, and *pa*, meaning "school").

■ The work is influenced by the yamato-e style of painting.

■ Tarashikomi technique, in which paint is applied to a surface that has not already dried from a previous application; creates a dripping effect, useful in depicting streams or flowers.

■ The artist was a member of a Kyoto family of textile merchants that serviced samurai, a few nobility, and city dwellers.

Content Area South, East, and Southeast Asia, Image 210

Web Source for Rinpa Style *http://www.metmuseum.org/toah/hd/rinp/hd_rinp.htm*

Figures 25.4a and 25.4b: Ogata Korin, *White and Red Plum Blossoms*, 1710–1716, ink, watercolor, and gold leaf on paper, MOA Museum of Art, Atami, Japan

Hokusai, *Under the Wave off Kanagawa (Kanagawa oki nami ura)*, called the Great Wave, from the series Thirty-six Views of Mount Fuji, 1830–1833, polychrome wood-block print; ink and color on paper, Metropolitan Museum of Art, New York (Figure 25.5)

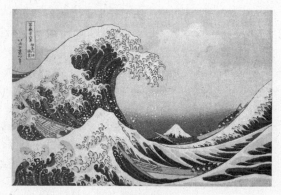

Figure 25.5: Hokusai, *Under the Wave off Kanagawa (Kanagawa oki nami ura)*, called the Great Wave, from the series Thirty-six Views of Mount Fuji, 1830–1833, polychrome wood-block print; ink and color on paper, Metropolitan Museum of Art, New York

Form

- Personification of nature; the wave seems intent on drowning the figures in boats.
- Mount Fuji, sacred mountain to the Japanese, seems to be one of the waves.
- The striking design contrasts water and sky with large areas of negative space.
- Imported color: Prussian blue, which made the print seem unusual and special to contemporaries.

Function

- Part of series of prints called Thirty-six Views of Mount Fuji.

Materials and Techniques

- Each wood-block print required the collaboration of a designer, an engraver, a printer, and a publisher.
- Conceived of as a commercial opportunity by the publisher, who may have doubled as a book dealer.
- The publisher determined the theme.
- The print was designed by an artist on paper, and then an engraver copied the design onto a woodblock.
- The printer rubs ink onto the block and places paper over the block to make a print.
- Many colored prints were made by using a separate block for each color.
- Prussian blue was highly prized in Japan; acquired through trade with Europe.

Context

- Mount Fuji, the highest mountain in Japan, is known for its symmetrical cone.
- Mount Fuji is considered a sacred site.
- In Shintoism, the forces of nature unite as one, as they do in the Hokusai print.
- This was the first time a landscape was a major theme in Japanese prints.

Content Area South, East, and Southeast Asia, Image 211

Web Source *http://www.metmuseum.org/toah/works-of-art/JP1847/*

- **Cross-Cultural Comparisons for Essay Question 1: Images of the Sea and Water**
 - Michelangelo, The Flood (Figure 16.2d)
 - Turner, *Slave Ship* (Figure 20.5)
 - Kusama, *Narcissus Garden* (Figures 22.25a, 22.25b)

VOCABULARY

Continuous narrative: a work of art that contains several scenes of the same story painted or sculpted in continuous succession (Figure 25.3a)

Genre painting: painting in which scenes of everyday life are depicted

Haboku (splashed ink): a monochrome Japanese ink painting done in a free style in which ink seems to be splashed on a surface

Kondo: a hall used for Buddhist teachings (Figure 25.1a)

Mandorla: (Italian, meaning "almond") a term that describes a large almond-shaped orb around holy figures like Christ and Buddha (Figure 25.1b)

Tarashikomi: a Japanese painting technique in which paint is applied to a surface that has not already dried from a previous application (Figures 25.4a and 25.4b)

Ukiyo-e: translated as "pictures of the floating world," a Japanese genre painting popular from the seventeenth to the nineteenth century (Figure 25.5)

Yamato-e: a style of Japanese painting that is characterized by native subject matter, stylized features, and thick bright pigments

Zen: a metaphysical branch of Buddhism that teaches fulfillment through self-discipline and intuition

SUMMARY

With much of its tradition intact, a firm history of Japanese artistic production can be studied from its earliest roots. Sculptures often survive in their original architectural settings.

The Japanese are particularly sensitive to the properties of wood construction. The earliest buildings maintain the beauty of untreated wood and show a great emphasis on harmonizing with the natural surrounding environment. Japanese buildings are meant to be viewed as part of an overall balance in nature. Japanese buildings never intrude upon a setting, but complement it fully.

Traditional Chinese forms of painting, such as scrolls, were admired in Japan. Nevertheless, uniquely Japanese artistic styles, such as ukiyo-e prints, were popular as well, particularly with the middle classes. The impact of ukiyo-e prints on nineteenth-century European art cannot be overstated.

PRACTICE EXERCISES

Multiple-Choice

1. The Nio guardian figures and the Lamassu from the Assyrian culture have in common that they are both

 (A) meant to symbolically protect the areas behind them
 (B) a combination of human and animal forms
 (C) made of stone and symbolize permanence
 (D) carved with the image of the ruler on their faces

2. The Great Buddha in Todai-ji's Great East Temple was probably influenced by similar works, such as

 (A) the Terra cotta warriors
 (B) Longmen Caves
 (C) Angkor Wat
 (D) the Great Stupa

3. Japanese wood-block prints can be seen as directly influencing works like Mary Cassatt's *The Coiffure* in that they both

 (A) share an affinity for brilliant coloring
 (B) place figures at odd angles to the picture plane
 (C) are concerned with solid modeling and massing of forms
 (D) use the conventional three-dimensional linear perspective

4. The yamato-e technique is characterized by

 (A) themes taken from Chinese literature
 (B) the figures, which are highly individualized with great emphasis on reality
 (C) compositions dominated by diagonals
 (D) the artists who were the first in Japan to specialize in the Western oil painting technique

5. Dry landscape gardens in Japanese art carry great symbolic value. The viewer was meant to

 (A) arrange the rocks and the sand in an artful display to suggest a real landscape
 (B) sit directly in the center of the garden and meditate on the natural environment
 (C) use the garden as a place to refresh the spirit by painting, writing poetry, or composing music
 (D) be refreshed through reflection, contemplation, and meditation

Short Essay

Practice Question 5: Attribution
Suggested Time 15 minutes

Attribute this painting to the artist who painted it.

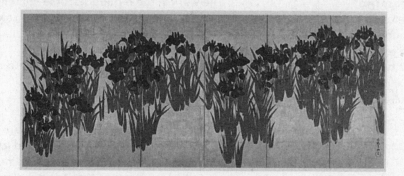

Using *at least two* specific details, justify your attribution by describing relevant similarities between this work and a work in the required course content.

Using *at least two* specific details, explain *why* these visual elements are characteristic of this artist.

ANSWERS EXPLAINED

Multiple-Choice

1. **(A)** Both the Nio guardian figures and the Lamassu are images at gateways, which act to shield the areas behind them.

2. **(B)** The grandeur of the Great Buddha in Todai-ji's Great East Temple is equal to the great Buddha statues at the Longmen Caves.

3. **(B)** Mary Cassatt's compositions were influenced by the unusual compositional angles seen in many Japanese wood-block prints.

4. **(C)** Yamato-e is more about Japanese history and literature depicted with diagonal compositions and depersonalized faces than about oil paint. Yamato-e was developed in Japan in the twelfth century, well before European contact.

5. **(D)** Viewers never entered a Japanese dry garden. They were enclosed environments meant for reflection, contemplation, and meditation.

Short Essay Rubric

Task	Point Value	Key Points in a Good Response
Attribute this painting to the artist who painted it.	1	Ogata Korin
Using *at least two* specific details, justify your attribution by describing relevant similarities between this work and a work in the required course content.	2	The work in the required course content is *White and Red Plum Blossoms* by Ogata Korin, 1710–1716, watercolor on paper. Two specific details could include: ■ Diagonals influenced by the yamato-e style of painting. ■ Rhythmic composition. ■ Painted on a screen. ■ View limited to a few details that are carefully painted rather than grand, detailed landscapes. ■ Tarashikomi technique in which paint is applied to a surface that has not already dried from a previous application; creates a dripping effect useful in depicting streams and flowers.
Using *at least two* specific details, explain *why* these visual elements are characteristic of this artist.	2	Answers could include Ogata Korin's belief in: ■ Concentrating on a few details. ■ A deeply personal view of nature. ■ An emphasis on a fragile, tender, and gentle—rather than an awesome, threatening, or overwhelming—nature. ■ Organizing natural forms into patterned compositions.

Art of the Americas

TIME PERIOD: 3500 B.C.E.–1492 C.E. AND BEYOND

Some of the main periods are these:

Civilization	Date	Location
Chavín	900–200 B.C.E.	Coastal Peru
Mayan	300–900 C.E. and later	Belize, Guatemala, Honduras, Yucatán
Ancient Puebloans	550–1400 C.E.	Southwestern United States
Mississippian	800–1500 C.E.	Eastern United States
Aztec	1400–1521 C.E.	Central Mexico, centered in Mexico City
Inka	1438–1532 C.E.	Peru
North American Indian	18th century to present	North America

ENDURING UNDERSTANDING: The culture, beliefs, and physical settings of a region play an important role in the creation, subject matter, and siting of works of art.

Learning Objective: Discuss how the culture, beliefs, or physical setting can influence the making of a work of art. (For example: Machu Picchu)

Essential Knowledge:

- The art of the indigenous people of America is among the oldest artistic traditions in the world. It extends from about 10,000 B.C.E. through the time of the European invasions.
- The art of this area can be divided into many cultural and historical groupings both in North and South America.
- Ancient Mesoamerican art (from parts of Mexico, Guatemala, Honduras, and Belize) is characterized by architectural structures such as pyramids, a strong influence of astronomy and calendars on ritual objects, and great value placed on green objects such as jade or feathers.
- Three major cultures of ancient Mesoamerica include the Olmec, the Maya, and the Mexica (also called the Aztecs).
- There is a great emphasis on figural art in ancient Mesoamerica, including representations of rulers and mythical events.
- Art of the central Andes (from Bolivia, Peru, and Ecuador) shows a deep respect for animals and plants, as well as shamanistic religions.

- The physical environment of the central Andes (the Amazon, the Andes mountains, and the coastal deserts) plays a large role in art making.
- Art in central Andes was generally made by groups in workshops, rather than by individuals.
- Themes in Andean art particularly address the earth-bound and the celestial.
- Native North American art has diverse themes, but many of the artworks concern nature, animals, and large rituals. Respect for elders is a key unifying factor.
- There is no unifying name for the native people of North America, other than terms that have been imposed by others (i.e., Native Americans, First Nations, etc.)

ENDURING UNDERSTANDING: Cultural interaction through war, trade, and travel can influence art and art making.

Learning Objective: Discuss how works of art are influenced by cultural interaction. (For example: Bandolier bag)

Essential Knowledge:

- Mesoamerican civilizations have had a broad impact on the world as a whole.
- Mesoamerican objects were valued and treasured in Europe by connoisseurs and collectors. National museums were opened to promote an understanding of ancient American art. Twentieth-century artists both in Latin America and elsewhere around the world have been influenced by the art of ancient America.
- Current Native Americans today strongly identify with the cultural achievements of their ancestors. Art forms are maintained and revived.
- There are exchanges of materials, ideas, and subject matter between Native Americans and Europeans.

ENDURING UNDERSTANDING: Art and art making can be influenced by a variety of concerns including audience, function, and patron.

Learning Objective: Discuss how art can be influenced by audience, function, and/or patron. (For example: Chavín nose ornament)

Essential Knowledge:

- The modern concept of art is different than the intended purpose of objects from this period. Objects were created to represent or contain a life force, and viewing was seen as a participatory activity.
- Art was generally generated in workshops.
- Rulers were the major patrons. Patrons could also include a family member, a tribal leader, or an elder.

ENDURING UNDERSTANDING: Art making is influenced by available materials and processes.

Learning Objective: Discuss how material, processes, and techniques influence the making of a work of art. (For example: Transformation mask)

Essential Knowledge:

- Mesoamericans and Native Americans use trade materials, animal-based products, and precious stones. Works of art are generally functional.
- Central Andean artists prized featherwork, textiles, and green stones, and favored works made of metal and bone. Ceramics and wood were considered as occupying the lowest end of the artistic scale.

- Pyramids began as earthworks and then grew to multilevel structures. Sites were often added to over many years. Most architecture is made of stone, using the post-and-lintel system and faced with painted sculpture. There are large plazas placed before the pyramids.
- North American Indians produced works which included ceramics, hide paintings, basketry, weaving, adobe structures, and monumental earthworks.

ENDURING UNDERSTANDING: Art history is best understood through an evolving tradition of theories and interpretations.

Learning Objective: Discuss how works of art have had an evolving interpretation based on visual analysis and interdisciplinary evidence. (For example: Great Serpent Mound)

Essential Knowledge:

- There are many differences in the cultures of the Americas and therefore many approaches to studying the various art forms.
- Examination of artwork from this period relies on many sources including archaeology and written accounts by colonists.
- A multi disciplinary approach is used to examine the works of this period.
- There are many approaches to Native North American art including archaeology, tribal history, and anthropology.

HISTORICAL BACKGROUND

Humans are not native to the "New World"; Americans do not have an ancestry dating back millions of years, the way they do in Africa or Asia. People migrated from Asia to America over a span of perhaps 30,000 years, crossing the Bering Strait when the frozen winters made the way walkable. Eventually people understood that the climate was good enough to raise crops, particularly in what is today Mexico and Central America, and the population boomed.

As in other parts of the world, local rivalries and jealousies have played their part in the ebb and flow of American civilizations. Some civilizations are intensely cultivated and technological, refining metal ore and developing a firm understanding of astronomy and literature. Others remained nomadic and limited their activities as hunter–gatherers. In any case, when the European colonizers arrived at the end of the fifteenth century, they encountered in some ways a very sophisticated society, but in others, one that did not even possess a functioning wheel and refined metals mostly for jewelry rather than for use.

Each succeeding civilization buried or destroyed the remains of the civilization before, so only the hardiest ruins have survived the test of time. Most of what can be gleaned about pre-Columbian American society is ascertained by archaeologists working on elaborate burial grounds or digging through the ruins of once-great ancient cities.

Patronage and Artistic Life

Artists were commoners, as was true in most societies in the ancient world. Because of their special abilities, however, artists were employed by the state to work at important sites instead of doing menial labor. Some were even members of the royalty. Artists were trained in an apprenticeship program, and reached fame through the rendering of beautifully crafted items.

Ancient Americans used an extremely wide variety of materials in their artwork, usually capitalizing on what was locally available. Since they did not have draught animals, and since wheeled carts were unknown, artists were reliant on what was locally produced, or on objects

small enough to trade and carry. Even so, Aztecs, for example, carved in obsidian, jade, copper, gold, turquoise, basalt, sandstone, granite, rock crystal, wood, limestone, and amethyst, among many other media.

Tropical cultures profited from the skins of animals and feathers of birds and produced great works using brilliant plumage. Featherwork became a distinguished art form in the hands of pre-Columbian artists.

CHAVÍN ART

Chavín is a civilization named after its main archaeological site, preserved in coastal Peru. Chavín art is dominated by figural compositions, often shown in a combination of human and animal motifs. Many figures unite various animal forms into one being: fanged mouths are merged with serpents in the hair, for example. Figures are generally heavily rendered with an eye to monumentality. Symmetry is desired; works are carved in low relief on polished surfaces that use rectangular formats.

Chavín architects chose sites that were dramatic, sometimes on mountain tops. Often buildings, such as those at Chavín de Huántar, were built around a U-shaped plan that embraced a plaza and faced out toward an expansive view. Stepped platforms rise to support ceremonial buildings. Some sites are oriented to the cardinal points on the compass, but at Chavín the site seems to be coordinated with an adjacent river, which some say was a reference to water sources and their importance to society.

Figure 26.1a: Plan of Chavín de Huántar, 900–200 B.C.E., stone, Northern Highlands, Peru

Chavín de Huántar, 900–200 B.C.E., stone, Northern Highlands, Peru

Function

- A religious capital.
- Temple, 60 meters tall, was adorned with a jaguar sculpture, a symbol of power.
- Hidden entrance to the temple led to stone corridors.

Content Area Indigenous Americas, Image 153

Web Source http://whc.unesco.org/en/list/330

Plan and Lanzón Stone, granite (Figures 26.1a and 26.1b)

Form

- Inside the old temple of Chavín is a mazelike system of hallways.
- Passageways have no natural light source; they are lit by candles and lamps.
- At the center, underground, is the Lanzón (Spanish for "blade") Stone; blade shaped; may also represent a primitive plough; hence, the role of the god in ensuring a successful crop.
- Depicts a powerful figure that is part human (body) and part animal (claws, fangs); the god of the temple complex.
- Head of snakes and a face of a jaguar.
- Eyebrows terminate in snakes.
- Flat relief; designs in a curvilinear pattern.
- 15 feet tall.

Figure 26.1b: Lanzón Stone, 900-200 B.C.E., granite, Peru

Function

■ Served as a cult figure.

■ Center of pilgrimage; however, few had access to the Lanzón Stone.

■ Modern scholars hypothesize that the stone acted as an oracle; hence a point of pilgrimage.

■ New studies show the importance of acoustics in the underground chamber.

Relief sculpture, granite, Chavín de Huántar (Figure 26.1c)

■ Shows jaguars in shallow relief.

■ Located on the ruins of a stairway at Chavín.

Nose ornament, hammered gold alloy, Cleveland Museum of Art (Figure 26.1d)

Form

■ Worn by males and females under the nose.

■ Held in place by the semicircular section at the top.

■ Two snake heads on either end.

■ Cf. Lanzón Stone (Figure 26.1b): serpent motif appears in both.

Function

■ Transforms the wearer into a supernatural being during ceremonies.

Context

■ Elite men and women wore the ornaments as emblems of their ties to the religion and eventually were buried with them.

■ The Chavín religion is related to the appearance of the first large-scale precious metal objects; revolutionary new metallurgical process.

■ Technical innovations express the "wholly other" nature of the religion.

Content Area Indigenous Americas, Image 153

Web Source *http://www.clevelandart.org/art/1958.183*

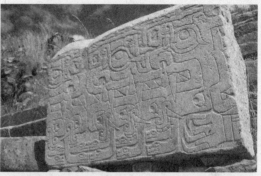

Figure 26.1c: Relief sculpture, granite, 900–200 B.C.E., Peru

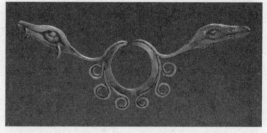

Figure 26.1d: Nose ornament, hammered gold alloy, Cleveland Museum of Art

MAYAN ART

Mayan sculpture is easy to recognize, because of the unusual Mayan concept of ideal beauty. The model seems to have been a figure with an arching brow, with the indentation above the nose filled in as a continuous bridge between forehead and nose. Most well-to-do Mayans put their children in head braces to create this symbol of beauty if the child was not born with it. Facial types are long and narrow, with full lips and mouths ready to speak. It is common to see figures elaborately dressed with costumes composed of feathers, jade, and jaguar skin. The Mayans preferred narrative art done in relief sculpture. Their relief work has crisp outlines with little attention given to modeling.

 Mayan sculpture is typically related to architectural monuments: Lintels, facades, jambs, and so on. Figures of gods are stylized and placed in conventional hieratic poses possessing symbols of beauty, most notably tattooing and crossed eyes. Most Mayan sculptures were painted.

 A typical work that appears everywhere in Mayan cities is the **chacmool**, a figure that is half-sitting and half-lying on his back. The unusual pose of the figure is balanced by the face

which turns 90 degrees from the body. Elbows firmly rest on the ground, lending a sloping sense to the body. On his stomach is a plate, which has made some scholars deduce that the figure was meant to receive offerings. Sculptures such as these influenced modern artists such as Henry Moore.

Mayan pyramids are set in wide plazas as a center of civic focus. Grandly proportioned temples accompany pyramids, although their interiors are narrow and tall, giving a certain claustrophobic effect enhanced by the use of **corbelled vaulting**. Temples had long roof combs on the roof to accentuate their verticality.

Yaxchilán, 725 C.E., limestone, Chiapas, Mexico (Figures 26.2a, 26.2b, and 26.2c)

Function
- City set on a high terrace; plaza surrounded by important buildings.
- Flourished c. 300–800 C.E.

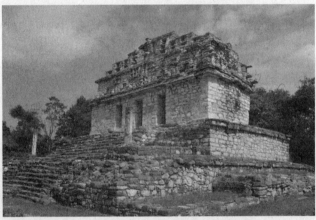

Figure 26.2a: Structure 40, Yaxchilán, Mayan, 725 C.E., limestone, Chiapas, Mexico

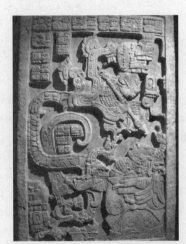

Figure 26.2b: Lintel 25, Structure 23, Yaxchilán, 725 C.E., limestone, British Museum, London

Structure 40, Yaxchilán, Mayan, 725 C.E., limestone, Chiapas, Mexico (Figure 26.2a)

Form
- Overlooks the main plaza.
- Three doors lead to a central room decorated with stucco.
- Roof remains nearly intact, with a large roof comb (ornamented stone tops on roofs).
- Corbel arch interior.

Patronage
- Built by ruler Bird Jaguar IV for his son, who dedicated it to him.

Content Area Indigenous Americas, Image 155

Lintel 25, Structure 23, Yaxchilán, 725 C.E., limestone, British Museum, London (Figure 26.2b)

Form and Content
- The lintel was originally set above the central doorway of Structure 23 as a part of a series of three lintels.
- Lady Xook (bottom right) invokes the Vision Serpent to commemorate her husband's rise to the throne.
- The Vision Serpent has two heads: one has a warrior emerging from its mouth, and the other has Tlaloc, a war god.
- She holds a bowl with bloodletting ceremonial items: stinging spine and bloodstained paper; she runs a rope with thorns through her tongue.
- She burns paper on a dish as a gift to the netherworld.
- The depicted ritual was conducted to commemorate the accession of Shield Jaguar II to the throne.

Function

■ Lintels intended to relay a message of the refoundation of the site—there was a long pause in the building's history.

■ Shield Jaguar's building program throughout the city may have been an attempt to reinforce his lineage and his right to rule.

Context

■ The building is dedicated to Lady Xook, Shield Jaguar II's wife.

■ The inscription is written as a mirror image—extremely unusual among Mayan glyphs; uncertain meaning, perhaps indicating she had a vision from the other side of existence and she was acting as an intercessor or shaman.

■ The inscription names the protagonist as Shield Jaguar II.

■ Bloodletting is central to the Mayan life. When a member of the royal family sheds his or her blood, a portal to the netherworld is opened and gods and spirits enter the world.

Theory

■ Some scholars suggest that the serpent on this lintel and elsewhere depicts an ancestral spirit or founder of the kingdom.

Content Area Indigenous Americas, Image 155

Web Sources http://www.britishmuseum.org/research/collection_online/collection_object_details.aspx?objectId=3086881&partId=1

https://learner.org/series/art-through-time-a-global-view/dreams-and-visions/lintel-25-of-yaxchilan-structure-23/

Structure 33, Yaxchilán, Mayan, 725 C.E., limestone, Chiapas, Mexico (Figure 26.2c)

■ Restored temple structure.

■ Remains of roof comb with perforations.

■ Three central doorways lead to a large single room.

■ Corbel arch interior.

Content Area Indigenous Americas, Image 155

Web Source https://www.peabody.harvard.edu/cmhi/site.php?site=Yaxchilan

■ **Cross-Cultural Comparisons for Essay Question 1: Temples**

 – White Temple and its ziggurat (Figures 2.1a, 2.1b)

 – Lakshmana Temple (Figures 23.7a, 23.7b)

 – Todai-ji (Figure 25.1a)

Figure 26.2c: Structure 33, Yaxchilán, Mayan, 725 C.E., limestone, Chiapas, Mexico

ANCIENT PUEBLOANS

Anasazi is a term that means "ancient ones" or "ancient enemies" in the Navajo language. This is the name that used to be used to indicate the culture of ancient puebloans. They are most famous for their meticulously rendered **pueblos**, which are composed of local materials. A core of rubble and mortar is usually faced with a veneer of polished stone. The thickness of the base walls were used to determine the size of the overall superstructure, with some pueblos daring to raise themselves five or six stories tall. All pueblos faced a well-defined plaza that was the religious and social center of the complex.

Figure 26.3 Mesa Verde cliff dwellings, Ancestral Puebloan (Anasazi), 450-1300 C.E., sandstone, Montezuma County, Colorado

Mesa Verde cliff dwellings, Ancestral Puebloan (Anasazi), 450–1300 C.E., sandstone, Montezuma County, Colorado (Figure 26.3)

Form

- The top ledge houses supplies in a storage area; cool and dry area out of the way; accessible only by ladder.
- Each family received one room in the dwelling.
- Plaza placed in front of the abode structure; kivas face the plaza.

Function

- The pueblo was built into the sides of a cliff, housed about one hundred people.
- Clans moved together for mutual support and defense.

Context

- Farming done on the plateau above the pueblo; everything had to be imported into the structure; water seeped through the sandstone and collected in trenches near the rear of the structure.
- Low winter sun penetrated the pueblo; high summer sun did not enter the interior and therefore it stayed relatively cool.
- Inhabited for two hundred years; probably abandoned when the water source dried up.

Content Area Indigenous Americas, Image 154

Web Source http://whc.unesco.org/en/list/27

- **Cross-Cultural Comparisons for Essay Question 1: Cliffside**
 - Bamiyan Buddhas (Figures 23.2a, 23.2b)
 - Longmen Caves (Figures 24.9a, 24.9b)
 - Petra (Figure 6.9b)

MISSISSIPPIAN ART

An increase in agriculture meant a population boom, as sustained communities evolved in fertile areas. Eastern Native Americans were mound-builders and created an impressive series of earthworks that survive in great numbers even today. Huge mound complexes, such as Cahokia, Illinois, were impressive city-states that governed wide areas. Other mounds, such as **Great Serpent Mound** (Figure 26.4), were built in effigy shapes of uncertain meaning. Many of these mounds have baffled archaeologists, because they clearly could only be fully appreciated from the air or a high vantage point, which mound builders did not possess.

Figure 26.4: Great Serpent Mound, Mississippian (Eastern Woodlands), c. 1070 C.E., earthwork/effigy mound, Adams County, southern Ohio

Great Serpent Mound, Mississippian (Eastern Woodlands), c. 1070 C.E., earthwork/effigy mound, Adams County, southern Ohio (Figure 26.4)

Context

- Many mounds were enlarged and changed over the years, not built in one campaign.
- Effigy mounds popular in Mississippian culture.
- Associated with snakes and crop fertility.
- There are no burials associated with this mound, though there are burial sites nearby.

Theories
- Influenced by comets? Astrological phenomenon? Head pointed to summer solstice sunset?
- Theory that it could be a representation of Halley's Comet in 1066.
- Rattlesnake as a symbol in Mississippian iconography; could this play a role in interpreting this mound?

Content Area Indigenous Americas, Image 156

Web Source *http://worldheritageohio.org/serpent-mound/*

- **Cross-Cultural Comparisons for Essay Question 1: Earthworks**
 - Smithson, *Spiral Jetty* (Figure 22.26)

AZTEC ART

Aztec art is most famously represented by gold jewelry that survives in some abundance, and jade and turquoise carvings of great virtuosity. The aggressive nature of Aztec religions, with its centering on violent ceremonies of blood-letting, was often manifest in great stone sculptures of horrifying deities such as **Coyolxauhqui**, whose characteristics include human remains from bloody sacrifices.

Templo Mayor (Main Temple), Mexica (Aztec), 1375–1520, stone, Tenochtitlán, Mexico City, Mexico (Figure 26.5a)

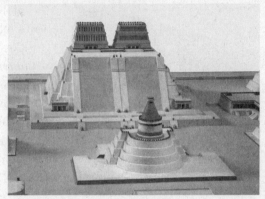

Figure 26.5a: Templo Mayor (Main Temple), Mexica (Aztec), 1375–1520, stone, Tenochtitlán, Mexico City, Mexico

Form
- Pyramids built one atop the other so that the final form encases all previous pyramids; seven building campaigns.
- Pyramids have a step-like series of setbacks; not the smooth-surfaced pyramids seen in Egypt.
- Characterized by four huge flights of very vertical steps leading to temples placed on top.

Function
- Tenochtitlán was laid out on a grid; city seen as the center of the world.
- The temple structures on top of each pyramid were dedicated to and housed the images of the two important deities.

Context
- Two temples atop a pyramid, each with a separate staircase:
 - North: dedicated to Tlaloc, god of rain, agriculture.
 - South: dedicated to Huitzilopochtli, god of sun and war.
 - At the spring and autumn equinoxes, the sun rises between the two.
 - Large braziers put on top where the sacred fires burned.
 - Temple structures housed images of the deities.
- Temples begun in 1375; rebuilt six times; destroyed by the Spanish in 1520.
- The destruction of this temple and reuse of its stones by the Spanish asserted a political and spiritual dominance over the conquered civilization.

Content Area Indigenous Americas, Image 157

Web Source *http://www.metmuseum.org/toah/hd/teno_2/hd_teno_2.htm*

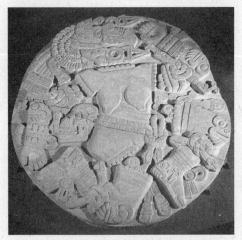

Figure 26.5b: Coyolxauhqui Stone, volcanic stone

Coyolxauhqui "She of the Golden Bells," 1469 (?), volcanic stone, Museum of the Templo Mayor, Mexico City (Figure 26.5b)

Form

- Circular relief sculpture.
- Once brilliantly painted.
- So called because of the bells she wears as earrings.

Context

- Coyolxauhqui and her many brothers plotted the death of her mother, Coatlicue, who became pregnant after tucking a ball of feathers down her bosom. When Coyolxauhqui chopped off Coatlicue's head, a child, Huitzilopochtli, popped out of the severed body fully grown and dismembered Coyolxauhqui, who fell dead at the base of the shrine.
- This stone represents the dismembered moon goddess, Coyolxauhqui, who is placed at the base of the twin pyramids of Tenochtitlán.

- Aztecs sacrificed people and then threw their dismembered remains down the steps of the temple as Huitzilopochtli did to Coyolxauhqui.

- Aztecs similarly dismembered enemies and threw them down the stairs of the great pyramid to land on the sculpture of Coyolxauhqui.
- A relationship was established between the death and decapitation of Coyolxauhqui with the sacrifice of enemies at the top of Aztec pyramids.

Content Area Indigenous Americas, Image 157

Web Source *http://www.getty.edu/art/exhibitions/aztec/interactive/index.html*

- **Cross-Cultural Comparisons for Essay Question 1: Human Figure in Relief**
 - Akhenaton, Nefertiti, and three daughters (Figure 3.10)
 - Victory adjusting her sandal (Figure 4.6)
 - Anthropomorphic stele (Figure 1.2)

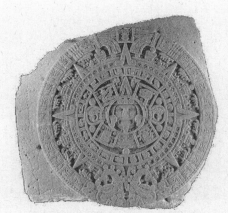

Figure 26.5c: Calendar Stone, basalt

Calendar Stone, basalt (Figure 26.5c)

Context

- Aztecs felt they needed to feed the sun god human hearts and blood.
- A tongue in the center of the stone coming from the god's mouth is a representation of a sacrificial flint knife used to slash open the victims.
- Circular shape reflects the cyclic nature of time.
- Two calendar systems, separate but intertwined.
- Calendars synced every fifty-two years in a time of danger, when the Aztecs felt a human sacrifice could ensure survival.

Content Area Indigenous Americas, Image 157

Web Source *http://www.kidsdiscover.com/quick-reads/understanding-mysterious-aztec-sun-stone/*

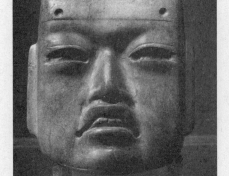

Figure 26.5d: Olmec-style mask, jadeite

Olmec-style mask, jadeite (Figure 26.5d)

- Found on the site; actually a much older work executed by the Olmecs.
- Olmec works have a characteristic frown on the face; pugnacious visage; baby face; a cleft in the center of the head carved from greenstone.

- Shows that the Aztecs collected and embraced artwork from other cultures, including early Mexican cultures such as the Olmec and Teotihuacán.
- Shows that the Aztecs had a wide-ranging merchant network that traded historical items.

Content Area Indigenous Americas, Image 157

Ruler's feather headdress (probably of Motecuhzoma II), Mexica (Aztec), 1428–1520, feathers (quetzal and blue cotinga) and gold, Museum of Ethnology, Vienna (Figure 26.6)

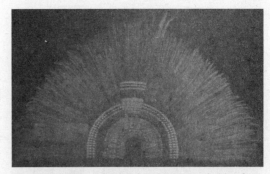

Figure 26.6: Ruler's feather headdress (probably of Motecuhzoma II), Mexica (Aztec), 1428–1520, feathers (quetzal and cotinga) and gold, Museum of Ethnology, Vienna

Form
- Made from 400 long green feathers, the tails of the sacred quetzal birds; male birds produce only two such feathers each.
- The number 400 symbolizes eternity.

Function
- Ceremonial headdress of a ruler.
- Part of an elaborate costume.

Context
- Only known Aztec feather headdress in the world.
- Feathers indicate trading across the Aztec Empire.
- Headdress possibly part of a collection of artifacts given by Motechuzoma (Montezuma) to Cortez for Charles V of the Holy Roman Empire.
- Current dispute over ownership of the headdress; today it is housed in the Museum of Ethnology in Vienna, Austria.

Content Area Indigenous Americas, Image 158

Web Source *https://www.researchgate.net/publication/236584714_Vienna's_Mexican_Treasures_Aztec_Mixtec_and_Tarascan_Works_from_16th_Century_Austrian_Collections*

- **Cross-Cultural Comparisons for Essay Question 1: Exotic Materials**
 – 'Ahu 'ula (Figure 28.4)
 – Circle of the González family, Screen with the Siege of Belgrade and hunting scene (Figures 18.3a, 18.3b)
 – González, *Virgin de Guadalupe* (Figure 18.4)

INKAN ART

Inkan architecture defies the odds by building impressive and well-designed cities in some of the most inaccessible or inhospitable places on earth. Typically Inkan builders used **ashlar masonry** of perfectly grooved and fitted stones placed together in almost a jigsaw puzzle arrangement. All stones have slightly beveled edges that emphasize the joints. The buildings tend to taper upward like a trapezoid, the favorite building shape of early Americans.

The impressive Inka Empire stretched from Chile to Colombia and was well-maintained by an organized system of roads that united the country in an efficient communication network. The Inka had no written language, so much of what we know about the civilization has been deduced from archaeological remains.

Figure 26.7: Maize cobs, c. 1440–1533, sheet metal/repoussé, metal alloys Staatliche Museen zu Berlin

Maize cobs, c. 1440–1533, sheet metal/repoussé, metal alloys, Staatliche Museen zu Berlin (Figure 26.7)

Technique and Form
- Repoussé technique.
- Hollow metal object.
- Life-size.

Function
- May have been part of a garden in which full-sized metal sculptures of maize plants and other items were put in place alongside actual plants in the Qorinkancha garden.
- May have been used to ensure a successful harvest.

Context
- Maize was the principal food source in the Andes.
- Maize was celebrated by having sculptures fashioned out of sheet metal.
- Black maize was common in Peru; oxidized silver reflects that.

Content Area Indigenous Americas, Image 160

Web Source http://denverartmuseum.org/article/staff-blogs/science-museum-analyzing-fifteenth-century-inca-corn-stalk-part-1

- **Cross-Cultural Comparisons for Essay Question 1: Metalwork**
 - Merovingian looped fibulae (Figure 10.1)
 - Golden Stool (Figure 27.4)
 - Muhammad ibn al-Zain, *Baptistère de Saint Louis* (Figure 9.6)

Figure 26.8a: Plan of the City of Cusco, c. 1440

City of Cusco plan, Peru, c. 1440 (Figure 26.8a)

Form
- In the shape of the puma, a royal animal.
- Modern plaza is in the place where the puma's belly would be.
- Head, a fortress; heart, a central square.

Function
- Historic capital of the Inka Empire.

Content Area Indigenous Americas, Image 159

Web Source http://whc.unesco.org/en/list/273

- **Cross-Cultural Comparisons for Essay Question 1: City Planning**
 - Athenian Agora (Figure 4.15)
 - Forum of Trajan (Figure 6.10a)
 - Forbidden City (Figures 24.2a, 24.2b, 24.2c, 24.2d)

Figure 26.8b: Qorikancha: main temple, church, and convent of Santo Domingo, c. 1440, convent added 1550–1650, andesite, Cusco, Peru

Qorikancha: main temple, church, and convent of Santo Domingo, c. 1440, convent added 1550–1650, andesite, Cusco, Peru (Figure 26.8b)

Form
- Ashlar masonry; carefully grooved and beveled edges of the stone fit together in a puzzle-like formation.
- Slight spacing among stones allows movement during earthquakes.

- Walls taper upward; examples of Inkan trapezoidal architecture.
- Temple displays Inkan use of interlocking stonework of great precision.
- Original exterior walls of the temple were decorated in gold to symbolize sunshine.
- Spanish chroniclers insist that the walls and floors of the temple were covered in gold.

Function

- Qorikancha: golden enclosure; once was the most important temple in the Inkan world.
- Once was an observatory for priests to chart the skies.

Context

- The location is important; placed at the convergence of the four main highways and connected to the four districts of the empire; the temple cemented the symbolic importance of religion, uniting the divergent cultural practices that were observed in the vast territory controlled by the Inkas.
- Remains of the Inkan Temple of the Sun form the base of the Santo Domingo convent built on top.

Content Area Indigenous Americas, Image 159

Web Source *https://www.theguardian.com/cities/2015/mar/25/cusco-coricancha-temple-history-cities-50-buildings*

Walls at Saqsa Waman (Sacsayhuaman), c. 1440, sandstone, Peru (Figure 26.8c)

Form

- Ashlar masonry.
- Ramparts contain stones weighing up to seventy tons, brought from a quarry two miles away.

Context

- Complex outside the city of Cusco, Peru, at the head of the puma-shaped plan of the city.

Content Area Indigenous Americas, Image 159

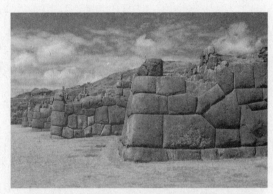

Figure 26.8c: Walls at Saqsa Waman (Sacsayhuaman), c. 1440, sandstone, Peru

Machu Picchu, Inka, 1450–1540, granite, Central Highlands, Peru (Figure 26.9a)

Form

- Buildings built of stone with perfectly carved rock rendered in precise shapes and grooved together; thatched roofs.
- Outward faces of the stones were smoothed and grooved.
- Two hundred buildings, mostly houses; some temples, palaces, and baths, and even an astronomical observatory; most in a basic trapezoidal shape.
- Entryways and windows are trapezoidal.
- People farmed on terraces.

Function

- Originally functioned as a royal retreat.
- The estate of fifteenth-century Inkan rulers.
- So remote that it was probably not used for administrative purposes in the Inkan world.
- Peaceful center: many bones were uncovered, but none of them indicate war-like behavior.

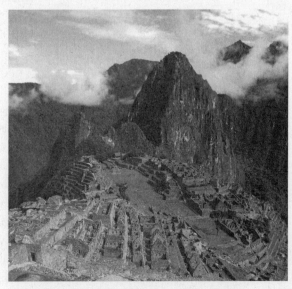

Figure 26.9a: City of Machu Picchu, Inka, 1450–1540, granite, Central Highlands, Peru

Figure 26.9b: Observatory, 1450–1540, granite, Peru

Figure 26.9c: Intihuatana Stone, 1450–1540, granite, Peru

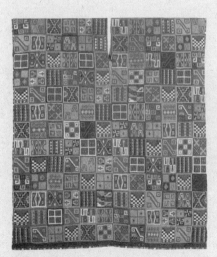

Figure 26.10: All-T'oqapu tunic, Inka, 1450–1540, camelid fiber and cotton, Dumbarton Oaks, Washington, D.C.

Content Area Indigenous Americas, Image 161

Web Source http://whc.unesco.org/en/list/274

- **Cross-Cultural Comparisons for Essay Question 1: Public spaces**
 - Acropolis (Figure 4.16a)
 - Persepolis (Figure 2.6a, 2.6b)
 - Mesa Verde (Figure 26.3)

Observatory, 1450–1540, granite, Peru (Figure 26.9b)

Form

- Ashlar masonry.
- Highest point at Machu Picchu.

Function

- Used to chart the sun's movements; also known as the Temple of the Sun.
- Left window: sun shines through on the morning of the winter solstice.
- Right window: sun shines through on the morning of the summer solstice.
- Devoted to the sun god.

Intihuatana Stone, 1450–1540, granite, Peru (Figure 26.9c)

- Intihuatana means "hitching post of the sun"; aligns with the sun at the spring and the autumn equinoxes, when the sun stands directly over the pillar and thus creates no shadow.
- Inkan ceremonies held in concert with this event.

All-T'oqapu tunic, Inka, 1450–1540, camelid fiber and cotton, Dumbarton Oaks, Washington, D.C. (Figure 26.10)

Form

- Rectangular shape; a slit in the center is for the head; then the tunic is folded in half and the sides are sewn for the arms.
- The composition is composed of small rectangular shapes called t'oqapu.
- Individual t'oqapu may be symbolic of individuals, events, or places.
- This tunic contains a large number of t'oqapu.

Function

- Wearing such an elaborate garment indicates the status of the individual.
- May have been worn by an Inkan ruler.

Technique

- Woven on a backstrap loom.
- One end of the loom is tied to a tree or a post and the other end around the back of the weaver.
- The movement of the weaver can create alternating tensions in the fabric and achieve different results.

Context

- Exhibits Inkan preference for abstract designs, standardization of designs, and an expression of unity and order.
- Finest textiles made by women, a highly distinguished art form; this tunic has a hundred threads per square centimeter.

Content Area Indigenous Americas, Image 162

Web Source http://doaks.org/library-archives/dumbarton-oaks-archives/historical-records/75th-anniversary/images/PreColumbianTextile.jpg/view

- **Cross-Cultural Comparisons for Essay Question 1: Status Symbols**
 - Rank badge of Sin Sukju (Figure 24.6)
 - Nun's badge in Portrait of Juana Inés de la Cruz (Figure 18.6)
 - Looped fibulae (Figure 10.1)

NORTH AMERICAN INDIAN ART

Local products form the basis of most North American art forms: wood in the Pacific Northwest; clay, plant fibers, and wool in the American Southwest; and hides in areas populated by large animals like bison and deer. As with most nomadic or semi nomadic peoples (although the Southwest Indians lived in large pueblos or cliff dwellings with fairly sophisticated agricultural programs), geometric designs on ceramics and utilitarian objects and highly decorated fabric with beading and weaving mark their art. Plains Indians even illustrated hides to relate myths and events pertinent to their tribal histories. As the influence of the European settlers spread throughout the Indian nations, native Indian artists were keen to adapt their traditional art forms to new media introduced from abroad. The Europeans also brought with them a curiosity about native art forms, and acted as collectors and patrons for works that appealed to their sensibilities. Thus native American artists, like Cadzi Cody in hide painting and Maria Martínez in ceramics, began serving an emerging tourist industry that appreciated their artistry.

Bandolier bag, Lenape (Delaware tribe, Eastern Woodlands), c. 1850, beadwork on leather, Museum of the American Indian (Figure 26.11)

Form

- The bandolier bag has a large, heavily beaded pouch with a slit on top.
- The bag was held at hip level with strap across the chest.
- The bag was constructed of trade cloth: cotton, wool, velvet, or leather.

Function

- It was made for men and women; objects of prestige.
- They were made by women.
- Functional and beautiful; acted also as a status symbol as part of an elaborate garb.
- Bandolier bags are still made and worn today.

Context

- Beadwork not done in the Americas before European contact.
- Beads and silk ribbons were imported from Europe.
- The bags contain both Native American and European motifs.

Content Area Indigenous Americas, Image 163

Web Source http://metmuseum.org/art/collection/search/319100

Figure 26.11: Bandolier bag, Lenape (Delaware tribe, Eastern Woodlands), c. 1850, beadwork on leather, Museum of the American Indian

Figure 26.12a: Transformation mask, Kwakwaha'wakw, Northwest Coast of Canada, late 19th century, wood, paint, and string, Musée du Quai Branly-Jacques Chirac, Paris, France

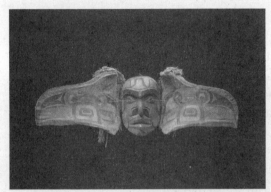

Figure 26.12b: Interior of Transformation mask

Figure 26.13: Attributed to Cotsiogo (Cadzi Cody), Painted elk hide, c. 1890–1900, painted elk hide, Brooklyn Museum, Brooklyn, New York

- Beads and silk ribbons were imported from Europe.
- The bags contain both Native American and European motifs.

Content Area Indigenous Americas, Image 163

Web Source *http://metmuseum.org/art/collection/search/319100*

- **Cross-Cultural Comparisons for Essay Question 1: Functional Works of Art**
 - Niobides Krater (Figures 4.19a, 4.19b)
 - Navigation chart (Figure 28.3)
 - Duchamp, *Fountain* (Figure 22.9)

Transformation mask, Kwakwaha'wakw, Northwest Coast of Canada, late 19th century, wood, paint, and string, Musée du Quai Branly-Jacques Chirac, Paris, France (Figures 26.12a and 26.12b)

Form

- The mask has a birdlike exterior face; when opened, it reveals a second human face on the interior.

Function

- The masks were worn by native people of the Pacific. Northwest, centered on Vancouver Island.
- They were worn over the head as part of a complete body costume.

Context

- During a ritual performance, the wearer opens and closes the transformation mask using strings.
- At the moment of transformation, the performer turns his back to the audience to conceal the action and heighten the mystery.
- Opening the mask reveals the face of an ancestor; there is an ancestral element to the ceremony.
- Although these masks could be used at a potlatch, most often they were used in winter initiation rites ceremonies.
- The ceremony is accompanied by drumming and takes place in a "big house."
- Masks are highly prized and often inherited.

Content Area Indigenous Americas, Image 164

Web Source *https://www.youtube.com/watch?v=f8WREmWxggU&list=PLoAgj1OfSJXMElG4mKifqwfnz0TrISinA&index=2*

- **Cross-Cultural Comparisons for Essay Question 1: Human and Animal Hybrids**
 - Sphinx (Figure 3.6a)
 - Running horned woman (Figure 1.9)
 - Mutu, *Preying Mantra* (Figure 29.25)

Attributed to Cotsiogo (Cadzi Cody), Painted elk hide, Eastern Shoshone, Wind River Reservation, Wyoming, c. 1890–1900, painted elk hide, Brooklyn Museum, Brooklyn, New York (Figure 26.13)

- Hide paintings mark past events.
- Bison considered to be gifts from the Creator.
- Horses, in common use around 1750, liberated the Plains people.
- Teepee: made of hide stretched over poles:
 - Exterior poles reach the spirit world or sky.
 - Fire represents the heart.
 - The doorway faces east to greet the new day.
- The sun dance was conducted around a bison head, and was outlawed by the U.S. government; viewed as a threat to order.
- The sun dance involved men dancing, singing, preparing for the feast, drumming, and constructing a lodge. They honored the Creator deity for the bounty of the land.
- The warrior's deeds were celebrated on the hide.

Function
- Worn as a robe over the shoulders of the warrior.
- Perhaps a wall hanging.

Context
- Depicts biographical details; personal accomplishments; heroism; battles.
- Men painted hides to narrate an event.
- Eventually, painted hides were made for European and American markets; tourist trade.
- Used paint and dyes obtained through trade.

Content Area Indigenous Americas, Image 165

Web Source *https://www.brooklynmuseum.org/exhibitions/tipi/*

- **Cross-Cultural Comparisons for Essay Question 1: Animal Imagery**
 - Apollo 11 stones (Figure 1.7)
 - Aka elephant mask (Figure 27.12)
 - Muybridge, *The Horse in Motion* (Figure 21.5)

Maria Martínez and Julian Martínez, Black-on-black ceramic vessel, Tewa, Puebloan, San Ildefonso Pueblo, New Mexico, mid-20th century, blackware ceramic, Smithsonian Museum of American Art, Washington, D.C. (Figure 26.14)

Form
- Black-on-black vessel.
- Highly polished surface.
- Contrasting shiny black and matte black finishes.
- Exceptional symmetry; walls of even thickness; surfaces free of imperfections.

Function
- Comes from the thousand-year-old tradition of pottery making in the Southwest.
- Maria Martínez preferred making pots using a new technique that rendered a vessel lightweight, less hard, and not watertight, as traditional pots were; this kind of vessel reflected the market shift away from utilitarian vessels to decorative objects.

Figure 26.14: Maria Martínez and Julian Martínez, Black-on-black ceramic vessel. Tewa, Puebloan, San Ildefonso Pueblo, New Mexico, mid-20th century, blackware ceramic, Smithsonian Museum of American Art, Washington, D.C.

Technique
- Used a mixture of clay and volcanic ash.
- The surface was scraped to a smooth finish with a gourd tool and then polished with a stone.
- Julian Martínez painted designs with a liquid clay that yielded a matte finish in contrast with the high shine of the pot itself.

Context

■ At the time of production, pueblos were in decline; modern life was replacing traditional life.

■ Artists' work sparked a revival of pueblo techniques.

■ Maria Martínez, the potter, developed and invented new shapes beyond the traditional pueblo forms.

■ Julian Martínez, the painter of the pots, revived the use of ancient mythic figures and designs on the pots.

■ Reflects an influence of Art Deco designs popular at the time.

Content Area Indigenous Americas, Image 166

Web Sources *http://www.mariajulianpottery.com/mariamartinezbio.html*
and https://nmwa.org/works/martinez-jar

■ **Cross-Cultural Comparisons for Essay Question 1: Limited Color**

– Weiwei, *Sunflower Seeds* (Figure 29.27)

– *Mblo* (Figure 27.7)

– Shiva as Lord of Dance (Figure 23.6)

VOCABULARY

Ashlar masonry: carefully cut and grooved stones that support a building without the use of concrete or other kinds of masonry (Figure 26.8b)

Bandolier bag: a large heavily beaded pouch with a slit on top worn at the waist with a strap over the shoulders (Figure 26.11)

Chacmool: a Mayan figure that is half-sitting and half-lying on his back

Corbel arch: a vault formed by layers of stone that gradually grow closer together as they rise and eventually meet

Coyolxauhqui: an Aztec moon goddess whose name means "Golden Bells" (Figure 26.5b)

Huitzilopochtli: an Aztec god of the sun and war; sometimes represented as an eagle or as a hummingbird

Kiva: a circular room wholly or partly underground used for religious rites

Potlatch: a ceremonial feast among northwest coast American Indians in which a host demonstrates his or her generosity by bestowing gifts

Pueblo: a communal village of flat-roofed structures of many stories that are stacked in terraces; made of stone or adobe (Figure 26.3)

Relief sculpture: a sculpture that projects from a flat background (Figure 26.1c)

Repoussé: (French, meaning "to push back") a type of metal relief sculpture in which the back side of a plate is hammered to form a raised relief on the front (Figure 26.7)

Roof comb: a wall rising from the center ridge of a building to give the appearance of greater height (Figure 26.2a)

Teepee: a portable Indian home made of stretched hides placed over wooden poles

Tlaloc: ancient American god who was highly revered; associated with rain, agriculture, and war

T'oqapu: small rectangular shapes in an Inkan garment (Figure 26.10)

Transformation mask: A mask worn in ceremonies by people of the Pacific Northwest, Canada, or Alaska. The chief feature of the mask is its ability to open and close, going from a bird-like exterior to a human-faced interior (Figures 26.12a and 26.12b)

It is difficult to condense into a simple format the complex nature of ancient American civilizations. Some societies were nomadic and produced portable works of art that were meant for ceremonial use. Others established great cities in which ceremonial centers were carefully designed to enhance religious and secular concerns.

Each society of Indians used the local available materials to create their works. Indians from rich forest lands produced huge totem poles that symbolized the spirit of the living tree as well as the gods or legends carved upon them. Those from drier climates made use of adobe for their building material, as in the desert Southwest, or earthenware for fancifully decorated jugs and pitchers. The great cities of Mesoamerica are hewn from stone to create a symbol of permanence and stability in cultures that were more often than not dynamic and in flux.

It is common in ancient America for societies to build on the foundations of earlier cultures. Thus new cities spring from the ruins of the old, as pyramids are built over smaller structures on the same site.

PRACTICE EXERCISES

Multiple-Choice

1. Transformation masks are best understood as works

 (A) used as centerpieces in homes
 (B) that are seen as part of a larger ceremony
 (C) used to recall ancestral spirits to cast a spell on the wearer's behalf
 (D) used as a display much the same way that totem poles are used

2. Native American artworks often show the influence of Europeans in that they

 (A) used European materials in their work
 (B) portrayed European historical events with their own histories
 (C) adapted European faith traditions and abandoned Native American imagery in their work
 (D) experimented with European artistic techniques such as contrapposto and chiaroscuro

3. The image of Coyolxauhqui was carved on a round disk and placed

 (A) at the top of an Aztec pyramid so people could worship it
 (B) at the entrance to an Aztec temple complex so people could see to whom the complex was dedicated
 (C) at the base of a pyramid so sacrificial victims could reenact the fate of Coyolxauhqui
 (D) in the coronation room of the king so that his ancestral lineage could be observed by all

4. The Hide Painting of a Sun Dance attributed to Cotsiogo is painted on the same kind of surface as

 (A) *Night Attack on the Sanjô Palace*
 (B) *The Book of Lindisfarne*
 (C) Folio from a Qur'an
 (D) *The Court of Gayumars*

5. The Hide Painting of a Sun Dance attributed to Cotsiogo draws on Native American traditions

 (A) in its use of the repoussé technique
 (B) in that it shows great virtuosity in the handling of classical forms
 (C) of articulating forms by placing them in an active sequence around a given space
 (D) that place humans on an exaggerated scale dominating all other figures in a work

Short Essay

Practice Question 4: Contextual Analysis
Suggested Time: 15 minutes

This is the Lanzón Stone from Chavín de Hunántar.

Describe the original placement of the Lanzón Stone.

Using *at least two* examples of contextual evidence, explain how the siting of the work has influenced the choice of materials *and* imagery.

Using *at least two* examples of contextual evidence, explain how the work relates to the site as a whole.

1. **B** 2. **A** 3. **C** 4. **B** 5. **C**

ANSWERS EXPLAINED

Multiple-Choice

1. **(B)** Transformation masks were only one part of a much larger ceremony of Kwakwaha'wakw Indians.

2. **(A)** When the Europeans settled in America, they often traded their materials for things the Indians valued. The bandolier bag, for example, is made from beads imported from Europe.

3. **(C)** The disk containing the image of Coyolxauhqui was placed at the bottom of a pyramid. The Aztecs sacrificed people and then threw them down the pyramid the way Huitzilopochtli did to Coyolxauhqui. There was a relationship established between the death and decapitation of Coyolxauhqui and the sacrifice of Aztec enemies at the top of the pyramid.

4. **(B)** Both the hide painting and *The Book of Lindisfarne* were executed on animal skins.

5. **(C)** Native American art often places figures in an active sequence around a given space.

Short Essay Rubric

Task	Point Value	Key Points in a Good Response
Describe the original placement of the Lanzón Stone.	1	Answers could include: ■ The stone was placed inside the temple Chavín at the center of a mazelike system of hallways. ■ The stone is underground and in a dark area.
Using *at least two* examples of contextual evidence, explain how the siting of the work has influenced the choice of materials and imagery.	2	Answers could include: ■ The blade shape of the stone might reflect a plough used for farming; hence the role of the god in ensuring a successful crop. ■ The figure carved on the surface is part human (body) and part animal (claws, fangs), with the head of snakes and the face of jaguars. ■ Figure done in flat relief. ■ Served as a cult figure with limited access. ■ Granite was chosen for its durable qualities.
Using *at least two* examples of contextual evidence, explain how the work relates to the site as a whole.	2	Answers could include: ■ Center of pilgrimage. ■ May have been an oracle. ■ Stone is buried beneath a large temple presumably dedicated to the gods. ■ The whole complex was a religious center.

African Art

TIME PERIOD: FROM PREHISTORIC TIMES TO THE PRESENT

Some chief African civilizations include:

Civilization	Time Period	Location
Great Zimbabwe	11th–15th Centuries	Zimbabwe
Bamileke	11th–21st Centuries	Cameroon
Benin	13th–19th Centuries	Nigeria
Luba	16th–21st Centuries	Congo
Kuba	17th–19th Centuries	Congo
Ashanti	17th–21st Centuries	Ghana
Chokwe	17th–21st Centuries	Congo
Yoruba	17th–21st Centuries	Nigeria
Baule	19th–21st Centuries	Côte d'Ivoire
Igbo	19th–21st Centuries	Nigeria
Fang	19th–21st Centuries	Cameroon, Gabon, Equatorial Guinea
Mende	19th–21st Centuries	Sierra Leone

ENDURING UNDERSTANDING: Art making is influenced by available materials and processes.
Learning Objective: Discuss how material, processes, and techniques influence the making of a work of art. (For example: *Bundu* mask)

Essential Knowledge:

■ African art is seen as a combination of the work of art itself in the context of events, media, and ceremonies. There is a wide variety of materials used in African art.

ENDURING UNDERSTANDING: The culture, beliefs, and physical settings of a region play an important role in the creation, subject matter, and siting of works of art.
Learning Objective: Discuss how the culture, beliefs, or physical setting can influence the making of a work of art. (For example: *Lukasa* (memory board))

Essential Knowledge:

■ Human life began in Africa. African art makes its first appearance around 77,000 years ago.
■ Rock art is the earliest form of African art. Animals are depicted most often.
■ The Sahara was once a vast grassland.

- African art is often rooted in belief systems and ideas. It is more concerned with the spiritual and intellectual than the physical.
- African art is involved in important stages of human life.
- Important civic and religious centers are often placed apart from places that involve herding or agriculture.

ENDURING UNDERSTANDING: Cultural interaction through war, trade, and travel can influence art and art making.

Learning Objective: Discuss how works of art are influenced by cultural interaction. (For example: Aka elephant mask)

Essential Knowledge:

- African art has been impacted by migration, world religions, and international trade.
- For many years, African art has been thought of as primitive by the outside world. However, African art is now understood as a vibrant series of artistic traditions.
- Contemporary African art understands artistic influences from around the world.

ENDURING UNDERSTANDING: Art and art making can be influenced by a variety of concerns including audience, function, and patron.

Learning Objective: Discuss how art can be influenced by audience, function, and/or patron. (For example: *Mblo*)

Essential Knowledge:

- African art is participatory. The arts express beliefs and maintain social and human relationships.
- African works are meant to be used and performed rather than simply viewed.
- Art is created for everyday use and important occasions. The object generally belongs to the person who commissioned it. Performances are highly organized.
- When an artwork represents authority, it legitimizes a leader.
- African art is presented to audiences through song and dance for specific reasons.

ENDURING UNDERSTANDING: Art history is best understood through an evolving tradition of theories and interpretations.

Learning Objective: Discuss how works of art have had an evolving interpretation based on visual analysis and interdisciplinary evidence. (For example: Great Zimbabwe)

Essential Knowledge:

- African art has been generally collected by outsiders. Generally, the artist's name and the date of creation are not known.
- Art history as a science is subject to differing interpretations and theories that change over time.
- African art has had a global impact.

HISTORICAL BACKGROUND

Despite the incredible vastness of the African continent, there are a number of similarities in the way in which African artists create art, stemming from common beliefs they share.

Africans believe that ancestors never die and can be addressed; hence a sense of family and a respect for elders are key components of the African psyche. Many African sculptures are representations of family ancestors and were carved to venerate their spirits.

Fertility, both of the individual and the land, is highly regarded. Spirits who inhabit the forests or are associated with natural phenomenon have to be respected and worshipped. Sculptures of suckling mothers are extremely common; it is implied that everyone suckles from the breast of God.

Great ancient civilizations in Nubia, Egypt, and Carthage dominated politics in North Africa for centuries before empires began to develop in southern Africa, or much of the rest of the world.

African kingdoms came and went with regularity; more populous and dominant people occupied wide swaths of African territory. Strong indigenous states were established in Christian Aksum in present-day Ethiopia in the fourth century, and in the Luba Empire concentrated in central Africa beginning in the fifteenth century. In the twelfth century an important center evolved in southern Africa on the Zimbabwe plateau. Whatever the location, African states developed strong cultural traditions yielding a great variety of artistic expression.

African affairs were largely internal struggles because outsiders were held back by natural barriers like the Sahara Desert and the Indian Ocean. However, by the fifteenth century African politics became greatly complicated by Asian and European incursions on both the east and west coasts of the continent. In general, outsiders restricted themselves to coastal areas that afforded the most access to African goods, and few bothered with the interior of the continent. All this changed in the late nineteenth century when a large series of invasions called the Scramble for Africa divided the continent into colonies.

The era of European control spanned less than a century. Most states achieved independence in the 1960s, with the Portuguese colonies waiting until the 1970s. Colonization brought African cultural affairs in direct contact with the rest of the world. Today African artists work both at home and abroad, using native and foreign materials, and marketing their work on a global scale.

Patronage and Artistic Life

Since traditional Africans rely on an oral tradition to record their history, African objects are unsigned and undated. Although artists were famous in their own communities and were sought after by princes, written records of artistic activity stem principally from European or Islamic explorers who happened to encounter artists in their African journeys.

African artists worked on commission, often living with their patrons until the commission was completed. The same apprenticeship training that was current in Europe was the standard in Africa as well. Moreover, Africans also had guilds that promoted their work and helped elevate the profession.

As a rule, men were builders and carvers and were permitted to wear masks. Women painted walls and created ceramics. Both sexes were weavers. There were exceptions; for example, in Sierra Leone and Liberia women wore masks during important coming-of-age ceremonies.

The most collectable African art originated in farming communities rather than among nomads, who desired portability. To that end, the more nomadic people of East Africa in Kenya and Tanzania produced a fine school of body art, and the more agricultural West Africans around Sierra Leone and Nigeria achieved greatness with bronze and wood sculpture.

African art was imported into Europe during the Renaissance more as curiosities than as artistic objects. It was not until the early twentieth century that African art began to find true acceptance in European artistic circles.

AFRICAN ARCHITECTURE

Traditional African architecture is built to be as cool and comfortable as a building could get in the hot African sun, and therefore is made of mud-brick walls and thatched roofs. While mud brick is certainly easy and inexpensive to make, it has inherent problems. All mud-brick buildings have to be meticulously maintained in the rainy season; otherwise, much would wash away. Nonetheless, Africans build huge structures of mud brick with horizontally placed timbers as maintenance ladders.

In a culture that generally eschews stonework, both in its architecture and its sculpture, the royal complex at **Zimbabwe** (Figure 27.1) from the fourteenth century is most unusual. The sophisticated handling of this type of masonry implies a long-standing tradition of construction of permanent materials, traces of which have all but been lost.

Great Zimbabwe, Shona peoples (Southeastern Zimbabwe), c. 1000–1400, coursed granite blocks, Zimbabwe (Figures 27.1a and 27.1b)

Form

- Walls: 800 feet long, 32 feet tall; 17 feet thick at base.
- Walls slope inward toward the top; made of exfoliated granite blocks.

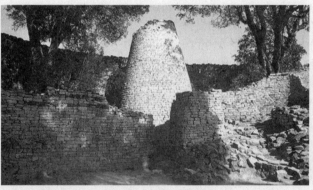

Figure 27.1a: Conical tower of Great Zimbabwe, c. 1000–1400, coursed granite blocks, Zimbabwe

Function

- Zimbabwe was a prosperous trading center and royal complex; items from as far away as Persia and China have been found.
- Stone enclosure was probably a royal residence.

Context

- Zimbabwe derives from a Shona term meaning "venerated houses" or "houses of stone."
- Internal and external passageways are tightly bounded, narrow, and long; occupants are forced to walk in single file, paralleling experiences in the African bush.
- The conical tower is modeled on traditional shapes of grain silos; control over food symbolized wealth, power, and royal largesse.
- The tower resembles a granary and represented a good harvest and prosperity; grain gathered, stored, and dispensed as a symbol of royal power.
- Abandoned in the fifteenth century probably because the surrounding area could no longer supply food and there was extensive deforestation.

Content Area Africa, Image 167

Web Source *http://whc.unesco.org/en/list/364*

- **Cross-Cultural Comparisons for Essay Question 1: Ashlar Masonry**
 - Saqsa Waman (Figure 26.8c)
 - Angkor Wat (Figure 23.8a)
 - Pantheon (Figures 6.11a, 6.11b)

Figures 27.1b: Circular wall of Great Zimbabwe

Great Mosque, founded c. 1200, rebuilt 1906–1907, adobe, Djenné, Mali (Figure 27.2)

Form

- Three tall towers; center tower is a mihrab.
- Vertical fluting drains water off the surfaces quickly.

Materials

- Made of adobe, a baked mixture of clay and straw; adobe helps maintain cooler temperatures.
- Torons: wooden beams projecting from walls.
- Wooden beams act as in-place ladders for the maintenance of the building.

Function

- Largest mud-brick mosque in the world.

Content

- Crowning ornaments have ostrich eggs, symbols of fertility and purity.
- Roof has several holes with terra cotta lids to circulate air into the main room.

Context

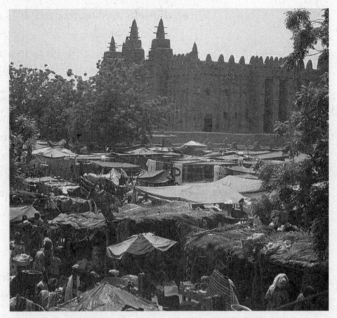

Figure 27.2: Great Mosque, founded c. 1200, rebuilt 1906–1907, adobe, Djenné, Mali

- Inhabited since 250 B.C.E., Djenné became a market center and an important link in the trans-Saharan gold trade.
- Two thousand traditional houses survive, built on small hills to protect against seasonal floods.
- Once a year there is a community activity to repair the mosque called Crepissago de la Grand Mosquée.

Content Area Africa, Image 168

Web Source http://whc.unesco.org/en/list/116

- **Cross-Cultural Comparisons for Essay Question 1: Other Mosques**
 - Great Mosque, Córdoba (Figures 9.14a, 9.14b, 9.14c)
 - Mosque of Selim II (Figures 9.16a, 9.16b, 9.16c)
 - Great Mosque, Isfahan (Figures 9.13a, 9.13b, 9.13c)

AFRICAN SCULPTURE

Despite the number of sculptural traditions in Africa, there are certain similarities.

- African art is basically portable. Large sculptures, the kind that grace the plazas of ancient Egypt or Rome, are unknown.
- Wood is the favorite material. Trees were honored and symbolically repaid for the branches taken from them. Ivory is used as a sign of rank or prestige. Metal shows strength and durability, and is restricted to royalty. Stone is extremely rare.
- Figures are basically frontal, drawn full-face, with attention paid to the sides. Symmetry is occasionally used, but more talented artists vary their approach on each side of the object.
- Africans did no preliminary sketches and worked directly on the wood. There is a certain stiffness to all African works.
- Heads are disproportionately large, sometimes one-third of the whole figure. Sexual characteristics are also enlarged. Bodies are immature and small. Hands and feet are very small; fingers are rare.

- Multiple media are used. It is common to see wood sculptures adorned with feathers, fabric, or beads.
- African sculpture prefers geometrization of forms. It generally avoids physical reality, representing the spirits in a more timeless world. Proportions are therefore manipulated.

Important sculpture is never created for decoration, but for a definite purpose. African masks are meant to be part of a costume that represents a spirit, and can only come alive when ceremonies are initiated. Every mask has a purpose and represents a different spirit. When the masks are worn in a ceremony, the spirit takes over the costumed dancer and his identity remains unknown—every part of his body is hidden from view. Moved by the beat of a drum, the masked dancer connects with the spirit world and can transmit messages to villagers who are witnesses.

BENIN

Wall plaque, from Oba's palace, Edo peoples, Kingdom of Benin (Nigeria), 16th century, cast brass, Metropolitan Museum of Art, New York (Figure 27.3a)

Form and Content
- Hierarchical proportions: largest figure is the king.
- Symbols of high rank are emphasized.
- King is stepping on a fallen leader.
- Emphasis on heads; bodies are often small and immature.
- Ceremonial scene at court.

Technique
- High-relief sculpture.
- Lost-wax process.

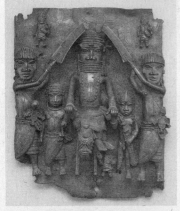

Materials
- One of 900 brass plaques produced, each between 16 and 18 inches.
- Metal products are rare in Africa, making these objects extremely valuable.
- There was an active trade with the Portuguese for brass.

Function
- It decorated the walls of the royal palace in Benin.
- It was part of a sprawling palace complex; wooden pillars covered with brass plaques.

Context
- Shows aspects of court life in the Benin culture.
- **Cross-cultural influences:**
 - The horse, an animal imported into Africa.
 - Rosette shapes inspired by Christian crosses from Europe.
 - May have been executed to reflect European books and prints that were available in Africa.
 - Imported goods reflected status: i.e., the king wears necklaces of coral.
- The oba (king) was believed to be a direct descendant of Oranmiyan, the legendary founder of the dynasty.

Figure 27.3a: Wall plaque, from Oba's palace, Edo peoples, Kingdom of Benin (Nigeria), 16th century, cast brass, Metropolitan Museum of Art, New York

- Only the oba was allowed to be shielded in the way depicted on the plaque.

Content Area Africa, Image 169

Web Source http://www.metmuseum.org/art/collection/search/310752

- **Cross-Cultural Comparisons for Essay Question 1: Bronze and Brass Work**
 - Donatello, *David* (Figure 15.5)
 - Great Buddha at Todai-ji (Figure 25.1b)
 - Shiva as Lord of Dance (Figure 23.6)

CONTEXTUAL IMAGE

The late Oba Akenzua II in full regalia, including a coral garment and headpiece (Figure 27.3b)

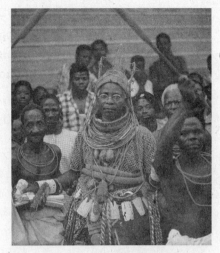

Figure 27.3b: The late Oba Akenzua II in full regalia, including a coral garment and headpiece

Context

- Coral is an important symbol of the identity of the oba, ruler of the land, with Olokun, ruler of the sea.
- Regalia reflects a continuous tradition of kingship and royal attire from the sixteenth century to the present.
- Photo dated December 24, 1964

Content Area Africa, Image 169

ASHANTI

Golden Stool (*sika dwa kofi*), Ashanti peoples (south central Ghana) c. 1700, gold over wood, and cast gold attachments, location unknown (Figure 27.4)

Form

- Entire surface inlaid with gold.
- Bells hang from the side to warn the king of danger.
- Replicas often used in ceremonies, but each replica is different.

Figure 27.4: Golden Stool (*sika dwa kofi*), Ashanti peoples (south central Ghana) c. 1700, gold over wood, and cast gold attachments, location unknown

Function

- Symbol of the Ashanti nation, in Ghana.
- Contains the soul of the nation.
- Never actually used as a stool; never allowed to touch the ground; it is placed on a stool of its own.
- According to Ashanti tradition, it was brought down from heaven by a priest and fell into the lap of the Ashanti king, Osei Tutu.
- It became the repository of the spirit of the nation; it is the symbol of the mystical bond among all Ashanti.

Context

- A new king is raised over the stool.
- The stool is carried to the king on a pillow; he alone is allowed to touch it.
- Taken out on special occasions.
- War of the Golden Stool: March–September 1900:
 - Conflict over British sovereignty in Ghana (formerly the Gold Coast).
 - A British representative who tried to sit on the stool caused an uproar and a subsequent rebellion.
 - The war ended with British annexation and Ashanti de facto independence.

Content Area Africa, Image 170

Web Source https://www.britannica.com/topic/Golden-Stool

- **Cross-Cultural Comparisons for Essay Question 1: Sacred Objects**
 - the Kaaba (Figure 9.11a)
 - Lanzón Stone (Figure 26.1b)
 - Gold and jade crown (Figure 24.10)

KUBA

Ndop (portrait figure) of King Mishe miShyaang maMbul, Kuba peoples, Democratic Republic of the Congo, 1760–1780, wood, Brooklyn Museum, Brooklyn, New York (Figure 27.5a)

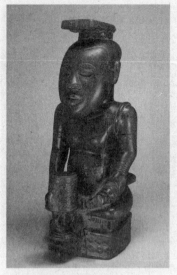

Figure 27.5a: *Ndop* (portrait figure) of King Mishe miShyaang maMbul, Kuba peoples, Democratic Republic of the Congo, 1760–1780, wood, Brooklyn Museum, Brooklyn, New York

Form

- Characteristics of a *ndop*:
 - Cross-legged pose.
 - Sits on a base.
 - Epicene body.
 - Face seems uninvolved, above mortal affairs.
 - A peace knife in his left hand.
- Royal regalia: bracelets, arm bands, belts, headdress.

Function

- *Ndop* sculptures are commemorative portraits of Kuba rulers, presented in an ideal state.
- Not an actual representation of a deceased king but of his spirit.
- Made after the death of the king.

Context

- Each king is commemorated by symbols on the base of the figure; this king has a sword in his left hand in a nonaggressive pose, handle facing out.
- One of the earliest existing African wood sculptures; oldest *ndop* in existence.
- Rubbed with oil to protect it from insects.
- Acted as a surrogate for the king in his absence.
- Kept in the king's shrine with other works called a set of "royal charms."

Content Area Africa, Image 171

Web Source *https://www.brooklynmuseum.org/opencollection/objects/4791*

- **Cross-Cultural Comparisons for Essay Question 1: Authority Figures**
 - Houdon, *George Washington* (Figure 19.7)
 - Lindauer, *Tamati Waka Nene* (Figure 28.7)
 - Code of Hammurabi (Figures 2.4a, 2.4b)

CONTEXTUAL IMAGE

Kuba Nyim (ruler) Kot a Mbweeky III in state dress with royal drum in Mushenge, Democratic Republic of the Congo (Figure 27.5b)

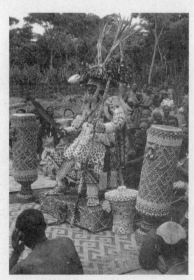

Figure 27.5b: Kuba Nyim (ruler) Kot a Mbweeky III in state dress with royal drum in Mushenge, Democratic Republic of the Congo

Form

- Photo of a Kuba king enthroned wearing royal regalia:
 - Headdress.
 - Necklace of leopard teeth.
 - Sword.
 - Lance.
 - Drums of reign.
 - Basket.
- Photo made in 1971, capturing a royal event.
- Costuming extremely elaborate; could weigh 185 pounds; king needed help to move.

Context

- Costuming represents the splendor of king's court, his greatness, and his responsibilities.
- Symbolizes the king's wealth, status, power.
- Kuba taste of accumulation of objects.
- Continuous tradition of honoring a Kuba king.
- Ruler often buried with the material after his death.

Content Area Africa, Image 171

KONGO

Power figure (*Nkisi n'kondi*), Kongo peoples, Democratic Republic of the Congo, c. late 19th century, wood and metal, Metropolitan Museum of Art, New York (Figure 27.6)

Form

- Alert pose.
- Rigid frontality.
- Arms akimbo, in an aggressive stance.
- Wears a headdress worn by chiefs or priests.
- Nails are pounded into the figure.

Function and Context

- Spirits are embedded in the images.
- Spirits can be called upon to bless or harm others, cause death or give life.
- In order to prod the image into action, nails and blades are often inserted into the work or removed from it.
- Medical properties are inserted into the body cavity, thought to be a person's life or soul.
- The figure has a role as a witness and enforcer of community affairs.
- The figure also cautions people on the consequences of actions contrary to community norms.

Content Area Africa, Image 172

Web Source http://metmuseum.org/art/collection/search/320053

- **Cross-Cultural Comparisons for Essay Question 1: Wood Sculpture**
 - *Röttgen Pietà* (Figure 12.7)
 - Transformation mask (Figures 26.12a, 26.12b)
 - Nio guardian figure (Figures 25.1c, 25.1d)

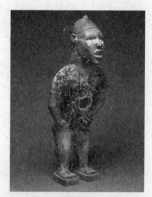

Figure 27.6: Power figure (*Nkisi n'kondi*), Kongo peoples, Democratic Republic of the Congo, c. late 19th century, wood and metal, Metropolitan Museum of Art, New York

BAULE

Portrait mask (*Mblo*), Baule peoples (Côte d'Ivoire), early 20th century, wood and pigment (Figure 27.7)

Form

- Broad forehead, pronounced downcast eye sockets, column-shaped nose: features associated with intellect and respect.
- Quiet faces; introspective look; peaceful face; meditative; eyebrows in an arch.

Function

- Presented at Mblo performances in which an individual is honored with ritual dances; tributes are performed in his or her honor.

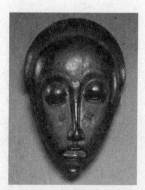

Figure 27.7: Portrait mask (*Mblo*), Baule peoples (Côte d'Ivoire), early 20th century, wood and pigment

- The dancer who wears the mask and wears the clothes of the person for the performance is accompanied by the actual person in the performance.
- The honoree receives a mask—an artistic double of the person—as a gift.

Context

- The masks are commissioned by a group of admirers, not by an individual; this one was made by the artist Owie Kimou.
- The masks are an idealized representation of a real person.
- This is the idealized representation of Moya Yanso.
- From the Ivory Coast.

Content Area Africa, Image 174

Web Source *http://metmuseum.org/art/collection/search/319512*

- **Cross-Cultural Comparisons for Essay Question 1: Commemoration**
 - Rivera, *Dream of a Sunday Afternoon on the Alameda Park* (Figure 22.20)
 - Lin, Vietnam Veterans Memorial (Figures 29.4a, 29.4b)
 - Olmec-style mask (Figure 26.5d)

CHOKWE

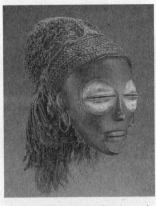

Figure 27.8: Female (*Pwo*) mask, Chokwe peoples, Democratic Republic of the Congo, late 19th to early 20th century, wood, fiber, pigment, and metal, National Museum of African Art, Washington, D.C.

Female (*Pwo*) mask, Chokwe peoples, Democratic Republic of the Congo, late 19th to early 20th century, wood, fiber, pigment, and metal, National Museum of African Art, Washington, D.C. (Figure 27.8)

Form

- Characteristics:
 - Enlarged eye sockets.
 - Pushed-in chin.
 - Slender nose.
 - High forehead.
 - Balanced features.
 - Almost-closed eyes.

Content

- Marks around the eyes may suggest tears; scarification marks including cosmogram on forehead.
- White powder around the eyes connects the figure to a spiritual realm.

Function

- These are female masks used by men in ritual dances.
- Male dancers are covered with their identities masked; they are dressed as women with braided hair.
- During the ritual, men move like women.
- Depicts female ancestors.

Context

- Chokwe, a matriarchal society.
- The mask is discarded when not in use and can be buried with the dancer.

Content Area Africa, Image 173

Web Source *http://metmuseum.org/exhibitions/view?exhibitionId=%7B3836826f-b525-4f56-bac3-dacb71d75b5c%7D&oid=320516*

MENDE

Bundu **mask, Sande society, Mende peoples (West African forests of Sierra Leone and Liberia), 19th to early 20th century, wood, cloth, and fiber, private collection (Figure 27.9a)**

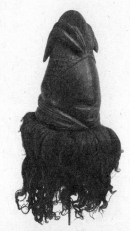

Figure 27.9a: *Bundu* mask, Sande society, Mende peoples (West African forests of Sierra Leone and Liberia), 19th to 20th century, wood, cloth, and fiber, private collection

Form

- Idealized female beauty, both physically and morally:
 - Elaborate hairstyle symbolizes wealth; worn by women of status.
 - High forehead indicates wisdom.
 - Small eyes in the shape of slits: she should be demure.
 - Tight-lipped mouth, symbolizing secrets not revealed.
 - Small ears: avoids gossip.
 - Rings around the neck symbolize concentric waves from which the water spirit, Sowei, breaks through the surface; also symbolizes the fat associated with a pregnant body.
- Small horizontal features.

Function

- Used for initiation rites to adulthood.
- Used by the elder women of the Sande society, a group of women who prepare girls for adulthood and their role in society.
- Mask rests on woman's head; head is not placed inside the mask.
- Mask is coated with palm oil for a lustrous effect; it has a shiny black surface.
- Black color symbolizes water, coolness, and humanity.

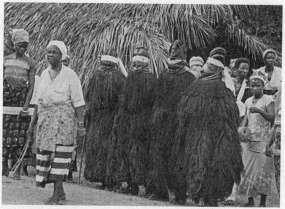

Figure 27.9b: *Bundu* masks worn in a ceremony

Context

- Only African wooden masks that are worn by women.
- Costumed women wear a black gown made of raffia that hides the body.
- Costumed as a Sowei, the female water spirit.
- Female ancestor spirits.
- Symbolic of the chrysalis of a butterfly; young woman entering puberty.
- Individuality of each mask is stressed.

Content Area Africa, Image 175

Web Source *www.metmuseum.org/art/collection/search/313757*

CONTEXTUAL IMAGE

Bundu **masks worn in a ceremony (Figure 27.9b)**

- **Cross-Cultural Comparisons for Essay Question 1: Art as Part of a Performance**
 - Presentation of Fijian mats and tapa cloths to Queen Elizabeth II (Figure 28.10)
 - Viola, *The Crossing* (Figures 29.18a, 29.18b)
 - Plaque of the Ergastines (Figure 4.5)

IGBO

Ikenga (shrine figure), Igbo peoples (Nigeria), c. 19th to 20th century, wood, Brooklyn Museum, Brooklyn, New York (Figure 27.10)

Function and Content

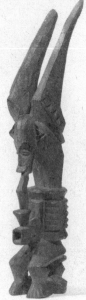

- Ikenga means "strong right arm" and thus physical prowess.
- It honors the right hand, which holds tools or weapons, makes sacrifices, conducts rituals, and alerts to speak at public forums.
- Ikenga embraces traditional masculine associations of strength and potency.
- Often a mix of human, animal, and abstract forms.
- Carved from hardwoods, considered masculine.
- It tells of the owner's morality, prosperity, achievements, genealogy, and social rank.

Context

- Enormous horns symbolize power.
- Requires blessings before use; consecrated with offerings before kinsmen.
- As the man achieves more success, he might commission a more elaborate version.
- It is maintained in the man's home and is destroyed when the owner dies; another can reuse it if not destroyed.

Figure 27.10: *Ikenga* (shrine figure), Igbo peoples (Nigeria), c. 19th–20th century, wood, Brooklyn Museum, Brooklyn, New York

Content Area Africa, Image 176

Web Source https://www.brooklynmuseum.org/opencollection/objects/101836

- **Cross-Cultural Comparisons for Essay Question 1: Sculpture in the Round**
 - Kneeling statue of Hatshepsut (Figure 3.9b)
 - Rodin, *The Burghers of Calais* (Figure 21.15)
 - Abakanowicz, *Androgyne III* (Figure 29.7)

LUBA

Lukasa (memory board), Mbudye Society, Luba peoples, Democratic Republic of the Congo, c. 19th to 20th century, wood, beads, and metal, Brooklyn Museum, Brooklyn, New York (Figures 27.11a and 27.11b)

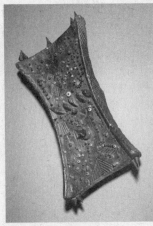

Figure 27.11a: *Lukasa* (memory board), Mbudye Society, Luba peoples, Democratic Republic of the Congo, c. 19th–20th century, wood, beads, and metal, Brooklyn Museum, Brooklyn, New York

Figure 27.11b: Court historian using *Lukasa* (memory board)

Form

- Carved from wood in an hourglass shape and adorned with beads, shells, or metal.
- Back, expressed by Luba people as the "outside," resembles the shell of a turtle.

Function

- Court historian who serves as reader of the memory board holds the lukasa in his left hand and gently touches the beads that he will discuss with his right index finger.
- Ability to read the board is limited to a few people.
- Memory board helps the user remember key elements in a story; for example:
 - Court ceremonies.
 - Migrations.
 - Heroes.
 - Kinship.
 - Genealogy.
 - Lists of kings.

Context

- Each board's design is unique and represents the divine revelations of a spirit medium expressed in sculptural form.
- Memory boards are controlled by the Mbudye, a council of men and women who interpret the political and historical aspects of Luba society.
- Zoomorphic elements represented by the turtle, an animal that lives on both land and water; the dual nature of the turtle is a metaphor for the Luba people's political organization as founded by two distinctly opposed embodiments of power: Kongolo Mwamba, avatar of all excess and tyranny, and Mbidi Kiluwe, sophisticated cultural hero who introduced royal culture to the Luba people.
- Reading example:
 - One colored bead can stand for an individual.
 - Large beads surrounded by smaller beads can signify a ruler and his court.
 - Lines of beads are journeys or paths, migrations or genealogies.

Content Area Africa, Image 177

Web Source *https://www.brooklynmuseum.org/opencollection/objects/102210*

CONTEXTUAL IMAGE

Court historian using *lukasa* (memory board) (Figure 27.11b)

Figure 27.12a: Aka elephant mask, Cameroon (western grassfields region), c. 19th–20th century, wood, woven raffia, cloth, and beads

BAMILEKE

Aka elephant mask, Cameroon (western grasslands region), c. 19th to 20th century, wood, woven raffia, cloth, and beads (Figures 27.12a and 27.12b)

Form

- The mask has the features of an elephant: long trunk, large ears (symbolizing strength and power).
- The mask fits over the head and two folds hang down in front (symbolizing the trunk) and behind the body.
- Human face.

Materials

- Beadwork on a fabric backing; beadwork is a symbol of power.
- Lavish use of colored beads and cowrie shells displays the wealth of the members of the men's Kuosi society; the colors and patterns express the society's cosmic and political functions.

Function

- Elite Kuosi masking society owns and wears the masks; worn on important ceremonial occasions.
- Only important people in society can own and wear an elephant mask.

Context

- Performance art: maskers dance barefoot to a drum and gong; they wave spears and horsetails.

Content Area Africa, Image 178

Web Source *www.metmuseum.org/art/collection/search/314264*

Figure 27.12b: Men wearing aka elephant masks during a ceremony

Men wearing aka elephant masks during a ceremony (Figure 27.12b)

- **Cross-Cultural Comparisons for Essay Question 1: Spiritual World**
 - Bernini, *Ecstasy of Saint Teresa* (Figures 17.4a, 17.4b)
 - Staff god (Figures 28.5a, 28.5b)
 - Kneeling statue of Hatshepsut (Figure 3.9b)

FANG

Reliquary figure (*byeri*), Fang peoples (southern Cameroon), c. 19th to 20th century, wood, Brooklyn Museum, Brooklyn, New York (Figure 27.13)

Form

- Feet dangling over the rim, a gesture of protecting the contents.
- Prominent belly button and genitals emphasize life; the prayerful gesture and somber look emphasize death.
- Emphasis on the head and the tubular nature of the body.

Function

- Such figures were placed on top of cylinder-like containers made of bark that held skulls and other bones of important clan leaders.
- The reliquary figure guards the head box against the gaze of women or young boys.

Context

- The surfaces were ritually rubbed with oils to add luster and protect against insects.
- Byeri figures are composed of characteristics the Fang people place a high value on: tranquility, introspection, and vitality.
- The Fang people were nomadic; these figures were made to be portable.
- The abstraction of the human body is an attraction for the early-twentieth-century artists.

Content Area Africa, Image 179

Web Source https://www.brooklynmuseum.org/opencollection/objects/4755

- **Cross-Cultural Comparisons for Essay Question 1: Male Figure**
 - *Apollo from Veii* (Figure 5.5)
 - Donatello, *David* (Figure 15.5)
 - Nio guardian figure (Figures 25.1c, 25.1d)

YORUBA

Veranda post of enthroned king and senior wife (Opo Ogoga), Olowe of Ise (Yoruba peoples), 1910–1914, wood and pigment, Art Institute of Chicago, Chicago, Illinois (Figure 27.14)

Form

- Wooden sculpture with tall vertical emphasis.
- Complicated and elaborate use of negative space.
- Negative space creates an openness in the composition.
- Most veranda posts were painted; this work has traces of paint remaining.

Function

- Olowe of Ise carved veranda posts for the rulers of the Ekiti-Yoruba kingdom in Nigeria.
- One of four carved for the palace at Ikere, Nigeria.

Figure 27.13: Reliquary figure (*byeri*), Fang peoples (southern Cameroon), c. 19th–20th century, wood, Brooklyn Museum, Brooklyn, New York

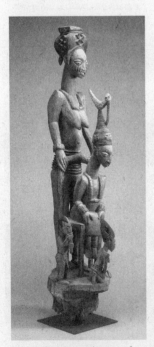

Figure 27.14: Veranda post of enthroned king and senior wife (Opo Ogoga), Olowe of Ise (Yoruba peoples), 1910–1914, wood and pigment, Art Institute of Chicago, Chicago, Illinois

Context

■ The king is the focal point between himself and others represented on the post.

■ Behind the king, his large-scale senior wife supports the throne.

■ She crowns the king during the coronation; protects him during his reign.

■ The smaller figures include his junior wife; his flute player, Eshu, the trickster god; and a figure of a fan bearer now missing.

Content Area Africa, Image 180

Web Source *http://www.artic.edu/aic/collections/artwork/102611?search_no=1&index=0*

■ **Cross-Cultural Comparisons for Essay Question 1: Multi-Figure Sculptures**

　– Helios, horses, and Dionysos (Figure 4.4)

　– Rodin, *The Burghers of Calais* (Figure 21.15)

　– King Menkaura and queen (Figure 3.7)

VOCABULARY

Adobe: a building material made from earth, straw, or clay dried in the sun (Figure 27.2)

Aka: an elephant mask of the Bamileke people of Cameroon (Figure 27.12a)

Byeri: in the art of the Fang people, a reliquary guardian figure (Figure 27.13)

Bundu: masks used by the women's Sande society to bring girls into puberty (Figure 27.9a)

Cire perdue: the lost wax process. A bronze casting method in which a figure is modeled in clay and covered with wax and then recovered with clay. When fired in a kiln, the wax melts away, leaving a channel between the two layers of clay which can be used as a mold for liquid metal (Figure 27.3a)

Fetish: an object believed to possess magical powers

Ikenga: a shrine figure symbolizing traditional male attributes of the Igbo people (Figure 27.10)

Lukasa: a memory board used by the Luba people of central Africa (Figure 27.11)

Mblo: a commemorative portrait of the Baule people (Figure 27.7)

Ndop: a Kuba commemorative portrait of a king in an ideal state (Figure 27.5a)

Nkisi n'kondi: a Kongo power figure (Figure 27.6)

Pwo: a female mask worn by women of the Chokwe people (Figure 27.8)

Scarification: scarring of the skin in patterns by cutting with a knife: when the cut heals, a raised pattern is created, which is painted

Torons: wooden beams projecting from walls of adobe buildings (Figure 27.2)

SUMMARY

African artists operated under the same general conditions of artists everywhere—learning their craft in a period of apprenticeship, working on commission from the powerful and politically connected, and achieving a measure of international fame. However, because African artists relied on the oral tradition, little written documentation of their achievements has been recorded.

Africans achieved great distinction in the carving of masks, both in wood and metal. Costumed dancers don the mask and assume the powers of the spirit that it represents. The role of the mask, therefore, indeed the role of African art, is never merely decorative, but functional and spiritual; works are imbued with powers that are symbolically much greater than the merely visible representation.

Multiple-Choice

Questions 1–3 refer to the image below.

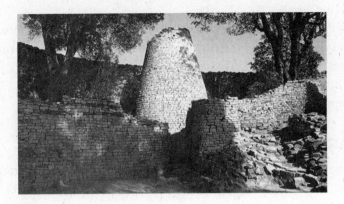

1. The function of the complex at Great Zimbabwe included

 (A) a storehouse for grain used for dispersal in times of need
 (B) a military fortress used to keep invaders out
 (C) a religious center meant to represent a Christian presence in Africa
 (D) a trading center with a stock and currency exchange

2. Visitors who entered Great Zimbabwe were meant

 (A) to be left with the feeling that they were in a major city and transportation hub
 (B) to be impressed that this was the center of manufacturing and industry
 (C) to admire the impressive and extensive use of stone in a part of the world that specialized in more perishable types of construction
 (D) to admire the painted friezes depicting the military exploits of the king

3. The stone walls of Great Zimbabwe exemplify the Southern African architectural practices of

 (A) using ashlar masonry to create force-dependent structures
 (B) making the stones from mud-backed bricks, similar to adobe construction
 (C) spanning large interior spaces with great arches
 (D) employing flying buttresses to support the massive walls

4. *Pwo* masks and *Bundu* masks are similar in that they both are

 (A) honoring women with an idealized representation
 (B) representations of an actual woman, and the rituals portray events from her life
 (C) worn by women in actual ceremonies
 (D) representations of the spirit of a deceased female ancestor

5. The power of *Nkisi n'kondi* figures is activated by

 (A) nailing blades into the surface of a figure
 (B) carrying a figure in a procession around a village square
 (C) "marrying" the image to a second power figure
 (D) masking the figure to allow its powers to work unseen

Long Essay

Practice Question 1: Comparison
Suggested Time: 35 minutes

This work is a *Pwo* mask from the Congo created in the early twentieth century.

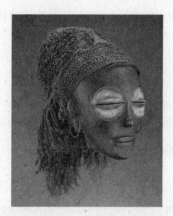

Select and completely identify another work of art that was worn as a mask.

Both masks were worn in ceremonies. Describe the purpose of each ceremony.

In addition to the masks, what other materials were used in the ceremony?

Analyze how the forms of both masks were meant to enhance the meaning of the ceremony.

How do the masks differ in function?

Malagan mask
Transformation mask
Buk (mask)

ANSWERS EXPLAINED

Multiple-Choice

1. **(A)** Christianity was unknown in this part of Africa at this time. Although Zimbabwe was an important trading center, the modern concept of a stock and currency exchange was unknown. Leaders controlled the food supply as a symbol of power.

2. **(C)** Stone buildings are rare in traditional African culture, making this complex admirable from both architectural and engineering points of view.

3. **(A)** No mortar is used in the construction of Great Zimbabwe; therefore, it is made of ashlar masonry.

4. **(A)** Both masks honor women. The *Pwo* mask is worn by men to honor female ancestors; the *Bundu* mask honors young women on the road to adulthood.

5. **(A)** The power figure is activated by nailing blades into the surface.

Long Essay Rubric

Task	Point Value	For the *Pwo* mask, answers could include:
Select and completely identify another work of art that was worn as a mask.	—	—
Both masks were worn in ceremonies. Describe the purpose of each ceremony.	1 point for *Pwo* mask	■ Female masks are used by men in ritual dances. ■ Male dancers are covered with their identities masked, dressed as women with braided hair. ■ It's a ritual in which men move like women. ■ The ritual depicts female ancestors.
In addition to the masks, what other materials were used in the ceremony?	1 point for *Pwo* mask	■ Dance. ■ Music. ■ Costumes.
Analyze how the forms of both masks were meant to enhance the meaning of the ceremony.	1 point for *Pwo* mask	■ Chokwe, a matriarchal society. ■ It depicts female ancestors with particular characteristics: enlarged eye sockets, pushed-in chin, slender nose, high forehead, balanced features, almost-closed eyes.
How do the masks differ in function?	1	■ Response depends on the other mask chosen. See the following.

Task	Point Value	For the Malagan, Transformation, and Buk masks, answers could include:
Select and completely identify another work of art that was worn as a mask.	1; two identifiers are needed to earn a point	**Malagan mask:** ■ New Ireland Province of Papua New Guinea, c. 20th century, wood, figment, fiber and shell. **Transformation mask:** ■ Kwakwaha'wakw, Northwest Coast of Canada, late 19th century, wood, paint, and string. **Buk mask:** ■ Torres Strait, mid- to late 19th century, turtle shell, wood, fiber, feathers, and shell.
Both masks were worn in ceremonies. Describe the purpose of each ceremony.	1 point for each work	**Malagan mask:** ■ Malagan ceremonies send the souls of the deceased on their way to the otherworld. **Transformation mask:** ■ Although these masks could be used at a potlatch, most often they were used in winter initiation rites ceremonies. ■ Opening the mask reveals the face of an ancestor; there is an ancestral element to the ceremony. **Buk mask:** ■ Ceremonies could involve initiation, funerary rites, and ensuring a good harvest.
In addition to the masks, what other materials were used in the ceremony?	1 point for each work	**Malagan mask:** ■ Dance. ■ Music. ■ Costumes. ■ Chanting. ■ Ceremonies take place in a purpose-built structure. **Transformation mask:** ■ Drumming. ■ Costumes. ■ Ceremony takes place in a "big house." **Buk mask:** ■ Fire. ■ Drumming. ■ Chanting. ■ Grass costumes.

Task	Point Value	For the Malagan, Transformation, and Buk masks, answers could include:
Analyze how the forms of both masks were meant to enhance the meaning of the ceremony.	1 point for each work	**Malagan mask:** ■ Masks are extremely intricate in their carving. ■ Mask indicates the relationship of a particular deceased person to a clan and to living members of the family. ■ Large haircomb reflects a hairstyle of the time, but masks are not physical portraits, only portraits of the soul. ■ Painted black, yellow, and red: important colors denoting violence, war, and magic. **Transformation mask:** ■ During a ritual performance, the wearer opens and closes the transformation mask using strings. ■ Bird exterior opens to reveal a human face on the interior. ■ At the moment of transformation, the performer turns his back to the audience to conceal the action and heighten the mystery. **Buk mask:** ■ Masks combine human and animal forms. ■ Turtle shell is peculiar to this region and may have had symbolic overtones. ■ Human face may represent a cultural hero or ancestor.
How do the masks differ in function?	1	Response depends on the masks chosen; however, differences can be noted in the purpose of the ceremony and therefore the mask.

Pacific Art

28

TIME PERIOD: FROM ANCIENT TIMES TO THE PRESENT

Except for the Easter Island sculptures, which date from the tenth century, most surviving Pacific Art dates from the nineteenth and twentieth centuries.

ENDURING UNDERSTANDING: Art making is influenced by available materials and processes.

Learning Objective: Discuss how material, processes, and techniques influence the making of a work of art. (For example: Buk (mask))

Essential Knowledge:

- Pacific art is seen as a whole: the work of art exists in the context of events, media, and ceremonies. There is a wide variety of materials used in Pacific art.
- Among the materials used in Pacific art are bone, seashell, fiber, wood, stone, and coral, as well as tortoise shell.
- Materials are likely to create a response in the audience; i.e., precious objects denote wealth.

ENDURING UNDERSTANDING: The culture, beliefs, and physical settings of a region play an important role in the creation, subject matter, and siting of works of art.

Learning Objective: Discuss how the culture, beliefs, or physical setting has affected the making of a work of art. (For example: Maoi from Rapa Nui)

Essential Knowledge:

- The Pacific has 1,500 inhabited islands, each with a distinct ecology.
- Australia was populated 30,000 years ago. The Lapita people migrated east about 4,000 years ago.
- Pacific peoples are seafaring.
- The sea is a major theme in Pacific art.

ENDURING UNDERSTANDING: Cultural interaction through war, trade, and travel can influence art and art making.

Learning Objective: Discuss how works of art are influenced by cultural interaction. (For example: Presentation of Fijian mats and tapa cloths to Queen Elizabeth II)

Essential Knowledge:

- Pacific art has been influenced by ecology, colonialism, social structure, missionary activity, and commerce.
- Europeans encountered the Pacific in the sixteenth century. Later, they divided the region into three distinct zones: Melanesia, Micronesia, and Polynesia.

ENDURING UNDERSTANDING: Art and art making can be influenced by a variety of concerns including audience, function, and patron.

Learning Objective: Discuss how art can be influenced by audience, function, and/or patron. (For example: Nan Madol)

Essential Knowledge:

- Pacific art is related to forces in the spiritual world. One's vital force, or *mana*, was often wrapped or shielded to be protected. Sometimes *mana* could represent a whole community. The act of protecting the *mana* through rituals or wrapping is called *tapu.*
- Pacific art is often performed using dance, singing, costuming, scent, and cosmetics.
- Objects often illustrate familial and societal history. Others are created to be performed and later destroyed.
- Sacred ceremonial spaces are common in the Pacific. Masks are key elements in Pacific performances.
- Rituals and performances often involve exchanging prearranged items that have symbolic value.
- A symmetry of relationships is often sought. Opposing forces, such as gender, are placed within a balancing situation in many rituals.

ENDURING UNDERSTANDING: Art history is best understood through an evolving tradition of theories and interpretations.

Learning Objective: Discuss how works of art have had an evolving interpretation based on visual analysis and interdisciplinary evidence. (For example: Lindauer, *Tamati Waka Nene*)

Essential Knowledge:

- Pacific art is an expression of a collection of beliefs and social relationships.
- Creating or destroying a work of art often carries great significance, sometimes more significant than the object itself. The act of performance contains the work's meaning. The objects in that performance contain no meaning unless brought to life by rituals.

HISTORICAL BACKGROUND

Certain areas of the Pacific are some of the oldest inhabited places on earth, and yet, paradoxically, some areas are among the newest. Aborigines reached Australia around 50,000 years ago, but the remote islands of the Pacific, like Hawaii, Easter Island, and New Zealand were occupied only in the last thousand years or so.

Around 1300 B.C.E. seafarers reached across the vast oceanic expanses to chart their way toward Fiji in the central South Pacific. Technological development of sailing craft meant greater territories could be mapped and charted for possible occupation. The particularly effective twin-hulled sailing canoe was used to traverse hundreds of nautical miles; Tonga was reached in 420 B.C.E., and then Samoa in 200 B.C.E.

The final push to populate the Pacific came with the discovery of New Zealand. This happened perhaps as early as the tenth century, but certainly by the thirteenth century by the ancestors of the Maori.

European involvement in the Pacific began with the circumnavigation of the globe by Portuguese explorer Ferdinand Magellan and his crew. Explorers of the eighteenth century were followed by occupiers from the nineteenth century, who implanted European customs, values, religions, and technologies onto the indigenous population. Many areas of the Pacific, however, achieved independence in the twentieth century.

Patronage and Artistic Life

Men and women had clearly defined roles in Pacific society, including which sex could create works of art in which media. Men carved in wood, woman sewed and made pottery.

One of the most characteristic works still done by Pacific women is the weaving of bark-cloth, or **tapa** (Figure 28.6). The inner bark of the mulberry tree is harvested and small strips are made malleable by repeated soakings. Each strip is placed in a pattern and then beaten in order to fuse them together. Designs were added by stenciling or painting directly onto the surface. The result is a cloth of refined geometric organization and intricate patterning.

MICRONESIA

Nan Madol, Saudeleur Dynasty, c. 700–1600, basalt boulders and prismatic columns, Pohnpei, Micronesia (Figures 28.1a and 28.1b)

Form
- 92 small artificial islands connected by canals, about 170 acres in total.
- Built out into the water on a lagoon—similar to Venice, Italy.
- Seawalls 15 feet high and 35 feet thick acted as breakwaters.
- Canals were flushed clean with the tides.
- Islands were arranged southwest to northeast to take advantage of the trade winds.
- Walls were made of prismatic basalt; roofs were thatched.

Function
- Ancient city that acted as the capital of the Saudeleur Dynasty of Micronesia.

Context
- City built to separate the upper classes from the lower classes.
- King arranged for the upper classes to live close to him, to keep an eye on them.
- Curved outer walls point upward at edges, giving the complex a symbolic boat-like appearance.

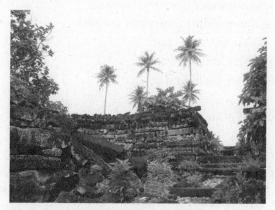

Figure 28.1a: Nan Madol, Saudeleur Dynasty, c. 700–1600, basalt boulders and prismatic columns, Pohnpei, Micronesia

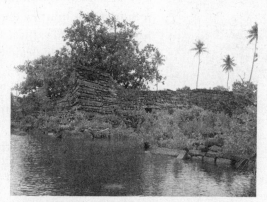

Figure 28.1b: Nan Madol, Saudeleur Dynasty, c. 700–1600, basalt boulders and prismatic columns, Pohnpei, Micronesia

Content Area Pacific, Image 213

Web Source *http://whc.unesco.org/en/list/1503*

■ **Cross-Cultural Comparisons for Essay Question 1: Water and Architecture**

– Ryoan-ji (Figures 25.2a, 25.2b, 25.2c)

– Gehry, Guggenheim Museum Bilbao (Figures 29.1a, 29.1b)

– Wright, Fallingwater (Figures 22.16a, 22.16b, 22.16c)

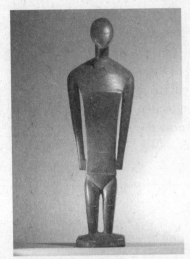

Figure 28.2: Female deity, c. 18th–19th century, wood, Nukuoro, Micronesia

Female deity, c. 18th to 19th century, wood, Nukuoro, Micronesia (Figure 28.2)

Form

■ Simple geometric form.

■ Erect pose, long arms, broad chest.

■ Chin drawing to a point; no facial features.

■ Horizontal lines were used to indicate kneecaps, navel, and waistline.

Function

■ Female deity.

Context

■ Many were kept in religious buildings belonging to the community.

■ They represent individual deities.

■ Sometimes they were dressed in garments; may have been decorated with flowers.

■ Taken by missionaries who did not record anything about the sculptures.

Content Area Pacific, Image 217

Web Source *http://www.britishmuseum.org/research/collection_online/collection_object_details.aspx?objectId=495859&partId=1&searchText=nukuoro&page=1*

■ **Cross-Cultural Comparisons for Essay Question 1: Wood Sculpture**

– Olowe of Ise, veranda post (Figure 27.14)

– Nio guardian figure (Figure 25.1c, 25.1d)

– *Röttgen Pietà* (Figure 12.7)

Figure 28.3: Navigation chart, Marshall Islands, Micronesia, 19th to early 20th century, wood and fiber, British Museum, London

Navigation chart, Marshall Islands, Micronesia, 19th to early 20th century, wood and fiber, British Museum, London (Figure 28.3)

Form

■ Chart is made of wood, therefore waterproof and buoyant.

■ Small shells indicate the position of the islands on the chart.

■ Horizontal and vertical sticks support the chart.

■ Diagonal lines indicate wind and water currents.

■ Charts indicate patterns of ocean swells and currents.

Function

■ Charts meant to be memorized prior to a voyage; not necessarily used during a voyage.

■ Charts enabled navigators to guide boats through the many islands to get to a destination.

■ Charts were individualized to their makers; others cannot read the chart.

Context

■ Marshall Islands are low lying and hard to see from a distance or from sea level.

■ Charts are called *wapepe* in the Marshall Islands.

Content Area Pacific, Image 221

Web Source *http://www.metmuseum.org/toah/works-of-art/1978.412.826/*

- **Cross-Cultural Comparisons for Essay Question 1: Utility**
 - Ambum Stone (Figure 1.4)
 - The Ardabil Carpet (Figure 9.7a)
 - Pyxis of al-Mughira (Figure 9.4)

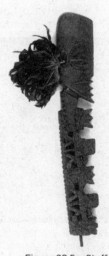

Figure 28.4: 'Ahu 'ula (feather cape), late 18th century, feathers and fiber, British Museum, London

HAWAII

'Ahu 'ula (feather cape), late 18th century, feathers and fiber, British Museum, London (Figure 28.4)

Materials

- The cape is made of thousands of bird feathers.
- Feathers numbered 500,000; some birds had only seven usable feathers.
- The feathers were tied to a coconut fiber base.

Function

- Only high-ranking chiefs or warriors of great ability were entitled to wear these garments; worn by men.

Context

- Red was considered a royal color in Polynesia; yellow was prized because of its rarity.
- The cape was created by artists who chanted the wearer's ancestors to imbue their power onto it.
- It protected the wearer from harm.
- The concept of "mana:" a supernatural force believed to dwell in a person or sacred object.
- Many capes have survived, but no two capes are alike.

Content Area Pacific, Image 215

Web Source *http://honolulumuseum.org/art/5780-feather-cape-ahu-ulaa_z*

- **Cross-Cultural Comparisons for Essay Question 1: Regalia**
 - Ruler's feathered headdress (Figure 26.6)
 - Gold and jade crown (Figure 24.10)
 - *Ndop* Contextual Photograph (Figure 27.5b)

Figure 28.5a: Staff god, Rarotonga, Cook Islands, central Polynesia, late 18th to early 19th century, wood, tapa, fiber, and feathers, British Museum, London

COOK ISLANDS

Staff god, Rarotonga, Cook Islands, central Polynesia, late 18th to early 19th century, wood, tapa, fiber, and feathers, British Museum, London (Figures 28.5a and 28.5b)

Form and Content

- Large, column-like, wooden core mounted upright in village common spaces; the wooden core is wrapped with tapa cloth (i.e., Hiapo, Figure 28.6).
- The wooden sculpture placed on top features a large carved head with several smaller figures carved below it (Figure 28.5a).
- The shaft is in the form of an elongated body (Figure 28.5b).

Figure 28.5b: Staff god, Rarotonga

- The lower end had a carved phallus. Some missionaries removed and destroyed the phalluses, considering them obscene.
- The soul of the god is represented by polished pearl shells and red feathers, which are placed inside the bark cloth next to the interior shaft.

Context

- Most staff gods were destroyed; only the top ends were retained as trophies.
- This is the only surviving wrapped example of a staff god.
- In the contextual image from a book by an English missionary (not shown), the staff gods have been thrown down in the village square in front of a European-style church; it represents the fall of one faith and the adoption of another.
- The contextual image is the only visual evidence that indicates how these staff gods were used.
- Reverend John Williams observed that the barkcloth contained red feathers and pieces of pearl shell, known as the manava or the spirit of the god. He also recorded seeing the islanders carrying the image upright on a litter.

Content Area Pacific, Image 216

Web Source *https://artsandculture.google.com/asset/god-stick-with-barkcloth/OwEzoiWYHZRkdA*

- **Cross-Cultural Comparisons for Essay Question 1: Gods and Spiritual Presences**
 - Last Judgment, Sainte-Foy, Conques (Figure 11.6a)
 - Great Buddha, Todai-ji, (Figure 25.1b)
 - Shiva as Lord of Dance (Figure 23.6)

POLYNESIA

Hiapo (tapa) from Niue, c. 1850–1900, tapa or bark cloth, freehand painting, Auckland War Memorial Museum, New Zealand (Figure 28.6)

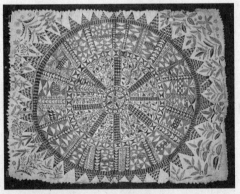

Figure 28.6: Hiapo (tapa) from Niue, c. 1850–1900, tapa or bark cloth, freehand painting, Auckland War Memorial Museum, New Zealand

Technique

- Tapa is cloth made from tree bark; the pieces are beaten and pasted together.
- Using stencils, the artists dye the exposed parts of the tapa with paint.
- After the tapa is dry, designs are sometimes repainted to enhance the effect.

Function

- Traditionally worn as clothing before the importation of cotton.

Context

- *Hiapo* is the word used in Niue for tapa (bark cloth).
- Tapa takes on a special meaning: commemorating an event, honoring a chief, noting a series of ancestors.
- Tapa is generally made by women.
- Each set of designs is meant to be interpreted symbolically; many of the images have a rich history.

Content Area Pacific, Image 219

Web Source *http://www.aucklandmuseum.com/collection/object/am_humanhistory-object-81487*

- **Cross-Cultural Connections: Art Forms Traditionally Associated with Women**
 - Martínez, Black-on-black ceramic vessel (Figure 26.14)
 - All-T'oqapu tunic (Figure 26.10)
 - Ringgold, *Dancing at the Louvre* (Figure 29.11)

NEW ZEALAND

Tamati Waka Nene, Gottfried Lindauer, 1890, oil on canvas, Auckland Art Gallery, Auckland, New Zealand (Figure 28.7)

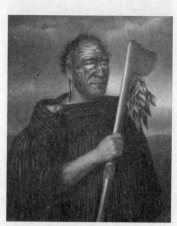

Figure 28.7: *Tamati Waka Nene*, Gottfried Lindauer, 1890, oil on canvas, Auckland Art Gallery, Auckland, New Zealand

Subject

- Subject is Tamati Waka Nene (c. 1780–1871), Maori chief and convert to the Wesleyan faith.
- Painting is posthumous, based on a photograph by John Crombie.

Content

- Emphasis is placed on symbols of rank: elaborate tattooing with Maori designs, staff with an eye in the center, feathers dangling from the staff.
- Ceremonial weapon has a finely wrought blade with dangling feathers and abalone shell as a focal point or eye.
- Status is revealed in oversize greenstone earring, which contains his power, or "mana," and kiwi feather cloak.

Context

- The painter was born in Bohemia and was famous for portraits of Maori chieftains upon his arrival in New Zealand in 1873–1874 until his death in 1926.
- He was a journeyman painter and tradesman who worked on commission.
- This is a European-style painting in its use of oil paint, canvas backing, coloring, modeling, shading, and atmospheric perspective.
- Conflicting interpretations of works such as these:
 - Maori may see the portraits as an embodiment of the spirit of a person, and as a link between past and present.
 - Westerners may see the paintings as a commercial adventure with a monetary value.
 - Some may see the portrait as a record of a vanishing culture.
 - Others may interpret the work as anthropology highlighting aspects of Maori costuming and physiognomy, and what they could mean.
 - Still others may see the portraits as expressions of colonial dominance.

Content Area Pacific, Image 220

Web Source *http://www.aucklandartgallery.com/explore-art-and-ideas/artist/2164/gottfried-lindauer*

- **Cross-Cultural Comparisons for Essay Question 1: Rulers**
 - Houdon, *George Washington* (Figure 19.7)
 - Wall plaque, from Oba's palace (Figure 27.3)
 - Augustus of Prima Porta (Figure 6.15)

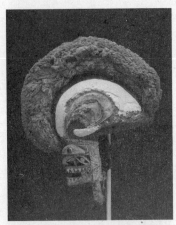

PAPUA NEW GUINEA

Malagan mask, New Ireland Province, Papua New Guinea, c. 20th century, wood, pigment, fiber, and shell, Dallas Museum of Art, Dallas, Texas (Figure 28.8)

Form

- Masks are extremely intricate in their carving.
- They are painted black, yellow, and red: important colors denoting violence, war, and magic.
- Artists are specialists in using negative space.

Function

- Sculptures of the deceased are commissioned; they represent the individual's soul, or life force, not a physical presence.
- The mask indicates the relationship of a particular deceased person to a clan and to living members of the family.
- The large haircomb reflects a hairstyle of the time; masks are not physical portraits, only portraits of the soul.

Figure 28.8: Malagan mask, New Ireland Province, Papua New Guinea, c. 20th century, wood, pigment, fiber, and shell, Dallas Museum of Art, Dallas, Texas

Context

- Malagan ceremonies send the souls of the deceased on their way to the otherworld.
- Sometimes ceremonies begin months after death and last an extended period of time.
- During the time after death the sponsors must organize the ceremonies and the feasts. They must also hire the sculptors who will carve the structures for the event.
- An expensive undertaking: families often combine their wealth and honor several individuals.
- The commissioned *malagan* sculptures are exhibited in temporary display houses. Each sculpture honors a specific individual and illustrates his or her relationships with ancestors, clan totems, and/or living family members.
- During the course of the ceremony it is believed that the souls of the deceased enter the sculptures.
- The ceremonies free the living from the obligation of serving the dead.
- Structures are erected to suit a purpose; after the ceremony, the structures are considered useless and usually destroyed or allowed to rot—they have fulfilled their function.

Content Area Pacific, Image 222

Web Source http://metmuseum.org/toah/hd/nwir/hd_nwir.htm

- **Cross-Cultural Comparisons for Essay Question 1: Faces**
 - *Mblo* (Figure 27.7)
 - Head of a Roman patrician (Figure 6.14)
 - Reliquary of Sainte-Foy (Figure 11.6c)

Buk (mask), Torres Strait, mid- to late 19th century, turtle shell, wood, fiber, feathers, and shell, Metropolitan Museum of Art, New York (Figure 28.9)

Form

- Some masks combine human and animal forms; this mask shows a bird placed on top.
- Turtle shell masks are unique to this region.

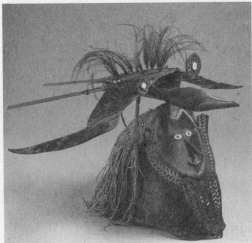

Figure 28.9: Buk (mask), Torres Strait, mid- to late 19th century, turtle shell, wood, fiber, feathers, and shell, Metropolitan Museum of Art, New York

Function

- The mask, like a helmet, is worn over the head.
- Part of a larger grass costume used in ceremonies about death, fertility, or male initiation, perhaps even to ensure a good harvest.
- Ceremonies involved fire, drum beats, and chanting; recreating mythical ancestral beings and their impact on these people in everyday activities.

Context

- Torres Strait is the water passageway between Australia and New Guinea.
- Human face may represent a cultural hero or ancestor.

Content Area Pacific, Image 218

Web Source *http://www.metmuseum.org/toah/works-of-art/1978.412.1510/*

- **Cross-Cultural Comparisons for Essay Question 1: Masks**
 - Aka elephant mask (Figure 27.12)
 - Olmec mask (Figure 26.5d)
 - Transformation mask (Figures 26.12a, 26.12b)

FIJI

Presentation of Fijian mats and tapa cloths to Queen Elizabeth II during the 1953–1954 royal tour, 1953, multimedia performance, photographic documentation, Alexander Turnbull Library, Wellington, New Zealand (Figure 28.10)

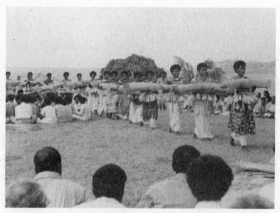

Figure 28.10: Presentation of Fijian mats and tapa cloths to Queen Elizabeth II during the 1953–1954 royal tour, 1953, multimedia performance, photographic documentation, Alexander Turnbull Library, Wellington, New Zealand

Materials

- Costume, cosmetics including scent.
- Chant; movement; *pandanus* fiber/hibiscus fiber mats.

Technique

- Men oversee the growth of the mulberry trees that produce the tapa; women turn the bark into cloth.
 - Bark is removed from the tree, soaked in water, and treated to make it pliable.
 - Clubs are used to beat the strips into a long rectangular block to form pieces of cloth.
 - The edges of these smaller pieces are then glued or felted together to produce large sheets.
 - The tapa is decorated according to a local tradition; sometimes stenciled, sometimes printed or dyed.

Function

- Enormous tapa clothes were made and presented to Queen Elizabeth II in 1953 in commemoration of her visit to Fiji on the occasion of her coronation as queen of England.

Context

- The presentation to the queen is an example of performance art.
- Cf. Lapita geometric motifs (Figure 1.6).

Content Area Pacific, Image 223

Web Source *https://www.youtube.com/watch?v=x_PeKOvr0ng*

- **Cross-Cultural Comparisons for Essay Question 1: Performance**
 - Viola, *The Crossing* (Figures 29.18a, 29.18b)
 - *Lukasa* (memory board) (Figure 27.11)

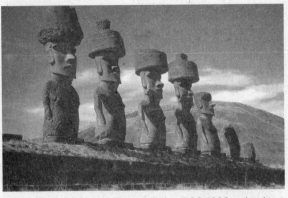

Figure 28.11: Moai on platform (*ahu*), c. 1100–1600, volcanic tuff figures on basalt base, Easter Island (Rapa Nui)

EASTER ISLAND (RAPA NUI)

Moai on platform (*ahu*), c. 1100–1600, volcanic tuff figures on basalt base, Easter Island (Rapa Nui) (Figure 28.11)

Form

- Prominent foreheads; large broad noses; thin pouting lips; ears that reach to the top of their heads.
- Short, thin arms fall straight down; hands on hips; hands across lower abdomen below navel.
- Breasts and navels are delineated.
- Backs are tattooed.
- Topknots were added to some statues.
- White coral was placed in the eyes to "open" them.

Function

- Images represent personalities deified after death or commemorated as the first settler-kings.

Context

- There are about 900 statues in all, 50 tons apiece, mostly male; almost all facing inland.
- They were erected on large platforms, called ahu, of stone mixed with ashes from cremations; the platforms are as sacred as the statues that are on them.
- After being carved, figures were said to have been "walked" into place from where they were quarried.
- Beneath an ahu is a cemetery where village elders were buried.
- The depletion of resources may have caused an ecological crisis which led to a decline in society and the destruction of the monuments.
- Monuments were toppled face down because it was believed that the eyes had spiritual power.

Content Area Pacific, Image 214

Web Source http://whc.unesco.org/en/list/715

- **Cross-Cultural Comparisons for Essay Question 1: Large-Scale Stone Sculpture**
 - Buddha from Bamiyan (Figure 23.2a, 23.2b)
 - Lamassu (Figure 2.5)
 - Longmen Caves Vairocana Buddha (Figure 24.9a, 24.9b, 24.9c)

VOCABULARY

'Ahu 'ula: Hawaiian feather cloaks (Figure 28.4)

Malagan: a large, traditional ceremony from Papua New Guinea, as well as the masks and costumes used in that ceremony (Figure 28.8)

Mana: a supernatural force believed to dwell in a person, or a sacred object (Figure 28.4)

Moai: large stone sculptures found on Easter Island (Figure 28.11)

Tapa: a cloth made from bark that is soaked and beaten into a fabric (Figure 28.6)

Wapepe: navigation charts from the Marshall Islands (Figure 28.3)

SUMMARY

The great expanses of the Pacific were peopled gradually over thousands of years. Indeed, the vast stretch of ocean is matched by the immense variety of artwork produced by disparate people speaking a myriad of languages.

A few generalities about Oceanic Art can be stated with foundation. Many items are portable, usually created for use in a ceremony, and made of wood or bark. When large wooden objects are introduced, they are carved with great precision using the whole of a wooden log. Intricately woven fabrics made of natural materials are a particular Pacific specialty. In all cases, intricate line definition is a hallmark of Oceanic artistic output.

None of these characteristics apply to the art of Easter Island, a unique place in which giant stone sculptures dominate a windswept landscape. These large torsos and heads find their closest artistic affinities with the cultures of ancient America, but the connection between the two cultures is still largely unproven.

PRACTICE EXERCISES

Multiple-Choice

Questions 1 and 2 refer to the illustration below.

1. This type of garment is used in which of the following contexts?

 (A) It established a royal lineage by discrediting rivals to the throne.
 (B) It linked the wearer to the gods.
 (C) It made a connection between the human world and the world of lizards and snakes.
 (D) It cast a spell on enemies.

2. This garment belonged to

 (A) Hawaiian royalty
 (B) Motecuhzoma II
 (C) King Mishe miShyaang maMbul
 (D) Coyolxauhqui

3. The Processional Welcoming Queen Elizabeth II is analogous in content to

 (A) Plaque of the Ergastines
 (B) Forum of Trajan
 (C) *Bayeux Tapestry*
 (D) Grave stele of Hegeso

4. The weaving technique used to make tapa requires

 (A) a heating process whereby the fabric is covered with wax and the threads are melted in place
 (B) the use of silk threads to be woven onto a background of sheep's wool
 (C) beating soaked strips of tree bark into a flat surface to be later woven into a cloth-like fabric
 (D) stitching thread into a pre-made backing to form a design

5. Prehistoric works from the Pacific, such as the Ambum Stone, illustrate the ongoing tradition of using animal motifs that appear in such works as

 (A) the Moai from Rapa Nui (Easter Island)
 (B) Navigation charts
 (C) Buk masks
 (D) the female deity from Nukuoro

Long Essay

Practice Question 1: Comparison
Suggested Time: 35 minutes

NOTE: Since the Pacific unit is such a small proportion of the testing material, the College Board has indicated that it is not likely that a long essay question will appear on this subject. However, an essay question is presented here so that students can practice a comparison essay.

The work shown, the 'Ahu 'ula (feather cape), is part of a ceremonial garb.

Select and completely identify another work of art that is a ceremonial garb. You may choose from the list below or any other relevant work.

Analyze how *each* work was meant to be used in a ceremony.

For *each* work, describe the relationship between its artistic decoration and its function in a ceremony.

For *each* work, explain the significance or symbolism of the work to contemporaries.

How does *each* work differ in function?

Ruler's feather headdress
Aka (elephant mask)
Funeral banner of Lady Dai

ANSWER KEY

1. **B** 2. **A** 3. **A** 4. **C** 5. **C**

ANSWERS EXPLAINED

Multiple-Choice

1. **(B)** The cloak was created by artists who chanted to the wearer's ancestors to imbue their power on it. Wearers chanted to create a link between the wearer and the world of spirits.

2. **(A)** The garment is associated with Hawaiian royalty.

3. **(A)** The Processional Welcoming Queen Elizabeth II is akin to the Plaque of the Ergastines because in both cases offerings are being made in a ceremonial procession.

4. **(C)** Tapa is made by beating soaked strips of tree bark into a flat surface to be later woven into a cloth-like fabric.

5. **(C)** Buk masks contain many animal motifs. The one on the curriculum guide has a turtle shell topped by a bird.

Long Essay Rubric

Task	Point Value	For the 'Ahu 'ula, answers could include:
Select and completely identify another work of art that is a ceremonial garb.	—	—
Analyze how *each* work was meant to be used in a ceremony.	1 point for each work	■ Only high-ranking chiefs or warriors of great ability were entitled to wear these garments. ■ Cape created by artists who chanted the wearer's ancestors to imbue their power on it. ■ The cape protected the wearer from harm.
For *each* work, describe the relationship between its artistic decoration and its function in a ceremony.	1 point for each work	■ The cape was made of as many as 500,000 bird feathers; it was worn only by men. ■ Some birds had only seven usable feathers. ■ Rarity of the feathers made the work especially valuable. ■ The feathers were tied to a base of coconut fiber.
For *each* work, explain the significance or symbolism of the work to contemporaries.	1 point for each work	■ In Polynesia, red was considered a royal color; yellow was prized because of its rarity. ■ Polynesian kings wore the cape as a symbol of their rank, prestige, power, and majesty.
How does *each* work differ in function?	1 point shared with the two works	This depends on the works selected. The Polynesian cape was worn as a symbol and covered the body; the Aztec feather headdress was part of an overall costume; the Lady Dai funeral banner was a burial cloth; the aka elephant mask was part of an elaborate ceremony.

Task	Point Value	For the Ruler's feather headdress, answers could include:
Select and completely identify another work of art that is a ceremonial garb.	1	1428–1520, feathers (quetzal and blue cotinga) and gold, Aztec. (Since the title is given in the directions, you may not use it in your identification. Two other identifiers are required.)
Analyze how *each* work was meant to be used in a ceremony.	1 point for each work	■ It is a ceremonial headdress of a ruler. ■ It's the only known Aztec feather headdress in the world.
For *each* work, describe the relationship between its artistic decoration and its function in a ceremony.	1 point for each work	■ The long green feathers (as many as 400) are the tails of sacred quetzal birds; male birds produce only two such feathers each. ■ Feathers indicate trading across the Aztec Empire. ■ Only the wealthy and powerful could trade across an empire for rare bird feathers, proof of the greatness of the king.

Task	Point Value	For the Ruler's feather headdress, answers could include:
For *each* work, explain the significance or symbolism of the work to contemporaries.	1 point for each work	■ Headdress was possibly part of a collection of artifacts given by Motechuzoma II (Montezuma) to Cortez for the Holy Roman emperor Charles V; if true, it was considered a gift great enough for an emperor. ■ The extravagant decorative feathers of the birds of paradise indicate a royal admiration for the exotic and the decorative.

Task	Point Value	For the Aka elephant mask, answers could include:
Select and completely identify another work of art that is a ceremonial garb.	1	c. 19th–20th century; wood, woven raffia, cloth, and beads; Bamileke. (Since the title is given in the directions, you may not use it in your identification. Two other identifiers are required.)
Analyze how *each* work was meant to be used in a ceremony.	1 point for each work	■ Performance art: maskers dance barefoot to a drum and gong, waving spears and horsetails. ■ The elite Kuosi masking society owns the masks, which are worn on important ceremonial occasions.
For *each* work, describe the relationship between its artistic decoration and its function in a ceremony.	1 point for each work	■ The masks have the features of an elephant: a long trunk and large ears (which symbolize strength and power). ■ The mask fits over the head, and two folds hang down in front (symbolizing the trunk) and behind the body. ■ The beadwork is a symbol of power. ■ Eyes, nose, and mouth indicate a human face on the elephant mask.
For *each* work, explain the significance or symbolism of the work to contemporaries.	1 point for each work	■ Only important people in society can own and wear an elephant mask. ■ The power of the elephant (the most massive of land animals) seen in this work symbolizes the power of the wearer. ■ The lavish display of colored beads and cowrie shells indicated the wealth of the members of the Kuosi society; the mask's colors and patterns expressed the society's cosmic and political functions.

Task	Point Value	For the Funeral banner of Lady Dai, answers could include:
Select and completely identify another work of art that is a ceremonial garb.	1	c. 180 B.C.E., painted silk, Chinese. (Since the title is given in the directions, you may not use it in your identification. Two other identifiers are required.)
Analyze how *each* work was meant to be used in a ceremony.	1 point for each work	■ T-shaped silk banner covering the inner coffin of the intact body in a tomb. ■ Probably carried in a procession to the tomb and then placed over the body to speed its journey to the afterlife.

Task	Point Value	For the Funeral banner of Lady Dai, answers could include:
For *each* work, describe the relationship between its artistic decoration and its function in a ceremony.	1 point for each work	■ Painted in three distinct regions: – Top: Heaven, with the crescent moon at the left and the legend of the ten suns on the right. • In the center, two seated officers guard the entrance to the heavenly world. – Middle: Earth, with Lady Dai in the center on a white platform about to make her journey to heaven with a walking stick that was found in her tomb. • Mourners and assistants appear by her side. • Dragons' bodies are symbolically circled through a bi in a yin and yang exchange. – Bottom: the underworld, where symbolic low creatures frame the underworld scene: fish, turtles, dragon tails; tomb guardians protect the body.
For *each* work, explain the significance or symbolism of the work to contemporaries.	1 point for each work	■ Lady Dai died in 168 B.C.E. in Hunan province, during the Han Dynasty. ■ A great woman was honored with fine objects buried in the tomb and hence taken to the afterlife. ■ Tomb, with more than 100 objects, was found in 1972. ■ Yin symbols at left; yang symbols at right; the center mixes the two philosophies.

Contemporary Art

29

TIME PERIOD: 1980–PRESENT

ENDURING UNDERSTANDING: Art making is influenced by available materials and processes.

Learning Objective: Discuss how material, processes, and techniques influence the making of a work of art. (For example: Paik, *Electronic Superhighway*)

Essential Knowledge:

- Contemporary art goes beyond traditional art forms and acknowledges technological developments.
- Often artwork is presented in nontraditional ways: i.e., digital experiences, video performances, graffiti art, and online museums.
- Digital technology increases awareness about artistic issues around the world.

ENDURING UNDERSTANDING: Art and art making can be influenced by a variety of concerns including audience, function, and patron.

Learning Objective: Discuss how art can be influenced by audience, function, and/or patron. (For example: Gehry, Guggenheim Museum Bilbao)

Essential Knowledge:

- Diverse art forms take on contemporary issues.
- Cities seek iconic buildings as a way of establishing their profile. Computers aid in the development of architectural design.
- Artistic venues are more plentiful: i.e., museums, galleries, exhibitions, books, festivals, etc.
- Modern artists appropriate images from the past to put a new light on cultural values.

ENDURING UNDERSTANDING: Cultural interaction through war, trade, and travel can influence art and art making.

Learning Objective: Discuss how works of art are influenced by cultural interaction. (For example: El Anatsui, *Old Man's Cloth*)

Essential Knowledge:

- Contemporary art is being produced globally. Areas of the world that were often neglected in terms of their modern artistic production are now being recognized as centers of productivity.
- Various social and political forces have contributed to a global artistic presence.

ENDURING UNDERSTANDING: The culture, beliefs, and physical settings of a region play an important role in the creation, subject matter, and siting of works of art.

Learning Objective: Discuss how the culture, beliefs, or physical setting can influence the making of a work of art. (For example: Salcedo, *Shibboleth*)

Essential Knowledge:

- The art world represents artists around the globe, regardless of race, gender, or sexual orientation. Art history theory has expanded to encompass diverse views.

ENDURING UNDERSTANDING: Art history is best understood through an evolving tradition of theories and interpretations.

Learning Objective: Discuss how works of art have had an evolving interpretation based on visual analysis and interdisciplinary evidence. (For example: Lin, Vietnam Veterans Memorial)

Essential Knowledge:

- Art history as a science continues to be shaped by theories, interpretations, and analyses applied to new art forms.

HISTORICAL BACKGROUND

The devastation of World War II formed the backdrop for much of the rest of the twentieth century. Far from solving the world's problems, it just replaced the Fascist menace with smaller conflicts no less deadly in the world's traditional hot spots. With the invention of television, global issues were brought into the living rooms of millions as never before. One disillusioning world problem after another—racism, the environment, weapons of mass destruction—has contributed to a tense atmosphere, even in parts of the world not physically touched by conflict. Artists are quick to pick up on social and political issues, using them as springboards to create artwork.

But not all is bleak in the contemporary world. The rapid growth of technology has brought great advances in medical science and everyday living. Inventions formerly beyond the realm of possibility, like home computers or cell phones, have turned into the necessities of modern life. New media have become fertile ground for artistic exploration. Artists exploit materials, like plastics, for their elastic properties. Video projections, computer graphics, sound installations, fiberglass products, and lasers are new technologies for artists to investigate. One challenge posed to the artist concerns how these media will be used in a way that will thoughtfully provoke the audience. Certainly the modern world has much to offer the artist.

MODERN ARCHITECTURE

Everything about architecture has changed since 1980, and most of the changes have been brought about by the computer. No longer are blueprints painstakingly drawn by hand to exacting specifications. Programs like AutoCAD and MicroStation not only assist in drawing plans, but also automatically check for errors. They also make feasible designs that heretofore existed only in the mind. Frank Gehry's **Guggenheim Museum Bilbao** (Figure 29.1) is a good example of how computers can help architects render shapes and meaningful designs in an imaginative way.

New age technology has produced an array of products that make buildings lighter, cheaper, and more energy efficient than before. All these developments, however, come aligned with new challenges for architects. How can cost efficiency and expensive new technology be brought into a meaningful architectural plan? The resources are there for the future to explore.

One would be hard-pressed to find a modern building with pediments, Doric columns, or flying buttresses; historical associations have been downplayed in modern architecture. What exists is a proud display of technology: Innovative materials like titanium in Gehry's work, or unusual shapes like the buildings of Hadid.

Dark interiors, as in Gothic or Romanesque buildings, are out. Natural light supplemented by artificial light is in. Domes presage a modern fascination, almost obsession, with glass and its properties.

Frank Gehry, Guggenheim Museum Bilbao, 1997, titanium, glass, and limestone, Bilbao, Spain (Figures 29.1a, and 29.1b)

Figure 29.1a: Frank Gehry, Guggenheim Museum Bilbao, 1997, titanium, glass, and limestone, Bilbao, Spain

Form

- The building has swirling forms and shapes that contrast with the industrial landscape of Bilbao.
- From the river side, the building resembles a boat, referencing Bilbao's past as a shipping and commercial center.
- The curving forms were designed by a computer software program called Catia.
- Fixing clips make a shallow dent in the titanium surface; it produces an effect of having a shimmering surface that changes according to atmospheric conditions.
- Curvilinear forms evoke the architecture of Borromini and the Italian Baroque in general (Figures 17.2a, 17.2b, 17.2c).

Function

- A modern art museum featuring contemporary art in a contemporary architectural setting.
- The work follows the tradition of the Guggenheim museums around the world, many also created by prominent architects in daring designs.

Context

- Frank Gehry is a Canadian-American architect based in Los Angeles.
- The revitalization of the port area of Bilbao is called the "Bilbao effect," a reference to the impact a museum can have on a local economy.

Content Area Global Contemporary, Image 240

Web Source https://www.guggenheim-bilbao.eus/en/

- **Cross-Cultural Comparisons for Essay Question 1: Curvilinear Forms**
 - Borromini, San Carlo alle Quattro Fontane (Figures 17.2a, 17.2b)
 - Walls at Saqsa Waman (Figure 26.8c)
 - Great Zimbabwe (Figures 27.1a, 27.1b)

Figure 29.1b: Detail of interior of Guggenheim Museum Bilbao

Figure 29.2a: Zaha Hadid, MAXXI National Museum of XXI Century Arts, 2009, glass, steel, and cement, Rome, Italy

Zaha Hadid, MAXXI National Museum of XXI Century Arts, 2009, glass, steel, and cement, Rome, Italy (Figures 29.2a and 29.2b)

Form

- Internal spaces are covered by a glass roof; natural light is admitted into the interior, filtered by louvered blinds.
- Walls flow and melt into one another, creating new and dynamic interior spaces.
- Constantly changing interior and exterior views.
- The transparent roof modulates natural light.
- Subtle modulations of color: grays, silvers, and whites contrast with blacks.

Function

- Two museums (MAXXI Art and MAXXI Architecture), a library, an auditorium, and a cafeteria.
- The complex specializes in art of the twenty-first century.
- The flowing form encourages various paths to understanding history rather than a single narrative.

Context

- Zaha Hadid was an Iraqi-born, British-based architect.
- The work references Roman concrete construction.

Content Area Global Contemporary, Image 249

Web Source *http://www.fondazionemaxxi.it/en/*

- **Cross-Cultural Comparisons for Essay Question 1: Public Spaces**
 - Forum of Trajan (Figure 6.10a)
 - Angkor Wat (Figures 23.8a, 23.8b, 23.8c, 23.8d)
 - Forbidden City (Figures 24.2a, 24.2b, 24.2c, 24.2d)

Figure 29.2b: Interior of MAXXI

MODERN PAINTING AND SCULPTURE

Oil on canvas used to be the preferred medium. In the 1950s, a new type of paint—**acrylic**—was developed to wide popular appeal. Acrylics take very little time to dry, unlike oils, which can take weeks or even months, and unlike watercolor, acrylics do not change color when they dry. However, acrylics crack with time much faster than other paints do. Contemporary artists who are working "for the ages" still prefer oils, although commercially available extenders can prolong the life of acrylics.

While traditional painting techniques are still popular, many modern artists have abandoned the canvas for the computer screen and have reached into cyberspace to create new forms and modes of representation. Computer programs make the process easier, bringing with them a dizzying array of applications and alternatives. The computer has revolutionized the creative spirit of fine art.

Marble carving is dead. All the great advantages to marble—its permanence, durability, and lustrous shine—have been cast into the dustbin of history. Few artists want to spend years studying marble carving in a world that will offer no commissions for laboring over an art form that is associated with the ancients and has seemingly nothing to offer beyond that. Marble is also unforgiving; once chipped, it cannot be repaired without showing the damage.

Modern forms of sculpture are faster to produce and even easier to reproduce. Unlike marble or bronze they come in a variety of textures, from the high-polish porcelains by Jeff Koons to the knotty fabrics of Magdalena Abakanowicz. Anything that can be molded, like beeswax, is experimented with to make a visceral impact.

On occasion, sculptors will combine objects into works of art, called **assemblages**. If the assemblages are large enough, they are called **installations** and can take up a whole room in a museum or gallery.

Christo and Jeanne-Claude, *The Gates*, 1979–2005, mixed-media installation, New York City (Figures 29.3a and 29.3b)

Form

- Installation of 7,503 "gates" of free-hanging saffron-colored fabric panels.
- The installation framed all the pathways in Central Park in New York City, a nineteenth-century park originally designed by Olmsted and Vaux.
- The work was mounted in the winter so the colors would have maximum impact; the trees were bare and the gates easily visible.
- The 16-foot-tall gates formed a continuous river of color.
- The work covered 23 miles of footpaths.

Figure 29.3a: Christo and Jeanne-Claude, *The Gates*, 1979–2005, mixed-media installation, New York City

Context

- Christo is Bulgarian-born; Jean-Claude was of French descent, born in Morocco.
- The work was put on hold for many years, but installed a few years after 9/11.
- Temporary installation: 16 days.
- After the exhibition closed, the materials were recycled.
- Spectators walked through the gates to see ever-changing views of the park.

Content Area Global Contemporary, Image 224

Artists' Website http://christojeanneclaude.net/

- **Cross-Cultural Comparisons for Essay Question 1: Gateways**
 - Great Portal, Chartres (Figure 12.6)
 - Todai-ji (Figure 25.1e)
 - Forbidden City (Figures 24.2a, 24.2b, 24.2c, 24.2d)

Figure 29.3b: Detail of *The Gates*

Maya Lin, Vietnam Veterans Memorial, 1982, granite, Washington, D.C. (Figures 29.4a and 29.4b)

Form

- This memorial is a V-shaped war monument cut into the earth.
- The memorial contains the names of 60,000 casualties of the Vietnam War listed in the order they were killed or reported missing.
- The earliest names appear in the vortex and extend out to one end of the monument and begin again at the other end working toward the vortex; a symbolic circular association.

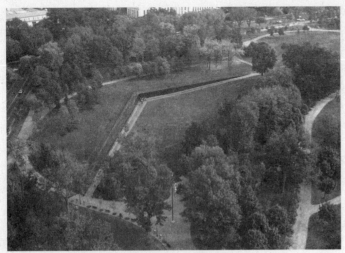

Figure 29.4a: Maya Lin, Vietnam Veterans Memorial, 1982, granite, Washington, D.C.

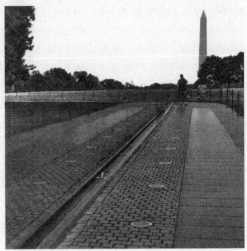

Figure 29.4b: Maya Lin, Vietnam Veterans Memorial, 1982, granite, Washington, D.C.

Function

- The war monument dedicated to the deceased and missing-in-action soldiers of the Vietnam War.

Materials

- Black granite, a highly reflective surface, is used so that viewers can see themselves in the names of the veterans.

Context

- Maya Lin is an Ohio-born Chinese-American.
- This was the winning design in an anonymous competition held to create a memorial on the mall in Washington, D.C.
- The work is not an overly political monument with a message, but a memorial to the deceased who sacrificed everything.
- One arm of the monument points to the Lincoln Memorial, the other to the Washington Monument, placing itself central to key figures in American history.
- It digs into the earth like a scar, a scar that heals but whose traces remain, a reflection of the impact of the war on the American consciousness.
- Strongly influenced by the Minimalist movement.
- Initially strongly criticized by those who wanted a more traditional war monument; later, a figural grouping was placed nearby.

Content Area Global Contemporary, Image 225

Artist's Website http://www.mayalin.com/

- **Cross-Cultural Comparisons for Essay Question 1: War and Reflection**
 - Goya, *And There's Nothing to Be Done* (Figure 20.2)
 - Oldenburg, *Lipstick (Ascending) on Caterpillar Tracks* (Figure 22.24)
 - Delacroix, *Liberty Leading the People* (Figure 20.4)

Jean-Michel Basquiat, *Horn Players*, 1983, acrylic and oil paintstick three canvas panels, The Broad, Los Angeles, California (Figure 29.5)

Form

- Flattened, darkened background; flat patches of color; thick lines; text.
- Heads seem to float over outlined bodies and dissolve as the eye goes down the body.

- The focus is on contrast and juxtaposition, not on balance or scale.
- Some traditional forms: triptych, canvas, oil paint.

Content

- The painting glorifies African-American musicians; in flanking wings there is a salute to jazz musicians Charlie Parker and Dizzy Gillespie.
- The words painted onto the canvas are those attributed to the musicians (ornithology misspelled; reference to Charlie "the Bird" Parker).
- Words such as "soap" critique racism.
- Gillespie used meaningless words "DOH SHOO DE OBEE" in improvisational, or scat, singing.

Context

- Jean-Michel Basquiat was an artist born in Brooklyn, New York, of Puerto Rican and Haitian parents.
- The artist rebelled against his middle-class upbringing.
- The artist was influenced by graffiti art and street poetry, and in turn he influenced these art forms.

Content Area Global Contemporary, Image 226

Artist's Website *http://www.basquiat.com/*

Figure 29.5: Jean-Michel Basquiat, *Horn Players*, 1983, acrylic and oil paintstick three canvas panels, The Broad, Los Angeles, California

- **Cross-Cultural Comparisons for Essay Question 1: Art and Words**
 - *Bayeux Tapestry* (Figure 11.7a, 11.7b)
 - Folio from a Qu'ran (Figure 9.5)
 - Code of Hammurabi (Figure 2.4a)

Song Su-nam, *Summer Trees*, 1983, ink on paper, British Museum, London (Figure 29.6)

Form

- Large vertical lines of various thickness.
- Subtle tonal variations of ink wash.

Context

- Song Su-nam was a Korean artist who used traditional ink on paper.
- The artist was one of the leaders of the Sumukhwa, a new type of ink brush painting in the 1980s.
- Ink painting is a traditional form of artistic expression in Korea; this movement revitalizes ink painting in a modern context.
- Inspired by Western abstraction.

Figure 29.6: Song Su-nam, *Summer Trees*, 1983, ink on paper, British Museum, London

Content Area Global Contemporary, Image 227

Web Source *http://www.britishmuseum.org/research/collection_online/collection_object_details.aspx?objectId=267937&partId=1*

- **Cross-Cultural Comparisons for Essay Question 1: Ink Technique**
 - Folio from a Qur'an (Figure 9.5)
 - Bichitr, *Jahangir Preferring a Sufi Shaikh to Kings* (Figure 23.9)
 - *Bahram Gur Fights the Karg* (Figure 9.8)

Magdalena Abakanowicz, *Androgyne III*, 1985, burlap, resin, wood, nails, and string, Metropolitan Museum of Art, New York (Figure 29.7)

Form

- The figure sits on a low stretcher of wooden legs, substituting for human legs.
- The figure is hollowed out, just a shell.
- The figure is placed to be seen in the round: the complete back and the hollow front are visible.
- The pose suggests meditation and/or perseverance.
- Sexual characteristics are minimized to increase the universality of the figure; hence the title *Androgyne*, or an androgynous figure, one that is neither male nor female.

Materials

- The work is made of hardened fiber casts from plaster molds.
- The hardened fiber has the appearance of crinkled human skin set in earth tones.

Context

- Magdalena Abankanowicz was a Polish artist who endured World War II, the Nazi occupation of Poland, and Stalinist rule.
- Since 1974, the artist had been making similar figures, often without heads or arms, in large groups or singly.

Content Area Global Contemporary, Image 228

Web Source https://www.metmuseum.org/art/collection/search/484422

- **Cross-Cultural Comparisons for Essay Question 1: Human Figure**
 - Tlatilco female figure (Figure 1.5)
 - Lakshmana Temple detail (Figure 23.7b)
 - Reliquary figure (*byeri*) (Figure 27.13)

Figure 29.7: Magdalena Abakanowicz, *Androgyne III*, 1985, burlap, resin, wood, nails, and string, Metropolitan Museum of Art, New York

Figure 29.8: Xu Bing, *A Book from the Sky*, 1987–1991, mixed-media installation, Elvehjem Museum of Art, University of Wisconsin-Madison, Madison, Wisconsin

Xu Bing, *A Book from the Sky*, 1987–1991, mixed-media installation, Elvehjem Museum of Art, University of Wisconsin-Madison, Madison, Wisconsin (Figure 29.8)

Form

- The work references Chinese art forms: scrolls, screens, books, and paper.
- Four hundred handmade books are placed in rows on the ground.
- One walks beneath printed scrolls hanging from the ceiling.
- All of the Chinese characters are inventions of the artist and have no meaning.
- The artist uses traditional Asian wood-block techniques.

History

- Original title: "An Analyzed Reflection of the End of This Century."
- Originally in the National Museum of Fine Arts in Beijing; filled a large exhibition space.
- The artist lost favor with the Communist government over this work.
- Mounted at many venues in the West afterward.

Context

- Xu Bing is a Chinese-born artist and U.S. resident.
- The artist was trained in the propagandistic socialist realist style; that background led to his critique of power in works such as this one.
- Criticized as "bourgeois liberation;" it was claimed that its meaninglessness hid secret subversions; others interpret the meaningless characters as reflecting the meaningless words found in political doublespeak.

Content Area Global Contemporary, Image 229

Artist's Website *http://www.xubing.com/*

- **Cross-Cultural Comparisons for Essay Question 1: Book Making**
 - *Book of Lindisfarne* (Figures 10.2a, 10.2b, 10.2c)
 - Golden Haggadah (Figures 12.10a, 12.10b, 12.10c)
 - Frontispiece of the Codex Mendoza (Figure 18.1)

Jeff Koons, *Pink Panther*, 1988, glazed porcelain, Museum of Modern Art, New York (Figure 29.9)

Form

- Artificially idealized female form: overly yellow hair, bright red lips, large breasts, pronounced red fingernails; overtly fake look.
- Life-size.

Content

- The woman is Jayne Mansfield (1933–1967), a popular screen star and a *Playboy* playmate.
- Pink Panther, a cartoon character, generally seen as an animated figure.
- The panther has a tender and delicate gesture around Jayne Mansfield.

Figure 29.9: Jeff Koons, *Pink Panther*, 1988, glazed porcelain, Museum of Modern Art, New York

Context

- Jeff Koons is a Pennsylvania-born artist, working in New York.
- This work is a commentary on celebrity romance, sexuality, commercialism, stereotypes, pop culture, and sentimentality.
- The work is kitsch but is made of "high art" porcelain.
- Creates a permanent reality out of something that is ephemeral and never meant to be exhibited.
- Part of a series called *The Banality* at a show in the Sonnenbend Gallery in New York in 1988.

Content Area Global Contemporary, Image 230

Artist's Website *http://www.jeffkoons.com/*

- **Cross-Cultural Comparisons for Essay Question 1: Porcelain and Ceramic**
 - The David Vases (Figure 24.11)
 - *Apollo from Veii* (Figure 5.5)
 - Terra cotta fragment (Figure 1.6)

Cindy Sherman, *Untitled #228* from the History Portraits series, 1990, photograph, Museum of Modern Art, New York (Figure 29.10)

Content

- This image explores the theme of the Old Testament figure Judith decapitating Holofernes (from the Book of Judith).

Figure 29.10: Cindy Sherman, *Untitled #228* from the History Portraits series, 1990, photograph, Museum of Modern Art, New York

- The richness of the costuming and the setting acts as a commentary on late-nineteenth-century versions of this subject.
- Richly decorative drapes hang behind the figure.
- Judith lacks any emotional attachment to the murder that has taken place.
- Judith uses her sexuality to attract and slay Holofernes.
- Holofernes appears masklike, alert, and nearly bloodless.
- Red garments denote lust and blood.

Context

- Cindy Sherman is a New Jersey–born American artist.
- The artist appears as the photographer, subject, costumer, hairdresser, and makeup artist in each work.
- The artist expresses the artifice of art by revealing the props used in the process.
- The artist's work comments on gender, identity, society, and class distinction.
- The artist uses old master paintings as a starting point, but the works are not derivative.
- This series sheds a modern light on the great masters in this case Italian Baroque.

Content Area Global Contemporary, Image 231

Artist's Website http://www.cindysherman.com/

- **Cross-Cultural Comparisons for Essay Question 1: References to the Past**
 - Jefferson, Monticello (Figures 19.5a, 19.5b)
 - Ringgold, *Dancing at the Louvre* (Figure 29.11)
 - Shonibare, *The Swing* (*after Fragonard*) (Figure 29.22)

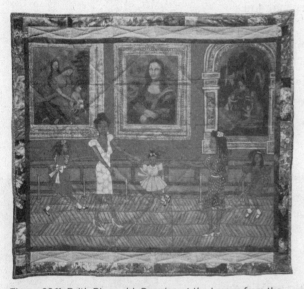

Figure 29.11: Faith Ringgold, *Dancing at the Louvre* from the series The French Collection, Part I; #1, 1991, acrylic on canvas, tie-dyed, pieced fabric borders, Private Collection

Faith Ringgold, *Dancing at the Louvre* from the series The French Collection, Part I; #1, 1991, acrylic on canvas, tie-dyed, pieced fabric borders, Private Collection (Figure 29.11)

Materials

- The artist uses the American slave art form of the quilt to create her works.
- Quilts were originally meant to be both beautiful and useful—works of applied art.
- These quilts are not meant to be useful.
- Quilting is a traditionally female art form.
- The artist combines the traditional use of oil paint with the quilting technique.

Content

- Figures in Ringgold's works often act out a history that might never have taken place, but that the artist would have liked to have taken place.
- The artist created a character named Willia Marie Simone, a young black artist who moves to Paris. She takes her friend and three daughters to the Louvre museum and dances in front of three paintings by Leonardo da Vinci.
- The story is spelled out in text written on the borders of the quilt.
- This is the first of twelve quilts in a series.

Context

- Faith Ringgold is a New York-born, African-American artist.
- The quilt has a narrative element.

- Feminist and racial issues dominate her work.
- Her works often reflect her struggle for success in an art world dominated by males working in the European tradition.

Content Area Global Contemporary, Image 232

Artist's Website http://www.faithringgold.com/

- **Cross-Cultural Comparisons for Essay Question 1: Woven Arts**
 - Bandolier bag (Figure 26.11)
 - Hiapo (Figure 28.6)
 - *The Bayeux Tapestry* (Figures 11.7a, 11.7b)

Jaune Quick-to-See-Smith, *Trade (Gifts for Trading Land with White People)*, 1992, oil and mixed-media on canvas, Chrysler Museum of Art, Norfolk (Figure 29.12)

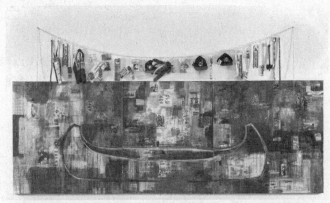

Figure 29.12: Jaune Quick-to-See-Smith, *Trade (Gifts for Trading Land with White People)*, 1992, oil and mixed media on canvas, Chrysler Museum of Art, Norfolk

Form
- This work is a combination of collage elements and abstract expressionist brushwork.
- Newspaper clippings and images of conquest are placed over a large dominant canoe.
- The red paint is symbolic of shedding of American Indian blood.

Content
- The array of objects sardonically represents Indian culture in the eyes of Europeans: sports teams, Indian-style knickknacks such as toy tomahawks, dolls, and arrows.
- A large canoe floats over the scene.

Context
- Jaune Quick-to-See Smith is a member of the Salish and Kootenai American Indian tribes of the Flathead Nation.
- The work was meant as the "Quincentenary Non-Celebration" of European occupation of North America (1492–1992).
- American Indian social issues caused by European occupation are stressed: poverty, unemployment, disease, alcoholism.
- Title *Trade* references events in American Indian history such as Manhattan being sold to the Dutch in 1626 for $24. Even if this story is apocryphal, it does highlight a history of "trade" in which Indians have been taken advantage of.

Content Area Global Contemporary, Image 233

Web Source http://jaunequick-to-seesmith.com/

- **Cross-Cultural Comparisons for Essay Question 1: Multimedia Works and Installations**
 - Paik, *Electronic Superhighway* (Figure 29.17)
 - Osorio, *No Crying Allowed in the Barbershop* (Figure 29.15a)
 - Shonibare, *The Swing (after Fragonard)* (Figure 29.22)

Figure 29.13: Emily Kame Kngwarreye, *Earth's Creation*, 1994, synthetic polymer, paint on canvas, Private Collection

Emily Kame Kngwarreye, *Earth's Creation*, 1994, synthetic polymer, paint on canvas, Private Collection (Figure 29.13)

Form
- The artist employed the dump-dot technique, which involves pounding paint onto a canvas with a brush to create layers with a sense of color and movement; related to "dream time" painting in Australia.
- This work is part of a larger suite of paintings.

Content
- The work references the color and lushness of the "green time" in Australia after it rains and the Outback flourishes.

Context
- Emily Kame Kngwarrere was an Australian aborigine artist.
- The artist was largely self-taught and began her career doing ceremonial painting.
- The artist was influenced by European abstraction of the mid-twentieth century.

Content Area Global Contemporary, Image 234

Web Source *http://nga.gov.au/exhibitions/Kngwarreye/index.html*

- **Cross-Cultural Comparisons for Essay Question 1: Landscape**
 - Fan Kuan, *Travelers among Mountains and Streams* (Figure 24.5)
 - Cézanne, *Mont Sainte-Victoire* (Figure 21.10)
 - Cole, *Oxbow* (Figure 20.6)

Figure 29.14: Shirin Neshat, photo by Cynthia Preston, *Rebellious Silence*, from the Women of Allah series, 1994, ink on photograph, Barbara Gladstone Gallery, New York

Shirin Neshat, photo by Cynthia Preston, *Rebellious Silence*, from the Women of Allah series, 1994, ink on photograph, Barbara Gladstone Gallery, New York (Figure 29.14)

Form and Content
- The poem written on the face is in Farsi, the Persian language; the poem expresses piety.
- The poem is by an Iranian woman who writes poetry on gender issues.
- The gun divides the body into a darker and a lighter side.
- The gun adds a note of ominous tension in the work.
- The work expresses the artist's duality as both Iranian and American.

Materials
- Black and white photograph.

Context

- Shirin Neshat is an Iranian-born artist, raised in the United States.
- Chador: a type of outer garment, like a cloak, that allows only the face and hands of Iranian women to be seen.
- The chador keeps women's bodies from being seen as sexual objects.
- Westerners could view the work as an expression of female oppression.
- Iranians could view the work as an image of an obedient, right-minded woman who is ready to die defending her faith and customs.
- The work contrasts with stereotypical Western depictions of exotic female nudes in opulent surroundings (cf. Figure 20.3).

Content Area Global Contemporary, Image 235

Artist's Website *http://www.gladstonegallery.com/artist/shirin-neshat/#&panel1-1*

- **Cross-Cultural Comparisons for Essay Question 1: Portraits**
 - Portait of Sin Sukju (Figure 24.6)
 - Head of a Roman patrician (Figure 6.14)
 - Vigée Le Brun, *Self-Portrait* (Figure 19.2)

Pepón Osorio, *En la Barberia no se Llora (No Crying Allowed in the Barbershop)*, 1994, mixed media installation, Collection of the Museo de Arte de Puerto Rico, San Juan, Puerto Rico (Figures 29.15a and 29.15b)

Form and Content

- This is a large installation recreating the center of Latino male culture: the barbershop.
- The interior of a barbershop in which "no crying is allowed"—a masculine attribute.
- Photos of Latino men on the walls.
- Video screens on the headrests depict men playing, a baby being circumcised, and men crying.
- Appropriately tacky and grimy setting.

Context

- Pepon Osario is a Puerto Rican–born artist living in New York (called a Nuyorican).
- Kitsch items are used everywhere as symbols of consumer culture.
- Originally a temporary work constructed in a neighborhood building, not in a museum.
- This work challenges the viewer to question issues of identity, masculinity, culture, and attitudes.

Content Area Global Contemporary, Image 236

Web Source *http://www.art21.org/artists/pepon-osorio*

- **Cross-Cultural Comparisons for Essay Question 1: Gender Identification**
 - Veranda post (Figure 27.14)
 - Delacroix, *Liberty Leading the People* (Figure 20.4)
 - Hogarth, *The Tête à Tête* (Figure 19.3)

Figure 29.15a: Pepón Osorio, *En la Barberia no se Llora (No Crying Allowed in the Barbershop)*, 1994, mixed-media installation, Collection of the Museo de Arte de Puerto Rico, San Juan, Puerto Rico

Figure 29.15b: Alternate view of Figure 29.15a

Figure 29.16: Michel Tuffery, *Pisupo Lua Afe (Corned Beef 2000)*, 1994, mixed media, Museum of New Zealand, Wellington, New Zealand

Michel Tuffery, *Pisupo Lua Afe (Corned Beef 2000)*, 1994, mixed media, Museum of New Zealand, Wellington, New Zealand (Figure 29.16)

Form

- Life-size sculpture of a bull made from flattened cans of corned beef.
- Two motorized bulls often engage in multimedia performance art called *The Challenge*.
- There are small concealed wheels at the feet for ease of movement.

Context

- Michel Tuffery was born in New Zealand of Samoan, Cook Islands, and Tahitian descent.
- The artist is interested in exploring aspects of his Polynesian heritage in a modern context.
- Canned corned beef is a favorite food in Polynesia; exported from New Zealand.
- Canned meat (pisupo, a Samoan language variant of "pea soup," the first canned food in the Pacific) is given as a gift on special occasions in Polynesia.
- However, canned meat has been a major contributor to Polynesian obesity.
- The introduction of canned meat caused a fall in traditional cultural skills of fishing, cooking, and agriculture.
- The artist introduces a tone of irony in that the cow is made of hundreds of opened cans of cow meat.
- The theme of recycling is emphasized by the reuse of these cans.

Content Area Global Contemporary, Image 237

Artist's Website *http://www.micheltuffery.co.nz/*

- **Cross-Cultural Comparisons for Essay Question 1: Animals in Art**
 - Matisse, *Goldfish* (Figure 22.1)
 - *Bahram Gur Fights the Karg* (Figure 9.8)
 - Lascaux Caves (Figure 1.8)

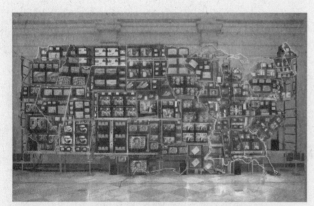

Figure 29.17: Nam June Paik, *Electronic Superhighway*, 1995, mixed-media installation, Smithsonian American Art Museum

Nam June Paik, *Electronic Superhighway*, 1995, mixed-media installation (49-channel closed-circuit video installation, neon, steel, and electronic components), Smithsonian American Art Museum (Figure 29.17)

Form

- Neon lighting outlines 50 states and the District of Columbia (Alaska and Hawaii are on the side walls).
- Each state has a separate video feed; hundreds of television sets and 50 separate DVD players.
- Themes associated with each state play on the state's screen; for example, the musical *Oklahoma!* plays on the Oklahoma screen.
- A camera is turned on the spectator and its TV feed appears on one of the monitors; it turns the spectator into a participant in the artwork.

Context

■ Nam June Pail was a Korean-born artist who lived in New York City.

■ Paik was intrigued by maps and travel:
 – Neon outlines symbolize multicolored maps of each state.
 – Neon symbolizes motel and restaurant signs.
 – Fascination with the interstate highway system.

■ The constant blur of so many video clips at the same time can lead to "information overload."

■ Paik is considered the father of video art.

Content Area Global Contemporary, Image 238

Web Source *http://americanart.si.edu/exhibitions/paik*

■ **Cross-Cultural Comparisons for Essay Question 1: New Media for Its Time**
 – Daguerre, *Still Life in Studio* (Figure 20.8)
 – The Colosseum (Figures 6.8a, 6.8b)
 – Cranach, *Allegory of Law and Grace* (Figure 14.5)

Bill Viola, *The Crossing*, 1996, video and sound installation (Figures 29.18a and 29.18b)

Form and Content

■ Room dimensions: 16 × 27.5 × 57 feet.

■ Performer: Phil Esposito.

■ Photo: Kira Perov.

■ These video installations are total environments.

■ Two channels of color video project from opposite sides of large dark gallery onto two large, back-to-back screens suspended from the ceiling and secured on the floor.

■ Four channels of amplified stereo sound come from four speakers.

■ There are two freestanding video screens that show a double-sided projection.
 – Fire: flames consume the figure of a man, beginning at his feet.
 • A figure approaches from a long distance. As he stops, a small flame appears at his feet and spreads rapidly to engulf him in a roaring fire. When it subsides, the man is gone.
 – Water: a man walks toward the viewer and water falls from above.
 • Similar to the fire scene, when the figure stops, a stream of water begins to pour upon his head. It quickly turns into a raging torrent, inundating the man. When the water slows, the man is gone.

■ The figures walk in extremely slow motion.

Figure 29.18a: Bill Viola, *The Crossing*, 1996, video and sound installation

Context

■ Bill Viola is a Queens, New York–born artist.

■ The artist promotes video as an art form.

■ The work shows actions that repeat again and again.

■ The artist is interested in sense perceptions.

■ There is an implied cycle of purification and destruction.

■ Filmed at high speed, but sequences are played back at super slow motion.

■ Evokes Eastern and Western spiritual traditions: Zen Buddhism, Islamic Sufism, Christian mysticism.

■ Requires the viewer to remain still and concentrate.

Figure 29.18b: Bill Viola, *The Crossing*

Content Area Global Contemporary, Image 239

Artist's Website *http://www.billviola.com/*

- **Cross-Cultural Comparisons for Essay Question 1: Motion**
 - Muybridge, *The Horse in Motion* (Figure 21.5)
 - *Winged Victory of Samothrace* (Figure 4.8)
 - Presentation of Fijian mats and tapa cloths to Queen Elizabeth II (Figure 28.10)

Mariko Mori, *Pure Land*, 1998, color photograph on glass, Los Angeles County Museum of Art, Los Angeles, California (Figure 29.19)

Content

- Mori herself appears as if in a vision in the guise of the Heian deity, Kichijōten.
- Kichijōten is the essence of beauty and the harbinger of prosperity and happiness.
- She holds a wish-granting jewel, a *nyoi hōju*, which has the power to deny evil and fulfill wishes.
- The jewel symbolizes Buddha's universal mind.
- Animated figures of lighthearted aliens play musical instruments on clouds.
- A lotus blossom floats on water and symbolizes purity and rebirth into paradise.
- Set in a landscape evoking the Dead Sea, a place of extremely high salinity: salt seen as an agent of purification.

Context

- Mariko Mori is a Japanese artist.
- Her work shows the merging of consumer entertainment fantasies with traditional Japanese imagery.
- The artist uses a creative interpretation of traditional Japanese art forms.

Content Area Global Contemporary, Image 241

Web Source *http://www.skny.com/artists/mariko-mori*

- **Cross-Cultural Comparisons for Essay Question 1: Photography**
 - Daguerre, *Still Life in Studio* (Figure 20.8)
 - Muybridge, *The Horse in Motion* (Figure 21.5)
 - Stieglitz, *The Steerage* (Figure 22.8)

Figure 29.19: Mariko Mori, *Pure Land*, 1998, color photograph on glass, Los Angeles County Museum of Art, Los Angeles, California

Kiki Smith, *Lying with the Wolf*, 2001, ink and pencil on paper, Centre Pompidou, Paris (Figure 29.20)

Figure 29.20: Kiki Smith, *Lying with the Wolf*, 2001, ink and pencil on paper, Centre Pompidou, Paris

Form

■ This is a large, wrinkled drawing pinned to a wall; reminiscent of a tablecloth or a bedsheet.

Context

■ Kiki Smith is an American artist who was born in Germany and lives in New York City.

■ A theme of Smith's work is the human body; this is a nude female figure.

■ Female strength is emphasized in the woman lying down with the wild beast.

■ The wolf seems tamed by the woman's embrace.

■ The wolf is traditionally seen as an evil or dangerous symbol, but not here.

Content Area Global Contemporary, Image 242

Web Source http://www.pacegallery.com/artists/442/kiki-smith

■ **Cross-Cultural Comparisons for Essay Question 1: Stereotypes**
 – Osorio, *No Crying Allowed in the Barbershop* (Figure 29.15a)
 – Salcedo, *Shibboleth* (Figure 29.26)
 – Lawrence, *The Migration of the Negro, Panel no. 49* (Figure 22.19)

Kara Walker, *Darkytown Rebellion*, 2001, cut paper and projection on wall, Collection Musée d'Art Moderne Grand-Duc Jean, Luxembourg (Figure 29.21)

Figure 29.21: Kara Walker, *Darkytown Rebellion*, 2001, cut paper and projection on wall, Collection Musée d'Art Moderne Grand-Duc Jean, Luxembourg

Technique

■ The artist draws images with a greasy white pencil or soft pastel crayon on large pieces of black paper and then cuts the paper with a knife.

■ Images are then adhered to a gallery wall with wax.

■ The artist uses traditional silhouette forms.

■ Overhead projectors throw colored light onto the walls, ceilings, and floor.

■ Cast shadows of the viewer's body mingle with the black paper images.

Context

■ Kara Walker is a California-born, New York–based, African-American artist.

■ The work explores themes of African-Americans in the antebellum South: a teenager holds a flag that resembles a colonial ship sail; one man has his leg cut off; a woman is caring for newborns.

■ The work explores how stereotypes and caricatures of African-Americans have been presented.

■ Inspired by an anonymous landscape called "Darkytown"; it was the artist's invention to have the figures in rebellion.

■ This is not a recreation of an historical event, but a commentary on history as it has been presented in the past and the present.

■ The viewer interacts with the work, walking around it, engaging in elements of it; the viewer is part of the history of the piece.

Content Area Global Contemporary, Image 243

Web Source *http://www.art21.org/artists/kara-walker*

- **Cross-Cultural Comparisons for Essay Question 1: Wall Surfaces**
 - Lascaux Caves, Great Hall of the Bulls (Figure 1.8)
 - Tomb of the Triclinium (Figure 5.3)
 - Michelangelo, Sistine Chapel ceiling (Figure 16.2a)

Figure 29.22: Yinka Shonibare, *The Swing (after Fragonard)*, 2001, mixed-media installation, Tate, London

Yinka Shonibare, *The Swing (after Fragonard)*, 2001, mixed-media installation, Tate, London (Figure 29.22)

Interpretation

- The artist was inspired by Fragonard's *The Swing* (Figure 19.1).
- This work is a life-size headless mannequin.
- The dress is made of Dutch wax fabric, sold in Africa: it references global trade and postcolonial life in Africa.
- Flowering vines are cast to the floor.
- A headless figure: guillotined by the French Revolution.

Context

- Yinka Shonibare was British born, but of Nigerian descent; he lives and works in London.
- Two men in the Fragonard painting are not included; the audience takes the place of the men; erotic voyeurism.

Content Area Global Contemporary, Image 244

Artist's Website *http://www.yinkashonibarembe.com/*

- **Cross-Cultural Comparisons for Essay Question 1: Depicting Motion**
 - Muybridge, *The Horse in Motion* (Figure 21.5)
 - *Alexander Mosaic* (Figure 4.20)
 - Rodin, *The Burghers of Calais* (Figure 21.15)

Figure 29.23: El Anatsui, *Old Man's Cloth*, 2003, aluminum and copper wire, Harn Museum of Art, Gainsville, Florida

El Anatsui, *Old Man's Cloth*, 2003, aluminum and copper wire, Harn Museum of Art, Gainsville, Florida (Figure 29.23)

Technique and Materials

- One thousand drink tops are joined by wire to form a cloth-like hanging.
- Bottle caps are from a distillery in Nigeria.
- The artist uses power tools such as chain saws and welding torches.
- The artist converts found materials into a new type of media that lies somewhere between painting and sculpture.
- Recycling of found objects.

Form

- The work is not flat, but hung as cloth.
- Curators are often left to hanging El Anatsui's work to the best advantage; the work appears slightly different in each setting.

Context

- El Anatsui was born in Ghana; spent much of his career in Nigeria.
- The artist produces colorful, textured wall hangings related to West African textiles.
- The gold color reflects traditional cloth colors of Ghana and references royalty.
- The gold also symbolizes Ashanti control over the gold trade in Africa.
- El Anatsui combines aesthetic traditions of his home country of Ghana, his adapted country of Nigeria, and the global art movement of abstract art.

Content Area Global Contemporary, Image 245

Web Source *http://www.jackshainman.com/artists/el-anatsui/*

- **Cross-Cultural Comparisons for Essay Question 1: Cloth**
 - All-T'oqapu tunic (Figure 26.10)
 - Hiapo (Figure 28.6)
 - Funeral banner of Lady Dai (Figure 24.4)

Julie Mehretu, *Stadia II,* 2004, ink and acrylic on canvas, Carnegie Museum of Art, Pittsburgh (Figure 29.24)

Form

- This work depicts a stylized rendering of stadium architecture.
- The forms suggest the excitement, almost frenzy, of a competition held in a circular space surrounded by international images.
- Dynamic competition is suggested in sweeping lines that create a vibrant pulse.
- The work uses multilayered lines to create animation.
- Sweeping lines create depth; the focus of attention is around a central core from which colors, icons, flags, and symbols resonate.

Figure 29.24: Julie Mehretu, *Stadia II*, 2004, ink and acrylic on canvas, Carnegie Museum of Art, Pittsburgh

Context

- Julie Mehretu was born in Ethiopia; she lives and works in New York City.
- She paints large-scale paintings.
- Although the paintings are done with abstract elements, the titles allude to their meaning.
- Flags can represent, in a positive or negative way, national pride, patriotism, or nationalism.
- Cf. Kandinsky's abstractions (Figure 22.2).

Content Area Global Contemporary, Image 246

Web Source *http://www.art21.org/artists/julie-mehretu*

- **Cross-Cultural Comparisons for Essay Question 1: Images of Entertainment**
 - The Colosseum (Figures 6.8a, 6.8b)
 - Seated boxer (Figure 4.10)
 - Basquiat, *Horn Players* (Figure 29.5)

Figure 29.25: Wangechi Mutu, *Preying Mantra*, 2006, mixed media on Mylar, Brooklyn Museum, Brooklyn, New York

Wangechi Mutu, *Preying Mantra*, 2006, mixed media on Mylar, Brooklyn Museum, Brooklyn, New York (Figure 29.25)

Form and Content

- Collaged female figure composed of human and animal parts, objects, and machine parts.
- She reclines in a relaxed position.
- A green snake interlocks with her fingers; bird feathers appear on the back of her head.
- Her left earlobe has chicken feet, insect legs, and pinchers.
- She has blotched skin.

Context

- Wangechi Mutu is a Kenya-born, New York–based artist.
- Art related to Afro-Futurism.
- Cyborg: a person whose function is aided by a mechanical device or whose powers are enhanced by computer implants.
- The work is a commentary on the female persona in art history.
- Ironic twist on the praying mantis:
 - Suggests religious rituals.
 - *Mantis* means "prophet" in Greek.
 - Insects use camouflage; this figure seems camouflaged.
 - Her seemingly contradictory roles seem to express "prey" and "preying" at the same time.

Content Area Global Contemporary, Image 247

Web Source *https://gladstonegallery.com/artist/wangechi-mutu*

- **Cross-Cultural Comparisons for Essay Question 1: Female Form**
 - Kneeling statue of Hatshepsut (Figure 3.9b)
 - Peplos Kore (Figure 4.2)
 - Manet, *Olympia* (Figure 21.3)

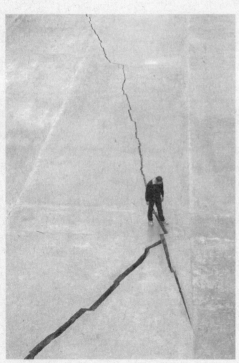

Figure 29.26: Doris Salcedo, *Shibboleth*, 2007–2008, installation, Tate Modern, London

Doris Salcedo, *Shibboleth*, 2007–2008, installation, Tate Modern, London (Figure 29.26)

Form

- This is an installation that features a large crack that begins as a hairline and then widens to two feet in depth.
- The floor of the museum was opened and a cast of Colombian rock faces was inserted.
- The work stresses the interaction between sculpture and space.

Context

- Doris Salcedo is a Colombian sculptor.
- Shibboleth: a word or custom that a person not familiar with a language may mispronounce; used to identify foreigners or people of another class.
- A shibboleth is used to exclude people from joining a group.
- Bible source: Judges 12:6: "They said, 'All right, say Shibboleth.' If he said, 'Sibboleth,' because he could not pronounce the word correctly, they seized him and killed him at the fords of the Jordan. Forty-two thousand Ephraimites were killed at that time."

- The crack emphasizes the gap in relationships.
- The work references racism and colonialism; keeping people away or separating them.
- The installation is now sealed, but it exists as a scar; it commemorates the lives of the underclasses.

Artist's words: "It represents borders, the experience of immigrants, the experience of segregation, the experience of racial hatred. It is the experience of a Third World person coming into the heart of Europe. For example, the space which illegal immigrants occupy is a negative space. And so this piece is a negative space."

Content Area Global Contemporary, Image 248

Web Source *http://www.art21.org/artists/doris-salcedo*

- **Cross-Cultural Comparisons for Essay Question 1: Works on the Ground**
 - Smithson, *Spiral Jetty* (Figure 22.26)
 - Great Serpent Mound (Figure 26.4)
 - Weiwei, *Sunflower Seeds* (Figure 29.27)

Ai Weiwei, *Kui Hua Zi (Sunflower Seeds)*, 2010–2011, sculpted and painted porcelain, Tate Modern, London (Figure 29.27)

Form and Content

- Installation containing millions of individually handcrafted ceramic pieces resembling sunflower seeds.
- They symbolically represent an ocean of fathomless depth; each seed is made in Jingdezhen, a city known for its porcelain production in Imperial China.
- The individual seed is lost among a sea of seeds, representing the loss of individuality in the modern world.
- Six hundred artisans worked for two years; each seed is handpainted.

Context

- Ai Weiwei is a Chinese artist.
- Sunflower seeds were eaten as a source of food during the famine era under Mao Tze-tung.
- The work reflects the ideology of Chairman Mao: he was the sun; his followers were the seeds.
- Originally a viewer could walk on the installation, but it raised harmful ceramic dust; viewing was then limited to the sidelines.

Content Area Global Contemporary, Image 250

Artist's Website *http://www.aiweiwei.com/*

- **Cross-Cultural Comparisons for Essay Question 1: Installations**
 - Osorio, *No Crying Allowed in the Barbershop* (Figures 29.15a, 29.15b)
 - Bing, *A Book from the Sky* (Figures 29.8a, 29.8b)
 - Shonibare, *The Swing (after Fragonard)* (Figure 29.22)

Figure 29.27: Ai Weiwei, *Kui Hua Zi (Sunflower Seeds)*, 2010–2011, sculpted and painted porcelain, Tate Modern, London

VOCABULARY

Action painting: an abstract painting in which the artist drips or splatters paint onto a surface like a canvas in order to create his or her work (Figure 22.21)

Assemblage: a three-dimensional work made of various materials such as wood, cloth, paper, and miscellaneous objects (Figure 29.12)

Earthwork: a large outdoor work in which the earth itself is the medium (Figure 22.26)

Installation: a temporary work of art made up of assemblages created for a particular space, like an art gallery or a museum (Figure 29.22)

Kitsch: something of low quality that appeals to popular taste (Figure 29.9)

SUMMARY

Contemporary art defies categorization because artists easily adapt to new styles and artistic impulses. Therefore, movements are intense but fleeting, and influenced by current politics and culture. Minimalists designed works that show a modern predilection for clean, open, and simple forms. Site Art expresses an awareness of the surroundings a work of art may have, and insists on a mutual coexistence of the object and its environment. Awareness of feminist issues influenced not only the production of Feminist Art, but also spurred the growth of female collectors, artists, and gallery owners.

Contemporary artists have a great range of materials and venues to express themselves—perhaps more than any other time in history. Artists experiment both with new art forms and with new ideas to create a dynamic range of effects. Architecture has been particularly affected by the growth of technology, both in the planning stages by using a computer, and in the construction phases by using new types of metal and glass.

Modern art is sensitive to all contemporary issues—setting, world politics, technological advances, new techniques, and to the dynamics of the art market itself.

PRACTICE EXERCISES

Multiple-Choice

1. Kitsch can be defined as a

 (A) performance art that uses music, dance, and costume
 (B) three-dimensional work made of found objects
 (C) temporary work made of assemblages
 (D) something of low quality that appeals to popular taste

2. Song Su-nam's *Summer Trees* references the

 (A) Asian tradition of painting with ink
 (B) Chinese tradition of painting on the scroll format
 (C) Korean tradition of painting screens that separate rooms
 (D) Japanese tradition of wood-block prints popular in Europe

3. Australian aboriginal artists such as Emily Kame Kngwarreye rely on their traditions for their work, while maintaining a presence in the contemporary global art world. Kngwarreye's work differs from traditional Pacific art in that it

 (A) has no emphasis on color
 (B) does not use patterns and markings
 (C) is not done for display
 (D) does not have figures

4. The Vietnam Veterans Memorial is designed so that the viewer would

 (A) think about the glory of war and ultimate victory
 (B) descend into a grave-like setting to remember the dead
 (C) commemorate the ultimate sacrifice people made to ensure peace
 (D) be able to protest American involvement in foreign wars

5. The anthropomorphized human figure in Wangchi Mutu's *Preying Mantra* symbolizes

 (A) the ancient tradition of combining human and animal forms in a single figure as a commentary on natural selection
 (B) a commentary on the depiction of females in works of art
 (C) an overreliance on computers and machines rather than direct human contact
 (D) the crisis in global warming and its effect on all of us

Long Essay

Practice Question 2: Visual and Contextual Analysis
Suggested Time: 25 minutes

In the contemporary world, artists often reference the past to create new works that comment on the present.

Select and completely identify a work from the contemporary world in which the artist has used past art forms in a creative new way.

In your answer, make sure to:

- Accurately identify the work you have chosen with *at least two* identifiers beyond those given.
- Respond to the question with an art historically defensible thesis statement.
- Support your claim with *at least two* examples of visual and/or contextual evidence.
- Explain how the evidence that you have supplied supports your thesis.
- Use your evidence to corroborate or modify your thesis.

A Book from the Sky
Dancing in the Louvre
Untitled #228 from the History of Portraits Series

ANSWERS EXPLAINED

Multiple-Choice

1. **(D)** Kitsch can be defined as something of low quality that appeals to popular taste. Jeff Koons references kitsch in many of his works.

2. **(A)** Painting with ink is an Asian specialty. Su-nam's work continues that tradition.

3. **(D)** Most art from the Pacific region is traditionally figural. Kngwarreye's work is primarily abstract.

4. **(B)** The Vietnam Veterans Memorial is about remembering the dead, and so it is appropriate that the viewer descend into a grave-like setting to see the impact of the names as they rise above them.

5. **(B)** Mutu's work *Preying Mantra* references depictions of females in art history such as Titian or Manet.

Long Essay Rubric

Task	Point Value	Key Points in a Good Response for *Book from the Sky* could include:
Accurately identify the work you have chosen with *at least two* identifiers beyond those given.	1	Xu Bing, 1987–1989, mixed-media installation
Respond to the question with an art historically defensible thesis statement.	1	The thesis statement must be an art historically sound claim that responds to the question and does not merely restate it. The thesis statement should come at the beginning of the argument and be at least one, preferably two sentences. For example: *A Book from the Sky* references historically linked Chinese art forms including scrolls, wood-block printings, and screens. However, these techniques are combined and used in an innovative way.
Support your claim with *at least two* examples of visual and/or contextual evidence.	2	*Two* visual *or* contextual examples are needed. For *A Book from the Sky*, evidence could involve a discussion of how the artist scripted books that look like they use ancient Chinese characters but don't, or how Chinese screens originally were used to divide spaces but here seem to hem the viewer in.

Task	Point Value	Key Points in a Good Response for *Book from the Sky* could include:
Explain how the evidence that you have supplied supports your thesis.	1	Good responses link the evidence you have provided with the main thesis statement. With Xu Bing's work it is important to stress how these traditional Chinese art forms would be viewed by a modern audience now that Xu Bing has made the art forms his own.
Use your evidence to corroborate or modify your thesis.	1	This point is earned when a student demonstrates a depth of understanding, in this case of Xu Bing's work. The student must demonstrate multiple insights on a given subject. For example, a connection should be made to the political situation in China, and how Xu Bing could be commenting on that situation with his work.

Task	Point Value	Key Points in a Good Response for *Dancing in the Louvre* could include:
Accurately identify the work you have chosen with *at least two* identifiers beyond those given.	1	Faith Ringgold, 1991, acrylic on canvas, tie-dyed, pieced fabric border.
Respond to the question with an art historically defensible thesis statement.	1	The thesis statement must be an art historically sound claim that responds to the question and does not merely restate it. The thesis statement should come at the beginning of the argument and be at least one, preferably two sentences. For example: *Dancing in the Louvre* references traditionally linked feminine art forms such as oil painting, quilting, and weaving with storytelling. Ringgold creates her own stories and illustrates them using traditional techniques in a new way.
Support your claim with *at least two* examples of visual and/or contextual evidence.	2	*Two* visual *or* contextual examples are needed here. For *Dancing in the Louvre*, evidence could involve a discussion of how the artist used oil paint to recreate the paintings by Leonardo daVinci or used quilting to tell the story narrated in the margins of the work.
Explain how the evidence that you have supplied supports your thesis.	1	Good responses link the evidence you have provided with the main thesis statement. You could show how the older techniques are used in a way that, for example, would never have been used in the past.
Use your evidence to corroborate or modify your thesis.	1	This point is earned when a student demonstrates a depth of understanding. With Ringgold's work it is important to stress how the use of the old technique in a modern way casts a commentary on the art scene in the contemporary world dominated by males and European-based art forms.

Task	Point Value	Key Points in a Good Response for *Untitled #228* could include:
Accurately identify the work you have chosen with *at least two* identifiers beyond those given.	1	Cindy Sherman, 1990, photograph
Respond to the question with an art historically defensible thesis statement.	1	The thesis statement must be an art historically sound claim that responds to the question and does not merely restate it. The thesis statement should come at the beginning of the argument and be at least one, preferably two sentences. For example: *Untitled #228* references a traditional subject from the Bible as well as traditional European painting, with a modern photographic process. The appropriation of traditional material onto a modern context makes for an innovative commentary on contemporary gender and identity issues.
Support your claim with *at least two* examples of visual and/or contextual evidence.	2	Two visual or contextual examples are needed here. For *Untitled #228* evidence could involve a discussion of how the artist represented the Old Testament figure of Judith decapitating Holofernes with both typical iconography and a new way of representing the figures.
Explain how the evidence that you have supplied supports your thesis.	1	Good responses link the evidence you have provided with the main thesis statement. The students should link the Biblical subject matter with the photographic process, stressing what the photograph can achieve that a painting does not.
Use your evidence to corroborate or modify your thesis.	1	This point is earned when a student demonstrates a depth of understanding, in this case of Sherman's work. The artist raises questions about gender, identity, and society through her work, as can be seen here.

PART FOUR
Practice Tests

ANSWER SHEET
Practice Test 1

Section I

1. Ⓐ Ⓑ Ⓒ Ⓓ
2. Ⓐ Ⓑ Ⓒ Ⓓ
3. Ⓐ Ⓑ Ⓒ Ⓓ
4. Ⓐ Ⓑ Ⓒ Ⓓ
5. Ⓐ Ⓑ Ⓒ Ⓓ
6. Ⓐ Ⓑ Ⓒ Ⓓ
7. Ⓐ Ⓑ Ⓒ Ⓓ
8. Ⓐ Ⓑ Ⓒ Ⓓ
9. Ⓐ Ⓑ Ⓒ Ⓓ
10. Ⓐ Ⓑ Ⓒ Ⓓ
11. Ⓐ Ⓑ Ⓒ Ⓓ
12. Ⓐ Ⓑ Ⓒ Ⓓ
13. Ⓐ Ⓑ Ⓒ Ⓓ
14. Ⓐ Ⓑ Ⓒ Ⓓ
15. Ⓐ Ⓑ Ⓒ Ⓓ
16. Ⓐ Ⓑ Ⓒ Ⓓ
17. Ⓐ Ⓑ Ⓒ Ⓓ
18. Ⓐ Ⓑ Ⓒ Ⓓ
19. Ⓐ Ⓑ Ⓒ Ⓓ
20. Ⓐ Ⓑ Ⓒ Ⓓ

21. Ⓐ Ⓑ Ⓒ Ⓓ
22. Ⓐ Ⓑ Ⓒ Ⓓ
23. Ⓐ Ⓑ Ⓒ Ⓓ
24. Ⓐ Ⓑ Ⓒ Ⓓ
25. Ⓐ Ⓑ Ⓒ Ⓓ
26. Ⓐ Ⓑ Ⓒ Ⓓ
27. Ⓐ Ⓑ Ⓒ Ⓓ
28. Ⓐ Ⓑ Ⓒ Ⓓ
29. Ⓐ Ⓑ Ⓒ Ⓓ
30. Ⓐ Ⓑ Ⓒ Ⓓ
31. Ⓐ Ⓑ Ⓒ Ⓓ
32. Ⓐ Ⓑ Ⓒ Ⓓ
33. Ⓐ Ⓑ Ⓒ Ⓓ
34. Ⓐ Ⓑ Ⓒ Ⓓ
35. Ⓐ Ⓑ Ⓒ Ⓓ
36. Ⓐ Ⓑ Ⓒ Ⓓ
37. Ⓐ Ⓑ Ⓒ Ⓓ
38. Ⓐ Ⓑ Ⓒ Ⓓ
39. Ⓐ Ⓑ Ⓒ Ⓓ
40. Ⓐ Ⓑ Ⓒ Ⓓ

41. Ⓐ Ⓑ Ⓒ Ⓓ
42. Ⓐ Ⓑ Ⓒ Ⓓ
43. Ⓐ Ⓑ Ⓒ Ⓓ
44. Ⓐ Ⓑ Ⓒ Ⓓ
45. Ⓐ Ⓑ Ⓒ Ⓓ
46. Ⓐ Ⓑ Ⓒ Ⓓ
47. Ⓐ Ⓑ Ⓒ Ⓓ
48. Ⓐ Ⓑ Ⓒ Ⓓ
49. Ⓐ Ⓑ Ⓒ Ⓓ
50. Ⓐ Ⓑ Ⓒ Ⓓ
51. Ⓐ Ⓑ Ⓒ Ⓓ
52. Ⓐ Ⓑ Ⓒ Ⓓ
53. Ⓐ Ⓑ Ⓒ Ⓓ
54. Ⓐ Ⓑ Ⓒ Ⓓ
55. Ⓐ Ⓑ Ⓒ Ⓓ
56. Ⓐ Ⓑ Ⓒ Ⓓ
57. Ⓐ Ⓑ Ⓒ Ⓓ
58. Ⓐ Ⓑ Ⓒ Ⓓ
59. Ⓐ Ⓑ Ⓒ Ⓓ
60. Ⓐ Ⓑ Ⓒ Ⓓ

61. Ⓐ Ⓑ Ⓒ Ⓓ
62. Ⓐ Ⓑ Ⓒ Ⓓ
63. Ⓐ Ⓑ Ⓒ Ⓓ
64. Ⓐ Ⓑ Ⓒ Ⓓ
65. Ⓐ Ⓑ Ⓒ Ⓓ
66. Ⓐ Ⓑ Ⓒ Ⓓ
67. Ⓐ Ⓑ Ⓒ Ⓓ
68. Ⓐ Ⓑ Ⓒ Ⓓ
69. Ⓐ Ⓑ Ⓒ Ⓓ
70. Ⓐ Ⓑ Ⓒ Ⓓ
71. Ⓐ Ⓑ Ⓒ Ⓓ
72. Ⓐ Ⓑ Ⓒ Ⓓ
73. Ⓐ Ⓑ Ⓒ Ⓓ
74. Ⓐ Ⓑ Ⓒ Ⓓ
75. Ⓐ Ⓑ Ⓒ Ⓓ
76. Ⓐ Ⓑ Ⓒ Ⓓ
77. Ⓐ Ⓑ Ⓒ Ⓓ
78. Ⓐ Ⓑ Ⓒ Ⓓ
79. Ⓐ Ⓑ Ⓒ Ⓓ
80. Ⓐ Ⓑ Ⓒ Ⓓ

Practice Test 1

SECTION I

TIME: 60 MINUTES
80 MULTIPLE-CHOICE QUESTIONS

> **DIRECTIONS:** Answer the multiple-choice questions below. Some are based on images. In this book the illustrations are at the top of each set of questions. Select the multiple-choice response that best completes each statement or question, and indicate the correct response on the space provided on your answer sheet. You will have 60 minutes to answer the multiple-choice questions.

Questions 1–3 are based on Figures 1 and 2.

Figure 1

Figure 2

1. Gianlorenzo Bernini drew inspiration for this work from his experience as a

 (A) writer of religious texts
 (B) friend of Saint Teresa
 (C) priest
 (D) stage designer

2. Baroque works such as these have an emotional realism that takes inspiration from

 (A) Hellenistic Greece
 (B) Benin Africa
 (C) Mongol India
 (D) Romanesque Europe

3. The patrons of the work were the Cornaro family of Rome

 (A) who objected to the work and wanted it removed
 (B) whose names are inscribed on the sculpture
 (C) who built the church and the sculptures in it
 (D) whose portraits are visible in the chapel

Questions 4–6 are based on Figure 3.

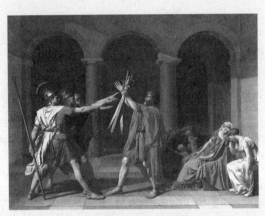

Figure 3

4. The formal qualities of this work identify it as an example of

 (A) Neoclassicism, because of the great attention to classical forms
 (B) Romanticism, because of the emotional content of the work and its vibrant brushwork
 (C) Rococo, because of the light color palette
 (D) Impressionism, because of the great attention to the effects of light and air on the subject

5. The themes used to create this work demonstrate the influence of

 (A) Renaissance epics
 (B) Russian literature
 (C) medieval folktales
 (D) ancient Roman legends

6. The work can be interpreted to mean

 (A) sacrifice for one's country is a noble cause
 (B) revolutions are necessary when governments fail to respond to the needs of the hungry and destitute
 (C) religious suppression cannot be tolerated in a free society
 (D) Papal authority needs to be questioned in an era of reform

Questions 7–10 are based on Figure 4.

Figure 4

7. This work is inspired by traditional wood-block print technology known in

 (A) India
 (B) Colonial Latin America
 (C) Southeast Asia
 (D) China

8. Many of the characters used in this work

 (A) are the invention of the artist and have no meaning
 (B) are antigovernment and a cause for political scandal
 (C) signify progressive attitudes toward family and relationships and therefore caused censure
 (D) are inked upside-down and cause viewer confusion

9. The artist of this work draws upon influence from other cultures like

 (A) New World symbolism and iconography
 (B) French Impressionist painting and printmaking
 (C) African rites and rituals
 (D) contemporary mass production and commercialism

10. The artist drew criticism for this work because

 (A) the importation of foreign materials into the United States without a permit was against the law
 (B) the Communist government thought it held secret subversive ideas
 (C) the content of the work was viewed as shocking and pornographic
 (D) it became a center of religious worship

Question 11 is based on Figure 5.

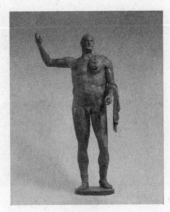

Figure 5

11. This work can be attributed to which of the following periods in art history?

 (A) Archaic Greek
 (B) Imperial Roman
 (C) Persian
 (D) Egyptian New Kingdom

Questions 12–15 are based on Figures 6 and 7.

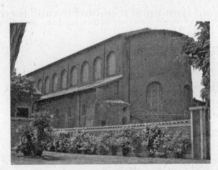 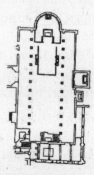

Figure 6 **Figure 7**

12. This Christian building was probably influenced by buildings such as the

 (A) Catacombs of Priscilla
 (B) Pantheon
 (C) Basilica of Ulpia
 (D) Temple of Amen-Re

13. The building has *spolia*, which are

 (A) the spoils of war
 (B) new types of stained glass having a multicolored effect
 (C) the reuse of architectural elements from other sites
 (D) permanently placed fountains, impluvia, and other water-based features

14. The ground plan indicates that this building is

 (A) a basilica with a focus on an apse
 (B) a combination of centrally planned and axially planned building formats
 (C) built over a sacred spot
 (D) constructed with a transept for clergy

15. The congregation in this building

 (A) acts independently and prays separately
 (B) worships together as they face the apse
 (C) worships together as they face a holy shrine
 (D) acts independently as they take turns circumambulating the altar

Question 16 is based on Figure 8.

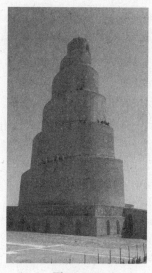

Figure 8

16. The function of this structure was to

 (A) ring bells to summon the faithful to church, as in a bell tower
 (B) be a look-out tower for defense purposes, as in a fortress
 (C) create a monument to the glory of a ruler, as in a tomb
 (D) signal a time to pray, as in a minaret

Figure 9

17. The function of the Athenian agora was to

 (A) give athletes space to exercise
 (B) create laws and conduct business
 (C) defend the city against invaders
 (D) hold a council with all the gods

18. The Panathenaic Way, which runs through the agora, was used for

 (A) the Olympics
 (B) secret diplomatic missions
 (C) sacred processions
 (D) shipping and commerce

19. A stoa is a

 (A) circular shrine with surrounding columns
 (B) meeting place set aside for the gods
 (C) prison for traitors to Athens
 (D) place of business and commerce

20. The Panathenaic Procession is similar to the imagery displayed on

 (A) the Great Altar of Zeus and Athena at Pergamon
 (B) *Bayeux Tapestry*
 (C) Great Zimbabwe
 (D) Presentation of Fijian mats and tapa cloths to Queen Elizabeth II

21. Which of the following statements is true about both the Pazzi Chapel and the Palazzo Rucellai?

 (A) They are both concerned with the soaring spiritual nature that architecture is capable of.
 (B) They both rely on Renaissance principles of proportion, measurement, and balance.
 (C) They both were commissioned by the same patrons in Florence.
 (D) They both were built as subsidiary buildings to the main building next to them.

22. Which of the following aspects of ancient Greek beliefs is reflected in the sculptural program of the Parthenon?

 (A) The gods are removed from earthly concerns and rarely interact with humans.
 (B) Humans are seen in subservient roles submitting before powerful gods.
 (C) Greek gods often challenged and contended with one another for dominance.
 (D) Ordinary humans, through hard work and sacrifice, could become gods themselves.

23. A pilgrim progressing through the Great Stupa at Sanchi is meant to worship by

 (A) walking clockwise in the direction of the sun's course
 (B) climbing to the top, to symbolize conquering of earthly pleasures and sins
 (C) kneeling facing East, in the direction of sunrise
 (D) offering sacrifices to the Buddha by placing offerings at the base of this monument

Question 24 is based on Figure 10.

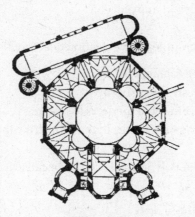

Figure 10

24. The ground plan of San Vitale indicates that the architects wanted the structure to appear to be influenced by

 (A) Greek temple designs, such as the Parthenon
 (B) Egyptian temple designs, such as the Temple of Amen-Re
 (C) Early Christian designs, such as the church of Santa Sabina
 (D) Roman temple designs, such as the temple of the Pantheon

25. Often sacred monuments show a mixture of two religions when they are originally designed. Which of the following monuments was built with two faiths in mind?

 (A) Lakshmana Temple

 (B) San Carlo alle Quattro Fontane

 (C) The Parthenon

 (D) Angkor Wat

Questions 26–28 are based on Figures 11 and 12.

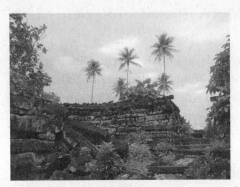
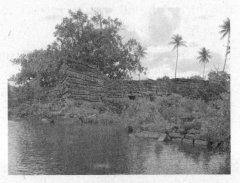

Figure 11 Figure 12

26. The location of Nan Madol is meant to

 (A) have a private enclosure for prayer and worship

 (B) simulate trade and growth among merchants in the kingdom

 (C) ensure prosperity of the country

 (D) bring the nobles to live in one place

27. The exterior walls of the complex serve the practical function of

 (A) allowing ample space for storage

 (B) ensuring a proper fresh water supply

 (C) giving the king a private set of quarters to live in

 (D) being a water break against waves that might strike the complex

28. This complex is unusual in Polynesian societies because it

 (A) is made of stone

 (B) is surrounded by water

 (C) is on a small island

 (D) contains a religious center

Questions 29 and 30 are based on Figure 13.

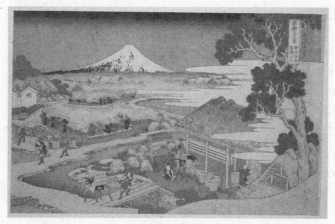

Figure 13

29. This work was done in which of the following techniques?

 (A) Wood-block printing
 (B) Lithography
 (C) Etching
 (D) Watercolor

30. This work is done in a tradition known as

 (A) Yamato-e
 (B) Tarashikomi
 (C) Zen
 (D) Ukiyo-e

Questions 31–33 refer to Figures 14 and 15.

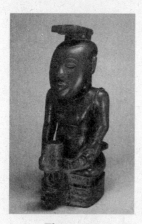

Figure 14

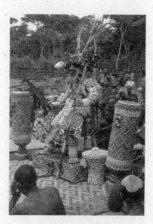

Figure 15

31. *Ndop* sculptures are characterized by

 (A) a face that seems uninvolved, above mortal affairs
 (B) anatomical proportions that emphasize the feet as stabilizing the sculpture
 (C) elaborate costumes that symbolize the wealth of the figure it represents
 (D) its presentations at performances in which an individual is honored by having ritual
 dances and tributes performed

32. In Figure 15, the king has

(A) shown his power by calling upon the spirit of his ancestors

(B) displayed a costume that renders him into a holy reliquary

(C) sought to imitate the sculpture in Figure 14

(D) symbolically shown his wealth, status, and power

33. *Ndop* sculptures represent a tradition that

(A) disappeared with the British occupation

(B) is still active today

(C) is performed, but has lost its original meaning

(D) is celebrated throughout Africa, and wherever Africans have traveled

Questions 34–36 are based on Figure 16.

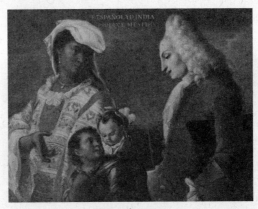

Figure 16

34. When this work was painted, it was not considered a work of art but rather

(A) the work of an illustrator

(B) a work of anthropology

(C) an illustration for a textbook

(D) a model for a future sculpture

35. The idea of mixed races, seen here, is also seen in the work of

(A) Wifredo Lam

(B) Pablo Picasso

(C) Frida Kahlo

(D) Wangechi Mutu

36. One can tell that this work was done by a European artist because

(A) it is done in fresco, a time-honored tradition in Europe

(B) it uses a mixture of experimental painting techniques

(C) it is life-size

(D) the artist uses the established oil-on-canvas technique

Question 37 is based on Figure 17.

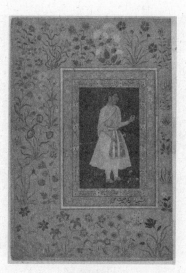

Figure 17

37. This work can be attributed to

 (A) Sultan Mohammad
 (B) Bichitr
 (C) Ogata Korin
 (D) Muhammad ibn al-Zain

38. Characteristics of the Islamic architectural aesthetic include

 (A) flying buttresses that support a tall roof line
 (B) the use of windowless interiors, which lend a sense of mystery
 (C) thin columns that render a sense of weightlessness
 (D) interiors with a dominant central focus sweeping the eye to an altar

39. The Hudson River School was

 (A) set up to train New York artists
 (B) a school of arts and crafts
 (C) a group of landscape painters
 (D) closed during World War II by the Nazis

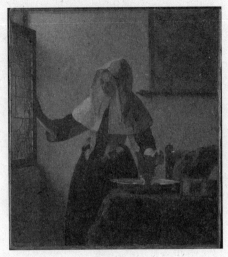

Figure 18

40. On the basis of style, this work can be attributed to

 (A) Johannes Vermeer

 (B) Peter Paul Rubens

 (C) Rembrandt van Rijn

 (D) Rachel Ruysch

41. This work shows the artist's interest in depicting

 (A) a satire on contemporary life

 (B) the drudgery of working-class people's lives

 (C) the religious symbolism behind everyday events

 (D) a person caught in a moment in time

42. One of the important aspects of Jeff Koons's work is that he

 (A) explores Old Testament themes in the context of modern cultures

 (B) uses advanced photographic processes to create an alternate reality

 (C) advocates for political change through his work

 (D) creates a permanent reality out of something that is ephemeral and never meant to be exhibited

43. Painters interested in the sublime characteristically

 (A) saluted the achievements of the Industrial Revolution

 (B) were impressed by the opulence of the court of Louis XIV

 (C) reveled in the realm of geometric precision

 (D) had a religious reverence for landscape

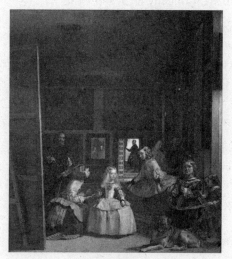

Figure 19

44. This painting seeks to elevate the occupation of the painter and declare it a noble calling. Velázquez wears the Order of Santiago, an expression of knighthood. Also symbolizing this noble calling is

 (A) the dog who keeps watch over the royal household and symbolizes fidelity
 (B) the paintings on the far wall that depict Minerva, goddess of wisdom and patroness of the arts
 (C) the use of dark passages in the painting to signal a deep recession into space
 (D) the heavenly glow cast around Velázquez

45. The original placement of this painting was

 (A) in the Prado Museum in Madrid, showing a willingness to be compared to great Spanish painters of the past
 (B) in the cathedral in Madrid, indicating a desire to find acceptance with the Catholic Church
 (C) in the study of King Philip IV, challenging him to consider the multitude of interpretations the painting represents
 (D) in the reception room at the Royal Palace in Madrid, where the portraits of the royal family would be viewable by visiting dignitaries

46. The title of the painting refers to

 (A) the chaperones on the right, who are in half-shadow in the background
 (B) the attendants to the princess in the foreground
 (C) the king and queen, seen in the reflected mirror
 (D) the dwarf and the midget in the right foreground

47. The Great Altar of Zeus and Athena at Pergamon depicts the battle between the gods and the giants, but also symbolically represents the

 (A) building of the Acropolis
 (B) rise of Greek power under Alexander the Great
 (C) Greek defeat of the Persians
 (D) Roman defeat of the Greeks

48. The sibyls on the Sistine Ceiling are meant to

 (A) align Christian belief with classical allusions
 (B) validate pagan beliefs to a nonbelieving audience
 (C) make the imagery reach across religious boundaries and incorporate all faiths
 (D) show the equality of Old and New Testament themes

Question 49 is based on Figure 20.

Figure 20

49. On the basis of style, this work can be attributed to

 (A) Donatello
 (B) Auguste Rodin
 (C) Constantin Brancusi
 (D) Jean-Antoine Houdon

50. Alfred Stieglitz's photograph *The Steerage* shows the impact of

 (A) Surrealism in its grouping of unalike images in one composition
 (B) Cubism in its angles and planes intersecting at odd points
 (C) Dada in its understanding of the foolishness and helplessness of the situation
 (D) Expressionism in its jarring use of brutal forms

Question 51 is based on Figure 21.

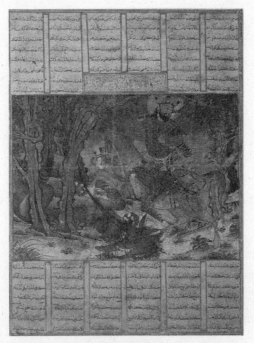

Figure 21

51. The work in Figure 21 shows the influence of Western art in its use of

 (A) classical contrapposto
 (B) atmospheric perspective
 (C) di sotto in sù
 (D) tenebrism

52. The artwork of Emily Kame Kngwarreye is often inspired by

 (A) references to objects in popular culture
 (B) multimedia artwork
 (C) commentary on contemporary political issues
 (D) the dump-dot technique of paint application

Figure 22

53. The landscapes of Fan Kuan, as seen in Figure 22, depict a

 (A) strong relationship between European and Asian art forms
 (B) complex interweaving of Buddhist and Confucian thought
 (C) reflection of Daoist philosophy and teachings
 (D) connection between Japanese and Chinese painting

54. The painting shown in Figure 22 can best be described as

 (A) an image that depicts the struggle against the forces of nature
 (B) one in a series of works that narrates the story of humanity's civilizing effect
 on nature
 (C) a work that shows how people can dominate their environment
 (D) people and nature living together in a harmonized universe

55. Brush effects are achieved by using techniques involving

 (A) classical composure
 (B) ink washes for special effects
 (C) tenebroso
 (D) the introduction of tempera paint into China

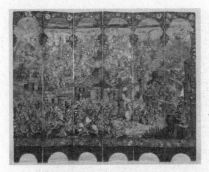

Figure 23 Figure 24

56. This screen has two sides, one showing a war scene and another showing a hunt. The war scene was meant to

 (A) display Habsburg's power
 (B) illustrate Mexican military victories
 (C) encourage people to enlist in the army
 (D) offer peace as an alternative to war

57. The hunting scene is meant for

 (A) grand rooms with large receptions
 (B) display of cultural artifacts
 (C) more intimate spaces
 (D) showing trophies of the hunt, like firearms and stuffed animal heads

58. This work contains enconchados, which are

 (A) freestanding screens
 (B) paintings that show people of mixed descent
 (C) shell inlay mother-of-pearl fragments
 (D) techniques imported from Europe and given a new expression in Mexico

───────────────

59. The terra cotta fragment from the Solomon Islands shows the characteristic use of

 (A) stamped patterns of circles and dots
 (B) cross-hatching to build up forms
 (C) realistic human anatomy
 (D) painted and sculpted figures

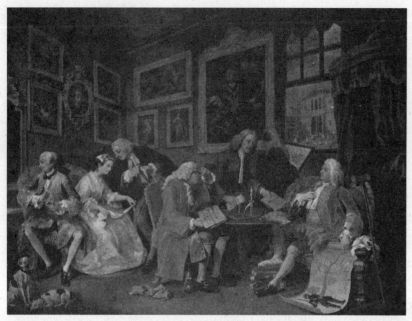

Figure 25

60. Based on the content and style of this work, it can be determined that it is one of a series of works called

 (A) *The Disasters of War*
 (B) *Marriage à la Mode*
 (C) casta paintings
 (D) The French Collection, Part 1

61. Shirin Neshat's photographs from the Women of Allah series challenge the viewer to

 (A) accept the reality that Iranian women will defend their faith
 (B) determine whether or not women clothed like this are treated as sexual objects
 (C) agree that Iranian women have their rights taken from them by an oppressive male-dominated society
 (D) understand women from both the Western and Iranian points of view

62. The catacombs in Rome were built to

 (A) bury the dead in underground tombs because land prices were too high in Rome for above ground burials
 (B) hide Christians from Roman persecutions in the second and third centuries
 (C) provide space for the burial of Roman emperors during times of crisis
 (D) hide the Roman artwork from the barbarian invasions

63. In which period did artists consistently paint sculpture?

 (A) Renaissance
 (B) Mannerism
 (C) Neoclassicism
 (D) Gothic

64. Kufic script is an Islamic form of writing that is

 (A) unusually read from left to right
 (B) very angular with the uprights at right angles to the baselines
 (C) flowing, having a curved and running look
 (D) found only on holy vessels and holy books

65. William Hogarth's works often contain narrative elements

 (A) taken from ancient myths and Biblical subjects
 (B) which underscore a satire of the King of England
 (C) illustrating stories taken from preexisting plays
 (D) which are generally seen in large-scale individual portraits done in the Grand Style

66. Monticello is influenced by European models although it

 (A) shows evidence of American Indian motifs
 (B) is made from local materials
 (C) references the African-American experience
 (D) is daring in its use of metal in its substructure

67. Gestures in Caravaggio's *Calling of Saint Matthew* are appropriated from the works of

 (A) Raphael
 (B) Leonardo da Vinci
 (C) Michelangelo
 (D) Pontormo

68. The Forbidden City is a highly expanded version of a Chinese architectural format called

 (A) the courtyard style residence
 (B) an axial plan
 (C) a central plan
 (D) a hypostyle hall

69. Dry Japanese gardens

 (A) serve as centers for tea ceremonies

 (B) symbolically represent the formations found in nature

 (C) are modeled on landscapes depicted in hanging and hand scrolls

 (D) are built to complement adjacent wet gardens

Questions 70 and 71 are based on Figure 26.

Figure 26

70. Realistic details set this work in

 (A) the home of a Medici prince with a view of his estates

 (B) a Florentine home with a view of the Arno valley

 (C) a monastery with a view of its extensive grounds

 (D) an orphanage with a view of an Alpine landscape

71. This painting is by

 (A) Donatello

 (B) Leonardo da Vinci

 (C) Sandro Botticelli

 (D) Fra Filippo Lippi

Figure 27

72. This painting can be attributed to a follower of Pontormo based on which characteristic?

 (A) Use of tenebrism
 (B) Elongated figures
 (C) Pyramidal composition
 (D) Stress on great emotions

73. Chokwe masks show a matriarchal society in African culture by having

 (A) women wear masks that call upon their status in African culture
 (B) women perform rituals wearing masks that identify their ancestors
 (C) men wear masks and perform dances in which they move like a woman
 (D) women wear male masks that depict male ancestors

74. A basic building technique of African architecture involves using a toron, which is used in buildings like

 (A) Great Zimbabwe, which is constructed of ashlar masonry
 (B) Great Zimbabwe, which needs vertical supports to frame the structure during construction
 (C) the Great Mosque at Djenne, which is made of adobe
 (D) the Great Mosque at Djenne, which is composed of a complex of buildings

75. The mosque at Córdoba is similar to many other mosques in that it

 (A) contains radiating chapels for the placement of relics
 (B) has a hypostyle hall that contains a myriad of columns
 (C) is domed over the central area to indicate the direction to Mecca
 (D) rejects the use of the axial plan and uses the central plan in its design

Questions 76 and 77 are based on Figure 28.

Figure 28

76. When this nose ornament is worn during ceremonies

 (A) it turns the wearer into a supernatural being
 (B) it symbolizes the wearer's royalty and power
 (C) it gives the wearer the power of the snakes depicted on both ends
 (D) it indicates the mortality of the wearer and his or her eventual death

77. This ornament indicates

 (A) the reciprocal relationship between the native Chavín religion and the growth of large-scale metalwork
 (B) how oracles used metal as a sacred object to predict future events
 (C) that pilgrimages to sacred sites necessitate the development of metal objects for veneration
 (D) that people in the Chavín region were buried only with their most precious objects to be presented in the afterlife to the gods

78. Navigation charts used in the Marshall Islands are characterized by

 (A) their practical use at sea
 (B) the labeling of distant features in Micronesian script
 (C) their diagonal lines, which represent wind and sea currents
 (D) their bright paint, which made the formations clearer to read

79. A traditional symbol of Saint Luke, as seen in the *Lindisfarne Gospels* and elsewhere, is a calf, which symbolizes the

 (A) pastoral nature of Saint Luke's gospel
 (B) sacrificial nature of Saint Luke's gospel
 (C) powerful and strong message of Saint Luke's gospel
 (D) determination of Saint Luke to write the gospels down as accurately as possible

80. Which of the following aspects of medieval Christian beliefs is reflected in the tympanum of Sainte-Foy at Conques?

 (A) Sainte-Foy will judge sinners at the end of time.
 (B) Each sinner will have his or her soul weighed and cast into purgatory.
 (C) Each sinner has the ability to be saved through devotion and righteous living.
 (D) The priests will determine who goes to heaven or hell in the afterlife.

SECTION II

TIME: 2 HOURS
6 QUESTIONS

DIRECTIONS: You have two hours to answer the six questions in this section.

Questions 1 and 2 are long essay questions, and you are advised to spend one hour on both.

Questions 3 through 6 are short essay questions, and you are advised to spend 15 minutes on each.

During the actual exam, the proctor will announce when each question's time limit has been reached, but you may proceed freely from one question to another.

Some of the questions refer to images; some do not.

Read the questions carefully. You can receive full credit only by directly answering all aspects of the question.

Question 1: 35 minutes suggested time

This work is *The Horse in Motion* by Eadward Muybridge. It is an albumen print from 1878.

This work depicts a horse and a man in motion.

Select and identify another work of art in which the artist has depicted someone or something in motion. You may choose a work from the list below or any other relevant work.

For both *The Horse in Motion* and your selected work, describe the effect the artist is trying to render by imitating motion in a two-dimensional object.

Discuss the method or technique that these artists used to create the illusion of movement in *each* work.

Discuss how the method used by each artist renders a different result.

Explain *at least one* difference in the method in which *each* work communicates motion.

The Crossing
Nadar Raising Photography to the Height of Art
The Swing (after Fragonard)

Question 2: 25 minutes suggested time

Many works of art represent scenes of everyday life. Sometimes these works also reflect on the world at large.

Select and completely identify a work of art from the list below, or any other relevant work that reflects everyday life as a commentary on contemporary society.

Explain how the artist used imagery, symbolism, materials, and/or techniques to express this commentary.

In your answer, make sure to:

- Accurately identify the work you have chosen with *at least two* identifiers beyond those given.

- Respond to the question with an art historically defensible thesis statement.

- Support your claim with *at least two* examples of visual and/or contextual evidence.

- Explain how the evidence that you have supplied supports your thesis.

- Use your evidence to corroborate or modify your thesis.

> *No Crying Allowed in the Barbershop*
> *Hunters in the Snow*
> *Woman Holding a Balance*

Question 3: 15 minutes suggested time

The work shown is *The Visitation* by Pontormo painted in 1528–1529.

What period in art history is this painting and this artist associated with?

Using *at least two* examples of visual evidence, discuss how elements of Pontormo's style can be seen in this work.

Using *at least two* examples of visual evidence, discuss how Pontormo's style represents a change from the art of the High Renaissance.

Question 4: 15 minutes suggested time

This work is *Chairman Mao en Route to Anyuan,* a color lithograph from 1969.

Describe the historical context for this work.

Using *at least two* examples of contextual *and/or* visual evidence, discuss how the context of this work has influenced the depiction and imagery of Chairman Mao.

Using *at least two* examples, explain how this work shows evidence of western art historical techniques.

Attribute this sculpture to the culture that produced it.

Using *at least two* specific details, justify your attribution by describing relevant similarities between this work and a work in the required course content.

Discuss where sculptures such as this were likely to be placed, *and* what ceremony is likely being depicted here.

Question 6: 15 minutes suggested time

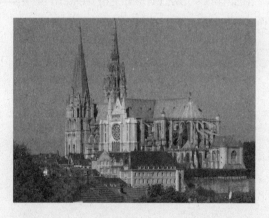 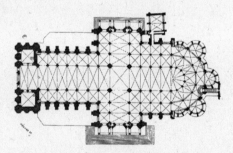

This is a photograph and a ground plan of the cathedral of Chartres, located in Chartres, France. It was begun in 1145 and reconstructed beginning in 1194.

Describe *at least two* materials or techniques used in the construction of this building or of the works contained within.

Describe how the architectural features of Chartres Cathedral continue the tradition of Christian church architecture.

Describe the innovative architectural features of the cathedral of Chartres *and* why those features represent a change from past church construction.

ANSWER KEY
Practice Test 1

Section I

1. **D**	21. **B**	41. **D**	61. **D**
2. **A**	22. **C**	42. **D**	62. **A**
3. **D**	23. **A**	43. **D**	63. **D**
4. **A**	24. **D**	44. **B**	64. **B**
5. **D**	25. **D**	45. **C**	65. **C**
6. **A**	26. **D**	46. **B**	66. **B**
7. **D**	27. **D**	47. **C**	67. **C**
8. **A**	28. **A**	48. **A**	68. **A**
9. **D**	29. **A**	49. **B**	69. **B**
10. **B**	30. **D**	50. **B**	70. **B**
11. **B**	31. **A**	51. **B**	71. **D**
12. **C**	32. **D**	52. **D**	72. **B**
13. **C**	33. **B**	53. **C**	73. **C**
14. **A**	34. **B**	54. **D**	74. **C**
15. **B**	35. **A**	55. **B**	75. **B**
16. **D**	36. **D**	56. **A**	76. **A**
17. **B**	37. **B**	57. **C**	77. **A**
18. **C**	38. **C**	58. **C**	78. **C**
19. **D**	39. **C**	59. **A**	79. **B**
20. **D**	40. **A**	60. **B**	80. **C**

ANSWERS EXPLAINED

Section I

1. **(D)** Bernini wrote plays, designed their stage settings, and built the theaters they took place in.

2. **(A)** The emotional realism seen in Bernini's work is inspired by Greek works from the Hellenistic period, such as the *Winged Victory of Samothrace*.

3. **(D)** There are eight portraits visible on the sides of the main sculptural group. These are portraits of the donors, the Cornaro family.

4. **(A)** Jacques-Louis David is the foremost exponent of the Neoclassical style, as can be seen by the adherence to classical values of composition, form, and figure style.

5. **(D)** *The Oath of the Horatii* references an episode from a Roman legend.

6. **(A)** The Roman legend of the Horatii has a moral reference to sacrificing one's self for the betterment of one's country.

7. **(D)** Traditional wood-block printing is a Chinese specialty.

8. **(A)** The artist has declared that the characters in his work have no meaning.

9. **(D)** The multiplicity of forms is inspired by mass production.

10. **(B)** Because the Communist government could not read the meaningless inscriptions in this work, they thought it was subversive.

11. **(B)** The heroic nature of this imposing figure with its emphasis on nudity places it firmly within the Imperial Roman era. Egyptian and Persian works would have found nudity debasing, and Archaic Greek works do not have the contrapposto displayed here.

12. **(C)** The Basilica of Ulpia has the same long nave that leads to a focal point. The other buildings do not.

13. **(C)** Spolia are the reused elements from older architectural monuments.

14. **(A)** The building is a basilica whose focus is on the apse.

15. **(B)** Worshippers in this building are Christians; they pray congregationally, facing a common point where the priest stands.

16. **(D)** This a minaret located in Iraq. It originally functioned as a tower to call people to prayer, and was attached to a mosque, which is now in a ruined state.

17. **(B)** The agora had many functions, among the most prominent of which was to conduct state and financial business.

18. **(C)** The Panathenaic Way was used for several occasions, the most important of which were the sacred processions.

19. **(D)** A stoa is a commercial center that conducts business and commerce.

20. **(D)** Since the Panathenaic Procession depicts the movement of presentation goods to a given point, it resembles the Presentation of Fijian mats, which directs gifts to a monarch, in this case Elizabeth II of England.

21. **(B)** Renaissance architecture can be characterized by its balance, symmetry, and harmonious proportions. Both of these buildings have these characteristics. Although the Pazzi Chapel is associated with the building next to it, Santa Croce, the Palazzo Rucellai is not dependent on its neighbors. Neither uses flying buttresses. Each building has a different patron.

22. **(C)** Greek gods often contended with one another for dominance. The pediment of the Parthenon illustrates how Athena and Poseidon both vied to be the representative god for Athens.

23. **(A)** Pilgrims worship at the Great Stupa at Sanchi by praying while walking clockwise in the direction of the sun's course.

24. **(D)** The centrally planned San Vitale resembles the central plan of the Pantheon in Rome.

25. **(D)** Angkor Wat was designed reflecting a mix of Hindu and Buddhist beliefs.

26. **(D)** Nan Madol was built, in part, to bring together nobles in one place.

27. **(D)** The exterior walls are built out into a lagoon and act as a breakwater for the complex.

28. **(A)** Not many Polynesian buildings are built of stone. This is unusual.

29. **(A)** Japanese prints are traditionally made in a woodblock printing technique. This work is from the Hokusai series called *Thirty-six Views of Mount Fuji.*

30. **(D)** Ukiyo-e is a Japanese tradition of genre painting that shows scenes of everyday life, in this case in the shadow of Mount Fuji. The other choices are all Japanese in derivation, but represent different aspects of Japanese art. Zen is a metaphysical branch of Japanese Buddhism. Yamato-e is a style of Japanese painting depicting episodes from Japanese history and literature and usually is seen on scrolls. Tarashikomi is a painting technique that shows paint applied to a surface before it has had a chance to dry from a previous application.

31. **(A)** *Ndop* sculptures are always depicted as uninvolved, above mortal affairs. They are celebrated only by the Kuba people, not throughout Africa. The anatomical proportions emphasize the head, not the feet. They are not wearing elaborate costumes but are often nude from the waist up.

32. **(D)** The extravagant costuming symbolizes the king's wealth and power.

33. **(B)** The *Ndop* sculptures represent an aspect of Kuba culture that is still active today.

34. **(B)** These works were considered an example of cultural anthropology, as illustrations of the caste system in the New World.

35. **(A)** Wifredo Lam often incorporates elements of Hispanic and African culture in his works.

36. **(D)** Oil on canvas is a technique found only in European traditional painting. This is an oil-on-canvas work.

37. **(B)** This work is similar to *Jahangir Preferring a Sufi Shaikh to Kings* and is by Bichitr.

38. **(C)** Buildings like the Alhambra employ light, thin columns that create the illusion of weightlessness.

39. **(C)** The Hudson River School was not really a school in the traditional sense. It was a group of landscape artists who shared the same artistic philosophy.

40. **(A)** This work is by Johannes Vermeer and is very similar to *Woman Holding a Balance*.

41. **(D)** As an artist, Vermeer had no interest in satire or depicting everyday life as monotonous and boring. Although religious symbolism does occur in his works, this painting is more interested in capturing the sitter in a moment in time.

42. **(D)** Jeff Koons's work, like the *Pink Panther*, creates a permanent reality out of something that is ephemeral and never meant to be exhibited.

43. **(D)** Painters interested in the sublime often had an appreciation for the awesome aspects of nature, as seen in *The Slave Ship* by Turner.

44. **(B)** The paintings on the far wall depict Minerva, the goddess of wisdom and patroness of the arts. There is a relationship expressed between the act of painting as a divinely sponsored act and King Philip as a divinely appointed monarch.

45. **(C)** The original placement of this painting was in the study of King Philip IV, challenging him to consider the multitude of interpretations the painting represents. Today it is in the Prado Museum in Madrid. It was never located in a cathedral and was painted before the building of the Royal Palace in Madrid.

46. **(B)** The title of the painting, *Las Meninas*, refers to the attendants to the princess in the foreground.

47. **(C)** Although the Pergamon Altar depicts the victory of the gods over the giants, it also references the Greeks as the gods and the Persians as the giants.

48. **(A)** The sibyls are Greek classical prophetesses who are aligned with Old Testament prophets on the Sistine Chapel ceiling.

49. **(B)** All of these artists are sculptors. Rodin is the correct response because of the way the bronze is treated, as if modeled in clay by hand. This tactile approach is a hallmark of Rodin's art. This work does not have the smooth finish of Houdon or Brancusi, nor does it have the heroic nudity of Donatello.

50. **(B)** Stieglitz was heavily influenced by modernist European trends in painting, including the analytical nature of Cubism.

51. **(B)** The background of this painting shows the European technique of atmospheric perspective.

52. **(D)** The dump-dot technique uses the brush to pound the color into a canvas and create layers of color and the effect of movement. This is a specialty of Emily Kame Kngwarreye.

53. **(C)** Fan Kuan isolated himself away from civilization to be with nature, study nature, and engage in a Daoist philosophy.

54. **(D)** The people in the painting, although tiny, live in harmony with the landscape.

55. **(B)** Fan Kuan was noted for achieving special effects with his delicate ink washes.

56. **(A)** The war scene illustrates the Siege of Belgrade and victory for the Hapsburg troops in eastern Europe.

57. **(C)** The hunting scene is meant to face a more intimate environment.

58. **(C)** Enconchados are shell inlays made of mother-of-pearl.

59. **(A)** The terra cotta fragment from the Solomon Islands is marked with stamped patterns of circles and dots.

60. **(B)** This is the first work in a series called *Marriage à la Mode* by William Hogarth. The second work, The *Tête à Tête*, is in the required course content.

61. **(D)** Many of Neshat's images can be interpreted as having a positive and negative message, depending on the viewer. Her work seeks to present both points of view.

62. **(A)** The catacombs were tombs, not refuges from persecution as tradition alleges. Emperors would not have been buried in such humble locations.

63. **(D)** Almost all Gothic sculpture, including the Royal Portals at Chartres and the *Röttgen Pietà*, were painted.

64. **(B)** Kufic script is noted for its angular forms, with direct uprights and perpendicular baselines.

65. **(C)** *Marriage à la Mode* is derived from a seventeenth-century play by John Dryden.

66. **(B)** Jefferson was strongly influenced by European design principals when he built Monticello, but the building is made from local materials found in the colonies.

67. **(C)** Caravaggio's paintings often reference Michelangelo's Sistine Ceiling, including Jesus's gesture in the *Calling of Saint Matthew*, which comes from *The Creation of Adam*.

68. **(A)** The Forbidden City is a large version of a traditional Chinese courtyard style residence.

69. **(B)** Japanese dry gardens use materials such as stone, plants, and sand to symbolically represent formations found in nature. They don't necessarily have wet gardens nearby.

70. **(B)** Lippi's paintings often take sacred subjects, like the Madonna and Child, and place them in the context of an Italian home with a view of the Arno river valley in the distance.

71. **(D)** This painting is by Fra Filippo Lippi.

72. **(B)** This painting was done by Bronzino, a follower of Pontormo. Bronzino uses the same kind of elongated figures found in Pontormo's work.

73. **(C)** Men wear Chokwe masks and ceremonially dance in imitation of a woman during rituals.

74. **(C)** Torons are used to hold the adobe walls of buildings like the Great Mosque at Djenne in place.

75. **(B)** The hypostyle hall at the mosque at Córdoba contains a myriad of columns. Radiating chapels is a characteristic of Christian Romanesque architecture. There are no domes at Córdoba, and the building is not on a centrally planned design.

76. **(A)** When this nose ornament is worn during ceremonies, it turns the wearer into a supernatural being.

77. **(A)** This ornament indicates the reciprocal relationship between the native Chavín religion and the growth of large-scale metalwork. There seems to be a direct link between the use of these precious metal objects and the development of Chavín religious practices.

78. **(C)** Navigation charts used in the Marshall Islands are characterized by their diagonal lines, which represent wind and sea currents.

79. **(B)** Many Christian stories deal with sacrifice. Saint Luke's gospel is symbolized by a calf, a sacrificial animal.

80. **(C)** Each sinner has the ability to save himself or herself. The tympanum at Sainte-Foy acts as a cautionary tale, warning people to behave appropriately to assure a happy life in the next world.

MODEL RESPONSE FOR QUESTION 1

The second work showing motion, <u>Nadar Raising Photography to the Height of Art</u> by Honore Daumier, is a lithograph print created around 1860.

In <u>The Horse in Motion</u>, Eadweard Muybridge attempted to imitate the motion of a horse running in order to prove whether or not all four of a horse's hooves leave the ground while it's running. Muybridge was hired by a California governor (who was also the founder of Stanford) to settle a bet over this question, and was able to prove that all four hooves leave the ground by taking a rapid series of photographs that capture the changing position of the horse while it was moving and imitate its motion. The series of images was able to settle the bet and created the effect of the horse actually moving, which was like a precursor for film. In <u>Nadar Raising Photography to the Height of Art</u>, Daumier imitates motion in the print in order to comment on the controversy regarding photography as an art form in the 1860s in a humorous manner. He uses a cartoon like style to portray famous photographer Nadar in a hot air balloon being blown across the sky, the motion making his work seem dangerous and thrilling. The effect of portraying motion in the piece makes Nadar's work seem more dangerous than it actually was (as he actually worked under calm conditions).

Muybridge took advantage of the technological developments of his time to take rapid photographs of the horse as well as develop them properly to create <u>The Horse in Motion</u>. The exposure time for images used to be much longer, but by Muybridge's time the technology had reached the point where treated glass plates that required only a fraction of a second exposure to capture an image were available. The much faster exposure times as well as the invention of mechanical shutters allowing the camera to capture images faster allowed Muybridge to set up a series of cameras along the track where the horse was running and capture the series of images that made up this work. Daumier's lithograph print <u>Nadar Raising Photography to the Height of Art</u> makes it seem like the hot air balloon, and therefore also Nadar and his camera, are moving by creating the illusion of strong winds in the image. The diagonal positioning of the hot air balloon's ropes and basket make it appear as if strong winds are buffeting it. Billowing fabrics, such as Nadar's clothes and the cloth on the basket, as well as the dangling rope and Nadar's lost hat all add to the illusion of there being strong winds in the image. This wind creates the illusion of movement in the piece, as the both the balloon and Nadar are blown around.

The result of Muybridge's method of imitating motion, a series of rapidly taken photographs of a horse during a short period of time, was a series of images that showed the animal's motion over that time. The images together created the illusion that the horse was actually running. Although viewers of the still images can see and imagine the motion of the horse, this work as well as later similar ones by Muybridge paved the way for the future of cinema. It was later that the realization the images shown in rapid succession as well as the human eye's persistence of vision (the eye continuing to see an image for a brief period despite it not being visible anymore) made it look like actual motion that let to filmmaking.

The result of Daumier's method of imitating motion was an image that was able to comment on the status of photography as an art form at the time it was created. Regardless of the controversy over whether photography was a fine art or not, photography was growing in popularity, and the motion of the balloon soaring upwards in the print alluded to this. Additionally, the motion of the balloon made Nadar's work seem more dangerous than it actually was and shows Nadar as so devoted to his art as to ignore the danger to himself.

One significant difference in the methods each work uses to communicate motion is that The Horse in Motion relies on a series of images to communicate the idea of motion. Each photograph seen individually is nothing more than a still image of a horse in mid motion. However, when seen together, the series of images creates the illusion of motion. Nadar Raising Photography to the Height of Art is a single image that communicates the idea of motion very differently. Daumier uses the composition of the image, strong diagonals and the placements of the hat and cloth, to show the strong wind which creates the illusion of motion in his piece.

—Clarisse C.

Criteria	Student Response	Point Value	Points Earned
Task: Select and identify another work of art in which the artist has depicted someone or something in motion.			
The student must supply two identifiers in addition to the one already listed. Here, Clarisse has named the artist, the medium, and the date.	"The second work showing motion, *Nadar Raising Photography to the Height of Art* by Honore Daumier, is a lithograph print created around 1860."	1	1
Task: For both *The Horse in Motion* and your selected work, describe the effect the artist is trying to render by imitating motion in a two-dimensional object.			
The context of both works illustrates why the artist is imitating motion in a still object.	"In *The Horse in Motion*, Eadweard Muybridge attempted to imitate the motion of a horse running in order to prove whether or not all four of a horse's hooves leave the ground while it's running." "In *Nadar Raising Photography to the Height of Art*, Daumier imitates motion in the print in order to comment on the controversy regarding photography as an art form in the 1860s in a humorous manner."	2; 1 point for *Horse in Motion*, 1 point for selected work	2
Task: Discuss the method or technique that these artists used to create the illusion of movement in *each* work.			
For Muybridge, it is important to stress the technological development in photography that makes these images possible. For Daumier, it is necessary to comment on the way he creates a sense of wind and motion in his work.	"Muybridge took advantage of the technological developments of his time to take rapid photographs of the horse as well as develop them properly to create *The Horse in Motion*...." "...by creating the illusion of strong winds in the image. The diagonal positioning of the hot air balloon's ropes and basket make it appear as if strong winds are buffeting it."	2; 1 point for *Horse in Motion*, 1 point for selected work	2
Task: Discuss how the method used by *each* artist renders a different result.			
Notice how Clarisse begins the response with "The result of Muybridge's [or Daumier's] method..." which indicates to the reader that this section of the question is being directly addressed.	"The result of Muybridge's method of imitating motion, a series of rapidly taken photographs of a horse during a short period of time..." "The result of Daumier's method of imitating motion was an image that was able to comment on the status of photography as an art form at the time it was created."	2; 1 point for *Horse in Motion*, 1 point for selected work	2

Criteria	Student Response	Point Value	Points Earned
Task: Explain *at least one* difference in the method in which *each* work communicates motion.			
Only one difference between the two works is needed, and Clarisse opts for the most obvious one to earn the point. This is a wise move, because the reader can easily detect the point and score the essay quickly and accurately.	"...*The Horse in Motion* relies on a series of images to communicate the idea of motion." "Daumier uses the composition of the image, strong diagonals and the placements of the hat and cloth, to show the strong wind which creates the illusion of motion in his piece."	1	1
		Total Points Possible: 8	**This essay earned: 8**
Remarks: Each task in the prompt requires a full response. It is a good strategy to answer each prompt one at a time, preferably giving each a separate paragraph so that the reader knows where to look to find the points. This is especially important in the long essays, in which a reader can sometimes get lost in the student's response. This essay clearly demonstrates how it should be done.			

MODEL RESPONSE FOR QUESTION 2

No Crying Allowed in the Barbershop, created by Pepon Osorio, is an installation located in Hartford, Connecticut. The installation consists of repurposed objects such as television monitors, barbershop chairs and tools, photographs of Puerto Rican men, and products geared towards men (e.g. baseballs, protein supplements, certain hair products).

Osorio comments on the Puerto Rican culture of machismo and hypermasculinity by contrasting traditionally masculine settings, imagery, and products to imagery of men crying. The setting of a barbershop comes from Osorio's own childhood memory. As a child he had been brought to the barbershop by his father, but when he began crying in fear of the electric razor, his father told him that no crying was allowed in the barbershop. This speaks volumes of what the barbershop represents as well as the expectations of Puerto Rican men in their community. The barbershop is meant to be a place exclusively for men and a boy coming in and getting his hair cut for the first time is a kind of coming of age. However, being told so early on not to cry while there shows the cultural expectation for men not to show outward emotions. The entire installation is filled with memorabilia and products representative of masculinity from the chairs and objects hanging on them to the framed photos on the wall. Each of these reflect what is expected of men. The monitors showing those of the community posing (often in more traditionally masculine poses like flexing) add to the atmosphere of a very masculine setting.

However, this is contrasted by the addition of the monitors of men crying. When being placed in such a setting, seeing this open vulnerability of men is intensified. Alone it would not have the same effect, but while placed in the cultural context of the barbershop and all that Osorio included inside it, the imagery speaks strongly of the issue of hypermasculinity and the effects of bottling up emotions and having to show oneself off as macho and strong.

—C.Z.

Criteria	Student Response	Point Value	Points Earned
Task: Select and completely identify a work of art from the list below, or any other relevant work that reflects everyday life as a commentary on contemporary society.			
Two identifiers are needed in addition to the name supplied above. The identifiers have to be those described on the image list. C.Z. supplies the name of the artist, but indicates a temporary location for the installation that is not included in the image list data. A date or the materials (1994, mixed-media installation) would be necessary to earn a point.	"*No Crying Allowed in the Barbershop*, created by Pepon Osorio, is an installation located in Hartford, Connecticut."	1	0
Task: Respond to the question with an art historically defensible thesis statement.			
It is important when answering this question to clearly state the purpose of the essay, as reflected in the prompt.	"Osorio comments on the Puerto Rican culture of machismo and hypermasculinity by contrasting traditionally masculine settings, imagery, and products to imagery of men crying."	1	1
Task: Support your claim with *at least two* examples of visual and/or contextual evidence.			
A connection must be firmly made between the thesis statement and examples of where this can be seen in the work. C.Z.'s response directly addresses this connection.	"The entire installation is filled with memorabilia and products representative of masculinity from the chairs and objects hanging on them to the framed photos on the wall. Each of these reflect what is expected of men."	2	2
Task: Explain how the evidence that you have supplied supports your thesis.			
This point is earned when the student analyzes the work of art. In this case, C.Z. states that there is a contrast between the masculine setting and the monitors of men crying.	"However, this is contrasted by the addition of the monitors of men crying. When being placed in such a setting, seeing this open vulnerability of men is intensified."	1	1
Task: Use your evidence to corroborate or modify your thesis.			
The student must show an understanding of the complexity of the issues involved to earn this point.	"Alone it would not have the same effect, but while placed in the cultural context of the barbershop and all that Osorio included inside it, the imagery speaks strongly of the issue of hypermasculinity and the effects of bottling up emotions and having to show oneself off as macho and strong."	1	1
		Total Points Possible: 6	**This essay earned: 5**
Remarks: This response creates a firm thesis statement and then explores the nuances of Osario's work in relationship to the prompt.			

MODEL RESPONSE FOR QUESTION 3

This work is from the Mannerist period.

The first example of visual evidence showing elements of Pontormo's style is his use of disproportionate figures. The heads of the figures are small compared to their ample bodies, and their floating feet look too small and delicate to support their frames. Pontormo also employs odd combinations of vivid colors, for example, orange and mint green. His use of non-complementary color combinations is also visible other work The Entombment of Christ.

The Mannerist period was a direct reaction to the High Renaissance period, and this painting shows a few visual examples of that. The first example is that the Renaissance painters heavily focused on symmetry and balance. Pontormo contradicts that by putting all the figures in the immediate foreground, and they are disproportionately spaced in relation to each other. Another example of the contrast between the two periods is that Renaissance painters often used linear perspective to create intricate and realistic backgrounds, but this work uses minimal linear perspective, shown in the buildings in the back. The buildings are plain and are painted with drab greys and blues, which keeps the focus on the foreground.

—Olivia B.

Criteria	Student Response	Point Value	Points Earned
Task: What period in art history is this painting and this artist associated with?			
The answer is Mannerism. The term Renaissance or Late Renaissance is not exact enough.	"This work is from the Mannerist period."	1	1
Task: Using *at least two* examples of visual evidence, discuss how elements of Pontormo's style can be seen in this work.			
The student needs *at least two* examples of Pontormo's style as seen in this work. Olivia provides more than two examples, and they are all excellent.	"The heads of the figures are small compared to their ample bodies, and their floating feet look too small and delicate to support their frames. Pontormo also employs odd combinations of vivid colors, for example, orange and mint green."	2	2
Task: Using *at least two* examples of visual evidence, discuss how Pontormo's style represents a change from the art of the High Renaissance.			
This prompt requires the student to know both the High Renaissance and the Mannerist period and how the latter is a reaction to the former.	"The first example is that the Renaissance painters heavily focused on symmetry and balance. Pontormo contradicts that by putting all the figures in the immediate foreground, and they are disproportionately spaced in relation to each other. Another example of the contrast between the two periods is that Renaissance painters often used linear perspective to create intricate and realistic backgrounds, but this work uses minimal linear perspective, shown in the buildings in the back."	2	2
		Total Points Possible: 5	**This essay earned: 5**

Remarks: Olivia's response is solid for many reasons, but chief among them is that she directs the reader's attention to exactly where in the painting the characteristics are best seen.

MODEL RESPONSE FOR QUESTION 4

This lithograph was painted during the emergence of China's Cultural Revolution. In this era, the Chinese government aimed to rid China of any threat to their ideal of a communist government. This meant that millions of intellectuals, teachers, writers, etc.—any citizen who posed new ideas that challenged China's inflexible communist objectives—were abused and/or executed by Mao's "Red Guards." In addition, artists that painted in traditional styles—styles prior to the age of China's communism—were tyrannized as a result of the ideology of the Chinese government. In this work, Chairman Mao is marching towards Anyuan, a town where Mao spurred workers in a coal mine to revolt for better treatment. This revolt was successful in that Mao converted the mine workers to Communism, and that it commenced a revolution.

In this work, Chairman Mao is depicted as the ultimate Chinese leader committed to communist values. Mao is the main focus of the work. He struts unaided in the center of the lithograph, and is depicted as confidently marching over the vast rural Chinese landscape as he reacts in favor of the Chinese people. His eyes gaze far into the future as he holds his chin high. Mao's left fist is tightly clenched, and his chest is proudly extended. He holds an old umbrella under his right arm, which displays his interconnectedness to the unadorned living to the Chinese middle class. Above the horizon, clouds roll back as the wind blows in Mao's black hair; he is on the eve of an incendiary uproar.

This work shows evidence of western art techniques in a number of ways. The artist employs atmospheric perspective in the landscape that envelopes Chairman Mao. In addition, perspective is further emphasized by the shading on Mao's traditional Chinese clothing. Both of these methods of depicting perspective are evident in Western Art.

—Owen M.

Criteria	Student Response	Point Value	Points Earned
Task: Describe the historical context for this work.			
The essay needs to pinpoint the exact historical context. Vague words like "the history of China" or "a Chinese revolution" are not specific enough to earn a point.	"This lithograph was painted during the emergence of China's Cultural Revolution…"	1	1
Task: Using *at least two* examples of contextual *and/or* visual evidence, discuss how the context of this work has influenced the depiction and imagery of Chairman Mao.			
The student needs *at least two* examples of how this work functions as a propagandistic image of Chairman Mao. More than two proves that the student has a good grasp of the subject matter. This essay provides more than two.	"He struts unaided in the center of the lithograph…" [he is] "depicted as confidently marching over the vast rural Chinese landscape…" "His eyes gaze far into the future as he holds his chin high." etc.	2	2
Task: Using *at least two* examples, explain how this work shows evidence of western art historical techniques.			
Western techniques could also include the use of lithography; the mass production of images, and a western-style landscape painting in background.	"The artist employs atmospheric perspective in the landscape…" "…the shading on Mao's traditional Chinese clothing."	2	2
		Total Points Possible: 5	**This essay earned: 5**
Remarks: This is a solid response that is strong on the discussion of the content of this work. Owen M. proves that he has mastered this material.			

MODEL RESPONSE FOR QUESTION 5

This sculpture can be attributed to the Maya culture, since it is most similar to the Mayan work in our set being Yachilan, Lintel 25 Vision of Lady Xoc.

A specific detail that justifies my attribution are the lintels themselves, since in both cases, they have a flat background with the foreground literally popping out and they are framed by a thin edge and in both cases, are rectangular about twice as tall as they are long.

The content that is emphasized justifies my attribution as well. For example, in both lintels, the subjects are wearing large, ornate headpieces. Furthermore, in both lintels, hieroglyphs are embedded in the sculpture and they both feature a bowl-shaped object. Finally, a very specific resemblance in both the sculptures is that both feature one person holding a weapon who stands above another person who is not carrying a weapon, with both being ornately dressed.

This sculpture would likely be placed in a temple to the gods. The ceremony likely being depicted here is a bloodletting ceremony, performed for the gods, since the Maya believed that the gods sacrificed blood to make humans, so humans need to sacrifice blood to repay the gods. This can be seen since it depicts a person insert a rope with thorns into their mouth, so they can bleed and perhaps drip the blood into what appears to be a bloodletting bowl below his mouth. By losing blood, they would have the added benefit of having visions which are interpreted as messages from the gods.

—Hector C.

Criteria	Student Response	Point Value	Points Earned
Task: Attribute this sculpture to the culture that produced it.			
The essay needs to pinpoint the exact American culture that produced it. Identifiers like "American" or "Native American" are not clear enough.	"This sculpture can be attributed to the Maya culture, since it is most similar to the Mayan work in our set being Yachilan, Lintel 25 Vision of Lady Xoc."	1	1
Task: Using *at least two* specific details, justify your attribution by describing relevant similarities between this work and a work in the required course content.			
The two similarities can be contextual or visual. Visual and content details are explained by Hector. It is clear to the reader that he is directly addressing the question.	"A specific detail that justifies my attribution are the lintels themselves, since in both cases, they have a flat background with the foreground literally popping out and they are framed by a thin edge and in both cases, are rectangular about twice as tall as they are long." "Furthermore, in both lintels, hieroglyphs are embedded in the sculpture and they both feature a bowl-shaped object."	2	2
Task: Discuss where sculptures such as this were likely to have been placed...			
It is important to understanding that this is a work that would have had religious significance.	"This sculpture would likely be placed in a temple to the gods."	1	1
Task: ...*and* what ceremony is likely being depicted here.			
The student needs to stress exactly what sacred ceremony is being performed.	"The ceremony likely being depicted here is a bloodletting ceremony, performed for the gods, since the Maya believed that the gods sacrificed blood to make humans, so humans need to sacrifice blood to repay the gods."	1	1
		Total Points Possible: 5	**This essay earned: 5**
Remarks: This is an exceptional essay that deliberately targets the response to each question.			

MODEL RESPONSE FOR QUESTION 6

Several new structural techniques used in the construction of the Chartres Cathedral include the ribbed groin vault, flying buttresses, pointed arches, and clerestory windows. The ribbed groin vault is supported by the pointed arches and flying buttresses, which carry the weight of the stone vaulting from the walls towards the ground, freeing the walls from their traditional role as the main structural support of the building. This technology enables the addition of clerestory stained glass windows, which allow light to permeate the interior of the church. This innovative support system also enables structures to be larger and more expansive, creating the church's stunning sense of soaring verticality.

The Chartres Cathedral continues the tradition of Christian church architecture through several shared architectural features that reflect a similar basic floor plan. Traditional Christian church architecture was based upon a simple basilica plan. Churches were traditionally a basic rectangular shape with a nave, single aisle, apse with altar, and the eventual inclusion of a narthex. Though the Chartres Cathedral has a more complex floor plan with additional features, both the cathedral and traditional churches share a central nave, large interior space, clear focal point down towards the apse, and an altar at the apse.

The innovative architectural features of the pointed ribbed groin vault, flying buttresses, clerestory windows, and expanded architectural plan of the Chartres Cathedral represent a change from past church construction. The changes to the floor plan are the result of pilgrimage. Earlier church plans were not designed to accommodate the large number of pilgrims visiting churches to view relics. Radiating chapels were added to display relics, transepts were built for pilgrims to enter and exit the church without disturbing mass, and an ambulatory was added as a walkway to the radiating chapels. Early Christian churches also had wooden roofs, which frequently caught fire. Wooden roofs were replaced with Romanesque stone barrel vaults, which did not burn. However, the walls of Romanesque churches could not be permeated with windows because they bore the weight of the stone barrel vaulting, making the churches very dark. Abbot Suger called for architecture that would allow Lux Nova, the presence of God within light, to pour into the church. The innovative structural technology of the pointed ribbed groin vault and flying buttresses in the Chartres Cathedral replaced the inferior support system of the Romanesque round barrel vault, which required thick walls, piers, and solid buttresses. This new support system enabled clerestory stained glass windows, which allow light to pour into the cathedral.

—Haley J.

Criteria	Student Response	Point Value	Points Earned
Task: Describe *at least two* materials or techniques used in the construction of this building or of the works contained within.			
The essay needs to pinpoint the exact architectural features that are used at Chartres. Haley begins with listing them, and then goes on to explain their importance.	"Several new structural techniques used in the construction of the Chartres Cathedral include the ribbed groin vault, flying buttresses, pointed arches, and clerestory windows."	2	2
Task: Describe how the architectural features of Chartres Cathedral continue the tradition of Christian church architecture.			
This essay directly addresses the prompt by rephrasing it as a basis for the answer. This is a solid approach to make sure that you respond directly to the question and earn the full point value.	"The Chartres Cathedral continues the tradition of Christian church architecture through several shared architectural features that reflect a similar basic floor plan...etc."	1	1
Task: Describe the innovative architectural features of the cathedral of Chartres...			
There are many innovative features at Chartres. Listing them is fine, but to earn full value, the student must describe.	"The innovative structural technology of the pointed ribbed groin vault and flying buttresses in the Chartres Cathedral..."	1	0
Task: ...and why those features represent a change from past church construction.			
Knowing what the features are and how they function is key to understanding Gothic architecture.	"This new support system enabled clerestory stained-glass windows, which allow light to pour into the cathedral."	1	1
		Total Points Possible: 5	**This essay earned: 4**
Remarks: This is a fine response. However, value statements like "inferior" should be avoided on this test. Also, the discussion about Early Christian architecture is irrelevant to the question.			

TEST ANALYSIS

NOTE: Because the AP Art History exam has been redesigned, there is no way of knowing exactly how the raw scores on the exams will translate into a 1, 2, 3, 4, or 5. The formula provided below is based on past commonly accepted standards for grading the AP Art History exam. Additionally, the score range corresponding to each grade varies from exam to exam, and thus the ranges provided below are approximate.

SECTION I: MULTIPLE-CHOICE (50% OF GRADE)

Number Correct: _____ (out of 80)

Number Correct × 1.25 = _____ (out of 100)
(Multiple-Choice Score)

SECTION II: ESSAYS (50% OF GRADE)

Essay 1: _____
(out of 8)

Essay 2: _____
(out of 6)

Essay 3: _____
(out of 5)

Essay 4: _____
(out of 5)

Essay 5: _____
(out of 5)

Essay 6: _____
(out of 5)

Total: _____ × 2.942 = _____ (out of 100)
(Essay Score)

FINAL SCORE

_____ + _____ = _____ (out of 200)

Multiple-Choice Essay Score Final Score
 Score (rounded to the nearest
 whole number)

Final Score Range	AP Score
150–200	5
132–149	4
110–131	3
75–109	2
0–74	1

ANSWER SHEET
Practice Test 2

Section I

1. Ⓐ Ⓑ Ⓒ Ⓓ
2. Ⓐ Ⓑ Ⓒ Ⓓ
3. Ⓐ Ⓑ Ⓒ Ⓓ
4. Ⓐ Ⓑ Ⓒ Ⓓ
5. Ⓐ Ⓑ Ⓒ Ⓓ
6. Ⓐ Ⓑ Ⓒ Ⓓ
7. Ⓐ Ⓑ Ⓒ Ⓓ
8. Ⓐ Ⓑ Ⓒ Ⓓ
9. Ⓐ Ⓑ Ⓒ Ⓓ
10. Ⓐ Ⓑ Ⓒ Ⓓ
11. Ⓐ Ⓑ Ⓒ Ⓓ
12. Ⓐ Ⓑ Ⓒ Ⓓ
13. Ⓐ Ⓑ Ⓒ Ⓓ
14. Ⓐ Ⓑ Ⓒ Ⓓ
15. Ⓐ Ⓑ Ⓒ Ⓓ
16. Ⓐ Ⓑ Ⓒ Ⓓ
17. Ⓐ Ⓑ Ⓒ Ⓓ
18. Ⓐ Ⓑ Ⓒ Ⓓ
19. Ⓐ Ⓑ Ⓒ Ⓓ
20. Ⓐ Ⓑ Ⓒ Ⓓ

21. Ⓐ Ⓑ Ⓒ Ⓓ
22. Ⓐ Ⓑ Ⓒ Ⓓ
23. Ⓐ Ⓑ Ⓒ Ⓓ
24. Ⓐ Ⓑ Ⓒ Ⓓ
25. Ⓐ Ⓑ Ⓒ Ⓓ
26. Ⓐ Ⓑ Ⓒ Ⓓ
27. Ⓐ Ⓑ Ⓒ Ⓓ
28. Ⓐ Ⓑ Ⓒ Ⓓ
29. Ⓐ Ⓑ Ⓒ Ⓓ
30. Ⓐ Ⓑ Ⓒ Ⓓ
31. Ⓐ Ⓑ Ⓒ Ⓓ
32. Ⓐ Ⓑ Ⓒ Ⓓ
33. Ⓐ Ⓑ Ⓒ Ⓓ
34. Ⓐ Ⓑ Ⓒ Ⓓ
35. Ⓐ Ⓑ Ⓒ Ⓓ
36. Ⓐ Ⓑ Ⓒ Ⓓ
37. Ⓐ Ⓑ Ⓒ Ⓓ
38. Ⓐ Ⓑ Ⓒ Ⓓ
39. Ⓐ Ⓑ Ⓒ Ⓓ
40. Ⓐ Ⓑ Ⓒ Ⓓ

41. Ⓐ Ⓑ Ⓒ Ⓓ
42. Ⓐ Ⓑ Ⓒ Ⓓ
43. Ⓐ Ⓑ Ⓒ Ⓓ
44. Ⓐ Ⓑ Ⓒ Ⓓ
45. Ⓐ Ⓑ Ⓒ Ⓓ
46. Ⓐ Ⓑ Ⓒ Ⓓ
47. Ⓐ Ⓑ Ⓒ Ⓓ
48. Ⓐ Ⓑ Ⓒ Ⓓ
49. Ⓐ Ⓑ Ⓒ Ⓓ
50. Ⓐ Ⓑ Ⓒ Ⓓ
51. Ⓐ Ⓑ Ⓒ Ⓓ
52. Ⓐ Ⓑ Ⓒ Ⓓ
53. Ⓐ Ⓑ Ⓒ Ⓓ
54. Ⓐ Ⓑ Ⓒ Ⓓ
55. Ⓐ Ⓑ Ⓒ Ⓓ
56. Ⓐ Ⓑ Ⓒ Ⓓ
57. Ⓐ Ⓑ Ⓒ Ⓓ
58. Ⓐ Ⓑ Ⓒ Ⓓ
59. Ⓐ Ⓑ Ⓒ Ⓓ
60. Ⓐ Ⓑ Ⓒ Ⓓ

61. Ⓐ Ⓑ Ⓒ Ⓓ
62. Ⓐ Ⓑ Ⓒ Ⓓ
63. Ⓐ Ⓑ Ⓒ Ⓓ
64. Ⓐ Ⓑ Ⓒ Ⓓ
65. Ⓐ Ⓑ Ⓒ Ⓓ
66. Ⓐ Ⓑ Ⓒ Ⓓ
67. Ⓐ Ⓑ Ⓒ Ⓓ
68. Ⓐ Ⓑ Ⓒ Ⓓ
69. Ⓐ Ⓑ Ⓒ Ⓓ
70. Ⓐ Ⓑ Ⓒ Ⓓ
71. Ⓐ Ⓑ Ⓒ Ⓓ
72. Ⓐ Ⓑ Ⓒ Ⓓ
73. Ⓐ Ⓑ Ⓒ Ⓓ
74. Ⓐ Ⓑ Ⓒ Ⓓ
75. Ⓐ Ⓑ Ⓒ Ⓓ
76. Ⓐ Ⓑ Ⓒ Ⓓ
77. Ⓐ Ⓑ Ⓒ Ⓓ
78. Ⓐ Ⓑ Ⓒ Ⓓ
79. Ⓐ Ⓑ Ⓒ Ⓓ
80. Ⓐ Ⓑ Ⓒ Ⓓ

Practice Test 2

SECTION I

TIME: 60 MINUTES
80 MULTIPLE-CHOICE QUESTIONS

DIRECTIONS: Answer the multiple-choice questions below. Some are based on images. In this book the illustrations are at the top of each set of questions. Select the multiple-choice response that best completes each statement or question, and indicate the correct response on the space provided on your answer sheet. You will have 60 minutes to answer the multiple-choice questions.

Questions 1–3 are based on Figure 1.

Figure 1

1. Michel Tuffery's reuse of existing materials draws inspiration from repurposed materials as seen in

 (A) the Kaaba
 (B) the Golden Stool
 (C) Duchamp's *Fountain*
 (D) the Intihuatana Stone

2. Michel Tuffery's sculpture is made of used cans of corned beef which symbolize

 (A) a rejection of a strict vegetarian lifestyle
 (B) the reliance on packaged meat rather than traditional food gathering activities
 (C) Polynesian traditional welcoming of new people and products
 (D) an affirmation of a meat-based diet

3. Michel Tuffery's objects become animated

 (A) when used in traditional coming-of-age ceremonies

 (B) when put on wheels and used as part of a multimedia performance art

 (C) when lit up from within and resembling an active bull

 (D) in cartoons and used to entertain children

Questions 4–7 are based on Figure 2.

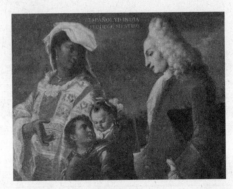

Figure 2

4. Works like this from New Spain betray a knowledge of European artistic traditions during which of the following periods?

 (A) Renaissance

 (B) Baroque

 (C) Gothic

 (D) Neoclassicism

5. This work presents a contrast in cultural identities. The figure on the right represents

 (A) the King of Spain and his generous actions toward his subjects

 (B) a member of the Spanish priesthood blessing a young child

 (C) a member of the Spanish aristocracy who cares for children who are born on his land

 (D) a member of the upper classes who has had a child with a Native American woman

6. The work is called a casta painting, a term that implies that

 (A) it is meant to show how children of mixed race need adoption

 (B) its purpose is to introduce the notion of mixed races to a European audience

 (C) it is a painting in a series of works that shows different levels of ancestry and hierarchy

 (D) it was used as a screen to divide rooms from one another

7. The woman on the left represents a Native American

 (A) but she is painted as a European woman with dark-colored skin

 (B) who is dressed as a European woman of the eighteenth century would be dressed

 (C) who tries to adopt the culture and conditions of her new home in Spain

 (D) who is eager to give up her children to the European male in the painting

Questions 8–12 are based on Figure 3.

Figure 3

8. By examining this ground plan we can determine that the building represents a

 (A) mosque
 (B) cathedral
 (C) department store
 (D) home

9. It was likely this building used which of the following architectural systems?

 (A) Groin vaults
 (B) Skeletal structure
 (C) Cantilevering
 (D) Fan vaults

10. The interior resembles the ground plan of

 (A) the mosque at Córdoba
 (B) the Parthenon
 (C) the Temple of Minerva
 (D) the Great Stupa

11. When walking into this building the viewer is greeted by

 (A) a central open nave
 (B) flights of stairs
 (C) an atrium surrounded by glass
 (D) a myriad of columns

12. The ground plan indicates that the building

 (A) faced Mecca
 (B) was oriented toward the sun
 (C) has long banks of windows so people can see in
 (D) was aligned for a ceremonial purpose

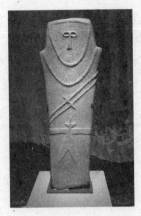

Figure 4 **Figure 5**

13. The work on the left has been anthropomorphized, meaning that

 (A) it was discovered by anthropologists
 (B) it is a work depicting a woman
 (C) it has characteristics of a human, but is not human itself
 (D) archaeology has yet to determine what this is

14. The work on the right, called the Ambum Stone, was carved in stone by artists who

 (A) used another stone to carve with
 (B) specialized in metalwork
 (C) used the repoussé technique
 (D) used hard-edged ceramics to smooth the stone surface

15. The work on the right has many theories surrounding its use. Among them is the hypothesis that it represents

 (A) a ceremonial animal that humans created in order to sacrifice
 (B) an anteater in a fetal position
 (C) a stylized kangaroo with a pouch ready for a newborn
 (D) a fish used to bait other fish

16. They are both stylized, which means they

 (A) are in the contemporary style
 (B) have later been recognized as part of a style
 (C) are schematic and represent the natural world in a nonrealistic way
 (D) are done in different parts of the world but are in the same style

Questions 17–20 are based on Figures 6 and 7.

Figure 6

Figure 7

17. Both of these works are examples of

 (A) genre paintings

 (B) still lifes

 (C) frescoes

 (D) di sotto in sù

18. The work on the right was created during a period called

 (A) Cubism

 (B) De Stijl

 (C) Expressionism

 (D) Fauvism

19. Unlike the work on the left, the work on the right shows an influence from

 (A) Asian decorative patterns

 (B) African architecture

 (C) Renaissance perspective

 (D) color theories based on musical notation

20. The work on the left, unlike the work on the right, is concerned with

 (A) the arrangement of objects in relationship to one another

 (B) the study of botany

 (C) demonstrating the artist's ability to depict objects in a natural environment

 (D) ecology

21. *Mblo* masks are works of art that

 (A) resemble kings and act in their place when the king is absent
 (B) seek to create a connection to fertility gods through ceremonies and rituals
 (C) honor an individual by being presented with an artistic double
 (D) have nails driven into them to prod the spirits into action

22. *Mblo* masks are characterized by their

 (A) powerful and aggressive nature
 (B) introspective and thoughtful look
 (C) faithful adherence to the likeness of the person or spirit depicted
 (D) feminine qualities

23. *The Lamentation* by Giotto is a work that is set in a context that

 (A) parallels Old and New Testament stories
 (B) emphasizes the punishment of the damned but not the forgiveness of sins
 (C) seeks salvation for those who refuse to repent
 (D) criticizes the Church and wants to reform it

24. Giotto's works most influenced the art of

 (A) Michelangelo
 (B) Rembrandt
 (C) Jan van Eyck
 (D) Lucas Cranach

Questions 25–27 are based on Figure 8.

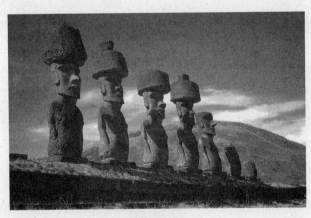

Figure 8

25. The sculptures are arranged facing

 (A) inland and toward the center of the island signifying protection from the sea
 (B) outward and toward the sea signifying where their creators came from
 (C) the sun signifying their creator's worshipping of solar deities
 (D) many directions signifying the artists' interest in adapting the sculpture to the individual site

26. The images on the sculptures are of

 (A) ancestral chiefs who have been deified after death
 (B) shamans who have led their congregations in worship
 (C) ancestors who have had the ability to contact the spirit world
 (D) Europeans who were considered gods in the eyes of the natives

27. Stone altar platforms on which these works sit are

 (A) common in Pre-Columbian art, where this tradition comes from
 (B) common in Polynesian sacred religious sites
 (C) uncommon in Pacific Island cultures and unique to this grouping
 (D) uncommon in Polynesian art, but common in the rest of the Pacific

Question 28 is based on Figure 9.

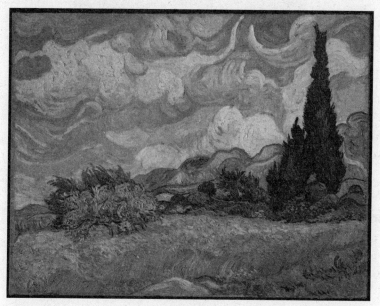

Figure 9

28. On the basis of style, this work can be attributed to

 (A) Paul Cézanne
 (B) Claude Monet
 (C) Jose María Velasco
 (D) Vincent van Gogh

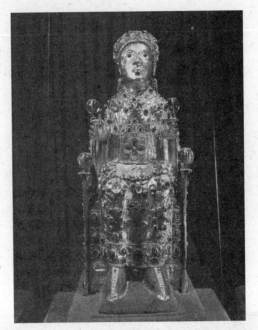

Figure 10

29. This reliquary commemorates

 (A) a king's splendid court
 (B) a martyr's death for her faith
 (C) victory over pagan gods
 (D) episodes from the life of a saint

30. Works like these were under criticism because some contemporaries felt

 (A) people used the objects for satanic rituals
 (B) the objects encouraged idolatry
 (C) the objects were ghoulish and disturbing
 (D) they were pagan and sinful

Question 31 is based on Figure 11.

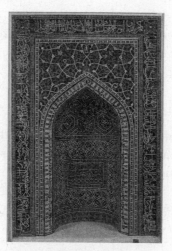

Figure 11

31. The function of this object is called

 (A) a jail
 (B) a minaret
 (C) an iwan
 (D) a mihrab

Question 32 is based on Figure 12.

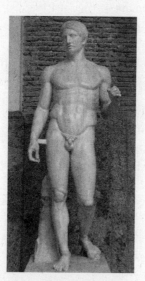

Figure 12

32. This sculpture is an expression of idealization developed in the

 (A) fifth century B.C.E. and called a canon
 (B) fourth century B.C.E. and called spolia
 (C) third century B.C.E. and called symmetry
 (D) fifth century B.C.E. and called peristyle

33. The Egyptian *Book of the Dead*

 (A) guides the progress of a soul to the afterlife
 (B) measures the time a soul has on earth and in the afterlife
 (C) shows how to embalm bodies for preparation to the afterlife
 (D) illustrates the funeral processions of the deceased

34. The Egyptian sculpture of a seated scribe is

 (A) depicted as a heroic figure, because the act of writing immortalizes the subject
 (B) shown as tired and weary, because writing is exhausting and draining
 (C) dressed as a member of the upper class, because only aristocrats were taught to read and write
 (D) illustrated as sedentary, because the lifestyle of a writer is one of long hours spent sitting still

35. *The Court of Gayumars* tells the story of

 (A) Sultan Muhammad and his rise to power in Tabriz
 (B) the Persian conquering of the Greeks under the reign of Xerxes
 (C) the legendary reign of the first Shah of the Persians
 (D) *The Arabian Nights* tale of Scheherazade

36. The mood and style of *The Court of Gayumars* can best be described as

 (A) monumental, grand, and awesome
 (B) intricate, decorative, and lively
 (C) serious, somber, and desolate
 (D) humorous, satiric, and farcical

37. Leonardo da Vinci's *Last Supper* was painted in a location that was meant to make a connection between a Biblical scene of eating and

 (A) pilgrims eating along a pilgrimage journey
 (B) a refectory where religious people ate
 (C) a banqueting hall for a royal court
 (D) a church celebrating the Eucharist

38. Claus Oldenburg's *Lipstick (Ascending) on Caterpillar Tracks* was made as an ironic commentary on

(A) the Feminist movement
(B) the art of Andy Warhol
(C) the Vietnam War
(D) consumerism and modern culture

Questions 39 and 40 are based on Figure 13.

Figure 13

39. This house was designed by

(A) Le Corbusier
(B) Frank Lloyd Wright
(C) Philip Johnson
(D) Frank Gehry

40. The architect's philosophy of building is expressed by the idea that

(A) construction should be environmentally friendly
(B) only the use of natural material would be permitted
(C) less is more
(D) a house is a machine for living

Question 41 is based on Figure 14.

Figure 14

41. The artistic technique shown in this Indian Buddha is called

 (A) horror vacui
 (B) pyxis
 (C) peristyle
 (D) one-point perspective

Question 42 is based on Figure 15.

Figure 15

42. This work was originally positioned

 (A) on the top of a building
 (B) on a mountainside
 (C) above a fountain in a town square
 (D) in a river

Questions 43 and 44 are based on Figures 16 and 17.

Figure 16

Figure 17

43. The interior columns in Santa Sabina, as seen in Figure 13, were

 (A) created from porphyry columns imported from Egypt
 (B) removed from a Roman temple and reused here
 (C) taken from Jewish temples in Jerusalem, whose significance was held in high regard
 (D) made of transparent gypsum and appear opaque in certain lighting conditions

44. The ground plan in Figure 17 shows a central nave and two side aisles constructed

 (A) so that worship can be done by men in the nave and women in the side aisles
 (B) for the clergy to use the nave as a processional space
 (C) for baptisms in the nave as the congregation watches in the side aisles
 (D) for the use of initiates in the side aisles

45. Marcel Duchamp's work as an artist prefigures the work of

 (A) Emily Kame Kngwarreye
 (B) Song Su-nam
 (C) Naum June Paik
 (D) Jeff Koons

Figure 18

46. This plan is that of a Roman house. It tells us that

(A) there is limited access to the inside from the outside
(B) windows are plentiful on the perimeter of the house
(C) the rooms are large and comfortable
(D) there is an accent on privacy

47. The large area on the left is probably

(A) an agora
(B) an amphiprostyle
(C) a stoa
(D) a peristyle

PRACTICE TEST 2

Question 48 is based on Figure 19.

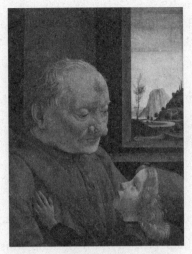

Figure 19

48. This painting by Domenico Ghirlandaio is inspired by works by

 (A) Giotto di Bondone
 (B) Sandro Botticelli
 (C) Fra Filippo Lippi
 (D) Diego Velázquez

49. Doris Salcedo's *Shibboleth* relies on the viewer understanding the title, which means

 (A) a dangerous procedure that needs proper attention before pursuing
 (B) a crack or a gulf in relationships symbolized by antisocial behavior
 (C) a word or custom that a person not familiar with a language may mispronounce
 (D) a virus that can contaminate a person both physically and morally

50. The strength of the female persona is strongly articulated in the works of

 (A) Kiki Smith
 (B) Rachel Ruysch
 (C) Julie Mehretu
 (D) Yinka Shonibare

51. Song Su-nam's works express an interest in

 (A) adapting traditional formulas onto contemporary works
 (B) moving people away from purely aesthetic concerns to contemporary issues
 (C) instructing young people in the arts of today
 (D) multimedia presentations of ancient works

52. Sinan, the chief architect for Suleyman the Magnificent, was chiefly influenced by

(A) the Parthenon in Athens
(B) the Hagia Sophia in Istanbul
(C) the Dome of the Rock in Jerusalem
(D) the Kaaba in Mecca

53. Aspects of the Enlightenment period in European art can be seen in the works of

(A) Jean-Honoré Fragonard
(B) Joseph Wright of Derby
(C) William Hogarth
(D) Peter Paul Rubens

54. The Jowo Rinpoche from the Jokhang Temple is unusual in that

(A) it is thought to have been blessed by the Buddha himself
(B) it is conceived of as a metal object, but ultimately was crafted in porcelain
(C) Buddhists, Hindus, and Muslims all revere the object
(D) it is a composite statue made from different parts of other works

55. Regeneration and fertility are often symbols depicted on images found in

(A) Islamic manuscripts
(B) tapa bark cloths
(C) Indian temples
(D) American Indian pottery

56. Congs were symbolic in Chinese culture because jade

(A) is linked with durability, subtlety, and beauty
(B) has a soft quality that associates it with female virtues
(C) is iridescent and stands for the heavenly realm
(D) is found in small quantities and therefore is very expensive and symbolizes wealth

57. Ashlar masonry is used in the construction of

(A) the Walls at Saqsa Waman in Peru
(B) the Colosseum in Rome
(C) the Houses of Parliament in London
(D) the Alhambra in Granada

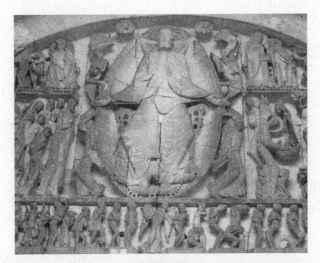

Figure 20

58. On the basis of style, this work can be attributed to which of the following periods?

 (A) Gothic
 (B) Romanesque
 (C) Early Medieval
 (D) Northern Renaissance

59. Prehistoric art can be found in groupings of objects as well as by themselves. Often groupings indicate that

 (A) they were done by a workshop with a unified artistic vision
 (B) artists traveled from place to place to establish a reputation
 (C) they were done over a vast period of time
 (D) there was commentary made on previous works by other artists

60. Joseph Turner's _Slave Ship (Slavers Throwing Overboard the Dead and Dying, Typhoon Coming On)_ was exhibited

 (A) with a poem composed by the artist
 (B) as part of an antislavery exhibition in London
 (C) in a private space so that authorities would not confiscate the work
 (D) in Paris, because it was safer to represent anti-British works abroad

61. An example of a work that is a caprice is

 (A) Jean-Honoré Fragonard's _The Swing_
 (B) Francisco de Goya's _And There's Nothing to Be Done_
 (C) Gustave Courbet's _The Stone Breakers_
 (D) José Maria Velasco's _The Valley of Mexico from the Hillside of Santa Isabel_

62. In Paul Gauguin's *Where Do We Come From? What Are We? Where Are We Going?* the artist has used symbols derived from

 (A) Neoclassical formulas of composition and body style
 (B) Postimpressionist brushwork as seen in the works of van Gogh
 (C) Tahitian imagery in the Polynesian idol
 (D) French Impressionism in the atmospheric effects

63. Based on the artistic style of his work, which of the following artists was a pupil of Gianlorenzo Bernini?

 (A) Johannes Vermeer
 (B) Giovanni Battista Gaulli
 (C) Caravaggio
 (D) Peter Paul Rubens

64. Although an Impressionist, Mary Cassatt often deviated from the works produced by other artists in that

 (A) her work shows an affection for landscape
 (B) group portraits are the dominant element in Cassatt's oeuvre
 (C) still life takes on a greater meaning for Cassatt than for other Impressionists
 (D) Cassatt emphasizes the role of women living lives independently from men

Questions 65–68 are based on Figure 21.

Figure 21

65. The Golden Stool (*sika dwa kofi*) fulfills which of the following functions?

 (A) A seat of power for the current religious leader
 (B) A receptacle for the soul of the nation
 (C) A physical embodiment of the culture's primary deity
 (D) A container for the culture's sacred relics

66. The *sika dwa kofi* (Golden Stool) inspired a war when

(A) a visiting ruler used it as spolia
(B) an opposing tribe stole it
(C) a deposed leader refused to return it
(D) a British representative tried to sit on it

67. This work shown can be attributed to

(A) the Etruscans
(B) the Ashanti
(C) the Inkans
(D) the Yarlung Dynasty

68. The Golden Stool (*sika dwa kofi*) and the gold and jade crown from Korea are similar in that both works

(A) are used in mortuary practices
(B) are symbols of national pride
(C) are used by visiting dignitaries as a sign of respect and welcome
(D) are used daily by the current political leader

69. Many Byzantine icons

(A) were meant to be touched and handled
(B) represented the real world and people's approach to everyday problems
(C) were painted by ivory carvers
(D) were kept in isolation so that few could see them

70. Which of the following statements is true about both the Basin (*Baptistère de Saint Louis*) and the Pyxis of al-Mughira?

(A) They were both created for one purpose and then reused for another.
(B) They are both works whose artists' names are known.
(C) They are both decorated using human and animal motifs.
(D) They are both grand objects used for majestic and important occasions.

Figure 22

71. The formal qualities of this work identify it as an example of

 (A) an Islamic manuscript done in Muslim Spain using animal motifs
 (B) a Byzantine manuscript done in Greece using gold leaf
 (C) a Mughal manuscript done in India using a combination of Indian and Islamic characteristics
 (D) a Chinese manuscript done in Japan combining the influence of scroll painting and ukiyo-e prints

72. This work can be interpreted to mean

 (A) Jahangir is on an equal footing with the other kings of the world
 (B) Jahangir sees that spiritual enlightenment is greater than all earthly concerns
 (C) that cosmic forces compel Jahangir to rule his country with no advice from others
 (D) that life is temporary, but Jahangir will live in the next world

73. The complex at Nan Madol is unusual in tradition in that

 (A) it is built near the sea for quick access to trade routes
 (B) it is decorated with stone sculpture that shows an ancient lineage
 (C) it is built on a mountaintop for all to admire
 (D) it is made of stone and gives a sense of permanence

74. A pilgrim progressing through the temple at Borobudur is meant to worship by

 (A) placing himself or herself in a meditative state at the entrance
 (B) placing written requests in a wall at the base of the monument
 (C) circumambulating each of the main terraces until he or she gets to the top
 (D) entering from the darkened areas and emerging into the light

75. Robert Smithson's *Spiral Jetty* draws inspiration from works such as

(A) de Kooning, *Woman, I*
(B) Pantheon, Rome
(C) Great Stupa
(D) Great Serpent Mound

76. Although the animals depicted in Albrecht Dürer's *Adam and Eve* may allude to a peaceful coexistence in the Garden of Eden, they may also allude to

(A) the four directions of the compass
(B) the four seasons of the year
(C) the four humors
(D) the four corners of the earth

77. Beads and cowrie shells used in works like the Aka (elephant mask) are meant to symbolize

(A) the wealth of the members of the Kuosi society, who used the masks in performance
(B) the subtle color patterns on the skin of elephants
(C) the use of materials to simulate the ivory of elephant tusks
(D) the magical powers and spells used by the Kuosi people

Question 78 is based on Figure 23.

Figure 23

78. On the basis of style, this painting can be attributed to

(A) Jan Vermeer
(B) Rembrandt van Rijn
(C) Caravaggio
(D) Peter Paul Rubens

79. The use of stone in such prehistoric structures as Stonehenge illustrates an architectural tradition that

(A) employed a mortise and tenon system for supporting lintels
(B) showed the enduring power of concrete to unify large blocks of stone
(C) maintained the stability of structures using a corbeled arch
(D) unified architectural works with carefully planned gardens

80. Installations, such as Doris Salcedo's *Shibboleth*, often are housed

(A) in government buildings, where freedom of expression is permitted by law
(B) in universities, where controversial works of art are set in spaces that stimulate discussion
(C) in art museums, where large works are housed for a certain period of time before they are removed for the next installation
(D) outdoors, where the ordinary people can interact with the works

SECTION II

TIME: 2 HOURS
6 QUESTIONS

> **DIRECTIONS:** You have two hours to answer the six questions in this section.
>
> Questions 1 and 2 are long essay questions, and you are advised to spend one hour on both.
>
> Questions 3 through 6 are short essay questions, and you are advised to spend 15 minutes on each.
>
> During the actual exam, the proctor will announce when each question's time limit has been reached, but you may proceed freely from one question to another.
>
> Some of the questions refer to images; some do not.
>
> Read the questions carefully. You can receive full credit only by directly answering all aspects of the question.

Question 1: 35 minutes suggested time

This illustration is Jean-Michel Basquiat's *Horn Players*, 1983, acrylic and oil paintstick on canvas panels.

This work is painted as a tribute to subjects the artist admired.

Select and identify another work of art in which the artist has depicted someone, or a group of people, as a subject of admiration. You may select a work from the list below or any other relevant work.

For both *Horn Players* and your selected work, describe what is being depicted.

Discuss *at least two* examples of visual evidence of how the artists showed their admiration for the subject of *each* work.

Using contextual evidence, explain how each work is a representation of the circumstances around which it was created.

Explain *at least one* difference in the representation of both of these works.

Portrait of Sin Sukju
Dream of a Sunday Afternoon in Alameda Park
Memorial Sheet for Karl Liebknecht

Question 2: 25 minutes suggested time

Many works of contemporary art are installations, that is, a temporary work made for a particular space.

Select and completely identify a contemporary work of art from the list below, or any other relevant work that is an installation.

Discuss the meaning behind the installation you have chosen, and how the artist has delivered that meaning through the choice of materials, techniques and/or siting of the work.

In your answer, make sure to:

- Accurately identify the work you have chosen with *at least two* identifiers beyond those given.
- Respond to the question with an art historically defensible thesis statement.
- Support your claim with *at least two* examples of visual and/or contextual evidence.
- Explain how the evidence that you have supplied supports your thesis.
- Use your evidence to corroborate or modify your thesis.

A Book from the Sky
Shibboleth
Sunflower Seeds

Question 3: 15 minutes suggested time

The work shown is *Broadway Boogie Woogie* by Piet Mondrian painted in 1942–1943.

What period in modern art is Mondrian associated with?

Using *at least two* examples of visual evidence, discuss how elements of Mondrian's style can be seen in this work.

Using *at least two* examples of visual evidence, discuss how Mondrian's style departs from earlier twentieth-century abstract works of art.

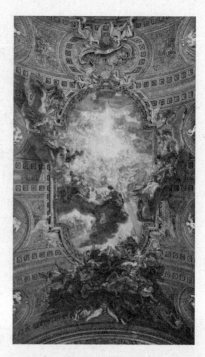

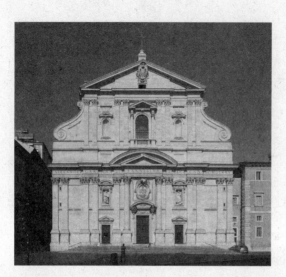

This work is Il Gesù, the façade designed by Giacomo della Porta, and the ceiling fresco by Giovanni Battista Gaulli.

What is the original function of this church?

Using *at least two* examples of contextual or visual evidence, explain how the original function influenced the design of this building.

Using *at least two* examples of contextual or visual evidence, discuss how the ceiling fresco reflects the function of the building.

Question 5: 15 minutes suggested time

Attribute this painting to the artist who painted it.

Using *at least two* specific details, justify your attribution by describing relevant similarities between this work and a work in the required course content.

Using *at least two* specific details, discuss *why* these visual elements are characteristic of this artist and the times in which he lived.

Question 6: 15 minutes suggested time

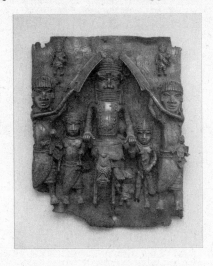 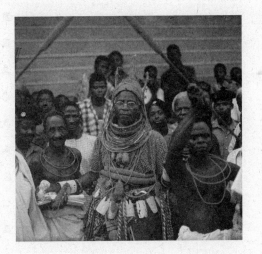

On the left is the wall plaque from the Oba's palace from the sixteenth century. It is made of brass. On the right is the late Oba Akenzua II in full regalia depicted in a photograph from 1964.

Explain the purpose of the wall plaque.

Discuss *at least two* specific visual elements in the wall plaque that illustrate its purpose.

Explain *at least two* reasons how these elements continue to represent the Oba king today, as seen in the contextual photograph.

Section I

1. **C**	21. **C**	41. **A**	61. **B**
2. **B**	22. **B**	42. **C**	62. **C**
3. **B**	23. **A**	43. **B**	63. **B**
4. **B**	24. **A**	44. **A**	64. **D**
5. **D**	25. **A**	45. **D**	65. **B**
6. **C**	26. **A**	46. **A**	66. **D**
7. **A**	27. **B**	47. **D**	67. **B**
8. **C**	28. **D**	48. **C**	68. **B**
9. **B**	29. **B**	49. **C**	69. **A**
10. **A**	30. **B**	50. **A**	70. **C**
11. **D**	31. **D**	51. **A**	71. **C**
12. **C**	32. **A**	52. **B**	72. **B**
13. **C**	33. **A**	53. **B**	73. **D**
14. **A**	34. **D**	54. **A**	74. **C**
15. **B**	35. **C**	55. **C**	75. **D**
16. **C**	36. **B**	56. **A**	76. **C**
17. **B**	37. **B**	57. **A**	77. **A**
18. **D**	38. **C**	58. **B**	78. **D**
19. **A**	39. **A**	59. **C**	79. **A**
20. **B**	40. **D**	60. **A**	80. **C**

ANSWERS EXPLAINED

Section I

1. **(C)** Marcel Duchamp used a repurposed urinal to create his work *Fountain*.

2. **(B)** When Europeans encountered Polynesians they brought with them cans of packaged meat, including corned beef, which led to the abandonment of traditional food gathering activities and a reliance on the convenience of canned meat. Polynesian diets were high in fish, vegetables, and fruit prior to European contact.

3. **(B)** Oftentimes Tuffery's sculptures are enlivened in multimedia performances by being placed on wheels and mounted with motors.

4. **(B)** The drapery found in the costuming of the figures is similar to that used in Baroque Europe.

5. **(D)** The figure on the right is not a specific individual, but rather a symbol of upper class Europeans who have had a child with a Native American.

6. **(C)** Casta, or "caste," paintings show the degrees of ancestry and hierarchy in Spanish society in the New World.

7. **(A)** The woman has the skin coloring of a Native American, but otherwise has the features of a European.

8. **(C)** This building is the Carson, Pirie, Scott and Company Building in Chicago. It does not have a focus the way mosques and cathedrals do. It could not be a typical home because of the great number of interior columns.

9. **(B)** This is a skeletal structure, held up by an interior framework rather than by exterior walls.

10. **(A)** The mosque of Córdoba has a forest of columns that divide up the space into segments.

11. **(D)** The plan tells us that the entrance is in the lower left hand corner, and the interior is marked by large columns indicated by the evenly placed dots.

12. **(C)** The double sets of lines along the left and bottom sides of the plan indicate rows of windows.

13. **(C)** An anthropomorphized figure is one that has some human characteristics, but essentially is not human.

14. **(A)** Many prehistoric objects are made of stone, and carved using another stone.

15. **(B)** It has been theorized that the Ambum Stone may be an anteater in a fetal position. There have been other theories as well, but none of the other choices fit those theories.

16. **(C)** A stylized work does not show a realistic view of someone or something, but rather a schematic rendering.

17. **(B)** These are two still lifes, that is, paintings of inanimate objects.

18. **(D)** The work on the right, by Henri Matisse, is from the Fauvist period in the early twentieth century.

19. **(A)** Matisse is said to have been generally influenced by Asian decorative patterns in many of his still lifes.

20. **(B)** Ruysch's father was a professor of anatomy and botany and influenced his daughter's interest in these fields.

21. **(C)** *Mblo* masks are artistic doubles of a real person, who is honored by receiving these works.

22. **(B)** *Mblo* masks are not realistic portraits, but seek instead to characterize the introspective nature of a person.

23. **(A)** Giotto's work is in a setting that parallels stories from the Old and New Testaments side by side.

24. **(A)** Giotto's sense of scale and size influenced the art of Michelangelo more forcefully than the other artists listed as choices.

25. **(A)** The sculptures are arranged on platforms and face inland toward the center of the island.

26. **(A)** The most prevalent theory is that the sculptures represent ancestral chiefs who have been deified after death.

27. **(B)** Large stone sculptures are extremely uncommon in Pacific art, but the platforms form the base of many architectural and sculptural projects throughout the region.

28. **(D)** Van Gogh's style is very distinctive with his swirling patterns and vibrant colors. This work shares with *The Starry Night* the thick application of paint and the horizontal composition.

29. **(B)** This reliquary is of Sainte-Foy, a young woman who was martyred for her faith.

30. **(B)** Works like these were often criticized at the time because the faithful often treated them as idols.

31. **(D)** This object is called a mihrab, and points the Muslim faith in the direction of Mecca, a necessary part of Islamic worship.

32. **(A)** The sculptor, Polykleitos, is famous for having written a canon of human proportions, which no longer exists, in the fifth century B.C.E.

33. **(A)** The Egyptian *Book of the Dead* charts the progress of a soul in the afterlife, among other things.

34. **(D)** The Egyptian sculpture of the seated scribe depicts a figure who has been used to a sedentary lifestyle, unmuscular and a bit flabby.

35. **(C)** This manuscript tells the story of the legendary ruler of early Persia.

36. **(B)** The intricate details, depicted in a decorative and lively fashion, are characteristic of this manuscript and many other manuscripts painted in Persian art.

37. **(B)** Leonardo's painting was painted in a refectory used by monks. The image of a sacred scene of eating complemented the activity in the room.

38. **(C)** Oldenburg's *Lipstick (Ascending) on Caterpillar Tracks* was done during the height of the Vietnam conflict and was an ironic commentary on the war.

39. **(A)** This is the Villa Savoye, designed by Le Corbusier.

40. **(D)** The architect often proclaimed that a house is supposed to be "a machine for living."

41. **(A)** Horror vacui literally means a fear of empty spaces. It is a term that is used in works of art in which the surface area is entirely covered in design.

42. **(C)** This sculpture was originally designed to be placed above a fountain in a town square to symbolize a naval victory.

43. **(B)** The columns in Santa Sabina are spolia, which are taken from a Roman temple and repurposed here.

44. **(A)** In Early Christian churches men worshipped in the main aisle, and the women were separated, worshipping in the side aisles.

45. **(D)** The reuse of common objects, as seen in Duchamp's *Fountain*, can be seen in the works of Jeff Koons.

46. **(A)** The ground plan of this Roman house shows few entrances.

47. **(D)** The large area on the left, surrounded by columns, is a peristyle courtyard, open to the sky.

48. **(C)** This painting by Ghirlandaio was done in the late fifteenth century, and has the same characteristics of Fra Filippo Lippi's *Madonna and Child with Two Angels*. The humanized figures are placed before a window frame depicting a landscape that fades atmospherically into the distance.

49. **(C)** A shibboleth is a word or a custom that is used to separate or discriminate against people. Hence, this work is a huge split down the center of the floor.

50. **(A)** Kiki Smith uses positive, strong images of women in her work.

51. **(A)** Traditional Korean ink painting has been updated in the work of Song Su-nam.

52. **(B)** Sinan was influenced by the Hagia Sophia when he designed the Mosque of Selim II.

53. **(B)** Joseph Wright of Derby's paintings often show activities of intellectual groups who gathered to discuss the latest advances in scientific theories.

54. **(A)** There is a tradition around the Jowo Rinpoche that it was blessed by the original Buddha himself.

55. **(C)** The façade of many Indian Hindu temples often contains scenes of fertility and regeneration. There are no images depicted on tapa cloths. Few images are on American Indian pottery, and those that are usually are extremely stylized. Persian manuscripts have images, but they virtually never show fertility in a direct manner. Other Islamic manuscripts have no images of humans.

56. **(A)** Jade is symbolic of durability, subtlety, and beauty in Chinese culture.

57. **(A)** Ashlar masonry—that is, masonry without mortar—is used in the walls as Saqsa Waman in Peru.

58. **(B)** This is the tympanum in Autun, France, designed by Gislebertus. Its flattened forms and active composition signal a resemblance to the tympanum at Conques.

59. **(C)** Prehistoric works that are found in large quantities were done over an extended period of time generally by different groups of people.

60. **(A)** Turner composed a poem called "The Fallacies of Hope" to accompany his painting.

61. **(B)** Goya's etching *And There's Nothing to Be Done* is a caprice, which is a work with a strong fantasy element.

62. **(C)** Paul Gauguin's stay in Tahiti and his interest in Polynesian culture and storytelling served as a basis for much of his work.

63. **(B)** Gaulli's dramatic use of color and action in his work stems from his tenure working under Gianlorenzo Bernini.

64. **(D)** Cassatt emphasized in her work how women could lead fulfilling lives independent of men. No other Impressionist took up this theme.

65. **(B)** Because of the sacred character of the Golden Stool, no one is allowed to touch it except the king because he—like the stool—contains the soul of the Ashanti nation.

66. **(D)** A British representative tried to sit on the stool in defiance of the sacredness that the stool represents. This act caused a rebellion.

67. **(B)** The work is from—and represents—the Ashanti people.

68. **(B)** The Korean crown was buried and therefore is a mortuary object, but the Golden Stool never had such a purpose. Today, both symbolize a pride in the history of their respective nations.

69. **(A)** Byzantine icons are not museum pieces; they were meant to be handled and touched and used in processions before the faithful.

70. **(C)** Both works have human and animal motifs carved into the surface. The name of the artist of the basin is known, but for the pyxis, only the name of patron is known. They are both small objects. Although the basin has changed function, the pyxis has always been used for the same purpose—as a small container for scented objects or gems.

71. **(C)** This manuscript contains both Indian and Islamic motifs. For example, the artist is a Hindu; as such, he used many images of people in his work (images generally are not seen in Islamic manuscripts). On the other hand, the writing is in Islamic script, and the patron is a Muslim.

72. **(B)** Jahangir's preference for a sufi shaikh indicates that he is more interested in spiritual enlightenment than earthly concerns.

73. **(D)** Nan Madol is unusual in Polynesian architecture in that it is made of stone. It gives a sense of permanence and power that other Polynesian buildings did not have.

74. **(C)** Worshippers at Borobudur are meant to circumambulate each of the main terraces until they get to the top.

75. **(D)** The spiral forms seen from aerial views of the Great Serpent Mound in Ohio served as inspiration for Robert Smithson's *Spiral Jetty*.

76. **(C)** The animals in Albrecht Dürer's *Adam and Eve* allude to the four humors: the cat (choleric or angry), the rabbit (sanguine or energetic), the elk (melancholic or sad), the ox (phlegmatic or lethargic); the four humors were kept in balance before the Fall of Man.

77. **(A)** Since beads and cowrie shells had to be imported, their use in ceremonies showed witnesses to the rituals that certain members of the Kuosi society were wealthy and powerful.

78. **(D)** The fluid brushwork, bold use of color, and compositional liveliness all point toward a work by Peter Paul Rubens.

79. **(A)** The mortise and tenon system was used at Stonehenge. At the top of some of the uprights, small protuberances can be seen, which show that the lintels were meant to fit into a socket that secured them in place. Concrete, corbeled arches, and planned gardens were unknown in prehistoric Britain.

80. **(C)** Doris Salcedo, Ai Weiwei, Pepon Osorio, Bill Viola, and many other installation artists have their works occupy spaces in art museums for a short period of time. The works are removed, housed, and stored for a later installation, usually in another space. Although the other choices are possible, installation artists generally prefer the protective environment of an established art museum for their work.

Section II Answers

MODEL RESPONSE FOR QUESTION 1

Both Jean-Micheal Basquiat's Horn Players and the Portrait of Sin Sukju show admiration and veneration of the subjects depicted in the two works.

In Horn Players, Basquiat has depicted Charlie Parker and Dizzy Gillespie who were two revered jazz musicians. Sin Sukju was the prime minister and collected a catalog of the prince's Chinese and Korean Paintings. He was highly regarded as a scholar and politician and he is heroically recognized in his portrait.

Basquiat shows his admiration for Charlie Parker and Dizzy Gillespie by using a huge canvas and making his subjects large and stand out against a black background. He also uses words to capture famous things about them. Charlie Parker was nicknamed The Bird, so Basquiat writes ornithology which means the study of birds. He also writes gibberish by Dizzy Gillespie to show the wordless improvisation that he often sang while performing on stage. These words call out the unique aspects of the two men and invoke their presence.

The Portrait of Sin Sukju also shows admiration of the man depicted. He is shown in official robes and a hat with the rank badge on his chest. The portrait is very detailed and captures the likeness of Sin Sukju, which makes it personalized and unique to only the man in the painting.

Horn Players is a representation of black culture in the 1980s, especially in New York where Basquiat was living. He uses his art and status to depict black heroes, something which was not seen at the time. Basquiat also hoped to write himself into the art history canon and did so by appropriating other famous works.

The Portrait of Sin Sukju is representation of Korean culture after a lengthy Mongol rule. It shows Confucianism and the rewards that come from abiding by them. These Confucian values are service to the state and loyalty to the ruler. These portraits were used for ancestral rituals after death, which shows the legacy of a person in life continuing after death.

A difference in the two works is that Basquiat uses words in the depiction of his heroes whereas the Portrait of Sin Sukju is entirely visual.

—Anna B.

Criteria	Student Response	Point Value	Points Earned
Task: Select and identify another work of art in which the artist has depicted someone, or a group of people, as a subject of admiration.			
While Anna selects a work of art from the list, she does not identify it beyond the title. Date and medium are required here.	"Both Jean-Micheal Basquiat's Horn Players and Portrait of Sin Sukju show admiration and veneration of the subjects depicted in the two works."	1	0
Task: For both *Horn Players* and your selected work, describe what is being depicted.			
For *Horn Players,* it is important to recognize who the jazz musicians are. For Sin Sukju, it is necessary to reference his standing in Korean society.	"In Horn Players, Basquiat has depicted Charlie Parker and Dizzy Gillespie who were two revered jazz musicians. Sin Sukju was the prime minister and collected a catalog of the prince's Chinese and Korean Paintings. He was highly regarded as a scholar and politician and he is heroically recognized in his portrait."	2; 1 point for *Horn Players,* 1 point for selected work	2
Task: Discuss *at least two* examples of visual evidence of how the artists showed their admiration for the subject of *each* work.			
Anna points out two examples of visual evidence that discuss the painter's admiration for the sitter.	"Basquiat shows his admiration for Charlie Parker and Dizzy Gillespie by using a huge canvas and making his subjects large and stand out against a black background. He also uses words to capture famous things about them...." "He is shown in official robes and a hat with the rank badge on his chest."	2; 1 point for *Horn Players,* 1 point for selected work	2

Criteria	Student Response	Point Value	Points Earned
Task: Using contextual evidence, explain how *each* work is a representation of the circumstances around which it was created.			
It is important to know the circumstances around which a painting is created. In this case, each is a reflection of the culture of its times, whether it be contemporary African-American or historical Korean.	"Horn Players is a representation of black culture in the 1980s, especially in New York where Basquiat was living. He uses his art and status to depict black heroes, something which was not seen at the time." "These portraits were used for ancestral rituals after death, which shows the legacy of a person in life continuing after death."	2; 1 point for *Horn Players*, 1 point for selected work	2
Task: Explain *at least one* difference in the representation of both of these works.			
The two works are so unalike that it is easy to find differences. Anna points out the use of words in the Basquiat and the lack of words in the Sin Sukju.	"A difference in the two works is that Basquiat uses words in the depiction of his heroes whereas the Portrait of Sin Sukju is entirely visual."	1	1
		Total points possible: 8	**This essay earned: 7**
Remarks: Neither of these works are portraits in a conventional sense. For example, we really don't know if Sin Sukju is a genuine likeness or a conventional portrait with a few distinguishing details. Be careful to supply two identifiers in addition to the one presented by the prompt. This is a fine essay that points out significant details in each work.			

MODEL RESPONSE FOR QUESTION 2

Overwhelmingly, this work, <u>Shibboleth</u>, symbolizes the discrimination and separation that comes along with the experience of immigrants and "outsiders". The work, a temporary installation accredited to Doris Salcedo, was housed in the Tate Modern between the years 2000 and 2010, and was constructed out of concrete and mesh wire. Visually, the allusions to cultural differences and divisions in general are apparent in the work's installation in the Tate Modern, as a large crack, hundreds of feet long and several feet deep runs along the concrete floor of the installation, creating a physical divide in space. This long and jagged crack represents the manner in which cultural groups can be isolated and separated, however it also has another interpretation. Many see the crack also as a sort of scar. This is extremely important because it suggests that in the same way that physical wounds can be healed, we can work towards healing and mending the effects of racism and discrimination.

At the same time, this image of a scar seems to say that even though as a society we can strive to fix the inequality and violence of our present and past, the impact of racism will remain forever. Additionally, although originally intended for safety purposes in case someone was to trip and fall into the crack, the mark is outlined with wire mesh, which is so relevant to the experience of immigrants because barbed wire fences are what so often define the physical borders between countries in our world.

Finally, even the title of this installation harkens back to the idea of isolating and discriminating against outsiders. The story of the word shibboleth dates back to Christian theology, in which, after a war between two groups, the losers attempted to seamlessly assimilate into one of the victor's bases for protection. In a ploy to single out all of the infiltrating soldiers, the victors used a test...the pronunciation of the word "shibboleth." Because of the differing dialects between the two groups only those from the victorious faction would have been able to correctly say the word, and so, through this strategy, thousands of the infiltrating warriors were taken and killed. This story shows how some of the most subtle characteristics are used to differentiate between cultural groups, and to set those considered to be different apart from the rest. Finally, many visitors ended up tripping while viewing this display, causing quite a controversy, but it the end, Salcedo appreciated this reaction, because she felt as though it reflected the negativity and controversy that immigrants face in their new environments. Together, these characteristics of the Shibboleth installation work to communicate the trials experienced by immigrants and outsiders.

—Nathan L

Criteria	Student Response	Point Value	Points Earned
Task: Select and completely identify a work of art that is an installation.			
Two identifiers are needed in addition to the name supplied above. The name of the artist is correct; the date is a little too broad since the work was displayed between 2007–2008. However, it is close enough to earn a point.	"The work, a temporary installation accredited to Doris Salcedo, was housed in the Tate Modern between the years 2000 and 2010, and was constructed out of concrete and mesh wire."	1	1
Task: Respond to the question with an art historically defensible thesis statement.			
It is important when answering this question to clearly state the purpose of the essay, as reflected in the prompt.	"...this work, *Shibboleth*, symbolizes the discrimination and separation that comes along with the experience of immigrants and 'outsiders.'"	1	1
Task: Support your claim with *at least two* examples of visual and/or contextual evidence.			
A connection must be firmly made between the thesis statement and examples of visual or contextual evidence.	"Visually, the allusions to cultural differences and divisions in general are apparent in the work's installation in the Tate Modern, as a large crack, hundreds of feet long and several feet deep runs along the concrete floor of the installation, creating a physical divide in space. This long and jagged crack represents the manner in which cultural groups can be isolated and separated, however it also has another interpretation. Many see the crack also as a sort of scar. This is extremely important..."	2	2
Task: Explain how the evidence that you have supplied supports your thesis.			
This point is earned when the student analyzes the work of art. Nathan expresses a solid interpretation of the meaning of the installation.	"...this image of a scar seems to say that even though as a society we can strive to fix the inequality and violence of our present and past, the impact of racism will remain forever."	1	1
Task: Use your evidence to corroborate or modify your thesis.			

Criteria	Student Response	Point Value	Points Earned
The student must show an understanding of the complexity of the issues involved to earn this point. The minor error of using "Christian" instead of "Jewish" or "Jewish and Christian" is overlooked given the excellence of the response.	"The story of the word shibboleth dates back to Christian theology, in which, after a war between two groups, the losers attempted to seamlessly assimilate into one of the victor's bases for protection."	1	1
		Total points possible: 6	This essay earned: 6

Remarks: This response accurately characterizes the meaning of installation by referencing contextual, textual, and visual evidence. This is a fine response.

MODEL RESPONSE FOR QUESTION 3

The modern art period in which Mondrian is associated with is known as the De Stijl movement.

The use of primary colors, other than the inclusion of whites and blacks, is one piece of visual evidence that is a common element in Mondrian's works. Mondrian consistently used this minimal color palette throughout his works. Another piece of visual evidence that can be seen is the repetition of rectilinear forms. These rectilinear forms are an essential part of Mondrian's style that create a sense of balance and calmness. Mondrian's style focuses on this balance without making his works symmetrical, allowing for a more dynamic equilibrium.

One piece of visual evidence that sets Mondrian's style apart from earlier twentieth-century abstract works of art is the pure abstraction. In many of Mondrian's works, Mondrian was not attempting to recreate something in front of him. Rather, Mondrian's goal was to create something that was visually calming. The flatness of many of Mondrian's pieces is another example of visual evidence that sets Mondrian apart. By refusing to use diagonal lines, Mondrian creates pieces that are extremely flat and lack any sense of depth. Additionally, Mondrian's ability to make his brushstrokes almost invisible is another difference from earlier twentieth-century abstract works. The invisibility of the brushstrokes allows for less movement throughout the piece which promotes the calmness in the piece.

—Paige A.

PRACTICE TEST 2

Criteria	Student Response	Point Value	Points Earned
Task: What period in modern art is Mondrian associated with?			
The answer is De Stijl or Neoplasticism. Abstract art is not acceptable.	"The modern art period in which Mondrian is associated with is known as the De Stijl movement."	1	1
Task: Using *at least two* examples of visual evidence, discuss how elements of Mondrian's style can be seen in this work.			
The student needs *at least two* examples of Mondrian's style as seen in this work. Paige provides more than two examples, and they are excellent.	"The use of primary colors, other than the inclusion of whites and blacks, is one piece of visual evidence that is a common element in Mondrian's works." "Another piece of visual evidence that can be seen is the repetition of rectilinear forms."	2	2
Task: Using *at least two* examples of visual evidence, discuss how Mondrian's style departs from earlier twentieth-century abstract works of art.			
This prompt requires the student to understand early-twentieth-century abstract artists, such as Kandinsky, and show how Mondrian evolved beyond them.	"The flatness of many of Mondrian's pieces is another example of visual evidence that sets Mondrian apart. By refusing to use diagonal lines, Mondrian creates pieces that are extremely flat and lack any sense of depth." "Mondrian's ability to make his brushstrokes almost invisible is another difference from earlier twentieth-century abstract works."	2	2
		Total Points Possible: 5	**This essay earned: 5**
Remarks: This is a solid response that pinpoints the answers to the questions, giving each a separate paragraph. While it is true that many of Mondrian's mature paintings do not attempt to recreate something concrete into an abstract format, the title of this particular painting suggests that the rhythms of Broadway are referenced here.			

MODEL RESPONSE FOR QUESTION 4

In the early sixteenth century, during the Protestant Reformation, masses of people abandoned the Catholic Church. As an early response, Popes were passive to this movement. Yet, when Pope Paul III was elected, he recognized this alarming trend and commenced the Catholic Church's responding movement:

the Catholic Counter Reformation. Knowing the church needed to foster participation, Pope Paul III, with the help of the Council of Trent, opted to promote art and architecture which galvanized emotion into viewers, while fostering more direct participation in the church. Il Gesu was then built to serve as the mother church for the Jesuits, a new order established by Ignatius of Loyola. Thus, the purpose of Il Gesu, in addition to serving as the mother church for the Jesuits, is to rouse emotion in its viewers while giving people a direct view of the altar to bring more people back into the Catholic Church.

Il Gesu's purpose to inspire emotion and for all people to have a direct view of the altar influenced its building in many ways. The facade, designed by Della Porta, contributes to this purpose. Because the facade is symmetrical around the portal, viewers' eyes are drawn to the center, which is where the altar is upon entrance. Also around the focal point are components, such as the broken triangular pediment, the arched window, and the Farnese family crest, that drive the viewers eyes upward towards the top. In addition, the facade projects out into the viewers space as it goes from the outer edges to the focal point, which draws viewers to it. On the interior, Il Gesu holds a large, open space where the entire congregation could gather as they view the altar and rituals without impediment. Il Gesu is comprised of one single, open nave lined with side chapels, without the interruption of aisles. Furthermore, lines on the cornices and the floor all taper towards the domed altar, which further captures the viewer's attention, all the while promoting drama and emotion.

Il Gesu's ceiling fresco reflects its purpose of promoting emotion and drama while encouraging people to return to the Catholic Church. Because this fresco is done in "di sotto in su" perspective, it gave viewers a realistic vision of looking up into heaven. In this fresco, Gaulli employs several methods that enhance its thespian nature. The gilded coffered wooden architectural ornamentation frames the space for the fresco, which gives the illusion of looking up into heaven. Unpainted and painted stucco sculptures overlay the edge of the fresco and peek into the viewer's area. Gaulli glazes the ceiling in a dark hue to create the mirage of a shadow from an adjacent cloud. In the fresco, the foreshortened figures create the illusion that they are being viewed from below as they ascend towards heaven. To support the churches goal of bringing people back into the church, the fresco depicts the devout rising towards the heavenly realm, while the impious fall earthward. Thus, the intersection between the viewer and the realistic illusion of heaven, in addition to the contrast between figures ascending and descending, increases the emotional impact on the viewer, thereby emphasizing the power of Catholicism drawing viewers back to the church.

—Owen M.

Criteria	Student Response	Point Value	Points Earned
Task: What is the original function of this church?			
The response should include the fact that the church was the mother church of the Jesuit order, and that this order of priests was organized to counteract the Protestant Reformation during the Counter-Reformation.	"Il Gesu was then built to serve as the mother church for the Jesuits, a new order established by Ignatius of Loyola. Thus, the purpose of Il Gesu, in addition to serving as the mother church for the Jesuits, is to rouse emotion in its viewers while giving people a direct view of the altar to bring more people back into the Catholic Church."	1	1
Task: Using *at least two* examples of contextual *or* visual evidence, explain how the original function influenced the design of this building.			
Owen combines visual and contextual references to solidify his argument. He also discusses the interior of the building. While not illustrated on the exam, it is a relevant part of the response.	"Because the facade is symmetrical around the portal, viewers' eyes are drawn to the center... etc." "...around the focal point are components, such as the broken triangular pediment, the arched window, and the Farnese family crest, that drive the viewers eyes upward towards the top."	2	1
Task: Using *at least two* examples of contextual *or* visual evidence, discuss how the ceiling fresco reflects the function of the building.			
The ceiling fresco contains many elements of Counter-Reformation thinking. Owen points out contextual meanings behind the ceiling decoration.	"Il Gesu's ceiling fresco reflects its purpose of promoting emotion and drama while encouraging people to return to the Catholic Church...." "To support the churches goal of bringing people back into the church, the fresco depicts the devout rising towards the heavenly realm, while the impious fall earthward."	2	1
		Total Points Possible: 5	**This essay earned: 5**
Remarks: This is a model response. One could also mention the fact that the ceiling fresco is a Last Judgment scene, something well within the Christian tradition. A Last Judgment scene, in this context, passes criticism onto the Protestant Reformation.			

MODEL RESPONSE FOR QUESTION 5

This painting is attributed to Joseph Wright of Derby.

This painting has specific details that are similar in Joseph Wright of Derby's A Philosopher Gives a Lecture on the Orrery. First, Wright's use of tenebroso is very specific and dramatic. Both the given painting and the previously mentioned painting are formatted in the way that there are people with their backs to the audience and the light falls on only some of the faces. Also similar are the sharp focus and the closeness of the viewer to the scene. The faces are all individualized and Joseph Wright demonstrates realistic depth and shadowing. Additionally, the subject of the painting itself is incredibly similar from this painting to A Philosopher Gives a Lecture on the Orrery. Both look to be a demonstration or lecture type situation that looks to be science related.

Some specific details that explain why these visual elements are characteristics of the artist and the times in which he lived are first, the subject of the painting. During the time of Enlightenment, Wright depicted inventions of the Industrial Revolution. During the mid to late eighteenth century there was a significant amount of change that was seen in the way that science was now being applied to practical situations. Also, Joseph Wright of Derby was a part of a group called the Lunar Society, which had a goal to raise the status of science and the scientist themselves. The society did this by having a scientist display an experiment. In both the given painting and Philosopher Gives a Lecture on the Orrery, this idea of displaying of knowledge is present, which further explains his use of light and the size of the painting. Joseph Wright of Derby used tenebroso in many of his paintings. He uses the light to demonstrate human intellect and he does this by highlighting the heads of the people. The significance of science is also emphasized by the size of the painting and how inviting the painting is. It elevates the value of science which falls in line with the philosophy of the Lunar Society.

—Leah C.

Criteria	Student Response	Point Value	Points Earned
Task: Attribute this painting to the artist who painted it.			
The artist is Joseph Wright of Derby, although Wright of Derby or simply Wright would be enough to earn a point.	"This painting is attributed to Joseph Wright of Derby."	1	1
Task: Using *at least two* specific details, justify your attribution by describing relevant similarities between this work and a work in the required course content.			
The two similarities can be contextual or visual. Leah references the correct work in the required course content and points out the similarities between the two.	"This painting has specific details that are similar in Joseph Wright of Derby's *A Philosopher Gives a Lecture on the Orrery*. First, Wright's use of tenebroso is very specific and dramatic.... Also similar are the sharp focus and the closeness of the viewer to the scene."	2	2
Task: Using *at least two* specific details, discuss *why* these visual elements are characteristic of this artist and the times in which he lived.			
For this response to be accurate, the student must reference the context in which Wright of Derby lived. This essay discusses the Industrial Revolution and the Lunar Society—both are correct. One could also discuss the Enlightenment, which is only mentioned here.	"During the mid- to late eighteenth century there was a significant amount of change that was seen in the way that science was now being applied to practical situations. Also, Joseph Wright of Derby was a part of a group called the Lunar Society, which had a goal to raise the status of science and the scientist themselves."	2	2
		Total Points Possible: 5	**This essay earned: 5**
Remarks: Each paragraph in the response neatly addresses one prompt each. This way, the reader can clearly and effectively judge the value of the essay as a whole.			

MODEL RESPONSE FOR QUESTION 6

This wall plaque, along with many others, served as a way for the Oba (King) to trace his royal lineage. Each plaque shows a previous Oba, all the way back until the very first Oba. These plaques were hung up in sequence on posts on the veranda of the royal palace. Each plaque shows the power and authority of the Oba along with the many different things that each Oba was known for.

Because this plaque is made of brass, we know that it is very durable and intended to last a long time. The brass medium illustrates the purpose of this plaque as somewhat of a history book that needs to last throughout many years. Also, the use of hierarchical scale and the attendants holding shields over the Oba's head, show the Oba's power and importance. Similarly, the Oba is shown wearing royal regalia. The bands shown around the Oba's neck represent coral necklaces traditionally worn by the Oba to connect them to Olokun, God of the sea, who brought economic prosperity to the Oba people.

In this photograph, the Oba is shown wearing coral necklaces, again, creating a connection between him and the God of the sea. Also, in the photograph the Oba is shown beneath the shields of his royal attendants and in the center of the image. This is the same as is shown in the plaque.

—E.L.

Criteria	Student Response	Point Value	Points Earned
Task: Explain the purpose of the wall plaque.			
The essay needs to pinpoint the exact historical context. E.L. avoids vague words like "decorate the Oba's palace."	"This wall plaque, along with many others, served as a way for the Oba (King) to trace his royal lineage. Each plaque shows a previous Oba, all the way back until the very first Oba."	1	1
Task: Discuss *at least two* specific visual elements in the wall plaque that illustrate its purpose.			
The student needs *at least two* examples of visual elements in the plaque that speak to its purpose. E.L. wisely offers more than the minimum requirement.	"the use of hierarchical scale and the attendants holding shields over the Oba's head, show the Oba's power and importance. Similarly, the Oba is shown wearing royal regalia."	2	2
Task: Explain *at least two* reasons how these elements continue to represent the Oba king today, as seen in the contextual photograph.			
A connection must be firmly made between elements in the sculpture and elements in the photograph. It is smart to indicate to the reader a direct link, as E.L. does in this response. Notice how E.L. firmly connects the two images so that the points are clearly earned.	"In this photograph, the Oba is shown wearing coral necklaces, again, creating a connection between him and the God of the sea. Also, in the photograph the Oba is shown beneath the shields of his royal attendants and in the center of the image. This is the same as is shown in the plaque."	2	2
		Total Points Possible: 5	**This essay earned: 5**
Remarks: This is an excellent response because it pays careful attention to both the work of art and the contextual photograph. Clearly the student has assessed the merits of both.			

TEST ANALYSIS

NOTE: Because the AP Art History exam has been redesigned, there is no way of knowing exactly how the raw scores on the exams will translate into a 1, 2, 3, 4, or 5. The formula provided below is based on past commonly accepted standards for grading the AP Art History exam. Additionally, the score range corresponding to each grade varies from exam to exam, and thus the ranges provided below are approximate.

SECTION I: MULTIPLE-CHOICE (50% OF GRADE)

Number Correct: _____ (out of 80)

Number Correct × 1.25 = _____ (out of 100)
(Multiple-Choice Score)

SECTION II: ESSAYS (50% OF GRADE)

Essay 1: _____
(out of 8)

Essay 2: _____
(out of 6)

Essay 3: _____
(out of 5)

Essay 4: _____
(out of 5)

Essay 5: _____
(out of 5)

Essay 6: _____
(out of 5)

Total: _____ × **2.942** = _____ (out of 100)
(Essay Score)

FINAL SCORE

_____ + _____ = _____ (out of 200)

Multiple-Choice Score Essay Score Final Score
(rounded to the nearest whole number)

Final Score Range	AP Score
150–200	5
132–149	4
110–131	3
75–109	2
0–74	1

Glossary

Abbey: a monastery for monks, or a convent for nuns, and the church that is connected to it (Figure 11.4a)

Abstract: works of art that may have form, but have little or no attempt at pictorial representation (Figure 22.14)

Academy: an institution whose main objects include training artists in an academic tradition, ennobling the profession, and holding exhibitions

Acropolis: literally, a "high city," a Greek temple complex built on a hill over a city

Action painting: an abstract painting in which the artist drips or splatters paint onto a surface like a canvas in order to create the work (Figure 22.21)

Adobe: a building material made from earth, straw, or clay dried in the sun (Figure 27.2)

Agora: a public plaza in a Greek city where commercial, religious, and societal activities are conducted (Figure 4.15)

'Ahu 'ula: Hawaiian feather cloaks (Figure 28.4)

Aka: an elephant mask of the Bamileke people of Cameroon (Figure 27.12)

Aerial perspective: *see* **Perspective**

Altarpiece: a painted or sculpted panel set atop an altar of a church

Ambulatory: a passageway around the apse or an altar of a church (Figure 11.3)

Amphiprostyle: having four columns in the front and rear of a temple

Amphora: a two-handled ancient Greek storage jar

Anamorphic image: an image that must be viewed by a special means, such as a mirror, in order to be recognized (Figure 19.9)

Andachtsbild: an image used for private contemplation and devotion (Figure 12.7)

Animal style: a medieval art form in which animals are depicted in a stylized and often complicated pattern, usually seen fighting with one another (Figure 10.2a)

Ankh: an Egyptian symbol of life

Annunciation: in Christianity, an episode in the Book of Luke 1:26–38 in which Angel Gabriel announces to Mary that she would be the Virgin Mother of Jesus (Figure 14.1)

Anthropomorphic: having characteristics of the human form, although the form itself is not human (Figure 1.2)

Apadana: an audience hall in a Persian palace (Figure 2.16)

Apocalypse: last book of the Christian Bible, sometimes called Revelations, which details God's destruction of evil and consequent rising to heaven of the righteous (Figure 12.9a)

Apotheosis: a type of painting in which the figures are rising heavenward (Figure 21.7)

Apotropaic: having the power to ward off evil or bad luck

Apse: the end point of a church where the altar is (Figure 7.2)

Aquatint: a kind of print that achieves a watercolor effect by using acids that dissolve onto a copper plate (Figure 21.7)

Arabesque: a flowing, intricate, and symmetrical pattern deriving from floral motifs (Figure 9.1)

Arcade: a series of arches supported by columns; when the arches face a wall and are not self-supporting, they are called a **blind arcade**

Arcadian: a simple rural and rustic setting used especially in Venetian paintings of the High Renaissance; it is named after Arcadia, a district in Greece to which poets and painters have attributed a rural simplicity and an idyllically untroubled world

Archaeology: the scientific study of ancient people and cultures principally revealed through excavation

Architrave: a plain nonornamented lintel on the entablature (Figure 4.14)

Archivolt: a series of concentric moldings around an arch (Figure 11.5)

Ashlar masonry: carefully cut and grooved stones that support a building without the use of concrete or other kinds of masonry (Figure 23.7a)

Assemblage: a three-dimensional work made of various materials such as wood, cloth, paper, and miscellaneous objects (Figure 29.12)

Athena: Greek goddess of war and wisdom; patron of Athens

Atmospheric perspective: *see* **Perspective**

Atrium (plural: **atria**)**:** a courtyard in a Roman house or before a Christian church (Figure 7.2)

Avant-garde: an innovative group of artists who generally reject traditional approaches in favor of a more experimental technique

Axial plan (Basilican plan, Longitudinal plan): a church with a long nave whose focus is the apse, so-named because it is designed along an axis (Figure 7.2)

Bandolier bag: a large heavily beaded pouch with a slit on top worn at the waist with a strap over the shouler (Figure 26.11)

Baptistery: in medieval architecture, a separate chapel or building generally in front of a church used for baptisms

Barrel vault: *see* **Vault**

Basilica: in Roman architecture, a large axially planned building with a nave, side aisles, and apses (Figure 6.10a). In Christian architecture, an axially planned church with a long nave, side aisles, and an apse for the altar (Figure 7.2)

Bas-relief: a very shallow relief sculpture (Figure 23.5b)

Bay: a vertical section of a church that is embraced by a set of columns and is usually composed of arches and aligned windows (Figure 11.2)

Bent-axis: an architectural plan in which an approach to a building requires an angular change of direction, as opposed to a direct and straight entry (Figure 2.1)

Bi: a round ceremonial disk found in ancient Chinese tombs; characterized by having a circular hole in the center, which may have symbolized heaven.

Biombos: folding free-standing screens (Figures 18.3a and 18.3b)

Biomorphism: a movement that stresses organic shapes that hint at natural forms

Bodhisattva: a deity who refrains from entering nirvana to help others (Figure 24.9c)

Bottega: the studio of an Italian artist

Buddha: a fully enlightened being; there are many Buddhas, the most famous of whom is Sakyamuni, also known as Gautama or Siddhartha (Figure 23.5)

Bundu: masks used by the women's Sande society to bring girls into puberty (Figure 27.9)

Bust: a sculpture depicting a head, neck, and upper chest of a figure (Figure 6.14)

Byeri: in the art of the Fang people, a reliquary guardian figure (Figure 27.13)

Calligraphy: decorative or beautiful handwriting (Figure 9.2)

Calotype: a type of early photograph, developed by William H. F. Talbot, that is characterized by its grainy quality; a calotype is considered the forefather of all photography because it produces both a positive and a negative image

Camera obscura: (Latin, meaning "dark room") a box with a lens which captures light and casts an image on the opposite side (Figure 20.7)

Caprice: usually a work of art that is an architectural fantasy; more broadly any work that has a fantasy element (Figure 20.2)

Cantilever: a projecting beam that is attached to a building at one end and suspended in the air at the other (Figure 22.15)

Canvas: a heavy woven material used as the surface of a painting; first widely used in Venice (Figure 17.11)

Capital: the top element of a column (Figure 3.3)

Caricature: a drawing that uses distortion or exaggeration of someone's physical features or apparel in order to make that person look foolish

Caryatid (male: **atlantid**): a column in a building that is shaped like a female figure

Cassone (plural: **cassoni**): a trunk intended for storage of clothing for a wife's trousseau (Figure 16.4)

Casta paintings: paintings from New Spain showing people of mixed races (Figure 18.5)

Catacomb: an underground passageway used for burial (Figure 7.1c)

Cathedral: the principal church of a diocese, where a bishop sits (Figure 11.4a)

Cella: the main room of a temple where the god is housed

Central plan: a building having a circular plan with the altar in the middle (Figure 9.12b)

Chacmool: a Mayan figure that is half-sitting and half-lying on its back

Chalice: a cup containing wine used in a Christian ceremony (Figure 8.6)

Chapter house: a building next to a church used for meetings (Figures 15.1a and 15.1b)

Chasing: to ornament metal by indenting into a surface with a hammer (Figure 10.1)

Chevet: the east end of a Gothic church (Figure 12.2)

Chiaroscuro: a gradual transition from light to dark in a painting; forms are not determined by sharp outlines, but by the meeting of lighter and darker areas (Figure 16.4)

Choir: a space in a church between the transept and the apse for a choir or clergymen (Figure 12.2)

Cinquecento: the 1500s, or sixteenth century, in Italian art

Cire perdue: the lost-wax process. A bronze casting method in which a figure is modeled in clay and covered with wax and then recovered with clay. When fired in a kiln, the wax melts away leaving a channel between the two layers of clay that can be used as a mold for liquid metal (Figure 21.15)

Clerestory: the third, or window, story of a church (Figure 12.4d); also, a roof that rises above lower roofs and thus has window space beneath (Figure 3.8b)

Cloissonné: enamelwork in which colored areas are separated by thin bands of metal, usually gold or bronze (Figure 10.1)

Close: an enclosed gardenlike area around a cathedral

Codex (plural: **codices**): a manuscript book (Figure 10.2a)

Coffer: in architecture, a sunken panel in a ceiling (Figure 6.5)

Coiling: a method of creating pottery in which a rope-like strand of clay is wrapped and layered into a shape before being fired in a kiln

Collage: a composition made by pasting together different items onto a flat surface

Colophon: 1) a commentary on the end panel of a Chinese scroll; 2) an inscription at the end of a manuscript containing relevant information on its publication (Figure 24.3a)

Color field: a style of abstract painting characterized by simple shapes and monochromatic color

Composite column: one that contains a combination of volutes from the Ionic order and acanthus leaves from the Corinthian order

Compound pier: a pier that appears to be a group or gathering of smaller piers put together (Figure 12.4c)

Confucianism: a philosophical belief begun by Confucius that stresses education, devotion to family, mutual respect, and traditional culture

Cong: a tubular object with a circular hole cut into a square-like cross section (Figure 1.3)

Continuous narrative: a work of art that contains several scenes of the same story painted or sculpted in continuous succession (Figure 8.7)

Contrapposto: a graceful arrangement of the body based on tilted shoulders and hips and bent knees (Figure 4.3)

Corbel arch: a vault formed by layers of stone that gradually grow closer together as they rise until they eventually meet (Figure 23.7a)

Corinthian: an order of ancient Greek architecture similar to the Ionic, except that the capitals are carved in tiers of leaves

Coyolxauhqui: an Aztec moon goddess whose name means "Golden Bells" (Figure 30.15)

Cornice: a projecting ledge over a wall (Figure 8.3b)

Cubiculum (plural: **cubicula**): a Roman bedroom flanking an atrium; in Early Christian art, a mortuary chapel in a catacomb (Figure 7.1c)

Cuneiform: a system of writing in which the strokes are formed in a wedge or arrowhead shape

Cupola: a small dome rising over the roof of a building. In architecture, a cupola is achieved by rotating an arch on its axis

Cyclopean masonry: a type of construction that uses rough massive blocks of stone piled one atop the other without mortar. Named for the mythical Cyclops

Daguerreotype: a type of early photograph, developed by Daguerre, which is characterized by a shiny surface, meticulous finish, and clarity of detail. A daguerreotype is a unique photograph; it has no negative (Figure 20.8)

Daoism: a philosophical belief begun by Laozi that stresses individual expression and a striving to find balance in one's life

Darshan: in Hinduism, the ability of a worshipper to see a deity and the deity to see the worshipper

Di sotto in sù: "from the bottom up," a type of ceiling painting in which the figures seem to be hovering above the viewers, often looking down at us (Figure 17.6)

Documentary photography: a type of photography that seeks social and political redress for current issues by using photographs as a way of exposing society's faults (Figure 25.33)

Donor: a patron of a work of art who is often seen in that work

Doric: an order of ancient Greek architecture that features grooved columns with no grooved bases and an upper story with square sculpture called metopes (Figure 4.11)

Drypoint: an engraving technique in which a steel needle is used to incise lines in a metal plate. The rough burr at the sides of the incised lines yield a velvety black tone in the print.

Earthwork: a large outdoor work in which the earth itself is the medium (Figure 22.26)

Embroidery: a woven product in which the design is stitched into a premade fabric (Figure 11.7a)

Encaustic: an ancient method of painting using colored waxes that are burned into a wooden surface

Enconchados: shell-inlay paintings; tiny fragments of mother-of-pearl placed onto a wooden support and canvas and covered with a yellowish tint and thin glazes of paint (Figure 18.4)

Engaged column: a column that is not freestanding but attached to a wall (Figure 3.2)

Engraving: a printmaking process in which a tool called a **burin** is used to carve into a metal plate, causing impressions to be made in the surface. Ink is passed into the crevices of the plate, and paper is applied. The result is a print with remarkable details and finely shaded contours (Figure 14.3)

Entablature: the upper story of a Greek temple (Figure 4.14)

Entombment: a painting or sculpture depicting Jesus Christ's burial after his crucifixion (Figure 16.5)

Escudo: a framed painting worn below the neck in a colonial Spanish painting (Figure 18.6)

Etching: a printmaking process in which a metal plate is covered with a ground made of wax. The artist uses a tool to cut into the wax to leave the plate exposed. The plate is then submerged into an acid bath, which eats away at the exposed portions of the plate. The plate is removed from the acid, cleaned, and ink is filled into the crevices caused by the acid. Paper is applied and an impression is made. Etching produces the finest detail of the three types of early prints (Figure 17.9)

Eucharist: the bread sanctified by the priest at the Christian ceremony commemorating the Last Supper

Exemplum virtutis: a painting that tells a moral tale for the viewer (Figure 19.6)

Façade: the front of a building

Ferroconcrete: steel-reinforced concrete; the two materials act together to resist building stresses

Fête galante: an eighteenth-century French style of painting that depicts the aristocracy walking through a forested landscape

Fetish: an object believed to possess magical powers

Fibula (plural: **fibulae**): a clasp used to fasten garments (Figure 10.1)

Flood story: as told in Genesis 7 of the Bible, Noah and his family escape rising waters by building an ark and placing two of every animal aboard (Figure 16.2d)

Flying buttress: a stone arch and its pier that support a roof from a pillar outside the building. Flying buttresses also stabilize a building and protect it from wind sheer (Figure 12.1)

Foreshortening: a visual effect in which an object is shortened and turned deeper into the picture plane to give the effect of receding in space (Figures 6.12a and 6.12b)

Forum (plural: **fora**): a public square or marketplace in a Roman city (Figure 6.10a)

Fresco: a painting technique that involves applying water-based paint onto a freshly plastered wall. The paint forms a bond with the plaster that is durable and long-lasting (Figure 6.13)

Frieze: a horizontal band of sculpture

Garba griha: a "womb chamber," the inner room in a Hindu temple that houses a god's image

Gallery: a passageway inside or outside a church that generally is characterized as having a colonnade or an arcade (Figure 11.4b)

Genesis: first book of the Bible that details Creation, the Flood, Rebecca at the Well, and Jacob Wrestling the Angel, among other episodes (Figure 8.7)

Genre painting: painting in which scenes of everyday life are depicted (Figure 14.6)

Gigantomachy: a mythical ancient Greek war between the giants and the Olympian gods (Figure 4.9)

Glazes: thin transparent layers put over a painting to alter the color and build up a rich sonorous effect

Gospels: the first four books of the New Testament that chronicle the life of Jesus Christ (Figure 10.2a)

Grand manner: a style of eighteenth-century painting that features large painting with figures posed as ancient statuary or before classical elements such as columns or arches

Grand tour: in order to complete their education young Englishmen and Americans in the eighteenth century undertook a journey to Italy to absorb ancient and Renaissance sites

Groin vault: *see* **Vault**

Ground line: a base line upon which figures stand (Figure 2.3)

Ground plan: the map of a floor of a building

Haboku (splashed ink): a monochrome Japanese ink painting done in a free style in which ink seems to be splashed on a surface

Haggadah (plural: **Haggadot**): literally "narration"; specifically, a book containing the Jewish story of Passover and the ritual of the Seder (Figures 12.10a, 12.10b, and 12.10c)

Hajj: an Islamic pilgrimage to Mecca that is required as one of the five pillars of Islam

Hammerbeam: a type of roof in English Gothic architecture, in which timber braces curve out from walls and meet high over the middle of the floor (Figure 12.5)

Hanja: Chinese characters used in Korean script with a Korean pronunciation

Happening: an act of performance art that is intially planned but involves spontaneity, improvisation, and often audience participation

Harlem Renaissance: a particularly rich artistic period in the 1920s and 1930s that is named after the African-American neighborhood in New York City where it emerged. It is marked by a cultural resurgence by African-Americans in the fields of painting, writing, music, and photography

Henge: a Neolithic monument, characterized by a circular ground plan; used for rituals and marking astronomical events (Figure 1.12b)

Hierarchy of scale: a system of representation that expresses a person's importance by the size of his or her representation in a work of art (Figure 3.4)

Hieroglyphics: Egyptian writing using symbols or pictures as characters (Figure 3.12)

Horror vacui: (Latin, meaning "fear of empty spaces") a type of artwork in which the entire surface is filled with objects, people, designs, and ornaments in a crowded and sometimes congested way (Figure 23.5b)

Huitzilopochtli: an Aztec god of the sun and war; sometimes represented as an eagle or as a hummingbird

Humanism: an intellectual movement in the Renaissance that emphasized the secular alongside the religious. Humanists were greatly attracted to the achievements of the classical past and stressed the study of classical literature, history, philosophy, and art

Hypostyle: a hall that has a roof supported by a dense thicket of columns (Figure 3.8b)

Icon: a devotional panel depicting a sacred image (Figure 8.8)

Iconoclasm: the destruction of religious images that are seen as heresy (Figure 23.3)

Iconostasis: a screen decorated with icons, which separates the apse from the transept of a church

Ignudi: nude corner figures on the Sistine Chapel ceiling

Ikenga: a shrine figure symbolizing traditional male attributes of the Igbo people (Figure 27.10)

Illuminated manuscript: a manuscript that is hand decorated with painted initials, marginal illustrations and larger images that add a pictorial element to the written text (Figures 10.2a, 10.2b and 10.2c)

Impasto: a thick and very visible application of paint on a painting surface

Impluvium: a rectangular basin in a Roman house that is placed in the open-air atrium in order to collect rainwater (Figure 6.7b)

In situ: a Latin expression that means that something is in its original location

Installation: a temporary work of art made up of assemblages created for a particular space, like an art gallery or a museum (Figure 22.25b)

Ionic: an order of Greek architecture that features columns with scrolled capitals and an upper story with sculptures that are in friezes (Figure 4.11)

Isocephalism: the tradition of depicting heads of figures on the same level (Figure 4.5)

Iwan: a rectangular vaulted space in a Muslim building that is walled on three sides and open on the fourth (Figure 9.13a)

Jali: perforated ornamental stone screens in Islamic art

Jamb: the side posts of a medieval portal (Figure 11.5)

Japonisme: an attraction for Japanese art and artifacts that were imported into Europe in the late nineteenth century

Ka: the soul, or spiritual essence, of a human being that either ascends to heaven or can live in an Egyptian statue of itself

Keystone: the center stone of an arch that holds the other stones in place (Figure 11.5)

Kiln: an oven used for making pottery

Kitsch: something of low quality that appeals to popular taste (Figure 29.10)

Kiva: a circular room wholly or partly underground used for religious rites

Kondo: a hall used for Buddhist teachings (Figure 25.1a)

Kouros (female: **kore**): an archaic Greek sculpture of a standing youth (Figures 4.1 and 4.2)

Krater: a large ancient Greek bowl used for mixing water and wine (Figure 4.19)

Kufic: a highly ornamental Islamic script (Figure 9.5)

Lamassu: a colossal winged human-headed bull in Assyrian art (Figure 2.5)

Lamentation: a scene that shows Jesus' followers mourning his death; usually includes Mary, Saint John, and Mary Magdalene (Figure 13.1c)

Lancet: a tall narrow window with a pointed arch, usually filled with stained glass (Figure 12.8)

Lapis lazuli: a deep-blue stone prized for its color

Last Judgment: in Christianity, the judgment before God at the end of the world (Figure 13.1b)

Last Supper: a meal shared by Jesus Christ with his apostles the night before his death by crucifixion (Figure 16.1)

Linear perspective: *see* **Perspective**

Lintel: a horizontal beam over an opening (Figure 1.12)

Literati: a sophisticated and scholarly group of Chinese artists who painted for themselves rather than for fame and mass acceptance. Their work is highly individualized

Lithography: a printmaking technique that uses a flat stone surface as a base. The artist draws an image with a special crayon that attracts ink. Paper, which absorbs the ink, is applied to the surface and a print emerges (Figure 24.7)

Loculi: openings in the walls of catacombs to receive the dead

Lost-wax process: *see* **Cire perdue**

Lukasa: a memory board used by the Luba people of central Africa (Figure 27.11)

Lunette: a crescent-shaped space, sometimes over a doorway, which contains sculpture or painting

Madonna: the Virgin Mary, mother of Jesus Christ (Figure 15.3)

Madrasa: a Muslim school or university often attached to a mosque

Malagan: a traditional ceremony from Papua New Guinea, as well as the masks and costumes used in that ceremony (Figure 28.8)

Mana: a supernatural force believed to dwell in a person or in a sacred object (Figure 28.4)

Mandorla: (Italian, meaning "almond") a term that describes a large almond-shaped orb around holy figures like Christ and Buddha (Figure 23.2)

Maniera greca: (Italian, meaning "Greek manner") a style of painting based on Byzantine models that was popular in Italy in the twelfth and thirteenth centuries

Martyrium (plural: **martyria**): a shrine built over a place of martyrdom or a grave of a martyred Christian saint

Mastaba: (Arabic, meaning "bench") a low flat-roofed Egyptian tomb with sides sloping down to the ground (Figure 3.1)

Mausoleum: a building, usually large, that contains tombs (Figure 9.17a)

Mblo: a commemorative portrait of the Baule people (Figure 27.7)

Mecca, Medina: Islamic holy cities; Mecca is the birthplace of Muhammad and the city all Muslims turn to in prayer; Medina is where Muhammad was first accepted as the Prophet, and where his tomb is located

Megalith: a stone of great size used in the construction of a prehistoric structure

Megaron: a rectangular audience hall in Aegean art that has a two-column porch and four columns around a central air well

Menhir: a large uncut stone erected as a monument in the prehistoric era

Mestizo: someone of mixed European and Native American descent (Figure 18.5)

Metope: a small relief sculpture on the façade of a Greek temple (Figure 4.14)

Mihrab: a central niche in a mosque, which indicates the direction to Mecca (Figure 9.10)

Minaret: a tall slender column used to call people to prayer (Figure 9.13a)

Minbar: a pulpit from which sermons are given

Mithuna: in India, the mating of males and females in a ritualistic, symbolic, or physical sense

Moai: large stone sculptures found on Easter Island (Figure 28.11)

Mobile: a sculpture made of several different items that dangle from a ceiling and can be set into motion by air currents

Modernism: a movement begun in the late nineteenth century in which artists embraced the current at the expense of the traditional in both subject matter and in media; modernist artists often seek to question the very nature of art itself

Moralized Bible: a Bible that pairs Old and New Testament scenes with paintings that explain their moral parallels (Figures 12.8a and 12.9b)

Mortise and tenon: a groove cut into stone or wood called a **mortise** that is shaped to receive a tenon, or projection, of the same dimensions

Mosaic: a decoration using pieces of stone, marble, or colored glass, called **tesserae**, that are cemented to a wall or a floor (Figure 8.5)

Mosque: a Muslim house of worship (Figure 9.14a)

Mudra: a symbolic hand gesture in Hindu and Buddhist art (Figure 23.1)

Muezzin: an Islamic official who calls people to prayer traditionally from a minaret

Muhammad (570?–632): the Prophet whose revelations and teachings form the foundation of Islam

Mullion: a central post or column that is a support element in a window or a door (Figure 15.2)

Muqarnas: a honeycomb-like decoration often applied in Islamic buildings to domes, niches, capitals, or vaults; the surface resembles intricate stalactites (Figure 9.15c)

Narthex: the closest part of the atrium to the basilica, it serves as a vestibule or lobby of a church

Nave: the main aisle of a church (Figure 11.4b)

Ndop: a Kuba commemorative portrait of a king in an ideal state (Figure 27.5a)

Necropolis (plural: necropoli): a large burial area; literally, a "city of the dead"

Negative space: empty space around an object or a person, such as the cut-out areas between a figure's legs or arms in a sculpture

Neoplasticism: a term coined by Piet Mondrian to describe works of art that contain only the primary and neutral colors and straight, vertical, or horizontal lines intersecting at right angles

Nike: ancient Greek goddess of victory (Figure 4.8)

Niobe: the model of a grieving mother; after boasting of her twelve children, jealous gods killed them

Nirvana: an afterlife in which reincarnation ends and the soul becomes one with the supreme spirit

Nkisi n'kondi: a Kongo power figure (Figure 27.6)

Oculus: a circular window in a church or a round opening at the top of a dome (Figure 7.15)

Odalisque: a woman slave in a harem (Figure 20.3)

Ogee arch: an arch formed by two S-shaped curves that meet at the top (Figure 13.3)

Oil paint: a paint in which pigments are suspended in an oil-based medium. Oil dries slowly allowing for corrections or additions; oil also allows for a great range of luster and minute details (Figure 14.2)

Orans (or orant) figure: a figure with its hands raised in prayer

Orthogonal: lines that appear to recede toward a vanishing point in a painting with linear perspective

Pagoda: a tower built of many stories. Each succeeding story is identical in style to the one beneath it, only smaller. Pagodas typically have dramatically projecting eaves that curl up at the ends

Panathenaic Way: a ceremonial road for a procession built to honor Athena during a festival (Figure 4.15)

Papyrus: a tall aquatic plant used as a writing surface in ancient Egypt (Figure 3.12)

Parchment: a writing surface made from animal skins; particularly fine parchment made of calf skin is called **vellum** (Figures 10.2a, 10.2b and 10.2c)

Passover: an eight day Jewish festival that commemorates the exodus of Jews from Egypt under the leadership of Moses. So-called because an avenging angel of the Lord knew to "pass over" the homes of Jews who, in order to distinguish their houses from those of the pagan Egyptians, had sprinkled lamb's blood over their doorways, thus preserving the lives of their first-born sons

Pastel: a colored chalk that when mixed with other ingredients produces a medium that has a soft and delicate hue

Paten: a plate, dish, or bowl used to hold the Eucharist at a Christian ceremony (Figure 8.5)

Pediment: the triangular top of a temple that contains sculpture (Figure 4.14)

Pendentive: a construction shaped like a triangle that transitions the space between flat walls and the base of a round dome (Figure 9.1)

Peplos: a garment worn by women in ancient Greece, usually full length and tied at the waist (Figure 4.2)

Peristyle: a colonnade surrounding a building or enclosing a courtyard (Figures 4.16b, 6.7a)

Perspective: having to do with depth and recession in a painting or a relief sculpture. Objects shown in **linear perspective** achieve a three-dimensionality in the two-dimensional world of the picture plane. Lines, called **orthogonals**, draw the viewer back in space to a common point called the **vanishing point**. Paintings, however, may have more than one vanishing point, with orthogonals leading the eye to several parts of the work. Landscapes that give the illusion of distance are in **atmospheric** or **aerial perspective**

Pharaoh: a king of ancient Egypt (Figure 3.11)

Photogram: an image made by placing objects on photo-sensitive paper and exposing them to light to produce a silhouette

Pier: a vertical support that holds up an arch or a vault (Figure 11.4b)

Pietà: a painting or sculpture of a crucified Christ lying on the lap of his grieving mother, Mary (Figure 12.7)

Pietra serena: a dark gray stone used for columns, arches, and trim details in Renaissance buildings (Figure 15.1b)

Pilaster: a flattened column attached to a wall with a capital, a shaft, and a base (Figure 16.6a)

Pinnacle: a pointed sculpture on piers or flying buttresses (Figure 12.1)

Plein-air: painting in the outdoors to directly capture the effects of light and atmosphere on a given object

Porcelain: a ceramic made from clay that when fired in a kiln produces a product that is hard, white, brittle, and shiny (Figure 24.11)

Portal: a doorway; in medieval art they can be significantly decorated (Figure 11.5)

Portico: an entranceway to a building; it has columns supporting a roof

Potter's wheel: a device that usually has a pedal used to make a flat, circular table spin, so that a potter can create pottery

Positivism: a theory that expresses that all knowledge must come from proven ideas based on science or scientific theory philosophy, promoted by French philosopher Auguste Comte (1798–1857)

Post-and-lintel: a method of construction with two posts supporting a horizontal beam, called a **lintel** (Figure 1.11)

Potlatch: a ceremonial feast among northwest coast American Indians in which a host demonstrates his or her generosity by bestowing gifts

Predella: the base of an altarpiece that is filled with small paintings, often narrative scenes (Figure 14.4a)

Propylaeum (plural: **propylaea**): a gateway leading to a Greek temple

Pueblo: a communal village of flat-roofed structures of many stories that are stacked in terraces. They are made of stone or adobe (Figure 26.3)

Puja: a Hindu prayer ritual

Pwo: a female mask worn by men of the Chokwe people (Figure 27.8)

Pyxis: (pronounced "pick-sis") a small cylinder-shaped container with a detachable lid used to contain cosmetics or jewelry (Figure 9.4)

Pylon: a monumental gateway to an Egyptian temple marked by two flat, sloping walls between which is a smaller entrance

Qiblah: the direction toward Mecca which Muslims face in prayer

Quattrocento: the 1400s, or fifteenth century, in Italian art

Qur'an: the Islamic sacred text, dictated to the Prophet Muhammad by the Angel Gabriel

Ready made: a commonplace object selected and exhibited as a work of art

Register: a horizontal band, often on top of another, that tells a narrative story (Figure 3.4)

Relief sculpture: sculpture which projects from a flat background. A very shallow relief sculpture is called a **bas-relief** (pronounced: bah-relief) (Figure 3.4)

Reliquary: a vessel for holding a sacred relic. Often reliquaries took the shape of the object they held. Precious metals and stones were the common material (Figure 11.6)

Repoussé: (French, meaning "to push back") a type of metal relief sculpture in which the back side of a plate is hammered to form a raised relief on the front (Figure 26.7)

Reserve column: a column that is cut away from rock but has no support function

Rib vault: a vault in which diagonal arches form rib-like patterns; these arches partially support a roof, in some cases forming a weblike design (Figure 11.1)

Roof comb: a wall rising from the center ridge of a building to give the appearance of greater height (Figure 26.2a)

Rose window: a circular window, filled with stained glass, placed at the end of a transept or on the façade of a church (Figure 12.4d)

Sahn: a courtyard in Islamic architecture (Figure 9.16)

Sakyamuni: the historical Buddha, named after the town of Sakya, Buddha's birthplace (Figure 23.3)

Salon: a government-sponsored exhibition of artworks held in Paris in the eighteenth and nineteenth centuries

Sarcophagus (plural: **sarcophagi**)**:** a stone coffin

Scarification: scarring of the skin in patterns by cutting with a knife. When the cut heals, a raised pattern is created, which is painted (Figure 27.7)

School: a group of artists sharing the same philosophy who work around the same time, but not necessarily together

Scriptorium (plural: **scriptoria**)**:** a place in a monastery where monks wrote manuscripts

Seder: a ceremonial meal celebrated on the first two nights of Passover that commemorates the Israelites' flight from Egypt as told in the Bible. It is marked by a reading of the Haggadah

Sfumato: a smoke-light or hazy effect that distances the viewer from the subject of a painting

Shaft: the body of a column (Figure 4.14)

Shamanism: a religion in which good and evil are brought about by spirits which can be influenced by shamans, who have access to these spirits

Shikara: a beehive-shaped tower on a Hindu temple (Figure 23.7a)

Shiva: the Hindu god of creation and destruction (Figure 23.6)

Sibyl: a Greco–Roman prophetess whom Christians saw as prefiguring the coming of Jesus Christ (Figure 16.2b)

Silkscreen: a printing technique that passes ink or paint through a stenciled image to make multiple copies (Figure 22.23)

Skeleton: the supporting interior framework of a building

Spandrel: a triangular space enclosed by the curves of arches (Figure 6.4)

Spire or **Steeple:** a tall pointed tower on a church (Figure 12.4b)

Spolia: in art history, the reuse of architectural or sculptural pieces in buildings generally different from their original contexts

Squinch: the polygonal base of a dome that makes a transition from the round dome to a flat wall (Figure 8.2)

Stele (plural: **stelae**)**:** a stone slab used to mark a grave or a site (Figure 4.7)

Still life: a painting of a grouping of inanimate objects, such as flowers or fruit (Figure 17.11)

Stoa: an ancient Greek covered walkway having columns on one side and a wall on the other (Figure 4.15)

Stucco: a fine plaster used for wall decorations or moldings

Stupa: a dome-shaped Buddhist shrine (Figure 23.4a)

Stylized: a schematic, nonrealistic manner of representing the visible world and its contents, abstracted from the way that they appear in nature (Figure 1.2)

The sublime: any cathartic experience from the catastrophic to the intellectual that causes the viewer to marvel in awe, wonder, and passion (Figure 20.5)

Sunken relief: a carving in which the outlines of figures are deeply carved into a surface so that the figures seem to project forward

Tarashikomi: a Japanese painting technique in which paint is applied to a surface that has not already dried from a previous application (Figures 25.4a and 25.4b)

Tapa: a cloth made from bark that is soaked and beaten into a fabric (Figure 28.6)

Tapestry: a woven product in which the design and the backing are produced at the same time on a device called a **loom**

Tempera: a type of paint employing egg yolk as the binding medium that is noted for its quick drying rate and flat opaque colors (Figure 15.3)

Tenebroso/Tenebrism: a dramatic dark-and-light contrast in a painting (Figure 17.5)

Tepee: a portable Indian home made of stretched hides placed over wooden poles

Terra cotta: a hard ceramic clay used for building or for making pottery (Figure 5.5)

Tessellation: a decoration using polygonal shapes with no gaps (Figure 9.3)

Theotokos: the Virgin Mary in her role as the Mother of God (Figure 8.8)

Throwing: molding clay forms on a potter's wheel

Tholos: (1) an ancient Mycenaean circular tomb in a beehive shape; (2) an ancient Greek circular building (Figure 4.12)

Tlaloc: ancient American god who was highly revered; associated with rain, agriculture, and war

T'oqapu: small rectangular shapes in an Inkan garment (Figure 26.10)

Torana: a gateway near a stupa that has two upright posts and three horizontal lintels. They are usually elaborately carved (Figure 23.4c)

Torons: wooden beams projecting from walls of adobe buildings (Figure 27.2)

Transept: an aisle in a church perpendicular to the nave (Figure 12.2)

Transformation mask: a mask worn in ceremonies by people of the Pacific Northwest, Canada, or Alaska. The chief feature of the mask is its ability to open and close, going from a bird-like exterior to a human-faced interior (Figures 26.12a and 26.12b)

Transverse arch: an arch that spans an interior space connecting opposite walls by crossing from side to side (Figure 11.4b)

Trecento: the 1300s, or fourteenth century, in Italian art

Triclinium: a dining table in ancient Rome that has a couch on three sides for reclining at meals or a room containing a triclinium (Figure 6.13)

Triforium: a narrow passageway with arches opening onto a nave, usually directly below a clerestory (Figure 11.2)

Trigylph: a projecting grooved element alternating with a metope on a Greek temple (Figure 4.14)

Triptych: a three-paneled painting or sculpture (Figure 14.1)

Trompe l'oeil: (French, meaning "fools the eye") a form of painting that attempts to represent an object as existing in three dimensions, and therefore resembles the real thing (Figure 17.6)

Trumeau (plural: **trumeaux**): the central pillar of a medieval portal that stabilizes the structure. It is often elaborately decorated (Figure 11.5)

Tufa: a porous rock similar to limestone

Tuscan order: an order of ancient architecture featuring slender, smooth columns that sit on simple bases; no carvings on the frieze or in the capitals (Figure 5.2)

Tympanum (plural: **tympana**): a rounded sculpture placed over the portal of a medieval church (Figure 11.5)

Ukiyo-e: translated as "pictures of the floating world," a Japanese genre painting popular from the seventeenth to the nineteenth centuries (Figure 25.5)

Urna: a circle of hair on the brows of a deity sometimes represented as the focal point (Figure 23.1)

Ushnisha: a protrusion at the top of the head, or the top knot of a Buddha (Figure 23.1)

Vairocana: the universal Buddha, a source of enlightenment; also known as the Supreme Buddha who represents "emptiness," that is, freedom from earthly matters to help achieve salvation (Figure 23.2a)

Vanitas: a theme in still life painting that stresses the brevity of life and the folly of human vanity

Vault: a roof constructed with arches. When an arch is extended in space, forming a tunnel, it is called a **barrel vault** (Figure 6.1). When two barrel vaults intersect at right angles it is called a **groin vault** (Figure 6.2). *See also* **rib vault**

Venice Biennale: a major show of contemporary art that takes place every other year in various venues throughout the city of Venice; begun in 1895 (Figure 22.25b)

Veristic: sculptures from the Roman Republic characterized by extreme realism of facial features (Figure 6.14)

Vishnu: the Hindu god worshipped as the protector and preserver of the world (Figure 23.8c)

Votive: an object, such as a candle, offered in fulfillment of a vow or a pledge (Figure 2.2)

Voussoir: (pronounced "vōō-swar") a wedge-shaped stone that forms the curved part of an arch; the central voussoir is called a **keystone** (Figure 9.14d)

Wapepe: navigation charts from the Marshall Islands (Figure 28.3)

Wat: a Buddhist monastery or temple in Cambodia (Figure 23.8a)

Woodcut: a printmaking process by which a wooden tablet is carved into with a tool, leaving the design raised and the background cut away (very much as how a rubber stamp looks); ink is rolled onto the raised portions, and an impression is made when paper is applied to the surface; woodcuts have strong angular surfaces with sharply delineated lines (Figure 14.5)

Yakshi (masculine: **yaksha**): female and male figures of fertility in Buddhist and Hindu art (Figure 23.4c)

Yamato-e: a style of Japanese painting that is characterized by native subject matter, stylized features, and thick bright pigments

Yin and yang: complementary polarities; the yin is a feminine symbol that has dark, soft, moist, and weak characteristics; the yang is the male symbol that has bright, hard, dry, and strong characteristics (Figure 24.3c)

Zen: a metaphysical branch of Buddhism that teaches fulfillment through self-discipline and intuition

Zeus: king of the ancient Greek gods; known as Jupiter to the Romans; god of the sky and weather

Ziggurat: a pyramidlike building made of several stories that indent as the building gets taller; ziggurats have terraces at each level (Figure 2.1a)

Zoomorphic: having elements of animal shapes

Zoopraxiscope: a device that projects sequences of photographs to give the illusion of movement (Figure 21.5)

The author gratefully acknowledges the contributions of many individuals who have given permission to have their work reproduced in this volume. Any inadvertent errors will be corrected in the next printing.

Introduction: 1: © Marc Deville/Gamma-Rapho via Getty Images; 2: WC (Wikimedia Commons): Web Gallery of Art; **Attribution:** 1: Metropolitan Museum Fletcher Fund, 1940; 2: Metropolitan Museum Gift of Dietrich von Bothmer, 1976 (1976.181.3) Lent by the Musée du Louvre (L.1975.65.14–.17, .19); 3: Metropolitan Museum Marquand Collection, Gift of Henry G. Marquand, 1889; 4: Metropolitan Museum Rogers Fund, 1905; 5: Metropolitan Museum Rogers Fund, 1929; 6: Metropolitan Museum Purchase, The Dillon Fund Gift, 1979; 7: Metropolitan Museum The James F. Ballard Collection, Gift of James F. Ballard, 1922; 8: Cleveland Museum René and Odette Delenne Collection, Leonard C. Hanna, Jr. Fund; 9: Cleveland Museum Leonard C. Hanna, Jr. Fund; 10: Cleveland Museum Edward L. Whittemore Fund; 11: Cleveland Museum Gift of Mrs. Francis F. Prentiss for the Dudley P. Allen Collection; 12: Cleveland Museum Severance and Greta Millikin Purchase Fund; 13: Cleveland Museum Gift of Mr. and Mrs. Paul Tishman; 14: WC: Anderskev; 15: WC: David Jones; 16: WC: Google Cultural Institute; 17: WC: Jensens; 18: WC: Sean Pathasema/Birmingham Museum of Art; 19: WC: Deepa Chandran2014; 20: WC: Google Cultural Institute; 21: WC: http://www.lindaueronline.co.nz/maori-portraits/taraia-ngakuti-te-tumuhia; 22: WC: https://britishmuseumblog.files.wordpress.com/2014/10/frau-mit-totem-kind-19490411_750.jpg; 23: WC: Sailko; 24: WC: VIANDUVAL;25: WC: Metropolitan Museum of Art, Purchase, Lila Acheson Wallace Gift, 1996; **Diagnostic Test:** Fig. 1: © The Estate of Magdalena Abakanowicz, courtesy Marlborough Gallery, New York; Fig. 2: WC: Szukas; Fig. 3: Smithsonian American Art Museum, Washington, DC/Art Resource, NY; Fig. 4: British Museum Image Free Service; Fig. 5: WC: http://learn.bowdoin.edu/heijiscroll/viewer.html; Fig. 6: WC; Fig. 7: WC: https://www.kettererkunst.de/; Fig. 8: WC: Jean-Pol GRANDMONT; Fig. 9: WC: PMR Maeyaert; Fig. 10: WC: Mountain; Fig. 11: WC: Milos Radevic; Fig. 12: G. Dagli Orti /De Agostini Picture Library/Bridgeman Image; Fig. 13: PwH8sj_E5QhPDQ at Google Cultural Institute; Fig. 14 WC: Andreas Praefcke; Fig. 15: WC: anagoria; Fig. 16: WC; Fig. 17: © 2019 Faith Ringgold/Artists Rights Society (ARS), New York, Courtesy ACA Galleries, New York; Fig. 18: Universal Color © 2019 Holt/Smithson Foundation and Dia Art Foundation/Licensed by VAGA at Artists Rights Society (ARS), NY; Fig. 19: WC: Nina Aldin Thune; Fig. 20: WC; Fig. 21: WC: Google Cultural Institute; Q1: British Museum Image Free Service; Q3: WC: Marie-Lan Nguyen; Q4: Wikimeida Commons: Yann Forget; Q5a: WC: dIPENdAVE; Q5b: WC: Javier Salazar, Cannon; Q6a: Brooklyn Museum: Purchased with funds given by Mr. and Mrs. Alastair B. Martin, Mrs. Donald M. Oenslager, Mr. and Mrs. Robert E. Blum, and the Mrs. Florence A. Blum Fund, 61.33; Q6b: Photograph by Eliot Elisofon, 1971, Eliot Elisofon Photographic Archives, National Museum of African Art, Smithsonian Institution; **1.1:** WC (WC): Marrovi, 1.2: WC: Explicit; 1.3 & 1.13: WC: Professor Gary Lee Todd; 1.4: National Gallery of Australia, Canberra/Purchased 1977/Bridgeman Images; 1.5: WC: Steven Zucker; 1.6: Metropolitan Museum of Art: Rogers Fund, 1980; 1.7: WC: Locutus Borg; 1.8: WC:Francesco Bandarin; 1.9: WC: The Yorck Project; 1.10: Werner Forman Archive/Bridgeman Images; 1.11: Carlos Rodriguez; 1.12a: Clipart.com; 1.12b: WC:Guenter Wisechendahl; **2.1a** & 2.7a: Richard Ashworth/Robert Harding; 2.1b: Clipart.com; 2.2: Clipart.com; 2.3a: WC: Babel Stone; 2.3b: WC: Least Common Ancestor; 2.4a & 2.8a: author; 2.4b & 28b: WC: Mbzt2011; 2.5: WC: M.Chohan; 2.6a: WC: Hansueli Krapf; 2.6b: © Gerard Degeorge/Corbis; **3.1**, 3.2, 3.3: Carlos Rodriguez;

3.4a &3.4b: WC; 3.5: WC: Ivo Jansch; 3.6a: WC: Kallerna; 3.6b: Dreamstime; 3.7: WC: Keith Schengili-Roberts; 3.8a: WC: Steve F-E-Cameron; 3.8b: WC: Francesco Gasparetti; 3.8c & 3.11: Clipart.com; 3.9a: WC: Remih; 3.9b: Metropolitan Museum of Art: Rogers Fund, 1929; 3.10: WC: José Luis; 3.11: DeAgostini Picture Library/S Vannini/Bridgeman Images; 3.12: British Museum Image Free Service; **4.1**: WC: Mountain. 4.2: WC: Marsyas; 4.3: WC: Marie-Lan Nguyen; 4.4 & 4.5: WC: Jastrow; 4.6: WC: Marsyas; 4.7: WC: Grb16; 4.8: WC: Marie-Lan Nguyen, 4.9 &4.21b: WC: Miia Ranta; 4.10: WC: Marie-Lan Nguyen; 4.11: Carlos Rodriguez; 4.12: WC: KufoletoAntonio De Lorenzo and Marina Ventayol; 4.13: Richard Nici; 4.14: author; 4.15: WC: Madmedea; 4.16a: clipart.com; 4.16b & 4.17: WC: Steve Swayne; 4.18a & 4.21a: WC: Lestat; 4.18b: clipart.com; 4.19a: WC: Suedo; 4.19b: Photo: Hervé Lewandowski © RMN-Grand Palais/ Art Resource, NY; 4.20: WC: Lucas; **5.1a** & 5.7a: clipart.com and author; 5.1b & 5.7b: clipart. com; 5.2: Carlos Rodriguez; 5.3: De Agostini Picture Library/G. Nimatallah/Bridgeman Images; 5.4: WC: Gerard M; 5.5 & 5.6: Universal Color; **6.1**, 6.2, 6.3, 6.4, & 6.5: Carlos Rodriguez; 6.6: WC: Ad Meskens; 6.7a: WC: Radomill; 6.7b: WC: M.violante; 6.8a: WC: Alessandroferri; 6.8b: WC: Dennis Jarvis; 6.9a: Shutterstock: B Stefanov; 6.9b, 6.9c & 6.18: WC: Bernard Gagnon; 6.10a: WC: Forma mentis; 6.10b: WC: 1911 Encyclopedia Britannica; 6.10c: WC: Carole Raddato; 6.11a: WC: KlausF; 6.11b: WC: Sergey Ashmarin; 6.12a & 6.12b: Carlos Rodriguez; 6.13: WC: Fondo Paolo Monti; 6.14: Alinari/Bridgeman Images; 6.15: WC: Till Niermann; 6.16: author; 6.17: WC: Gfawkes05; **7.1a**: WC: Romaine; 7.1b: WC: Kristicak; 7.1c: Scala/Art Resource, New York; 7.2: Carlos Rodriguez; 7.3a: WC: MM; 7.3b & 7.4a: WC: Sailko; 7.3c & 7.4b: Clipart. com; **8.1** & 8.2: Carlos Rodriguez; 8.3a, 8.9b & 9.19: WC: Milos Radevic; 8.3b: G. Dagli Orti /De Agostini Picture Library/Bridgeman Image; 8.3c & 8.9a: Carlos Rodriguez; 8.4a: WC: DavidConFran; 8.4b: De Agostini Picture Library/A. De Gregorio/Bridgeman Images; 8.4c: WC: Vask; 8.5: Dreamstime: Tomas Marek; 8.6: WC: Bender 235; 8.7a, 8.7b & 8.10a, 8.10b: WC: Dsmdgold; 8.8: WC; **9.1**, 9.2 & 9.3: clipart.com; 9.4: WC: Marie-Lin Nguyen; 9.5: The Morgan Library & Museum/Art Resource, NY; 9.6 & 9.18: WC: Captain M, derivative work by Pole 2001; 9.7a & 9.7b: WC; 9.8: Harvard Art Museums/Arthur M. Sackler Museum, Bequest of Abby Aldrich Rockefeller © President and Fellows of Harvard College; 9.9: WC; 9.10: clipart.com; 9.11a: © Ali Jareji/Reuters; 9.11b: WC: Aiman titi; 9.12a: WC: Andrew Shiva; 9.12b: Photos.com; 9.13a: WC: Alex O. Holcombe; 9.13b: WC: Aarash; 9.13c: WC: Bernard Gagnon; 9.13d: WC: Hans Bernhard (Schnobby); 9.14a: WC: Toni Castillo Quero; 9.14b: WC: Karl 432; 9.14c: WC: Рустам Абдрахимов; 9.14d: Photos.com; 9.14e: WC: Americo Toledano; 9.15a: WC: bernjan; 9.15b: WC: Jim Gordon; 9.15c: Photo © Raffaello Bencini/Bridgeman Images; 9.15d: clipart.com; 9.16a & 9.20: Dreamstime; 9.16b: istockphotos; 9.17a: WC: Yann; 9.17b: WC: William Donelson **10.1**: Photo: Gerard Blot © RMN-Grand Palais/Art Resource, NY; 10.2a: WC; 10.2b & 10.3a: © British Library Board. All Rights Reserved/Bridgeman Image; 10.2c & 10.3b: WC; **11.1**, 11.2 & 11.3: Carlos Rodriguez; 11.4a, 11.8a: WC: Jean-Pol GRANDMONT; 11.4b, 11.8a: WC: PMR Maeyaert; 11.5: Carlos Rodriguez; 11.6a: WC: Titanet; 11.6b: WC: Daniel Villafruela; 11.6c: De Agostini Picture Library/A. Dagli Orti/Bridgeman Images; 11.7a: WC; 11.7b: WC: Myrabella; **12.1**, 12.2 & 12.3: Carlos Rodriguez; 12.4a: WC: Olvr; 12.4b: WC: Atlant; 12.4c: WC: PMR Maeyaert; 12.4d: WC: JB Thomas4; 12.5: WC: Jwslubbock; 12.6: WC: Nina Aldin Thune; 12.7 & 12.11: clipart. com; 12.8: WC: Eusebius; 12.9a: British Library, London, UK© British Library Board. All Rights Reserved/Bridgeman Images; 12.9b: WC: RAEUHtEGAy7O3Q at Google Cultural Institute; 12.10a: © British Library Board. All Rights Reserved/Bridgeman Images; 12.10b: The National Library of Israel Collections; 12.10c: http://www.bl.uk/catalogues/illuminatedmanuscripts/ILLUMIN.ASP?Size=mid&IllID=57013; 12.10d: WC: British Library; **13.1**: WC: I, Sailko; 13.1b & 13.2: WC: Rastaman3000; 13.1c & 13.3: WC: Yorck Project; **14.1**: WC; 14.2 & 14.7: WC; 14.3:

Metropolitan Museum of Art Fletcher Fund 1919; 14.4a: WC; 14.4b: WC Yorck Project; 14.5: WC; 14.6: WC: Google Art Project; 14.7: WC: Google Cultural Institute; **15.1a** & 15.1b: WC: Gryffindor; 15.2 & 15.7: WC: Sailko; 15.3: WC: Google Art Project; 15.4: WC: Google Art Project; 15.5 & 15.6: WC: Patrick A. Rodgers; **16.1:** WC; 16.2 & 16.8: WC: Antoine Taveneaux; 16.2b: WC: Maus-Trauden; 16.2c: WC; 16.2d: WC: Andrew Graham-Dixon; 16.2e: Morguefile.com; 16.3: WC: PDArt; 16.4: WC: The Yorck Project; 16.5 & 16.7: Universal Color; 16.6a: WC: Alejo2083; 16.6b: WC: Tango7174; **17.1:** WC: Architas; 17.2a: WC: Victor Andrade; 17.2b: WC: Welleschik; 17.2c: clipart.com; 17.3a: WC: ToucanWings; 17.3b: WC: Jean-Christophe BENOIST; 17.3c: author; 17.3d: WC: Myrabella; 17.3e: WC: Jorge Eduardo Guimarães; 17.4a: WC: Livioandronico2013; 17.4b: WC: Alves Gaspar; 17.5: WC: http://www.ibiblio.org/wm/paint/auth/caravaggio/calling/calling.jpg; 17.6: WC: Livioandronico2013; 17.7: WC: Galeria Online; 17.8: WC: The Yorck Project; 17.9: Art Institute of Chicago; 17.10: WC: Google Cultural Institute; 17.11: WC: Web Gallery of Art; **18.1:** WC; 18.2 & 18.7: WC; 18.3a, 18.3b & 18.8a, 18.b: Brooklyn Museum: Gift of Lilla Brown in memory of her husband, John W. Brown, by exchange, 2012.21; 18.4: Los Angeles County Museum of Art; 18.5: Bridgeman Images; 18.6: WC: Nameneko; **19.1:** WC: http://www.wga.hu/index1.html; 19.2: WC: Art Renewal Center; 19.3: WC: National Gallery; 19.4: WC: europeana.eu; 19.5a: WC: YF12s; 19.6: WC: wartburg.edu; 19.7: WC: Albert Herring; 19.8: WC: Google Art and Culture; **20.1a:** WC: Peter Trimming; 20.1b &20.9a: WC: Jorge Royan; 20.1c & 20.9b: WC: I, Sailko; 20.2: Metropolitan Museum of Art: Gift of Mrs. Grafton H. Pyne, 1951; 20.3: WC; 20.4: WC: Erich Lessing Culture and Fine Arts Archives via artsy.net; 20.5: WC: Museum of Fine Arts, Boston; 20.6: Metropolitan Museum of Art: Gift of Mrs. Russell Sage, 1908; 20.7 & 20.8: clipart.com; **21.1:** WC: The Yorck Project; 21.2: Brooklyn Museum: Frank L. Babbott Fund; 21.3: WC: Google Art Project; 21.4: WC: Google Art Project; 21.5: WC: Provided directly by Library of Congress Prints and Photographs Division; 21.6: WC: Google Art Project; 21.7: Metropolitan Museum of Art: Gift of Paul J. Sachs, 1916; 21.88: WC: Google Cultural Institute; 21.9: WC: The Yorck Project; 21.10: WC: The Yorck Project; 21.11: Universal Color; 21.12: WC: Google Art Project; 21.13 & 21.14a: author; 21.14b: WC: Beyond My Ken; 21.14c: © Jonathan Rutchik; 21.15: WC: PMRMaeyaert; 21.16: WC: Google Art Project; **22.1:** © 2019 Succession H. Matisse/Artists Rights Society (ARS), New York; 22.2: Universal Color © 2019 Artists Rights Society (ARS), New York; 22.3: WC; 22.4: WC: https://www.ketter-erkunst.de/ 22.5: Universal Color; © 2019 Estate of Pablo Picasso/Artists Rights Society (ARS), New York; 22.6: Offentliche Kunstsammlung, Basel, Switzerland/Bridgeman Images. © 2019 Artists Rights Society (ARS), New York/ADAGP, Paris; 22.7: The Philadelphia Museum of Art, Pennsylvania, PA, USA, The Louise and Walter Arensberg Collection, 1950/Bridgeman Images, © Succession Brancusi - All rights reserved (ARS) 2019; 22.8: clipart.com; 22.9: Universal Color; © Association Marcel Duchamp/ADAGP, Paris/Artists Rights Society (ARS), New York 2019; 22.10: © 2019 Artists Rights Society (ARS), New York/ProLitteris, Zurich; Digital Image © The Museum of Modern Art/Licensed by SCALA/Art Resource, NY; 22.11: © 2019 Banco de México Diego Rivera Frida Kahlo Museums Trust, Mexico, D.F./Artists Rights Society (ARS), New York clipart.com; 22.12: Museum of Modern Art, New York, USADe Agostini Picture Library/Bridgeman Images, © 2019 Artists Rights Society (ARS), New York/ADAGP, Paris; 22.13: Museum of the Revolution, Moscow, Russia/Bridgeman Images; © 2019 Artists Rights Society (ARS), New York/UPRAVIS, Moscow; 22.14: WC; 22.15: Carlos Rodriguez; 22.16a & 22.16b: Library of Congress: Jack E. Boucher; 22.16c: WC: Arsenalbubs; 22.17a & 22.17b: WC: Kate Wagner; 22.18: author; 22.19: The Phillips Collection, Washington, DC. Acquired 1942; © 2019 The Jacob and Gwendolyn Knight Lawrence Foundation, Seattle/Artists Rights Society (ARS), New York; 22.20: Alfredo Dagli Orti/Art Resource, NY; © 2019 Banco de México Diego

Rivera Frida Kahlo Museums Trust, Mexico, D.F./Artists Rights Society (ARS), New York; 22.21: Digital Image © The Museum of Modern Art/Licensed by SCALA/Art Resource, NY; © 2019 The Willem de Kooning Foundation /Artists Rights Society (ARS), New York; 22.22: Detroit Institute of Arts, USA/Bridgeman Images; 22.23 Private Collection Photo © Christie's Images/ Bridgeman Images; © 2019 The Andy Warhol Foundation for the Visual Arts, Inc. /Licensed by Artists Rights Society (ARS), New York; Marilyn Monroe™; Rights of Publicity and Persona Rights: The Estate of Marilyn Monroe LLC. marilynmonroe.com; 22.24: Yale University Art Gallery, Gift of Colossal Keepsake Corporation Copyright 1969 Claes Oldenburg; 22.25a & 22.25b: Copyright Yayoi Kusama; 22.26: Universal Color © 2019 Holt/Smithson Foundation and Dia Art Foundation/Licensed by VAGA at Artists Rights Society (ARS), NY; 22.27a: The Architectural Archives, University of Pennsylvania, by the gift of Robert Venturi and Denise Scott Brown, photo by Matt Wargo; 22.27b: The Architectural Archives, University of Pennsylvania, by the gift of Robert Venturi and Denise Scott Brown; **23.1:** clipart.com; 23.2: WC: Fars News Agency; 23.2b: WC: Unesco F. Riviere; 23.3: Iconotec/Alamy Stock Photo; 23.4a & 24.4b: WC: Biswarup Ganguly; 23.4c: WC: Raveesh Vyas; 23.4d & 23.4e: WC: H. Gardner, Art Through the Ages, (New York: Harcourt, Brace, & Co., 1926), p 409, fig. 119; 23.4a: WC: Tropenmuseum, part of the National Museum of World Cultures; 23.4b: WC: Gunawan Kartapranata; 24.4c: WC: Jan-Pieter Nap; 23.6: Metropolitan Museum of Art, Gift of R. H. Ellsworth Ltd., in honor of Susan Dillon, 1987; 23.7a & 23.10a: WC: Itsmalay~commonswiki; 23.7b & 23.10b: WC: Hiroki Ogawa; 23.7c: WC: Arnold Betten; 23.7d: Jonathan Rutchik; 23.8a: istockphoto; 23.8b: WC: BluesyPete; 23.8c: WC: Markalexander100; 23.8d: WC: Hans Stieglitz; 23.8e: WC: Baldin; 23.9: WC; 23.10: WC; **24.1:** Carlos Rodriguez; 24.2a: WC: kallgan; 24.2b: WC: Ekrem Canli; 24.2c & 24.12a: WC: Thorsten; 24.2d & 24.12b: WC: Tommy Chen; 24.3a & 24.3b: Carlos Rodriguez; 24.3c: clipart.com; 24.4: WC: Yann Forget; 24.5: WC: Google Cultural Institute; 24.6: WC: Cultural Heritage Information Center of South Korea; 24.7: © The Chambers Gallery, London/Bridgeman Images; 24.8a: WC: Jmhullot; 24.8b: WC: G41rn8; 24.9a: WC: Aberlin; 24.9b: WC: Headrock; 24.9c: WC: Alex Kwok; 24.10 & 24.12: WC: David Trowbridge; 24.11: WC: Szukas; **25.1a:** WC: Wiiii; 25.1b, 25.1c & 25.1d: WC: sailko; 25.1e: WC: Jakubhal; 25.2a: WC: Dingy; 25.2b: WC: Bjørn Christian Tørrissen; 25.2c: Jonathan Rutchik; 25.3a & 25.3b: WC: http://learn.bowdoin.edu/heijiscroll/viewer.html; 25.4a & 25.4b: WC; 25.5: Metropolitan Museum of Art: H. O. Havemeyer Collection, Bequest of Mrs. H. O. Havemeyer, 1929; 25.6: WC: Nezu Gallery; **26.1a:** author; 26.1b & 26.15: WC: Reto Luescher; 26.1c: © Charles and Josette Lenars/Corbis; 26.1d: Cleveland Art Museum: Gift of Mr. and Mrs. Paul Tishman 1958.183; 26.2a: Dreamstime/Nick Leonard; 26.2b: WC: Joaquín Bravo Contreras; 26.3: WC: Toby 87; 26.4: WC: Timothy A. Price and Nichole I.; 26.5a: WC: Wolfgang Sauber; 26.5b: WC: miguelão; 26.5c: WC: Ceridwen; 26.5d: G. Dagli Orti /De Agostini Picture Library/Bridgeman Images; 26.6: WC: MaunusA; 26.7: Werner Forman Archive/Bridgeman Images; 26.8a: author; 26.8b: WC: Diego Delso, delso.photo, License CC-BY-SA; 26.8c: WC: Bcasterline; 26.9a: WC: icelight; 26.9b: WC: Pavel Š pindler; 26.9c: WC: Cyntia Motta; 26.10: WC; 26.11: National Museum of the American Indian; 26.12a & 26.12b: Photo: Hughes Dubois © musée du quai Branly - Jacques Chirac, Dist. RMN-Grand Palais/Art Resource, NY; 26.13: Brooklyn Museum: Dick S. Ramsey Fund, 64.13; 26.14: Smithsonian American Art Museum, Washington, DC/Art Resource, NY; **27.1a** & 27.15: WC: Simonchihanga; 27.1b: WC: Siyajkak; 27.2: Flicker: upyernoz; 27.3a: Metropolitan Museum of Art: The Michael C. Rockefeller Memorial Collection, Gift of Nelson A. Rockefeller, 1965; 27.3b: Werner Forman Archive/Bridgeman Images; 27.4: © Marc Deville/Gamma-Rapho via Getty Images; 27.5a: Brooklyn Museum: Purchased with funds given by Mr. and Mrs. Alastair B. Martin, Mrs. Donald M. Oenslager, Mr. and Mrs. Robert

and the Mrs. Florence A. Blum Fund, 61.33; Fig. 15: Photograph by Eliot Elisofon, 1971 , Eliot Elisofon Photographic Archives, National Museum of African Art, Smithsonian Institution; Fig. 16: Bridgeman Images; Fig. 17: Metropolitan Museum, Purchase, Rogers Fund and The Kevorkian Foundation Gift, 1955; Fig. 18: Metropolitan Museum, Marquand Collection, Gift of Henry G. Marquand, 1889; Fig. 19: WC: Galeria Online; Fig. 20: Metropolitan Museum, Gift of Iris and B. Gerald Cantor Foundation, 1984; Fig. 21: Harvard Art Museums/Arthur M. Sackler Museum, Bequest of Abby Aldrich Rockefeller © President and Fellows of Harvard College; Fig. 22: WC: Google Cultural Institute; Fig. 23 & 24: Brooklyn Museum: Gift of Lilla Brown in memory of her husband, John W. Brown, by exchange, 2012.21; Fig. 25: WC: The Yorck Project (2002); Fig. 26: WC: Google Art Project; Fig. 27: WC: National Gallery; Fig. 28: Cleveland Art Museum: Gift of Mr. and Mrs. Paul Tishman 1958.183; Q1: WC: Provided directly by Library of Congress Prints and Photographs Division; Q3: WC; Q4: © The Chambers Gallery, London/Bridgeman Images; Q5: WC: Michel Wal; Q6a: WC: Olvr; Q6b: WC: JB Thomas4; **Practice Test 2**: Fig. 1: © Michel Tuffery, Purchased 1995 with New Zealand Lottery Grants Board funds; Fig. 2: Bridgeman Images; Fig. 3: © Jonathan Rutchik; Fig. 4: WC: Explicit; Fig. 5: National Gallery of Australia, Canberra/Purchased 1977/Bridgeman Images; Fig. 6: WC: Web Gallery of Art; Fig. 7 © 2019 Succession H. Matisse/Artists Rights Society (ARS), New York; Fig. 8: WC: Guillaume Massardier; Fig. 9: Metropolitan Museum: The Annenberg Foundation Gift, 1993; Fig. 10: De Agostini Picture Library/A. Dagli Orti/Bridgeman Images; Fig. 11: Metropolitan Museum of Art: Harris Brisbane Dick Fund, 1939; Fig. 12: WC: Marie-Lan Nguyen; Fig. 13: WC: Kate Wagner; Fig. 14: Metropolitan Museum of Art: Gift of Jeff Soref and Paul Lombardi, in honor of Natalie Soref, 2015; Fig. 15: WC: Marie-Lan Nguyen; Fig. 16: WC: MMPublic domain; Fig. 17: clipart.com; Fig. 8: WC: M.violante; Fig 19: WC; Fig. 20: WC: Christophe Finot; Fig. 21: © Marc Deville/Gamma-Rapho via Getty Images; Fig. 22: WC; Figure 23: WC: Yorck Project; Q1: The Broad Art Foundation Photo credit: Douglas M. Parker Studio, Los Angeles; Q3: WC; Q4a: WC: Alejo2083; Q4b: WC: Livioandronico2013; Q5: WC; Q6a: Metropolitan Museum of Art: The Michael C. Rockefeller Memorial Collection, Gift of Nelson A. Rockefeller, 1965; Q6b: Werner Forman Archive/Bridgeman Images; **Online Test 1:** Fig. 1 & Fig. 2: © Kira Perov, Bill Viola Studio; Fig. 3: The National Library of Israel Collections; Fig. 4: http://www.bl.uk/catalogues/illuminatedmanuscripts/ILLUMIN.ASP?Size=mid&IllID=57013; Fig. 5: WC: Grb16; Fig. 6: WC: Peter Trimming; Fig. 7: WC: I, Sailko; Fig. 8: WC; Fig. 9: WC: Web Gallery of Art; Fig. 10: Metropolitan Museum of Art, Rogers Fund, 1948; Fig. 11: WC: JB Thomas4; Fig. 12: Universal Color; Fig. 13: Brooklyn Museum: Dick S. Ramsey Fund, 64.13; Fig. 14: © RMN-Grand Palais/Art Resource, NY; Fig. 15: © The Chambers Gallery, London/Bridgeman Images; Q1: Harvard Art Museums/Arthur M. Sackler Museum, Bequest of Abby Aldrich Rockefeller © President and Fellows of Harvard College; Q3: WC: Myrabella; Q4: WC: Antoine Taveneaux; Q5: Neue Galerie New York; Q6: WC: Keith Schengili-Roberts; **Online Test 2:** Fig 1: Copyright Yayoi Kusama; Fig. 2: WC: Romaine; Fig. 3: Scala/Art Resource, New York; Fig. 4: © Marc Deville/Gamma-Rapho via Getty Images; Fig. 5 & Fig 6: WC: Gryffindor; Fig. 7: WC: Till Niermann; Fig. 8: WC: AlbertHerring; Fig. 9: Library of Congress: Jack E. Boucher; Fig. 10: WC; Fig. 11: WC: Myrabella; Fig. 12: WC: Atlant; Fig. 13: WC; Fig. 14: WC: Markalexander100; Fig. 15: WC: Steve Swayne; Fig. 16: Metropolitan Museum of Art: The Michael C. Rockefeller Memorial Collection, Gift of Nelson A. Rockefeller, 1965; Fig. 17: Courtesy of the artist and Metro Pictures, New York; Q1: Art Institute of Chicago; Q3: Metropolitan Museum, Bequest of Sam A. Lewisohn, 1951; Q4: WC; Q5: Metropolitan Museum, Gift of Mr. and Mrs. Klaus G. Perls, 1990; Q6: WC: Till Niermann

Index